Collins complete
artist's
manual

Collins complete
artist's
manual

SIMON JENNINGS

Collins

First published in 2005 by
Collins, an imprint of
HarperCollins*Publishers*
77–85 Fulham Palace Road
Hammersmith
London W6 8JB

Original concept, design and editorial direction of *Collins Artist's Manual* and *Collins Art Class*, from which this new edition has been created, by Simon Jennings; and produced, edited and designed by Inklink

This new, redesigned edition was produced by
SP Creative Design
Editor: Heather Thomas
Design and production: Rolando Ugolini

The Collins website address is www.collins.co.uk

10 09 08 07 06
6 5 4 3 2

A catalogue record for this book is available from the British Library

ISBN - 13 978 0 00 719782 8

ISBN - 10 0 00 719782 9

Colour origination by Colourscan, Singapore
Printed and bound by Imago, China

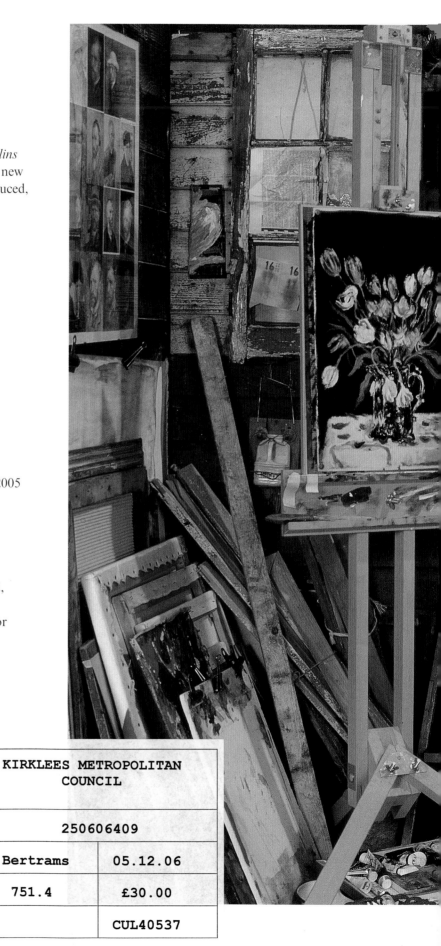

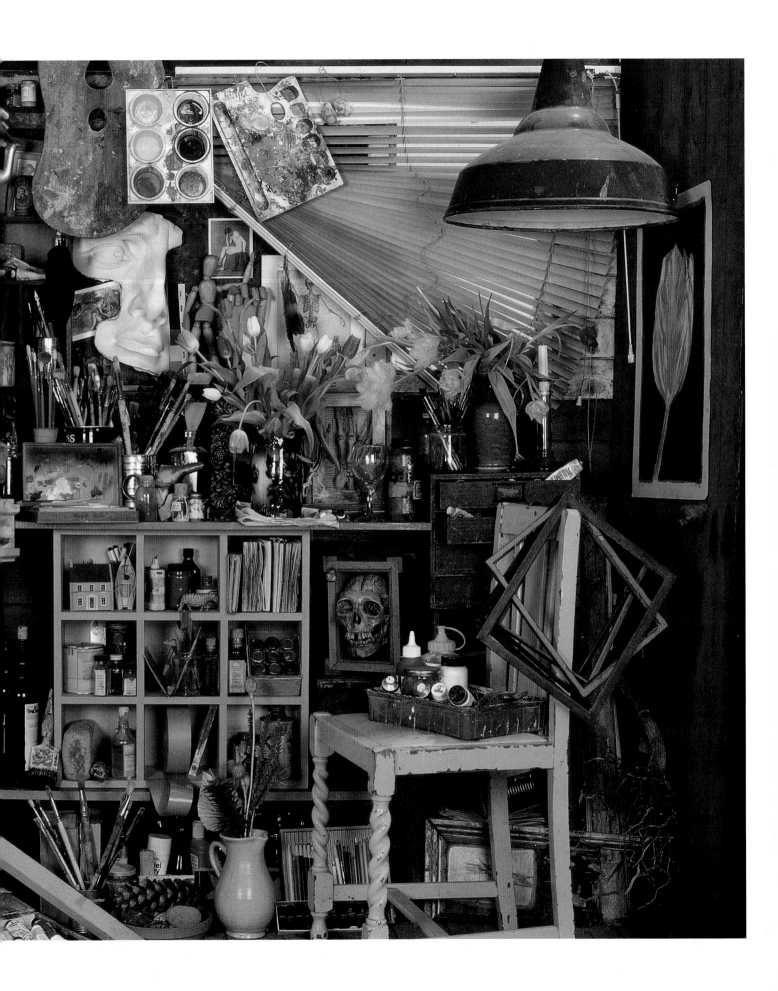

Contents

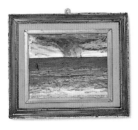

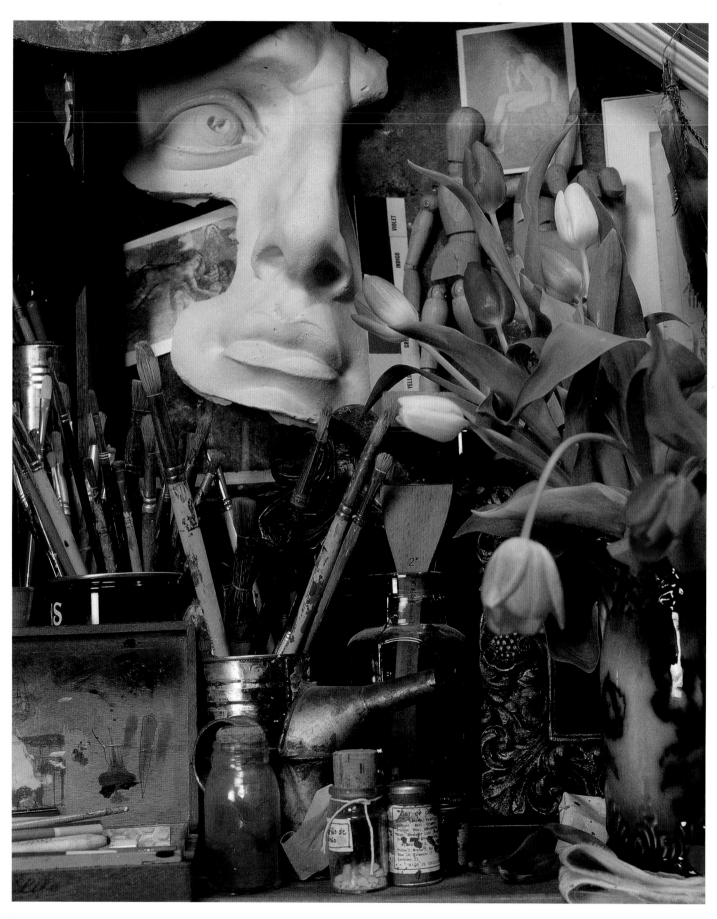

Renoir once observed that 'painting isn't just daydreaming, it is primarily a manual skill, and one has to be a good workman'. Too often it is forgotten that painting is a craft as well as an art – and a difficult craft to master, at that.

At first sight, dipping a brush into paint and applying it to a surface seems easy enough. But there are traps for the unskilled: an inadequately prepared support may warp or buckle; the wrong support can adversely affect the way the paint handles; ill-chosen colours turn muddy when mixed together; poor-quality or fugitive colours will fade in time. By understanding the materials and techniques at his or her disposal, the artist can avoid such pitfalls and increase the pleasures of making art. In recent decades, art schools have tended to dismiss basic skills and techniques as 'irrelevant', and they have been neglected in favour of 'freedom of expression'. In so doing, tutors have thrown the baby out with the bathwater, for without a thorough technical grasp of materials and methods, students of art have no real freedom to express their ideas – it is like asking someone with no knowledge or concept of grammar or syntax to write a novel.

This is not to imply that a good craftsperson is necessarily a good artist. Manual dexterity and technical know-how are meaningless if an artist's work is deficient in thought and feeling. Along with a learning hand, one must develop a seeing eye – and for many people, this is the most difficult part. In the desire to produce a 'finished' picture, the impatient student often overlooks the two things that are fundamental to all art: drawing and observation. It is vital to train your eyes by really looking at the world around you, and to keep sketching and drawing all the time. When you draw what you see, you develop your powers of observation and analysis. Your mind absorbs many details – for instance, the way light and shadow create form, how tone and colour alter with distance – enabling you to draw a surprising amount from memory and from imagination.

The purpose of this manual, then, is twofold. First, by providing an in-depth examination of the skills and techniques involved, not only in painting and drawing but also in preparing a support and in choosing and mixing colours, it endeavours to encourage a pride in the craftsmanship needed to produce a work of art. Second, by using a wide range of work by respected professional artists as a source of inspiration, it aims to help you develop your personal vision of the world and to find your own voice in interpreting that vision.

Acknowledgements

This book is the work of many hands, and is the result of several years' planning and preparation. The designers, editors and producers are indebted to all who have contributed and have given freely of their time and expertise. Our thanks go to the following:

Editorial Consultants

Dr Sally Bulgin
Editor and owner of *The Artist* and *Leisure Painter* magazines. Author of several art instruction books

Angie Gair
Author of several art instruction books

Art and Technical Consultants

Trevor Chamberlain, ROI, RSMA
Carolynn Cooke
David Curtis, ROI, RSMA
John Denahy, NEAC
John Lloyd
Terry McKivragan
John Martin
Ian Rowlands
Brian Yale

With special thanks to:
Ken Howard, RA, ROI, RWS, NEAC
Daler-Rowney Ltd
Emma Pearce
Winsor & Newton

Demo Artists

Alastair Adams
Ray Balkwill
David Day
Jennie Dunn
David Griffin
Timothy Easton
Robin Harris
Nick Hyams
David Jackson
Ella Jennings
Simon Jennings
Ken Howard
John Lidzey
Debra Manifold
Alan Marshall
Kay Ohsten
Ken Paine
Peter Partington
Jackie Simmonds
Shirley Trevena
Valerie Wiffen
Colin Willey
Laurence Wood
John Yardley

Artists

Grateful thanks also go to the following artists, who generously loaned samples of materials, artworks and transparencies, and who provided much time, advice and assistance:

Alastair Adams
Victor Ambrus
Nick Andrew
Penny Anstice
Paul Apps
Barry Atherton
Gigol Atler
Ray Balkwill

Valerie Batchelor
Joan Elliott Bates
Richard Bell
John Blockley
Jane Camp
Sarah Cawkwell
Trevor Chamberlain
Terence Clarke
Tom Coates
Jill Confavreux
Grenville Cottingham
Edwin Cripps
James Crittenden
Fred Cuming
David Curtis
David Day
John Denahy
Sarah Donaldson
Jennie Dunn
Timothy Easton
Sharon Finmark
Roy Freer
Kay Gallwey
Annabel Gault
Geraldine Girvan
Peter Graham
David Griffin
Gordon Hales
Roy Hammond
Robin Harris
Desmond Haughton
Andrew Hemingway
Ken Howard
Michael Hyam
Nick Hyams
Alan Hydes
David Jackson
Pauline Jackson
Ella Jennings
Simon Jennings
Ronald Jesty
Carole Katchen
Sally Keir
Sophie Knight
Tory Lawrence

John Lidzey
Anna Macmiadhachain
Padraig Macmiadhachain
Debra Manifold
John Martin
Judy Martin
Simie Maryles
Donald McIntyre
Alex McKibbin
Terry McKivragan
John Monks
Alison Musker
Patricia Mynott
Keith New
Kay Ohsten
Ken Paine
Peter Partington
Elsie Dinsmore Popkin
Penny Quested
John Raynes
Jacqueline Rizvi
Keith Roberts
Dennis Mathew Rooney
Leonard Rosoman
George Rowlett
Naomi Russell
Hans Schwarz

Hil Scott
Barclay Sheaks
Jackie Simmonds
Richard Smith
Michael Stiff
Sally Strand
David Suff
Robert Tilling
Shirley Trevena
Jacquie Turner
Sue Wales
Valerie Wiffen
Colin Willey
Anna Wood
Leslie Worth
Brian Yale
John Yardley
Rosemary Young

Galleries

Art Space Gallery, London
Chris Beetles Gallery,
London
Browse and Darby, London
The Fine Art Society,
London
Fischer Fine Art, London
Kentmere House Gallery,
York
Lizardi / Harp Gallery,
Pasadena, California
Llewellyn Alexander
Gallery, London
Montpelier Studio, London
Museum of Modern Art,
New York
National Gallery, London

New Academy Gallery,
London
New Grafton Gallery,
London
On Line Gallery,
Southampton
Piccadilly Gallery, London
Redfern Gallery, London
Brian Sinfield Gallery,
Burford
Tate Gallery, London
Westcott Gallery, Dorking

Companies

Acco-Rexel
Arnesby Arts
The Artist magazine
Berol
Bird & Davis
Ken Bromley's Perfect Paper
Stretcher
R.K. Burt & Co.
Canson
ChromaColour
ColArt
L. Cornelisson & Son
Daler-Rowney Ltd
Falkiner Fine Papers
Frisk Products
Inscribe
Intertrade International
Jakar International
Khadi
Koh-i-Noor
Letraset UK
A. Levermore & Co.
Liquitex UK

David Lloyd Picture
Framers
Martin/F. Weber Co.
Osborne & Butler
Pentel
Philip & Tracey
Pro Arte
Project Art
C. Robertson & Co.
Raphael & Berge
Rotring UK
Royal Sovereign
St Cuthbert's Paper Mills
Tate Gallery Publications
Tollit & Harvey
Unison
Winsor & Newton

Photographers and picture sources

Studio photography by Paul
Chave and Ben Jennings
Other photography by:
Acco-Rexel Ltd; John
Couzins; Daler-Rowney
Ltd; Ikea Ltd; Simon
Jennings; Raphael & Berge
SA; and Shona Wood

Supports

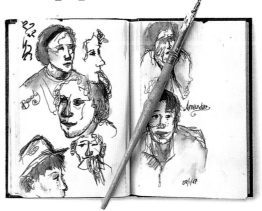

Before starting a painting or drawing, it is worth spending some time choosing and preparing the surface, or support, as this will have a great bearing on which medium you use, and the effects that you are able to achieve with it. Although the range of canvases, panels and papers may seem somewhat bewildering at first glance, finding the right support for your purpose is not very difficult when you understand the properties of each one. A properly prepared support will greatly increase the longevity of a work and, in addition, you can derive a lot of pleasure and satisfaction from this aspect of the artist's work.

Canvas

In painting, canvas is still the most widely used of all supports. Stretched-and-primed canvas is taut but flexible, and has a unique receptiveness to the stroke of the brush. The two most common fibres for making canvas are linen and cotton, although hessian and synthetic fibres are also used. Each of these fibres differs in terms of durability, evenness of grain, ease of stretching and cost.

Wet the stretched linen canvas and allow it to dry.

• Canvas weights
The weight of canvas is measured in grams per square metre (gsm) or ounces per square yard (oz). The higher the number, the greater density of threads. Better-grade cotton canvas, known as cotton duck, comes in 410gsm (12oz) and 510gsm (15oz) grades. Lighter-weight canvases of between 268gsm (8oz) and 410gsm (12oz) are recommended for practice only.

Popular artist's canvases
1 Ready-primed cotton-rayon mix
2 Ready-primed cotton duck
3 Ready-primed artist's linen
4 Superfine artist's linen
5 Cotton duck
6 Flax canvas
7 Cotton and jute twill

Linen canvas
Linen is considered the best canvas because it has a fine, even grain that is free of knots and is a pleasure to paint on. Although expensive, it is very durable and, once stretched on a frame, retains its tautness. Good-quality linen has a tight weave of even threads which will persist through several layers of primer and paint; avoid cheap linen, which is loosely woven.

Preparing linen canvas
The weaving process makes raw linen canvas prone to shrinking and warping when it is stretched, and it has a tendency to resist the application of size. However, both these problems can be solved by temporarily stretching the canvas, wetting it and allowing it to dry. Then remove the canvas from the stretcher bars and re-stretch it; this second stretching creates a more even tension across the cloth.

Cotton canvas
A good-quality 410–510gsm (12–15oz) cotton duck is the best alternative to linen, and is much cheaper. Cotton weaves of below 410gsm (12oz) are fine for experimenting with, but they stretch much more than linen and, once stretched, they are susceptible to fluctuations in tension in either humid or dry conditions. The weave of cheap cotton quickly becomes obscured by layers of primer and paint, leaving the surface rather flat and characterless.

Ready-prepared supports
You can buy ready-primed and stretched supports which consist of a piece of canvas mounted on a stretcher. These supports are convenient, but are expensive when compared to the cost of stretching, sizing and priming your own canvas.

▶ SEE ALSO
▶ **Stretching canvas 16**
▶ **Sizing for oils 22**
▶ **Priming 24**
▶ **Oil paints 64**
▶ **Acrylic paints 110**

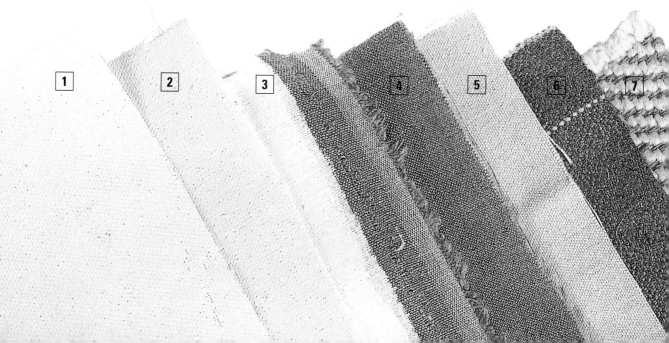

1 2 3 4 5 6 7

Hessian

Hessian is inexpensive, but has a very coarse weave and requires a lot of priming. It is liable to become brittle and lifeless in time.

Synthetic fibres

Synthetic fabrics, such as rayon and polyester, are now used in the manufacture of artists' canvas. These canvases come ready-prepared with acrylic primer and are worth trying out, as they are exceptionally strong and durable, flexible but stable, and resistant to chemical reaction.

Canvas textures

If you use bold, heavy brushstrokes, canvas with a coarsely woven texture is the most suitable. A smooth, finely woven texture is more suited to fine, detailed brushwork. Another consideration is the scale of your painting. A fine-grained canvas is best for small works, as the texture of coarse-grained canvas may be too insistent and detract from the painting.

Ready-primed canvas

Ready-primed canvas comes prepared with either an oil- or an acrylic-based primer. It is better to use an oil-primed canvas for oil painting and leave acrylic-primed ones for acrylic paintings, but you can use an acrylic-primed canvas for oils if you paint thinly and on a small scale.

Canvas may be single- or double-primed. The latter is more expensive; it has a denser surface, but it is less flexible than single-primed canvas.

Overlap
Remember to add a minimum of 50mm (2in) of canvas all round, for when you attach it to the stretcher.

Canvas texture
The formal elegance of this abstract painting is enhanced by the subtle texture of the linen canvas, which appears through the thin layers of oil paint.

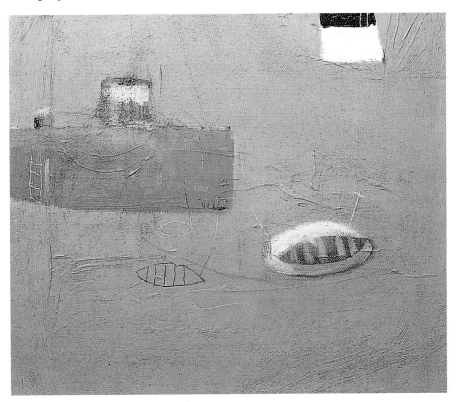

Pádraig Macmiadhachain
Blue Morning
Oil on canvas
25 x 30cm (10 x 12in)

15

Stretching canvas

Stretching your own canvas not only offers a saving in cost, but also means that you can prepare a canvas to your own specifications.

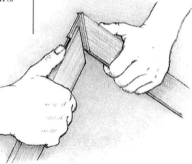

Stretcher bars

Wooden stretcher bars are sold in most art-supply stores and come in different lengths. They have pre-mitred corners with slot-and-tenon joints. The face side of each stretcher bar is bevelled to prevent the inner edge of the stretcher creating 'ridge' lines on the canvas.

Stretcher bars come in varying widths and thicknesses, depending on the size of support you wish to make. For a work under 60 x 60cm (24 x 24in), use 45 x 16mm (1³/₄ x ⁵/₈in) stretcher bars. For larger works, use 57 x 18mm (2 ¹/₄ x ³/₄in) bars.

Wedges

You will also need eight wedges or 'keys' for each stretcher. These fit into slots on the inside of each corner of the assembled stretcher; if the canvas sags at a later date, the wedges can be driven in further with a hammer, to expand the corners and make the canvas taut again.

Canvas-straining pliers

Canvas-straining pliers are especially useful for stretching ready-primed canvases. They grip the fabric firmly without any risk of tearing, and the lower jaw is bevelled to give good leverage when pulling fabric over a stretcher bar; the correct tension is achieved by lowering the wrist as the canvas passes over the back of the frame.

Other equipment

Use a heavy-duty staple gun and non-rusting staples with a depth of at least 10mm (³/₈in) to fix the canvas to the frame. You will also need a rule or tape, a pencil and a pair of scissors to measure and cut out the canvas; a wooden mallet to tap the stretcher bars together; and a T-square to check that the frame is square (or you can use a length of string to ensure that the diagonal measurements between the corners are the same).

• Large canvases
A support that is larger than 80 x 100cm (32 x 40in) will require an extra crossbar between the two longest sides, to support them when the canvas contracts during preparation, exerting a great deal of force.

• Tacks
Using a hammer and non-rusting tinned tacks to fix the canvas to the frame is more economical than stapling, but means more work.

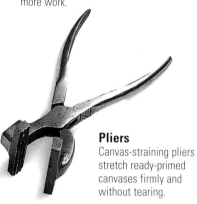

Pliers
Canvas-straining pliers stretch ready-primed canvases firmly and without tearing.

Cutting the canvas
Use pinking shears to cut canvas; they avoid the need to fold the edges over at the back of the frame to prevent the canvas fraying.

Assembling the stretcher frame
Slot the stretcher bars together, checking that all the bevelled edges are at the front, Tap the corners gently with a wooden mallet or a piece of wood for a close fit.

Checking for square
Use a T-square to check that all the corners of the assembled frame make right angles. Double-check by measuring the diagonals with an expanding tape measure or a length of string; they should be of equal length. If the frame is out of true, correct it by gently tapping the corners with the mallet.

▶ SEE ALSO
▶ Canvas 14
▶ Sizing for oils 22

Stretching the canvas

Working on a large table or the floor, lay the frame bevel-side down on a piece of canvas. Cut the canvas to fit the frame, allowing a margin of about 50mm (2in) all round for stapling (**1**).

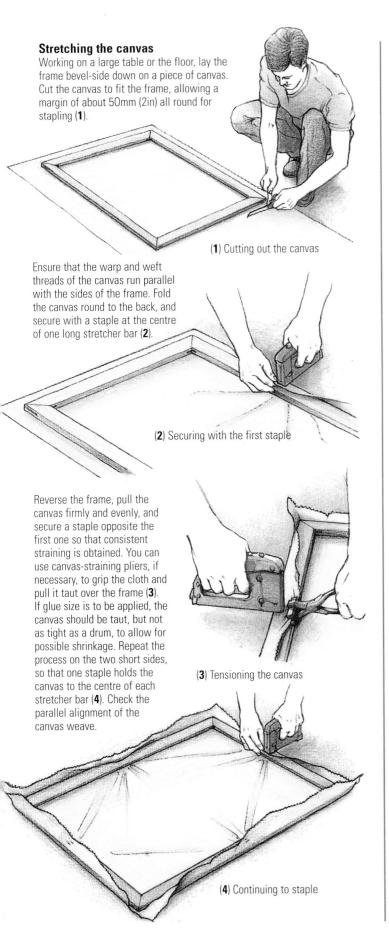

(**1**) Cutting out the canvas

Ensure that the warp and weft threads of the canvas run parallel with the sides of the frame. Fold the canvas round to the back, and secure with a staple at the centre of one long stretcher bar (**2**).

(**2**) Securing with the first staple

Reverse the frame, pull the canvas firmly and evenly, and secure a staple opposite the first one so that consistent straining is obtained. You can use canvas-straining pliers, if necessary, to grip the cloth and pull it taut over the frame (**3**). If glue size is to be applied, the canvas should be taut, but not as tight as a drum, to allow for possible shrinkage. Repeat the process on the two short sides, so that one staple holds the canvas to the centre of each stretcher bar (**4**). Check the parallel alignment of the canvas weave.

(**3**) Tensioning the canvas

(**4**) Continuing to staple

Securing the canvas

Now add two more staples to each of the four stretcher bars – one on either side of the centre staples – following the sequence shown in the diagram (**5**). The staples should be evenly spaced at 50mm (2in) intervals. Continue adding pairs of staples to each side, gradually working towards the corners. Insert the final staples about 50mm (2in) from each corner. Note that working systematically out to the corners keeps each side in step with the others. Fastening the canvas completely on one side before doing the next, stretches the canvas unevenly.

Finishing off

The corners should always be finished off neatly; if they are too bulky you will have difficulty in framing the picture. Pull the canvas tightly across one corner of the stretcher, and fix with a staple (**6**). Then tuck in the flaps on either side smoothly and neatly (**7**) and fix with staples. Take care not to staple across the mitre join, as this will make it impossible to tighten the canvas later on. Then fix the diagonally opposite corner, followed by the remaining two. If necessary, hammer the folds flat to produce a neat corner (**8**). Finally, insert two wedges in the slots provided in each of the inner corners of the frame; for correct fit, the longest side of each wedge should lie alongside the frame (**9**). Tap the wedges home very lightly. The canvas is now ready for sizing and priming.

(**5**) Stretching and stapling

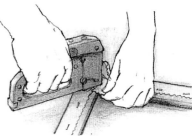

(**6**) Fixing the first corner staple

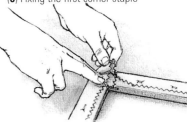

(**7**) Folding the flaps

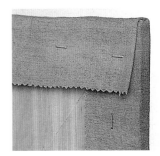

(**8**) The finished corner

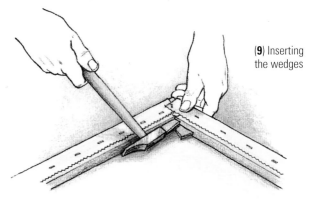

(**9**) Inserting the wedges

Boards and panels

Man-made boards are cheaper to buy and prepare than stretched canvas; they are also easier to store and transport, and they will provide a more durable support than canvas.

Wood panels

Wood, for centuries the traditional support for oil and tempera painting, can no longer be relied upon to be well seasoned, so it tends to split and warp. It is also heavy to transport, and is now largely superseded by economical composition boards.

Hardboard (masonite)

Hardboard is inexpensive, strong and lightweight. It is available in two forms: tempered and untempered. The tempered variety is suitable for oil paints and primers, and it does not require sizing. For acrylic painting, however, use untempered board, which has no greasy residue. Sundeala board, grade 'A', is particularly recommended, as it is lightweight and its surface is slightly more porous than standard hardboard, giving a good key for size and primer.

Hardboard has one smooth and one rough side; the smooth side is the one most often used. The rough side has a texture which resembles coarse canvas, but it is only suitable for heavy impasto work, as the texture is very mechanical and over-regular.

Hardboard is prone to warping, particularly in humid climates, but this risk is reduced by priming the front, back and edges of the board. Paintings larger than 45cm (18in) square should additionally be braced with a framework of wood battening across the back (see left).

Plywood

Plywood comes in various thicknesses and has smooth surfaces. It does not crack, but it can warp. To keep the sheet stable, size and prime it on the front, back and edges. Large sheets should be battened or 'cradled' by gluing wooden battens to the back of the board (see left).

Chipboard

Chipboard is made from wood particles compressed into a rigid panel with resin glue. Thick panels of chipboard are a sound support as they do not crack or warp and don't require cradling, but they are heavy to transport. Another disadvantage is that the corners and edges may crumble, and, being absorbent, they need to be well primed.

Medium-density fibreboard [MDF]

MDF is made from pressed wood fibre and is available in a wide range of thicknesses and in standard board sizes. It is a dense, heavy, but very stable, material and has fine, smooth surfaces. MDF is easily cut by hand or with machine tools. Large, thin panels may need to be cradled, to help keep them flat (see left).

• **Keying hardboard**
Before painting on the smooth side of hardboard, lightly sand the surface to provide a key for the application of primer.

• **Preparing a panel**
To save time, an artist will periodically prepare a batch of panels at once, all cut from one sheet of board. For example, from a sheet of hardboard measuring 120 x 240cm (4 x 8ft) you can cut thirty-two 30 x 30cm (12 x 12in) panels, or thirty-eight 25 x 30cm (10 x 12in) panels. Most timber yards cut board for a small fee, or you can cut it yourself.

• **Cutting panels**
Mark out the sheet with a rule and pencil, making sure all the corners are square, and saw along these lines. Now 'dress' the edges of each panel with a sanding block to remove any burrs from the saw cuts. To provide a key for the size or priming coat, lightly sand the surface of each panel. Always use a light touch; too much downward pressure may create depressions in the board.

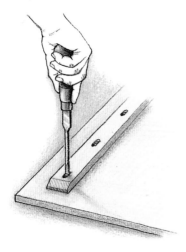

Cradling boards
Cut two battens 50mm (2in) shorter than the width of the board. Chamfer the ends and then secure the battens to the back of the board, using wood glue for man-made boards, or woodscrews for solid wood or thicker boards.

▶ SEE ALSO
▶ Sizing for oils 22
▶ Priming 24
▶ Watercolour papers 28
▶ Supports for pastels 34
▶ Oil paints 64
▶ Watercolour paints 87
▶ Gouache 104
▶ Tempera 108
▶ Acrylic paints 110

Cardboard

Degas and Toulouse-Lautrec painted on unprimed cardboard on occasions; they used its warm brown colour as a middle tone, and produced a matt, pastel-like effect on the absorbent surface. However, a finished painting must be framed under glass if it is to last. Cardboard must be sized on both sides and on the edges, to prevent warping and to stop impurities in the cardboard from leaching into the paint.

Mount board

Heavy mount board, or pasteboard, is available in a range of colours and has a smooth surface suitable for painting in acrylics and gouache, particularly when thin washes and glazes are applied. It is also used for pen-and-ink drawing. Always choose conservation board for work that is intended to last, as this is guaranteed acid-free.

Watercolour board

Watercolour board consists of a solid core faced with good-quality watercolour paper. The board provides extra strength and stability, and dispenses with the need for stretching paper prior to painting. Check that the core of the board, as well as the paper, is acid-free. Watercolour boards also perform well with pastel and charcoal.

Pastel board

Pastel paper mounted on board is available in a range of sizes, colours and finishes, from soft velour to a high-tooth, abrasive surface.

• Cardboard and hardboard
Cardboard's warm colour brings a mellow harmony to Toulouse-Lautrec's oil sketch (below). Note how the brush drags on the absorbent surface. For his bravura painting (below right), Tom Coates used the reverse side of some unprimed hardboard. There is a lively interplay between thick impastos and thin, drybrushed marks, with the paint catching on the tooth of the board.

Henri de Toulouse-Lautrec (1864–1901)
Woman in Profile (detail)
Oil on cardboard

• Gesso panels
Gesso panels are the traditional support for egg-tempera painting. They can also be used for oil, acrylic and watercolour painting, but are quite difficult and time-consuming to prepare. Ready-prepared gesso panels can be bought from specialist art stores, though they are expensive. Gesso boards have an exceptionally smooth, brilliant-white finish which particularly enhances the translucence of tempera colours.

Tom Coates
Alfred Daniels Painting
Oil on panel
25 x 20cm (10 x 8in)

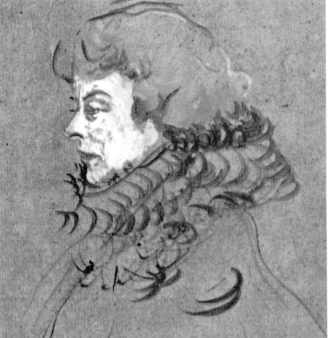

Marouflaging a board

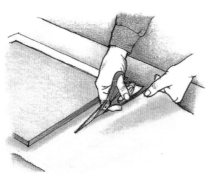

(**1**) Cutting the fabric to size

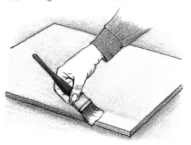

(**2**) Applying size to the face and edges

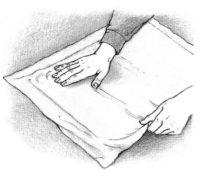

(**3**) Smoothing the fabric

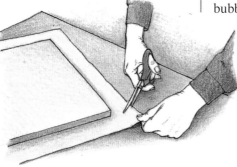

(**4**) Trimming the corners

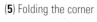

(**5**) Folding the corner

Canvas boards and panels

Commercially prepared canvas boards and panels consist of acrylic-primed cotton canvas mounted on rigid board. They come in a range of standard sizes and surface textures, and are a good choice for beginners. Because they are compact and lightweight, they are ideal for painting outdoors. Cheaper-quality canvas boards with an imitation-canvas surface have an unsympathetic, mechanical texture and a rather slippery surface priming, and the backing board is prone to warping.

Marouflaging board

Many artists prepare their own canvas boards by covering them with canvas or muslin – a method known as marouflaging. Fabric glued to board provides a surface which combines the unique feel of working on canvas with the greater stability of a firm surface which is not prone to movement under atmospheric changes. Any natural fabric can be used, such as worn linen, cotton sheets or tablecloths, unbleached calico, butter muslin or canvas offcuts.

Method

Check that the board is cut square and true. Dress the edges and lightly sand the smooth side to provide a key for the glue. Brush away all sawdust. Lay the board over the fabric, then cut the fabric to size, allowing a 50mm (2in) overlap all round (**1**).

With a household paint brush, apply size to the face and edges of the board (**2**). Smooth the fabric over the board with an equal overlap all round (**3**). Ensure that the warp and weft threads lie straight and parallel with the edges, as any distortion in the weave will show in the finished picture and be visibly distracting.

Apply more size to the cloth, brushing from the centre outwards and smoothing out any creases or air bubbles. When the size has dried, turn the board over and trim across the corners (**4**).

Size a margin around the edge of the reverse of the board, wide enough to stick down the overlapped cloth, which should not be pulled too tight as it may cause the board to warp. Smooth down the flaps of material and fold the corners over neatly (**5**). Add a final coat of glue over the reverse side to prevent warping. Leave to dry flat overnight before priming.

Priming for oil paint
To provide a sympathetic surface for oil paint, prime a marouflaged board with alkyd or acrylic primer. If you prefer a slightly absorbent, matt surface, thin the primer with white spirit (about 10 per cent by volume).

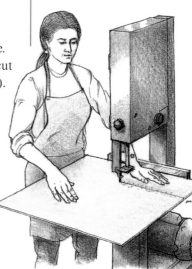

Time-saving
When making up several small boards, you will find it quicker and easier to glue the fabric to a large piece of board. Leave it to dry and then cut it up into the required number of boards, using a bandsaw As long as the fabric is glued down firmly, it won't matter that some edges have no overlap.

• Preparing canvas board
If you dislike the slippery surface of some commercially primed canvas boards, you can simply apply a further coat of alkyd or acrylic primer, in order to give a more absorbent surface. Matt household paint may be used for sketches or practice work.

▶ SEE ALSO
▶ Priming 24

Papers for oils and acrylics

Paper is a perfectly satisfactory support for small-to-medium-size paintings as well as preparatory sketches, as long as it is a heavy, good-quality one with plenty of tooth to grip and hold the paint. Thin papers will buckle when they are sized or primed.

Acrylic sketching paper
This comes in the form of spiral-bound pads of embossed, acrylic primed paper, which are very convenient for small paintings and sketches.

Preparation

Paper must always be sized before oil paint is applied in order to prevent the oil binder being absorbed and leaving the paint film underbound. The paper may be sized with rabbit-skin glue, PVA glue or acrylic matt medium, or primed with acrylic primer. Sizing is not necessary for acrylic paints.

Types of paper

Watercolour paper

Heavy, rough-surfaced watercolour paper or handmade Indian paper can be used as a support for oil and acrylic painting. The paper's texture shows to advantage when the colour is applied in thin washes. For extra strength, the paper can be mounted on to hardboard.

Oil-painting paper

Sheets of paper, textured to resemble canvas and primed ready for oil painting, are available in fine or coarse grades. Cheaper-grade oil-sketching paper comes in pad and block form. This is convenient for sketching out of doors and is economical for practice work, but you may find that the surface is greasy and unpleasant to work on, like that of the cheaper painting boards.

• Paper for oil painting
Size this with rabbit-skin glue, PVA glue or acrylic matt medium, or coat with acrylic primer.

Indian paper (top) and canvas-texture paper (above)

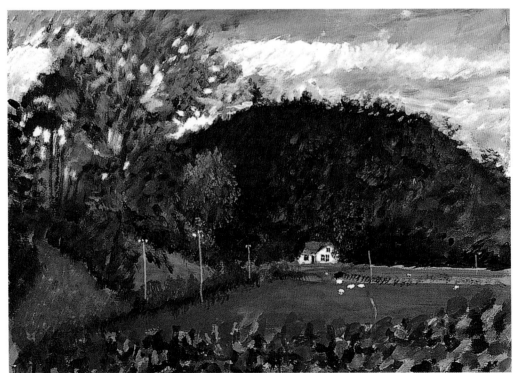

Painting on paper
Paper is an excellent and economical support for painting. It will accept most media, as long as you follow the rules of preparation. This painting is in acrylics, worked directly onto a good-quality, heavy-weight watercolour paper. A toned wash of thinned acrylic was applied first, to tone down the white surface and to act as an extra size for the support.

Dennis Mathew Rooney
Haunt of Ancient Peace
Acrylic on watercolour paper
38 x 53cm (15 x 21¼in)

▶ **SEE ALSO**
▶ **Sizing for oils 22**
▶ **Watercolour papers 28**
▶ **Oil techniques 162**
▶ **Acrylic techniques 202**

Sizing for oils

Supports for oil painting must always be scaled with a thin coat of glue size, before the application of a priming coat. However, you should not prepare the canvas with glue size if you are going to use an acrylic ground or acrylic paints.

Function of size

Size seals the pores between the fibres of the support, making it less absorbent. This prevents the oil binder in the priming and paint layers from sinking into the support, leaving the paint film underbound and liable to sinking, flaking and cracking.

Rabbit-skin glue

Rabbit-skin glue has traditionally been used for sizing oil-painting supports, as it has good adhesive strength. It comes in the form of granules, and is available in most art-supply shops. The glue size is made by mixing dry glue with water and gently heating it – but be warned, as it smells unpleasant!

Preparing size

The ingredients should be carefully measured to produce the required strength (see right). If the size is too strong, it forms a brittle layer which could cause the primer and the painting to peel and crack; too dilute a size will produce a weak film which allows oil from the upper layers to sink into the canvas.

Place the dry granules into the top part of a double boiler. Add the water and leave for about two hours to swell. Heat the resulting solution gently in the double boiler until it has melted, stirring until all the granules have completely dissolved, and never allowing the size to boil – this will destroy much of its sizing qualities. If you don't have the use of a double boiler, you can heat the glue in a bowl standing in a pan of water (as shown in the illustration, right).

Set aside the glue for a couple of hours, to cool and form a jelly. Keep the container covered to prevent any loss of water through evaporation, and to protect from dust and flies. Test the strength of the glue with a finger – the surface should be rubbery, yet just soft enough to split. The split formed should be irregular; if it is smooth and clean, the size is too strong. If this is the case, just rewarm it, add water, and allow it to reset. If the size has not set, you can stir in up to 10g (¼oz) of glue and then leave to soak for 12 hours.

Preparing size in advance

If you are mixing up a batch for later use, it is useful to note that glue size can be kept in a refrigerator for up to a week before starting to decompose.

Rabbit-skin glue
This is the time-honoured size for rendering canvas impervious. Available in granule form, it is dissolved in hot water.

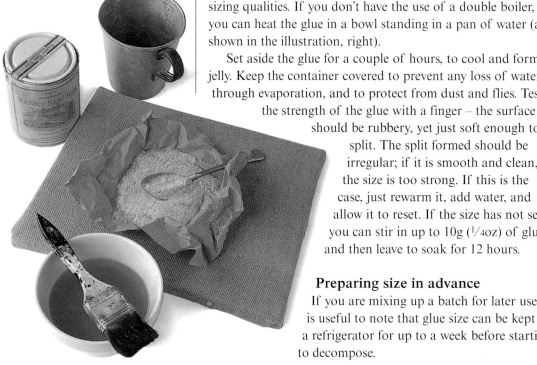

• Recipes for glue size
These measurements are a good starting guide, although you may wish to vary them slightly.

For sizing canvas:
You need 55g (2oz) – two rounded tablespoons – glue to 1.1 litres (2 pints) water. (Alternatively, use 1 part by volume of glue to 13 parts water.)

For rigid panels:
Use a stronger solution of 85g (3oz) glue to 1.1 litres (2 pints) water. This recipe will make enough size to cover a support measuring about 120 x 180cm (4 x 6ft).

Improvised double boiler
An effective substitute can be made from a bowl or clean tin can heated in a pan of water.

▶ SEE ALSO
▶ Canvas 14
▶ Boards and panels 18
▶ Priming 24
▶ Fat-over-lean 166
▶ Underpainting 164

Applying size

Rabbit-skin glue is a strong adhesive and must be used thinly, or it will crack. One thin coat is sufficient to size a canvas; too thick a layer forms a continuous, level film on the surface, and prevents the subsequent priming layer from bonding with the canvas. Gently reheat the size until it is just lukewarm and almost jelly-like in consistency. Apply it to the canvas in a thin layer, working quickly before the size begins to dry. Start from the edge, and brush in one direction only – do not make a back-and-forth motion with the brush, as too much size will be applied. Size the back flaps and edges of the support as well as the front. Leave to dry in a dust-free place for about 12 hours before applying primer.

Brush size in one
direction only

Temperature

Size may be applied hot to panels and boards, but on canvas it must be applied lukewarm. If too hot, it will soak through and glue the canvas to the stretcher, making you prise it free with a palette knife. Hot glue size may also cause fabric to over-tighten.

Sizing boards and panels

For boards and panels, use the slightly stronger solution described on the opposite page. Thin boards should also be sized on the reverse and edges, to prevent warping. Leave to dry for 12 hours, then sand lightly.

Sizing implements
The best brush for sizing is a flat hog varnishing brush, with a good width and long bristles. Decorators' brushes can be used, but poor-quality ones may shed hairs. Some artists use a natural sponge, which gives more control; gently squeeze out more glue when you feel the surface going dry. It can also be used to mop up any excess.

Unprimed supports
The warm brown tone of surfaces such as hardboard, plywood, cardboard and linen canvas, provides a middle tone which can be incorporated into the painting. To make them suitable for painting on, while maintaining their colour and texture, seal them with a coat of dilute glue size (for oils) or acrylic medium (for all media). Here, Ken Howard uses very thin, turpentine-diluted paint, so that the canvas colour shows through. This gives a marvellous impression of reflected light on the model's back.

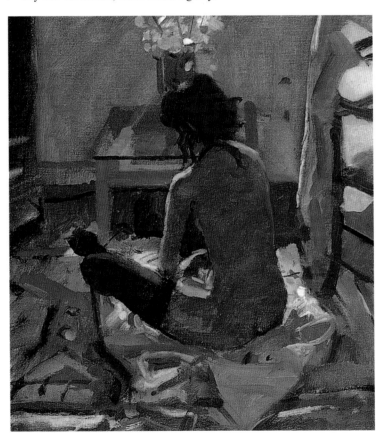

Ken Howard
Homage to Lautrec
Oil on unprimed canvas
40 x 30cm (16 x 12in)

• Alternative glue size
A modern alternative to traditional glue size is carboxymethyl/cellulose (CMC). This expands and contracts at the same rate as the canvas, greatly reducing the risk of cracking. It is also easier to use: just dissolve the granules in either warm or cold water (using an eight per cent solution by volume), leave to swell and apply with a stiff brush. There is no heating involved – and no smell.

Priming

Checking primers
Commercially produced primers may become hard if kept on the shelf for too long, so it is wise to shake a tin before buying it, to make sure that the contents are still liquid.

The primer, or ground, not only seals and protects the support, but also provides a base that will readily accept the application of paint.

Choosing primer
There are various types of primer, each with its different characteristics. It is important to choose the right one for your needs, as it affects the way paint is 'pulled' from the brush, and its finished appearance. For example, if you like to work on a smooth surface, you will require a different ground to someone who prefers a slightly textured, dryish surface that gives the paint a matt, chalky appearance.

In addition, it is vital that you select the right type of primer for your chosen support. Canvas expands and contracts, and thus requires a flexible ground; therefore an inflexible gesso ground is not suitable.

The ground should be absorbent enough to provide a key for the paint, but not so absorbent that it sucks oil from it – a common cause of sinking (the appearance of dull patches of paint across the canvas).

Oil primer
The traditional, and best, primer for oil painting, particularly on stretched canvas, is oil-based lead-white primer. This is flexible, stretching and contracting with the canvas on changes in temperature and humidity. It dries to form a durable base, which will not absorb too much oil from the paint.

Applying oil primer
Lead-white primer is quite stiff, and should be let down slightly with turpentine so that it can be brushed out easily. Apply an even coat as thinly as possible, brushing it in well (**1**). Finish off with a long smoothing stroke in line with the weave of the cloth (**2**). You should leave this first coat to dry for two days before applying a second coat.

The primed canvas should either be used while touch-dry (within a week or two) or be left to cure for four to six months before use. If paint is applied between these times, the primer sucks oil from the paint, leaving it underbound and with insufficient adhesion to the support.

Yellowing
The linseed oil in which lead white is ground turns the priming coat yellow if the primed support is stored away from the light for any length of time. The whiteness is restored upon exposure to sunlight.

Alkyd primer
This is a valid alternative to oil primer, as it is flexible, non-yellowing and fast-drying; each coat can be overpainted after 24 hours. Dilute alkyd primer with white (mineral) spirit to the required consistency.

Applying primer:
• Apply it in several thin coats – a thin coat is pliable while a thick coat is likely to crack and may even flake off the support.
• Cover the entire surface evenly. Don't go back over brushstrokes.
• Make sure that each coat is touch-dry before any subsequent coat is applied, and also before starting to paint.

(**1**) Applying a thin, even coat

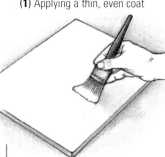

(**2**) Finishing off

Paint rollers
It is a good idea to use a paint roller to apply acrylic primer. A roller keeps the paint moving and delivers an even coat; for small supports, use a small radiator roller.

Using primer creatively
The lovely, matt, airy quality of Fred Cuming's paint is due in part to the ground he works on. After many years of painting, Cuming still finds the best primer is a good-quality, matt, white undercoat. When the primer is thoroughly dry, he applies a thin layer of linseed oil to the surface and wipes it off immediately, leaving just a trace of oil. When this is dry – after two weeks – the resulting surface provides a sound key for the paint, and prevents it sinking.

Fred Cuming
Bathers – Cap Ferrett
Oil on panel
60 x 50cm (24 x 20in)
Brian Sinfield Gallery, Burford

Acrylic primer

Acrylic primer is flexible, durable, water-thinnable, fast-drying and inexpensive. It can be used to prime canvas, board, paper and other surfaces, and can be applied directly to the support without the need of an isolating layer of size. It dries in a few hours.

Acrylic primer is the ideal surface for acrylic paints, providing a bright undercoat which brings out the vividness of the colours and gives added luminosity to thin washes. It can also be used with oil paints on rigid supports, but this is not recommended for canvas painting, except in a thin layer: acrylic is more flexible than oil, and the different tensions may eventually lead to cracking of the paint surface.

Acrylic primer is often referred to as acrylic gesso, a confusing term as it is not a gesso at all; traditional gesso is prepared with animal glue and chalk, and is very absorbent.

Applying acrylic primer

Work from the edges and apply the primer quickly in sections. Use a large brush or a paint roller, and keep the working edge moving, as acrylic primer dries quickly. Leave to dry for a few hours. The second coat should be applied at right angles to the first.

When priming board, you can apply as many as five coats for greater whiteness and opacity. For a really smooth finish, thin the last coat with a little water. For a textured finish, impress a piece of canvas (or any textured fabric) into the final coat of primer while it is still damp. Pull it away, then let the panel dry.

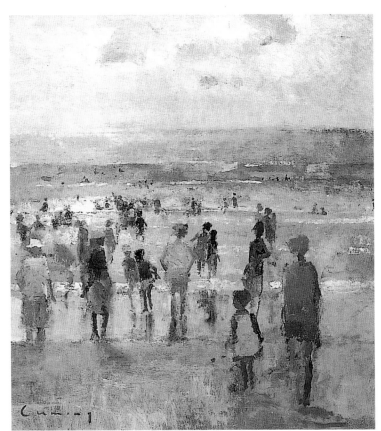

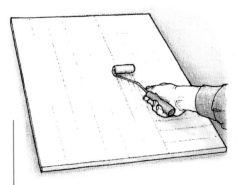

Working sequence
Work in sections; leave primer to dry between coats; apply subsequent coats at right angles.

Emulsion paint
An economical primer, often used by students, is ordinary matt household paint, which provides a sympathetic, semi-absorbent ground. However, household paint should only be used on rigid supports, and not on stretched canvas. Use only good-quality paint; cheap emulsions have a limited life span.

Textured finish
For a textured finish, lay and then press a piece of textured material, such as an old piece of sacking, into the final primer coat.

Making primers

- titanium white pigment
- one egg
- linseed oil
- glue size
- water

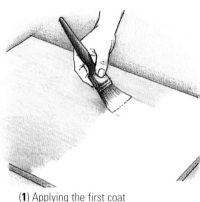

(**1**) Applying the first coat

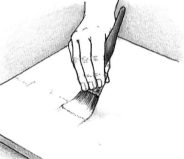

(**2**) Adding coats at right angles

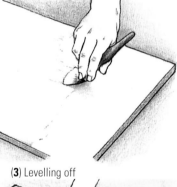

(**3**) Levelling off

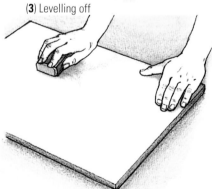

(**4**) Sanding between coats

Ready-made primers are adequate for general needs, but obviously they cannot be tailored to individual requirements. Making your own primer is economical and will give you greater control over its quality and absorbency.

Egg-oil emulsion

This general-purpose, easily made primer is suitable for canvas and board. It is ready to paint on after two days' drying (see list of ingredients, above left).

Break the egg into a jar. Using the eggshell as a measure, add the same volume of refined linseed oil and twice the volume of cold water. Screw the lid on the jar and shake vigorously until an emulsion is formed. Grind a little emulsion with titanium white pigment until it forms a stiff white paste; add the rest of the emulsion to bring the mixture to the consistency of double cream. Thin the mixture to a milky consistency with lukewarm glue size mixed 1 part to 12 parts cold water. Brush very thinly onto a sized support.

Traditional gesso

Brilliant-white gesso (see ingredients, right), is very smooth and porous, and is the ideal base for painting luminous colours and detail. Gesso is best applied to a rigid support prepared with glue size – it is not flexible enough for use on canvas. It is most suited to water-based paints, such as tempera, acrylics and Chroma colours.

Heat the size, mixed 1 part to 8 parts cold water, gently in a double boiler. Slowly add some warm size to the whiting and stir until it forms a thick paste. Blend without creating excess bubbles. Gradually add the rest of the size until a smooth, creamy mixture is obtained. (Keep the pot of gesso warm and covered, otherwise it will harden, the water will evaporate and the glue will become too strong.) To increase the brilliance, add powdered white pigment. Leave for a few minutes before using.

Applying gesso

Apply gesso carefully in thin layers and work quickly: if you go back over an area, streaks will develop. Dampen the brush with some water to prevent air bubbles forming on the surface. Apply the first coat of hot gesso in short, even strokes (**1**), keeping the working edge moving – when the gesso begins to cool, move on to an adjacent area. Apply up to six coats for a dense, white finish; add each coat at right angles to the last (**2**), using short back-and-forth strokes. Each coat should be completely dry before the next one is applied. Level off in one direction (**3**). Lightly sand between coats with fine sandpaper (**4**), dusting off the surface before applying the next coat.

- 1 part Gilder's whiting
- 1 part glue size

Sealing gesso
On an absorbent gesso surface, oil paint takes on a matt, airy quality which is pleasing but makes the paint quite difficult to handle. In addition, gesso soaks up much of the oil from subsequent paint layers, leaving it brittle and prone to cracking. To overcome this, the dry gesso surface should be partially sealed with a weak solution of glue size (about half the strength used to make the gesso).

► SEE ALSO
► Priming 24
► Tempera 108
► Acrylic paints 110
► Chroma colour 116

Toned grounds

Some artists like to paint on a toned or coloured ground, as a white ground can be inhibiting; by covering the canvas or paper with a wash of neutral colour, you immediately create a more sympathetic surface on which to work.

'Reading' tones and colours

A white ground can give a false 'reading' of tones and colours, especially in the early stages of a painting, when there is nothing to relate them to. Most colours appear darker on a white surface than when they are surrounded by other colours, and this creates a tendency to paint in too light a key. If you work on a neutral, mid-toned ground you will find it much easier to assess colours and tones correctly, and you can paint towards light or dark with equal ease.

If the colour of the ground is allowed to show through the overpainting in places, it acts as a harmonizing element, tying together the colours that are laid over it.

Choosing a ground colour

The colour chosen for a toned ground will depend on the subject, but it is normally a neutral tone somewhere between the lightest and the darkest colours in the painting. The colour should be subtle and unobtrusive, so that it does not overwhelm the colours in the overpainting. Diluted earth colours, such as Venetian red, raw sienna or burnt umber, work very well, as do soft greys and greens.

Transparent and opaque grounds

A toned ground can be either opaque or transparent. With a transparent ground (also known as *imprimatura*), the paint is heavily diluted and applied as a thin wash. A transparent ground allows light to reflect up through the succeeding colours, thereby retaining their luminosity, and it is used where transparent or semi-transparent colour is to be applied. Opaque toned grounds are used with opaque painting methods, where the light-reflecting qualities of a white ground are not so important.

Applying transparent grounds

Dilute the colour until it is thin, and then apply it with a large decorator's brush or a lint-free rag. Loose, vigorous strokes give a more lively effect than a flat stain of colour. After a few minutes, you should rub the wash with a clean rag, leaving a transparent stain.

Making opaque grounds

You should mix a little tube colour into the white priming or gesso before applying it (see left). Alternatively, you can mix the colour with white paint, dilute it a little, and then brush a thin layer over the priming. Never mix oil paint with an acrylic primer, or vice versa.

Soft-pink ground
About ¼ tube of burnt sienna mixed with ½ litre (1 pint) of ready-made primer or gesso will give you a pleasing, soft-pink ground, which is excellent for landscape painting. This photograph shows a blue underdrawing on pink-toned ground.

▶ **SEE ALSO**
▶ **Acrylic primer 25**
▶ **Colour harmony 225**

Drying times
A toned ground must be dry before you can paint over it. An oil ground takes a day or two to touch-dry; an acrylic ground is dry in minutes. So long as it is applied thinly, you can use acrylic paint for the toned ground and work over it with oils.

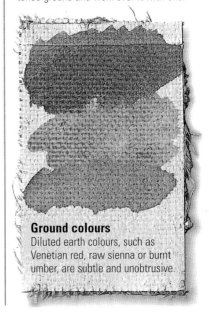

Ground colours
Diluted earth colours, such as Venetian red, raw sienna or burnt umber, are subtle and unobtrusive.

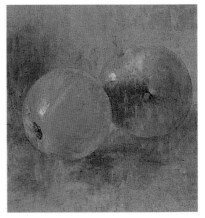

Jacqueline Rizvi
Two Apples
Watercolour and body colour on toned paper
17.5 x 22.5cm (7x 9in)

Jacqueline Rizvi rarely works on white paper. The rich, glowing effect of this simple still life is enhanced by the use of toned paper as a base for delicate washes of watercolour and body colour.

Watercolour papers

'First of all, respect your paper!'
J. M. W. Turner (1775–1851), on
being asked for his advice about painting

Try before you buy
Trial-and-error can be a costly affair, given the price of the average sheet of watercolour paper. However, most paper manufacturers produce swatches or pochettes – booklets containing small samples of their ranges. These provide an excellent and inexpensive means of trying out several types of paper.

A well-known professor of painting used to say that no artist really succeeds until he has found his ideal paper. Today there are plenty of excellent watercolour papers on the market to choose from, and it is well worth experimenting in order to find the one that best responds to your working method.

Paper production

There are three ways of producing watercolour paper: by hand; on a mould machine; and on a fourdrinier machine.

Handmade paper

The very best papers are made of 100 per cent cotton, and are usually made by skilled craftsmen. Handmade papers are lively to use, durable, and have a pleasing irregular texture. They are expensive, but worth the cost.

Mould-made paper

European mills produce watercolour paper on cylinder-mould machines. The paper fibres are formed into sheets with a random distribution, close to that of handmade papers. The paper is durable, extremely stable, and resistant to distortion under a heavy wash.

Machine-made paper

Although inexpensive to produce and to purchase, machine-made papers are less resistant to deterioration, but they may distort when wet. Some papers also have a mechanical, monotonous surface grain.

Choosing paper

Watercolour paper is an excellent surface for acrylics, pencil, ink, gouache and pastel, as well as watercolour. The character of the paper, and its surface texture, play a vital role in the finished picture. Very often it is the choice of paper that is to blame for a painting going wrong, rather than any inadequacy on the part of the artist.

Some papers are superior in quality to others, but it does not necessarily follow that an expensive paper will give you better results. The important thing is to find a paper that is sympathetic to what you want to do. For example, it is no good using an absorbent rag paper if your technique involves repeated scrubbing, lifting out and using masking fluid; the surface will soon become woolly and bruised.

Popular papers are available in local art shops. Specialist art shops stock less-common and handmade or foreign papers; some of these are also available by mail-order direct from the mill or though distributors, who can send sample swatches, price lists and order forms.

Once you have settled on a favourite paper, it pays to buy in quantity. The bigger the order, the more you save.

• Paper sizes
Sizes of papers will differ from country to country, and it is still common practice for art suppliers to describe paper in imperial sizes. The following table is a guide to imperial sizes and their metric equivalents.

Medium
22 x 17½in
(559 x 444mm)

Royal
24 x 19in
(610 x 483mm)

Double Crown
30 x 20in
(762 x 508mm)

Imperial
30½ x 22½in
(775 x 572mm)

Double Elephant
40 x 26¼in
(1016 x 679mm)

Antiquarian
53 x 31in
(1346 x 787mm)

▶ SEE ALSO
▶ Stretching paper 33
▶ Watercolour
 paints 87
▶ Watercolour
 techniques 180

Smooth-texture paper

Medium-texture paper

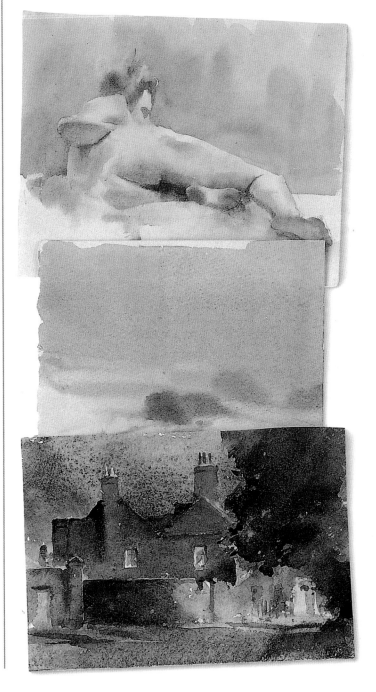

Rough-texture paper

Experimenting with watercolour papers

Try out different textures and makes of watercolour paper until you find one which suits your painting style. As you become more knowledgeable, you will also be able to choose a paper to suit your subject.

In these examples, the artist has chosen a smooth texture for the nude study (below), which is perfectly appropriate for the tone and texture of the flesh. The winter-evening snow scene (centre) is ideally suited for a medium-texture paper which conveys the effect of misty light and captures the subtle grain of the snow. A rough-texture paper (bottom) communicates the solidity of the building and the dampness of the weather to the viewer.

Trevor Chamberlain
(from top to bottom)
Reclining Nude
Snow, Late-evening
Effect
Showery Evening,
Isleworth
All watercolour on paper
Various dimensions

Texture
There are three different textures of watercolour paper: (from top to bottom) hot-pressed or HP (smooth), Not or cold-pressed (medium grain) and rough. Each manufacturer's range is likely to have a slightly different feel.

Hot-pressed paper
Hot-pressed paper has a hard, smooth surface that is suitable for detailed, precise work. Most artists, however, find this surface too smooth and slippery, and the paint tends to run out of control.

Cold-pressed paper
This is also referred to as 'Not', meaning not hot-pressed. It has a semi-rough surface equally good for smooth washes and fine brush detail. Thuis is the most popular and versatile of the three surfaces, and is ideal for less-experienced painters. It responds well to washes, and has enough texture to give a lively finish.

Rough paper
This has a more pronounced tooth (tiny peaks and hollows) to its surface. When a colour wash is laid on it, the brush drags over the surface and the paint settles in some of the hollows, leaving others untouched. This leaves a sparkle of white to illuminate the wash.

Watercolour papers *(continued)*

Choosing watercolour papers

Choice of watercolour papers is very much a matter of personal preference; one artist's favourite may be another artist's poison. The chart below is intended only as a guide to a versatile selection of widely available papers. They have all been tried and tested by professional watercolour artists; however, your own assessment may be quite different.

▶ **SEE ALSO**
▶ **Watercolour techniques 180**
▶ **Art-materials suppliers 392**

Handmade papers **Mould-made papers**

Esportazione
by Fabriano
Surfaces: Not and rough
Weights: 200, 315, 600gsm
Content: 100% cotton rag, tub-sized
A robust, textured surface that stands up to erasure and scrubbing, carries washes without sinking. Four deckle edges. Watermarked.

Richard de Bas
by Richard de Bas
Surfaces: HP, Not and rough
Weight: 480gsm
Content: 100% cotton rag, internally sized
A thick, robust paper with a fibrous texture. Washes fuse into paper structure. Four deckle edges. Watermarked.

Indian
by Khadi
Surfaces: HP and Not
Weights: 200 and 300gsm
Content: 100% cotton rag, internally sized
A strong paper, which is able to withstand plenty of wear and tear. Lifting out colour is easy, and masking fluid rubs off well.

Artists' Paper
by Two Rivers
Surface: Not
Weights: 175, 250gsm
Content: 100% cotton rag, tub-sized, loft-dried; buffered with calcium carbonate
Gently absorbent, but robust and firm. Also available in cream, oatmeal and grey. Four deckle edges.

Arches Aquarelle
by Canson
Surfaces: HP, Not and rough
Weights: 185, 300, 640, 850gsm
Content: 100% cotton rag, tub-sized, air-dried
A warm white paper with a robust, yet soft, texture. Carries washes without undue absorption. Resists scrubbing and scratching. Lifting out is difficult, and fibre-lift occurs when masking fluid is removed.

Lana Aquarelle
by Lana
Surfaces: HP, Not and rough
Weights: 185, 300, 600gsm
Content: 100% cotton rag, tub-sized
A good, textured surface. Lifting out and removal of masking fluid are easy. All weights stand up well to washes without undue buckling.

Bockingford
by Inveresk
Surface: Not
Weights: 190, 300, 425, 535gsm
Content: 100% cotton rag, internally sized, buffered with calcium carbonate
A versatile, economical paper, Robust yet gently absorbent. Lifting out is easy; masking fluid comes away cleanly. 300gsm also in tints.

Saunders Waterford
by St Cuthbert's Mill
Surfaces: HP, Not and rough
Weights: 190, 300, 356, 640gsm
Content: 100% cotton rag, internally and gelatine sized
A stable, firm paper, which is resistant to cockling, and with a sympathetic surface. Scrubbing, lifting out and masking are easy.

Weights of watercolour paper	
Metric	Imperial
150gsm	72lb
180gsm	90lb
300gsm	140lb
410gsm	200lb
600gsm	300lb
850gsm	400lb

• Acid content
Papers that contain an acid presence, such as newsprint and brown wrapping paper, are prone, in time, to yellowing and deterioration. Paper acidity is measured by the pH scale. An acid-free paper does not contain any chemicals which might cause degradation of the sheet, and will normally have a pH of around 7 (neutral). All good-quality watercolour papers are acid-free, to prevent yellowing and embrittlement with age. Some are also buffered with calcium carbonate, to protect against acids in the atmosphere.

Paper content
Apart from water, the main ingredient in making paper is cellulose fibres, derived from either cotton or woodpulp. Cotton is used for high-grade papers, woodpulp for others. Some papers contain a blend of cotton and other cellulose fibres, offering a compromise between cost and quality.

Cotton rag
The best paper is made from 100 per cent cotton. Although the term 'rag paper' is still used, the raw material nowadays is natural cotton linters. Rag papers are very strong, yet pliable, and withstand demanding techniques.

Woodpulp
Woodpulp produces a more economical, but less durable, paper. Confusingly, papers made of 100 per cent woodpulp are sometimes advertised as 'woodfree'; this is a technical term meaning wood broken down by chemical means, rather than mechanical ones – it does not signify that the paper has not been made from wood. Mechanical woodpulp still contains lignin, which releases acids into the paper over a period of time, causing it to yellow and embrittle. The chemical woodpulp used in woodfree paper is processed to remove all the lignin.

Weight
The weight (thickness) of watercolour paper traditionally refers to the weight of a ream (500 sheets) of a given size, most often imperial (about 22 x 30in or 56 x 76cm). For instance, a 72lb paper is a light paper, 500 sheets of which weigh 72lb. The more accurate metric equivalent of grammes per square metre (gsm) is now common. Lighter papers (less than 300gsm/140lb) tend to buckle and wrinkle when washes are applied, and need wetting and stretching on a board before use. Heavier grades don't need to be stretched unless you intend to flood the paper with washes.

Absorbency and sizing
All watercolour paper is internally sized to varying degrees, to control its absorbency and produce a more receptive working surface. Heavy sizing produces a hard surface with little absorption and a long drying time; this allows you to push the paint around on the surface. Colours remain brilliant, as they are not dulled by sinking into the paper. Lightly sized papers are softer and more absorbent, with a shorter drying time. Alterations are more difficult because the paint sinks into the fibres of the paper, but absorbent papers are suited to direct, expressive painting methods.

Internal sizing
Internal, or 'engine' sizing means that size is added to the paper at the pulp stage, and contained in the body of the paper. Internal sizing renders the paper robust and prevents colour washes cross-bleeding beneath the paper surface, even when it has been abraded.

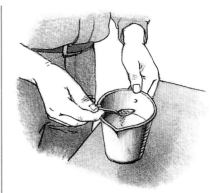

Increasing sizing
If paper is too absorbent, paint sinks into it and colours appear dull. To remedy this, dissolve a teaspoon of gelatin granules in half a litre (1.1 pints) of water and apply to the surface before painting.

Reducing sizing
If a heavily sized paper does not take paint well, then pass a damp sponge over the surface several times. Leave it for 30 minutes, then dampen again before painting. Some handmade papers may need to be soaked for up to two hours in some warm water.

Trying for size
The amount and quality of sizing varies according to the brand of paper. A quick test is to lick a corner of the paper with the end of your tongue: if it feels dry and it sticks to your tongue, you will know that it is absorbent paper.

Watercolour papers *(continued)*

Surface sizing

Many watercolour papers are also surface-sized, which is done by being passed through a tub of gelatin size (hence the term 'tub-sized'). Surface sizing not only reduces the absorbency of the paper but it also produces a more luminous wash (on absorbent papers, colours tend to dry far paler than they appear as a wet wash). It also reduces the risk of fibre lift when you are removing masking material and lifting out washes of colour.

Tinted papers

Most watercolour paper is either white or off-white, in order to reflect the maximum amount of light back through the transparent washes of colour. Some manufacturers, however, specialize in a range of tinted papers, and these are often used when painting with body colour or gouache.

You should always check that the tinted paper you buy is sufficiently lightfast. Good-quality papers will not fade under normal conditions, but cheaper paper may not be as permanent as the colours that are laid on it, and in time the change could affect the overall tone of your painting.

Many artists prefer to apply their own tint by laying a very thin wash on white paper.

Watercolour sheets

Watercolour paper is most commonly sold in sheet form. In addition, many mills supply their papers in rolls, which are more economical, and pads. Spiral-bound pads are particularly useful for when you are working outdoors. They are available in a wide range of sizes, although they usually contain 300gsm (140lb) Not paper.

Watercolour blocks

These comprise sheets of watercolour paper which are 'glued' together round the edges with gum. This block of paper is mounted on a backing board. A watercolour block removes the need for stretching paper.

When the painting is completed, the top sheet is removed by sliding a palette knife between the top sheet and the one below. Although more expensive than loose sheets, watercolour blocks are convenient and time-saving for artists.

Watercolour boards

Watercolour board is yet another way of avoiding the use of stretching paper. It consists of watercolour paper which is mounted onto a strong backing board in order to improve its performance with heavy washes.

Spiral pads
Watercolour paper can also be purchased in the form of spiral-bound pads, which are convenient for outdoor sketching. They generally contain 300gsm (140lb) Not paper.

► **SEE ALSO**
► **Watercolour techniques 180**

Stretching paper

Wet paint causes the fibres in watercolour paper to swell, and this can lead to buckling, or 'cockling' of the surface. To prevent this happening, you should stretch paper before starting to work on it.

Achieving a smooth painting surface

The paper is wetted and then securely taped to a board. On drying, it will contract slightly and become taut, giving a smooth surface that is less prone to cockling. With heavier papers (300gsm and over) there is less need for stretching, unless heavy, saturated washes are to be applied. Lighter papers always need stretching.

Method

Cut four lengths of gummed brown-paper tape 50mm (2in) longer than the paper. Do this first, to avoid panic at the crucial moment, when wet hands, crumpled tape and a rapidly curling sheet of paper could cause chaos.

Immerse the paper in cold water for a few minutes (**1**), making sure it has absorbed water on both sides; heavier papers may take up to 20 minutes Use a container large enough to take the sheet without being cramped. For large sheets, use a clean sink or bath.

Immerse only one sheet at a time in fresh water, as each sheet will leave a residue of size in the water.

Hold the paper up by one corner and shake it gently to drain the surplus water. Place the paper onto the board (**2**) and smooth it out from the centre, using your hands, to make sure that it is perfectly flat.

Take a dry sponge around the edges of the paper where the gummed tape is to be placed, to remove any excess water (**3**). You should moisten each length of gum strip with a damp sponge immediately before use. Beginning with the long sides, stick the strips around the outer edges of the paper, half their width on the board, half on the paper (**4**).

Leave the paper to dry flat, allowing it to dry naturally, away from direct heat. Do not attempt to use stretched paper until it is dry. Leave the gummed strips in place until the painting is completed and dry.

Commercial paper stretchers

For those artists who find stretching paper a time-consuming chore, the only previous alternative to this has been to use expensive heavyweight papers or boards. However, there are now various effective devices available, which are designed by watercolour painters and which will stretch lightweight papers drum-tight in minutes. Among the ingenious designs, one uses a two-piece wooden frame to hold the paper firmly in place as it dries; another employs a system of plastic gripper rods which are pushed into grooves in the edges of the board, to hold the paper.

Choosing the best equipment

Use only gummed brown-paper tape for stretching paper – masking tape and self-adhesive tape will not adhere to damp paper. A clean wooden drawing board is the ideal surface for stretching paper; traces of paint or ink might stain the paper. Plastic-coated boards are not suitable, because gummed tape will not stick to them.

• Immersion times

These depend on the weight and degree of surface sizing of the paper. Thin paper soaked for too long will expand greatly, and may tear as it contracts; too brief an immersion means the paper will not expand enough, and will buckle when wet paint is applied. The correct soaking time for each paper will come through trial and error, but in general lightweight papers and those not strongly sized should be soaked for 2–3 minutes; heavily sized papers may need 5–10 minutes. (If a fine layer of bubbles appears when the paper is immersed, this indicates a strongly sized paper.)

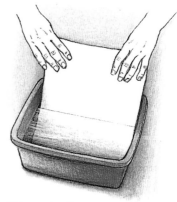

(**1**) Immersing the paper

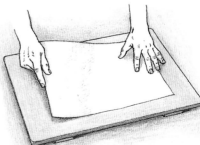

(**2**) Smoothing the paper

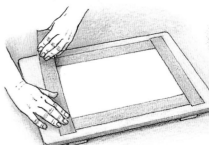

(**3**) Removing excess water

(**4**) Sticking the gummed strip

Supports for pastels

Some pastel artists like to work on primed hardboard, muslin-covered board or canvas, but most prefer to paint on one of the many tinted papers made specially for pastel work.

Effects

The subtle texture of pastel paper catches at the pastel particles to just the right degree. When the pastel stick is passed lightly over the surface, the colour of the paper shows through and gives an interesting broken-colour effect; when the pastel is pressed firmly into the tooth of the paper, solid patches of colour are obtained.

Types of paper

Canson Mi-Teintes
A machine-made paper produced in France. A lightly sized rag paper with a neutral pH, it has a fairly soft surface, suitable for pastel, charcoal and chalk. It is available in a wide range of colours.

Ingres
A mould-made paper produced in Italy, Ingres is one of the most widely used papers for pastel work. It has a hard surface and a laid finish, with a neutral pH. Suitable for charcoal and chalk, it also has a wide selection of colours.

Velour paper
Also known as flock paper, this has a soft surface like velvet which produces a rich, matt finish more like a painting than a drawing. It is best not to blend pastel colours too vigorously on velour paper, as this may spoil the nap of the surface.

Sand-grain paper
This has a pronounced tooth which grips the pastel particles and there is enough resistance to the drawn line to make it very pleasant to work on. The rough surface is suited to a bold and vigorous approach. It is, however, an expensive surface for large-scale work, as it shaves off the pastel fairly rapidly.

Sansfix
The unique tooth of this paper, similar to that of a very fine sandpaper, is made from a thin layer of fine cork particles, which eliminates the need for using fixative. Similar in feel to Mi-Teintes paper, it has a light card backing, and is acid-free. It is ideally suited to pastel work.

Charcoal paper
This inexpensive paper is useful for rough pastel sketches. However, it is rather thin and fragile, and you may find its regular, linear surface texture too monotonous.

• **Watercolour papers**
Watercolour papers are excellent for pastel painting, as they stand up to a lot of wear. Choose a Not (medium surface) or rough surface; hot-pressed papers are too smooth for pastels. It is best to use a tinted paper, or to tint your own (see right) as white paper makes it difficult to judge the tones of your colours.

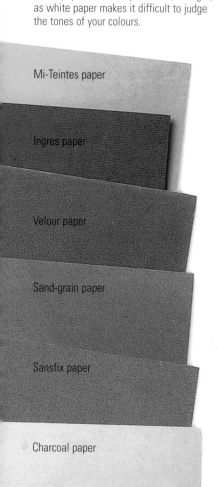

Mi-Teintes paper

Ingres paper

Velour paper

Sand-grain paper

Sansfix paper

Charcoal paper

• **Tinting papers**
There may be times when you wish to tint your paper by hand. For instance, you may find the colours of pastel papers too flat and mechanical, and prefer the more painterly look of a handtinted ground. Or you may want to work on watercolour paper because you like its texture, but white paper doesn't show the vibrant colours of pastel to best advantage; it makes them look darker than they actually are.

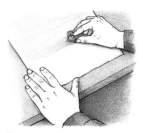

Using a teabag

• **Methods for tinting papers**
Watercolour, acrylic or gouache paints can be applied with a brush, sponge or spray diffuser to leave a pale tint of colour. You can modernize an ancient Chinese method by rubbing a damp teabag across the surface of the paper; this creates a warm undertone. Another technique is to save the broken ends of pastels and crush them to a powder with a heavy object. Dip a damp rag into the powder and rub it over the paper. When the paper is dry, tilt the board and tap the surplus powder off.

Using crushed pastels

▶ SEE ALSO
▶ Watercolour papers 28
▶ Pastels 48
▶ Colour harmony 225

Choosing a surface

A pastel painting is very much a marriage of the medium and the paper. The two work side by side, creating an exciting fusion of texture and colour. When choosing a surface for pastel painting, there are three factors to be considered.

Texture

Texture is a vital part of pastel work, and the choice of surface can make or mar the finished picture. Smooth papers allow you to blend colours smoothly and evenly where a soft, delicate effect is required, whereas rougher papers break up the colour and provide a vigour and sparkle.

Colour

Pastel paper is available in a wide range of colours. In pastel painting, areas of the paper are very often left untouched, and contribute to the picture. For example, the paper can be chosen to harmonize with the subject, or it can provide a contrast.

Tone

The tone of the paper has considerable importance in a painting. 'Tone' refers to the relative lightness or darkness of the paper, regardless of its colour. In general, a light-toned paper emphasizes the dark tones and colours in a painting. For dramatic effects, use light pastels on a dark paper.

• Using rough paper

If you work in a bold, vigorous style, with thick layers of colour, choose a rough-textured paper such as sandgrain, or a rough-textured watercolour paper. The hollows in rough paper are capable of holding enough pigment for you to apply several layers of colour without the surface becoming 'greasy'. The rough texture of the paper also contributes to the visual effect of the painting: the pigment catches on the ridges of the grain and skips the grooves, creating a sparkling, broken-colour effect.

• Using smooth paper

Smooth papers are best suited to fine details and linear work because the shallow grain quickly fills up with pastel particles, and the surface becomes greasy and unworkable if too many layers of pastel are applied.

• Using mid-toned papers

These are generally the most sympathetic for pastel drawings. They make it easy to judge how light or dark a particular colour should be, and provide a harmonious backdrop to most colours.

Working on pastel papers

Choosing and exploiting the qualities of a particular paper is one of the pleasures of working with pastels. These examples (left) show how different textures, tones and colours interact with the pastel pigment, thereby creating a range of expressive effects.

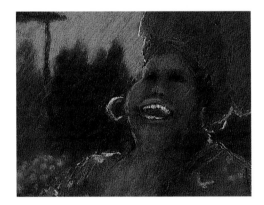

Detail on rough Mi-Teintes paper

Detail on velour paper

Detail on toned Ingres paper

Detail on watercolour paper with coloured-acrylic tint

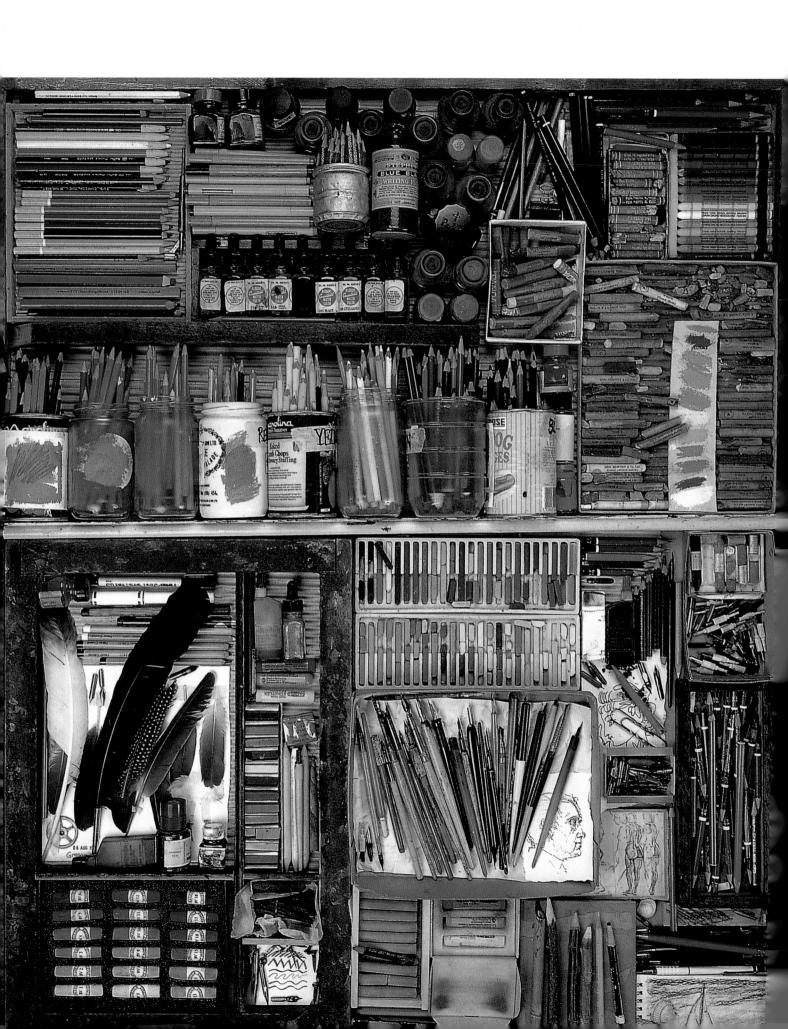

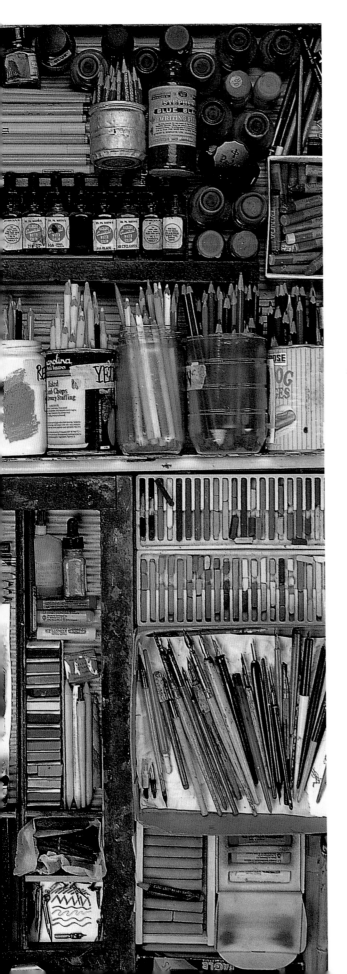

Chapter two

Drawing media

Anything that makes a mark can be used as a drawing tool, but over the years the versatility of certain materials – especially pencil, pastel, charcoal and ink – has made them enduringly popular among artists of all abilities. No one drawing medium is intrinsically superior to another. One artist may enjoy the broad handling that is possible with charcoal or soft pastel, while another may prefer the control and precision of a harder point, such as pencil. The best course is to experiment with different materials and techniques until you discover which ones allow you to express your artistic vision most fully.

Drawing papers

No matter what your chosen medium, the paper you draw upon plays an important role in the success of the finished work.

Cartridge paper

Cartridge paper is a good general-purpose drawing paper. Poor-quality paper is lightweight, with little or no sizing, and tends to yellow with age; heavier cartridge paper is more versatile and is likely to be acid-free.

The surface of cartridge paper varies between brands. It is usually fairly smooth, but with a fine-grained texture. Its colour varies, too, ranging from a bright white to a mellow cream.

Bristol paper

Bristol paper, or Bristol board, is made from two or more layers of paper bonded together to make a thick sheet. It has a smooth surface which is ideal for fine line drawing, and is also perfect for pen-and-ink work.

Japanese papers

Specialist paper shops offer a range of Japanese handmade rice papers which are suitable for drawing, watercolour and gouache techniques. These papers are very thin and delicate, with some unusual surface patterns. Japanese papers are very absorbent; they tend to soak up ink or paint, creating hazy, soft-edged shapes of a delicate and elegant nature.

Indian papers

Handmade Indian papers are more robust than Japanese papers, with a surface similar to rough watercolour paper. They are inexpensive and come in a range of tints as well as white and cream. They make an excellent support for soft drawing media such as charcoal, and for wash drawings.

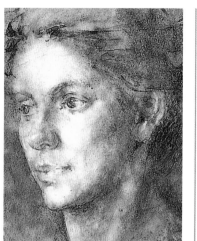

Michael Hyam
Study of Bernadette
Ink on Japanese paper
25 x 17.5cm (10 x 7in)

Michael Hyam uses Japanese paper for many of his preparatory portrait studies. The thin, absorbent texture helps him to achieve great sensitivity of line and wash tone.

Sketchbooks
Sketchbooks with a spiral binding can be held in one hand while drawing; some have tear-off, perforated sheets, while others come in book form so you can work right across the spread. A small sketchbook, about 15 x 10cm (6 x 4in), fits conveniently into a pocket and can be taken out when inspiration strikes. A larger book, though bulkier, offers more scope for large-scale studies, such as landscapes.

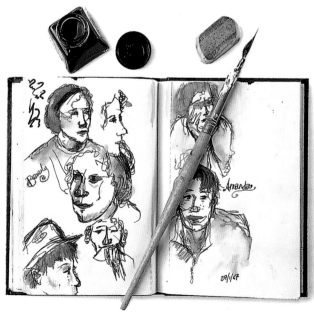

Naomi Russell
Sketchbook
Ink on paper
15 x 10cm (6 x 4in)

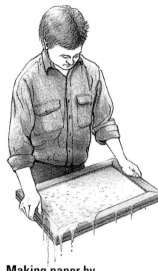

Making paper by hand
Handmade papers are produced by pulping cotton fibres and sizing agents in a vat of water. The paper-maker places a wooden frame, or deckle, over a flat screen made of wire mesh; this is lowered into the pulp and lifted out horizontally. Water drains out through the holes in the wire screen, leaving the fibres in the pulp deposited as a flat sheet on the mesh surface. The deckle is then removed; fibres trapped under the frame produce the 'deckle edge', a feature of most handmade paper. Each wet sheet is transferred onto a piece of woollen felt and, when a number of sheets have been sandwiched into a 'post', they are pressed to remove excess water. The sheets are then laid out on screens to dry (some makers use the traditional method of drying over ropes). This is known as loft drying, and results in paper with better dimensional stability than machinemade papers, because humidity is released at a slower rate.

▶ SEE ALSO
▶ **Watercolour papers 28**
▶ **Drawing & observation 138**
▶ **Sketching 154**

Texture

The texture, or 'tooth' of the paper has a direct influence on the character and appearance of the drawn marks. An uncoated, unpressed paper, such as Ingres, has plenty of natural tooth to bite and hold powdery drawing media such as charcoal, chalk and pastel. Rough textures are also suited to bold work, as they emphasize the drawn marks and become part of the drawing.

For fine pencil work and pen-and-ink drawing, a smooth surface is preferred; pen nibs can snag on a rough surface and the ink will spread, preventing clean lines.

Colour

The choice of colour and tone can make a positive contribution to the picture when using coloured drawing materials such as pastel and coloured pencil. Toned papers provide a good middle ground from which to work up to the lights and down to the darks.

• Weight

Heavy papers made of 100 per cent cotton are preferred for permanent work, as they are sturdy and can take a lot of working and erasing without damage. They are also less prone to wrinkling when using ink and watercolour washes. Cheaper woodpulp and lightweight papers, some of which are now made from eco-friendly, recycled paper, are fine for sketches and practice work.

Kay Gallwey
Mr Bill
Charcoal, chalk and wash
on paper
12.5 x 20cm (5 x 8in)

Supports and media

These drawings on different types of paper demonstrate the importance of the support.

In Kay Gallwey's lively sketch (left), beige Ingres paper provides a soft mid-tone which shows through the drawn marks, tying them together.

Naomi Russell used coloured tissue paper, crumpled and then smoothed out, for this charming study (below).

The rough surface of handmade Indian paper imparts an attractive texture to watercolour washes in the still life (below right).

Sarah Donaldson
Still Life with Pumpkins
Watercolour on Indian paper
40 x 28.5cm (16 x 11½in)

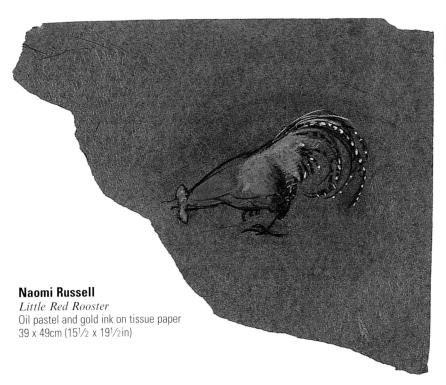

Naomi Russell
Little Red Rooster
Oil pastel and gold ink on tissue paper
39 x 49cm (15½ x 19½in)

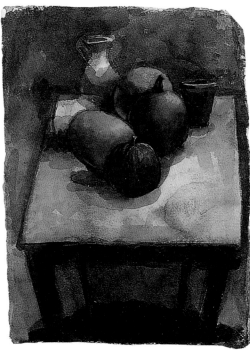

Pencils

Equally capable of producing a quick sketch or a finely worked drawing, the pencil is the most immediate, versatile and sensitive of the drawing media. It can be used, on one hand, for great subtlety and delicacy, and, on the other, for striking boldness and vigour; you can produce a soft, velvety quality or a crisp sharpness. One of the pencil's most attractive characteristics is the ease with which line and tone can be combined in one drawing.

'Drawing is the true test of art.'
Jean-Auguste-Dominique Ingres (1780–1867)

Manufacturing pencils

How pencils are made

In graphite, or 'lead' pencils, natural graphite is reduced to a powder and blended with clay in exact proportions, then kneaded into a stiff paste. To make the leads, the paste is compressed and extruded into thin strips, which are dried before being fired in a kiln. After firing, the leads are impregnated with waxes to ensure that they draw smoothly. They are then encased in shafts of cedarwood which are finished with one or more coats of paint.

Graphite pencils

Drawing pencils come in a range of grades, from 'H' for hard to 'B' for soft. The hardness of the lead is determined by the relative proportions of graphite and clay used: the more graphite, the softer the pencil. Typically, hard pencils range from 9H (the hardest) to H, and soft pencils range from 9B (the softest) to B. Grades HB and F are midway between the two.

A very soft lead will produce rich, black marks, and is an excellent choice for rapid sketches and expressive line-and-tone drawings, especially on textured paper. Hard leads make grey, rather than black marks. They are suitable for precise lines and details because they can be sharpened to a fine point. Although a single pencil of grade HB or 2B gives you considerable scope for expression, many artists use several grades of pencil in one piece of work, creating a rich interplay of line and tone.

Graphite sticks
These are made of high-grade compressed and bonded graphite formed into thick, chunky sticks. They glide smoothly across the surface of the paper, lending themselves to bold and expressive drawing, and to large-scale work. The marks can be varied by using the point, the flattened edge of the point, or the length of the stick.

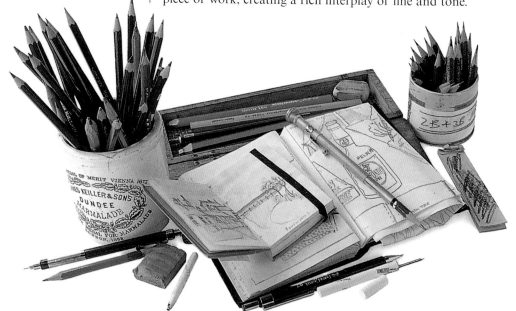

► **SEE ALSO**
► Supports 13
► Accessories 61

Valerie Wiffen
Model and artist
Graphite pencil on paper
21 x 14.5cm (8½ x 5¾in)

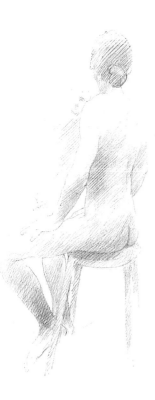

Linear marks

The weight, quality and nuance of a pencil line can be varied and controlled by the grade of pencil chosen, its sharpness, the degree of pressure applied, and the texture of the paper surface. A soft graphite lead gives considerable control over the tone and thickness of a line, which may be graded to describe the contours of a form and the play of light.

Hatching and crosshatching

Areas of tone can be built up with hatching – roughly parallel lines drawn close together. These can be straight and mechanical or free and sketchy. Altering the direction of the lines describes shape and form. In crosshatching, lines are crisscrossed on top of one another to create a fine mesh of tone. The lines may run in any direction: vertical, horizontal and diagonal. The density of tone can be varied, as is demonstrated above: the closer the lines, the blacker the pencil used, and the more pressure applied, the deeper the tone. Build up hatched and crosshatched lines gradually; too much deepening of tone early on can make the finished drawing dark and heavy.

Shading

Continuous gradations of tone can be created by shading with soft pencils. These areas are first drawn in broadly, using the edge of the lead, working from the lightest to the darkest tones or vice versa. The marks are then carefully blended together using a paper stump, as here, the fingers, or an eraser.

Drawing with an eraser

Erasers can also be used as drawing instruments. In this lively study, line and areas of tone were laid on the paper with a soft pencil, then drawn into and modified with a kneaded-putty eraser. This is a form of 'negative' drawing, in which the image emerges gradually from dark to light.

Pauline Jackson
Sneakers
Graphite pencil on paper
34 x 25cm (13½ x 10in)

Valerie Wiffen
Portrait I (above left)
Portrait II (below left)
Graphite pencil on paper
12.5 x 12.5cm (5 x 5in)

Coloured pencils

Coloured pencils are made from a mixture of pigment, clay and filler, bound together with gum. The coloured sticks are soaked in wax, which gives them their smooth-drawing properties, before being pressed into rods and encased in wood. Since David Hockney set a precedent in the 1960s with his series of coloured-pencil drawings, this medium has become increasingly popular with fine artists.

Choice and variety

Of late, there has been an enormous increase in the variety of coloured pencils available on the market. Not only has the range of colours been vastly expanded, but the colours themselves are now much more consistently lightfast than previously. You can also obtain watercolour pencils which allow you to dissolve or partially dissolve the colours on the paper with water.

Clean, quick and portable, coloured pencils are very useful sketching and drawing tools. They allow you to work with the accuracy of pencil while involving colour; they are soft enough to allow delicate shading, and they can be sharpened to a point for controlled lines.

Buying coloured pencils

Coloured pencils are available individually or in sumptuous-looking sets with dozens of colours. Brands vary considerably in the range of available tones and in the quality and proportion of pigments, binders, clays and waxes they contain. Some brands have hard, waxy 'leads' that can be sharpened to a long, fine point; others are soft and crumbly, producing a broader, more grainy mark.

Fine or broad
Most pencils have a colour core 3.5mm (³/₈in) in diameter, which is particularly suitable for finely detailed drawings. Some ranges also carry pencils with a 4mm (⁵/₃₂in) diameter colour strip, which allows for broad strokes and strong lines. As with ordinary lead pencils, they can be obtained in round or hexagonal wooden shafts.

• Buy the best
For fine-art work, look for the best quality pencils. They should have strong, lightfast and rich colours that come out uniformly and vividly, with no feeling of grittiness.

▶ **SEE ALSO**
▶ **Supports 13**
▶ **Pencils 40**
▶ **Water-soluble pencils 44**
▶ **Mixing colours 220**

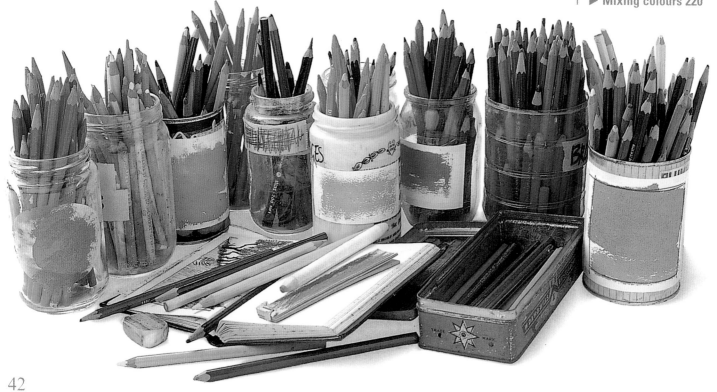

Optical colour mixing

You can use hatching and crosshatching techniques to create colours and tones. Just lay lines of different colours side-by-side, or overlay lines at right angles to one another to create the illusion of a third colour.

Toothed paper

Coloured-pencil drawings are characterized by a certain delicacy, softness and clarity, due to the effect of the grain of the paper. Unless you press hard with the pencil, the pigment particles catch only on the raised tooth of the paper, leaving the indents untouched; these tiny flecks of white paper reflect light, and this lends translucency to the colours.

Making the paper work

As with watercolours, the secret is to make the white of the paper work for you. Rather than applying dense layers of colour – which quickly makes the surface greasy and unworkable, preventing any further build-up of colour – deepen the colour by degrees, allowing plenty of white paper to show through the lines.

Light hatching

Coloured pencils produce a translucent effect that allows you to layer coloured marks to create subtle tones and hues. Here, the figure's solidity is achieved through lightly hatched lines. The illumination is suggested by highlights, using the white paper.

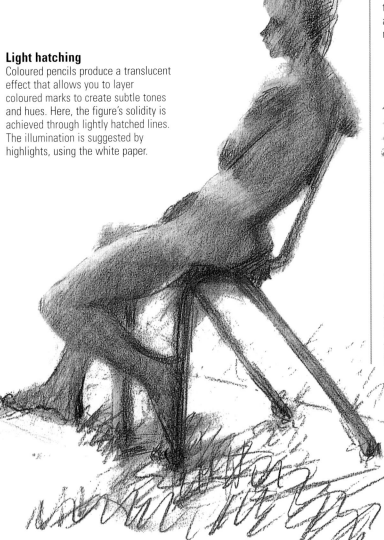

Building up colour

In many ways, coloured pencils work like watercolours. When they are used on white paper, the marks they make are transparent or semitransparent, which means you can put down one colour on top of another, building up hues, tones and intensities until you achieve the result you want.

Maintaining the best point

Using the natural backwards-and-forwards motion of the arm, work speedily, fractionally rotating the shaft of the pencil in your fingers from time to time, to find the best shading edge and to make the tip flatter or sharper as required.

Sarah Donaldson
Seated Nude
Coloured pencil on paper
42 x 30cm (16¾ x 12in)

43

Water-soluble coloured pencils

Colour applied dry

Dissolved with wet watercolour brush

Dissolved with wet sponge

Dissolved with wet finger

Dry point on wet paper

Point dipped in water, on dry paper

Combined with other materials

These offer all the advantages of coloured pencils, but include a water-soluble ingredient in the lead, so that it is possible to thin out their colour into a transparent wash.

Using water-soluble pencils

You can apply the colour dry, as you would with an ordinary coloured pencil, and you can also use a wet watercolour brush, a wet sponge, or even a wet finger, to loosen the pigment particles and create a subtle watercolour effect. When the washes have dried, you can then add further colour and linear detail, using the pencils dry. If you dampen the paper first, the marks made by the pencil will bleed slightly and produce broad, soft lines.

This facility for producing tightly controlled work and loose washes makes water-soluble pencils a flexible medium, and they are very appropriate for rendering natural subjects. They are often used in combination with watercolours, felt-tipped pens, pencil or pen and ink.

Techniques

Apply the colours with light, hatched strokes, then use a soft brush, rinsed regularly in clean water, to gently blend the strokes and produce a smooth texture. This can take a little practice, as too much water will flood the paint surface and make it blotchy, while insufficient water will prevent the colours from blending well; the ideal result resembles a watercolour wash. Heavy pencil strokes will persist and show through the wash.

Textures

Interesting textures can be created by building up the picture with multiple layers of dry pigment and water-dissolved colour. When adding dry colour over a dissolved base, however, the paper must first be completely dry; if it is still damp, it will moisten the pencil point and produce a blurred line, and the paper may even tear.

▶ SEE ALSO
▶ Coloured pencils 42
▶ Watercolour techniques 180

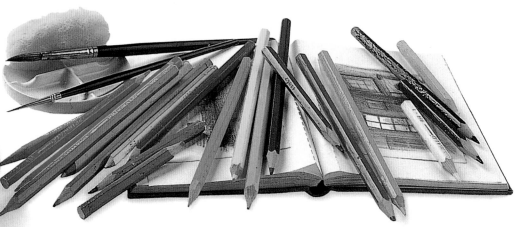

Coloured and water-soluble pencils

These pencils offer a surprisingly varied range of techniques and effects.

Anna Wood uses water-soluble crayons – which are thicker and juicier than pencils – which suit her spontaneous way of working. Suggestions of form, texture and space emerge from the accidental marks left as the colour washes spread and dry.

The astonishing detail and beautiful texture in David Suff's drawing are built up painstakingly with tiny strokes, which are applied layer on layer.

Michael Stiff's work has a similar sense of heightened reality. He blends pastel dust into a smooth layer to produce the basic tonal areas, over which he applies finely hatched strokes of coloured pencil.

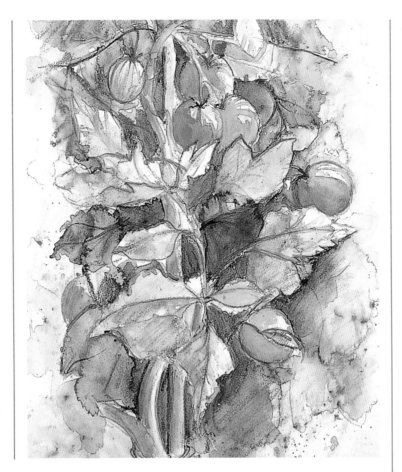

Anna Wood (left)
Tomatoes
Water-soluble pencil on paper
50 x 35cm (20 x 14in)

Michael Stiff (above)
Detail, Greek-Thomson Church, Glasgow
Coloured pencil and pastel on paper
25 x 20cm (10 x 8in)

David Suff
The History Garden (Twa Corbies)
Coloured pencil on paper
90 x 90cm (36 x 36in)

45

Charcoal

Charcoal has been used for drawing since prehistoric times: using soot and sticks of charred wood from the fire as drawing tools, early cavemen covered the walls of their caves with images of the animals they hunted. Since then, charcoal has never lost its popularity.

A user-friendly medium

Charcoal is an excellent medium for beginners, as it encourages the student to treat subjects in broad terms and not become lost in detail. At the same time it is a forgiving medium, which is very easy to erase and correct by rubbing marks off with a finger or a wad of tissue.

Charcoal sticks

Stick charcoal is made from vine, beech or willow twigs charred at high temperatures in airtight kilns. Willow is the commonest type; vine and beech charcoal are more expensive, but make a richer mark. 15cm (6in) lengths are available in boxes, and vary in thicknesses and degrees of hardness. Soft charcoal is more powdery and adheres less easily to the paper than hard charcoal, so it is better-suited to blending and smudging techniques and creating broad tonal areas. The harder type of charcoal is more appropriate for detailed, linear work, as it does not smudge so readily. The only drawback with stick charcoal is that it is very brittle and fragile, and tends to snap when used vigorously.

Vine, beech and willow charcoal

Compressed charcoal

This is made out of powder ground from charcoal, mixed with a binder and pressed into short, thick sticks. Compressed charcoal is stronger than stick charcoal and does not break so easily. It produces dense, velvety blacks, but is less easy to dust off than natural charcoal.

Charcoal pencils

These pencils are made from thin sticks of compressed charcoal encased in wood. They are cleaner to handle and easier to control than stick charcoal, and have a slightly harder texture. Only the point can be used, so they cannot produce a broad side-stroke, but they make firm lines and strokes. Charcoal pencils come in hard, medium and soft grades; the tip can be sharpened, like graphite pencils.

Versatility

Charcoal is a wonderfully liberating medium, so immediate and responsive in use that it is almost like an extension of the artist's fingers. Simply by twisting and varying the pressure on the stick, you can make fluid lines that vary from soft and tentative to bold and vigorous. Rich tonal effects, ranging from deep blacks to misty greys, are achieved by smudging and blending charcoal lines with the fingers or with a paper stump, and highlights can be picked out with a kneaded-putty eraser.

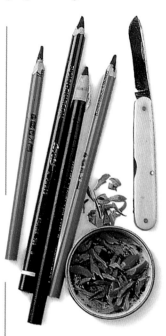

Detailed work
Easily sharpened, pencils are perhaps the best form of charcoal for doing detailed drawing.

▶ SEE ALSO
▶ Accessories 61

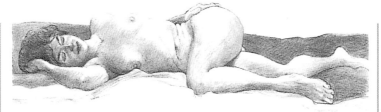

Working at a distance

Charcoal works well for large-scale drawings executed at the easel. You need to stand well back from the easel, so that your drawing arm is not cramped and so that you can view the drawing as a whole through each stage of progress.

Attaching charcoal to a cane

Working at a distance is made easier by securing the charcoal stick to the end of a cane – a method used by Renaissance painters when drawing images for frescoes. Cut a piece of cane to the required length. At one end of the cane make two 25mm (1 in) cuts at right angles. Push the charcoal firmly into the end, leaving a reasonable length protruding, and then secure with tape wound round the cane.

Tonal effects

The most effective method of achieving these is by smudging and blending charcoal lines with fingers or with a paper stump.

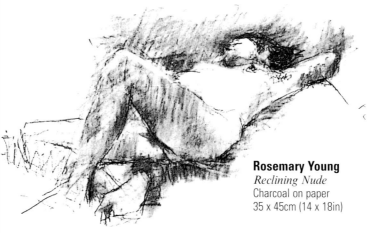

Rosemary Young
Reclining Nude
Charcoal on paper
35 x 45cm (14 x 18in)

Charcoal is a painterly medium, allowing a rich patina of marks to be built up with line and tone. Both of these artists' drawings evolve gradually, the final image being enriched by the previous alterations. Rosemary Young works at an easel, using charcoal attached to a length of cane to allow her greater mobility.

Sarah Cawkwell
Hair Piece
Charcoal on paper
147.5 x 118.7cm
(59 x 47½in)

Highlights

These can be picked out with a kneaded putty eraser.

Exploiting the grain of the paper

One of the most interesting of charcoal's characteristics is that it is sympathetic to the texture and grain of the paper, allowing it to show through and contribute to the surface interest of the drawing. This is especially the case when the charcoal stick is used on its side and swept lightly over the surface.

Fixing charcoal

The soft nature of charcoal makes it messy to handle, and the strokes may be accidentally smeared with the heel of the hand. Keep a damp rag handy, and wipe your fingertips regularly to avoid leaving 'prints' on the paper. It is advisable to spray finished charcoal drawings fairly liberally with fixative to protect them from smudging.

Pastels

Pastels are made from finely ground pigments mixed with a base such as chalk or clay and bound together with gum to form a stiff paste. This is then cut and shaped into sticks and allowed to harden. There are four types of pastel available: soft and hard pastels, pastel pencils and oil pastels. They are available in different shapes – round or square, thin or chunky.

Let the buyer beware
Since the degree of softness varies noticeably from one brand of soft pastel to another, you should try out individual sticks from different manufacturers until you find the one that suits you best. Only then buy a full range.

Tints and shades

Pastels are made in a wide range of tints and shades, derived from a selection of full-strength pigment colours. The tints are achieved by adding more base and white pigment to the original colour, and by repeating this process to produce a series of increasingly lighter shades.

The tonal range of each pastel colour is usually indicated by a system of numbering which corresponds to the various strengths of each colour; for example, in some ranges burnt umber has No. 1 against its lightest shade, and No. 8 against its darkest. This system of numbering, however, is not standardized from one manufacturer to another, so it is worth checking catalogues and colour charts.

Soft pastels

Soft pastels are the most widely used of the various pastel types, because they produce the wonderful velvety bloom which is one of the main attractions of pastel art. They contain proportionally more pigment and less binder, so the colours are rich and vibrant.

The smooth, thick quality of soft pastels produces rich, painterly effects. They are easy to apply, requiring little pressure to make a mark, and can be smudged and blended with a finger, a rag or a paper stump.

The only drawback of soft pastels is their fragility. Because they contain little binding agent they are apt to crumble and break easily, and they are more prone to smudging than other types of pastels. A light spray with fixative after each stage of the work will help to prevent such smudging.

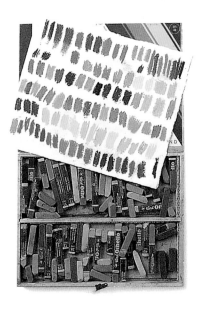

Permanence
Reputable manufacturers provide the names of lightfast pigments, such as burnt umber, that are used in pastels. Pastels in cheaper ranges often are given romantically descriptive names which, however, give no indication of the nature or permanence of the pigment.

Pastel pencils
Thin pastel sticks are available encased in wooden shafts, like pencils. Pastel pencils are clean to use, do not break or crumble like traditional pastels, and give greater control of handling. They are suitable for line sketches and detailed or small-scale work, and can be used in conjunction with hard and soft pastels.

Hard pastels

These contain less pigment and more binder than the soft type of pastels, so although the colours are not as brilliant, they do have a firmer consistency. Hard pastels can be sharpened to a point with a blade and used to produce crisp lines and details. They do not crumble and break as easily as soft pastels, nor do they clog the tooth of the paper; they are often used in the preliminary stages of a painting, to outline the composition, or to add details and accents in the latter stages, sometimes in combination with other drawing and painting media.

▶ **SEE ALSO**
▶ Supports 34
▶ Accessories 61

Versatility

Pastels are both a painting and a drawing medium. Working with the side of the crayon creates broad, painterly strokes that can be blended and smudged or built up in thickly impasted layers, with the solid, buttery appearance of an oil painting. Working with the tip of the crayon, you can make thin lines and crisp marks that create a very different feel.

Working with the tip

Blending

One of the attractions of a powdery medium such as pastel is that it is easily blended to create soft, velvety tones and subtle gradations from dark to light. Blending has many uses – in softening fine lines and details, suggesting smooth textures, modelling form with degrees of light and shade, lightening tones, and tying shapes together. To create an area of blended tone, either apply lightly scribbled strokes with the point of the stick, or use the side of the stick to make a broad mark, but do not press too hard – if the mark is too ingrained it will be difficult to blend. Then lightly rub the surface with the tip of your finger or a rag, tissue or paper stump, to blend the marks together and create an even tone. Repeat the process if a darker tone is required.

Working with the side

Blending with a fingertip

Line and tone

You can use blended tones alone, or mix blended and linear techniques to add variety and texture. Another approach is to create an area of soft blending and then overlay it with linear strokes. Here, the blended tones act somewhat like an underpainting, adding extra depth and subtlety to the image, while the strokes tie the image together.

Lines over soft blending

Scumbling

Scumbling modifies the colour of a tinted paper or a layer of pastel by applying a thin, semi-opaque layer of another colour over it. Loose, circular strokes are applied with the side of the pastel stick to create a thin veil of colour which does not entirely obliterate the one underneath. Scumbling not only creates subtle colour effects, but it also gives a very attractive surface texture. Use it to give depth and luminosity to your colours, and to soften and unify different areas of the drawing.

Scumbling

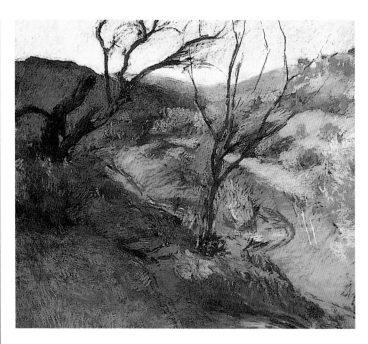

Among the many ways of applying pastel, the 'painting' and 'drawing' disciplines can be used alongside each other to create a breathtaking range of effects. These two pictures show some of the varied textures that can be produced, from broken, grainy strokes to delicate 'washes'.

James Crittenden
Windy Day
Pastel on paper
65 x 75cm (26 x 30in)

Jackie Simmonds
The Glass Table
Pastel on paper
45 x 60cm (18 x 24in)

Oil pastels

Oil pastels are made by combining raw pigments with animal fat and wax; this makes them somewhat different in character from soft pastels, which are bound with gum. Whereas soft pastels are known for their velvety texture and subtle colours, oil pastels make thick, buttery strokes, and their colours are more intense. Oil pastels are also stronger, harder and less crumbly than soft pastels; since they tend not to smudge, they require little or no fixative, but they are more difficult to blend.

'Drawing and colour are not separate at all; in so far as you paint, you draw. The more colour harmonizes, the more exact the drawing becomes.'
Paul Cézanne (1839–1906)

Using oil pastels

Working with a robust medium such as oil pastels will encourage a bold and direct approach which is of enormous benefit in developing confidence in your drawing and using colours. In fact, oil pastels are not ideally suited to small-scale, detailed work; the sticks are too chunky for this, and fine blending is not possible. It is far better practice to exploit the tactile qualities of the medium and to work on a large scale, using various, textural strokes and building up a rich patina of waxy colour.

As with the other types of pastels and crayons, optical-colour mixtures can be created by techniques such as hatching, crosshatching or gentle shading with superimposed colours.

▶ **SEE ALSO**
▶ **Mixing colours 220**

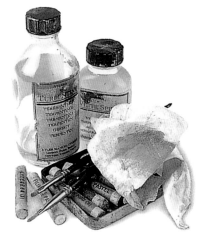

Diluents for oil pastels
Turpentine and white (mineral) spirit dissolve oil pastel and can be used for blending colours and obtaining painterly surface effects Your initial drawing can be modified using a brush which has been dipped in a diluent and worked over the surface.

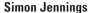

Simon Jennings
Upstream Greenwich
Oil pastel and graphite pencil on paper
41 x 57.5cm (16½ x 23in)

Oil pastels work particularly well in combination with other media. Here, the artist emphasized the sky and the dramatic sweep of the river with lines and flecks of oil pastel, which were then blended with turpentine. The details of the buildings in the foreground were added with graphite pencil, which glides over an oil-pastel ground.

Dry oil pastel on
blended pastel

Blended with a wet finger

Scratched back or sgraffito

Wax-resist

Blending and mixing

Because of their waxy texture, only a minimal amount of blending is possible with oil pastels. The colours can, however, be applied to the support and then spread and blended with a brush, rag or tissue which has been dipped in white (mineral) spirit or turpentine. As the pastel mixes with the turpentine it dissolves and takes on the quality of thinned oil paint, and the colours become richer and darker. When they are dry, you can work over the 'painted' areas with linear strokes of dry oil pastel to add textural variety.

Finger blending

The drawn surface can be smoothed and blended with a wet finger. Because oil and water are incompatible, a dampened finger will not pick up the colour from the paper but will just smooth and blend the surface of the oil pastel.

Sgraffito

A layer of solid colour can be built up, and the waxy surface scratched into with a sharp tool to create lively patterns and textures – a technique known as sgraffito. Further interest is added by applying one colour over another and then scratching back through the top layer to reveal the colour below.

Wax resist

Oil pastel can be used with watercolour paint to build up a lively surface or to suggest natural textures. The paint adheres to the paper but is resisted by the waxy pastel marks, and results in a random, mottled effect. A more pronounced pattern can be achieved by working on rough-surfaced paper.

Simon Jennings
Portrait of a Tulip
Oil pastel on paper
58.7 x 41cm (23½ x 16½in)

A painterly surface was built up by using oil painting techniques, which included blending into thick layers of colour, scraping back with a knife, blending and smudging with fingers and scratching in lines with a pointed paintbrush handle. The oil-paint shine that resulted can be seen in the surface reflection.

Blended oil pastel

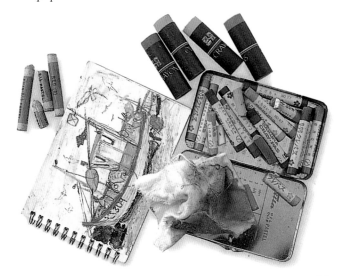

Conté crayons

These crayons were invented by the Frenchman Nicolas-Jacques Conté, who was also responsible for inventing the modern lead pencil in the eighteenth century. Made from pigment and graphite bound together with gum and a little grease, conté crayons are similar to pastels in their consistency and appearance, but are slightly harder and oilier. They are available in pencil form, and in the original form of square-section sticks about 75mm (3in) long.

Modern, pencil-form colours

Types and colours

Conté crayons are similar in effect to charcoal, but because they are harder they can be used for rendering fine lines as well as broad tonal areas. Although conté crayons are now available in a wide range of colours, many artists still favour the restrained harmony of the traditional combination of black, white, grey and earth colours – sepia, sanguine (terracotta red) and bistre (cool brown). These colours impart a unique warmth and softness to a drawing, and are particularly appropriate to portraits and nude-figure studies. The traditional colours also lend to drawings an antique look, reminiscent of the chalk drawings of Leonardo da Vinci, Michelangelo, Rubens or Claude.

Fine and broad strokes

As with pastels, the most practical method of using conté crayons is to snap off small pieces about 25mm (1in) long. This way, you can rapidly block in tonal areas with the side of the stick and use a sharp corner at the end for drawing expressive lines.

Blending conté

Conté is soft enough to blend colours by rubbing them together with a finger, a soft rag or a paper stump. However, because they are less powdery than chalk and charcoal, conté colours can be mixed by laying one colour over another, so that the colours beneath show through.

Traditional colours

Coloured conté
There is now a wide range of conté colours available, in addition to the time-honoured ones.

▶ SEE ALSO
▶ Supports 13
▶ Pastels 48
▶ Accessories 61

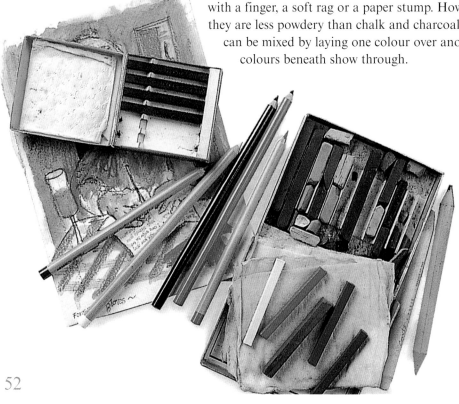

Snap off small pieces

Blending by laying (top) and rubbing colours

Conté work

Like pastels, conté crayons are used to their best advantage on tinted paper with a textured surface, which brings out the distinctive qualities of the marks.

John Raynes (right) uses white conté skilfully to capture crisp highlights on his model's white shirt.

The two drawings by Victor Ambrus (below) show the surprising range of textures that can be achieved by using only coloured or black crayons on a cream coloured paper.

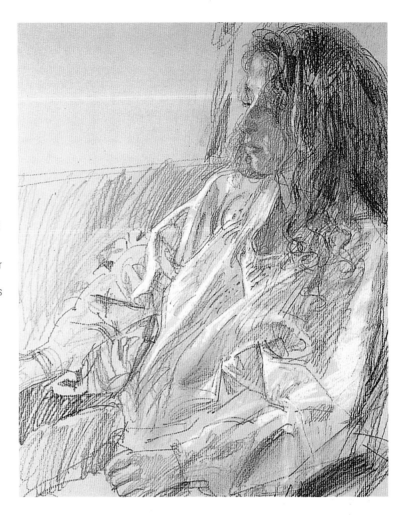

Victor Ambrus
Dorothy's Dog, Lalla
Black conté crayon, on paper
76 x 56.5cm (30 x 22¼in)

John Raynes
Portrait of a Girl
Coloured and white conté crayon on tinted paper
51 x 34cm (20½ x 13½in)

Victor Ambrus
Morag
Coloured conté crayon on paper
56.5 x 76cm (22½ x 30in)

53

Pen and ink

Pen and ink is a delightful and flexible medium which has been popular with artists since ancient-Egyptian times. The medium is capable of an enormous range of techniques and effects, but the materials required are very simple. The choice available of drawing pens and nibs is large, but falls into two distinct categories: dip pens and reservoir pens.

Nibs
The nib itself is known as the 'pen', and the main shaft is the 'penholder'. A great variety of nib shapes and sizes is readily available. Each nib makes a different range of marks, and the more flexible the nib, the more varied the thickness of line it makes. Since they are so inexpensive, it is worth trying several before buying.

Metal pens
Dip pens with metal nibs have long been the traditional tool of pen-and-ink artists and illustrators. Inexpensive and versatile, these pens consist of a holder and an interchangeable steel nib.

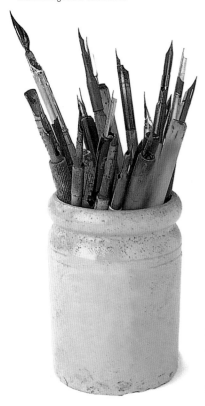

Dip pens
Reed, quill and metal pens (metal nibs set into holders) are all classified as dip pens, as they are loaded by being dipped directly into the ink. The nib retains a small amount of ink, which is held in place by its own surface tension. Dip pens produce very expressive lines which swell and taper according to the amount of pressure applied to the pen.

Mapping pens
Mapping pens have a very fine, straight point for detailed drawings. Because the metal nibs are flexible, you can vary the thickness of line to a considerable degree.

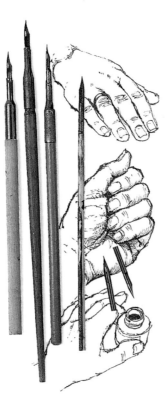

Crow-quill pens
Crow-quill pens (a type of mapping pen) also have a delicate point for producing detailed work, but can be less flexible than mapping pens.

Bamboo and reed pens
Bamboo and reed pens may have declined in popularity since the availability of more sophisticated pens, but many artists still use them. Their blunt, coarse and slightly irregular strokes make them ideal for bold line drawings, and their appeal often lies in the sheer pleasure that can be derived from drawing with such a 'primitive' instrument.

Ink for metal pens
Metal pens can be used with any type of ink – waterproof or water-soluble – because there is no mechanism to clog up. However, the nibs should be cleaned regularly under running water to prevent the ink from caking.

Making a quill pen
Use a stout, round feather, preferably a goose feather. Trim the barbs back (**1**), to make the feather easier to hold when drawing. Shape the tip of the quill with a sharp knife. Make a curved, diagonal cut (**2**), then remove the keratin filling from the quill. Finally, make a single cut, running up from the tip of the quill, to make a channel for ink (**3**).

Quill pens
Quill pens are made from the wing feathers of birds such as geese, turkeys or swans. They are often an ideal choice if you want to make fine, responsive lines. However, the nib is fragile, so this type of pen is best suited to small sketches and detailed drawings, rather than large-scale works.

Reservoir pens

Reservoir pens carry ink in a special holder or cartridge and need only to be refilled from time to time, but in general their nibs are less flexible than those of dip pens.

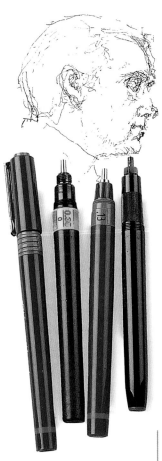

Fountain pens

Fountain pens feel much smoother to draw with than dip pens, and because they produce a steady flow of ink to the nib, they don't need to be dipped frequently. This makes them useful for impromptu sketching. However, since fountain-pen nibs have little flexibility, it is not very easy to vary the thickness of your lines. The nib range is also quite limited.

Technical pens

Originally designed for use by professional illustrators and designers, technical pens deliver ink down a narrow tube instead of a nib. This produces a very even line of a specific and unvarying width, regardless of the direction in which the pen is moved. The fine, fragile strokes made by technical pens are most appropriate for a controlled, graphic style of drawing. Like fountain pens, technical pens are easily portable and contain their own supply of ink. But, unlike fountain pens, the ink flow is fine and even, and lasts much longer, so you no longer have to carry bottles of ink which can break, leak or spill. The narrow tubular nibs for technical pens, available in an increasing variety of point sizes, are interchangeable within each range, and can be quickly switched.

Nib units for technical pens

For most drawings, you will need only one holder and several nib units in a range of different sizes.

Ink for technical pens

Technical pens should only be used with technical-pen inks. These are usually, though not always, lightfast, but are not waterproof. The ink supply is held in a reservoir and can be topped up with a dropper, or from a purpose-made filler bottle. The nibs should not be left uncovered, as the ink will dry in its channel, and they must be cleaned regularly with warm water. If the pens are not to be used for some time, they should be emptied and cleaned.

Ink for fountain pens

To prevent them clogging, most fountain pens require non-water-proof ink, drawn into the barrel by suction through the nib. An exception to this rule is Indian-ink pens, which are made specially for use with this type of ink and have a choice of two sketching nibs, graded 'ordinary' and 'bold'.

Sketching pens

Also known as 'art pens', these combine the expressive qualities of a dip pen with the convenience of a reservoir pen. In appearance they resemble an ordinary fountain pen, but they have flexible nibs designed specially for drawing, which deliver ink smoothly to the paper via a pre-filled ink cartridge.

Coloured sketching-pen cartridges

Filler adaptors

'Art pens' also have a filler adaptor which enables you to fill them with a range of liquid colours.

Drawing inks

For monochrome drawings, Indian ink is still the favourite choice of many artists, as it is both permanent and waterproof. Sepia and blue-black inks also have their own appeal, and all can be diluted with water to produce a range of light-to-dark tones in one drawing.

Diluting coloured inks
Coloured inks may be diluted with distilled water, not only to improve their flow, but also to produce a range of lighter tones. The inks can also be mixed with each other, but it is advisable to stick to the range of a single manufacturer, because brands of ink vary in consistency and in the surface finish they produce when dry. Pigment in ink settles at the bottom of a jar if left unused for some time, so the jar should be shaken before use.

Waterproof coloured inks

Waterproof coloured inks, also called artists' drawing inks, come in a range of about 20 colours. Waterproof inks are essential if you intend to apply a wash or tint on top of a line drawing, otherwise the linework will run. These inks are denser than non-waterproof varieties, drying to a slightly glossy finish that gives the work a precise, painted quality. Unfortunately, the shellac that is added to the ink to make it waterproof also makes it clog up easily, so be sure to clean brushes and pens thoroughly after use. Never use waterproof ink in fountain pens or technical pens.

Non-waterproof coloured inks

These contain no shellac, and they are primarily used for laying washes over waterproof-ink drawings. They are fine for line drawings, too, as long as you don't overlay them with washes. Non-waterproof inks sink into the paper more than waterproof types, and they dry to a matt finish.

Soluble inks

If you want the flexibility to be able to dissolve and blend lines, you should choose a soluble ink such as Chinese ink (see right), which is also more delicate than Indian ink.

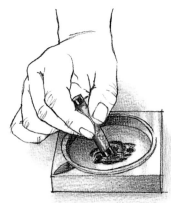

Oriental inks
Chinese and Japanese inks come in solid-stick form and are usually supplied with an ink stone. The ink stick is rubbed down on the stone, with a little water being added until it is the desired consistency.

• Restoring flow
If ink evaporates slightly while it is uncorked during a day's work, the colour becomes deeper and the ink thicker. Adding a little distilled water will thin it and restore an even flow.

• Permanence of inks
Only black and white inks are permanent. Coloured inks consist of soluble dyes rather than pigments, and are not lightfast. To minimize fading, always protect your finished drawings from prolonged exposure to light.

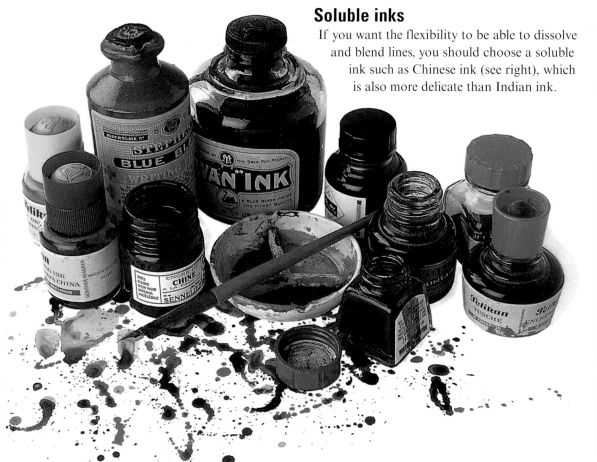

▶ SEE ALSO
▶ Drawing papers 38
▶ Watercolour brushes 96

Linework

Pen-and-ink drawings are usually composed of lines; hatching, crosshatching, stippling, dots and dashes, spattering and scribbling are just some of the techniques that can be employed to convey form and volume, texture, light and shade.

First strokes

Do not begin pen-and-ink work until you have tried drawing and practising movement and line with a pen or a brush. Work on a smooth paper, and learn to use a minimum of pressure to get an even flow of ink from the nib on to the paper. If you are practising with a dip pen, learn to judge when the ink will run out, so that you are not in the middle of a long unbroken line when it happens.

Spontaneity

It is a great advantage to make a very light preliminary design with a soft pencil if you want an accurate pen-and-ink drawing, rather than a quick sketch. But once the technique of pen-and-ink drawing becomes more familiar, spontaneous free-flowing lines and observations translated instantly onto paper will often make a far more exciting ink drawing than one which is premeditated. An ink drawing must be completely dry before preliminary pencil lines are erased or any washes added. Drying time is at least 12 hours, and even longer for a thick layer of ink.

Pen-and-ink work must be positive to look successful: once an ink mark has been made on paper, it is very difficult (and sometimes impossible) to erase, so there is no room for hesitation. Ideally, you need to have had enough drawing practice to know exactly what you want to put down before you start.

'Do you realize what will happen to you if you practise drawing with a pen? – that it will make you expert, skilful and capable of much drawing out of your own head.'
Cennino D'Andrea Cennini (Fl. 14th century)

Leslie Harris (1906–89)
Preparatory Studies
Ink and wash on paper
Various dimensions

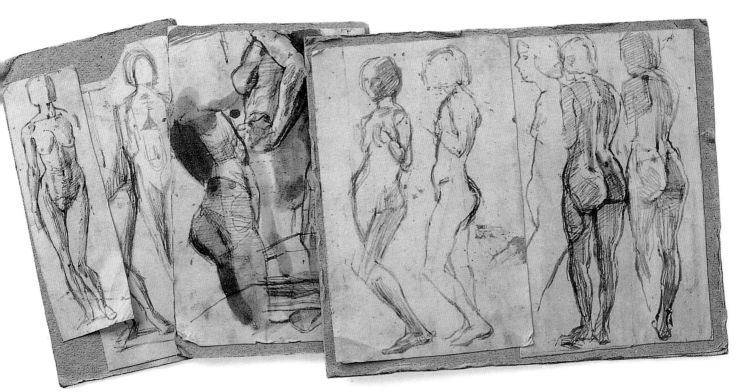

Edmund J. Sullivan (1869–1933)
Bearded Man
Pen and ink on paper
15 x 12.5cm (6 x 5in)

The illustrator Edmund J. Sullivan was regarded by his contemporaries as one of the finest draughtsmen of his day. This sketch displays great control of line and tone, allied to a remarkable sensitivity to the subject. It is a triumph of penmanship, all too rarely found today.

Pen drawing

Using the techniques mentioned earlier, you can create areas of tone, volume, texture and the illusion of light and shade with just pen and ink. Increase your options by adding washes of ink or watercolour – an exciting fusion of drawing and painting which allows you to build up experience of both disciplines.

Line and wash

Line-and-wash drawings are highly expressive, suggesting more than is actually revealed. The secret is to work rapidly and intuitively, allowing the washes to flow over the 'boundaries' of the drawn lines and not be constricted by them. The combination of crisp, finely drawn lines and fluid washes has great visual appeal, capturing the essence of the subject with economy and restraint. Line and wash also helps improve your drawing skills because it forces you to be selective and to develop a direct, fluid approach.

Line-and-wash methods

The traditional method is to start with a pen drawing, leave it to dry and then lay in light, fluid washes of ink or watercolour on top. Alternatively, washes can be applied first to establish the main tones, with the ink lines drawn on top when the washes have dried. The most integrated method is to develop both line and tone together, so that they emerge as an organic whole. You might begin with a skeleton of lines, add some light tones, then some bolder lines and stronger tones, and so on until the drawing is complete.

Hil Scott
Squatting Nude
Pen, brush and ink on paper
43 x 33cm (17 x 13in)

In this vigorous line-and-wash study, Hil Scott combines calligraphic lines, drawn with a reed pen, with fluid tonal washes of Chinese brush and ink. With her sureness of touch she is able to convey a wealth of information – form and modelling, gesture and mood – with breathtaking simplicity and confidence.

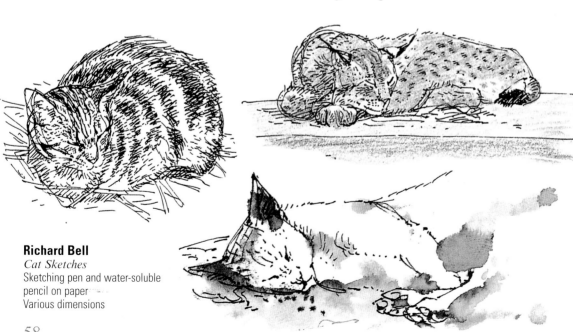

Richard Bell
Cat Sketches
Sketching pen and water-soluble pencil on paper
Various dimensions

▶ **SEE ALSO**
▶ **Drawing papers 38**
▶ **Watercolour brushes 96**
▶ **Watercolour washes 182**

Soft brushes

The brush is an incredibly flexible drawing tool. A sable brush with a good point can, in a single stroke, convey line, rhythm, and even the play of light on a subject. It can change direction easily, twisting and rounding corners where a pen or pencil might falter. Sable and other soft-hair brushes are suitable for ink drawing; experiment with various types of brush on both smooth and textured papers, and compare the different marks they make.

Chinese brushes

Chinese bamboo-handle brushes, which were originally designed as a writing tool, are versatile, inexpensive and extremely expressive. The belly holds a lot of ink, and comes to a fine point for drawing rhythmic, flowing lines.

Brush drawing

Brushes tend to be overlooked as instruments for drawing, as they are usually associated with painting techniques. Yet many great artists of the past – Rembrandt, Goya and Claude among them – produced some of their finest drawings with brush and ink.

Gordon Hales
On the Estuary
Brush and ink on watercolour board
15 x 22cm (6 x 9in)

Speed and fast attack are both vital in capturing the telling gestures of a moving subject. Gordon Hales distilled the essentials of the scene above with his confident brushwork, using dilutions of ink to convey light and movement. Richard Bell sketched his subject with an expressive bamboo pen outline, filled in with a dense black mass of ink.

Richard Bell
Carrion Crows
Pen and ink on paper
Various dimensions

Markers and fibre-tip pens

Water, spirits and alcohol

Some markers contain water-based ink and are water-soluble; others contain spirit- or alcohol-based inks and are waterproof when dry. If you want to overlay colours, choose solvent-based markers, which are easily distinguished from water-based markers by their smell (alcohol-based ink has less odour than spirits). On a sketch pad, the colours may bleed through onto the next page, but you can buy marker pads in which the paper is formulated to resist colour bleeding.

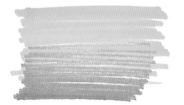

Solvent-based waterproof markers

Water-based soluble markers

Ordinary paper

Bleed-proof paper

Gigol Atler
Sketchbooks
Various markers on paper
15 x 10cm (6 x 4in)

Though normally associated with the graphic designer's studio, pens with felt, fibre or plastic tips are now widely used by fine artists as well.

Versatility

The large range of markers and fibre-tip pens available makes them extremely useful for rendering both free, spontaneous sketches and sophisticated, detailed drawings. Coloured markers are especially convenient for outdoor sketching, because the colours are consistent and ready to use, and dry almost instantly.

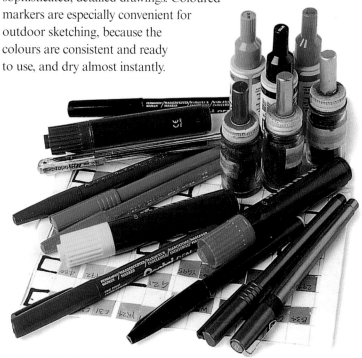

Markers are ideal for on-the-spot sketching, giving a rapid impression of form, colour and atmosphere.

Colour permanence

Markers come in many colours, with intensity and permanence varying according to brand. Since marker colours consist of dyes and not pigments, they tend to fade in time or when exposed to strong sunlight. This doesn't matter for rough sketches, but for permanent artwork, make sure you buy a lightfast brand.

Marker tips

These range from soft felt to hard tungsten carbide. Softer tips make smoother lines; hard ones keep their shape longer.

Fibre-tip markers are fairly firm and smooth-flowing, and come with tips of all shapes and in most sizes.

Plastic-tip markers are hard and durable. They are used for tips that make the finest lines.

Brush pens have resin tips. They are quite flexible and ideal for sketches and colour washes.

Roller pens are extremely tough, keeping their shape well. They produce a smooth, fine line.

Tip shapes

Coloured-marker tips vary from broad wedges to fine points.

Wedge-shape tips cover solid areas well. Drawing with the thin edge will produce fairly fine lines.

Bullet-shape tips are appropriate for bold strokes and solid areas, as well as dots suitable for stippling.

Fine-point tips are similar to technical pens, in that they produce even, fine lines with little variation.

Accessories

• Sharpening pencils
Pencil sharpeners are very convenient, but using a craft knife or scalpel will produce a longer, tapering cone that exposes enough lead for drawing broadly with the side.

Sharpening with sandpaper
Sandpaper blocks, which consist of small, tear-off sheets of sandpaper stapled together, are very handy for putting fine points on graphite sticks, pastels, crayons and lengths of charcoal.

One of the best things about drawing media is that you will require very few accessories. The drawing aids described here are all easily purchased in specialist art shops and are inexpensive.

Erasers

Plastic or putty erasers are best, as India rubber tends to smear and can damage the paper surface. Putty erasers are very malleable; they can be broken off into smaller pieces and rolled to a point to reach details. You can also press the putty eraser onto the paper and lift off unwanted marks by pulling it away. Use it on soft graphite, charcoal or pastel drawings, both to erase and to create highlights.

Paper stumps

Paper stumps, also called torchons, are used for blending or shading charcoal, pastel or soft-graphite drawings. They are made of tightly rolled paper, with tapered ends for working on large areas, or a sharp point for small details.

Knives and sharpeners

You will need a sharp craft knife or penknife for sharpening pencils and cutting paper. Knives or other blades are also very useful for sgraffito work – scratching lines into an oil-pastel drawing, for example, to create interesting textures.

Drawing board

You will need a firm support for drawing on sheets of loose paper. Drawing boards are available from art shops, but it is far less costly to get a good piece of smooth board, such as MDF, from a timber yard. If the board feels too hard, place a few extra sheets of paper under the top one to create a more yielding surface.

Fixative

The best way to preserve drawings is to spray them with fixative, which binds the particles of pigment to the surface of the paper. Fixative is available in aerosol-spray form or mouth-type atomizers. Aerosol sprays give an even coat, and are the most convenient to use when covering a large area. An atomizer is a metal diffuser with a plastic mouthpiece, which is stood in a bottle of fixative. Blowing through the atomizer will distribute a fine spray of fixative onto the drawing. Atomizers are ideal for spraying small areas, but it takes practice to get accustomed to using them, and they also need regular cleaning to prevent clogging.

Blowing fixative through an atomizer

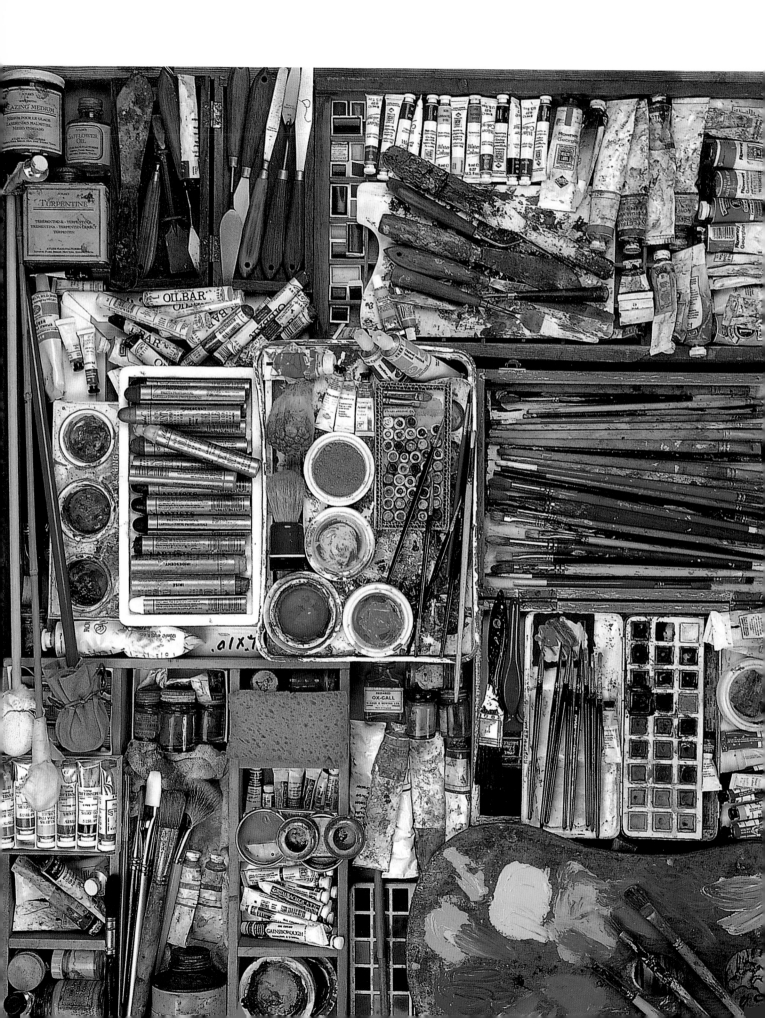

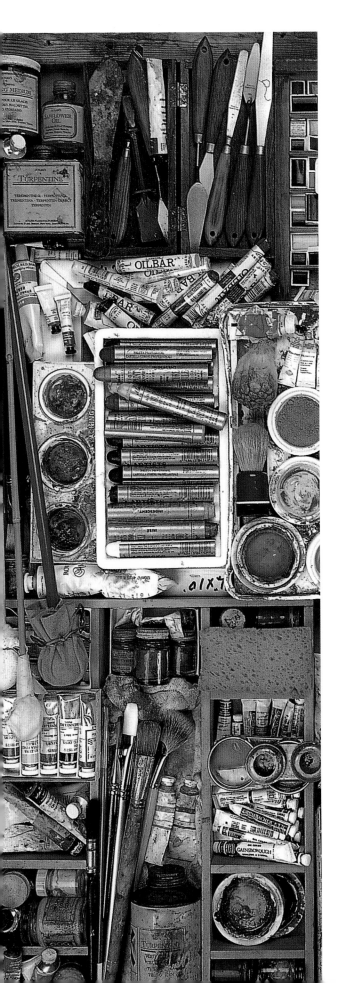

Painting media

Painting is a tactile and visual experience; in all good pictures there is a fascinating dialogue between the subject and the way the paint itself is applied and manipulated to express that subject. Whether you prefer the delicacy of watercolours, the richness of oils, the versatility of acrylics, the intricacy of tempera or the immediacy of gouache, the experience of working with a range of painting media will widen the scope of your artistic expression. Visit art-supply shops to stay in touch with what is new on the market, and don't be afraid to experiment with unfamiliar materials and techniques.

Oil paints

Art shops stock an overwhelming range of paints, brushes, mediums, varnishes and assorted oil-painting paraphernalia. The equipment for painting in oils can be costly but, if you choose wisely and according to your own requirements, it need not be so. The basic essentials are about 10 or 12 tubes of paint, a few bristle brushes, a bottle of thinners or a prepared painting medium, a palette and a surface on which to paint. The painting surface, or support, can be anything ranging from a sheet of top-quality linen canvas to a piece of hardboard.

• Caring for your paints
Paints tend to solidify in the tube if left uncapped. Replace the cap once you have used the paint, and make sure the threads on the cap and neck remain clean. Stuck caps can be opened with pliers, or by holding the tube under hot running water. As a last measure, stand the tube upside down in turpentine or white spirit for a few minutes, so that the cap and top of the tube are covered. Always squeeze a tube of paint from the bottom upwards, thus ensuring that there is as little air as possible inside the tube.

Oil-paint constituents

Oil paint consists of dry pigments ground in a natural drying oil such as linseed, or a semi-drying oil such as safflower or poppy. Some brands of oil paint are matured and then remade with more pigment in order to achieve the right consistency, but most are given additives, such as plasticizers, driers and wax, to improve their flexibility and make them consistent in texture and drying speed. Stabilizers may also be added to prevent the oil and pigment separating in the tubes during storage. Most manufacturers offer at least two grades of paint: artists', or first quality, and students', or sketching quality.

Artists' colours

Artist-quality oil paints offer the widest range of colours and the greatest colour strength. They contain a high concentration of pigment, which is very finely ground with the finest-quality oils.

Students' colours

Students' colours are cheaper than artists' colours, because they are made in larger quantities and the colour range is more limited. The more expensive pigments, such as cadmiums and cobalts, are replaced with some cheaper, but equally permanent, alternatives, and these colour names are suffixed with the word 'hue'. Students' colours may have lower pigment levels and contain small amounts of fillers, such as chalk, which will slightly weaken the colour strength of the paint.

Combining paints

Students' colours are perfectly adequate for the beginner to practise with, and it is even possible to cut costs by combining the two types: for example, using artists' paints for the pure, intense colours and students' paints for the earth colours, which are often just as good as in the artists' range. Some artists use students' colours for underpainting, before adding artists' paints for the final layers.

Avoiding waste
Oil paints are expensive. A palette knife held at an oblique angle and scraped along a finished paint tube will help to remove the last scrap of paint.

A selection of artists' oil paints

A selection of students' oil paints

▶ **SEE ALSO**
▶ Supports 13
▶ Binders 74
▶ Mediums 76
▶ Brushes 78
▶ Pigments 92

Size and price

Oil-paint tubes range from 5ml (0.17 US fl.oz) to a generous 200ml (6.66 US fl.oz). The most useful size of all is probably 37ml (1.25 US fl.oz), and a larger tube of white – say 56ml (1.86 US fl.oz) – works out more economical, since white is used more than most other colours.

Artist-quality paints vary in price according to the initial cost of the pigment. In some brands, they are classified according to 'series', typically from 1 (the cheapest) to 7 (the most costly). The earth colours are the least expensive, while the cadmium colours will cost four times more. Some pigments, such as vermilion, are prohibitively expensive, and most manufacturers now replace them with modern synthetic pigments. Student-quality colours are sold at a uniform price.

Drying times

The speed at which oil paint dries depends on the colour. Some pigments act upon the drying oils in which they are bound, speeding up the drying process; others slow it down (see right). Earth pigments dry rapidly, acquiring a skin overnight, whereas alizarin crimson may need up to 10 days to become touch-dry.

To accommodate these extremes, some paint manufacturers add drying agents to the slower-drying pigments; others grind fast-drying pigments with slower-drying oils, to obtain a paint range with more consistent qualities. Others add no drying agents, allowing the artist to decide whether to use fast-drying mediums.

Tinting strength

There is a variation in the tinting strength of different pigments. For example, Prussian blue and alizarin crimson will produce vivid colours when added in even very small quantities to white, whereas terre verte and raw umber become very pale when mixed with only a little white. When mixing a pale tint using strong colour, always add it to the white and in very small quantities – otherwise, you may get through a great deal of paint for little result.

Differences

Manufacturers do not formulate their paints in the same ways, so although colours in different brands may have the same names, their contents vary not only in the appearance of the colour but also in their cost, consistency, handling qualities, permanence and drying rates.

Assortment of tube sizes

• Humidity and temperature
Both affect drying time, and thicker layers of paint will naturally take longer to dry than thin layers.

• Darkening
Oil paintings require a normal amount of daylight while drying. If a painting dries in a dark or dimly lit room, the colours will darken. If this happens, the colours can be restored by exposing the picture to normal – not bright – daylight for a week.

Drying speeds of oil paint

The following is a guide to approximate drying speeds of pigments bound in linseed oil. The drying rates may vary between brands, and colours bound with safflower or poppy oil are relatively slow-drying. When colours are mixed together, their drying rates may be altered.

Fast-drying
(approximately two days)

Raw sienna
Burnt umber
Raw umber
Flake white
Prussian blue
Cobalt blue

Medium-drying
(approximately five days)

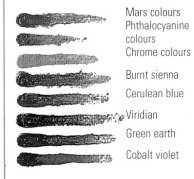

Mars colours
Phthalocyanine colours
Chrome colours
Burnt sienna
Cerulean blue
Viridian
Green earth
Cobalt violet

Slow-drying
(five to eight days)

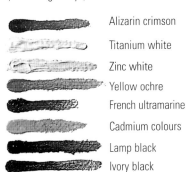

Alizarin crimson
Titanium white
Zinc white
Yellow ochre
French ultramarine
Cadmium colours
Lamp black
Ivory black

Prussian blue

Alizarin crimson

Terre verte

Raw umber

Pigment strength
Note the contrast in tint between the two pigments on the left and those on the right, when they have all been mixed with the same amount of white.

Flake white
Also known as lead white or silver white, this is a comparatively quick-drying, durable and flexible paint, widely used in underpainting. It accelerates the drying of colours mixed with it. Flake white lacks the opacity of titanium white and the whiteness of zinc white. It is harmful if it is swallowed, as it contains lead, so keep it out of the reach of children.

Titanium white
Also known as permanent white, this is the whitest and most opaque white, which dries very slowly to a soft, chalky film. Its strong covering power is useful for mixing tints, and for highlights and final painting. It is classed as non-hazardous.

Zinc white
This has a pure, cold-white appearance which does not darken with time. It is semi-opaque, and is suitable for tinting and glazing, but not for underpainting. Zinc white dries very slowly to a hard, brittle film. It is classed as non-hazardous.

Which white?

The most important pigment in the oil painter's palette is white, because it is used more than any other colour. It is therefore essential to use good-quality whites; even if you are using student-quality paints, it is worth buying a large tube of artist-quality white, as it has better covering power than the student grade.

Several whites are available, each with different properties, although as a general rule titanium white is the most reliable and versatile (see left).

Whites ground in poppy or safflower oil should not be used for priming or extensive underpainting. They are slow-drying, and can cause cracking of subsequent paint layers unless allowed to dry thoroughly. Use flake white, which is quick and thorough-drying, or one of the alkyd or underpainting whites.

Alkyd paints

These are made from pigments bound in an oil-modified synthetic resin. They handle in the same way as traditional oil paints, but have the advantage of being much faster-drying – in normal use, the paint surface is generally dry within an hour. Alkyds may be mixed with oil paints, which has the effect of speeding up the oils' drying time and retarding that of the alkyds, so that all the colours dry at a relatively even rate. Any supports that are suitable for oil and acrylic paints may be used for alkyds, once primed with oil or acrylic primer.

Water-friendly oil paints

The American company Grumbacher has introduced a range of oil paints in which the linseed-oil binder has been modified to mix with, rather than repel, water. This does not affect the use of traditional oil-based mediums and diluents, but means that thinning paint and cleaning brushes can be done with water. Another advantage is that this eliminates the use of solvents, to which many people are allergic, and avoids a possible build-up of potentially dangerous vapours.

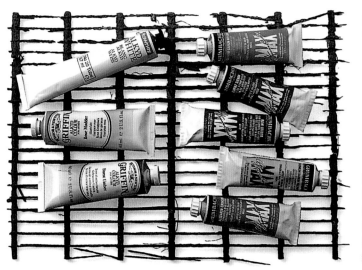

A selection of alkyd and water-friendly oil paints

▶ **SEE ALSO**
▶ **Mixing colours 67**
▶ **Basic palette 72**
▶ **Underpainting 164**
▶ **Pigments 92**
▶ **Health & safety 386**

Mixing oil colours

Oil paint is expensive, but do not be mean with it. Always squeeze the paint out in generous mounds, or you will be constantly unscrewing tube caps and mixing up fresh batches of paint, which can become a chore. Any paint that is left over at the end of the session can always be re-used in one way or another.

Keep colours clean

Try to avoid using more than two or three colours in any one mixture. Any more than this, and the colours become lifeless and muddy. Always have a large jar of turpentine and a rag nearby, so that when you have finished with a particular colour you can clean the brush or palette knife thoroughly and not contaminate the next colour.

Mixing methods

When mixing oil paints on the palette, use either a brush or a palette knife. A knife is preferable for mixing large quantities of paint, and it will certainly save a lot of wear and tear on your brushes. When working fast and mixing small quantities of colour, however, a brush is more convenient. Old, worn brushes are useful for this purpose – never mix paint with sable brushes, as it quickly ruins them.

Adding diluents

Mediums and diluents should be added to paint gradually, and in small amounts. Including an excess of thinning agent may result in an underbound paint film that is prone to flaking.

Mixing paint
Fully mixing two colours produces a solid third colour (top); partly mixing them allows the two original colours to still be part of the mixture (above).

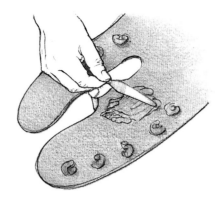

Palette-knife method
A palette knife is convenient for mixing large amounts of paint and avoids damaging your brushes. Use a scoop-and-slide action to mix the colours thoroughly.

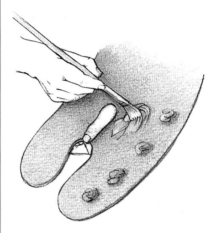

Brush method
When mixing paint with a brush, you should use gentle sweeping and rotary motions in order to minimize excessive wear and tear on the bristles.

• Reusing oil colour

Scrape paint off the palette with a knife and store in an airtight container for use next time round. Even 'palette mud' (the dull colour left when many colours have been mixed) can be useful – thin it down with turpentine and use it for tinting canvases and boards. Paint which has been exposed on the palette for long periods will have begun to oxidize, and is therefore not stable enough for use. If the paint feels gummy or it requires a lot of thinners to make it workable, then it should be discarded.

▶ **SEE ALSO**
▶ **Diluents 75**
▶ **Mediums 76**
▶ **Brushes 78**
▶ **Accessories 86**

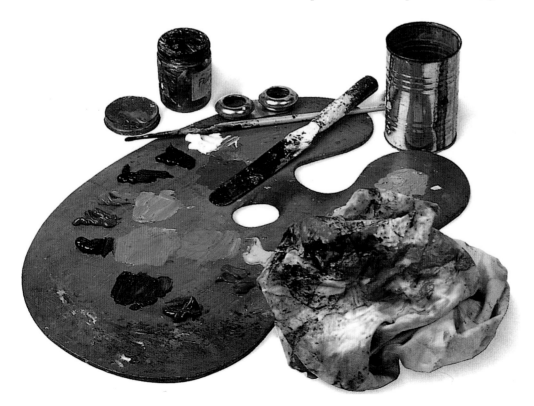

Making oil paints

Until the nineteenth century, oil paints were made by hand in the artist's own studio. However, since then, artists' colourmen have perfected the way in which oil paints are manufactured to such a degree that, in terms of quality and handling properties, they are now considered far superior to those of hand-ground paints. But home preparation of oil colours is a quite straightforward process, and it allows the artist to have complete control over the ingredients in the paint.

Home preparation

It is much cheaper to buy the raw materials than the ready-made tube colours, and the larger art-supply stores carry a wide range of raw pigments from which you can mix colours to your specific requirements. Finally, there is undoubtedly a lot of satisfaction and pleasure to be gained from working with colours that you have prepared yourself.

Method

Spoon a handful of powdered pigment onto a glass slab, and make a well in it. Pour in a spoonful of oil, and mix to a stiff paste with a palette knife (**1**). Ensure that all the pigment is thoroughly wetted, but do try to use the minimum of oil to produce the stiffest workable paste. Too much oil may result in yellowing and wrinkling of the paint film.

Mulling

Grind the pigment-and-oil mixture on the slab with a glass muller, using reasonable pressure and a continuous smooth, circular or figure-of-eight motion (**2**). Your weight should be well balanced over the muller. The objective is to disperse the pigment particles evenly through the binder and to achieve a smooth, glossy paint, free from grittiness. Be warned – mulling paint to the right consistency can take up to an hour, depending on the pigment! It is best to mull a small amount of pigment at a time, moving each freshly mulled batch to the edge of the slab.

The resulting paint should be stiff enough to be workable while containing the minimum of oil. If the paint doesn't 'peak' when lifted with the tip of a palette knife, it probably contains too much oil; add more pigment and re-mull.

Using lightweight pigments

Those pigments that are fluffy or flyaway, due to their light weight and fine particle size (for instance, alizarin and the quinacridones), need wetting before they can be ground with oil. Saturate the pigment with white spirit until all the powder is wet, then leave to dry out a little on absorbent paper before mixing to a paste with oil.

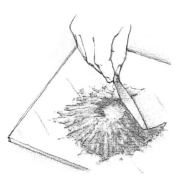

(**1**) Mix the pigment and oil to a stiff paste with a palette knife.

(**2**) Grind the pigment-and-oil mixture with a smooth figure-of-eight motion.

• Safety precautions

When handling dry pigments, wear a dust mask, to avoid breathing in the pigment particles. Do not handle toxic pigments without a mask and gloves. Disposable face masks are not adequate; respiratory masks designed for use with toxic dusts are available from major art-supply stores and safety equipment companies. Do not eat or drink when working with dry pigments. Keep all materials out of reach of children. Label all dry pigments so that they can be identified in case of accident.

Improving texture

Some pigments, such as ultramarine, viridian and zinc white, make a rather stringy paint. To improve the texture, use 4 parts linseed oil to 1 part poppy oil as a binder.

• Amounts of oil

Some pigments require quite a lot of oil to make a smooth paste – alizarin crimson, for example, needs far more oil than flake white.

• **Shelf life**
Without the addition
of any stabilizers and
preservatives, handmade
paint should always be
used within a few months
of making.

Filling the tubes

The freshly mulled handmade paint can be stored in empty collapsible tubes which are obtainable from major art-supply stores. As a guide, roughly 300g (10.6oz) of paint should fill a 150ml (5 US fl.oz) tube.

Loosen the cap of the tube a little so that air can escape as you fill it. Hold the tube upright and scoop the paint into the open end, using a palette knife (**3**). Fill the tube to within about 25mm (1in) of the open end, occasionally tapping the tube on the table to settle the pigment and disperse any air bubbles.

Pinch the tube 30 to 40mm (1¼ to 1½in) from the end to expel any air. Wipe the tube clean, then make a double fold at the end by folding it over the blade of a clean palette knife.

Label the tubes, and paint out a small swatch of each colour onto canvas paper as a record for the future.

(**3**) Pack the freshly mulled paint in empty collapsible tubes. First loosen the cap of the tube a little so that air can escape. Hold the tube upright and fill from the open end with a palette knife (see left).

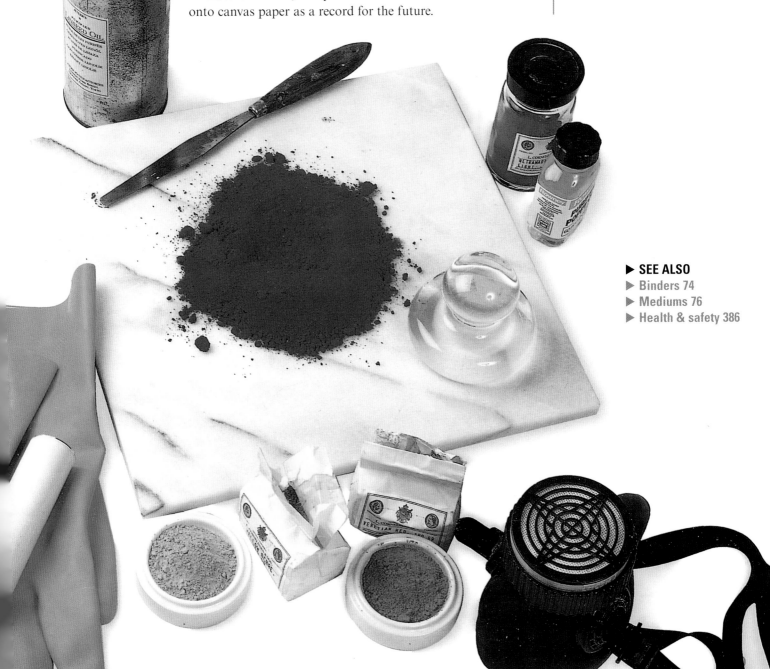

▶ **SEE ALSO**
▶ Binders 74
▶ Mediums 76
▶ Health & safety 386

Oil-paint sticks

A few manufacturers are now producing oil paints in stick form, which are fundamentally different from oil pastels or crayons. They are made by combining artist-quality pigments with highly refined drying oils, into which are blended special waxes which enable them to be moulded into stick form.

First-time use
Brand-new oil-paint sticks must have the film removed after the protective wrapper has been taken off.

• Protective skin
An invisible, dry film forms on the surface of the stick, and helps to keep it clean when not in use. The film is removed from the tip of the stick by rubbing it with a cloth, and reforms in a day or two after use to keep the paint from drying out while being stored.

• Using diluents
You can work on a support that has been given a liberal wash of turpentine, or dip the tip of the oil stick into diluent or medium, to create a more liquid line.

Using oil-paint sticks

These sticks can be considered as either a drawing or a painting medium. They combine the richness of oil colour with the freedom and directness of pastels or charcoal. The chunky sticks glide across the support, making expressive, flowing lines. Some brands are thixotropic – they become more creamy in texture when applied with slight pressure, and harden again on the support. The lightfastness rating is the same as for tube oil colours; the range of colours is smaller, but the basic oils palette is sufficient.

Blending and brushing

Different colours can be blended together on the support, using a brush or a painting knife. Alternatively, special colourless sticks are available: these aid the blending process and increase the transparency of the colours. The paint can also be brushed out on the support, using the same solvents and mediums employed with tube oil colours. The end of the stick may be dipped into the medium or solvent before working on the support, thereby improving the flow of colour. You can even apply the paint in thickly impasted layers and model it with a paintbrush or knife. The paints remain workable for several hours.

Compatibility

Oil-paint sticks are compatible with a range of painting and drawing media, including conventional oil, alkyd and acrylic colours, oil pastels and pencil. They can be used on primed canvas or hardboard (Masonite), acid-free sized paper, fabrics, and other surfaces.

• Outdoor uses
Sticks are particularly useful when you're painting outdoors, as they remove the need to carry some of the accessories associated with tube oil paints.

• Different brands
As with tube oil colours, there are variations in the texture, handling properties and drying rates between one brand of paint stick and another, and thus it is advisable to sample different brands. Do not intermix different brands in the same painting, as the chemicals may be incompatible.

▶ **SEE ALSO**
▶ **Supports 14**
▶ **Basic palette 72**
▶ **Diluents 75**
▶ **Mediums 76**
▶ **Knife painting 174**

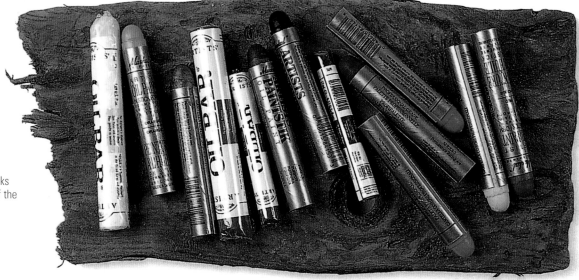

Types of stick
The selection of oil-paint sticks shown here includes some of the iridescent colours available.

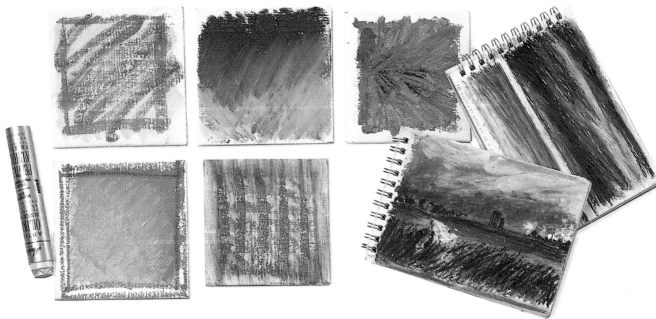

Oil-stick versatility

The five square-format examples (above) show some basic oil-stick techniques. The two sketchbook paintings (top right) used oil sticks and oil pastels, brushed out with turpentine. The framed picture (below) was worked directly with oil sticks and then blended and brushed out with turpentine.

Drying times

The actual drying time depends on temperature and the type of surface being painted, but on the whole oil paint in stick form dries more quickly than tube oil paints. It is important to note, however, that paint sticks should not be used for underpainting if tube paint is to be applied on top. The reason is that although paint sticks dry faster than tube paints, they dry to a more flexible film, due to their high wax content; if less flexible paint is applied on top. this may lead eventually to cracking of the paint surface.

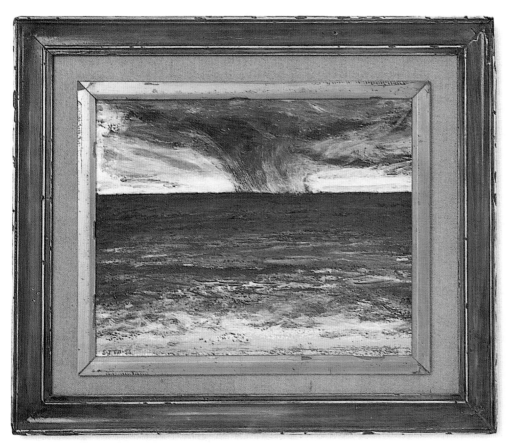

Basic palettes for oils

The twelve colours featured here form the 'backbone' of most professional painters' palettes. This palette is versatile enough to cope with a wide range of subjects, and the colours are all lightfast.

Titanium white
Permanence excellent (ASTM I). A very bright opaque white, with high tinting strength and slow drying time. Mixes well, maintains its intensity.

French ultramarine
Permanence excellent (ASTM I). A transparent colour, with high tinting strength, medium-to-slow drying time, and a deep, warm blue hue. The most versatile of the blues; mix with burnt umber to make interesting dark shades.

Cobalt blue
Permanence excellent (ASTM I). A transparent colour, with weak tinting strength and a fast drying time. It is greener and paler than ultramarine. Useful for skies and for mixing greens; very expensive, but good for glazing.

Yellow ochre
Permanence excellent (ASTM I). A fairly opaque colour, with weak tinting strength, medium-to-slow drying time, and a dark yellow hue verging on brown. Indispensable for landscape painting and for toning down mixtures.

Raw sienna
Permanence excellent (ASTM I). A transparent colour, with weak tinting strength and fast-to-medium drying time. A warmer hue than yellow ochre. Mixes well, and is excellent for glazing.

Burnt sienna
Permanence excellent ASTM I) A transparent colour, with strong tinting strength, fast-to-medium drying time, and a rich, reddish-brown hue. It is useful for modifying sky colours, and is a good glazing colour.

Permanent rose
Permanence excellent (ASTM I). A very transparent colour, with very high tinting strength, slow drying time, and a bright pink-red hue with a violet tinge. A lightfast alternative to alizarin crimson; though expensive, a little goes a long way.

Viridian
Permanence excellent (ASTM I). A transparent colour, with good tinting strength, slow drying time, and bright, deep green hue with a bluish tinge. Mix with white to make cool greens.

Cadmium red
Permanence excellent (ASTM I). An opaque colour, with good tinting strength, slow drying time, and a bright, warm red hue. A strong, pure pigment.

Cadmium yellow
Permanence excellent (ASTM I). An opaque colour, with good tinting strength, slow drying time, and a warm hue with a hint of orange. Mix with cadmium red to form cadmium orange.

Lemon yellow
Permanence excellent (ASTM I). A transparent colour, with good tinting strength, medium drying time, and a cool, pale yellow hue. Forms delicate, cool greens when mixed with blues.

Winsor violet
Permanence excellent (ASTM I). A transparent colour, with high tinting strength, medium drying time, and a strong, warm hue. Very useful for modifying blues in skies, and making greys with yellows, browns and greens.

Starter palette

The ASTM (American Society for Testing and Materials) codes for lightfastness:

ASTM I:	excellent lightfastness
ASTM II:	very good lightfastness
ASTM III:	not sufficiently lightfast

• Variations

Pigments may vary both in their hue and handling characteristics, according to the manufacturer. This applies particularly to the earth colours – ochres, umbers and siennas – which are natural pigments and vary in hue according to source. Some burnt sienna, for example, is yellowish, while others have a reddish tint.

Roy Freer
Blue Pathways
Oil on canvas
100 x 120cm (40 x 48in)

Roy Freer's work uses rich, saturated hues. He sees his subjects in terms of colour, rather than tone: This painting employs his 'spectrum palette', which consists of lemon yellow, cadmium yellow, yellow ochre, cadmium orange, vermilion, rose madder, cobalt blue, cobalt violet and viridian.

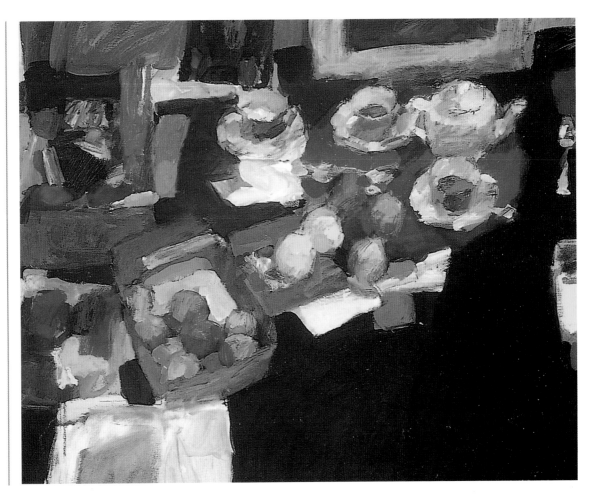

Terre verte
Permanence excellent (ASTM I). A transparent colour, with low tinting strength, medium-to-slow drying time, and a pale greenish-grey hue. An excellent green for landscapes, it is best applied in thin glazes.

Raw umber
Permanence excellent (ASTM I). A transparent colour, with good tinting strength, fast drying time, and a greenish-brown hue. Raw umber is a very useful colour for underpainting, as it dries rapidly.

Phthalocyanine blue
Permanence excellent (ASTM I). Transparent colour, with a very high tinting strength, medium-to-slow drying time, and a very bright, deep-blue hue. More permanent and more intense than Prussian blue.

Alizarin crimson
Permanence very weak (ASTM III). A very transparent colour, with high tinting strength, very slow drying time, and a cool, slightly bluish-red hue. It tends to fade in thin washes, or when mixed with white.

Ivory black
Permanence excellent (ASTM I). An opaque colour, with good tinting strength, very slow drying time, and a slight brown tinge. Mixing ivory black with yellow makes a versatile green.

Auxiliary colours
Should you wish to augment your basic palette with additional colours for particular subjects, you may find some of the colours shown here useful.

73

Binders for oils

Binders, mediums and diluents are the various fluids that are either combined with the pigment at the manufacturing stage or added to the tube colour to facilitate the application of paint to the support.

Binder composition

Pigments for oil paints are ground into a drying vegetable oil, which is known as a vehicle or binder. When bound, the pigment particles are suspended in the oil and can be easily brushed onto the painting surface. When the oil has dried by absorbing oxygen, it seals the pigment to the surface.

Linseed oil

This oil, pressed from the seeds of the flax plant, is available in several forms, and acts both as a binder and as an ingredient in oil-painting mediums. Linseed oil dries quickly at first, but the complete drying process will take many years. It oxidizes into a tough, leathery film which hardens and becomes more transparent on ageing.

Poppy and safflower oils

These are semi-drying oils which are used to slow down the naturally fast drying times of some pigments. Paler than linseed oil, they are also used for grinding white and light colours, as they are less prone to yellowing.

• Cold-pressed linseed oil
The purest form of linseed oil is extracted cold from the seed and has a golden-yellow colour. It maximizes wetting and dispersion of pigment particles during manufacture, and is less likely to embrittle with age.

• Refined linseed oil
Alkali-refined linseed oil wets pigment less easily than cold-pressed. Refined linseed oil is perfectly acceptable as a binder, however, and is cheaper than cold-pressed oil.

• Sun-thickened linseed oil
Sun-thickened oil dries quickly, but is less flexible and more prone to yellowing than cold-pressed and refined oils.

▶ SEE ALSO
▶ Making oil paints 68
▶ Underpainting 164
▶ Varnishes 350

Selection of binders
A typical assortment of binders that can be used for most oil-painting purposes. Top shelf, from left to right: cold-pressed linseed oil; purified linseed oil; sun-thickened linseed oil; assorted brushes; turpentine. Bottom shelf, from left to right: poppy oil; safflower oil; rags; low-odour thinners; white (mineral) spirit.

• Oils for underpainting
Paints ground with poppy or safflower oil should not be used for underpainting, because they are so slow to dry and are prone to cracking. Drying poppy oil, however, is faster-drying and is safe to use for this purpose.

Diluents for oils

• **Disposing of solvents**
It is illegal to dispose of solvents by pouring them down a sink, toilet or outside drain. They should be taken to a garage for disposal by specialist waste-disposal companies.

• **Odourless thinners**
Some manufacturers offer low-odour paint thinners as an alternative to white spirit. They have the same evaporation rate as turpentine, but do not deteriorate in storage, and have low flammability.

• **Storing turpentine**
Turpentine thickens and discolours on exposure to air and light, and should be stored in closed metal cans or dark glass bottles filled to the top. Avoid long-term storage.

Keith Roberts
Windows
Oil on canvas
150 x 120cm (60 x 48in)
New Academy Gallery, London

This artist intentionally keeps his paintings in a state of flux up to the last moment. Here, the overall tonality is established by a loose but vigorous underpainting of thin paint diluted with turpentine. In the further layers, which are scrubbed on quickly, Keith Roberts mixes the paint with a medium of turpentine, linseed oil and dammar varnish.

Diluents, or 'thinners', are liquids used to thin down paints to aid their application to the support. They may be used alone, or mixed with oils and varnishes to create mediums for specific purposes. They all evaporate quickly on exposure to air, and they do not alter the characteristics of the paint.

Rectified turpentine

Always use double-distilled or rectified turpentine for painting purposes. Ordinary household turpentine, sold in hardware shops, is not suitable, because it leaves a gummy residue which yellows badly and leaves the paint sticky and non-drying. Turpentine evaporates from paint mixtures at a relatively slow rate, and gives a more viscous mix than white (mineral) spirit.

White (mineral) spirit

This refined petroleum spirit dries more quickly than either form of turpentine. White spirit is now becoming more popular than turpentine as a diluent, as it has several advantages: it is less harmful, it does not deteriorate in storage, its smell is less pronounced than that of turpentine, and it is much cheaper. In the past, white spirit had a tendency to cause a white bloom on the surface of oil paintings, but with improved formulation this problem has now been eradicated.

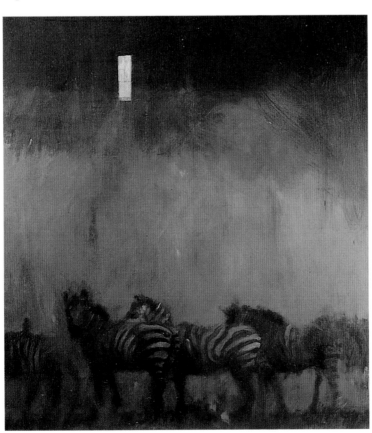

• **Using diluents safely**
Turpentine has a characteristic strong smell, and is the most harmful of oil-colour solvents. If it irritates your skin or gives you a headache, use white spirit instead. Even small quantities of solvents and thinners can be hazardous if not used with care, because their fumes are rapidly absorbed through the lungs. Many solvents can also be absorbed through the skin. When using solvents, avoid inhalation, and use in a well-ventilated room. Wear rubber gloves or a barrier cream, and do not eat, drink or smoke in the studio.

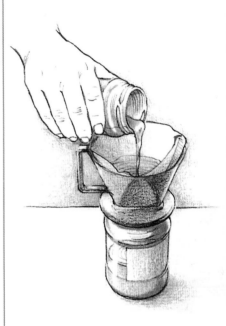

Recycling solvents
Dirty solvents can be filtered and reused. Leave the used solvent to stand for a few hours, to allow the pigment to settle. Pour the liquid into a clean jar through a coffee filter paper, taking care not to disturb the sediment. Leave to stand again, to allow the pigment that may have passed through the filter to settle, then transfer to a clean jar. Repeat the process if necessary.

▶ **SEE ALSO**
▶ **Water-friendly oil paints 66**
▶ **Mediums 76**
▶ **Health & safety 386**

Mediums for oils

Oil paint used straight from the tube, or diluted with thinners, produces the most stable paint film. However, various drying oils, resins, waxes and diluents, used alone or in combination, allow the artist to alter or enhance the characteristics of the tube colour.

Prepared painting mediums

In the past, it was general practice for artists to mix their own mediums for painting, particularly since they ground and mixed their own pigments as well. Today, almost everything we buy comes pre-packaged for our convenience, and painting mediums are no exception.

Most manufacturers offer several types of medium, some based on traditional recipes, others the result of modern laboratory research. Depending on the ingredients used, these mediums are variously formulated to improve the flow of the paint, alter its consistency, and produce either a matt or a gloss finish. Some are slow-drying, whereas others contain agents to speed up the drying rate.

Bear in mind that prepared painting mediums are not standardized; different brands of glaze medium, for example, may vary in their formulation. Reputable manufacturers include technical notes on the contents and uses for specific painting mediums in their catalogues.

Manufactured mediums

Alkyd mediums

Alkyd is a translucent, synthetic resin which has been oil-modified to make it suitable as a paint medium. Good-quality alkyd mediums speed the drying process and form a flexible, virtually non-yellowing film. They come in various consistencies, from a liquid gel which is suitable for glazing and subtle blending, to a stiff gel specifically for impasto and texture work. Alkyd mediums may be thinned with turpentine or white spirit.

• Using linseed oil

It is not advisable to use linseed oil undiluted, as there is a risk that the paint layer may wrinkle. In addition, the paint becomes so 'fat' that it is difficult to apply and dries slowly.

• Using mediums

Mediums are additives and should be kept to a minimum within your technique, as an excess may be detrimental to the paint film. When applying paint in layers and using mediums and diluents, observe the golden rule of oil painting and work 'fat-over-lean', using less oil in the lower layers than the upper ones.

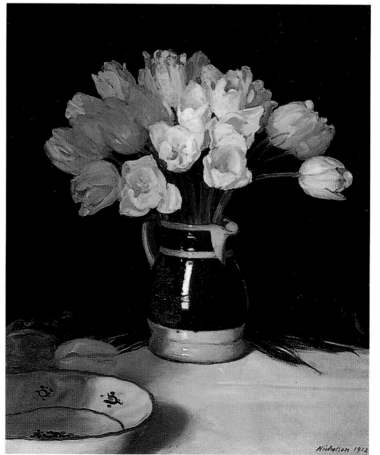

William Nicholson (1872–1949)
White Tulips, 1912
Oil on canvas
60 x 53.7cm (24 x 21½in)
Browse and Darby Gallery, London

Whereas paint diluted with turpentine has quite a dry, matt appearance, the addition of a painting medium adds a richness and lustre to the paint surface. This beautiful study is reminiscent of the seventeenth-century Dutch school of still-life painting in its use of rich, creamy paint, softly blended forms and lustrous glazes.

▶ SEE ALSO
▶ Diluents 75
▶ Fat-over-lean 166
▶ Glazing 170
▶ Impasto 172

Making mediums

Some artists still like to mix their own mediums because it is an economical process. Mixing also gives them more control over the ingredients employed, which are obtainable from most art-supply stores.

Making dammar varnish
This varnish imparts a rich, glassy effect to glazes. Because it is resoluble, do not use it neat; cut with stand oil and solvent. Ready-prepared dammar varnish is available, but you can make your own with small lumps of dammar resin. Crush the resin, place in a muslin bag and suspend for two or three days in a jar of turpentine (use 1 part by measure of crushed resin to 4 parts of turpentine). When the resin has dissolved, strain again through a clean muslin bag, and it is ready for use.

Turpentine medium
The most commonly used medium is a slow-drying mixture of refined linseed oil and white spirit or distilled turpentine. The two liquids are poured into separate containers so that the artist can add more oil as paint layers are built up. The normal proportions are 1 part oil to at least 2 parts diluent, with increasing amounts of oil being added in the final layers, to a maximum of 50 per cent oil.

Glaze medium (resin-oil medium)
This gives clarity and brilliance to glazes. It uses stand oil, a thick, viscous form of linseed oil which dries slowly (five days or more in a thin layer), levels out well and dries to a durable, elastic film that yellows less than linseed oil.

Beeswax medium
This makes oil paints go further, and provides a thick texture which is suitable for impasto. Use purified beeswax with a natural colour; refined, bleached beeswax yellows with age.

• **Method for glaze medium**
Mix 1 part stand oil and 1 part dammar varnish (see right), and then add 5 parts turpentine. Stir the glaze each time it is used. If a more viscid medium is required, use less turpentine.

• **Method for beeswax medium**
Melt 100g (3½ oz) beeswax in a double boiler (or two cans as shown below) over low heat; do not overheat. Remove from the heat, add 85ml (3 US fl.oz) rectified turpentine, and stir. Leave to cool and solidify, then store in a sealed jar.

Medium-making materials
The selection of materials that are shown below will enable you to make the two mediums describe. Clockwise from top left: clean cans; linseed oil; turpentine; beeswax; glaze oil; ready-made stand oil; home-made dammar varnish.

▶ **SEE ALSO**
▶ Glazing 170
▶ Impasto 172

Brushes for oils

Oil painting requires responsive brushes which are durable enough to withstand both repeated scrubbing against the canvas, and the effects of solvents used in cleaning. Best-quality brushes are always worth the extra expense, as they hold the paint well and produce a more satisfying mark than cheaper brushes. They also retain their working edge far longer and quickly spring back to their original shape after use.

Testing a bristle brush
To test a new brush, press and draw it firmly against a flat surface. The ferrule end of the bristles should not bend too close to the edge of the ferrule.

Buying brushes

When buying brushes, always check that the brush hair is firmly attached inside the ferrule. if there is too big a gap between the hair and the inside of the ferrule, paint can get lodged in the space and make cleaning the brush more difficult. There should be no loose or splayed hairs, and the brush handle should be balanced to feel comfortable in use.

Bristle brushes

Hard-wearing, tough and springy, bristle brushes are particularly suitable for oil painting, as they can cope with the thick, heavy texture of the paint and are robust enough to be worked against the textured surface of canvas. Each strand of a hog-bristle brush splits into several microscopic points, called 'flags', at its tip; these help hold the paint to the brush. Bristle brushes are excellent for ladling on the paint and moving it around on the surface, and for applying thick dabs of colour in which the brushmarks remain visible, adding interest to the surface of the painting. When properly cared for, these brushes can actually improve with age, as they soften and become more responsive after a period of use.

Hog bristle

The majority of brushes used in oil painting are made from hog bristle. The finest bristle comes from the Chunking region of China, and is hand-picked from a narrow strip on either side of the hog's spine.

Sable brushes

Sable brushes are soft and springy, similar to those used in watercolour painting, but with longer handles. Soft-hair brushes are not vital in oil painting, but are useful for painting fine details in the final layers and for applying thinly diluted colour. Sable brushes are expensive, however, and for oil painting some artists find synthetic brushes quite acceptable.

Brights
With shorter, stiffer bristles than those on flats, brights are mostly used for textural effects, such as applying heavy impasto or for scraping off wet paint.

Household brushes
Good-quality decorator's brushes can be used for several tasks other than applying paint. Use wide brushes for applying glue size to stretched canvas, and narrower ones for priming the support.

• Fitch brushes
On lower-grade bristle brushes the brush head is shaped by cutting and trimming the bristle ends, thus losing the flags, so the brush has less shape and holds less colour. These are called 'fitch' brushes, and they are perfectly adequate for blocking in large areas of colour in the initial stages of a painting.

Synthetic brushes

Both soft and stiff-hair types of synthetic brush have been considerably improved in recent years, and make an economical alternative to traditional natural-hair brushes. The most recent development in synthetic-hair brushes is the introduction of interlocking fibres which mimic the make-up of natural hog bristles, giving them better paint-holding capacity than the nylon filaments that were formerly used. Synthetic brushes are easily cleaned and can withstand repeated scrubbing against the canvas, but the cheaper ones tend to lose their shape more quickly than natural-hair brushes.

Flats and filberts

Flats are good general-purpose brushes, and are especially useful for washes and painting in large areas. The softer filberts help soften edges. Both types also produce very fine lines when turned on their edges.

Rounds

Rounds are extremely versatile; they can be used for soft strokes in basic underpainting.

Bristle

The best bristles have split ends, known as 'flags'. These give a softness to the very end of the brush and help the bristles to hold plenty of paint.

Ferrule

This holds the bristles together and shapes them into rounds, riggers, filberts, flats and fan blenders. Good-quality ferrules are firmly crimped onto the handle.

Handle

The length of an oil-brush handle allows the artist to work at a distance from the canvas, and helps to balance the weight of the ferrule and tip. The size, series and type of brush are usually embossed on the handle. There may also be a description of the hair used. Handles are often painted and varnished; this is mainly for cosmetic reasons, and plays little part in protecting the wood, despite manufacturers' claims to the contrary.

▶ SEE ALSO
▶ Brush shapes 80
▶ Watercolour brushes 96

Brush shapes

Brushes for oil painting come in a wide range of sizes and shapes. Each is designed to make a different kind of mark, but some are more versatile than others. Selecting a brush depends on the effects you wish to achieve, and with experience you will discover which ones are best suited to your own painting style. Rounds and flats are the most useful and versatile to begin with; brights and filberts can be added later.

Brush sizes

Most types of oil-painting brush come in a range of sizes, from 000 (the smallest) to around 16 (the largest). Brush sizes are not standard between manufacturers worldwide, and there is no relationship between sizes in sable or soft hair and sizes in bristle. The width of the handle is proportional to the size of the brush head, so that the handle of a bigger brush is thicker. The characteristic handle shape, with the wood thickening just below the ferrule, is designed to keep the wet hairs of separate brushes from touching when you are holding more than one brush.

Round brushes

Round brushes have a large 'belly' with good paint-holding capacity, and smooth, tapered ends. With thinly diluted paint, they make soft strokes that are ideal for blocking in the basic composition in the initial stage of a painting. When loaded with thick paint, they make bold, vigorous marks and cover large areas of the support. Round sable and soft-hair brushes come to a fine point, useful for delicate lines and details, but fine points are impossible with hog-hair brushes.

Flat brushes

Long flat brushes have square ends and long bristles that are flexible and hold a lot of paint. Used flat, they make long, fluid strokes, and are extremely useful for filling in large areas and for blending. Using the edge or tip of the brush, they make fine lines and small touches.

'One day a few hairs came out of my brush and got stuck on the picture. I then painted a bird's nest.'
Pablo Picasso (1881–1973)

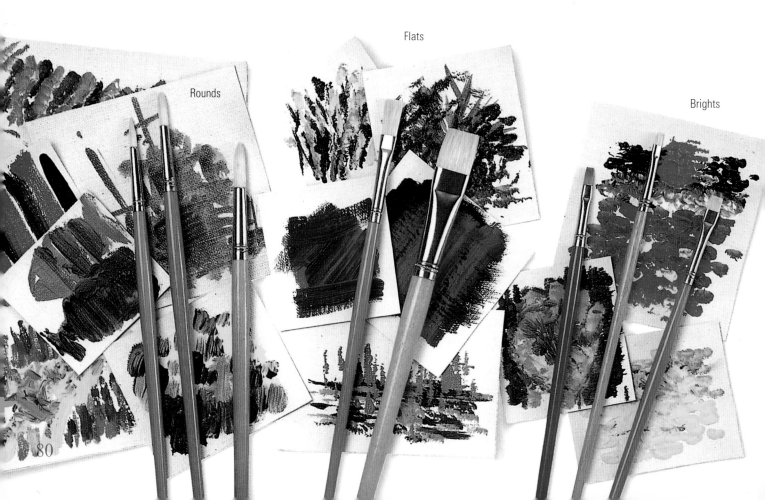

Flats

Rounds

Brights

Brights

Short flat brushes are often referred to as 'brights'. They are the same shape as long flats, but with shorter, stiffer bristles that dig deeper into the paint and leave strongly textured, rectangular marks. They are useful for applying thick, heavy paint to produce impasto effects. Because of their shorter bristles, brights are easier to control, making them better than long flats for painting details.

Filberts

Filberts are a compromise between flat and round brushes, being shaped to a slight curve at the tip to produce soft, tapered strokes. The curved tip allows you to control the brush well, and is useful for fusing and softening edges.

Fan blenders

Fan blenders are available in sable, synthetic, badger hair and hog bristle. Where a smooth, highly finished result is required, fan blenders are used to feather wet paint to soften brushstrokes and to effect smooth gradations of tone. Fan blenders are particularly useful for painting soft edges on clouds.

Riggers

Riggers, named after their original use in executing the fine detail of rigging on marine paintings, have very long, flexible hairs. These carry a good amount of paint in their belly, yet come to a very fine point for painting long, thin lines. They are available in sable, ox or synthetic hair.

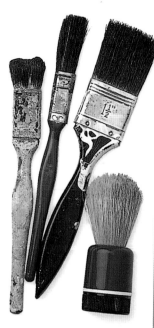

Household brushes
Decorator's brushes are inexpensive, hard-wearing and extremely useful for applying broad washes of colour in the preliminary stages of a large-scale painting. Good-quality brushes, although more expensive, will not shed hairs as readily as cheap ones. Shaving brushes are an alternative to using soft blending brushes.

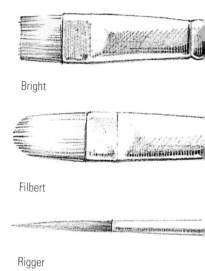

Bright

Filbert

Rigger

Fan blender

Flat brush

Round brush

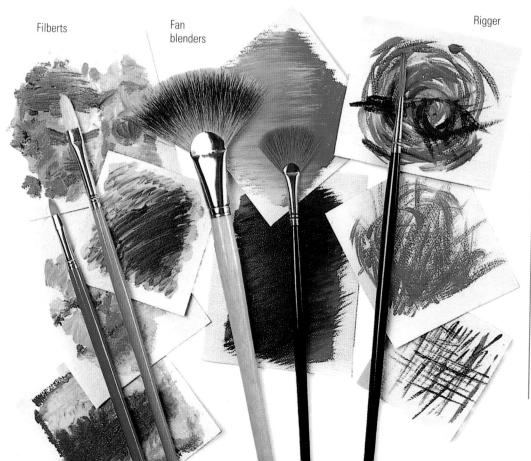

Filberts

Fan blenders

Rigger

81

Choosing brushes
A recommended starter selection includes long flats and rounds, and a synthetic soft-hair brush.

The artist Joan Miró (1893–1983) using an extended paintbrush.

Selecting oil brushes

The number of brushes you use and their sizes will depend on the scale and style of your paintings. Whereas one artist may use a dozen or more brushes, another may be perfectly happy with just a few. As a rule, having a good selection of brushes makes the work easier, because you spend less time cleaning them between colours. If you can keep, say, one brush for light colours and another for dark colours, your mixtures are more likely to stay fresh and unsullied.

Starter selection

In general, it is better to start with medium-to-large brushes as they cover large areas quickly, but their tips can also be used for small touches. Requirements differ, but a useful selection of brushes to start with might include the following in hog bristle: a No. 10 long flat for roughing in and applying toned grounds; long flats and rounds in Nos 6, 4 and 2; and possibly a No. 4 synthetic soft-hair brush for smooth areas and details. As you become more experienced, you may add filberts and brights to this list and increase the range of sizes you use.

Making an extended paintbrush

When painting at the easel, especially with a large-scale work, it is important to be able to stand well back from the picture so that you can see the whole as well as the details.

Paintbrushes with extra-long handles don't seem to exist, but artists are an inventive lot, and you can make your own with a few simple tools. Working with a long-handled brush takes a little getting used to at first, but it gives greater freedom of movement to your painting arm and encourages lively brushstrokes.

In the method shown on the right, the brush is joined to the handle of an old, worn brush which would otherwise be thrown away. The handle of the brush to be attached should be slightly smaller in circumference than that of the old brush, because it is pushed into a hole drilled into the wood of the old brush handle.

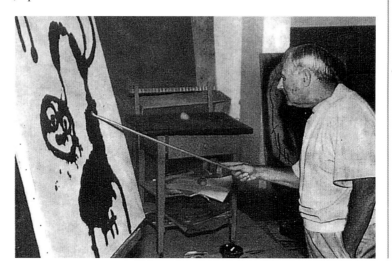

Making an extended brush

1 Use a sharp craft knife to cut the bristles off the old brush.

2 Grip the brush in the jaws of a metal vice. Using a hand drill, slowly drill down through the opening of the ferrule and into the thick part of the wooden handle.

3 Drip some wood glue into the hole and around the end of the new brush handle. Push the end of the new brush firmly into the hole. Leave until the glue has set.

4 With a pair of pliers, squeeze and crimp the ferrule of the old brush around the new brush handle. Tightly bind the join with insulating tape.

Reshaping brushes
If brushes are beginning to splay out after prolonged use, wrap the bristles with toilet tissue while they are still wet; as the paper dries it contracts and pulls the bristles back into shape.

Maintaining brushes

Oil-painting brushes should be thoroughly cleaned after each session. This is especially important when using sable or other soft-hair brushes. Never leave a brush soaking with the bristles touching the bottom of the container.

Cleaning brushes

To clean a brush, first clean off the residue of paint with a rag or paper towel. Rinse in turpentine or white spirit, and wipe with a rag. Then clean the bristles with some mild soap and lukewarm running water, rubbing the brush around gently in the palm of your hand to work up a lather. It is essential to remove all the paint that has accumulated at the neck of the ferrule. If paint hardens here, the bristles will splay out. Rinse the brush and repeat the soaping until no trace of pigment appears in the lather.

Give the brush a final rinse, then shake it out and gently smooth it into shape with the fingers. Leave it to dry naturally, with the head pointing upwards.

Storing brushes

Always make sure that brushes are dry before storing them in a closed container, or they may develop mildew. Moths are rather partial to sable, so once the brushes are dry, store them in boxes and use mothballs for extra protection.

An economical brush washer

When cleaning brushes, jars of solvent quickly become dirty and need changing. It is illegal, however, to dispose of solvents such as turpentine and white spirit by pouring them down the sink, or even an outside drain. In any case, wastage can be avoided by re-using the solvents.

You will need two jars with lids. Clean the brushes in solvent in the first jar, and screw on the lid. By the next day most of the pigment in the solvent will have settled to the bottom of the jar; you can then carefully decant the clear solvent into the second jar, ready to be used again.

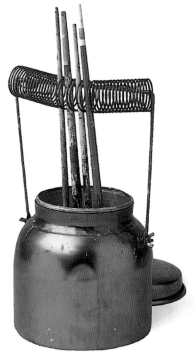

Brush washers
These metal containers come in various sizes, and have a special coiled handle for keeping brushes suspended in the cleaning agent during soaking. This prevents the bristle tips being pressed against the bottom of the container.

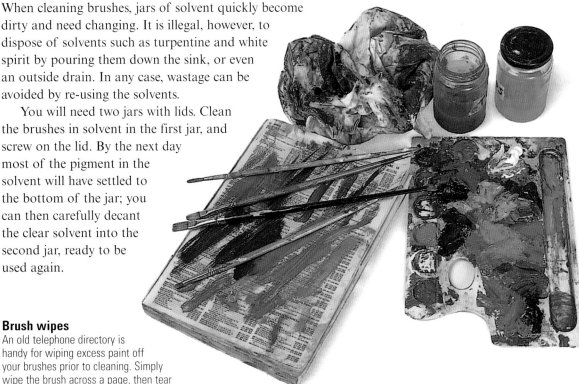

Brush wipes
An old telephone directory is handy for wiping excess paint off your brushes prior to cleaning. Simply wipe the brush across a page, then tear it off and throw it away, leaving the next page ready for use.

Palettes

Palettes come in a variety of shapes, sizes and materials, designed to suit the artist's individual requirements. A large palette is better than a small one, because you need plenty of space for mixing variations of colour. A palette measuring approximately 36 x 46cm (14 x 18in) is a good size, allowing the colours to be well spaced around the edge and leaving plenty of room in the centre for mixing colours.

Choosing

Where possible, it is extremely helpful to choose a palette which approximates to the colour of the ground you are working on, so that you get an accurate idea of how the colours will look on the painting itself. For example, choose a wooden palette if working on a red/brown ground, and a white one if working on a white ground.

Manufactured palettes

Below is a selection of commercially made palettes that are suitable for use with oil paints. Clockwise from left: large solid-wood kidney-shaped; two medium melamine oblong; medium melamine recessed, two melamine recessed; small ceramic oblong; medium solid-wood oblong.

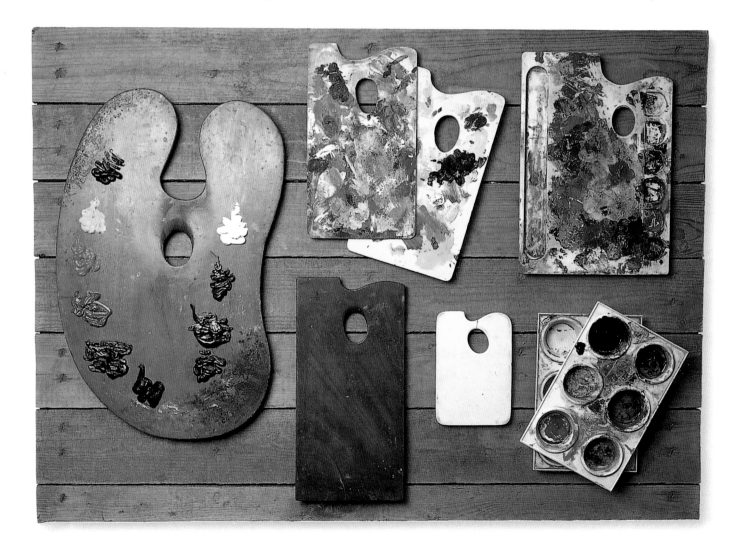

Preparing wooden palettes

Before they are used for the first time, wooden palettes should be treated by rubbing with linseed oil. This seals the wood and prevents it from sucking oil from the paint, thus causing it to dry out too quickly on the palette. It also makes the surface easier to clean after use. Rub a generous coating of linseed oil into both sides of the palette and leave it for several days until the oil has hardened and fully penetrated the wood grain.

Types of palette

Plywood or melamine palettes are economically priced, while those made of mahogany veneer look wonderful and feel very comfortable, but they do cost a lot more. Before investing in a new palette, try several for comfort; the better ones are balanced and will tire your arm less.

Thumbhole palettes

Thumbhole palettes are designed to be held in the hand while you are painting at the easel. They have a thumbhole and indentation for the fingers, and the palette is supported on the forearm. They are available in a range of sizes, either rectangular (called 'oblong'), oval or kidney-shaped.

Recessed palettes

Recessed palettes are available in aluminium, plastic and china, and are used for mixing thin dilutions of paint.

Disposable palettes

Made of oil-proof paper, disposable palettes are useful for outdoor work, and remove the necessity for cleaning a palette after painting. They are sold in pads with tear-off sheets; some have a thumbhole.

Disposable palette

Cleaning the palette

If resuming painting within a day or two, cover the squeezes of paint with clingfilm or foil to keep them moist, otherwise discard them. At the end of each session, scrape off the excess paint onto some newspaper with a knife. Wipe any diluent or medium left in the dipper over the palette with a rag until clean.

Improvised palettes

For studio work, many artists prefer to use a 'home-made', table-top palette, which can be rested on a nearby surface and can be of any size or colour. Any smooth, non-porous material is suitable, such as a sheet of white laminate or melamine board, a glass slab with white or neutral-coloured paper underneath, or a sheet of hardboard (Masonite) sealed with a coat of paint. Old cups, jars and tins are perfectly adequate for mixing, and can be covered with plastic film to stop the paint drying between sessions.

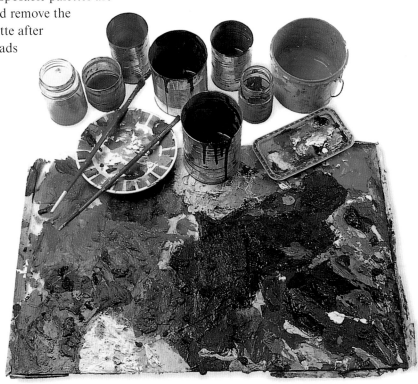

Accessories for oils

• Mahlstick

A mahlstick is a long handle with a pad at one end, which is rested on the support for steadying the painting arm when executing detailed, controlled work.

Home-made mahlstick

Traditionally, mahlsticks had bamboo handles and chamois-leather padded tips, but nowadays they are usually made of aluminium with rubber tips. You can improvise your own: tightly wrap cotton wool into a ball around the end of a garden cane. Cut a disc of cloth, chamois leather or chamois substitute, larger than the ball, and secure it round the cane with a cord or elastic bands.

Painting in oils can be quite a messy business, so the most essential accessories are large jars or tins to hold solvents for cleaning brushes, and a plentiful supply of cotton rags and newspaper. The following items are not essential, but some, such as palette knives, are certainly useful.

Palette knives

These are for mixing colours on the palette, scraping palettes clean, and for scraping away wet paint when making alterations to a picture. Palette knives have a straight, flat, flexible blade with a rounded tip. The long edges of a palette knife are ideal for removing wet paint, and the tip is good for picking up and mixing dabs of paint on the palette.

Painting knives

Painting knives are for mixing and spreading colour directly on the support, and come in several sizes. They have delicate, flexible blades which come in a variety of shapes for making different kinds of marks; the cranked handles keep your hand clear of the wet-paint surface while you are working. The angular blade is ideal for applying a variety of marks: use the tip of the blade for making fine details and stippled marks, the flat part for broad strokes, and the edge of the blade for linear marks.

Dippers

These are small open metal cups that clip onto the edge of a thumbhole palette to hold oils and solvents during painting. You can buy single dippers or double dippers. Some have screw caps to prevent spillage or evaporation of solvents. However, in the studio it may be more convenient to use small jars or cups resting on a nearby surface.

Using a mahlstick

If you are right-handed, hold the end of the stick in your left hand and rest the padded end lightly on a dry section of the work, or on the edge of the stretcher, so that the stick crosses the painting diagonally. You can then steady your painting arm on the cane.

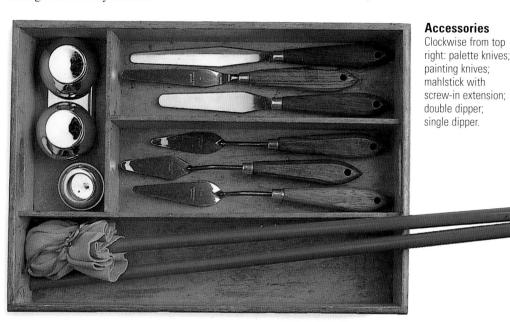

Accessories

Clockwise from top right: palette knives; painting knives; mahlstick with screw-in extension; double dipper; single dipper.

Watercolour paints

Paints for watercolour consist of very finely ground pigments that are bound with gum-arabic solution. The gum enables the paint to be heavily diluted with water to make thin, transparent washes of colour, without losing adhesion to the support. Glycerine is added to the mixture to improve solubility and prevent paint cracking, along with a wetting agent, such as ox gall, to ensure an even flow of paint across the paper.

Choosing and buying paints

It is natural to assume that there is little difference in formulation between one brand of watercolour paint and another. In reality, the types and proportions of ingredients used by manufacturers do differ, so there are often variations in consistency, colour strength, handling qualities, and even permanence between one paint range and another.

It is worth trying out several brands of paint initially, as you may find that one suits your personal style of working better than another. You don't have to stick to one brand, however; good-quality watercolour paints are compatible across the ranges, and you may discover that certain individual colours perform better in one range than another. Viridian is a good example: in some brands it has a tendency to be gritty, while in other ranges it is perfectly smooth and clear.

• Differences between brands
Colours that are mixtures of pigments (sap green and Payne's gray, for example) show a marked variation in hue between brands because they are formulated differently, so do not expect a familiar colour name to be exactly the same colour in a different brand.

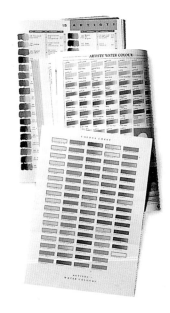

Using charts
When purchasing paints, don't depend on manufacturers' colour charts as a guide to a colour's appearance. Most of them are printed with inks that are not accurate representations of the colours. Handmade tint charts produced with actual paint on swatches of watercolour paper are more reliable; any reputable art supplier should have one which you can refer to.

Types of paint
Watercolours are available in two main forms: as small, compressed blocks of colour, called 'pans' or 'half pans' according to size, and as moist colour in tubes. The formulations of tube and pan colours are very similar, and which type you choose is a matter of personal preference. Good-quality watercolour equipment will repay you with many years' loyal service.

A selection of pans, half pans and tubes

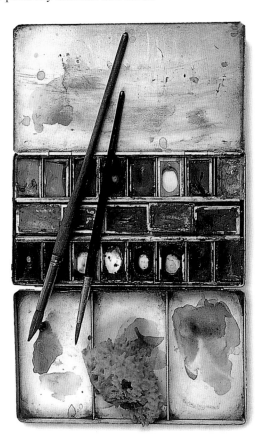

▶ SEE ALSO
▶ Pigment and colour 92
▶ Basic watercolour palettes 94

Watercolour paints *(continued)*

Pans and half pans

Preventing lids sticking
After a painting session, remove any
excess moisture from the pan colours
with a damp sponge.

Standard tube sizes

Pans and half pans

Pans and half pans slot neatly into tailor-made, enamelled-metal
boxes with recesses to hold them in place and separate them, and
a lid that doubles as a palette when opened out. You can either buy
boxes containing a range of preselected colours or, preferably, fill an
empty box with your own choice. Colour is released by stroking
with a wet brush; the wetter the brush, the lighter the tone obtained.

Pans are light and easy to use when painting out of doors.
The colours are always in the same position in the box when
you want them, and they don't leak. They are also economical
to use, with minimal wastage of paint. However, it takes a little
effort to lift enough colour onto the brush. Paints also become
dirtied when you dart from one to the other without rinsing out
your brush in between.

Care of pans

New pans tend to stick to the inside of the lid when you close
the box; when you next open the lid, they may scatter out of
order. It is good practice to remove excess moisture from pans
with a damp sponge after a painting session. Leave the box open
in a warm room for a few hours to let the colours dry off before
closing the lid, and dry the palette on the inside of the lid before
closing it, or the paints absorb the moisture and become sticky.

When using pan colours for the first time, wet them with a drop
of water and leave until the water has been absorbed. This will
ensure easier paint release when the pans are stroked with the brush.

Tubes

Tubes of colour are available in sizes ranging from 5 to 20ml
(0.17 to 0.66 US fl.oz), the standard size being 15ml (0.5 US
fl.oz). The smaller sizes are designed to fit into travelling
watercolour boxes, but the bigger tubes are more economical
for large-scale work. Tubes can be bought either singly or in
pre-selected sets. Choosing your own tubes means you can
obtain precisely the colours you need.

Tube colours are more cumbersome than pans when painting
out of doors, but they are more suitable for large-scale work in
the studio. Because tube paint is more fluid than the equivalent
pan form, it is better for mixing large amounts of paint. Tubes
can be more wasteful than pan colours, however, because it is easy
to squeeze out more than you need, and the paint can leak and
solidify if the cap is not replaced properly. Tube colour is also
prone to settling, as old stock may harden or separate in the tube.

Care of tubes

Always clean the tube thread before replacing a cap, or it may
stick – the gum arabic in the paint acts as a glue. Stuck caps
can be opened with pliers, or by holding the tube under a hot
tap so that the cap expands and is easier to remove. Do not
throw away tubes of hard paint, as it is often possible to
salvage the contents (see right).

Improvised pans
Always replace caps of
tube colours immediately,
otherwise the paint will
harden in the tube. If this
does happen, however, cut
open the tube and use it
as an improvised pan. So
long as the paint is not so
old that the gum-arabic
binder has become
insoluble, it should be
possible to reconstitute
the paint with water.

Salvaging tubes
It is possible to bring
dried-up tube paint back
to its former paste-like
consistency. Unroll the
tube, then cut the end
off, and add a few drops
of water. Now let the
hardened paint absorb
the moisture, and rework
it back to a paste.

Grades of paint

There are two grades of watercolour paint: artists' (first quality) and students' (second quality). Although student-grade oil paints can be recommended for those beginners wishing to experiment without breaking the bank, student-grade watercolours are usually a false economy because they lack some of the subtlety and transparency of first-quality paints. Artist-quality paints are more expensive, but they are worth it and, besides, you don't need a truckload of paints in order to produce a good painting.

Having said this, reputable paint manufacturers go to great lengths to maintain high standards at an economic price, and some artists will find students' colours perfectly acceptable for everyday use. Certain student-grade colours may even have particular qualities which you prefer over the artists' equivalent. For example, if you want a bright green, you may find a mixture of student-grade cobalt blue and cadmium yellow better than the subtle green produced by the same mixture in artists' colours.

Artists' paints

Artist-quality paints contain a high proportion of good quality, very finely ground, permanent pigments. The colours are transparent and luminous, they mix well, and there is a wide range. Paints are often classified by 'series', usually from 1 to 5, according to the availability and cost of the pigments. Generally, series 5 pigments are the most costly, and series 1 the least.

Students' paints

Student-quality paints are usually labelled with a trade name, such as 'Cotman' (Winsor & Newton) or 'Georgian' (Daler-Rowney), and should not be confused with the very cheap paints imported from the Far East, which should be avoided.

Students' paints are sold at a uniform price, offering the beginner an affordable selection of colours. They do contain less pure pigment and more fillers and extenders; many of the more expensive pigments, such as the cadmiums and cobalts, are substituted by cheaper alternatives. Such substitution is commonly indicated by the word 'hue' after the pigment name. The selection of colours is usually smaller than that of artists' ranges.

Permanence

Watercolour is as permanent as any other medium, provided that permanent colours are used. You should always check the manufacturer's permanency rating, which is printed either on the tube label or in their catalogue. It is also important to use acid-free paper, and to protect watercolour paintings from bright sunlight. An interesting experiment is to paint a patch of colour onto paper, cover half with a piece of card and place it in bright, indirect light for several weeks. When you remove the card, you can judge the colour loss. Most good-quality paints show little or no fading.

Students v. Artists
Mixing student-grade cobalt blue and cadmium yellow may give you a brighter colour than that achieved by the same mixture in artists' colours.

Testing colour permanence
This colour chart of student-quality watercolours was left taped to a window with half of it exposed to northern light for four months. The effects of fading can be clearly seen.

▶ SEE ALSO
▶ Pigment and colour 92
▶ Basic watercolour palettes 94

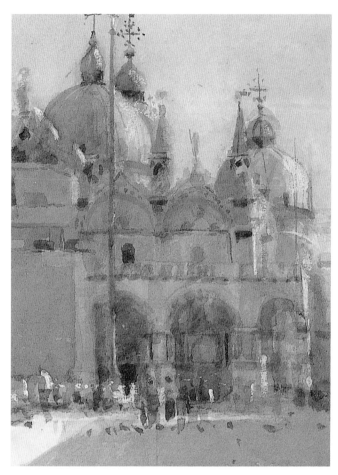

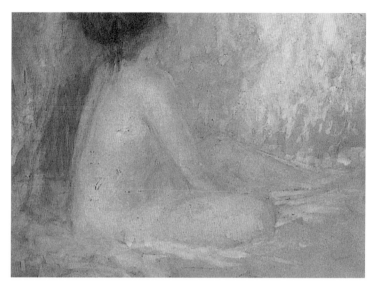

Ken Howard
*San Marco,
Morning*
Watercolour on paper
27.5 x 22.5cm
(11 x 9in)

Jacqueline Rizvi
Danae
Watercolour on paper
27.5 x 21.2cm
(11 x 8 ½in)

Alex McKibbin
Environs of Pamajera
Watercolour on paper
55 x 75cm (22 x 30in)

**Transparency of
colour**
Three ways of using the
unique transparency of
pure watercolour, which
gives a luminous glow
unmatched by other media.

Ken Howard (above left)
has captured the haze of
early-morning sunlight on
St Mark's, Venice, with thin
veils of shimmering colour,
applied one over the other.

Jacqueline Rizvi (above)
uses watercolour mixed
with Chinese white and
applies translucent layers
of colour very gradually,
using fairly dry paint. This
delicate and unusual
technique maintains the
transparent, atmospheric
quality of watercolour
while giving it a more
substantial texture. This
study is worked on brown
Japanese paper, which
provides an underlying
warm tone.

Alex McKibbin's aim (left)
is always to capture the
pulse and energy of
nature, and to this end he
manipulates his brush,
pigments and water with
great bravura, alternating
crisp strokes and drybrush
with softer areas. The
white surface of the paper
plays an integral part,
reflecting light through the
thin layers of colour.

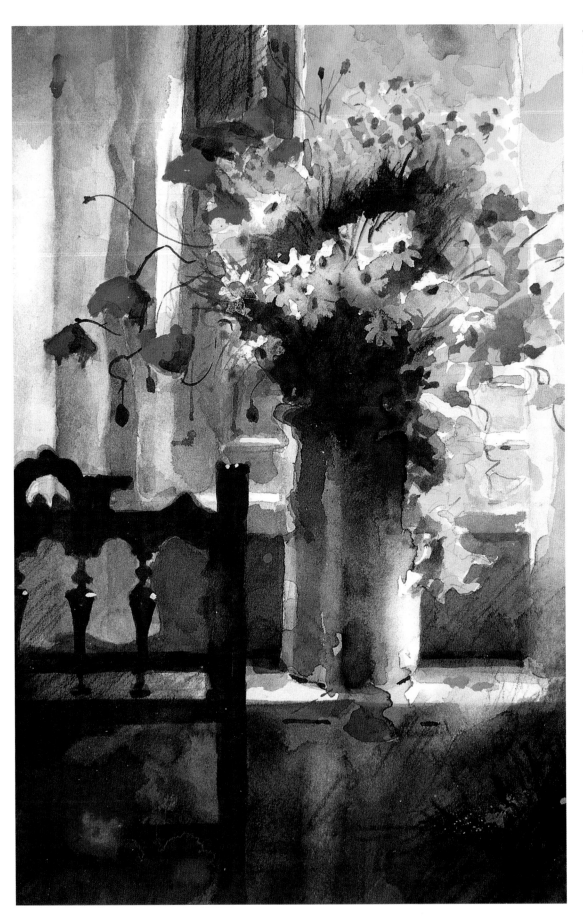

John Lidzey
*Wild Flowers by the
Window*
42 x 27 cm (16½ x 10½ in)

Pigment and colour

Although watercolour is regarded as a 'transparent' medium, the pigments fall into three groups: transparent, opaque and staining. The characteristics of each group depend on the substances from which they are derived. Additionally, some colours are intense and have greater tinting strength than others.

The list below shows the characteristics of some popular colours. However, brands of paint vary widely in their formulation; therefore, test the colours yourself.

Transparent non-staining

French ultramarine

Cobalt blue

Rose madder genuine

Aureolin

Hooker's green

Raw sienna

Payne's gray

Transparent staining

Winsor red, blue and green

Scarlet lake

Alizarin crimson

Viridian

Sap green

Prussian blue

Gamboge

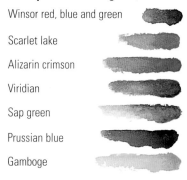

Opaque

All cadmium colours [cadmium red shown]

Indian red

Yellow ochre

Burnt umber

Davy's grey

Cerulean blue

Lemon yellow

Raw umber

Chrome oxide green

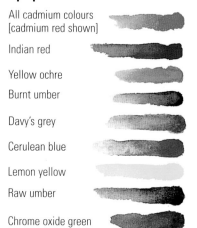

Transparent pigments

Highly transparent colours permit the white reflective surface of paper to shine through. They have an attractive, airy quality which is perfect for capturing the illusion of atmosphere, space and light. Some transparent colours are also strong stainers, though this will not concern you unless you wish to lift out colours.

Opaque pigments

In watercolour, so-called 'opaque' colours are obviously far more transparent than they are in oils, particularly when they are thinly diluted. Many opaque pigments are brilliant, while others are beautifully subtle. However, these pigments impart a degree of opacity to all colours they are mixed with – if used carelessly, they create cloudy colours lacking brilliance and luminosity.

Staining pigments

Some transparent colours, such as alizarin crimson, are highly staining: they penetrate paper fibres and cannot be removed without leaving a trace of colour. Some earth colours, cadmiums and modern organic pigments also tend to stain; if you intend to 'lift out' or sponge out areas of colour, you should always choose non-staining pigments where possible.

Tinting strengths

The tinting strength of pigments varies considerably. Some are very strong and overpower in mixtures, so only a small amount is needed. Others are so delicate that you must use a large amount to make an impact on another colour. Knowing how strong or weak each colour is will save you a lot of time and frustration when mixing colours together.

Strong tints
Colours such as alizarin crimson, cadmium red, phthalocyanine blue and burnt sienna are very strong, and need to be diluted heavily.

Low-strength tints
Pigments with a low tinting strength include raw umber, yellow ochre, cerulean blue and raw sienna.

▶ SEE ALSO
▶ Watercolour papers 28
▶ Wet-in-wet 188
▶ Wet-on-dry 189
▶ Creating highlights 190
▶ Textures and effects 194

Cobalt blue
Wet paint (above) compared with a dry example (below).

Chinese white
A cool white, ideal for tinting other colours.

Colour mixing

You should always mix more paint than you think you will need; it is surprising how quickly it is used up. It is frustrating to run out of colour halfway through a wash and then have to try to remix the exact colour again.

One of the keys to good colour is to restrain yourself from mixing pigments too much. If you are blending two colours together, for example, the mixture should show three: the two original pigments and the mixture itself. This gives a livelier vibration to the colour.

Another way to ensure that you don't overmix your colours is to apply each one separately, mixing directly on the support. Colours may be applied in successive glazes (wet-on-dry), or allowed to blend on dampened paper (wet-in-wet).

Trial and error

You cannot tell by looking at paint on a palette whether you have achieved the right colour or tone: the colour must be seen on paper. Watercolour paint always dries lighter on paper than it appears when wet (see left), so mixing is often a matter of trial and error. When mixing, therefore, it is useful to have a piece of spare paper to hand for testing the colours before applying them to a painting.

Using body colour

To purists, the use of opaque paint in a watercolour is nothing short of heresy. A watercolour is supposed to be transparent, they would say, and paler tones are achieved by adding more water to paint, while pure white areas are achieved by reserving areas of white paper. However, most watercolourists take a more pragmatic approach and use opaque paint when it seems appropriate for a particular stage in a painting – when creating highlights, for example.

Transparent watercolours can be rendered opaque or semi-opaque by mixing them with Chinese white to produce what is called body colour. Chinese white is a blend of zinc-oxide pigment and gum arabic; it is a dense, cool white which produces pastel tints in mixtures due to its high tinting strength.

'One makes use of pigments, but one paints with feeling.'
Jean-Baptiste Chardin (1699–1779)

Mixing

Pigments should not be mixed too much. Stop mixing while you can still see the original colours along with the mixture. The lightly mixed examples (below, **2** and **3**) can be seen to be more lively and colourful than the overmixed example (**1**).

1 French ultramarine and alizarin crimson overmixed on the palette.

2 The same colours, this time partly mixed on the palette.

3 The same colours partly mixed on wet watercolour paper.

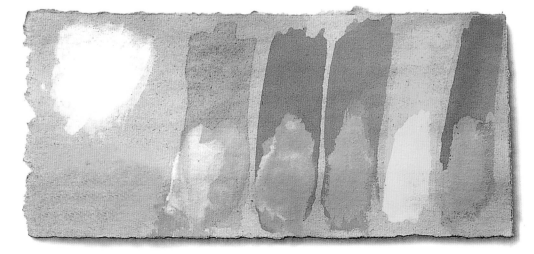

Semi-transparent colours
One way of using Chinese white is to dilute it and then mix it directly with transparent colours. This gives a semi-transparent, slightly milky effect that is particularly effective on toned papers.

Basic watercolour palettes

The enormous range of pigments available makes it difficult to choose colours in a considered way. Who can resist those endless rows of gorgeous colours in the local art store? Sets of good-quality watercolours are available in boxes, but these are expensive and may contain far more colours than you need. A wiser course is to buy an empty box and fill it with colours of your own choice.

Starter palette

Starter palette

The colours shown below on this page will make a suitable starting selection. Colour is a highly subjective area; however, the colours here are chosen for their all-round uses and permanence. It is also possible to mix a wide range of hues from them.

The ASTM (American Society for Testing and Materials) codes:

ASTM I: excellent lightfastness

ASTM II: very good lightfastness

ASTM III: not sufficiently lightfast

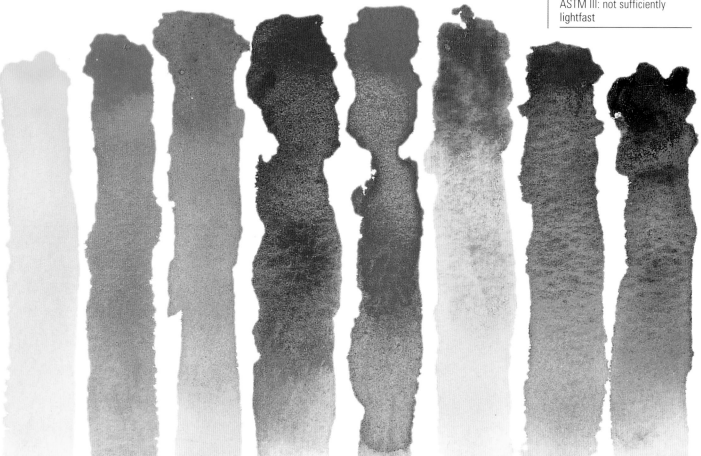

Cadmium yellow
Permanence excellent (ASTM I). An opaque colour with a warm and orange-yellow hue. Very clear and bright.

Cadmium red
Permanence excellent (ASTM I). An opaque colour with a bright vermilion tone. Very clear and bright.

Permanent rose
Permanence good (ASTM II). A transparent colour with a cool pinkish-red hue. A softer and more permanent alternative to alizarin crimson.

French ultramarine
Permanence excellent (ASTM I). An excellent transparent colour with a deep blue, violet-tinged hue. Makes a range of subtle greens when mixed with yellows.

Cobalt blue
Permanence excellent (ASTM I). A transparent colour with a soft blue hue. Cooler than French ultramarine.

Raw sienna
Permanence excellent (ASTM I). A transparent colour, excellent for layering washes, with a deep golden-yellow hue. A very lightfast and durable colour.

Burnt sienna
Permanence excellent (ASTM I). A transparent colour with a deep red-brown hue. Mixes well with other pigments, giving muted and subtle colours.

Burnt umber
Permanence excellent (ASTM I). A more transparent colour than raw umber, with a warm brown hue. Excellent in mixtures of pigments.

Auxiliary palette

The seven colours that are shown below on this page have been selected as a range that will extend your starter palette (see opposite page) for watercolour painting. Apart from the additional possibilities they provide you with for further mixing and experimentation, you will also find them very useful when you are painting on location outdoors, particularly for landscapes.

Preselected boxes

This typical shop-bought watercolour-pan box (right) contains the following colours:

Cadmium yellow pale
Cadmium red
Alizarin scarlet
Alizarin crimson
Viridian
Burnt umber
Yellow ochre
Burnt sienna
Light red
French ultramarine
Prussian blue
Ivory black

Auxiliary palette

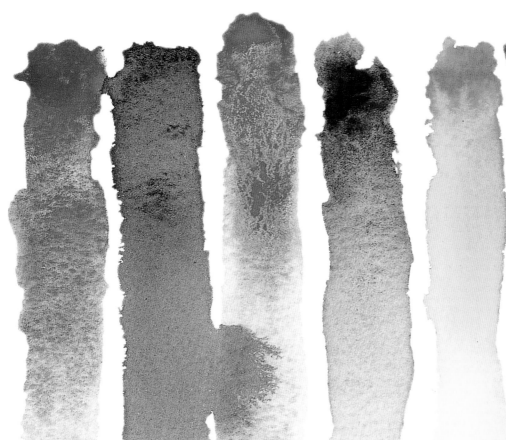

Cerulean blue
Permanence excellent (ASTM I). A semi-transparent colour with a cool and greenish-blue hue. Ideal for painting skies.

Phthalocyanine blue
Permanence good (ASTM II). A transparent colour with a deep, intense blue hue and a cold, sharp tone. A strong staining colour.

Cobalt violet
Permanence excellent (ASTM I). A transparent colour with a bright, red-violet hue. A pure violet that cannot be mixed or imitated.

Raw umber
Permanence excellent (ASTM I). A transparent colour with a greenish-brown hue. Useful in mixes.

Yellow ochre
Permanence excellent (ASTM I). A transparent colour with a soft golden-yellow hue. Has a calming effect on other colours.

Viridian
Permanence excellent (ASTM 1). A transparent colour with a cool bluish-green hue. Makes a good basis for warm, bright greens.

Venetian red
Permanence excellent (ASTM 1). A semi-opaque colour with a warm terracotta-red hue. Very useful for mixing flesh tones.

95

Watercolour brushes

Brushes are a very important element in watercolour painting, so it is worth buying the best quality you can afford. Cheap brushes are a false economy, as they do not perform well and quickly wear out.

Brush making
Even today, brush making is largely a hand-skill process utilizing traditional components and natural materials.

A good brush

A good brush should have a generous 'belly' capable of holding plenty of colour, yet releasing paint slowly and evenly. The brush should also point or edge well – when loaded with water, it should return to its original shape at the flick of the wrist. The best brushes have a seamless ferrule made of cupro-plated nickel, which is strong and resistant to corrosion. Lower-grade brushes may have a plated ferrule with a wrapover join; with repeated use this may tarnish or open up.

Sable

Sable hair is obtained from the tail of the sable marten, a relative of the mink. Sable brushes are undoubtedly the best choice for watercolour painting. They are expensive, sometimes alarmingly so, but they give the best results and, if cared for well, will last a lifetime. Sable hair tapers naturally to a fine point, so that brushes made from it have very delicate and precise tips which offer maximum control when painting details. Good-quality sable brushes are resilient yet responsive; they hold their shape well and do not shed their hairs, and have a spring and flexibility which produce lively, yet controlled brushstrokes.

Kolinsky sable

The very best sable is Kolinsky sable; it comes from the Kolinsky region of northern Siberia, where the harshness of the climate produces hair that is immensely strong, yet it is both supple and springy.

Red sable and pure sable

Brushes marked 'red sable' or 'pure sable' are made from selected non-Kolinsky hair. They do not have the spring and shape of Kolinsky, but are perfectly adequate and more moderately priced. However, you should beware of buying very cheap sable brushes just because they carry the name 'sable' – good-quality sable is springy and strong, while being at the same time fine and soft.

▶ **SEE ALSO**
▶ Drawing inks 56
▶ Brush shapes and sizes 98
▶ Textures and effects 194

Portable brushes
Small retractable brushes, with a 'travelling' set of pans, are ideal for making sketches when painting out of doors.

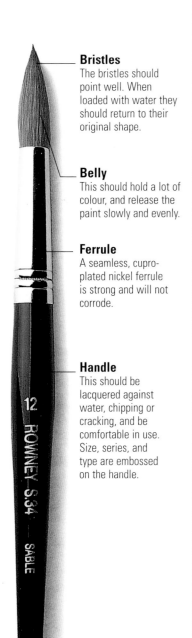

Bristles
The bristles should point well. When loaded with water they should return to their original shape.

Belly
This should hold a lot of colour, and release the paint slowly and evenly.

Ferrule
A seamless, cupro-plated nickel ferrule is strong and will not corrode.

Handle
This should be lacquered against water, chipping or cracking, and be comfortable in use. Size, series, and type are embossed on the handle.

12 ROWNEY S.34 SABLE

Squirrel hair

This is dark brown in colour, and is much softer than sable. Although at first sight it is much cheaper than sable, squirrel-hair brushes are generally a false economy, as they do not point well and have little resilience. Squirrel-hair 'mop' brushes, however, retain a large amount of colour, allowing extensive washes to be laid quickly and evenly. This makes them an economical alternative to large-size sable wash brushes.

Ox hair

This hair comes from the ear of a breed of cow and is strong and springy, but quite coarse. It does not point very well and is not suitable for making fine-pointed brushes, but it is a very good hair for use in square-cut brushes. Ox-hair brushes usually have a long hair-length, which increases their flexibility.

Goat hair

A type of hair often used in traditional Oriental watercolour brushes. The hair is soft but sturdy, and goat-hair brushes hold a lot of water. This makes them ideal for laying broad washes and for working wet-in-wet.

Synthetic fibres

These brushes have been introduced in an attempt to achieve the performance of natural hair at a cheaper price. Sable-type synthetics are a golden-yellow colour, and are made from polyester filaments with tapered ends which imitate the real thing. They can be a little stiff and unsympathetic in comparison to natural hair, and have less colour-holding capacity, but synthetics in smaller sizes are a better choice for fine work than, say, squirrel hair.

Combination brushes

Some manufacturers offer brushes which combine synthetic hair with real sable, to achieve good colour-holding and pointing properties at a reasonable cost.

Components and materials used in brush making

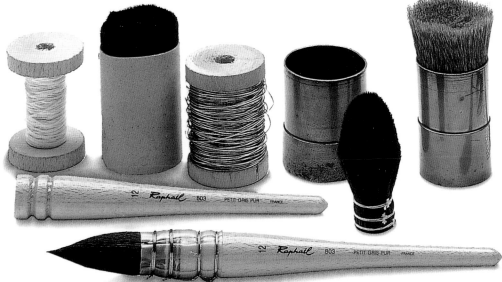

Guide to watercolour-brush hair

Kolinsky sable
The best: very expensive, immensely strong, yet supple and springy.

Red or pure sable
More moderately priced, springy and strong, yet fine and soft.

Squirrel hair
Softer and cheaper than sable, this does not point well and has little resilience. A less-costly alternative to large-size sable wash brushes.

Ox hair
Strong and springy, but quite coarse, ox hair does not point very well. Good hair for square-cut brushes.

Goat hair
Soft but sturdy, goat hair is ideal for laying broad washes.

Synthetic fibres
Synthetic fibres can be a little stiff and unsympathetic, with less colour-holding capacity than animal hair.

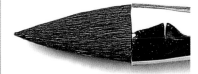

Combination hair
The brush shown is a combination of squirrel and goat hair. Other blends of animal hairs are also available, as are animal-synthetic combinations.

Brush shapes and sizes

Art-supply stores and manufacturers' catalogues offer a wide range of variations on watercolour brushes, but those detailed below will provide all you need for successful watercolour painting.

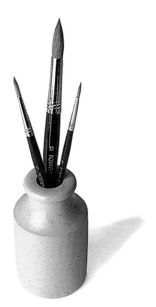

Starter selection
For a good starter set, choose Nos 3, 5 and 12 round brushes.

Round brushes

The round is perhaps the most useful and most common brush shape. A brush of this type can be used for both fine, delicate strokes and broader strokes and flat washes. Apart from the standard length of brush head, rounds also come in short lengths ('spotter' brushes) and long lengths ('rigger' brushes).

Spotter brushes

Retouching or spotter brushes have a fine point, and the very short head gives you extra control. They are used mainly by miniaturists and botanical artists, for precise details.

Rigger brushes

A long-haired round brush is known as a designer's point, writer or rigger (from when the brush was used for painting the finely detailed rigging on sailing ships). The long shape gives an extra-fine point and good colour-holding properties, allowing fine lines and tapered strokes.

Mops and wash brushes

These are made from synthetic, goat or squirrel hair, and are used for laying in large areas of colour quickly. Wash brushes are generally wide and flat, while mops have large round heads.

• Care of brushes

Brushes will last longer and be far more pleasant to work with if you follow a few simple rules.

While painting, do not leave brushes resting on their bristles in water for long periods, as this can ruin the hairs and handles.

Immediately after use, rinse brushes in cold running water, making sure that any paint near the ferrule is fully removed.

After cleaning, shake out the excess water and gently shape up the hairs between finger and thumb. A little starch solution or thinned gum solution stroked onto the bristles will help them retain their shape; it is easily rinsed out with water when the brush is used again.

Leave brushes to dry either flat or up-ended in a pot or jar. When storing brushes for any length of time, make sure they are perfectly dry before placing them in a box that has a tight-fitting lid – mildew may develop if wet brushes are stored in an airtight container.

Moths are partial to animal-hair bristles, so protect your brushes in the long term with mothballs or a sachet of camphor. Horse chestnuts also keep moths at bay.

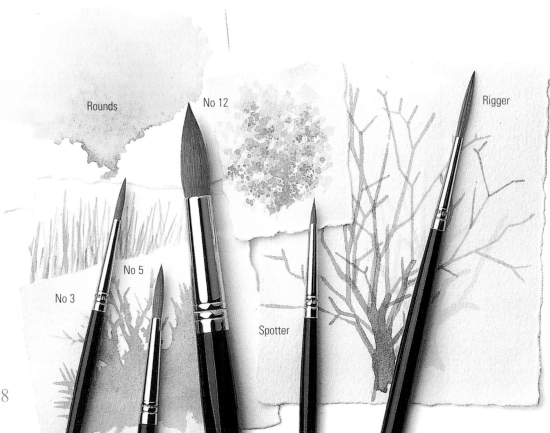

Rounds
No 12
Rigger
No 5
No 3
Spotter

▶ **SEE ALSO**
▶ Drawing inks 56
▶ Watercolour brushes 96

Flat brushes

Flat watercolour brushes are also known as 'one-strokes'. These square-ended brushes, set into a flattened ferrule, are designed to give a high colour-carrying capacity and free flow of colour for laying in broad washes, while the chisel end creates firm, clean linear strokes. As with round brushes, a longer-haired flat is available, made from hard-wearing ox hair.

Brush sizes

All watercolour brushes are graded according to size, ranging from as small as 00000 to as large as a No. 24 wash brush. The size of a flat brush is generally given by the width of the brush, measured in millimetres or inches. Brush sizes are broadly similar between one manufacturer and another, but they do not appear to be standard – thus a No. 6 brush in one range will not necessarily be the same size as a No. 6 in another.

Choosing brushes

It is a good idea to experiment with all types and sizes of brush to discover their potential. Eventually, as you develop your individual approach to watercolour, you will settle on a few brushes which are suited to your own way of painting, and which you find comfortable to hold. To start with, a selection of three sable brushes – for instance, a No. 3, a No. 5 and a No. 12 round – should be sufficient.

As a rule, choose the largest suitable brush for any given application, as it is more versatile and holds more colour than a smaller version. A fairly large, good-quality brush, such as a No. 12, will cover large areas, yet come to a point fine enough to paint precise details.

Oriental brushes
Oriental brushes, made from goat, wolf or hog hair set into hollow bamboo handles, are inexpensive and versatile. The thick, tapering head can make broad sweeps of colour, and can be drawn up to a very fine point for painting delicate lines. The heads are coated in starch size; remove this by soaking and teasing the hairs in a jar of water for a minute or two.

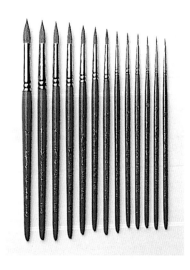

Sable rounds
The brushes shown here range from 000 up to 12; even smaller and larger brushes are available.

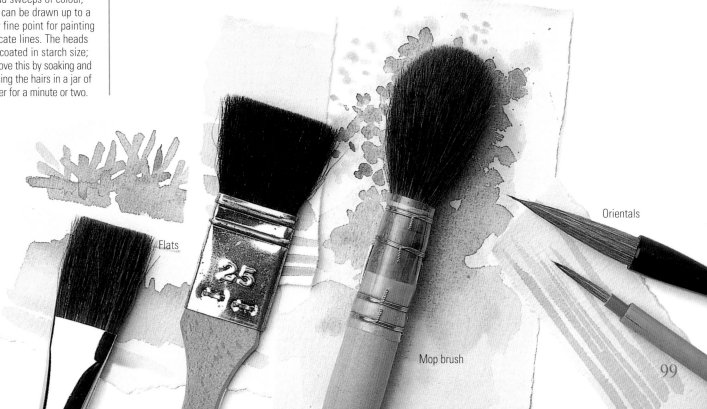

Flats

25

Mop brush

Orientals

Palettes

Watercolour palettes are available in a variety of shapes and sizes, but they all feature recesses or wells which allow you to add the required quantity of water to the paint, and prevent separate colours from running together.

Choosing a palette

Manufactured palettes are made of white ceramic, enamelled metal or plastic; ceramic is perhaps the most sympathetic surface for mixing colours. Plastic palettes are cheap and lightweight; although ideal for outdoor painting, they eventually become stained with paint residue because they are slightly absorbent.

Which kind of palette you prefer will be largely dependent on personal taste and the scale and style of your work. However, certain types of palette are best suited to particular purposes.

Integral palettes

Enamelled-metal painting boxes, designed to hold pans or tubes of paint, are particularly useful when working outdoors, as the inside of the lid doubles as a palette and mixing area when opened out. Some boxes also have an integral hinged flap for mixing and tinting, and a thumb ring in the base.

Slanted-well tiles

These are long ceramic palettes divided into several recesses or wells, allowing several colours to be laid out without them flowing into one another. The wells slant so that the paint collects at one end ready for use and can be drawn out for thinner washes.

Some slanted-well tiles have a row of smaller and a row of larger wells; paint is squeezed into the small wells and moved to the larger wells, to be diluted with water or mixed with other colours.

Tinting saucers

These small round ceramic dishes are used for mixing larger quantities of paint. They are available divided into four recesses, for mixing separate colours, or undivided, for mixing a single colour.

Palette trays

When mixing large quantities of liquid paint, you will need a palette with deep wells. These palettes are usually made of plastic or more stain-resistant, high-impact polystyrene.

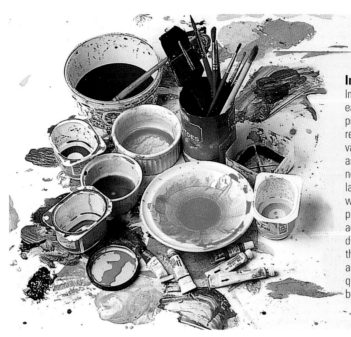

Improvised palettes

Improvised palettes are cheap and easy to obtain, and artists often prefer them because there is no restriction on size. You can use a variety of household containers, as long as they are white and non-porous. Depending on how large a mixing area you want, a white saucer, plate or enamelled pie plate, can make a perfectly adequate palette. Hors-d'oeuvres dishes are particularly useful, as they provide several large mixing areas. When you are mixing large quantities of wash, use old cups, bowls or yoghurt pots.

Palettes for watercolour

Shown here and on the opposite page are a selection of manufactured palettes suitable for watercolour painting. Opposite (left), from top to bottom: quartered tinting saucer; round cabinet saucers (all ceramic). Centre, from top to bottom: deep-well palette tray; large mixing palettes with thumb hole and divisions (all plastic). Left and below: enamelled-metal painting box with integral palette; ceramic segmented, white china round palette; slanted-well tile.

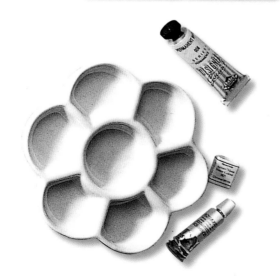

Watercolour accessories

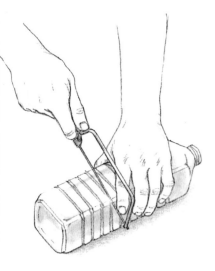

Improvised containers
You can recycle plastic bottles into useful containers – some bottles have convenient guidelines for cutting. Cut to the required height with a hacksaw or craft knife; the leftover neck can be used as a funnel.

Useful items, such as mediums, masking fluid, scraping tools and sponges, will all broaden the range of painting techniques at your disposal.

Water containers

Do not skimp on water when painting in watercolour – use as large a container as you can find, otherwise the water quickly becomes murky as you rinse your brush between washes, and this may spoil the transparency of your colours. Some artists prefer to use two water containers, one to rinse brushes and the other to use as a dipper for mixing colours.

Masking fluid

This is a quick-drying, liquid latex which is used to mask off selected areas of a painting when applying colour in broad washes. There are two types available: tinted and colourless. The tinted version is preferable, as it is more versatile and is easier to work with on white paper.

Gum arabic

A pale-coloured solution of gum arabic in water will increase both the gloss and transparency of watercolour paints when it is mixed with them. Diluted further, it improves paint flow. Too much gum arabic will make paint slippery and jelly-like, but in moderation it enlivens the texture and enhances the vividness of the colours.

Ox gall

A straw-coloured liquid made from the gallbladders of cattle, which is added to water in jars to improve the flow and adhesion of watercolour paints, particularly for wet-in-wet techniques. It has been largely replaced by synthetic products.

Gelatine size

This liquid, sold in small bottles, may be applied to the surface of a watercolour paper which is too absorbent. Apply with a large soft brush, and leave to dry for a few minutes. The size reduces the absorbency of paper, making it easier to apply washes.

Glycerine

You will find glycerine useful when working outdoors in dry conditions. A few drops added to water will counteract the drying effects of wind and hot sun by prolonging the time that it takes for watercolour paint to dry naturally.

Alcohol

This has the opposite effect to glycerine, speeding up the drying time of watercolour paint. It is extremely useful when working outdoors in damp weather conditions.

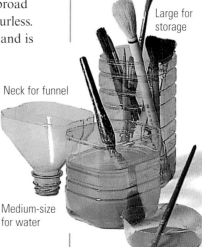

Large for storage

Neck for funnel

Medium-size for water

Shallow for mixing

▶ SEE ALSO
▶ Watercolour papers 28
▶ Flat and graded washes 184
▶ Wet-in-wet 188
▶ Creating highlights 190
▶ Textures and effects 194

Scraping and colour-lifting tools

You can use a single-edged razor blade, scalpel, cocktail stick, the end of a paintbrush handle, even your thumbnail, for scraping out unwanted areas of still-wet watercolour or for scratching lines into dry paint to create textured effects. Fine sandpaper can be used to rub away some of the colour, creating a drybrush-like sparkle. Cotton buds can be employed for lifting out small areas of still-wet colour. Blotting paper is also useful for lifting out colour and for mopping up spills.

Sponges

Natural and synthetic sponges are often used for dabbing on areas of rough-textured paint. They are also used for wetting paper in preparation for applying washes, and to lift out wet paint or mop up paint that has run too much. Natural sponges are more expensive than synthetic ones, but they have a pleasing silky texture and produce interesting random patterns.

Selection of accessories
Shown below is a typical assortment of materials used to create watercolour textures and expand techniques. Top shelf, from left to right: water container for mixing and wetting; gelatine; ox gall; masking fluid; cotton buds and cocktail sticks; natural and synthetic sponges. Bottom shelf, from left to right: clips for holding paper; gum arabic; glycerine; water container for washing brushes; alcohol abrasive paper; craft knives and sharpened paintbrushes for lifting and scraping.

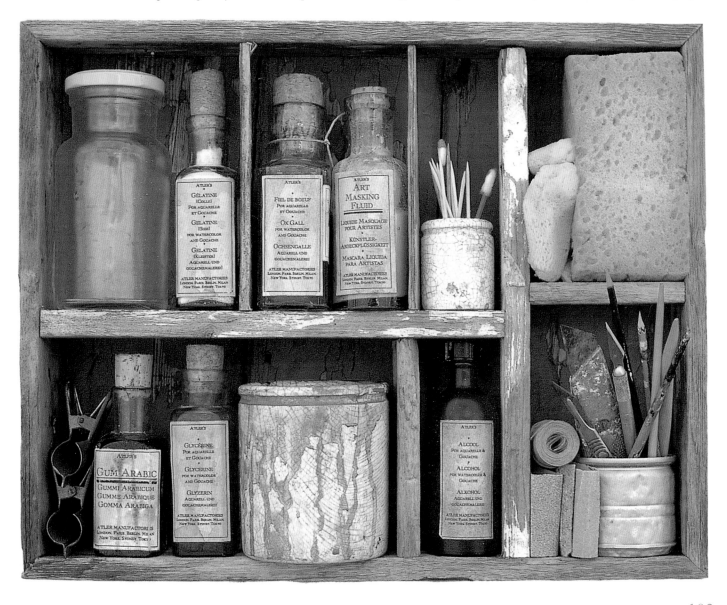

Gouache

The term 'gouache' originates from the Renaissance, when the Italian masters painted 'a gouazzo' – with water-based distemper or size paints. The opacity of gouache and its matt, chalky appearance when dry, make it a quite separate and distinct medium from pure, transparent watercolour, but the equipment, supports and techniques that are used are similar for both media.

Testing gouache
In terms of permanence, covering power and flow, gouache colours will vary considerably from one manufacturer to another, and it is advisable to try out samples from different ranges in order to determine which are best suited to your own method of working.

Paints
The best-quality gouache paints contain a very high proportion of pigment; its density creates an opaque effect. The colours are therefore pure and intense, and create clean colour mixes. Because the natural covering power of each pigment is not increased artificially, it varies according to the pigment. The less-expensive gouache ranges contain an inert white pigment, such as chalk or blanc fixe, to impart smoothness and opacity.

Availability of gouache
Standard-size tubes are convenient when painting outdoors, but pots of gouache are more economical for large-scale paintings.

Choosing paint
Gouache paints are sold in tubes, pots and bottles, often labelled 'designers' colour'. This refers to the medium's popularity with graphic designers, who require bright colours with a matt finish. A vast range of colours is available, but this includes some brilliant colours which are fugitive; while this does not matter to designers, whose work is of a temporary nature, these fugitive colours are not recommended for fine permanent painting.

Colour migration
Certain dye-based gouache colours – the lakes, magentas and violets – have a tendency to 'migrate', or bleed through when overpainted with light colours. One solution is to apply bleed-proof white between layers, to halt any further migration. This is a very dense designers' colour that may be classed as gouache.

Preventing colour migration
Colours may be mixed with acrylic glaze medium, which converts gouache into paint with an acrylic finish that is both flexible and water-resistant. It allows washes to be superimposed without disturbing those below.

▶ **SEE ALSO**
▶ **Watercolour papers 28**
▶ **Pastel paper 34**
▶ **Watercolour paints 87**
▶ **Watercolour accessories 102**
▶ **Mediums for acrylics 118**

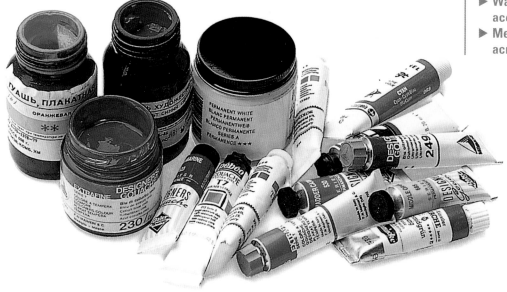

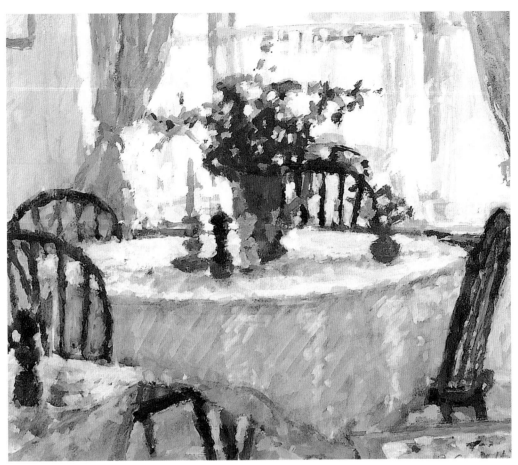

The versatility of gouache

Depending on your temperament as an artist, you can choose either to exploit the brilliance and opacity of gouache or to create soft, subtle effects.

Although gouache is used in much the same way as watercolour, the feel of a gouache painting is more solid and robust. This quality is exploited to the full in the still life study (below), in which the exuberance of the flowers is matched by the artist's joyous and uninhibited use of colour.

In contrast, the interior study (left) evokes a quiet, reflective mood. Here, the artist has used overlaid washes of semi-opaque colour, softened with white. The matt and airy quality of the paint surface beautifully recreates the suffused light on the scene.

Rosemary Carruthers
Window Table (The Moorings)
Gouache on paper
21.2 x 23.7cm (8½ x 9½in)
*Llewellyn Alexander Gallery,
London*

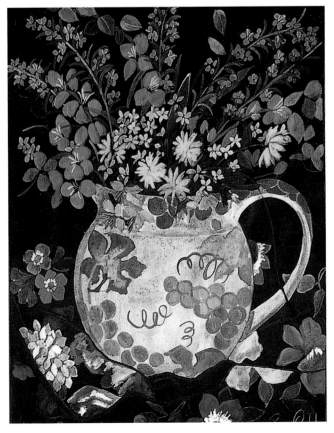

Penny Quested
Still Life with Flowers
Gouache on Japanese paper
67.5 x 57.5cm (27 x 23in)

Basic gouache palette

As with the basic watercolour palette, this selection of colours will enable you to discover the basic characteristics of gouache paints. The selection may then be augmented by further colours from the range available, depending on the subjects you wish to paint.

Gouache mixed with water

Gouache mixed with permanent white

Starting selection

All manufactured gouache colours are opaque and have a high degree of permanence: a starting selection is shown above. The colours can be intermixed and thinned with water (above left) to create transparent colours which look similar to true watercolour paint, or mixed with white paint (above right) to create opaque tints.

The ASTM (American Society for Testing and Materials) codes for lightfastness:

ASTM I: excellent lightfastness

ASTM II: very good lightfastness

ASTM III: not sufficiently lightfast

• Permanent white
Permanence good (ASTM II). Cool white with good covering power. Include this colour in your starter palette.

Starting selection, from top to bottom:

Cadmium yellow
Permanence excellent (ASTM I). Lemon shades through to warm orange. Mixes well, forming strong greens when mixed with viridian.

Cadmium red
Permanence excellent (ASTM I). Warm orange-red to deep red. A strong, pure pigment, which is excellent in mixes.

French ultramarine
Permanence excellent (ASTM I). Deep blue with a slightly violet tinge. When mixed with yellows, it provides a useful, versatile range of greens.

Raw umber
Permanence excellent (ASTM I). Brown with a slightly greenish-brown tinge. Raw umber is good for neutralizing other colours.

Viridian
Permanence excellent (ASTM I). Cool, bluish green. Retains its brilliance, even in mixes.

Yellow ochre
Permanence excellent (ASTM I). Soft, golden yellow. Tones down brighter colours in mixes.

Edward McKnight Kauffer (1890–1954)
Untitled Litho Print, 1919
75 x 112cm (30 x 44¾in)
Museum of Modern Art, New York

Posters were traditionally painted on board or stretched paper with gouache, tempera or cheap and impermanent 'poster colours'. Gouache colours were the first choice of graphic designers and commercial artists for many years. Their strong colour and solid, velvety, non-reflective surface finish photograph well, enabling artwork to be converted accurately to print.

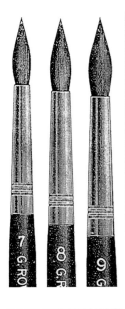

Supports

Since gouache is opaque, the translucency of white paper is not as vital as it is in watercolour, so it can be applied to a wide variety of supports. Lightweight papers should be avoided; the paint film of gouache is thicker than that of watercolour, and is liable to crack if used on a too-flimsy support. Gouache can also be used on surfaces such as cardboard, wood or primed canvas, so long as they are free from oil. You can also employ toned and coloured papers, as used for pastel work.

Brushes

Watercolour brushes are normally used for gouache painting, though bristle brushes are useful for making textural marks. However, because gouache does not handle in the same way as watercolour, experiment to determine which type and size of brush best suits your technique.

Using toned paper

This can be highly effective; the surface acts as a mid-tone from which to work up to the lights and down to the darks, and also helps to unify the elements of the composition (see sketch below). If you intend leaving some areas of the paper untouched, however, do make sure that you choose a good-quality paper which will not fade.

John Martin
Untitled Sketch (above)
Gouache on tinted paper
10 x 15cm (4 x 6in)

Geraldine Girvan
Plums in a Green Dish
Gouache on paper
40 x 30cm (16 x 12in)
Chris Beetles Gallery, London

This artist revels in the bright colours and strong patterns that are found in both natural and man-made objects. She finds that gouache is the perfect medium to give her the fluidity and richness suited to her interpretation of the subject.

▶ **SEE ALSO**
▶ Oils supports 18
▶ Watercolour papers 28
▶ Pastel paper 34
▶ Pigment and colour 92
▶ Watercolour brushes 96

Egg tempera

Egg-tempera paint has a long, venerable history, and it was universally used by artists until the fifteenth century. Then a method of mixing oils into tempera pigments, in order to give them greater flexibility, eventually produced a pure oil medium which supplanted tempera.

Basic palette
Manufactured-tempera colours are all relatively transparent, and all have a high degree of permanence. The colours cannot be mixed on the support. A starting selection would be similar to that described for gouache, but the technique used for building up tones with small strokes means that the artist will develop a personal palette, depending on the subjects chosen.

Paints

Tempera is a water-based paint which is made by mixing egg yolk with pigments and distilled water. As this mixture dries on the painting surface, the water evaporates, leaving a hard, thin layer of colour which is extremely durable.

Prepared egg-tempera colours are available from a few manufacturers, although formulations vary. Daler-Rowney, for example, produce a range of egg-tempera paints, based on a nineteenth-century recipe for an emulsion made from egg yolk and linseed oil. The oil makes the paint slower-drying, more flexible and easier to manipulate, yet it remains water-thinnable. However, because the colour range of ready-made paints is relatively limited, many artists working in tempera prefer to prepare their own paints, using the vast range of colour pigments that are available.

Pigments
Commercial pigments that are suitable for making tempera paints can be purchased from art shops.

▶ **SEE ALSO**
▶ **Oils supports 18**
▶ **Underpainting 164**
▶ **Watercolour brushes 96**

The ASTM (American Society for Testing and Materials) codes for lightfastness:

ASTM I: excellent lightfastness

ASTM II: very good lightfastness

ASTM III: not sufficiently lightfast

• **Titanium white**
Permanence excellent (ASTM I). Include this colour in your palette.

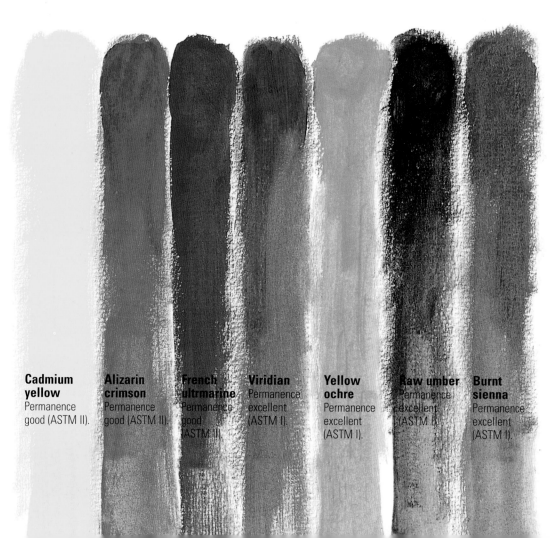

Cadmium yellow
Permanence good (ASTM II).

Alizarin crimson
Permanence good (ASTM II).

French ultrmarine
Permanence good (ASTM II).

Viridian
Permanence excellent (ASTM I).

Yellow ochre
Permanence excellent (ASTM I).

Raw umber
Permanence excellent (ASTM I).

Burnt sienna
Permanence excellent (ASTM I).

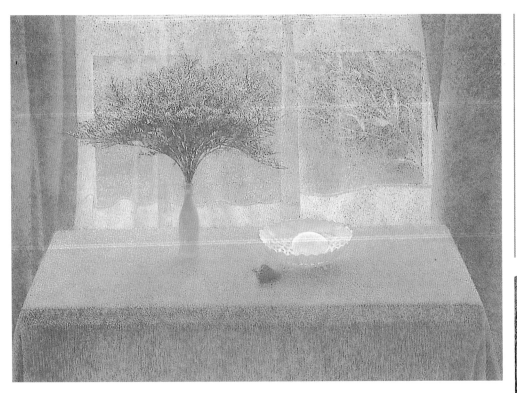

David Tindle
Strawberry
Egg tempera on board
58.5 x 81.3cm (23³⁄₈ x 32¹⁄₂in)
Fischer Fine Art, London

As a painter in the quiet, Romantic tradition, David Tindle is concerned with small, intimate, domestic subjects. He uses pure egg tempera and a delicate and painstaking application of tiny hatched marks in order to portray the disembodying effect of light filtered through a curtained window, reducing solid objects to veils of luminous tone.

Techniques

Tempera is not a spontaneous medium, but is suited to artists who enjoy using a meticulous technique. The paint dries within seconds of application, so colours cannot be blended on the support as they can with other media. Instead, tones and colours are built up with thin colour applied in glazes, or with tiny, hatched strokes. Any number of coats can be superimposed without the finished painting losing any of its freshness. Indeed, repeated layers of translucent colour enhance, rather than diminish, the luminous clarity of tempera.

Different 'temperas'

Tempera paints are no longer made exclusively with egg, and thus the term tempera has also come to cover emulsions of various sorts. Some paint manufacturers on the European continent, for example, refer to their gouache paints as 'tempera', so you should check carefully before buying.

Surfaces

Tempera can be used on a wide variety of supports, including canvas panels and paper, but the traditional ground is still gesso-primed board, where the smooth, brilliant-white surface reflects light back through the paint, giving the colours their extraordinary luminosity.

Underpainting for oils

Tempera also makes a wonderful underpainting for oils. When applied to a white ground, the colour gleams through each layer, giving a painting a deep, luminous glow.

• Brushes
Round sables or synthetics with a good point are the best brushes for tempera painting. The long-haired varieties, such as riggers and lettering brushes, are the most suitable; they hold more colour and can be worked for longer than short-haired brushes. As tempera dries quickly, brushes must be washed frequently in distilled or boiled water.

Acrylic paints

Until the early twentieth century, artists had been working with the same painting materials for hundreds of years. Modern oil and watercolour paints are essentially the same as those used by the old masters, and those changes and developments that have occurred have been slow and evolutionary. Then, in the 1940s and 1950s, acrylic paint burst upon the art scene. This new medium, which was based on a synthetic resin, had all the advantages of the traditional media and few of the drawbacks.

Artist-quality acrylic paints

• Permanence
All acrylic colours, apart from fluorescent colours, are labelled either extremely permanent or permanent, which means that none of them will yellow, fade or darken with time.

• Students' and artists' quality
As with watercolours and oils, acrylics are available in both artists' and the cheaper students' qualities. Artist-quality acrylic colours vary in price according to the initial cost of their pigments, but they are considerably cheaper than oil paints. Student-quality acrylics are all the same price, but the colour range is smaller. Expensive pigments are usually substituted with highly lightfast, synthetic organic pigments, and the pigment name is suffixed with 'hue'.

Quality
In recent years, the quality of acrylic paints has improved enormously. There is now a higher pigment content, the resin binder is more flexible, and a wide range of mediums is available for mixing with the paint, extending its versatility and expressive qualities. Although some die-hard traditionalists still regard them with disdain, acrylics are becoming increasingly popular with all levels of painters.

Composition
The name acrylic paint is derived from acrylate resin, which is the vehicle or binder in which the pigments are suspended. It is this synthetic binder, consisting of an emulsion of extremely fine particles of resin dispersed in water, which largely determines the differences in character and handling qualities between oil paints and acrylic paints.

The binder for oil paint consists of a vegetable drying oil, such as linseed or poppy oil, which dries by absorbing oxygen from the air. This process is known as oxidative drying, and is a very slow process. Acrylic paints, in contrast, are physically drying, which means that they dry rapidly through evaporation of the water contained in the binder. As the water evaporates, the acrylic-resin particles fuse to form a fairly compact paint film in which each minute particle of pigment is coated in a film of resin. The result is a permanently flexible paint film which is water-resistant, does not yellow and reveals no signs of ageing.

Advantages
The major advantages of using acrylics are their permanence, their resistance to the effects of ageing, and their flexibility. Unlike oils, acrylics do not yellow, embrittle, wrinkle or crack. Whereas oil paints harden as they dry, and the paint film becomes brittle as it ages, acrylics dry and harden quickly, but remain flexible and durable. Once dry, an acrylic painting on canvas can be rolled up, stored and restretched years later, with no danger of the paint surface cracking. Another advantage of acrylics is that all colours dry at the same rate – unlike oil paints.

Student-quality acrylic paints

▶ SEE ALSO
▶ Oil paints 64
▶ Pigments 92
▶ Mediums 76
▶ Brushes and knives 120
▶ Palettes 84

• Acrylics and water
Acrylics are water-soluble when wet, which means no solvents are needed for diluting the paint or for cleaning the brushes and palettes. Once it is dry, however, an acrylic painting is completely waterproof – this is useful when working outdoors, when there is always the risk of a sudden shower.

• Rapid drying
Acrylics dry rapidly and, because they dry insoluble, successive layers can be overpainted without danger of lifting the colour beneath. This is a great advantage when using techniques such as glazing, scumbling and drybrush.

• Versatility
Acrylic is a highly versatile paint. Use it opaquely or diluted with water and/or medium for transparent washes. In addition to the more traditional techniques, it is ideal for mixed-media work, collage and textural effects, and can be diluted and used with an airbrush.

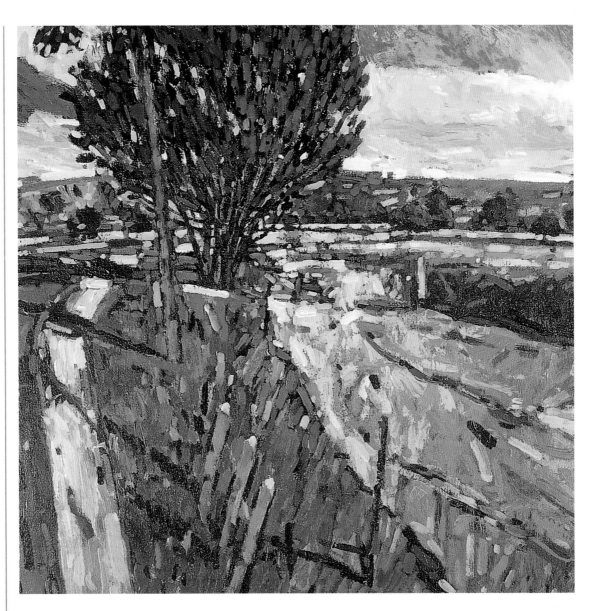

Disadvantages

'The advantage of acrylic paint is that it dries quickly, but it has one disadvantage – which is that it dries quickly.' This wry joke neatly sums up the dilemma that is presented by acrylics to artists – their fast drying time has advantages over slower-drying oil paints, but there are also a few drawbacks. For example, brushes must be kept in water when you are not actually painting with them, to prevent paint drying hard on the bristles. Paint also dries out quickly on the palette unless it is sprayed with water at regular intervals, or you use a special palette developed for use with acrylics.

The rapid drying time also means that the paint cannot be manipulated extensively on the support for a relatively long period, as is possible with oils. This is only a drawback if you like to work slowly, using smooth blending techniques; most artists, however, choose acrylics because they enjoy being able to apply layers of colour in rapid succession, without disturbing the underlayers.

Terence Clarke
Castlemorton Common
Acrylic on canvas
90 x 90cm (36 x 36in)

Terence Clarke exploits the vibrancy and intense hues of acrylic paints. The fast-drying qualities of acrylics allow him to build up the body of paint quickly, using thin washes and glazes. Even with a restricted palette of only five colours, plus white and pure black, he is able to achieve a vibrant, stained-glass effect.

111

Acrylic paints *(continued)*

Colours

The range of acrylic colours is slightly restricted compared to that of oils or watercolours, because certain pigments, such as alizarin crimson and viridian, do not mix readily with the resin binder, and tend to curdle. In such cases, an alternative pigment is used. The range of colours and colour names varies widely from one brand to another.

Buying acrylics in tubes
All acrylic colours are available in tubes, but the largest sizes are limited to the black and white ranges.

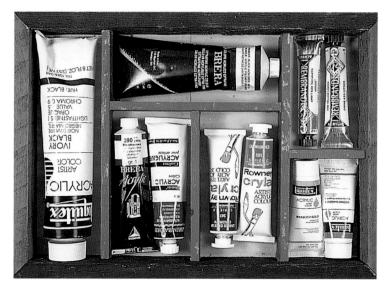

Removing acrylic paint
Because acrylic paint is water-based, it is easy to wipe up spills and splashes when wet. Once dry, however, it is difficult to remove, especially from fabrics. It is therefore advisable to wear old clothes when painting, and to protect surrounding floors and furniture. Keep a damp cloth handy, in case of accidents.

• Mixing brands
Since each manufacturer uses a different chemical formula for making their paints, it is wise to stick to the range of a single brand of acrylics. If not, problems, such as curdling when mixing, insufficient adhesion and colour changes on drying, may arise. Only acrylic paints based on the same sort of binder and of the same quality should be used in combination.

Tube colour

The thickness of tube paint varies from brand to brand, but in general it has a soft, buttery consistency which is similar to that of oil paints. It retains the mark of the knife or brush, and is excellent for impasto techniques. Most colours are available in tube sizes ranging from approximately 22ml (0.75 US fl.oz) to approximately 200ml (6.6 US fl.oz).

Jar colour

Jar-acrylic colours
Their fluid consistency makes jar acrylics ideal for creating large-scale paintings. You can buy an extensive range of colours in all sizes.

Smoother and more fluid than tube colour, jar colour is easily thinned with water and/or medium. This makes it ideal for watercolour techniques and for covering large areas of flat colour. The colours dry to a smooth, even film, slightly more matt than tube colour. The paint comes in wide-top tubs and jars or plastic bottles with nozzles ranging in capacity from 59ml (2 US fl.oz) up to 946ml (31.5 US fl.oz); note that titanium white and Mars black are also available in 3.79 litre (1 US gallon) containers.

• Care of paint tubes
At the end of a painting session, it is worth making the effort to wipe all tube caps and screw heads with a damp cloth before replacing the caps. Encrusted paint builds up and will prevent the cap going on properly, allowing air into the tube, and the paint quickly dries out. Dried paint also makes it difficult to remove the cap next time you paint. If tube caps stick, you can usually loosen them by running them under hot water. Never leave the lids or caps off containers, as the paint will dry rock-hard within hours.

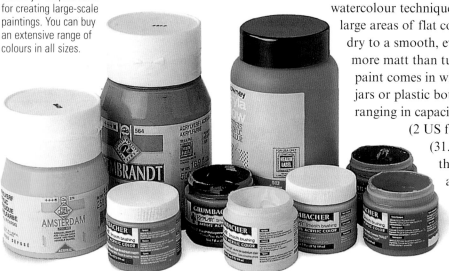

Colour charts
The manufacturers' hand-painted colour charts are the best source of information on the range and permanence of commercially made colours; the charts made with printers' inks are not as accurate.

• Acrylic drying times
Most neat acrylic paint applied thinly will dry in about 15 minutes, while thick layers of impasto may take more than a day before all the water has evaporated. In warm, humid conditions the paint will take a little longer to dry, and in hot, dry conditions it will dry more rapidly.

• Extending drying time
If the rapid drying of acrylics is a problem for you, there are a few solutions: add a little retarding medium to the paint, to keep it workable for longer; you can use a plantsprayer to spray a fine mist of water over the painting from time to time; or seal absorbent surfaces, such as paper and raw canvas, with matt medium before painting.

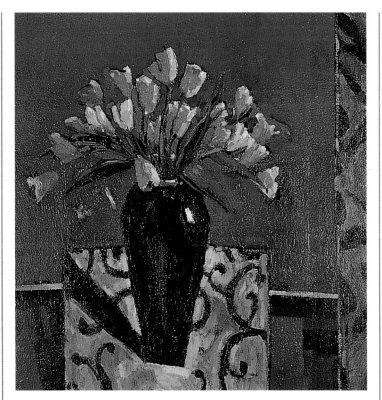

Terence Clarke
The Blue Wall
Acrylic on canvas
90 x 90cm (36 x 36in)

Because the artist's working methods call for quite large quantities of paint, he prefers to use acrylics that are supplied in jars for economy and convenience, as well as for their fast-drying and smooth-flowing characteristics.

Liquid acrylics
Liquid acrylics flow readily from the brush and are similar to brilliant drawing inks – but whereas many coloured inks fade on exposure to light, most liquid acrylics are permanent. They are supplied in bottles with dropper caps, and are suitable for wash techniques and fine-pen work. Liquid acrylics are made with an alkali-base resin, and they can be removed using an alkali cleaner.

Mixing colours
Try to limit all mixtures to just two or three colours, to avoid muddied hues. Avoid mixing them too thoroughly – as soon as the colour looks right, stop. While the resin binder still contains water it is 'milky' in colour, so acrylic colours appear slightly lighter and more subdued in shade when they are wet than they do when dry. As the paint dries the binder will become transparent, so the colours will dry with a slightly deeper shade and full brilliance.

Supports
Acrylics can be used on a wide range of supports: paper, board, canvas, wood, metal, and even exterior walls. There is one important thing to remember, however, when you are choosing a painting surface: acrylics will not adhere to any surface which contains oil or wax. This fact rules out all canvas or board which has been prepared for oil paint, so check with your retailer that the canvas or board you buy has been prepared with acrylic primer and not oil-based primer.

Liquid-acrylic bottles

▶ **SEE ALSO**
▶ **Supports 13**
▶ **Mediums for acrylics 118**
▶ **Mixing colours 220**

Basic acrylics palette

The ASTM (American Society for Testing and Materials) codes for lightfastness:

ASTM I - excellent lightfastness	
ASTM II - very good lightfastness	
ASTM III - not sufficiently lightfast	

The selection of a palette of acrylic colours is largely a matter of personal preference, but often the initial temptation is to buy too many tubes. However, it is better to begin with a limited range of colours, adding to these gradually as your needs arise from experience. A broad spectrum of hues can be mixed from the colours that are shown below.

Starter palette

Cadmium red
Permanence excellent (ASTM I).
An opaque colour with a very pure, bright, warm-red hue and strong tinting strength.

Permanent rose
Permanence excellent (ASTM I).
A very transparent colour with a bright, pinkish-red, violet-tinged hue and very strong tinting strength. Mixes well with blues to make clear purples.

Yellow ochre
Permanence excellent (ASTM I).
A semi-opaque colour with a soft, tan yellow hue and weak tinting strength. This is an indispensable colour for use in landscapes and portraits.

Cadmium yellow pale
Permanence excellent (ASTM I).
A fairly opaque colour with a strong, sunny-yellow hue and strong tinting strength. Makes strong greens and oranges when mixed with blue and red colours respectively.

Phthalocyanine blue
Permanence excellent (ASTM I).
A transparent colour with a cold, vivid blue hue, a green undertone and very strong tinting strength. A very strong colour, for sparing use in mixes.

Ultramarine blue
Permanence excellent (ASTM I).
A transparent colour with a deep, warm blue hue and strong tinting strength. The most versatile of the blues.

Burnt umber
Permanence excellent (ASTM I).
A fairly opaque colour with a rich, warm brown hue and good tinting strength. Mixes well to produce a range of rich tones.

Titanium white
Permanence excellent (ASTM I).
A very opaque colour with a bright, pure white hue and strong tinting strength. The only available acrylic white.

Speciality colours

Jacquie Turner
San Francisco from Coit Tower
Acrylic on paper
107.5 x 140cm (43 x 56in)

In order to successfully capture the dazzle of light reflecting off the glass-and-metal structures in this modern cityscape, the artist has used a range of pearlescent and metallic acrylic colours in combination with the conventional tube and jar paints.

An ever-increasing range of shimmering and metallic acrylic colours is now available from some companies, with decorative techniques in mind as well as fine-art applications.

Colour range

These pigments, known variously as iridescent, pearlescent, or 'interference' colours, are available in orange, red, blue, green, violet and gold, and are all durable. Made from titanium-coated mica flakes, they have a glittery appearance which changes according to the way in which the light falls on a painting, or the angle at which it is viewed.

Fluorescent colours

These absorb ultraviolet light and emit visible light of a longer wavelength. As a result, they appear to fluoresce or glow. The effect, however, fades rather rapidly as the dyes are not stable. Fluorescent colours are not recommended for permanent painting.

• PVA colours

Polyvinyl-acetate paints are a less expensive alternative to acrylic paints, but the pigment is bound by a vinyl emulsion, so they tend to be inferior to real acrylics in quality and lightfastness. Although they are ideal for use in schools, avoid PVA colours if you are concerned about the longevity of your work.

Iridescent colours

The iridescents may be used singly, or combined with regular acrylic colours to produce luminous surface qualities. They are used to best effect on a dark background, especially black. Also available are iridescent mediums, which can be mixed into any of the ordinary colours to pearlize them. When applied to a white surface or over light colours, they 'refract' their complementary colour: interference green, for example, refracts red.

▶ **SEE ALSO**
▶ **Mediums for acrylics 118**
▶ **Mixing colours 220**

Chroma colour

Chroma colour is a relatively new type of water-based paint – a development of the animation cell paint which is used for colouring cartoon films. Based on a superior type of acrylic resin, the paint can be used in the same way as acrylics – and watercolour, gouache, oils and ink – but with certain additional benefits.

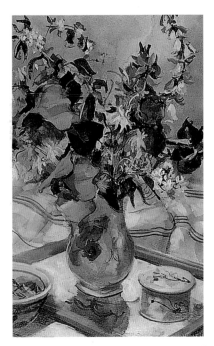

Sue Wales
Iris and Foxgloves
Chroma colour on paper
52.5 x 35cm (21 x 14in)

Originally a watercolourist, Sue Wales uses heavily diluted Chroma colour in the classic wet-in-wet technique. The bold washes are enhanced by the strength of the colours, which dry to the same shade as when they were applied.

Versatility

Chroma colour is similar to acrylic paint in that it is fast-drying, thins with water, and becomes waterproof when dry. The colours may be used directly from the container or diluted with water. They may be applied using any technique on virtually any support, with a brush, dip pen, painting knife or airbrush, in any thickness, from a heavy impasto to the lightest wash.

Using chroma

Chroma as acrylic

Tube colours have a smooth, buttery texture which is similar to that of acrylic paints, and can be used in the same way. They do, however, dry a little more slowly than acrylics, which can be an advantage. Because of their higher pigment loading, the colours tend to be stronger and more vivid, even when thinly diluted, and the tone values do not change as the paint dries.

Chroma as gouache

Used straight from the tube or pot, Chroma is similar to gouache, in that it is highly opaque and dries to a velvety, matt finish. Unlike gouache paints, however, where not all colours are lightfast, Chroma colours do not fade. Another advantage that Chroma has over gouache is that it dries to a waterproof state, so overpainting can be achieved without the risk of colour pick-up.

Chroma as ink

By adding water to pot or tube colours, Chroma can be used in the same way as a coloured ink; the effect can be either opaque or transparent, according to the degree of dilution and the end result required.

Chroma as watercolour

When it is diluted even further than for ink effects, Chroma colour will produce subtle, translucent washes which, unlike traditional watercolour washes, do not fade appreciably on drying. Chroma colours dry insoluble, so it is possible for the artist to lay wash over wash without any danger of previous applications being disturbed. Once dry, however, Chroma colours cannot be lifted out to create highlights, as is the case with watercolour paints.

Mediums
Chroma colours are supported by a range of mediums: a gel thickener for heavy impasto work, a retarder to extend drying times, and a gloss medium to give the paint a glossy sheen and increase its transparency when applying glazes. A gesso primer and matt and gloss varnishes are also available.

Chroma pots and tube

► **SEE ALSO**
► **Supports 13**
► **Drawing inks 56**
► **Brushes and knives 120**
► **Oil techniques 162**
► **Watercolour techniques 180**
► **Acrylic techniques 202**
► **The language of colour 214**

Edwin Cripps
Irises
Chroma colour on canvas
90 x 120cm (36 x 48in)

In contrast to the watercolour method (see opposite), this large painting approaches a similar subject using a technique associated with oils. The artist painted the entire canvas black before underpainting the shapes in white; he then built up layers of glazes and used neat colour to provide the final surface. The result glows against the background, and stands out with startling intensity.

Pigments

The level of pigment loading is higher than is typically found in other water-based media, giving Chroma colours greater tinting strength and opacity. Currently, there are 80 colours in the range, all of which are non-toxic and completely lightfast.

Dilution

Chroma is capable of massive dilution: the colours retain their vibrancy and strength, even at 1 part paint to 500 parts water. The paints are highly concentrated, which makes them very economical to use. Only a small amount of colour is needed to produce a large amount of wash; when used as a watercolour, it is necessary to dilute up to seven times more than with traditional watercolours in order to achieve a wash of comparable strength.

Pots and tubes

The paint is supplied in two formulations: as a thick liquid in 50ml (1.66 US fl.oz) pots, and as a gel paste in 50ml (1.66 US fl.oz) tubes. The liquid type is the better for wash techniques, as very small amounts of colour can be dispensed from the nozzle. Tube colour is more suitable for thick applications and heavy impastos.

Mediums for acrylics

Acrylics dry to a flat, eggshell finish. However, some mediums can be added to the acrylic paint, in order to produce a range of consistencies and finishes and to give the colours brilliance and depth. A medium will help thinly diluted paint to maintain its adhesion and improve its flow and 'brushability'. Some mediums can be used to control the paint's drying rate.

Gloss medium
Acrylic gloss medium makes paint thinner and more fluid, and it enhances colour luminosity. It also makes paint more transparent, allowing thin glazes to be built up and producing colours of exceptional depth and brilliance. The surface dries to a soft sheen.

Matt medium
This is gloss medium with the addition of a matting agent such as wax emulsion or silica. Used in the same way as gloss, it dries to a matt, non-reflective finish. Blend equal parts of gloss and matt mediums for a semi-gloss effect.

Gel medium
This paste-like substance thickens paint for prominent, textured brushstrokes and for impasto effects. It is used for collage work, as it increases the adhesive qualities of paint.

Barry Atherton
Italianate Vase
Acrylic gesso, pastel and gold and silver leaf on wood panel
132.5 x 102.5cm (53 x 41 in)
New Academy Gallery, London

This rich, decorative image was produced by a complex technique. Barry Atherton pasted a sheet of handmade paper onto a wood panel with acrylic adhesive. He mixed powdered pigment into acrylic gesso to colour it, and then applied the mixture to the support using brushes and knives. Gold and silver leaf were laid on top of the slightly textured, low-relief surface, and pastel was added.

Mediums and paint
There are no special rules governing the use of acrylic mediums, unlike oils, where each paint layer must be more flexible than the one beneath. Acrylic paints and mediums are manufactured with the same emulsion base, so they dry at the same rate, and there is no danger of the paint cracking.

Add mediums to paint a little at a time, and mix well with a palette knife. You can further dilute the paint with some water. Always mix colours before adding a medium.

• Mediums as varnish
Don't use gloss or matt mediums as a varnish to protect your completed paintings. A layer of acrylic medium picks up as much dirt as paint, but cannot be removed for cleaning. Protect paintings with a removable varnish which can be replaced.

• Mediums and brushes
Acrylic mediums will dry rapidly, so keep brushes in a container of water when they are not in use, or they will become hard and unusable in a few minutes.

• Oil mediums and acrylics
Turpentine, white spirit, linseed oil, and other mediums and solvents for oil paints should never be added to acrylic paint.

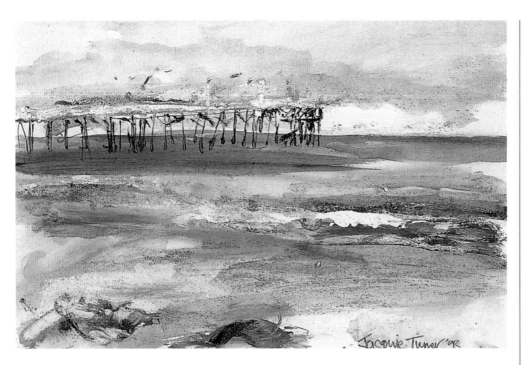

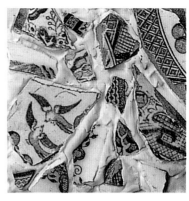

Ceramic shards pressed into texture paste

A mixture of sand and acrylic paint

Jacquie Turner
The Old Jetty, San Simeon
Acrylic on paper
75 x 105cm (30 x 42in)

For this sea-coast scene, Jacquie Turner mixed a little sand in with texture paste and paint, to provide an appropriately granular foreground. The sparkle of the waves is conveyed by small touches of silver-metallic paint.

• Mixing texture paste
Texture paste lightens the colour of paint, so allow for this when mixing your colours. Use neat texture paste only on rigid surfaces such as wood or board; on flexible surfaces, such as canvas, use a mixture of equal parts of texture paste and gel medium.

Texture paste

Texture, or modelling, paste is used for building up thick wedges of paint with a knife. It can be applied directly to a support, to build up a relief that can be sanded or carved when dry. Some pastes imitate the textures of stucco, sand or blended fibres. The paste can be mixed with colour, or allowed to dry before being painted over in thin glazes. Texture paste is ideal for collage work, as quite heavy objects can be embedded into it, and also for imprinting, in which forms are pressed into the paste and then removed, leaving an indented pattern. A gritty or granular surface can be produced by mixing inert substances, such as sand, sawdust or wood shavings, with the texture paste.

Apply the paste in layers no more than 6mm (¼in) thick, and allow each layer to dry before adding the next one. If the layers are too thick, the outside dries more quickly than the inside, resulting in a cracked surface.

Retarding medium

This reduces the drying time of acrylic paint, so you can move paint around on a surface and blend colours slowly and smoothly. It is available in liquid and gel forms; the latter holds more water, thus keeping the paint film open for longer. Mix the retarder in the ratio of 1 part to 6 for earth colours; 1 to 3 for other colours. Too much retarder makes paint sticky and unpleasant to use. Add a very small amount of water to increase fluidity.

Flow improver

Flow improver, or water-tension breaker, thins acrylic colours without reducing the colour's strength or affecting the finish of dried paint. It improves flow properties, allowing flat, even washes to be applied over large areas.

Iridescent tinting medium
This is a special-effects medium containing mica-coated flakes. When mixed with acrylic colours, it produces an iridescent quality.

Brushes and knives

All the brushes used for oil and watercolour painting – both natural-hair and synthetic fibre – are also suitable for use in acrylic painting. Decorators' brushes are inexpensive, come in a range of sizes, and are invaluable for blocking in large areas of colour.

Lay brushes in a shallow tray of water

Synthetic bristle brushes

Some manufacturers have developed synthetic-bristle paintbrushes specifically for acrylic painting (many artists also find them ideal for oils). These brushes are easy to clean, and are built to withstand the tough handling demanded by acrylics.

Care of brushes

Because acrylic paint dries so fast, you must take extra care of your brushes. Be sure to moisten them with water before loading them with acrylic paint, otherwise the paint will stick to the dry bristles and gradually build up to a hardened film that ruins them.

Do not leave your brushes soaking in a jar of water for long periods; the bristles will become distorted when resting on the bottom of the jar, and the lacquer paint on the handle will eventually flake off. Lay the brushes in a shallow tray of water, with the bristles resting in the water and the handles propped on the edge, clear of the water.

Knife painting

The buttery consistency of acrylics makes them appropriate for knife painting. Again, the same painting and palette knives used for oils are suitable for acrylics, provided they are made of stainless steel and not ordinary steel. Easy-to-clean plastic knives are also available with acrylics in mind.

• Cleaning solidified paint

If paint has solidified on your brush, try soaking it in methylated spirits for at least 12 hours and then working the paint out between your fingers. Thoroughly wash the brush with soap with some warm water.

• Using oil-paint brushes

Brushes previously used with oil paint must be carefully cleaned, to remove all traces of oil or turpentine from the bristles before being used with acrylics.

▶ SEE ALSO
▶ Oils brushes 78
▶ Oils knives 86
▶ Watercolour brushes 96

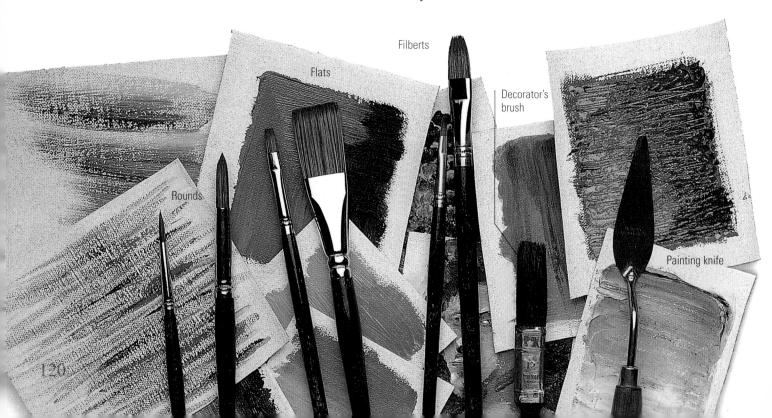

Filberts

Flats

Decorator's brush

Rounds

Painting knife

Palettes for acrylics

Wooden palettes, such as those used for oils, are not recommended for acrylic painting, as the paint gets into the porous surface of the wood and is difficult to remove.

Home-made palettes

Use a plastic palette, or make one yourself from a sheet of white melamine or perspex, an offcut of hardboard (Masonite) coated with acrylic primer, or a sheet of glass with white paper underneath. Many artists prefer these 'home-made' palettes because there is no restriction on size. Paper plates are also very useful, as they can be thrown away after use. When you are mixing very fluid washes, use disposable plastic containers, paper cups or metal bun trays.

Keeping palettes moist

Acrylic paints dry out rapidly on palettes, so keep them moist while in use by spraying them with water at intervals. Covering the palette with clingfilm will prevent paints drying out during a temporary break from painting. It is also a good idea to squeeze out only small amounts of paint at a time, to prevent wastage.

Special palettes

Special palettes have been developed for use with acrylic paint, which keep colours moist and workable, so that you are not constantly remixing colours and discarding dried paint. They work on the principle of osmosis, and consist of a lidded plastic tray which is lined with a sheet of absorbent paper and a sheet of membrane paper. In use, the absorbent paper is soaked with water and the sheet of membrane paper is laid on top. The colours are squeezed out onto the membrane paper and absorb moisture from the absorbent paper below, preventing them drying out.

Making a moist palette
This improvised palette is quick and inexpensive to make, and solves the problem of paints drying out. Line the bottom of a shallow plastic tray or aluminium baking tray with three or four damp sheets of blotting paper or paper towel. Cover the damp pad with a sheet of greaseproof paper, patting it down so that it has contact with the damp surface. Use the greaseproof paper as your palette. When the damp pad begins to dry out, remove the greaseproof paper and re-wet the absorbent paper. When you finish work, cover the palette with a sheet of clingfilm, and your acrylics will be ready for use the next day.

▶ **SEE ALSO**
▶ Oils palettes 84
▶ Watercolour palettes 100

Types of palette
Two commercial 'moist' palettes (left and centre) and an improvised palette, made with a sheet of glass over white paper (right).

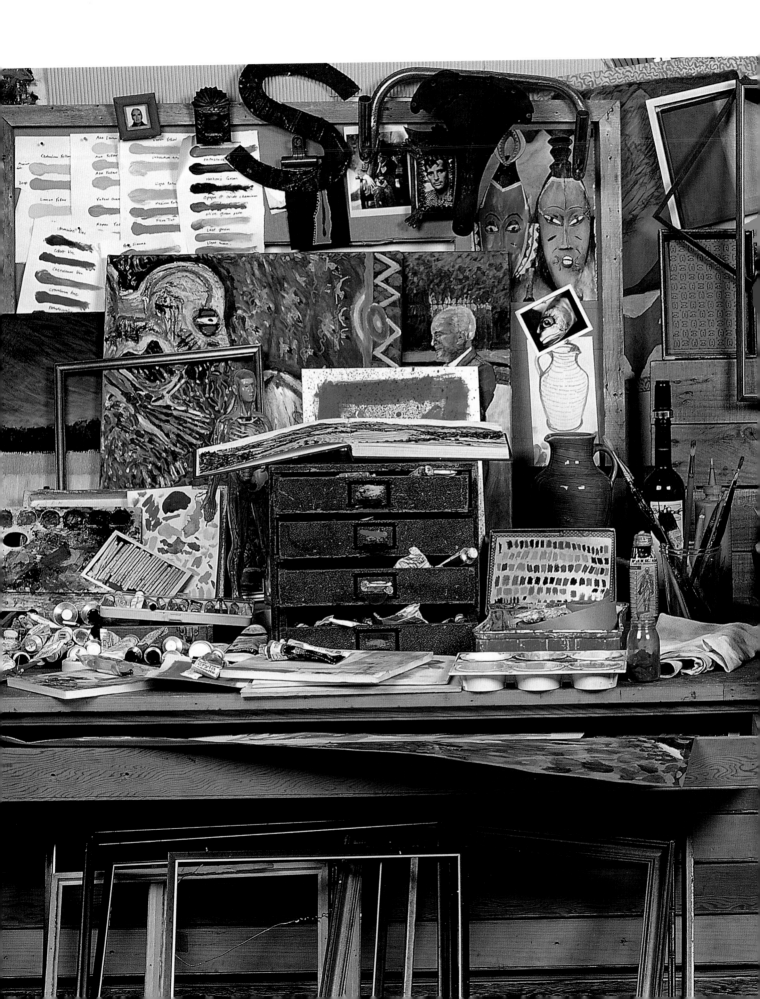

Chapter four

Where shall I start?

For many people, especially amateurs, how to start a painting and which subject to choose are the most difficult decisions to make. It is important that you choose a subject that is enjoyable and interesting, and that you let your own style and personality shine through. Painting is a wonderful way for you to be yourself, and it will also give you an opportunity to convey feeling and atmosphere. Do not be afraid of paint or colour. Artists' paints are quite expensive materials and you may well be reluctant to squander them – but many a potentially good amateur painting has been spoilt through lack of boldness in the application of paint. Experiment with a range of media and subjects to discover what you like.

Starting to paint

Where shall I start? A difficult question but an easy answer – you have taken the first step by picking up this book and leafing through the pages. Maybe you are returning to painting and have not picked up a paintbrush since leaving school, but have a warm memory of a rewarding and engaging pursuit. Or maybe you are an absolute beginner whose experience of landscape painting is to put blue at the top, brown in the middle, and green at the bottom.

Beginner painters

As an inexperienced painter, you will probably be among those people who find it difficult to begin a painting. However, there are plenty of instances where the the serious amateur or semi-professional artist, or even the full-time professional, will 'draw a blank' or have considerable difficulty in getting going. Indeed, getting going is often the hardest part of all. Making those first marks on a blank canvas can be a daunting prospect, even for a professional painter. If you feel daunted, you will not be alone.

Many artists have often remarked on the fact that there are no definitive rules in painting. This seems to be particularly true of getting started. There are all sorts of ways to begin a painting, but the desire to do so is the most important requirement – once you have made a start, you can pick the route you want to go down.

Professional advice

Among the words that kept cropping up during interviews with the professional artists who contributed to this book were expressions such as 'choices', 'freedom' and 'satisfaction'. These key words point to the fact that, although painting is not an easy process, it is an enjoyable and rewarding one. They also imply that there are a number of steps you can take to help you get started – and that, combined with perseverance, these steps will gradually lead towards a pleasing finished painting. Opposite and on the following pages you will find a variety of practical hints and suggestions for choosing subjects and how to start a painting.

Getting started

So, in order to get started, what should you do? From the outset, you should always try to avoid setting yourself up for disappointment. Choose a subject and a medium that you feel comfortable with, one that you feel you can handle. Don't try to run before you can walk – but by the same token don't be too timid or too 'tight' in your approach, or scared to try an unfamiliar medium.

Be bold and confident in your painting, and remember that it is your choice. You have decided to paint and what to paint; you are not in a competition, and you aren't under any pressure or under an obligation to anyone other than yourself. You alone can select your media and create your own personal style.

• Shine through

Choose a subject that is enjoyable and interesting. Be open-minded in your approach. Let the painting sometimes lead you – celebrate the accidental brushstroke, the chance blending of colours, the misplaced or quirkily drawn object. Painting is not photography; if you want to get an exact copy of a scene or an object, go out and buy a camera.

A blank canvas
Many people are influenced by an object, an idea, a photograph, a situation or scene, or something that just catches their eye. Even a dream or an experience can inspire a painting.

▶ **SEE ALSO**
▶ **Choosing your medium 128**
▶ **Gallery of art 356**
▶ **Resources and references 126**
▶ **Keeping a sketchbook 152**

First steps

Many painters like to start by making pencil or colour studies and sketches. Some make meticulous drawings and transfer them to canvas; some put in the simplest and most basic of drawn lines; some make a thin wash drawing with a brush; and others prefer to jump right in with brush and knife and pure neat colour. Shown right is a selection of photographs of the first steps taken in the creation of four paintings.

Charcoal drawing

Artist Ken Howard (see page 324) follows a traditional approach and makes a very simple yet measured charcoal drawing of the salient points before proceeding with a brush and laying in the dark areas (top row).

Brush drawing

Timothy Easton (see page 258) likes to make a fairly detailed neutral-colour brush drawing of the whole composition before he starts laying in the colours (second row). Valerie Wiffen (see page 318) starts with a water-soluble coloured pencil and quickly proceeds to simple brushwork, drawing in thin washes to lay in what she calls 'sightlines' (third row).

Pencil drawing

Pencil line tends to be the favoured drawing medium of many watercolourists – often drawn in lightly, and sometimes erased so that it is barely noticeable. Using a photographic reference, Kay Ohsten (see page 298) plots a light yet accurate pencil-line sketch to serve as the basis for her landscape painting (bottom row).

Charcoal

This is the preferred drawing material for plotting a painting on canvas. Its soft friable consistency glides over the grainy textile surface of canvas, making a strong positive line that responds instantly to the pressure applied and creating thick or fine lines. It has the merit of being fast and spontaneous, and is easily obliterated by opaque mediums such as oil and acrylic paints.

125

Resources and references

Artists are invariably avid collectors of what to the uninitiated eye is nothing short of junk. Accumulating anything and everything of interest is a fascinating and often amusing way to build an invaluable resource of objects for the still-life table. Both printed ephemera and reproductions can also inspire ideas for paintings and provide visual information that may be difficult to acquire first-hand. They also constitute a rich yet inexpensive source of material for collages.

Objets trouvés
Cheap to obtain and fun to collect, other people's junk makes fascinating subjects for still-life paintings.

Copying

In the world of art, 'copying' is a time-honoured way of learning to paint and draw. Traditionally, students were encouraged to make studies of what were known as 'antiques' – plaster casts of statues from antiquity, usually including Venus de Milo, Michelangelo's David and fragments of the Parthenon frieze.

Eventually students would progress to copying Old Masters in museums and galleries. In addition, a sound knowledge of human anatomy was required before pupils were allowed to set foot in the life room. In many ways, students sought to become accomplished artists by learning to see through other people's eyes.

▶ **SEE ALSO**
▶ Collage 208
▶ Composing from imagination 338

An organic theme
As shown, the human form features prominently in this selection of objects. We see an artist's full-figure manikin and hand, a plastic kit of the human body, and an acupuncturist's model. Together, they represent a convenient source of reference for figure drawing, obtainable at little cost. In the box there is a mummified frog which was found in a cellar, and a pigeon's skull retrieved from the garden.

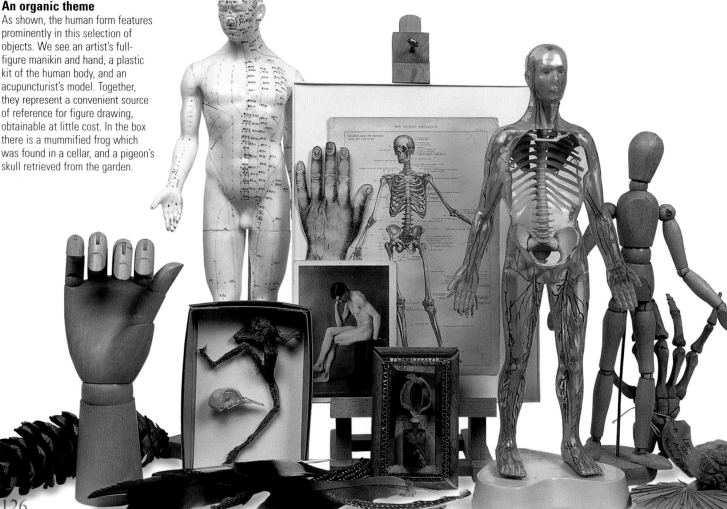

Personal exploration

Today these traditional approaches to teaching have mostly been superseded by a quest for free expression and personal exploration. However, whilst slavish copying is not recommended, it is always of value to see how other artists have tackled particular themes, and you may be able to pick up useful tips on methods and materials along the way. A lively interest in the world around you is essential grounding for good observational drawing and painting. Training yourself to see with an artist's eye will help you to develop an awareness of form, colour, texture and pattern, without putting brush to canvas.

Graphic ephemera
Dipping into a file of magazine cuttings, graphic ephemera and printed reproductions can often provide ideas and information for your paintings.

Looking for the unexpected
A trained eye can spot potential in unexceptional material. Inexpensive china and pottery can make a colourful theme for a still-life painting; and discarded shards that have no intrinsic value take on a new and surprisingly rich quality when viewed en masse.

127

Choosing your medium

Oil paints, brushes and frames

A selection of pastels

Oil paints and brushes

The seemingly infinite variety of styles and painting techniques stems not only from the immense diversity of the human race, but is also strongly influenced by the availability of a vast range of art materials. Within each medium, every colour has its own characteristics to be discovered and exploited; and when different binders are used, those colours take on quite different personalities. Here are some hints and tips on how to choose a painting medium that will suit you and the way you like to paint.

Your personality

The first thing to consider is you. Think about what it was that first attracted you to painting. Was it a particular painter's work? Or was it a strong desire to create images of things that give you pleasure? Choosing the medium used in pictures you like not only fuels your enthusiasm but will make it possible technically to achieve the result you are after.

Your temperament is also a consideration. If you are a careful, fastidious person who cannot be hurried, you'll probably find painting architectural studies in watercolour more appealing than, say, abstract expressionism, whereas a bubbly extravert may have an affinity for the latter.

Space and equipment

Personal circumstances are always a deciding factor in a person's choice of medium. Having a spare room or a warm shed to work in will probably avoid complaints from the family about the smell of oil paints or solvents, but unless the space is roomy you won't be able to paint large canvases. Bear in mind that you will need well-organized storage space, too.

Even though it will accommodate less equipment, some artists still prefer to work in a small studio because it gives them the excuse to dabble in private, only emerging when they feel confident enough to show their work. Others take pleasure in elaborate preparations before getting down to work – indeed, many a lovingly crafted home easel or palette has been produced without any sign of a single painting.

Perhaps you are the type of artist who is attracted to working outdoors. Without doubt, watercolour is the most easily portable medium – but with a little planning, even oils can be taken and used on location.

The cost of getting started

Surprisingly, cost is rarely a major priority. Even art students, who have little disposable income, will buy what they need for their paintings. But cost may be the deciding factor between one medium and another – and if you can get started for a small outlay, it means you have nothing to lose and all to gain.

Millilitre for millilitre, acrylics are the cheapest; but because watercolour goes further, it does not necessarily cost more in

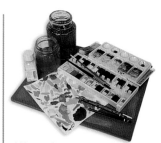

Watercolours

Acrylics

the end. When starting out, oil painting is the most expensive, because you need more accessories. Whatever medium you choose, buy just the quantities you are likely to use in a year or two. Although many colours will last decades or more, if you don't keep the caps scrupulously clean you'll find that the paint dries out. Larger volumes are for prolific users.

Different qualities

Generally, there are two qualities available within each medium: students' and artists'. Always buy the best-quality colours you can afford – they not only make painting more enjoyable, quicker and easier, but in some cases they are the only colours that will actually work with certain techniques.

Be enthusiastic

If you've been encouraged to join an art class or accompany a friend on a painting trip, it may be best to go with the flow and choose the medium that the other artists are using. This will get you started and make it easier to learn from your colleagues. You can always break out into other media later on.

Most important, don't be deterred by negative thoughts or criticism. Forget your schooldays, when someone else was always better than you. Now you have the opportunity to blossom, with a more mature approach and enthusiasm that may produce results you never thought possible.

Versatility
Acrylic paint is a relative newcomer that seems to be loved and despised in equal measure. Nevertheless, its versatility as a medium has to be acknowledged. It can be applied in thin veils of fluid colour, similar in appearance to watercolour, or as thick impasted brushwork that resembles oil paint. But acrylic paint behaves quite differently from the two more-traditional painting mediums – especially in that it dries very, very quickly.

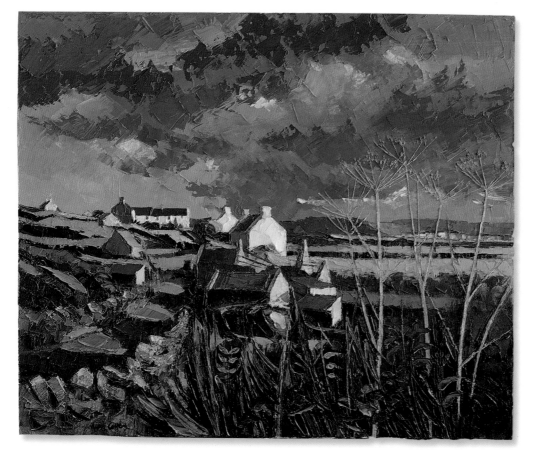

Alan Cotton
Co. Kerry Cottages at Ventry Harbour
Oil on canvas
76 x 91.5cm (30 x 36in)

Painting in various media
In this bold landscape painting, we see the application of an opaque buttery medium, in this case oils. The paint has distinct physical properties in the form of clearly defined knife marks and brush-strokes. Similar surface textures can be created using acrylic paint.

Watercolour

The most popular painting medium. Its great appeal is its immediacy – a small paintbox, a sheet of paper, a brush, and you're away. And you only require water for painting and cleaning up with, which also makes watercolour painting feel easy. Being compact and lightweight, watercolours are highly portable. You can paint on top of a mountain, or even on a bus. You need little storage space; a single portfolio will house dozens of paintings.

Watercolour does, however, have some hidden pitfalls, and it is a lot more difficult than it looks. You have to learn not to fiddle and overwork a painting, and to develop the knack of building it up without mistakes. Using the best paints makes it easier; and good-quality watercolour paper is vital, otherwise your colours will be flat and lifeless. Cheap, thin paper will cockle.

Although most watercolourists use both tubes and pans, they tend to favour tube colours because you can mix stronger colours more quickly and in larger quantities. However, pans are easier to carry around.

Acrylics

The second most popular medium is acrylic paint, primarily because it is so extraordinarily versatile. If you want to stick to just one range of paints, acrylics are for you. They can be applied straight from the tube, or diluted with water.

Unlike other painting media, acrylics are made in different consistencies. Generally there are two types available: tube colour and pot paint, also known as 'concentrated'. Tube colour has a soft paste-like consistency, similar to oil paint. By comparison, acrylic paint sold in pots is more fluid, but it is just as good in terms of colour strength.

Concentrated acrylics should not be confused with the lower-priced craft colours – which are likely to be less permanent, and have lower pigment strength and fewer artists' colours in the range.

Liquid acrylics are available, too. In actuality, these are inks that are most often used by artists for mixed-media techniques, rather than as a medium on their own.

Gouache

This type of paint was not available commercially until the 1930s. In the l9th century it was known as 'body colour' and was achieved by mixing Chinese White into other water-colours, to make them opaque. Body colour was used to give extra solidity and for highlights when painting watercolours, or to create paintings from solid colour.

Today the best-quality gouache is highly pigmented, giving dense, matt, opaque colours that flow well and dry without streaks. Gouache is popular with designers and illustrators, as strong, matt colours are most suitable for reproduction. Watercolourists tend to use Permanent White gouache for strong highlights. Gouache on coloured pastel paper is a popular combination among wildlife artists.

Oils

Oil paint is, without doubt, the professional's medium. Art galleries prefer oils to acrylics, and so do the general public. Its popularity amongst patrons can largely be attributed to its 500-year history, and the fact that the majority of famous pictures have been executed in oils. With painters, its appeal lies in its marvellous buttery consistency, its evocative smell and its versatility. Oils not only produce better glazes than any other paint medium, they also retain brush and knife marks exceptionally well.

Oil paint is not as difficult to handle as you might think. However, you will have to buy a number of accessories, and you need plenty of storage space for drying and keeping pictures. If you are well-organized, you can keep clutter to a minimum, but a lot of painters seem to get more paint on the carpet and doorknobs than on

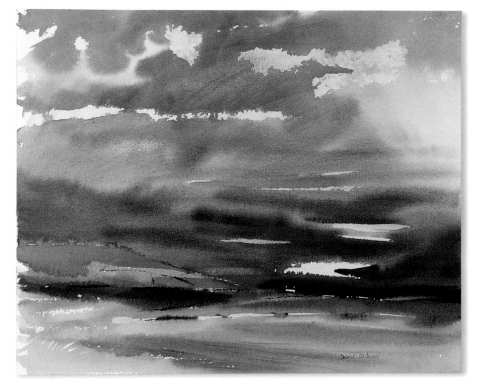

David Jackson
Towards Wastwater
Watercolour on paper
46 x 58.5cm (17 x 23in)

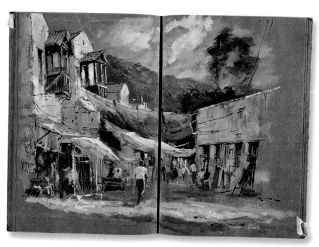

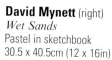

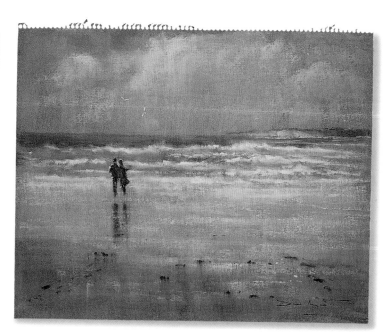

David Mynett (above)
Kalkan – Southern Turkey
Tempera on sketchbook pages
30.5 x 40.5cm (12 x 16in)

David Mynett (right)
Wet Sands
Pastel in sketchbook
30.5 x 40.5cm (12 x 16in)

the canvas. A word of warning for oil painters: don't ignore the technical rules. If you fail to follow the correct techniques, you can go badly wrong.

Water-mixable oil colours

The most exciting development since the emergence of acrylics in the 1960s has been water-mixable oil colours. Stringent regulations concerning the use of solvents had led to a decline in the use of oils in art schools. And as more people took up painting as a leisure activity, they too found oils less appealing because of the strong smell of white spirit and turpentine. Water-mixable oil colours were the answer. They have all the characteristics of traditional oils, but are both diluted and cleaned up with water.

Alkyds

These fast-drying oil colours are touch-dry within 18 to 24 hours instead of the usual 2 to 12 days. They are also more transparent than conventional oils, making them good for glazing, and perfect for painting outdoors.

Oil sticks

Oil colour can be blended with waxes to make solid painting sticks. They are wonderfully expressive, but are used up quickly if you paint large canvases. The best-quality oil sticks are superior to oil pastels, which have lower pigment strength and lower permanence.

Pastels

Although it is termed as a painting medium, the pastel technique is similar to drawing. Pastels are available in ranges comprising hundreds of pure colours. Large colour ranges are necessary because, unlike paints, pastels cannot be mixed to create secondary and tertiary colours.

Colours can be blended, however, either physically on the paper or by means of hatching. Pastels are opaque and they work best on coloured backgrounds, which tend to unify a picture and sometimes help to suggest a particular mood.

A disadvantage of pastel paintings is their dusty, fragile surface, which makes them difficult to store safely. This fragility is reduced by applying fixative – but do not apply fixative heavily, or the colour change will be too great.

The best way of storing pastel paintings is within picture mounts, which are an extra cost but prevent the finished paintings from rubbing against each other.

Soft pastels

The best pastels are soft and creamy, transferring just the right amount of colour to the paper. Larger pastels are preferable to the small-diameter sticks, because they break less easily and apply more colour with each stroke.

Hard pastels

Hard pastels are also available, though in more limited ranges. They are good for final definition and for applying highlights, and are particularly suited to linear work. The colours are less brilliant but have a firmer consistency.

Water-soluble pencils and crayons

Water-soluble pencil is yet another drawing medium that beginners sometimes find useful in bridging the gap between drawing and painting. However, the results are not the same as those that may be achieved by applying a conventional watercolour wash, and the quality of the pigments is not as high as those that are used for the best watercolours.

Thicker water-soluble crayons are also available, which are capable of producing broader marks and denser hatching, making them more of a painter's medium.

Organizing your studio

Every artist dreams of having a dedicated studio for his or her sole use, but that is not an essential requisite for good painting. You can work almost as well in a shared space, so long as there is room for you to leave your paints and materials set out ready for you to resume work when the mood strikes you. With a little planning, it is easy to provide a practical solution to meet your needs, but a studio should be stimulating as well as efficient – and for that, you need to stamp your own personality on the place.

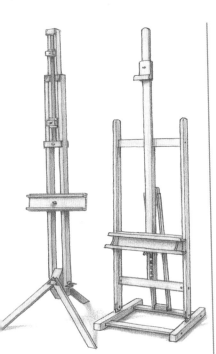

Radial easel Heavy-duty studio easel

Studio easels

If you plan to produce large paintings, you will want to buy a floor-standing studio easel. Heavy-duty easels, usually made from wood, have a strong base frame. Less expensive versions, in wood or aluminium, have tripod legs. All easels are adjustable in height and angle, so that you are able to sit or stand while you paint. If you work from a wheelchair, tripod designs allow you to get closer to the painting. To avoid throwing your shadow across the work, set up the easel so that the light source is to one side and over your shoulder.

Daylight-simulation bulb

• Water supply

Make sure there is a sink close by, or have one fitted in your studio.

▶ SEE ALSO
▶ Canvas 14
▶ Resources and references 126

Artificial lighting

Good lighting is essential to prevent eyestrain and to render colours accurately. When levels of natural light are low, you need good artificial lighting, preferably ceiling-mounted fluorescent lamps fitted with blue-tinted daylight tubes. To provide an even spread of light and avoid any problems with shadows, install at least two fluorescent fittings. For table-top work, use an adjustable lamp, also fitted with a daylight bulb.

Natural lighting

Natural light from a large north-facing window is ideal (south-facing in the Southern Hemisphere), since it will provide even, neutral-coloured illumination that remains constant throughout the day.

Workstations

If you don't like to work flat on a table, support your paintings on a table-top easel. Made from wood or metal, this type of easel can be adjusted to different angles and folded flat for storage.

Most artists set out their painting materials on the worktable. But a mobile storage box or trolley may be more convenient, since you can move it from table to studio easel.

Storing materials and paintings

Ideally, works on paper should always be laid flat in a plan chest or, if space is limited, stored in a strong portfolio. For added protection, interleave your work with acid-free tissue paper. A bank of shallow wall-hung shelves is useful for storing reference books, props, boxed materials, storage pots for brushes, even wet canvases. Store your stretched canvases in a partitioned rack mounted on castors. If there is room, you can park the rack under your worktable.

Plan chest

All-purpose studio (opposite)

A well-equipped studio can be installed relatively cheaply in a spare room or small outbuilding. Your first requirement is a dry, adequately heated space that is light and airy. Since it is practically impossible to paint without creating a mess, it pays to make surfaces easy to clean. Plain white-painted walls will make the most of available light, and can be washed down when necessary. Choose a smooth floorcovering such as sheet vinyl or tiles, or sealed strip-wood flooring. Have a sink installed, or make sure there is a water supply close by. Get a large bin for waste, and put flammable rags in a metal bin with a tightly fitting lid.

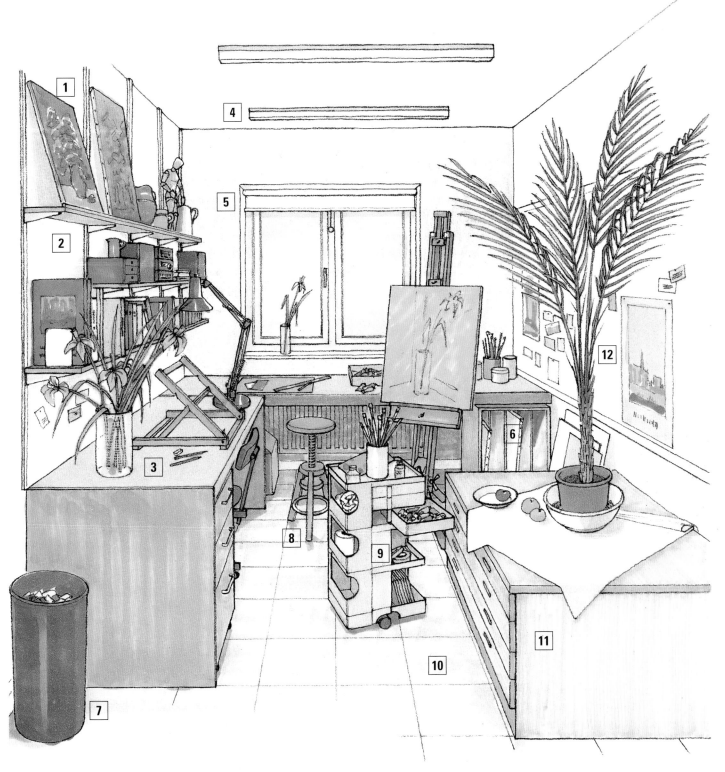

1 Work in progress
To support half-finished paintings, fix a wooden stop bead to the front of a shallow shelf.

2 Shelving
Use adjustable wall-hung shelving for general storage.

3 Worksurfaces
You need plenty of worksurfaces for laying out your work and materials, and for tasks such as cutting paper to size.

4 Artificial light
Install overhead fluorescent lights for overall illumination, and a desk lamp with a daylight bulb for close work.

5 Daylight
If your studio hasn't got a north-facing window, fit a fine-fabric roller blind to diffuse harsh daylight.

6 Canvas storage
Provide a partitioned rack for stretched canvases.

7 Waste disposal
Have a large bin handy for safe studio waste.

8 Seating
If you don't want to stand at your easel, provide an adjustable stool. You will need a comfortable chair when working at a table.

9 Mobile storage
Use a mobile trolley to place your paints and equipment close to hand.

10 Flooring
Lay easy-clean floorcovering, such as sheet vinyl or tiles, or install sealed strip-wood flooring.

11 Plan chest
Provides long-term storage for artwork. Also doubles as a valuable worktop.

12 Pinboard
Serves as a temporary exhibition and viewing area, and is useful for displaying references and ephemera.

Painting outdoors

Many inexperienced artists are reluctant to work in public; but once they have overcome their initial shyness, they discover the exhilaration that comes from painting directly from nature. The challenges that are presented by the weather and fleeting light may force you to develop the ability to work quickly, and you may have to put up with a little discomfort – but it's the sights, sounds and smells of the living landscape that give outdoor painting its singular vitality.

Making a start

Many artists like to record their initial impressions on location, then finish the painting at home. Others like to paint in the studio, using preparatory sketch drawings and colour notes taken on the spot. Although some prefer to work from photographic references, especially as an aid to composition, very few painters rely on photographs for accurate colour rendering.

Choosing your medium

It's always tempting to carry more equipment than you need – but once you have made a few forays into the countryside carrying a loaded rucksack, you will soon learn to keep your kit to the bare minimum.

Watercolours and acrylics have obvious advantages. Both dry relatively quickly and need only water as a diluent. Unless you want to work on relatively large paintings, a portable watercolour box containing small pans is marginally more convenient than tubes of paint. Some boxes also include storage for water; if not, carry a plastic water bottle to save weight. For expediency, use small tubes of acrylic paint, and buy a stay-wet palette to help keep the paint moist. Cover the palette with clingfilm before carrying it home.

A pochade contains all the equipment you will need for oil painting, including a palette. To save cleaning your palette, cover it with clingfilm before you start work; you can then peel it off afterwards and throw it away. Alternatively, you could use a disposable paper palette.

Personal considerations

For long sittings, you will need to protect yourself from the elements, whether it's hot sun or winds, cold and rain.

In summer, wear a broad-brim hat and a long-sleeved shirt, or protect your skin with high-factor sunscreen cream. It's also a good idea to keep insect repellent in your bag. A sunshade will help keep you cool and protect your painting from glare. If you plan to work outside for the whole day, remember to take a picnic lunch and plenty to drink.

In winter, wrap up warmly and wear stout waterproof footwear. To keep your hands warm but maintain your sense of touch, wear some fingerless gloves.

Oil painter's pochade box

Traditional watercolour box designed to be portable

Handy watercolour box with integral water flask

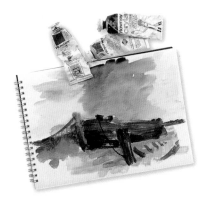

Working on location
Before leaving home, make sure you have everything you need for a day's painting. Having found your spot and settled down to paint, there is nothing worse than discovering that you have forgotten an essential item of equipment.

Choosing an easel

If you prefer to work standing up, use an adjustable easel. A sketching easel is easy to carry, but you may have to stake the legs to the ground on windy days. A box easel is a sturdier portable platform. It combines a tripod easel with a carrying case for your paints, palette and small canvases. The pull-out drawer is convenient for supporting your palette.

Sketchbooks and drawing boards

A hand-held sketchbook will not need any support, but you could utilize a small office clipboard to carry separate sheets of paper. Buy a lightweight folding table from a camping-equipment supplier if you prefer to work flat.

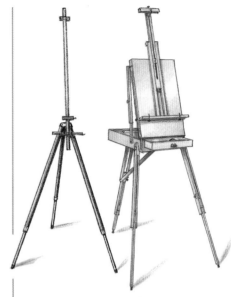

Sketching easel Box easel

Optimum size
Don't be too ambitious when painting outdoors. Limit the size of your work to about 38 x 50cm (15 x 20in), otherwise your canvas may be awkward to carry and could become unstable, especially in breezy conditions.

Double-pointed canvas pins

Wet canvases
To transport wet canvases insert a double-pointed canvas pin at each corner, and use another stretched canvas to protect a wet oil painting.

Working standing up
Holding larger drawing boards is tiring. Attach a canvas or leather strap to two corners of your board, and take the weight on your shoulder.

Folding stool
A compact folding stool allows you to work in reasonable comfort. Some backpacks are made to carry a folding canvas stool.

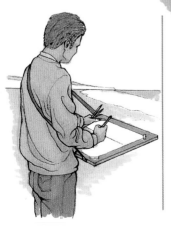

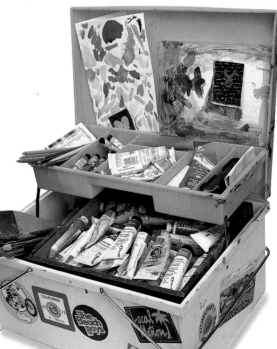

A portable studio
Many outdoor painters transport their equipment in large soft bags or haversacks (above); but a compartmentalized toolbox or art box (right), with lift-out or hinged trays, is ideal for carrying all those loose materials that are easily mislaid outdoors. Choose a lightweight plastic box, but make sure it has strong carrying handles.

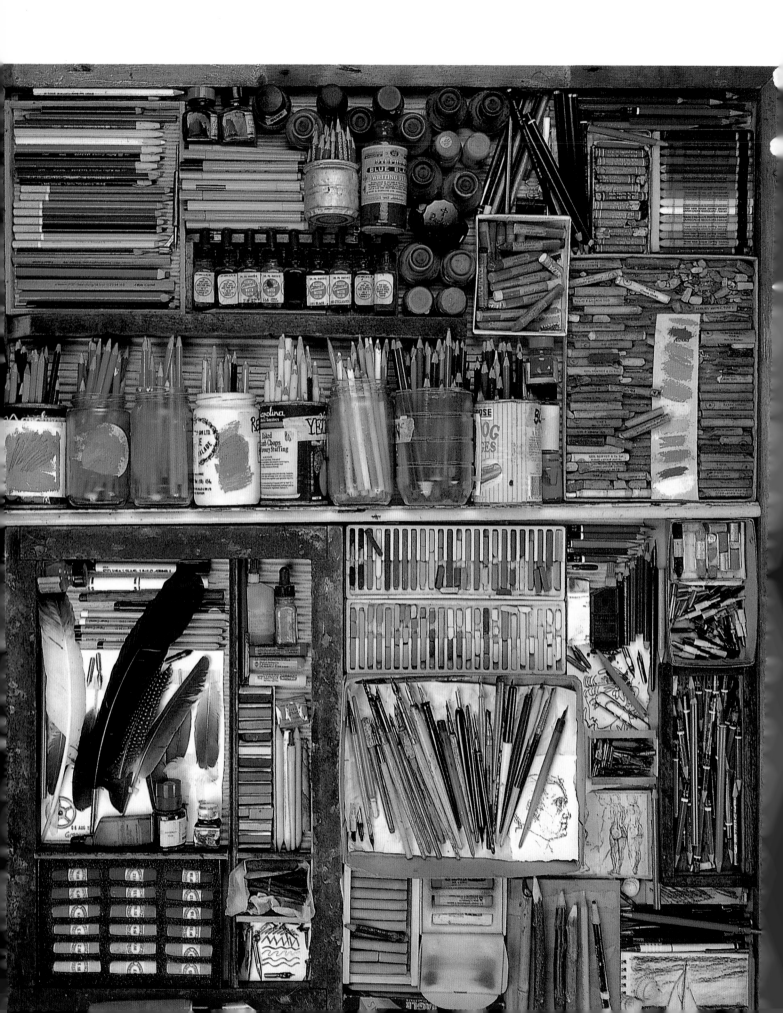

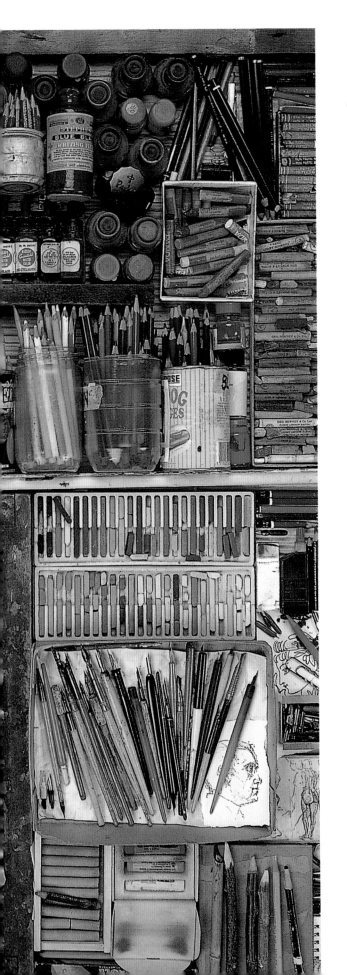

Drawing and sketching

Manual dexterity and technical know-how are meaningless if an artist's work is deficient in thought and feeling. Along with the learning hand, one must develop a seeing eye – and for most people, this is the most difficult part. In the desire to produce a 'finished' picture, the impatient student often overlooks the two things that are fundamental to all art: drawing and observation. It is vital to train your eyes by really looking at the world around you, and to keep sketching and drawing all the time. When you draw what you see, you develop your powers of observation and analysis, and in turn your skill as an artist.

Drawing and observation

Drawing is a form of language, and is a learnable skill. Just as writing is made up of letters that make words that make sentences, so drawing starts with points that make lines that make shapes. Add light and shade to make three-dimensional shapes, and we start to compose – making shapes fit together in space.

A firm foundation

There are many reasons for practising drawing. To begin with, it is a source of much pleasure and satisfaction; and it also heightens our awareness, helping us to see colours and shapes anew. Most importantly, drawing is an excellent foundation for learning to paint. Indeed, if we rush headlong into painting without first developing drawing skills, our efforts are more likely to end in frustration.

Enjoy and improve

Fear of failure is the thing that prevents many from learning to draw. But if you can ignore that little critical voice in your head that spoils the fun of drawing, you will begin to draw with ease, spontaneity and freedom.

Accepting limitations

The main thing is not to regard each drawing as a finished thing in itself. Accept the fact that, to begin with, many of your drawings will be failures, and just enjoy the sheer pleasure of the drawing process.

'*Draw lines, many lines, from memory or nature; it is by this that you will become a good artist.*'
Jean-Auguste-Dominique Ingres (1780–1867)

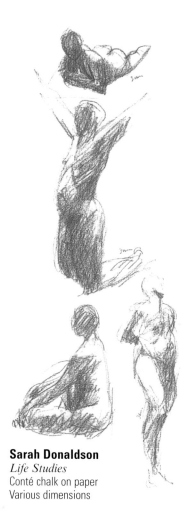

Sarah Donaldson
Life Studies
Conté chalk on paper
Various dimensions

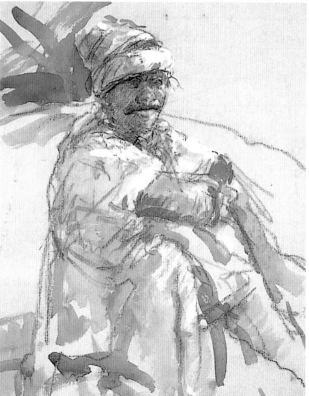

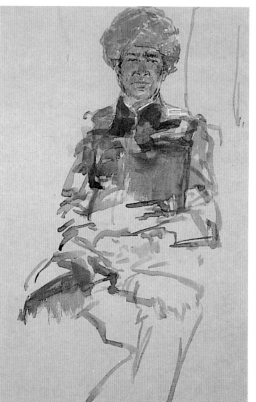

Little and often

Drawing is like physical exercise; short sessions at regular intervals are of more benefit than a prolonged session every now and again. Even if you only have the time to draw for ten minutes a day, you will be amazed at how quickly your skills and observation improve.

Tom Coates
Figure and Portrait Studies (details)
Pencil and wash on paper

138

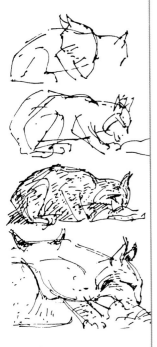

Using a pen

It is very good discipline to practise drawing with a pen as well as with a pencil, so that when you make a mark you don't subconsciously think that you can rub it out if it's not right. With a pen you are forced to make a committed statement, and if it is wrong you have to make another one next to it – and you still have the marks that were wrong to compare with. In fact, you are more likely to get it right first time, because you tend to look properly and question what you are doing before you make a mark.

Communication

Making a drawing is first about communication with yourself. When you look at an object, no matter how interesting, you only see it to a certain degree, whereas if you make a drawing from that object – even if you can't draw well – you will gain a much deeper understanding of what you see. The eye feeds the information to the brain, which analyzes it and feeds it to the hand, and the hand makes the mark that expresses your emotional reaction to what you see, and ultimately communicates it to others.

Restarting

In a wry remark about life in general, someone once observed, 'Everybody makes mistakes. That's why they put those little erasers on the ends of pencils.' When it comes to line drawing, however, an eraser can be a dangerous thing. If you draw in pencil, it is all too easy to erase an inaccurate line, only to redraw it in exactly the same position; you may spend so much time correcting that you stop looking at your subject and never get it right.

Mistakes

When mistakes occur, don't be afraid to leave them in and draw more accurate lines alongside. In other words, restate the lines. Drawing is a vital, changing process, a voyage of discovery. Feeling out forms and composition, adjusting and correcting, are vital elements in this process. On many master drawings, corrections and restatements are deliberately left evident, because they add to the vitality of the drawing; these are known as 'pentimenti'.

Retaining corrections

Think of each drawing as a battlefield, in which you are going to solve problems and learn something about the process of seeing. In fact, when you are learning to draw, your drawing should look like a battlefield, with mistakes and restatements visible. If your work is too perfect, with no corrections showing, you haven't been questioning what you are doing, and the result may be lifeless.

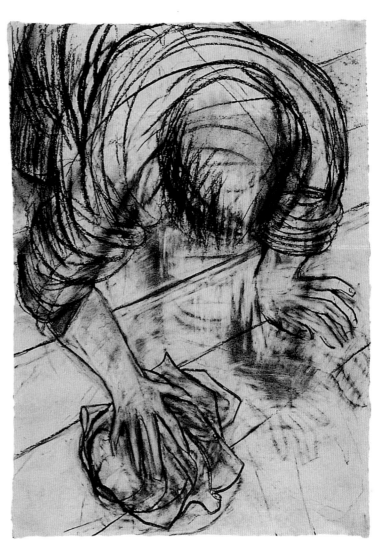

Sarah Cawkwell
Figure Cleaning
Charcoal on paper
75 x 55cm (30 x 22in)

139

Figure drawing

Representing the human figure is one of the most challenging of artistic disciplines, as well as the most fascinating. In addition to individual studies, figures may form the central element in a narrative picture, or perhaps the focal point in a landscape or interior.

Sketching figures

Confidence in drawing depends on careful observation. Carry a pocket sketchbook with you and take every opportunity to sketch people – in cafés, on public transport, at the beach. By watching people and sketching them frequently, you will gradually build up a store of visual information about physical shapes, body language and facial expressions in a variety of situations. Translating this information from eye to hand to paper becomes easier the more you practise.

Using your medium
All kinds of techniques can be applied to drawing or painting any subject, but it is often helpful to let your medium suggest an approach.

Using a pencil may lead you naturally to small-scale drawings that depend on a precise outline of the figure and sensitive detailing of smaller shapes (left).

Victor Ambrus
Luisa
Graphite pencil on paper
48.5 x 33cm (19½ x 13¼in)

Broad and flowing lines
Charcoal or pastel encourage a broad sweep that captures the overall balance and weight of the body and implies movement (see opposite).

With watercolours and a large, soft brush, you can flow the paint around body shapes and the drapes and folds of clothing (below).

Tom Coates
Model Adjusting Her Dress
Watercolour on paper
50 x 30cm (20 x 12in)

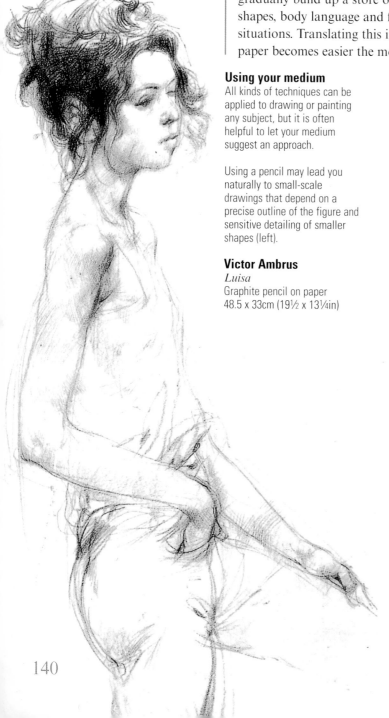

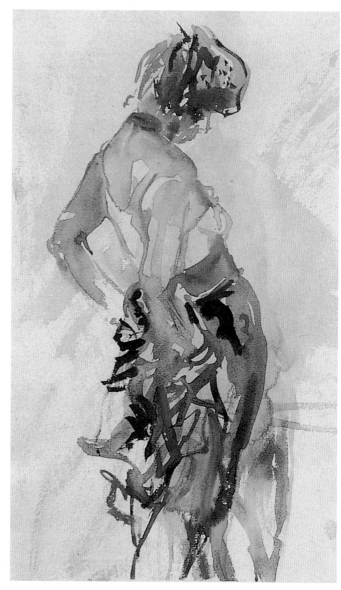

Action and pose

A 'lifelike' figure looks as if it could move. Capturing the energy and the dynamics inherent in the human form is largely a question of the right choice of pose and the vitality of the drawn and painted marks.

Gesture

It is important to notice the internal rhythms of the figure, whether in motion or in repose, and how the outer shapes respond to movement. If you can capture the essential gesture of the pose by defining the telling angles and directions of the body, the energy of the whole figure is naturally implied.

Expressive marks

The other important aspect of pictorial movement is the energy and impact of the marks you make. A single mark outlining a leg will make it look static, but a series of loose, fluid lines will generate energy. Let your hand follow the contours of the figure instinctively, so that the pressure of pencil, chalk or brush echoes its flow and direction. You will not achieve a 'finished' image in this way, but you will learn a lot about how the human figure works.

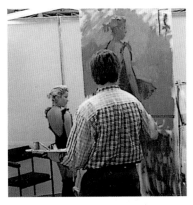

Keep your distance
It is important not to stand too close to the model. Set up your easel at a distance of about 2m (6ft), positioned so that you can see the whole figure without moving your head too much.

Relaxed pose
Tom Coates took the opportunity to draw his model while she took a break during life class. Her unselfconscious gesture has an easy naturalness and a sense of implied movement often lacking in a formal pose.

Tom Coates
Rest Period
Pastel on paper
100 x 75cm (40 x 30in)

Dynamic drawing
When drawing from life, be bold and work with the rhythm of the figure's movements. Using bold lines and smudged tones, Rosemary Young captures the essential gesture of the pose without freezing it.

Rosemary Young
Three Standing Nudes
Charcoal on paper
Various dimensions

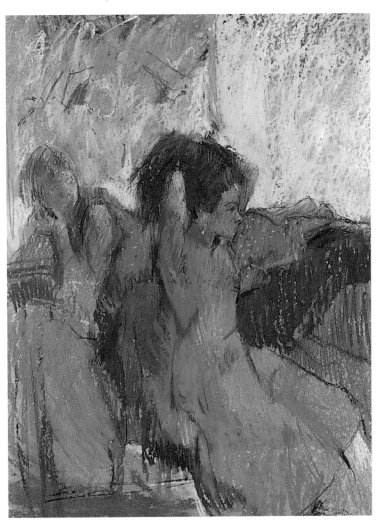

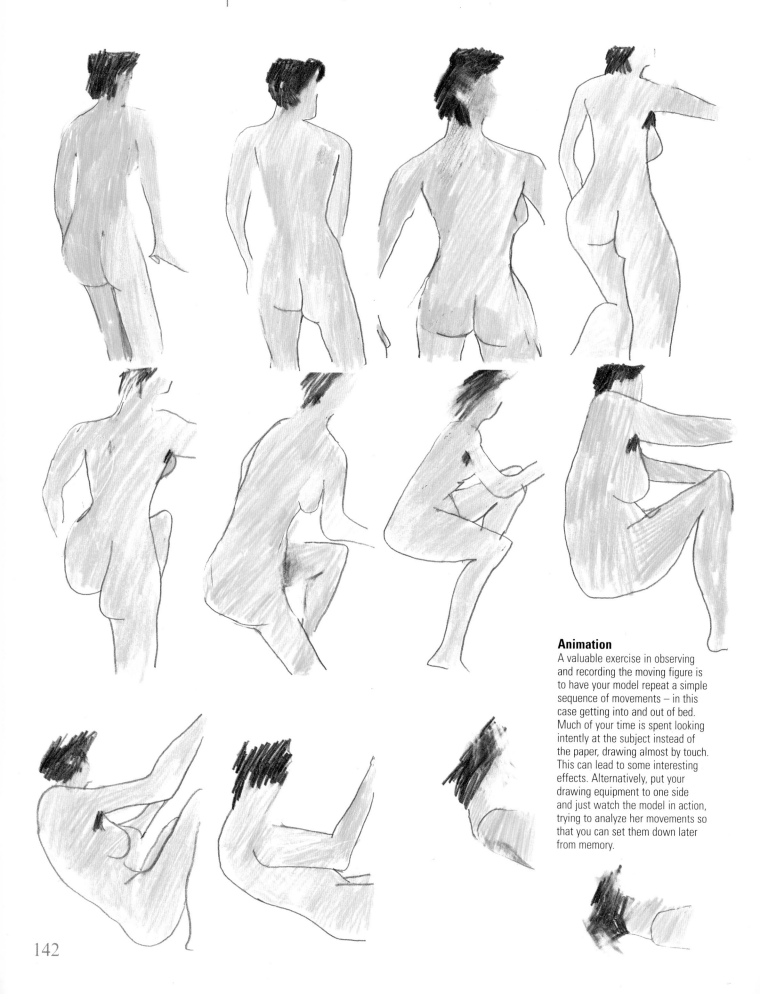

Animation
A valuable exercise in observing and recording the moving figure is to have your model repeat a simple sequence of movements – in this case getting into and out of bed. Much of your time is spent looking intently at the subject instead of the paper, drawing almost by touch. This can lead to some interesting effects. Alternatively, put your drawing equipment to one side and just watch the model in action, trying to analyze her movements so that you can set them down later from memory.

Movement in space

Using a camera and ready-made photographic references (see page 151) may help you to discover how people move through space and perform a variety of tasks, but nothing can beat direct observation to capture the dynamics of the human body.

The life-drawing class is traditionally an exercise in studying the posed model, but don't be afraid to ask your subject to move so that you can capture the human figure in action. With this type of exercise, it is difficult to make anatomically correct drawings – just get your marks down quickly to record those attitudes which capture energy, animation and, above all, life.

Human male in motion
This frame from Eadweard Muybridge's (1830–1904) pioneering documentation of Animals in Motion is one of many hundreds of high-speed photographs which helped further the course of art and science in the late nineteenth century.

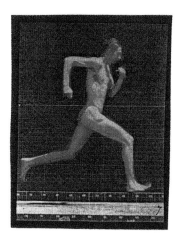

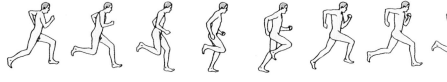

Running man
A sequence of sketches based on Muybridge's photographic records. Prior to photography, a great many artists made incorrect assumptions about the way humans and animals move through space.

Dancing figures
These sketches were made from figure drawings seen on prehistoric African pottery. With their simplicity and elegance, these delightfully economic brush drawings capture perfectly the human form in motion.

Swimmers
A quick oil-pastel sketch, drawn loosely in colour and then blended with the fingers, successfully freezes a moment of summertime pleasure.

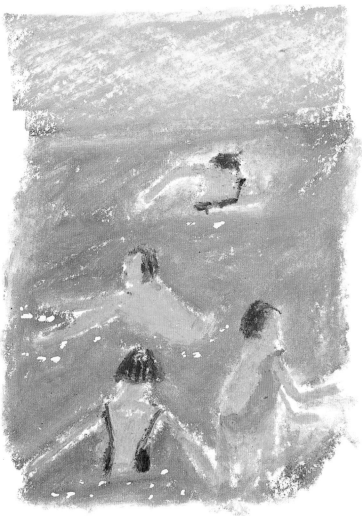

The life class

An excellent way to develop drawing skills and boost your confidence is to join a life-drawing class. This provides a practical and affordable opportunity for the amateur artist to draw professional nude models with the benefit of a tutor on hand. A life class also gives you the chance to work with a group of fellow artists with whom you can compare drawing techniques and ideas.

Starting points
The drawings shown here and opposite demonstrate first sketches and construction work – a sort of warm-up session at the beginning of a class. The artist has spent some time moving around the model, getting a feel for shape and proportion. The tutor changed the pose every 10 minutes or so.

Jacqueline Day
Life Drawing, Sketches
Pencil, charcoal, pen and
ink on paper
50 x 37.5cm (20 x 15in)

Drawing in colour
In a life class, oil pastel is an ideal medium for bridging the gap between painting and drawing. The simplicity of the medium – no need for solvents or diluents – allows the artist to execute tone and colour studies in a relatively short time.

David Day
Nude Torso
Oil pastel on paper
30 x 25cm (12 x 10in)

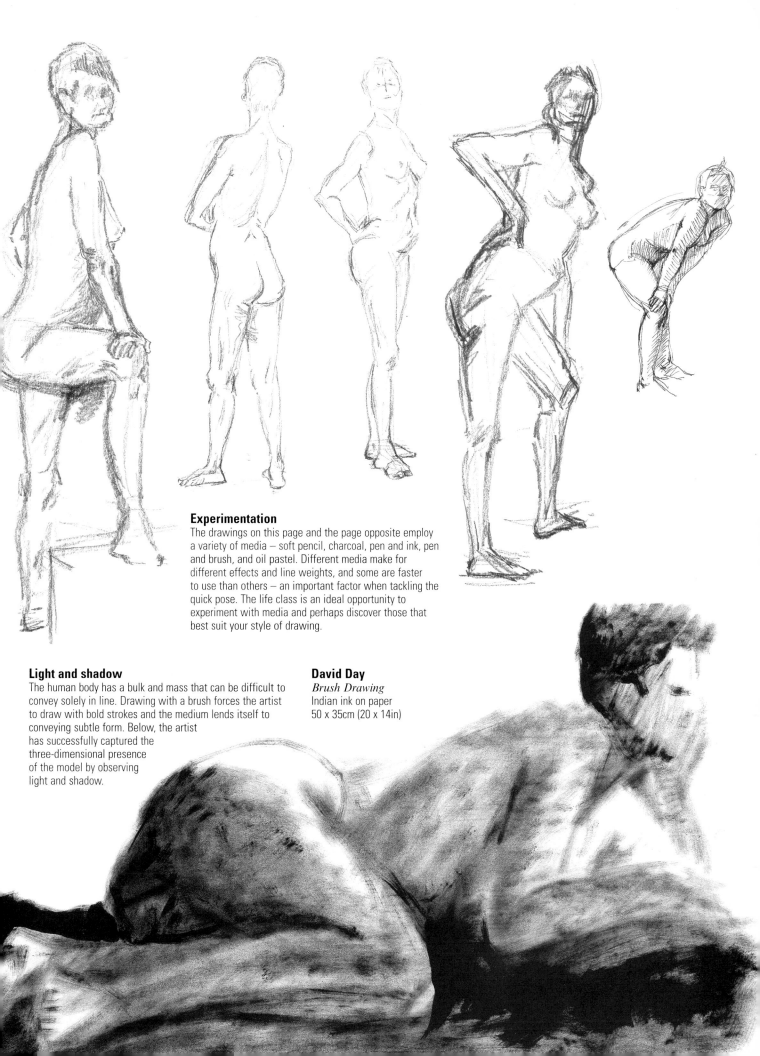

Experimentation
The drawings on this page and the page opposite employ a variety of media – soft pencil, charcoal, pen and ink, pen and brush, and oil pastel. Different media make for different effects and line weights, and some are faster to use than others – an important factor when tackling the quick pose. The life class is an ideal opportunity to experiment with media and perhaps discover those that best suit your style of drawing.

Light and shadow
The human body has a bulk and mass that can be difficult to convey solely in line. Drawing with a brush forces the artist to draw with bold strokes and the medium lends itself to conveying subtle form. Below, the artist has successfully captured the three-dimensional presence of the model by observing light and shadow.

David Day
Brush Drawing
Indian ink on paper
50 x 35cm (20 x 14in)

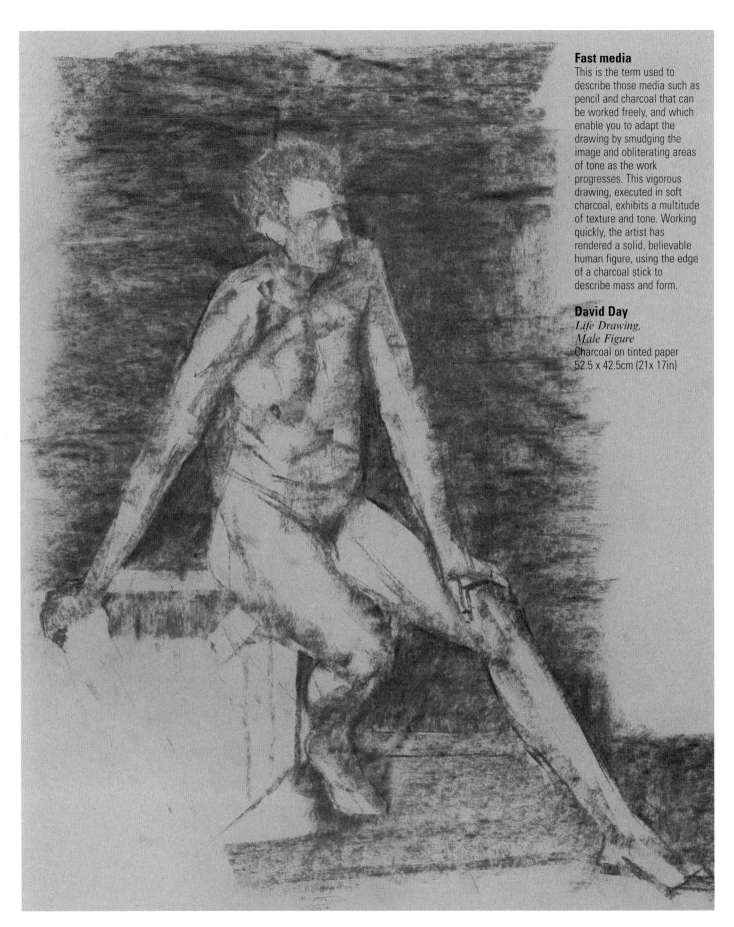

Fast media
This is the term used to describe those media such as pencil and charcoal that can be worked freely, and which enable you to adapt the drawing by smudging the image and obliterating areas of tone as the work progresses. This vigorous drawing, executed in soft charcoal, exhibits a multitude of texture and tone. Working quickly, the artist has rendered a solid, believable human figure, using the edge of a charcoal stick to describe mass and form.

David Day
*Life Drawing,
Male Figure*
Charcoal on tinted paper
52.5 x 42.5cm (21x 17in)

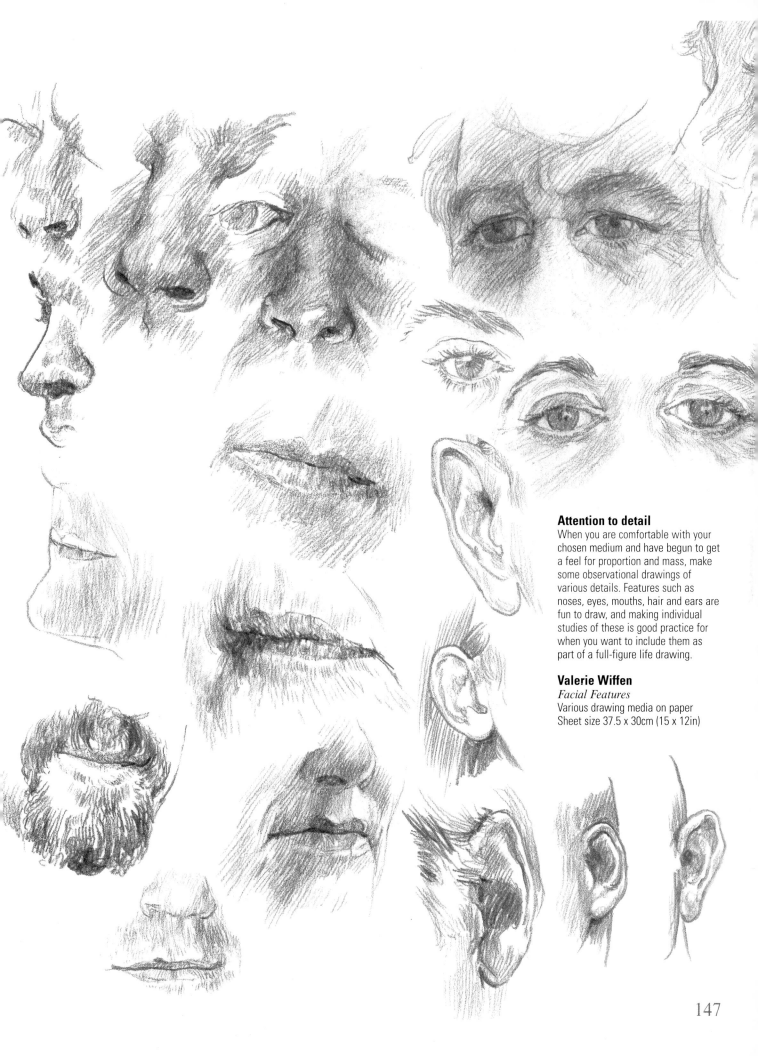

Attention to detail

When you are comfortable with your chosen medium and have begun to get a feel for proportion and mass, make some observational drawings of various details. Features such as noses, eyes, mouths, hair and ears are fun to draw, and making individual studies of these is good practice for when you want to include them as part of a full-figure life drawing.

Valerie Wiffen
Facial Features
Various drawing media on paper
Sheet size 37.5 x 30cm (15 x 12in)

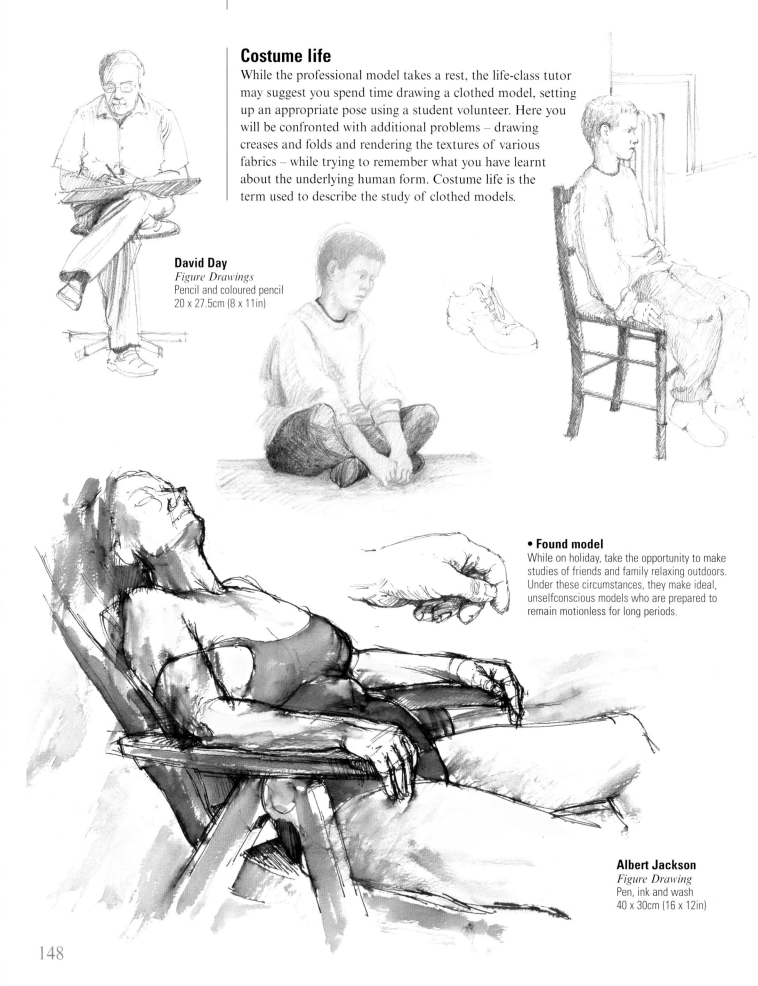

Costume life

While the professional model takes a rest, the life-class tutor may suggest you spend time drawing a clothed model, setting up an appropriate pose using a student volunteer. Here you will be confronted with additional problems – drawing creases and folds and rendering the textures of various fabrics – while trying to remember what you have learnt about the underlying human form. Costume life is the term used to describe the study of clothed models.

David Day
Figure Drawings
Pencil and coloured pencil
20 x 27.5cm (8 x 11in)

• Found model
While on holiday, take the opportunity to make studies of friends and family relaxing outdoors. Under these circumstances, they make ideal, unselfconscious models who are prepared to remain motionless for long periods.

Albert Jackson
Figure Drawing
Pen, ink and wash
40 x 30cm (16 x 12in)

Found models and self portraits

Gigol Atler
Feet and Shoes
Pencil on paper
51 x 37.5cm (20$\frac{1}{2}$ x 15in)

You can continue the discipline of figure drawing outside the life class by drawing family and friends, sketching people in the street, and making studies of your own body and clothes. These are opportunities for experimenting with unfamiliar media and for dabbling with novel techniques before trying them out in public under the watchful eyes of a tutor or fellow students.

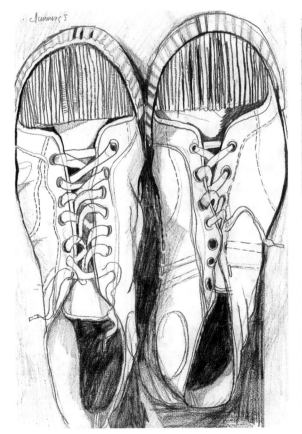

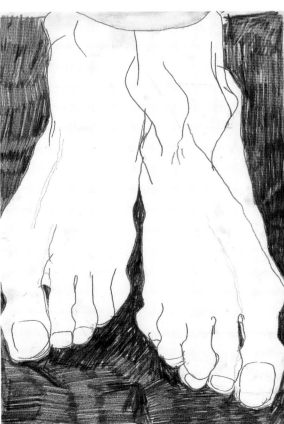

• Draw yourself

Throughout the history of art there is a very strong tradition of self portraiture. As an experiment in drawing the human form – clothed or unclothed – try using your own body and clothing as models or references for other works of art. Here the artist has chosen his feet and shoes as subjects for quick, simple studies.

Using drawing aids

'A picture is something which requires as much knavery, trickery and deceit as the perpetration of a crime.'
Edgar Dégas (1834–1917)

Throughout history, artists have called on a variety of devices to assist them in their endeavours to get a recognizable image down on paper. They have used mannequins, models, transfers, complex machinery and all manner of prescribed systems of measurement to render the real, three-dimensional world on the two-dimensional plane of paper or canvas.

Purists may disagree with using artificial drawing aids but, while there is no substitute for direct observation and constant practice at recording images from life, many professional artists continue to use cameras, photocopiers, grids and framing devices as aids to good drawing. The tips and techniques shown here could help you to see objects with greater clarity and to compose your pictures more harmoniously.

Concentrate the eye
Many artists use a frame to help concentrate the eye while working on a drawing. You can cut a simple frame from card or paper – always make the frame darker than the image or scene you are observing. Alternatively, improvise a frame to isolate your subject from the background, using your hands to form a basic square or rectangle.

Lay figures
Also known as mannequins, lay figures are jointed wooden models which are available from art-supply shops. They are useful in helping to set up a pose or work out proportions.

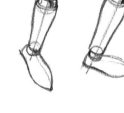

Foreshortening
This is a way of adjusting the proportions of a figure to give the illusion of depth. Lay figures are handy for experimenting with foreshortening.

Drawing machines
Renaissance artists used a variety of drawing machines and camera obscuras to help them with their work in the days before photography. With this simple device the artist could trace the object onto glass as if looking through a window.

Facial proportions
The bottom of the eyesockets are located approximately halfway down the head. The eyebrows and tops of the ears usually align.

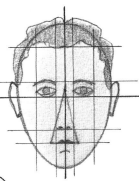

Lay hands
Life-size models of hands can be bought from most art shops. They can be adjusted to take up simple poses and grip a variety of objects. A lay hand is an excellent drawing aid as, unlike a live model, it never tires and remains perfectly still.

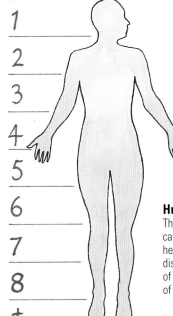

1
2
3
4
5
6
7
8
+

Human proportions
The average adult body can be divided into eight head lengths, plus the distance from the middle of the ankle to the sole of the foot.

Alignment
When drawing a human face from an unusual angle, make sure to realign the eyes with the plane of the tilted head.

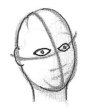

• Working from photographs
Many professional artists and illustrators build up reference libraries of found photographic images to capture fleeting images and help them with poses that would be difficult for a live model.

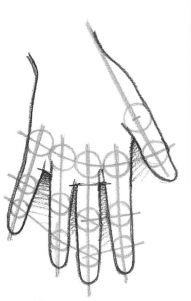

Keeping a sketchbook

An artist's sketchbook can take on many guises. It can be a means of recording fleeting impressions, colour notes and compositions for turning into paintings. It can be a portable scrapbook in which to collect interesting pieces of printed ephemera and pictorial references. It can be a notebook for observations and ideas that, one day, may provide that essential spark of inspiration. And, if nothing else, a sketchbook gives you somewhere to develop and practise your drawing and painting skills.

Sketching in colour

Water-soluble paints and pencils have obvious advantages, particularly when you are sketching outdoors. Illustrated here are some pages from a sketchbook in which the artist was able to make simple colour studies of changing weather and varying light conditions from a single viewpoint. Colour sketching provides the ideal opportunity for experimenting with style and technique.

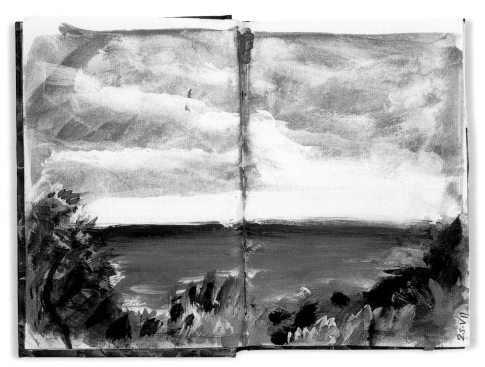

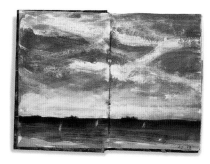

Simon Jennings
Sea and Sky Studies
Mixed media on paper
15 x 21cm (6 x 8¼in)

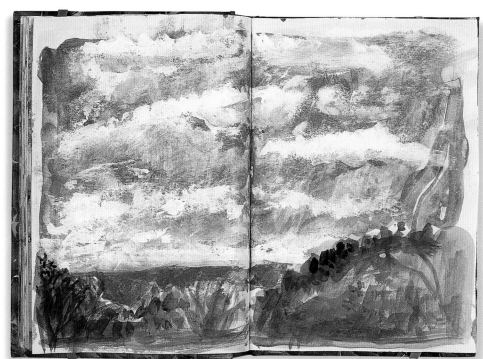

152

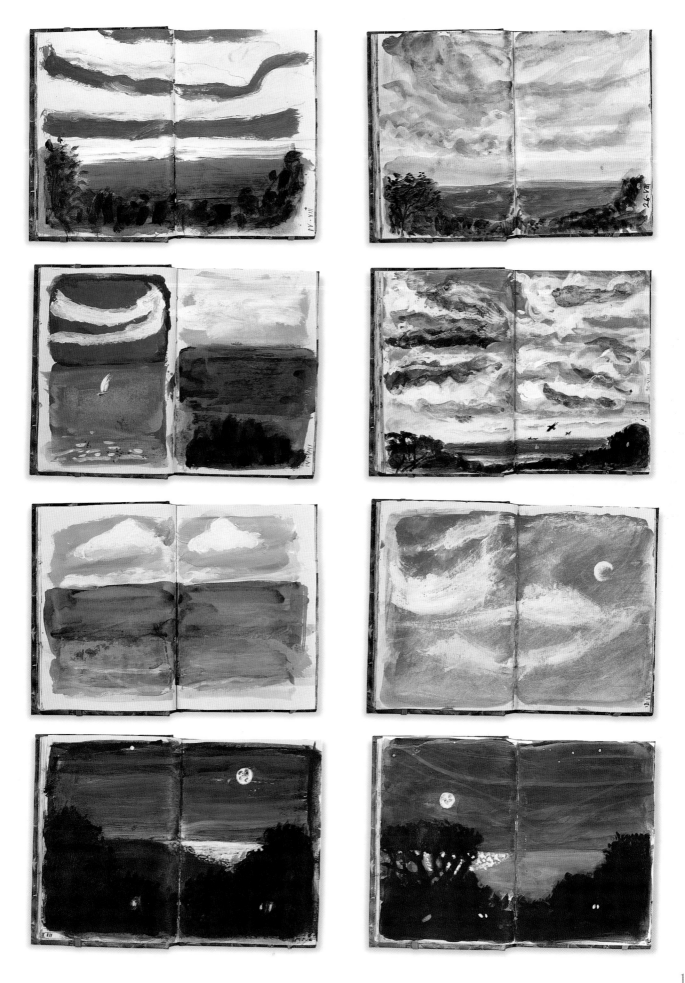

Sketching

Despite the ubiquitous camera, most contemporary artists still prefer to carry a sketchbook and pencil with them. Because a sketch is the immediate result of observation, capturing a personal impression in a few essential strokes, it is an absolutely vital adjunct to, and preparation for, more considered studio work.

Keeping a sketchbook

A sketchbook is an artist's most valuable piece of 'equipment'. It is the perfect place in which to improve your drawing skills and powers of observation, and to develop new ideas. It is also a place to note and record anything of interest, and as such becomes a valuable storehouse of visual references.

A sketchbook also helps to build up your confidence; rapid and frequent sketching aids you to express more intuitively what you feel and see. With a sketchbook and pencil, you can catch life on the wing.

The artistic process

The most interesting aspects of the work of any artist are often to be found, not in their finished paintings, but in their sketchbook drawings. Artists talk to themselves in the candour of their sketches, leaving immediate impressions as they jot down their reactions to the world around them.

For the onlooker, there is a fascination in looking at these sketches, because it helps us to understand how that mysterious creature, the artist, actually comes by and shapes his or her inspiration. There is also, perhaps, a fascination with the unfinished rather than the complete, which appeals to the romantic in all of us.

• Anything goes
A chance arrangement of objects on the breakfast table, a transitory effect of light; anything can be noted down rapidly and later used as the basis for a later composition – or simply for the sheer joy of observing and recording something which is pleasurable to the eye.

Richard Bell, David Day, Simon Jennings, Anna Wood
Sketchbooks
(below and opposite)
Various drawing media on paper

These collages of artists' sketchbooks show the sheer variety of styles, occasions and intentions to be found. Each one is different, and each is a document of one particular artistic moment.

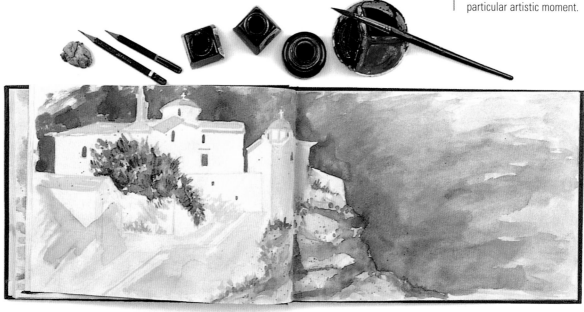

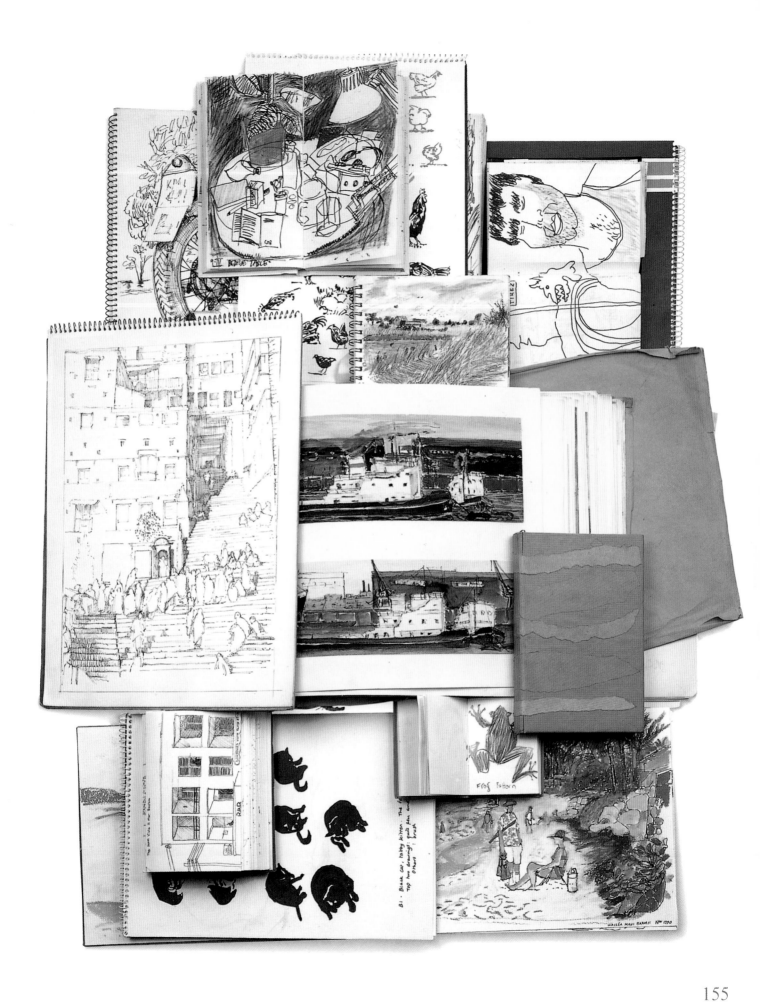

155

Simon Jennings
Cormorant
Brush and ink
Sketchbook detail

Sketching outdoors

Some artists turn their sketchbooks into finished works of art, recording in line, tone and colour the infinite qualities of landscape and nature. Alternatively, they might use sketches and colour notes as the foundation for developing more ambitious landscapes back in the studio where they have access to a greater range of equipment.

Whatever your approach, it makes sense to carry a variety of easily transportable drawing media when working outdoors. The availability of a wide range of water-soluble coloured crayons and pencils makes it possible to create quick colour studies without having to resort to the traditional paintbox, diluents and brushes.

In addition, you might want to pack a couple of soft graphite pencils and some fibre-tip pens, or perhaps you prefer a small brush and a bottle of ink. For highlighting, some artists carry around with them a correction-fluid pen – the type used for obliterating typing errors.

Whatever you decide, everything should fit into a small pencil case which you can get in your pocket or bag.

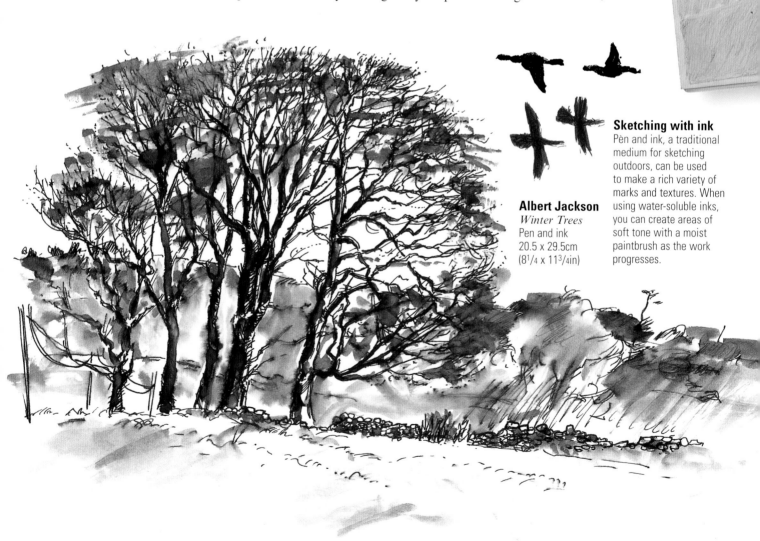

Albert Jackson
Winter Trees
Pen and ink
20.5 x 29.5cm
(8¼ x 11¾in)

Sketching with ink

Pen and ink, a traditional medium for sketching outdoors, can be used to make a rich variety of marks and textures. When using water-soluble inks, you can create areas of soft tone with a moist paintbrush as the work progresses.

André Thompson (left)
Cassis Plage
Graphite and coloured pencils
Sketchbook page
41.25 x 29.5cm (16$^1$/$_2$ x 11$^3$/$_4$in)

Colour sketching

Roughly sketch your subject in pencil, then draw into your sketch with water-soluble pencils or crayons, blending the colour with a moist finger, or create broader washes with a wet brush. Conventional coloured pencils are useful for applying highlights, details and linear textures.

Albert Jackson
(above)
Irish Landscape
Water-soluble crayons
Sketchbook page
25 x 17.5cm (10 x 7in)

Simon Jennings
Greenwich Park
Water-soluble pencils,
fibre-tip pen and white
body colour
Sketchbook page
20.5 x 14.5cm
(8$^1$/$_4$ x 5$^3$/$_4$in)

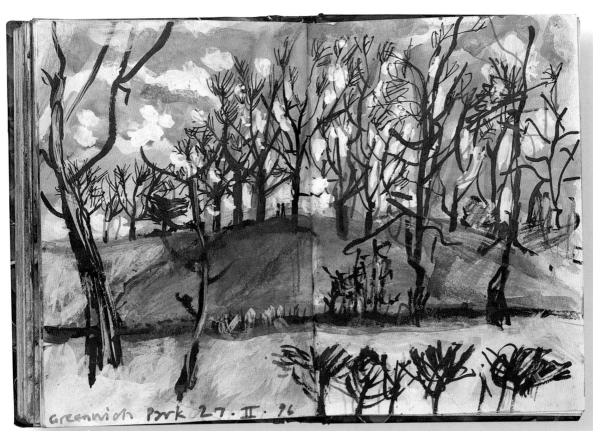

Mixing media

There are no rules to say you cannot mix media. Working with a variety of materials allows you to build up your drawing with layers of textures and washes. The sketch below was made using sepia ink before coloured washes were applied with a brush. You can get even more interesting line-and-wash effects when working with coloured inks.

The centre bottom sketches illustrate the advantages of wax resist. The flowers were drawn with candle wax, then a wash of black ink was applied freely to the background – the ink will not stick to paper that has been waxed. Additional details were sketched in with oil pastels and a pale pink wash was applied.

Nicola Hosie
Lilies
Mixed media
Sketchbook pages
20.5 x 14.5cm
(8¼ x 5¾in)

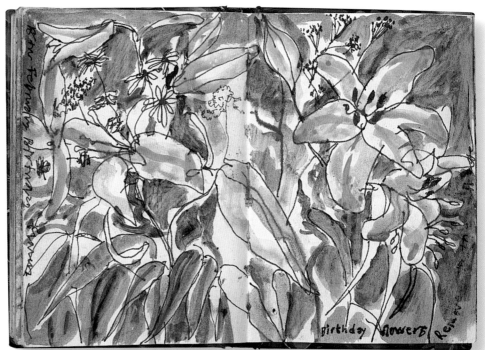

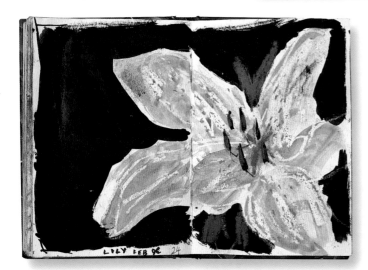

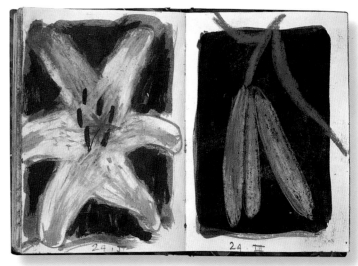

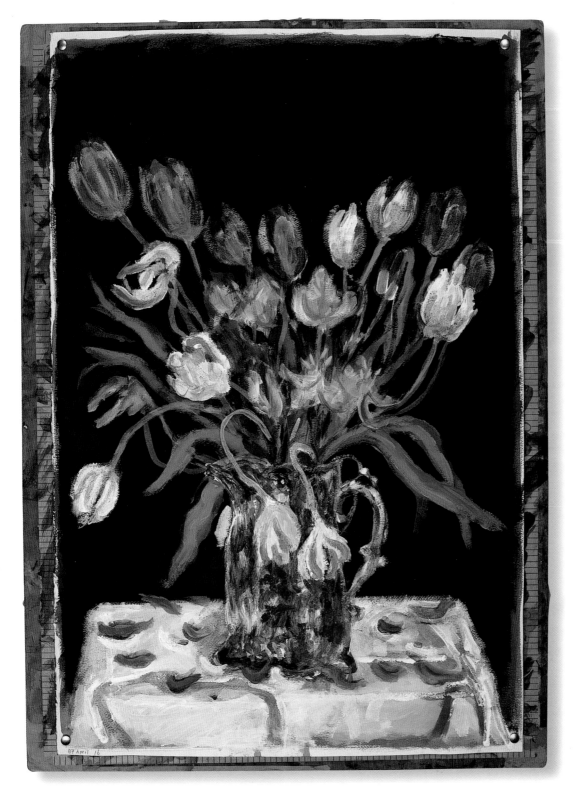

Preparatory sketches

Preparatory sketches help artists to familiarize themselves with a subject before committing to the final act in colour on paper or canvas. They are akin to samplers that enable artists to tune their eyes to shape and proportion and to assess colour and tonal values.

Here, Nicola Hosie made a simple pencil sketch on paper to ascertain the arrangement of stems, blooms and leaves for a still-life with jug. This is the only drawing that she made in relation to the subsequent picture which is painted 'alla prima' in acrylics on white coarse-grained paper. The paper was primed with a red-oxide tone prior to starting the brushwork. The whole painting took about eight hours to complete to this stage.

Nicola Hosie (above)
Preparatory Sketch
Pencil on paper
20.5 x 29.5cm (8$^1$/$_4$ x 11$^3$/$_4$in)

Nicola Hosie (left)
Jug of Tulips
Acrylic on paper
50 x 75cm (20 x 30in)

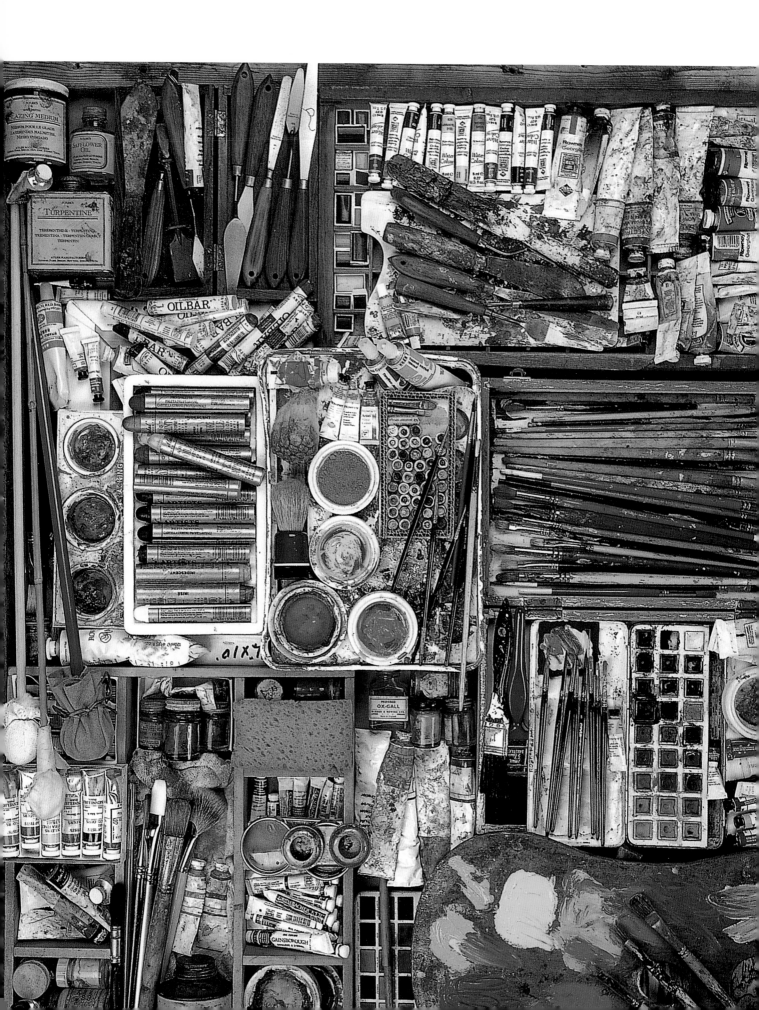

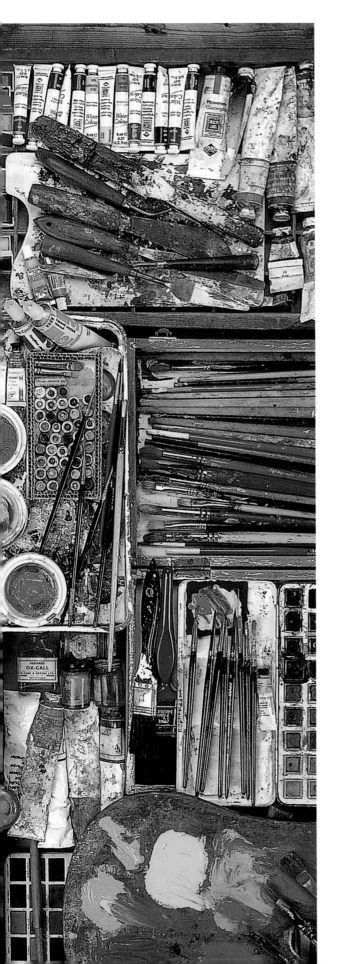

Chapter six

Painting techniques

In the following pages you will learn about the wide range of techniques that artists use to produce their paintings. However, as you will see, many of them are not purists, and they will adapt and combine techniques in order to create the effects they are looking for. Whichever medium you choose to work in – oils, watercolours, gouache or acrylics – you can enjoy experimenting with colours, textures and special effects, and can learn how to produce these yourself.

Oil techniques

When oil paint was first developed in the early Renaissance, it was hailed as 'a most beautiful invention'. Since then, it has been the preferred medium of the majority of artists. The smooth, buttery consistency of oils, coupled with their slow drying time, means they can be manipulated freely and extensively on the support to produce an infinite variety of textures and effects, from thin, transparent washes to thick, textured impastos.

Ken Howard
Sarah Allongée
Oil on canvas
60 x 120cm (24 x 48in)

Underpainting

The traditional way of starting an oil painting is to use thin paint to roughly block in the main shapes and tones, before adding the main details and surface colour. This underpainting provides a foundation from which the painting can then be developed, as the composition and the relationships of the colours and tones have been made clear right from the start.

Advantages of underpainting

There are three principal advantages to making an underpainting. First, it can subdue the harsh white of a primed support (when a toned ground has not been laid), making it easier for you to accurately gauge the relative tones of the succeeding colours.

Second, using underpainting as part of the compositional process enables you to check that the picture works as intended, before it is too late to make changes to the overall construction. Because the paint used for underpainting is so thin, any alterations that are needed can be easily effected by wiping the paint with a rag which has been soaked in turpentine; this will not be possible in the subsequent stages, as you run the risk of overworking the painting.

Third, because the decisions about composition and tonal modelling have been dealt with at a preliminary stage, you are free to concentrate purely on the details of colour and texture in the later stages of the painting.

Fat-over-lean

Always keep in mind the principle of working fat-over-lean: to create a stable paint film, the underpainting should be thin and fast-drying, and the succeeding layers should be slower-drying and more oil-rich.

Flake white and diluted earth colours are all suitable for underpainting, as they are rapid driers and form a hard film with just the right degree of flexibility. They also have a catalytic effect when they are mixed with other fast-drying colours. Alkyd and tempera paints are also suitable for underpainting because they dry rapidly.

Acrylic paints

These are also suitable, as they are fast-drying, but they must be diluted with a little water (not medium) and applied thinly. The presence of water renders the surface of the paint a little more porous when dry, ensuring proper adhesion between the acrylic and oil layers.

If acrylic paint is applied at all thickly, it may cause some cracking of the oil layers, because acrylics are so flexible when dry. In addition, a thick acrylic layer has insufficient tooth to adhere well. This applies particularly when you are painting on a flexible support such as canvas, but less so on panels and boards, where there is far less movement of the paint film. Never apply acrylics on an oil-based ground.

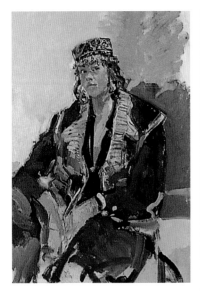

Tom Coates
Charlotte in Arabic Costume
Oil on canvas
125 x 90cm (50 x 36in)

In this unfinished painting, the artist has used the traditional method of monochrome underpainting in neutral greys and browns. These colours form a solid base from which to model the figure.

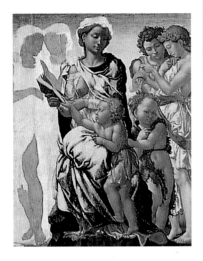

Michelangelo Buonarroti (1475–1574)
Madonna, Child and St John with Angels, c. 1506
Oil on wood
105.4 x 76.8cm (42¹⁄₈ x 30³⁄₄in)
National Gallery, London

The effect of using complementary or contrasting underpainting colours can be seen here; the cool greens enhance the warmth of the subsequent skin tones.

• Colours for underpainting
Flake white and diluted earth colours are suitable for underpainting, as they will dry rapidly and form a hard film.

• Colours to avoid
The colours listed below should not be used at full strength in underpainting, because they naturally contain a lot of oil. They may, however, be used for the purpose when mixed with less oil-rich colours. Alizarin crimson; aureolin; cadmium colours; cobalt blue; ivory black; lamp black, phthalocyanine colours; quinacridone colours; viridian.

▶ SEE ALSO
▶ Supports 13
▶ Oil paints 64
▶ Diluents 75
▶ Fat-over-lean 166
▶ Glazing 170
▶ Acrylic paints 110
▶ Varnishes 350

Alan Hydes
The Most Reverend and Rt Hon
Dr David Hope KCVO
Oil on canvas
55 x 40 cm (22 x 16 in)

When he was painting this portrait, the artist explored his sitter's facial structure, emphasizing the eyes and the shape of the nose. This sequence shows how he built up his painting from his original drawing (far left) through the underpainting to the finished portrait (below).

Fat-over-lean

Correct preparation of the painting surface is important, and the principle of painting fat-over-lean is also sound technique when painting in layers. The most important thing, however, is not to become hidebound by 'correctness' but to enjoy the act of painting.

Removing excess oil
If you wish to use an oily pigment in an underlayer, this can lead to problems, as subsequent layers must not contain any less oil. One way to resolve this is to leach out some of the oil; here, alizarin crimson is squeezed onto an absorbent paper towel and left for a short time. It can then be scraped onto a palette and confidently used for underpainting.

Movement and sinking
In this detail of the painting below right, it can be seen that contrasting drying rates and flexibility in the various paint layers have caused movement and sinking of the surface. This is caused by Turner's sometime practice of using straight oil paint in the lower layers, but subsequently mixing his colours with waxes, resins and bitumens in the upper layers.

Working fat-over-lean

The term 'fat-over-lean' is synonymous with 'flexible-over-inflexible'. 'Fat' describes paint which contains a high percentage of oil, and is therefore flexible; 'lean' paint has little or no extra oil added, and is thinned with turps or white spirit, making it comparatively less flexible.

To ensure a sound structure to a painting which is built up in layers, you should apply the fat-over-lean principle, in which each successive layer of paint is made more flexible by increasing the percentage of oil in the paint – the same principle, in fact, used in house-painting, where paint for the undercoat contains less oil to pigment than the final coat.

The reason for this has to do with the way in which the paint film dries. The oil binder in the paint dries not by evaporation, but by absorbing oxygen from the air. During the first stage of drying, it increases in weight and expands. It will then begin to lose weight, contract slightly and harden. If lean (less flexible) paint is applied over oily (flexible) paint, some cracking may occur because there is more movement in the lower layers than in the upper layers.

When painting in layers, begin with an underpainting which is thinner, leaner and faster-drying than subsequent layers. For example, start with paint thinned with diluent or mixed with a fast-drying alkyd medium. The next layer may consist of either neat, undiluted tube paint, or paint mixed with diluent and a little oil. Any successive layers may contain either the same or increasing amounts of oil, but they should not contain less oil.

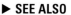

• Drying times
Lean paint dries faster than fat paint, and thin layers dry faster than thick ones. If a lean or thin layer is applied over a fat or thick layer, the layer beneath dries more slowly and contracts as it does so, causing the hardened paint on top to crack in due course.

▶ **SEE ALSO**
▶ Priming 24
▶ Oil paints 64
▶ Binders 74
▶ Mediums 76
▶ Underpainting 164
▶ Knife painting 174

J. M. W. Turner (1775–1851)
The Opening of the Walhalla, 1842–3
Oil on mahogany board
112.7 x 200cm (45 x 80in)
Tate Gallery, London

Sinking of paint film

Patches of dull, matt paint across the canvas indicate sinking of the paint film. Sunken patches can occur on paintings which are worked on over a period of time, and are caused by the overlaid layers of colour drying out at different rates.

As it dries, a layer of oil paint goes through a sponge-like stage, when it becomes very absorbent. This starts after a few days, and may last for around six months. During this time, if further layers are added they may sink because the absorbent underlayer sucks the oil from the fresh layers, leaving them starved and dry-looking. However, this can be avoided by working on the painting consistently, so that the paint films are drying together. If you leave a painting for more than a week and then resume work on it, sinking is more likely to occur.

Reviving sunken paint patches

Sunken patches can be brought back to life by 'oiling out', and this will also prevent subsequent layers being weakened. Mix a solution of 80 per cent stand oil and 20 per cent white spirit and rub this sparingly over the affected area, using a soft, lint-free cloth. Leave to dry for a few days before applying further layers of paint. If small patches remain, repeat the process until all the sunken areas have disappeared.

• Additional drying oil
Mixing additional drying oil (e.g. linseed or poppy oil) with tube oil paints can also cause wrinkling of the paint film, but the inclusion of a diluent should prevent this.

Oil-rich colours
Some oil-rich colours, e.g. alizarin crimson, have a tendency to wrinkle when applied in thick layers, because they dry slowly. If a thick layer is required, it should consist of several thin applications.

• Alternative method
If time is short, brush a little retouching varnish over the sunken patches. This reduces the absorbency of the paint already on the canvas, while providing a 'key' for the next layer. Apply a small amount of the varnish with a soft brush and leave to dry for 10 minutes before continuing to paint. The drawback is that retouching varnish is a soluble resin, which can result in the oil-colour film being susceptible to solvents used in subsequent painting, varnishing or cleaning. A paint layer which is touch-dry on top but wet underneath should not be overpainted with retouching varnish, as this may cause cracking.

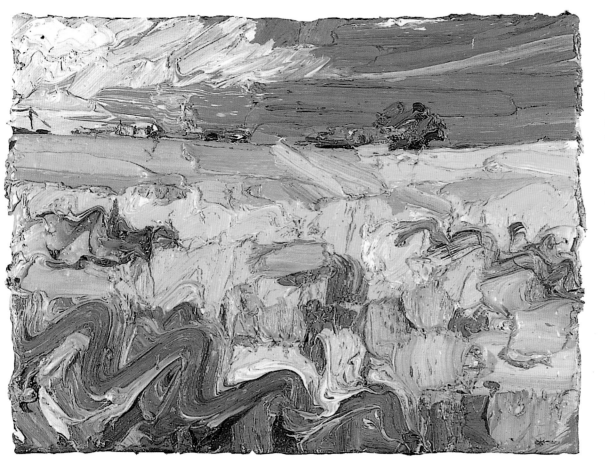

George Rowlett
The Great Rapefield
Oil on canvas
45 x 60cm (18 x 24in)

Some of the paint on this landscape is as thick as 38mm (1¹/₂in), yet no cracking or sinking of the paint film has occurred. This is because the artist uses pure oil paint, without the addition of any mediums, diluents or binders; he applies a relatively thin underlayer, and then builds up the very thick texture. He does not mix colours, so the potential problems of mixing oil-rich and oil-lean paints are avoided.

▶ **SEE ALSO**
▶ Oil paints 64
▶ Mediums 76

Alla prima

Italian for 'at the first', alla prima describes a painting which is completed in a single session. In alla-prima painting there is often no preliminary underdrawing or underpainting; the idea is to capture the essence of the subject in a bold, intuitive way, using vigorous, expressive brushstrokes and minimal colour mixing on the palette or support.

Speed and spontaneity

This direct painting method requires confidence, but it is very liberating – the artist works rapidly, using the brush freely to express an emotional response to the subject.

The ability to apply paint quickly and confidently is the key to the alla-prima approach. It is, of course, possible to scrape away and rework unsuccessful areas of a painting, but the danger is that some of the freshness and spontaneity will be lost. It is therefore important to start out with a clear idea of what you want to convey in your painting, and to dispense with inessential elements which do not contribute to that idea. For the same reason, you should stick to a limited range of colours so as to avoid complicated colour mixing, which might inhibit the spontaneity of your brushwork.

• Forerunners

Alla prima first came into favour with the Impressionists and their forerunners, Constable (1776–1837) and Corot (1796–1875). Working directly from nature, these artists introduced a liveliness and freedom of brushwork that was instrumental in capturing the effects of light and movement in the landscape.

• Drying

Although many alla-prima paintings are worked rapidly with thick paint, they are technically sound. This is because colours are applied in one session, while the surface is still wet. There is effectively only one paint layer, so there is no problem with different drying speeds between layers, which can lead to cracking of the paint surface.

Annabel Gault
Flax Field
Oil on paper
19 x 25cm (7⅝ x 10in)
*Redfern Gallery,
London*

Intrigued by the drama of the dark, brooding landscape and the luminous evening sky, Annabel Gault worked quickly to distill the essence of the scene, using fingers, the edge of her hand and brushes to manipulate the paint.

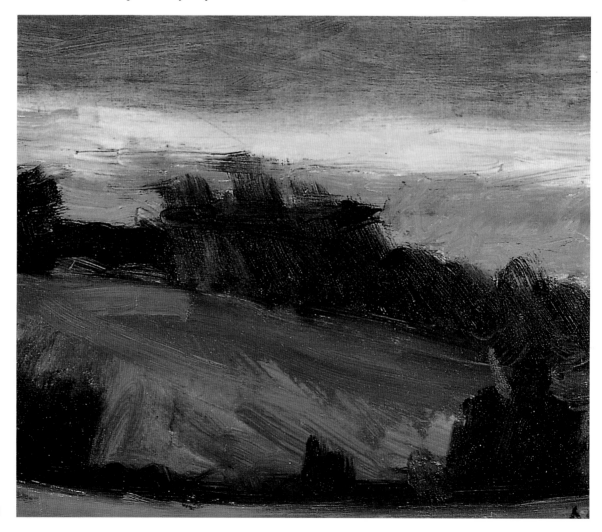

▶ **SEE ALSO**
▶ Fat-over-lean 166

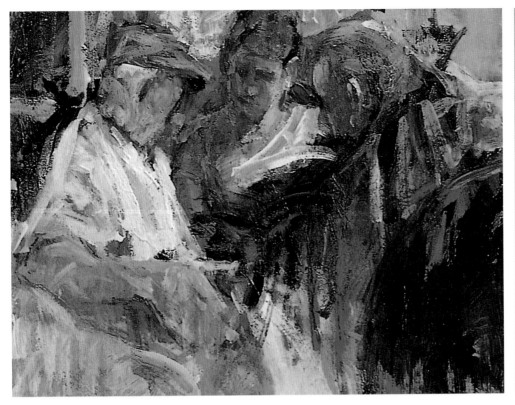

Arthur Maderson
A Fair Deal
Oil on canvas
60 x 70cm (24 x 28in)

Small studies painted on-the-spot have a directness and vigour difficult to achieve in the studio. The lively brushwork here makes an obvious contribution to the character of the painting, and is also highly descriptive; we gain a definite impression of the personalities of these three men engrossed in making a deal.

Ken Howard
Racing Dinghies
Oil on wood
15 x 22.5cm (6 x 9in)

The artist had finished a long day's painting when these dinghies sailed into harbour. Inspired, he quickly unpacked his paints and completed this painting in ten minutes. He was able to do this because he had been painting all day and was 'warmed up'; it would have been difficult to achieve the same energy and verve at the beginning of the day.

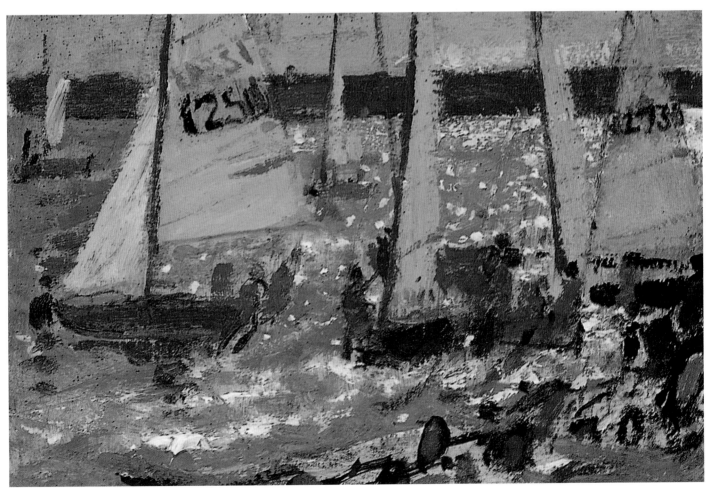

Glazing

Glazing is one of the traditional techniques that is associated with oil painting. The Renaissance painters, in particular, used glazing as a method of colour mixing. Rather than stirring their colours together on the palette, they applied each colour separately, in successive glazes of thin, transparent paint. Each glaze modified the colour beneath, rather like sheets of coloured glass, resulting in hues of wonderful richness and luminosity.

Optical mixing

With a slow-drying medium such as oils, glazing can be a laborious process, because each colour must be completely dry before the next is applied, otherwise they simply mix together and become muddied. Nevertheless, glazed colours have a resonance which is unobtainable by physically mixing them on the palette, because transparent colours transmit and reflect light. Glazing is a method of optical mixing, in which the colours blend in the viewer's eye. Each successive glaze modifies the underlying colour, but does not completely obscure it; this incomplete fusion of the colours, combined with the effects of reflected light, is what gives a glazed passage its luminous quality.

Glazing and opaque paint

Glazes can also be used in conjunction with opaque layers of paint, so long as the latter are dry to the touch – for example, colours which are too cool can be corrected by the application of a glaze of warm colour, and vice versa. Similarly, a thin glaze that is applied over a finished picture will soften any harsh contrasts and will bring harmony to the colours, without obscuring the forms beneath.

Glazing mediums

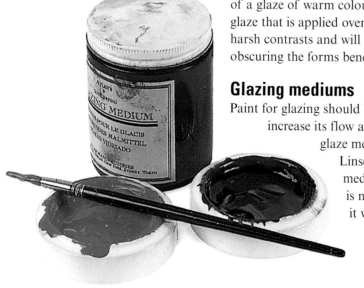

Paint for glazing should be thinned with a glazing medium, to increase its flow and transparency. Fast-drying synthetic glaze mediums speed up the drying process. Linseed oil is not suitable as a glazing medium: because a high proportion of oil is needed to make the paint transparent, it will simply run down the support. Turpentine makes the colour go flat and dull, and a cracked surface is the result if it is applied over paint containing a high proportion of oil.

• Glazing over other paints
Save time by glazing with oils over an underpainting done in egg tempera, alkyds or acrylics, all of which dry in minutes rather than days. Acrylics must be applied thinly, otherwise the oil-paint layer may lack adhesion and there is a danger of cracking. Although oil paint can be applied over acrylic, the reverse is not possible.

Comparative effects
In glazing, a third colour is produced by laying a thin wash of colour over another, dry, colour. Glazed colours appear richer and more luminous than colours mixed on the palette. Here a transparent glaze of cobalt blue applied over cadmium yellow light produces a lively colour (top). However, the same combination of two colours mixed on the palette produces a flatter effect (above).

► SEE ALSO
► Diluents 75
► Mediums 76
► The language of colour 214

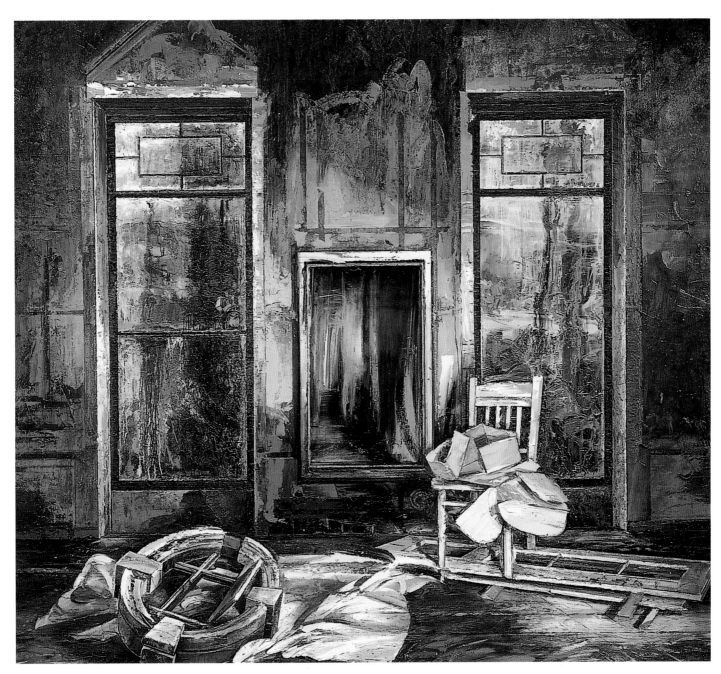

Applying a glaze

For best results, choose a transparent colour, such as cobalt blue or raw sienna, and avoid opaque colours such as the cadmiums. The underpainting must be touch-dry before a glaze can be applied over it. Mix the paint with glaze medium to the consistency of thin cream; do not over-thin to make the paint transparent. Apply the glaze and leave for a few minutes. If the glaze is too strong, take a clean, dry fan blender (or an old shaving brush) and dab the glaze with short strokes, holding the brush vertically. This process removes some of the paint, leaving a soft, lustrous film through which the underpainting is visible. As paint builds up on the bristles, dab them regularly on a piece of rag to keep them clean and dry.

John Monks
Portrait of a Room
Oil on canvas 225 x 300cm (110 x 120in)

In this interior, the box and chair were painted with a palette knife before earth-colour glazes were overlaid. Monks painted the landscape through the windows and then used a soft brush to apply glazes on top. The window frames were painted directly over the glazing, to create depth.

▶ **SEE ALSO**
▶ **Alkyd paints 66**
▶ **Tempera 108**
▶ **Acrylic paints 110**

Impasto

In contrast to glazing – the methodical building-up of thin layers of paint – impasto involves applying the paint thickly and liberally, so that it retains the marks and ridges left by the brush. Most artists enjoy the expressive and textural qualities which impasto gives to a painting, and the buttery consistency of oil paint lends itself well to this technique.

Techniques

Impasto can be applied with a brush or a painting knife. The paint may be used straight from the tube, or diluted with a little medium so that it is malleable, yet thick enough to stand proud of the support.

When thick layers of paint are left to dry slowly, cracking or wrinkling of the paint film may occur. This can be avoided by using a fast-drying alkyd medium or one of the mediums specifically designed for use with impasto work. These thicken the paint without altering its colour, speed the drying process, and make the paint go a great deal further, into the bargain.

Excessively oily paints make it difficult to achieve highly textured, impasto brushstrokes. Squeeze such a paint onto absorbent paper and leave it for a few minutes – not too long, or it will become underbound. The paper absorbs excess oil, and the paint has a stiffer consistency.

Planning

A heavily impasted painting should look free and intuitive, but will need careful planning. Just as colour loses its vitality when too thoroughly mixed on the palette, directly applied paint quickly loses its freshness when the pigment is pushed around on the canvas for too long, or carelessly applied. Oil paint has a wonderful tactile quality, and the temptation is to build it up in juicy dollops. The danger is that each new brushstroke picks up colour from the one below, and the result is muddy colour and an unpleasant, churned-up surface. You can rescue an oil painting by tonking it (see right), or by scraping the wet paint off with a painting knife and starting again. However, it is best to avoid the problem in the first place by starting with a thin underpainting and gradually building up thicker layers.

Brushes

Flat bristle or synthetic brushes are best for impasto work, as they hold a lot of paint. Load the brush with plenty of colour and dab it onto the canvas, working the brush in all directions to create a very obvious, almost sculptural texture. Be sure your brush carries plenty of paint, apply it with a clear sense of purpose, and then let it stay.

Straight from the tube
Oil paint may be used straight from the tube, or diluted with a little medium to make it malleable enough to stand proud of the support.

Extra texture
Try mixing sand and sawdust with oil paint to create a highly textured surface. You can also make expressive marks by scratching into the wet paint with a painting knife, the end of a brush handle, or any sharp tool.

Glazing over impasto
Once an impasted layer is completely dry, you can glaze over it, if desired, with a thin film of paint mixed with a glaze medium. The glaze must contain more oil than the underlayers, to prevent cracking.

Tonking
If an oil painting becomes clogged with too much paint, the excess can be removed when still wet by tonking. Place a sheet of absorbent paper, such as newspaper or toilet tissue, over the overloaded area and gently smooth with the back of the hand. Peel the paper away, lifting excess paint with it.

Arthur Maderson
Evening Light on River
Oil on canvas
85 x 85cm (34 x 34in)

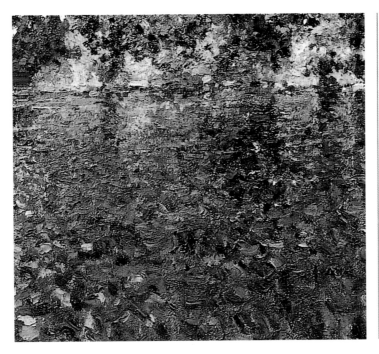

Impasto

The paintings on this page show just three of the many textures and effects possible with impasto.

Arthur Maderson's painting (left) is composed entirely of impasted brushmarks, which have been dabbed and stippled to create a shimmering mosaic of colour. The use of complementary colours enhances the vibrancy.

In Ian Houston's coastal landscape (below), small touches of impasto provide a contrast with the areas of smooth paint. The raised touches appear to come forward, thereby increasing the depth in the picture.

George Rowlett uses an extremely heavy impasto to achieve a three-dimensional, sculptural quality in his painting (below left). Note the braid on the right, which ends up off the support.

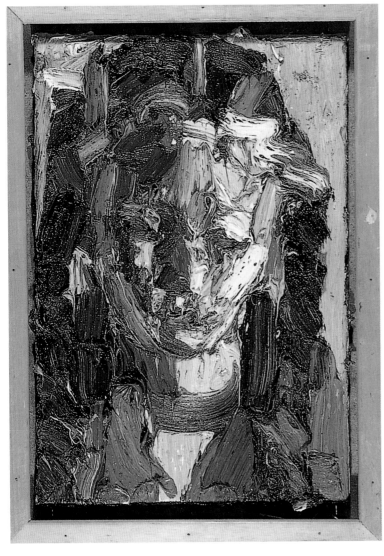

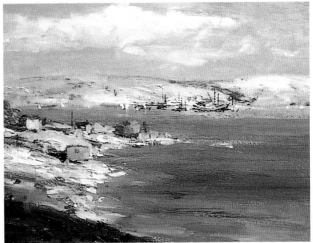

Ian Houston (above)
Symi
Oil on canvas
40 x 60cm (16 x 24 in)
Kentmere House Gallery, York

George Rowlett
(left)
Head of Hannah Dunn
Oil on canvas
40 x 23.7cm (16 x 9½in)

▶ SEE ALSO
▶ Supports 14
▶ Mediums 76
▶ Brushes 78
▶ Fat-over-lean 166
▶ Alla prima 168
▶ Knife painting 174

Knife painting

• **Scraping back**
Painting knives can be used to push the paint into the weave of the canvas and build up a series of translucent stains. Alternatively, scrape some of the paint off the canvas while it is still wet, leaving behind a thin layer of colour, a 'ghost image', on the support. Further layers may be added and then scraped back, to partially reveal the colours beneath. The finished effect is delicate and subtle, with minimal brushmarks.

Painting knives may be used instead of, or as well as, brushes, to apply thick impastos of oil paint. Painting knives should not, however, be confused with palette knives, which have stiffer blades and are mostly used for mixing paint on the palette. A painting knife has a shorter blade and a cranked handle, to prevent the knuckles accidentally brushing against the canvas when applying paint. The blade is made of forged steel, giving it spring and flexibility, and allowing sensitive control.

Many uses

Although a painting knife is by no means an essential piece of equipment, many artists enjoy the tactile sensation of applying thick, juicy oil paint to the canvas with a knife, moving it around and partially scraping it off with the edge of the blade, or scratching into the wet paint, to suggest details and texture.

Painting with a knife is initially trickier than painting with a brush, so it is wise to practise until you get the feel of it. By holding the knife at different angles, varying the pressure on the blade and using different parts of the blade, you can achieve quite different strokes and effects. For example, painting with the flat base of the blade, spreading the paint very thickly, produces a smooth surface that reflects the maximum amount of light.

Holding the knife at a slight angle to the canvas and applying firm pressure will give a thinner covering, which allows the texture of the canvas to show through the paint. Using a brisk patting motion with the tip of the blade creates a rough, stippled texture. You can also use the tip of the blade to scratch through a layer of wet paint and to reveal the colour beneath, a technique known as sgraffito.

Techniques

Pick up the paint on the underside of the knife. To make bold, broad strokes, grip the knife handle as you would a trowel, and use the full width of the blade to squeeze the paint onto the surface. Do not move the knife back and forth; instead, set it down firmly on the canvas and spread the paint with a single, decisive movement, lifting the blade cleanly away when the stroke is completed.

To lay in smaller patches of colour, grip the handle and push the index finger against the steel shaft; this will give greater control when working over smaller and more delicate areas.

Laying in smaller patches of colour

Laying in bold, broad strokes

▶ **SEE ALSO**
▶ **Accessories 86**

Knives for painting
Painting and palette knives, and even a scraper can be used.

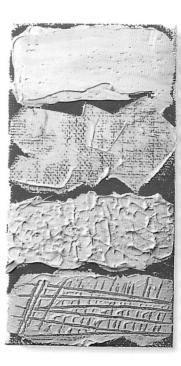

Applying paint
Be generous with the paint, applying enough to fill the grain of the canvas. Take care not to build it up too thickly, or it may crack in time.

Utilize the flat base of the blade to produce a smooth surface (top). Hold the knife at a slight angle to give a thinner covering and allow the texture of the canvas to show through (second row). Make a brisk patting motion with the tip of the blade to create a rough, stippled texture (third row). Scratch through a layer of wet paint with the tip of the blade, to reveal the colour beneath (bottom).

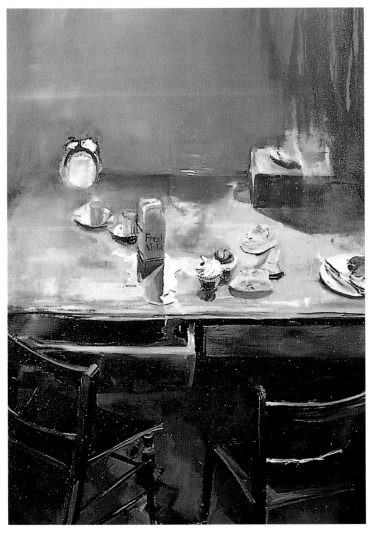

Sophie Knight
Spilt Milk
Oil on canvas
150 x 105cm (60 x 42in)

John Denahy
Bosham
Oil on canvas
31.2 x 37.5cm (12½ x 15in)

Tory Lawrence
Four Sheep
Oil on canvas
35 x 75cm (18 x 30in)
Montpelier Studio, London

Knife painting

Painting knives are usually associated with thick impasto, but they are capable of detailed and delicate effects.

Sophie Knight combines textures and techniques (above). For the table top and background she used wet-in-wet washes; in contrast, the cakes and spilt milk consist of thick paint, sculpted and smoothed with a knife.

John Denahy uses knives, brushes and scrapers to apply paint, overlaying transparent glazes with broken, opaque passages. In this painting (above right), the thin lines of the masts were made by loading the edge of a knife with paint and pressing it onto the surface.

Knife strokes are always part of Tory Lawrence's painting process. The ridged and smeared features that create a lively texture were built up with knives and brushes, while linear marks were scratched into the paint with the tip of the knife.

Scumbling, drybrush & blending

While oil paints are well suited to thick applications and strong brushwork, they are equally capable of producing subtle textures and softly blended passages in which there is a gradual transition from light to shadow or from one colour to another: for example, the gradation of a blue sky from strong colour at the zenith to pale on the horizon, or the subtle effects of light and shade in a portrait.

Scumble
A thin film of dry, semi-opaque colour on a dry underlayer.

Scumbling

Scumbling is an excellent way of modifying colour while retaining the liveliness of the paint surface. A thin film of dry, semi-opaque colour is loosely brushed over a dry underlayer, creating a delicate 'veil' of colour. Because the technique involves unequal applications of paint, the underlayer is only partially obscured, and it shimmers up through the scumble. For example, white scumbled over a black underlayer creates an optical blue; crimson scumbled over this produces an optical violet.

Modifying colour

Try scumbling over a colour with its complementary (opposite) colour. The two mix optically and thus appear more resonant than an area of flat colour. Similarly, a colour which is too 'hot' can be modified with a cool scumble, and vice versa. A scumble should be lighter than its background colour; add a touch of titanium white to the pigment, to lighten it and make it semi-opaque.

Techniques

Use a bristle or synthetic brush for scumbling. Indeed, an old, worn brush is preferable, because the scrubbing action may damage the hairs of your best brushes if you use the technique frequently. Load the brush with diluted paint and wipe it on a rag to remove any excess. Lightly scrub on the support with free, vigorous strokes, to produce a very thin film of colour. The paint can be worked with a circular motion, with back-and-forth strokes, or in various directions. You can also scumble with a clean, lint-free rag.

Brushes for scumbling
Use old, worn brushes, as the scrubbing action may damage the hairs of your best brushes.

Resonant effect
Scumbling over a colour with its complementary colour.

Modifying colour
A warm or hot colour can be modified by scumbling with a cool or cold colour.

▶ **SEE ALSO**
▶ Brushes 78
▶ Glazing 170
▶ The language of colour 214
▶ Mixing colours 220

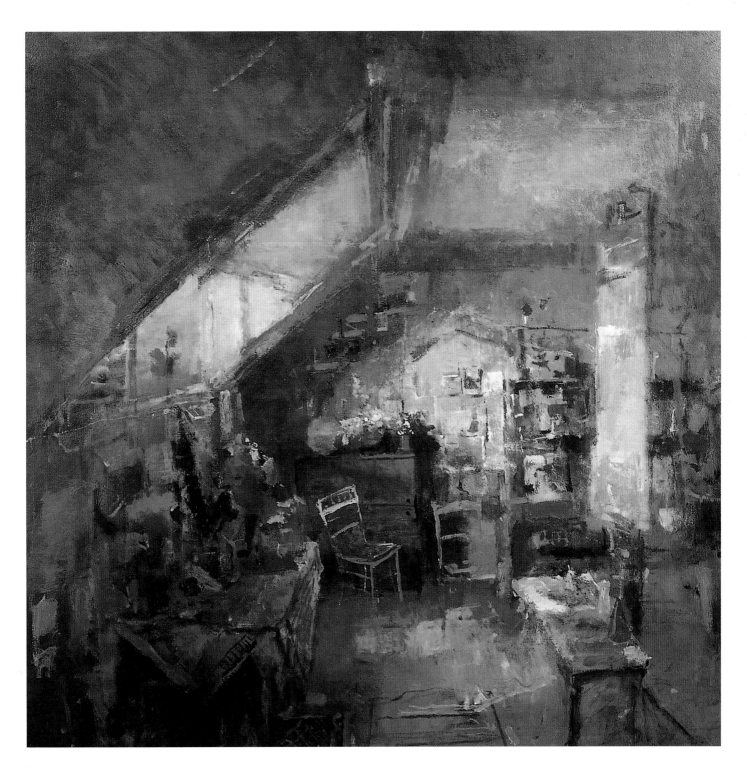

Fred Cuming
Studio Interior, Early Morning
Oil on hardboard
90 x 85cm (36 x 34in)
Brian Sinfield Gallery, Burford

The artist worked over the whole canvas with thin veils of stiff, chalky paint, scumbled and dragged over dried underlayers. The interaction between the two layers produces a soft, pearly effect which is particularly evocative. Each colour modifies the preceding one and creates subtle harmonies of tone and colour.

Drybrush

This is most successful when there is already some existing texture, either that of the canvas or that provided by previous brushstrokes, which helps to break up the paint. With drybrush, a small amount of neat colour is picked up on a brush and skimmed lightly over a dry painting surface. The paint catches on the raised 'tooth' of the canvas and leaves tiny speckles of the ground, or the underlying colour, showing through. The brushstrokes should always be made quickly and confidently, as overworking destroys the effect.

The ragged, broken quality of a drybrush stroke is extremely expressive, and this technique is particularly suitable for when you want to suggest and depict natural textures and effects in your painting, such as weathered wood and rock, long grass, or the sparkle of light on water.

Blending

The soft, pliant consistency of oils, and their prolonged drying time, enable the artist to brush and re-brush the area where two colours or tones meet, so that they merge together imperceptibly.

Depending on the subject and the style of the painter, blending can be achieved simply by dragging one colour over the edge of the next so that they are roughly knitted together but the marks of the brush are evident. Alternatively, it can involve methodically stroking with a soft-hair brush or fan blender, to create a smooth, highly finished join in which the marks of the brush are invisible.

Drybrush

Two contrasting uses show the technique's versatility.

In Arthur Maderson's painting (below left), dry, chalky paint, deposited on the crests of the canvas weave, creates broken strokes suggesting movement and light on water.

Annabel Gault uses rapid calligraphic drybrush strokes to capture the gestures of windswept trees (below). The economy of line is reminiscent of oriental brushwork.

▶ **SEE ALSO**
▶ Brushes 78

Annabel Gault
Trees
Oil on paper
26 x 35cm (10³/₈ x 14in)
*Redfern Gallery,
London*

Arthur Maderson
Pointing
Oil on canvas
37.5 x 27.5cm (15 x 11in)

**Derek Mynott
(1926–94)**
*Towards Lots Road,
1990*
Oil on canvas
55 x 47.5cm (22 x 19in)

Richard Smith
Pensive
Oil on canvas
30 x 40cm (12 x 16in)
*Brian Sinfield Gallery,
Burford*

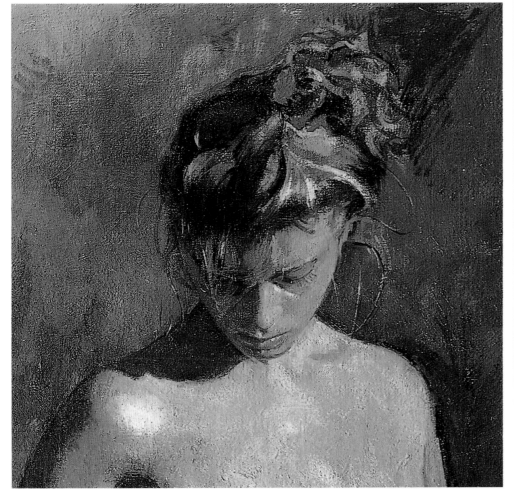

Blending

Both these paintings apply different wet-in-wet blending techniques, in order to achieve distinctive results.

Derek Mynott's meticulous and distinct brushstrokes blend the wet paint to allow tiny gradations of tone and hue, to create an impression of soft, hazy light (left).

In his striking figure study (below left), Richard Smith gently blended paint applied wet-in-wet; this subtle use of tone and colour captures the youthful sheen of the model's skin and hair.

Two styles of blending

With rough blending (top), the colours are roughly knitted together, and the brushmarks are evident. In contrast, smooth blending (above) produces a highly finished join in which the marks of the brush are invisible.

179

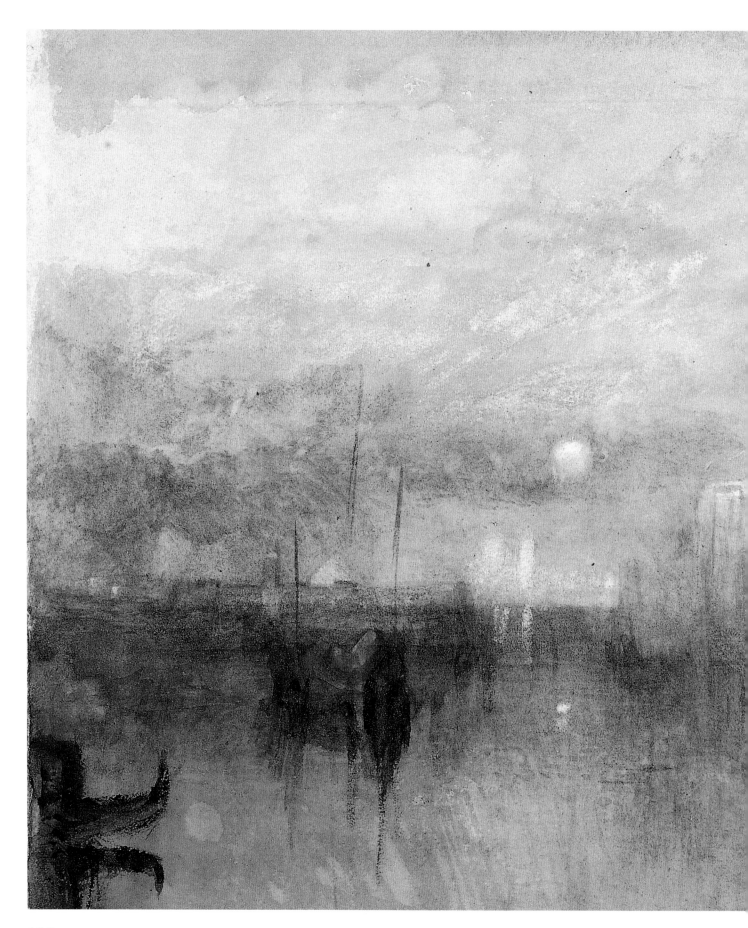

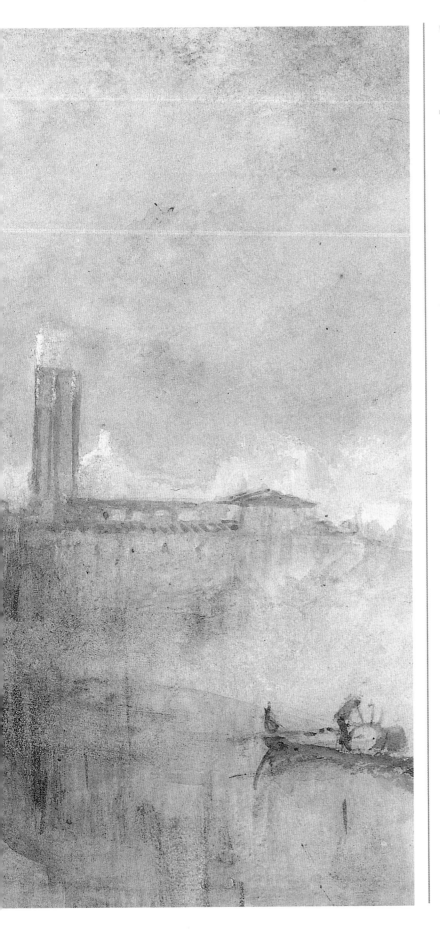

Watercolour techniques

This has a delicacy and transparency that makes it the perfect medium for capturing the subtle nuances of light and colour in nature. Because the paint is transparent, the white reflective surface of the paper shines through the colours, and gives them their unique luminosity. The fluid nature of watercolour makes it less predictable than other painting media, but this is more than compensated for by the range of exciting and beautiful effects it can create – sometimes more by accident than design. The element of chance and risk can make watercolour a frustrating medium, as well as an exciting and challenging one. However, armed with the right equipment and a basic understanding of how pigments, water and paper interact, you can stay one step ahead of the game.

J. M. W. Turner (1775–1851)
Venice Suburb, Moonlight, 1821
Watercolour on paper
22 x 31.9cm (8¾ x 12¾in)
Tate Gallery, London

Wash techniques

Washes are the very foundation of watercolour painting. One of the unique qualities of the medium is the way in which atmosphere and light can be conveyed by a few brushstrokes swept over sparkling white paper.

Choosing paper

The appearance of a wash depends on several factors: the type of pigment used and the level of dilution; the type of paper; and whether the surface is wet or dry when the wash is applied. For example, when washes are applied to an absorbent, low-sized paper, they dry with a soft, diffused quality. On hard-sized paper, wet washes spread more quickly and with less control, but this can create exciting effects. When a wash is laid on dampened paper, the paint goes on very evenly, because the first application of water enables the pigment to spread out on the paper and dissolve without leaving a hard edge. Working on dry paper gives a much sharper, crisper effect, and some painters find it a more controllable method.

Sized paper
The effect of painting washes on low-sized paper (below left) and hard-sized paper (bottom left).

Damp and dry paper
Washes laid on damp paper (below right) and dry paper (bottom right), both medium-sized.

• **Laying washes**

These tips will help you to make successful washes.

• Mix more colour than you think will be needed to cover an area – you cannot stop in the middle of laying a wash to mix a fresh supply.

• A watercolour wash dries much lighter than it looks when wet, so allow for this when mixing paint.

• Tilting the board at a slight angle will allow a wash to flow smoothly downward without dripping.

• Use a large round or flat brush. The fewer and broader the strokes, the less risk of streaks developing.

• Always keep the brush well loaded, but not overloaded. Streaking is caused when a brush is too dry, but if your brush is overloaded, washes can run out of control.

• Don't press too hard. Sweep the brush lightly, quickly and decisively across the paper, using the tip, not the heel.

• Never work back into a previously laid wash to smooth it out – it will only make matters worse.

Low-sized paper for soft and diffused washes Medium-sized wet paper for softer washes

Hard-sized paper for quick-spreading washes Medium-sized paper for sharper, crisper washes

▶ SEE ALSO
▶ **Watercolour papers 28**
▶ **Stretching paper 33**
▶ **Watercolour brushes 96**
▶ **Watercolour accessories 102**
▶ **Flat and graded washes 184**
▶ **Wet-in-wet 188**
▶ **Wet-on-dry 189**

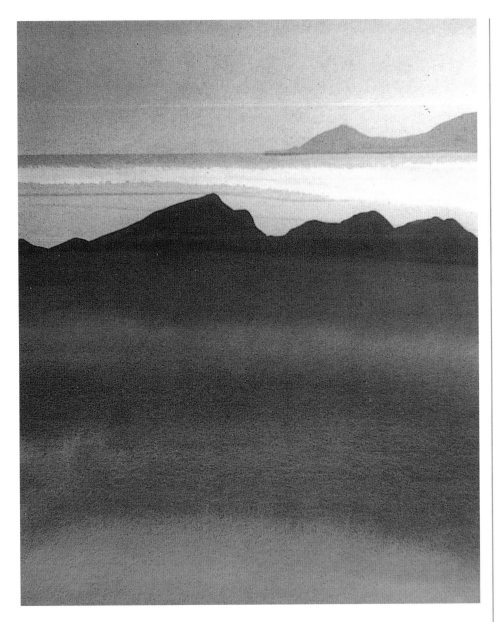

Wash-laying equipment
As well as natural sponges, synthetic-sponge rollers and sponge brushes (above) can be used to lay a smooth wash. For a dense, thick covering, make sure the sponge is filled with plenty of paint. For paler tones or variegated effects, squeeze out some of the paint.

Robert Tilling
Rocks, Low Tide
Watercolour on paper
50 x 65cm (20 x 26in)

Tilling uses the wet-in-wet method to explore the interactions of sky, sea and land. He mixes large quantities of paint in old teacups and applies it with large brushes, tilting his board at an acute angle so that the colours flow down the paper, then reversing the angle to control the flow. When the paper has dried, he paints the dark shapes of rocks and headland wet-on-dry for more crisp definition.

Achieving smooth washes

Laying a large, overall wash free of streaks or runs requires practice. Where heavy washes are to be applied, the paper must be stretched and taped firmly to a board, to prevent cockling or wrinkling. Opinions vary as to whether large areas of wash should be laid on dry or damp paper. Some artists find that a uniform tone is easier to achieve on dry paper, while others find that the paint streaks. Some feel that washes flow more easily on damp paper, and still others find that slight cockling, even of stretched paper, can produce streaks and marks as the paint collects in the 'dips'. Results vary, too, according to the type of paper used; the only answer is to experiment for yourself.

Flat and graded washes

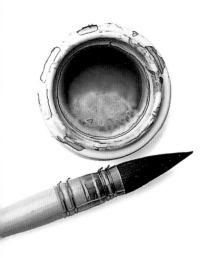

There are two basic types of wash: a flat wash is evenly toned and is often used to cover the whole area of the paper with a unifying background colour. A graded wash moves gradually from light to dark, from dark to light, or from one colour to another. Graded washes are most often used in painting skies, where the colour fades gradually towards the horizon.

Flat washes

Water colourists normally employ flat washes as integral parts of a painting, frequently overlaying one wash with another. However, a flat wash is also used merely to tint white paper as a background for body colour or gouache.

▶ **SEE ALSO**
▶ **Wash techniques 182**
▶ **Wet-in-wet 188**
▶ **Wet-on-dry 189**
▶ **Skies 286**

Laying a basic wash
Here the flat-wash method is used to create an overall sky effect using diluted indigo blue.

1 Mix up plenty of colour in a saucer or jar. Place the board at a slight angle, then dampen the paper surface with water, using a mop brush or a sponge.

2 Load the brush with paint and draw a single, steady stroke across the top of the area. Due to the angle of the board, a narrow bead of paint will form along the bottom edge of the brushstroke; this will be incorporated into the next stroke.

3 Paint a second stroke beneath the first, slightly overlapping it and picking up the bead of paint. Continue down the paper with overlapping strokes, each time picking up the excess paint from the previous stroke. Keep the brush well loaded with paint.

4 Use a moist, clean brush to even up the paint that gathers along the base of the wash. Leave to dry in the same tilted position, otherwise the paint will flow back and dry, leaving an ugly tidemark.

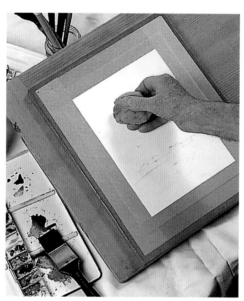

1 Dampen the paper surface with a sponge.

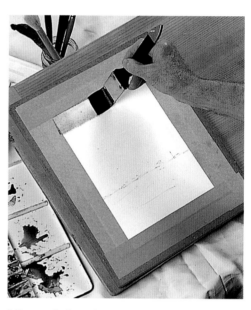

2 Draw a single stroke across the top.

3 Paint a second stroke beneath the first.

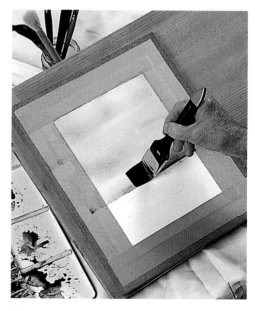

4 Even up any paint that gathers along the base.

Graded washes

The method of applying a graded wash is the same as for a flat wash, except that with each successive brushstroke the brush carries more water and less pigment (or vice versa if you are working from light to dark).

It takes a little practice to achieve a smooth transition in tone, with no sudden jumps. The secret is to apply a sufficient weight of paint so that the excess flows very gently down the surface of the paper, to be merged with the next brushstroke.

1 Lay a line of colour at full strength across the top.

2 Add more water and lay a second band of colour.

3 Continue down the paper adding water to the paint with each stroke.

Variegated washes

The technique shown below enables you to lay two or more colours in a wash.

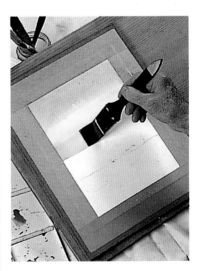

Mix your chosen colours beforehand, and then apply the first line of colour along the top of the paper. Always washing the brush between colours, apply another colour, partly on blank paper and partly touching the first. Repeat this with any other colours.

185

John Blockley
Shop Flowers
Watercolour on
paper
43.2 x 43.2cm
(17 x 17in)

Sophie Knight
*Still-life
Reflections*
Watercolour and
acrylic on paper
35 x 55cm (14 x 22in)

Roy Hammond
London Sunset
Watercolour on paper
16.2 x 23.7cm (6$\frac{1}{2}$ x 9$\frac{1}{2}$in)
Chris Beetles Gallery, London

Variety and contrast (opposite)
A flower painting, a table-top still life and a landscape demonstrate some of the variety of technique and contrast of style which can be achieved with watercolour.

The flower painting (above left) belies watercolour's reputation for being a medium for little old ladies. Blockley attacks his subjects with gusto – using broad household paintbrushes to apply vertical streaks of colour in the foreground.

Watercolour is combined with acrylic paint (above right) to give it body while retaining its translucence. Most of the paint is applied wet-in-wet, so that the shapes and colours are suggested rather than literally described.

The evening sky (below left) has been beautifully described by means of graded washes of pale, pearly colour. The dark tones of the buildings, painted with overlaid washes, accentuate the luminosity of the sky.

Different approaches (right)
Experiment with watercolour and get to know its characteristics. With experience, you will develop a painting style as unique and individual to you as your handwriting style.

It is interesting to compare the two very different approaches to a similar theme adopted here by Penny Anstice and Ron Jesty. Working on damp paper, Anstice applies wet pools of colour and allows them to flood together, relishing the element of chance that makes wet-in-wet such an exciting technique.

In contrast, Jesty uses a careful and methodical approach, building up form and tone with superimposed washes applied wet-on-dry. He leaves the painting to dry between stages so that the colours aren't muddied but remain crisp and clear.

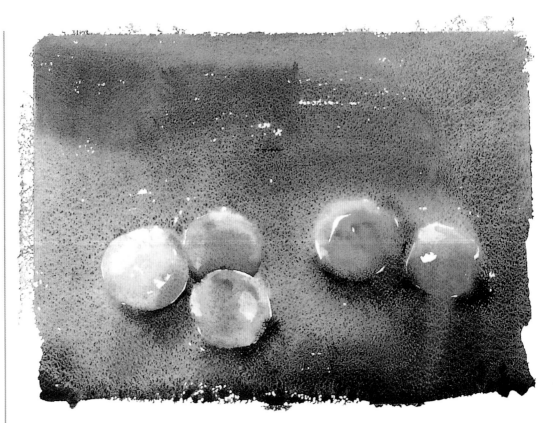

Penny Anstice
Nectarines
Watercolour on paper
30 x 45cm (12 x 18in)

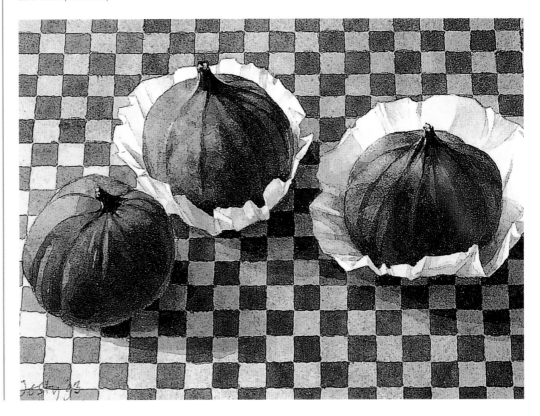

Ronald Jesty
Three Figs
Watercolour on paper
15 x 20.6cm (6 x 8¼in)

187

Wet-in-wet

Wet-in-wet is one of the most expressive and beautiful techniques in watercolour painting. When colours are applied to either a damp sheet of paper or an area of still-wet paint, they run out over the wet surface, giving a soft, hazy edge to the painted shape. This technique is particularly effective in painting skies and water, producing gentle gradations of tone which evoke the ever-changing quality of light.

Choosing paper

It is essential to choose the right type of paper for wet-in-wet. Avoid papers which are too smooth or which are heavily sized, as the paint tends to sit on the surface. A gently absorbent Not (cold-pressed) surface is ideal, allowing washes to fuse into the paper structure. The paper should also be robust enough to bear up to frequent applications of water without cockling. Lighter papers must be stretched and taped to the board. With heavier-grade papers of 410gsm (2001b) or over, you may get away without stretching, but where heavy applications of wash are to be used, it is best to err on the side of caution.

Wet-in-wet effects
Paint applied directly onto wet paper (top). Paint applied into wet paint (centre). Controlled single-colour paint run on wet paper (right).

Controlling

Although wet-in-wet painting produces spontaneous effects, it takes practice and experience to be able to judge how wet the paper and the strength of the washes need to be, in order to control the spread and flow of the paint. Use a soft sponge or large brush to dampen the paper with clean water. The surface should be evenly damp overall; use a tissue to blot up any pools of water, then take your courage in both hands – and your brush in one – and apply the colours. Work quickly and confidently, allowing the colours to diffuse and go where they will. Some degree of control can be gained by tilting the board in any direction, but only slightly – this is where the interest and creative tension come in. If a wash runs out of control or goes where it shouldn't, lift out some of the colour with a soft, dry brush, or gently blot it with a tissue.

Dilution and colour

Make sure you don't over-dilute paint, as this can make the finished picture appear pale and wan. Because you have wetted the paper, it is possible to use rich paint – but not so thick that it doesn't spread. The paint will keep its rich hue as it softens on the damp paper. The colour will appear darker when wet and will dry to a lighter shade, particularly where an absorbent paper is used, so make allowances for this when applying paint.

Tilting the board
The board should be tilted at an angle of roughly 30 degrees so that the colours can flow gently down the paper. If the board is laid flat, washes cannot spread and diffuse easily, and there is a danger of colours creeping back into previously laid colours, creating unwanted marks and blotches.

▶ SEE ALSO
▶ Watercolour papers 28
▶ Stretching paper 33
▶ Wash techniques 182

Wet-on-dry

In this classic technique, tones and colours are applied in a series of pure, transparent layers, one over the other, each wash being allowed to dry before the next is added.

Superimposed colour

The dry surface of the paper 'holds' the paint, so that brushstrokes will not distort or run out of control. Light travels through each transparent wash to the white paper beneath, and reflects back through the colours. Superimposed washes of thin, pale colour result in more resonant areas of colour than can be achieved by a single, flat wash of dense colour.

Choosing paper

The most suitable paper for this technique is one which is surface-sized, presenting a smooth, hard surface that holds the paint well. Working wet-on-dry requires a little patience, as each layer must dry before the next is applied; otherwise the colours will mix and become muddied, and crispness and definition are lost. To speed up the process, you can use a hair dryer on a cool-to-warm setting – let the wash sink in a little first, otherwise it will get blown around on the paper and lose its shape.

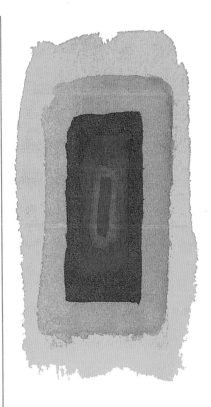

Keeping colours fresh
If you apply too many layers of paint, the attractive delicacy and freshness of the medium may be lost. It is best to apply a few layers confidently rather than risk muddying the painting by continually adding more, so it is advisable always to test colours by layering them on scrap paper (above) before committing them to the surface. Another common cause of muddy colours is dirty water, so always rinse your brush thoroughly between colours and ensure that you regularly refill your water jar with clean water.

Patrick Procktor
Portrait of Emil Asano
Watercolour on paper
63.5 x 47cm
(25½ x 18¾in)
Redfern Gallery,
London

The success of this painting relies on the simplicity of the design and the controlled, almost restrained, use of two basic watercolour techniques. A series of flat washes indicates the walls and furnishings, capturing the oriental simplicity of the interior. The pattern of the blouse employs the wet-in-wet technique, successfully conveying the softness and fluid colour of the model's costume, which is also reflected in the table top. Note, too, the softness of the hairline against the background, again achieved by working wet-in-wet.

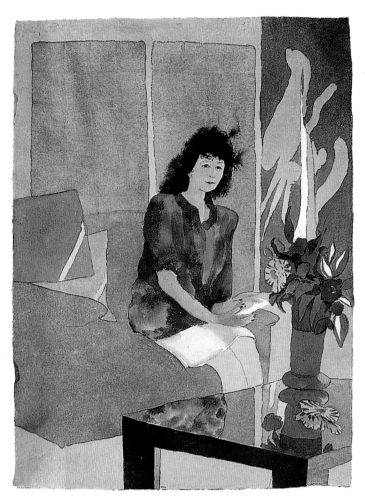

Creating highlights

Many inexperienced water colourists make the mistake of trying to cover every part of the paper with paint: in fact, with watercolour this is neither necessary nor desirable. The light-reflecting surface of watercolour paper provides a uniquely brilliant white which can be used to great effect, adding sparkle to your colours and allowing the painting to 'breathe'. Described below are some of the techniques that may be used to manipulate the paint to create white highlights in a watercolour wash.

Reserving white areas

The simplest way to create white highlights in a watercolour painting is to paint around them, thereby preserving the white of the paper, with its brilliant light-reflecting properties. Reserving highlights in this way requires careful planning, because it is not always possible to retrieve the pristine white of the paper once a colour has been inadvertently applied.

 When you paint around an area to be reserved for a highlight, the paint will dry with a crisp hard edge. For a softer edge, work on damp paper or blend coloured edges into the white area with a soft, damp brush while the paint is still wet.

Lifting out

Another method of creating highlights is by gently removing colour from paper while it is still wet, using a soft brush, a sponge or some tissue. This lifting-out technique is often used to create soft diffused highlights, such as the white tops of cumulus clouds. It can also be used to soften edges and to reveal one colour beneath another.

 Paint can be lifted out when it is dry by gentle coaxing with a damp sponge, brush or a cotton bud. The results will vary according to the colour to be lifted (strong stainers such as alizarin crimson and phthalocyanine green may leave a faint residue) and the type of paper used (paint is more difficult to remove from soft-sized papers). In some cases, pigment may be loosened more easily using hot water, which partially dissolves the gelatine size used on the surface of the paper.

Using body colour

Some of the greatest watercolourists, from Dürer to Turner to Sargent, used touches of body colour for creating the highlights in their paintings, with some breathtaking results. As long as the opaque parts of your painting are as sensitively and thoughtfully handled as the transparent areas, they will integrate naturally into the whole scheme.

Creating a soft edge
Use damp paper or blend into the white area with a soft, damp brush.

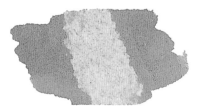

Lifting out wet paint
Use a soft brush, a sponge or tissue for creating soft highlights.

Lifting out dry paint
Use a damp sponge, brush or cotton bud.

Using body colour
Small amounts of body colour can provide the finishing touches.

▶ **SEE ALSO**
▶ **Watercolour papers 28**
▶ **Pigment and colour 92**
▶ **Body colour 93**
▶ **Watercolour accessories 102**

William Dealtry
North Yorkshire Stream
Watercolour on paper
16.2 x 22.5cm (6½ x 9in)
*Brian Sinfield Gallery,
Burford*

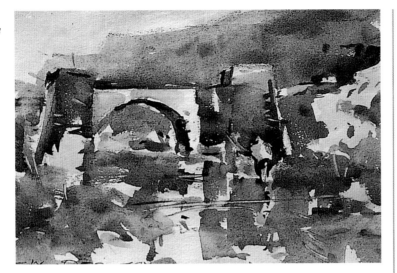

In this fresh painting, broad washes have been rapidly manipulated with a flat brush, simplifying the scene almost to abstraction, yet keeping its essential character. The unpainted areas serve to give an impression of movement and changing light.

Trevor Chamberlain
Bowls Match, Sidmouth
Watercolour on paper
22.5 x 30cm (9 x 12in)

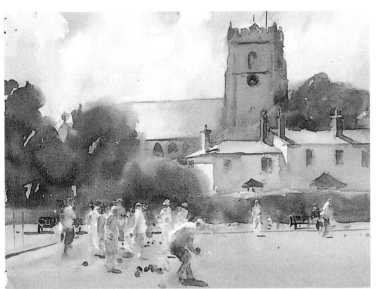

Chamberlain's painting of a quintessential country scene exudes an air of calm and tranquillity. The effect of the sunlight glancing off the players' white shirts is skilfully wrought by means of a little judicious lifting out of colour to create suffused highlights.

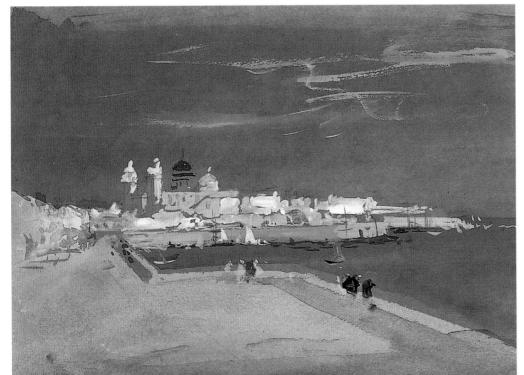

**Hercules B. Brabazon
(1821–1906)**
Cadiz, 1874
Watercolour and body colour
on tinted paper
26.2 x 35cm (10½ x 14in)
Chris Beetles Gallery, London

Although he did not receive public recognition until he was 71, Brabazon's bravura technique and boldly conceived compositions placed him among the most progressive artists of his day. This painting is typical of his ability to pare down to the essentials of his subject. It is painted with transparent colour on tinted paper, with rich, creamy accents provided by white body colour overlaid with watercolour.

191

Masking out

Because of the transparent nature of watercolours, light colours and tones cannot be painted over dark ones, as they can in oils or acrylics. Light or white areas must be planned initially and painted around. This is not difficult for broad areas and simple shapes, but preserving small shapes, such as highlights on water, can be a nuisance, as the method inhibits the flow of the wash.

One solution is to seal off these areas first with masking fluid, thus freeing yourself from the worry of accidentally painting over areas that you wish to keep white.

Using masking fluid

Masking fluid is a liquid, rubbery solution which is applied to paper with a brush. It dries quickly to form a water-resistant film which protects the paper underneath it. When both the masking fluid and the surrounding paint are dry, the fluid can be removed by rubbing with a clean fingertip or with an eraser.

Masking fluid can also be used in the later stages of a painting, in order to preserve areas of any specific tone or colour in a surrounding wash (always make sure the area to be preserved is completely dry before applying the fluid).

Ideally, masking fluid should be removed from a painting within 24 hours of application, otherwise it will be difficult to rub off and may leave a slight residue.

If you intend to use masking fluid, then choose a paper with a Not (cold-pressed) surface, from which it is easily removed; it is not suitable for rough papers, as it sinks into indents and cannot be peeled off completely.

Scratching out

Fine linear highlights, such as light catching the blades of grass, can be scratched out of a painted surface when it is dry, using a sharp, pointed tool, for instance a scalpel or craft knife, or even a razor blade. Avoid digging the blade into the paper, and work gently by degrees.

Diffused highlights

A more diffused highlight, such as the pattern of frothy water on ocean waves or waterfalls, can be made by scraping the surface gently with the side of the blade or with a piece of fine glasspaper. This removes colour from the raised tooth of the paper only, leaving colour in the indents and creating a mottled, broken-colour effect.

More delicate, muted highlights can be scratched out of paint that is not quite dry, using the tip of a paintbrush handle, or even your fingernail – Turner is said to have grown one fingernail long, especially for scratching out highlights from his watercolours.

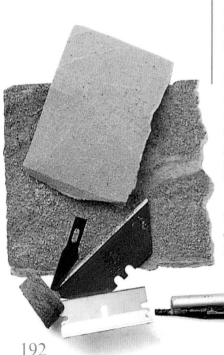

Highlights created with glasspaper

Scratched highlights and marks
The examples above show four ways of creating highlights: (from top to bottom) scratching with a blade point; scratching with a blade edge; scraping with a blunt paintbrush handle; scraping with a sharpened brush handle.

▶ **SEE ALSO**
▶ **Watercolour papers 28**
▶ **Watercolour brushes 96**
▶ **Watercolour accessories 102**

Blades, abrasive papers and sharpened brush handles make useful highlighting tools.

Cleaning brushes

Masking fluid is tough on brushes – even with careful cleaning, dried fluid can build up on brush hairs over a period of time. Always use cheap synthetic brushes to apply fluid – not your best sable! The best method of cleaning synthetic brushes is to rinse them in lighter fuel and leave them to dry.

Shirley Trevena
White Lilies on a Patterned Screen
Watercolour and gouache on paper
45.5 x 35cm (18¼ x 14¼in)

On the oriental screen (see detail above), the patterns were painted with masking fluid before the dark washes were applied. The mask was then removed and the mother-of-pearl colours painted in.

• Using masking fluid

Shake the bottle before using to ensure the correct consistency. Too-thin fluid will not resist paint. Once opened, a bottle of masking fluid has a shelf life of around one year. After this, it will not work well. Excessive heat can make it unworkable. When painting in hot climates, store masking fluid somewhere cool, and work in the shade when applying it to paper.

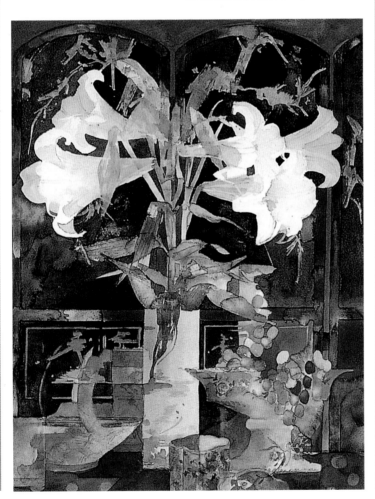

Erasing masking fluid

Use a pencil eraser or a fingertip.

Masking-fluid effects

Masking fluid is an invaluable accessory to watercolour painting. Use it where you want light areas or highlights to appear in your picture. Apply paint over the masking fluid and then remove it (see far left) to reveal the white of the paper or the previously laid colour (above).

Textures and effects

One of the main attractions of watercolour is its freshness and immediacy – its power to suggest without overstatement. The experienced artist knows that, very often, magical things happen quite unexpectedly when water and pigment interact on paper; the paint actually does the work for you, producing atmospheric effects or patterns that resemble natural textures. A 'bloom' appears in a wash, resembling a storm cloud; a wash dries with a slightly grainy quality that adds interest to a foreground; or a swiftly executed brushstroke catches on the ridges of the paper and leaves a broken, speckled mark suggestive of light on water.

Subtlety and restraint

Because these effects occur naturally, they do the job without appearing laboured. Of course, it is possible for the artist to take an interventionist approach and deliberately manipulate the paint or even add things to it, in order to imitate certain textures and surface effects. Some of these techniques are described below, but it is very important to realize that, if they are overdone, texturing techniques can easily appear facile. You should only use them with subtlety and restraint, so that they are incorporated naturally within the painting as a whole.

Granulation

This is a phenomenon which often occurs seemingly by accident, yet can impart a beautiful, subtle texture to a wash. Certain watercolour pigments show a tendency to precipitate: the pigment particles of the earth colours, for example, are fairly coarse. As the wash dries, tiny granules of pigment float in the water and settle in the hollows of paper, producing a mottled effect.

Only experience and testing will enable you to tell how much granulation may take place. Some colours granulate only when they are laid over a previous wash; and granulation may not happen at all, or may be hardly noticeable, if paint is heavily diluted.

Flocculation

A similar grainy effect can be produced by pigments, such as French ultramarine, which flocculate: the pigment particles are attracted to each other rather than dispersing evenly. This causes a slight speckling which lends a wonderful atmospheric quality to skies and landscapes in particular.

Simply by experimenting with watercolour paints, and by knowing which colours have this settling tendency, it is possible for you to suggest all sorts of different textures in your paintings, such as weatherbeaten rocks, newly fallen snow, or sand, quite effortlessly.

Pigment granulation
Some pigments show a tendency to granulate or flocculate, producing subtly textured washes, while others produce flat, even washes. An understanding of how different pigments behave will open up exciting possibilities for creating particular effects.

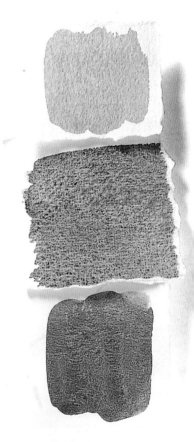

Experiment with various colours and makes to find out which pigments tend to granulate or flocculate.

▶ SEE ALSO
▶ Pigment and colour 92
▶ Accessories 102
▶ Wash techniques 182
▶ Creating highlights 190

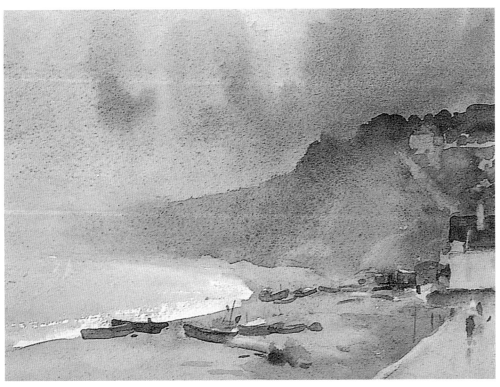

Granulation of pigments

Certain watercolour pigments separate out, giving a granular effect which can be subtly descriptive and expressive.

In each of the three paintings on this page, the artists have made quite deliberate use of granulation. It enlivens the background wash in Patrick Procktor's portrait, while Trevor Chamberlain and Robert Tilling have used it to suggest subtle, atmospheric effects in the sky and landscape.

Trevor Chamberlain (left)
Rain at Budleigh Salterton
Watercolour on paper
17.5 x 25cm (7 x 10in)

Robert Tilling (below left)
Evening Light
Watercolour on paper
65 x 50cm (26 x 20in)

Patrick Procktor (below)
Vasco
Watercolour on paper
50.8 x 35.5cm (20³/₈ x 14¹/₄in)
Redfern Gallery, London

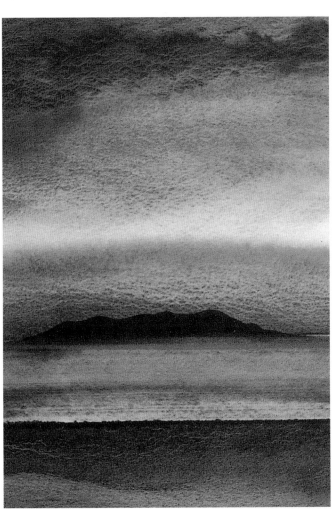

Textures and effects *(continued)*

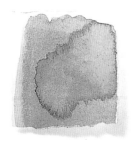

Blooms

Blooms, or backruns, will sometimes occur when a wet wash is flooded into another, drier wash; as the second wash spreads, it dislodges some of the pigment particles beneath. These particles collect at the edge of the wash as it dries, thereby creating a pale, flower-like shape with a dark, crinkled edge.

Although blooms are usually accidental – and often unwanted – they can be used to create some textures and effects that are difficult to obtain using normal painting methods. For example, a series of small blooms creates a mottled pattern suggestive of weathered, lichen-covered stone; in landscapes, blooms can represent amorphous shapes such as distant hills, trees and clouds, or ripples on the surface of a stream and they add texture and definition to the forms of leaves and flowers.

Creating blooms

It takes a little practice to create deliberate blooms. Apply the first wash and allow it to dry a little. When the second wash is applied, the first should be damp rather than wet; if it is too wet, the washes will merge together without a bloom.

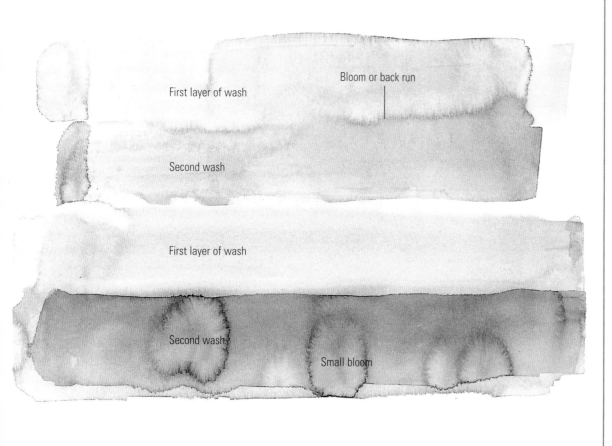

First layer of wash

Bloom or back run

Second wash

First layer of wash

Second wash

Small bloom

Making small blooms

Small, circular blooms are formed by dropping paint from the end of a brush into a damp wash. You can also create pale blooms in a darker wash by dropping clear water into it.

• Drybrush technique

This is most effective on rough textured paper, where the pigment catches on the raised tooth of the paper and misses the hollows, leaving tiny dots of white which cause the wash to sparkle with light.

Drybrush

The drybrush technique is invaluable in watercolour painting, because it can suggest complex textures and details by an economy of means. Drybrush is used most often in landscape painting, to suggest a range of natural effects such as sunlight on water, the texture of rocks and tree bark, or the movement of clouds and trees.

Moisten your brush with a very little water, and then take up a small amount of paint on the tip. Remove any excess moisture by flicking the brush across a paper tissue or a dry rag before lightly and quickly skimming the brush over dry paper.

▶ SEE ALSO
▶ Watercolour papers 28
▶ Watercolour brushes 96
▶ Accessories 102
▶ Wash techniques 182

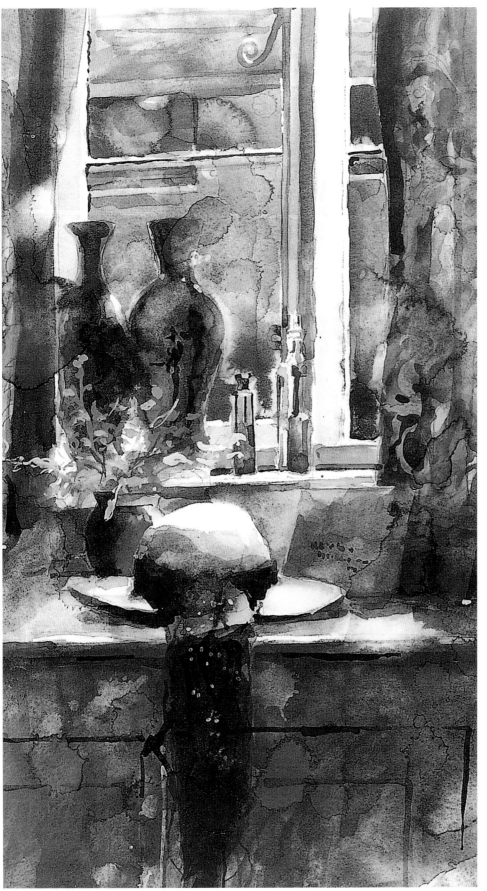

John Lidzey
Interior with Hat
Watercolour on paper
45 x 30cm (18 x 12in)

Unpredictable effects

The experienced watercolourist has experimented with a range of techniques, and knows how to exploit the element of 'happy accident' in the paint.

The mercurial, unpredictable nature of watercolour is one of its chief joys. In the still-life paintings on this page, both artists have used the descriptive potential of backruns to suggest textures and enrich the picture surface.

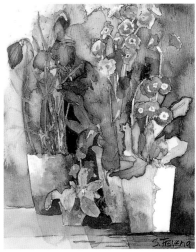

Shirley Trevena
Four Flowerpots
Watercolour on paper
27.5 x 21.5cm (11 x 8⅝in)

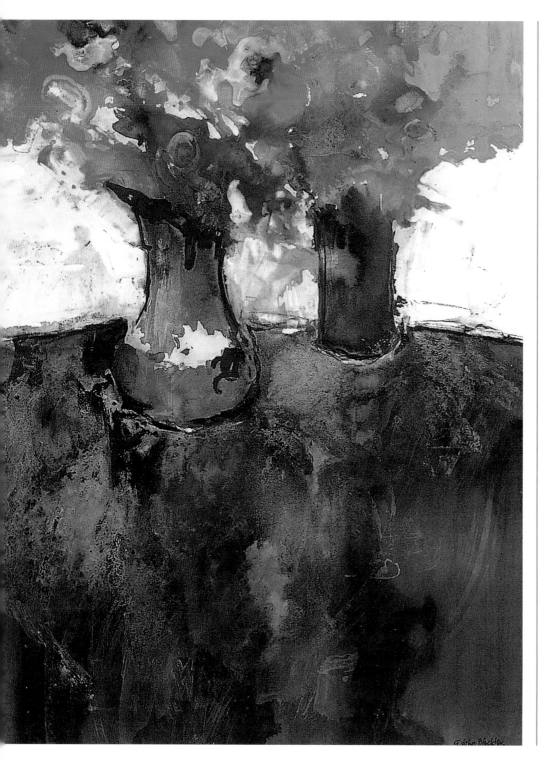

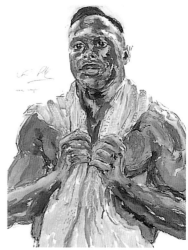

Hans Schwarz
Glazz Campbell, after Training
Watercolour on paper
80 x 55cm (32 x 22in)

Brushmarks and effects
Brushmarks and effects play a vital and expressive part in watercolour painting.

Hans Schwarz (above) has used a bold and direct approach, the brushmarks following and sculpting the forms of the face and figure to create a lively, energetic portrait.

John Blockley's painting method involves a continual and daring process. He makes some areas wetter than others, then dries only some parts with a hair dryer. He then plunges the painting into a bath of water; the dry paint remains intact, but the wet paint floats off, leaving areas of white paper lightly stained with colour.

John Blockley
Table Flowers
Watercolour on paper
47 x 38cm (18½ x 15in)

▶ SEE ALSO
▶ Watercolour papers 28
▶ Watercolour brushes 96
▶ Watercolour accessories 102

Using salt

Unpredictable effects can be obtained by scattering grains of coarse rock salt into wet paint. The salt crystals soak up the paint around them; when the picture is dry and the salt is brushed off, a pattern of pale, crystalline shapes is revealed. These delicate shapes are very effective in producing the illusion of falling snow in a winter landscape, or for adding a hint of texture to stone walls and rock forms.

Although it may seem an easy technique, timing the application of salt requires practice. The wash should ideally be somewhere between wet and damp, neither too wet nor too dry. Applying salt to a wet wash will create large, soft shapes; applying it to a barely damp wash will produce smaller, more granulated shapes. Apply the salt sparingly to a horizontal surface, let it dry, and then brush the salt off.

Using salt
As salt crystals soak up paint, a pattern of shapes emerges.

Using a sponge

Painting with a sponge can create textures and effects which are often impossible to render with a brush. For example, a mottled pattern suggesting clumps of foliage or the surface of weathered stone may be produced by dabbing with a sponge dipped in some paint. Use a natural sponge, which is softer and more absorbent than a synthetic sponge, and which has an irregular, more interesting texture.

Using a sponge
Apply paint lightly with a natural sponge for textural effects.

Wax resist

A broken texture can be created by rubbing or drawing with a white wax candle or a coloured wax crayon and then overpainting with watercolour. Wax adheres unevenly to paper, catching on the raised tooth and leaving the hollows untouched. When a wash of colour is applied, the wax repels the paint, causing it to coagulate in droplets. The broken, batik-like effect created by wax resist can be used to suggest textures and surface effects, such as rocks, tree bark, sand, or light on water or grass.

This technique works best on a Not or rough surface. Skim a candle or wax crayon across the paper so that it touches the high points but not the indents, then apply your watercolours in the normal way. When the painting is completely dry, the wax can be removed by covering it with absorbent paper and pressing with a cool iron until the paper has absorbed all the melted wax.

Using a candle
Paint over rubbed- or drawn-on wax to create natural-looking textures.

Turpentine, salt and wax can be used to create unpredictable textures.

Using turpentine

In a variation on the resist technique, turpentine or white spirit can be sparingly applied to well-sized paper, allowed to dry slightly and then painted over. The paint and the oil will separate, creating an interesting marbled effect.

Using turpentine
Another version of the resist method involves applying turpentine.

199

Gouache techniques

Gouache is somewhat underrated as a painting medium, considering how versatile it is. Like watercolour, it can be thinned with water to a fluid consistency, but its relative opacity gives it a more rugged quality, ideal for bold, energetic paintings and rapid landscape sketches. When wet, gouache can be scrubbed, scratched and scumbled, and interesting things happen as colours run together and form intricate marbled and curdled patterns.

Washes and tones

Gouache is equally suitable for a more delicate, lyrical style of painting, in which washes of thin, semi-transparent colour are built up in layers which dry with a soft, matt, velvety appearance.

With gouache colours, tones may be lightened either by adding white or by thinning the paint with water, depending on the effect you wish to achieve. Thinning with water gives gouache a semi-opaque, milky quality, while adding white gives a dense, opaque covering.

Using white
There are two whites available: permanent white (sometimes called titanium white) and zinc white. Permanent white has the greater covering power; zinc white is cool and subtle.

Painting dark-over-light

Gouache is technically an opaque paint, so you can, in theory, apply light colours over dark. In practice, though, it is best to stick to the dark-over-light method, as gouache is not as opaque as oils or acrylics – in fact some colours are only semi-opaque. Gouache will completely cover a colour if used very thick and dry, but this is not advisable, as it may lead to subsequent cracking of the paint surface.

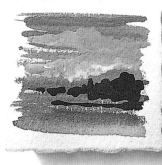

Versatile gouache
These sketchbook examples illustrate the versatility of gouache paint and show the relative opacity of this underrated medium.

Solubility

Because gouache colours contain relatively little binder, they remain soluble when dry, so an application of wet colour may pick up some colour from the layer below. This can be prevented by allowing one layer to dry completely before applying the next. Apply the paint with a light touch, and avoid overbrushing your colours.

Added white

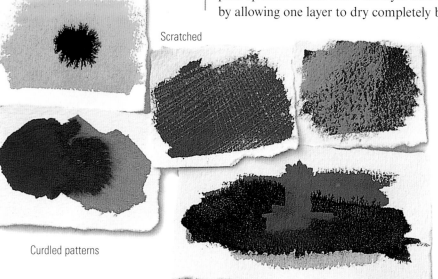

Scratched

Scrubbed and scumbled

Curdled patterns

Light paint over dark

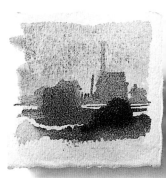

Thinned with water

Lightening tones
The examples (left and above) demonstrate how gouache colours can be modified by adding either water or white paint.

Jane Camp
Last Chukka
Gouache on paper
35 x 25cm (14 x 10in)
*Westcott Gallery,
Dorking*

This is a marvellous
example of the fluid and
vigorous use of gouache
to convey movement and
energy. The beauty of the
medium is its inherent
ability to create appropriate
textural marks, almost of
its own free will.

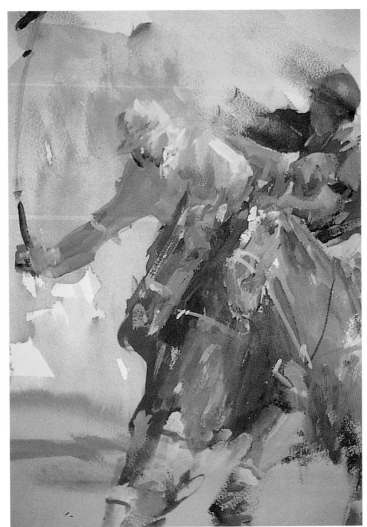

Sally Keir
Red Poppies
Gouache on paper
24 x 26.5cm (9⅜ x 10⅜in)

Although lacking the
luminous effect of pure
watercolour, gouache has
a brilliant, light-reflecting
quality that is ideally
suited to flower studies.
This painting has all the
clarity and detail of
botanical illustration, but
the vibrant intensity of
gouache colours keeps the
subject alive in a way that
many detailed flower
paintings fail to do.

Making and using gouache impasto

The impasto technique is usually
associated with oil or acrylic painting,
but the addition of impasto gel turns
gouache or watercolour paint into a thick,
malleable paste. You should mix the gel
approximately half-and-half with the
paint, and apply to the support with a
knife or a brush to make textured effects.

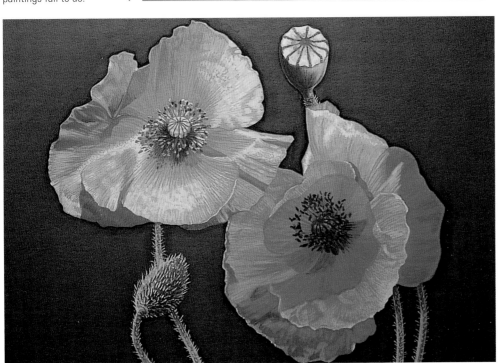

► **SEE ALSO**
► **Wash techniques 182**
► **Textures and effects 194**
► Gouache 104

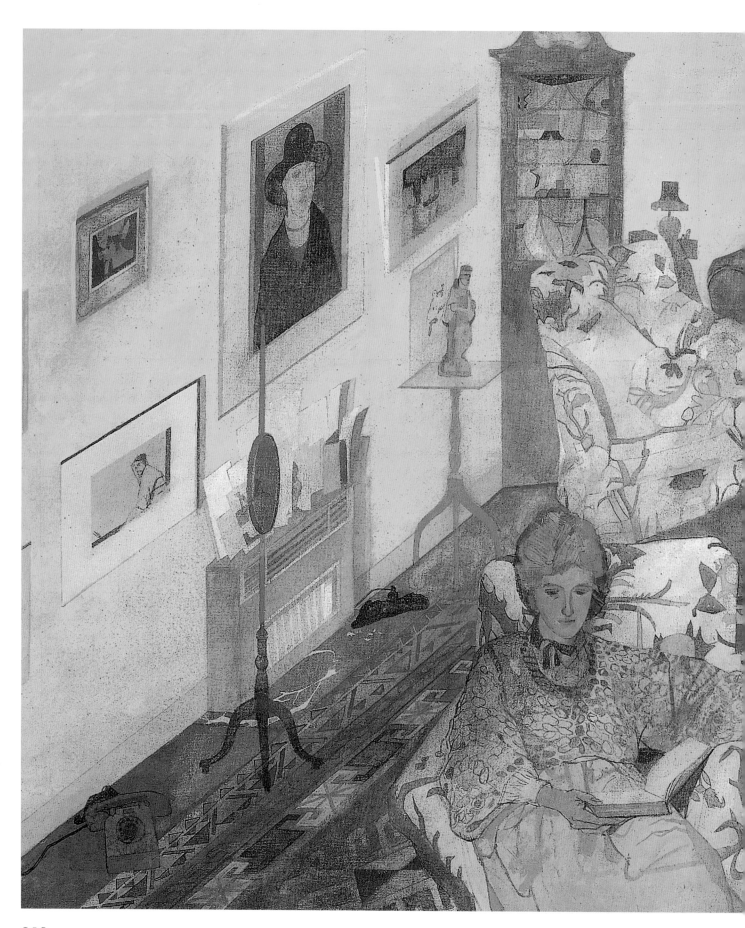

Acrylic techniques

Acrylics seem to divide artists into two camps. Those who dislike acrylics tend to compare them unfavourably with traditional painting media. However, those who use acrylics recognize that they are a unique medium in their own right. The remarkable thing about these relatively new paints is their extraordinary versatility. Although oil, watercolour and gouache techniques can be used successfully with acrylics, the medium nevertheless retains its own distinct character and creative possibilities.

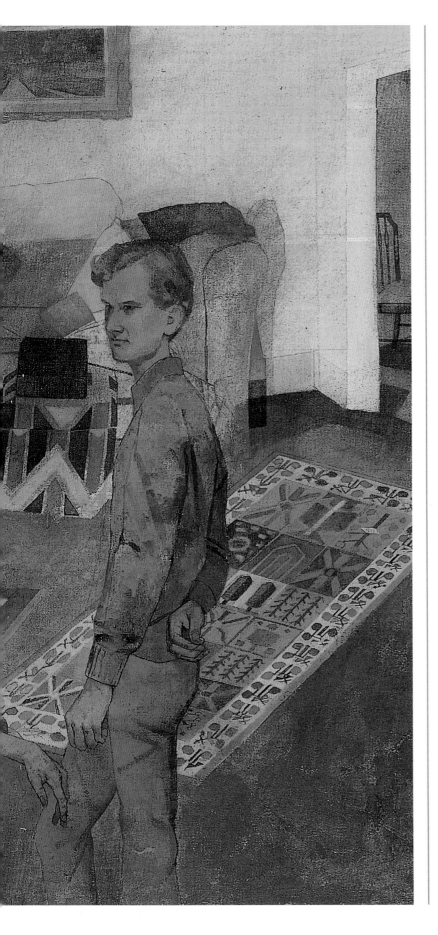

Leonard Rosoman
James Knox and Lucy Abel-Smith
Acrylic on canvas
75 x 125cm (30 x 50in)
The Fine Art Society, London

Wash techniques

When acrylic paints are diluted with enough water and/or medium, they behave in a way that is similar to traditional watercolours and oils, producing delicate washes and glazes through which the white surface of the paper or canvas shines, thereby enhancing the luminosity of the colours.

Watercolour effects

The main difference between acrylics and watercolours is that acrylic colours tend to dry with a smoother and slightly more matt finish than watercolours. However, once the colour is dry, acrylic paint is insoluble and permanent. This means that successive washes of transparent colour can be built up to achieve the depth of tone required, without disturbing the underlying colours.

Another advantage of acrylics is that there is a wider choice of supports on which to work. All the traditional watercolour papers are suitable, and acrylic washes can also be used directly onto unprimed canvas, as well as gesso boards and other surfaces primed for acrylics.

Nick Andrew
Crown
Acrylic on paper
46.2 x 46.2cm (18¹/₂ x 18¹/₂ in)
On Line Gallery, Southampton

Nick Andrew's method of creating acrylic washes is to begin with very wet watercolour paper, and subsequently to spray a fine mist of water onto the areas where he is working, to keep them damp. This extremely liquid technique allows him to achieve subtle blends and diffusions of colour.

Acrylic washes
The examples above show how underlying washes will maintain their strength of tone through subsequent layers.

• Controlling washes
One problem with using watercolour is controlling a wash so that the colour is evenly distributed. With acrylics, this problem can be solved by adding either flow improver or a little matt or gloss medium to a wash. This thickens the paint just enough to help it roll smoothly onto paper or canvas. Brushstrokes hold their shape better when applied with medium and water rather than water alone, and are easier to control. As with watercolours, fluid washes should be applied swiftly and confidently, and left alone.

Keith New
Path Across the Common
Acrylic and pastel on paper
83.9 x 58.9cm
(33½ x 23½in)
Llewellyn Alexander Gallery, London

Spattering is an important part of Keith New's paintings. He sometimes masks off parts of the surface to use different spattering methods. In this calm, monumental painting, spatter was applied on top of scratched and sandpapered acrylic washes overlaid with pastel. Some further pastel work was then applied, to unify the various parts of the image.

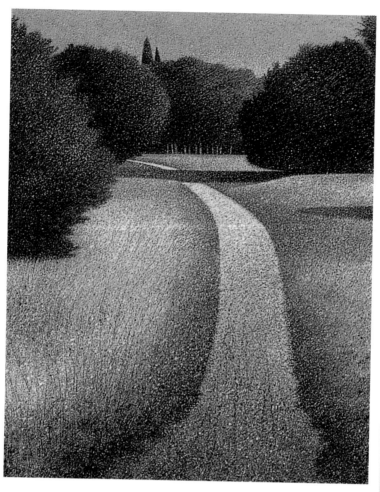

▶ **SEE ALSO**
▶ Supports 13
▶ Watercolour techniques 181
▶ Paints 110

Spattering

Spattering, or flicking paint onto a support, is an effective means of suggesting textures such as sand and pebbles, or sea foam. It can also be used to enliven and add interest to a large area of flat colour.

There are two methods of spattering. One is to dip an old toothbrush into fairly thick paint and, holding it horizontally, above the painting surface, quickly draw a thumbnail through the bristles. This releases a shower of fine droplets onto the painting.

The second method is to load a paintbrush and then tap the brush sharply across your outstretched finger or across the handle of another brush. This will produce a slightly denser spatter, with larger droplets of paint.

For either method, lay the painting flat on a table or on the floor, otherwise spattered paint may run down the surface. Use scrap paper to mask off areas that are not to be spattered.

• Experimenting with spattering

Spattering is a random and fairly unpredictable technique, so experiment on scrap paper before using it on a painting. Vary the distance between the brush and the painting surface to increase or decrease the density of the dots. Try spattering onto a damp surface, so that the dots become softened and diffused, or spatter with two or more colours, one after the other.

Using a toothbrush
This method gives a fair amount of control over how much is spattered.

Using two brushes
A larger area can be spattered using this technique.

• **Using transparent colours**
For best results, restrict your mixtures to transparent colours. Glazing with opaque colours is less successful, as the colours appear somewhat muddy.

• **Unifying with glazes**
If colours and tones appear disjointed, a final glaze with a soft, transparent colour, such as raw sienna, will help to pull the picture together so the elements harmonize.

• **Modifying with glazes**
Unsatisfactory colour areas can be corrected with a thin tone of a different colour. For example, a hot red can be toned down with a glaze of its complementary colour, green (and vice versa). Again, if the background of a landscape appears to jump forward in the picture, a glaze of cool blue or blue-grey will make it recede.

Glazing

The principle of glazing in acrylics is the same as for oil painting – successive thin, transparent washes create areas of glowing, translucent colour. But acrylic is even better suited to the technique, since you don't have to wait long for each layer to dry. Because dry colours are insoluble, it is possible to build up many transparent layers in order to create colours with the brilliance and clarity of stained glass, with no danger of picking up the colour beneath.

Glazing techniques

Paint for glazing can simply be diluted with water, but it dries to a dull, matt finish, and colours lose some of their intensity. Adding gloss medium gives much better results: it increases the transparency of the paint while retaining its binding qualities, enriches the colours and makes the paint flow more evenly.

Place the support horizontally so that the colour does not run out of control, apply the glaze with a soft-haired brush and allow to dry.

Since a glaze is transparent, the effects are most noticeable when a dark colour is laid over a light one, although you can subtly modify a darker colour by glazing light-over-dark.

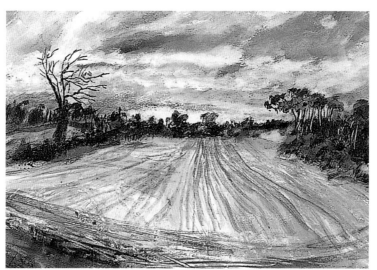

'The great way to paint with acrylics is the very old-fashioned method of glazing with washes – which you can do with acrylics, of course, marvellously.'
David Hockney
(B.1937)

Gigol Atler
Suffolk Landscape
Acrylic on paper
38.5 x 52cm (15 x 20½in)

In this dynamic painting, the artist used acrylics to combine the transparency of watercolour with the opacity of oil paint. He applied a cadmium-red wash over a white ground to provide an overall luminescence, and then built up the sky and land with a series of transparent glazes.

Raw canvas stained with thinned paint

• **Acrylics for staining**
Fluid acrylics are particularly suitable for staining techniques. You will find it helpful to add flow improver (water-tension breaker) to the paint used for staining. This improves the flow of the paint, making it easier to apply in flat, even washes over large areas. It also helps to maintain the brilliance of the colour, which is often diminished when diluted in thin washes.

Staining

In this technique, raw, unprimed canvas is stained with acrylic colours which are thinned with water and medium to a creamy consistency. While the acids in oil paint will attack and destroy raw canvas in time, acrylics are non-corrosive, and so sizing and priming are not necessary.

Lay the canvas horizontally, and brush or pour the colour on to the surface. Colours may be manipulated by tilting the canvas or using sponges, squeegees, brushes or improvised tools. As unprimed canvas is porous, the thinned colour will penetrate through to the back, and the paint becomes an integral part of the canvas.

▶ **SEE ALSO**
▶ **Supports** 14
▶ **Mediums** 118
▶ **Optical mixing** 220
▶ **Colour harmony** 225

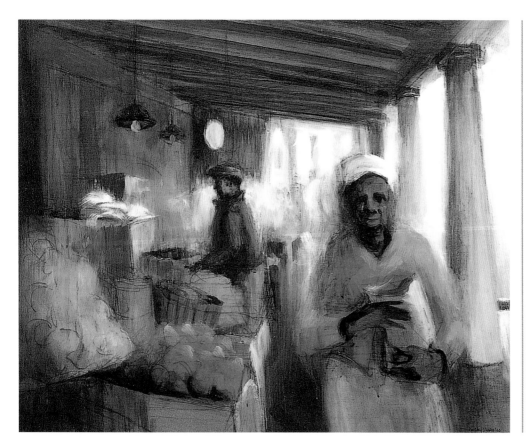

Barclay Sheaks
The French Market, New Orleans
Acrylic on hardboard
60 x 75cm (24 x 30in)

Glazing and staining

Using acrylics in washes allows you to build up a delicate paint surface with layered, transparent glazes, or to achieve rich, stained colours on canvas.

Barclay Sheaks used the brown of sanded-and-cleaned hardboard as an undercolour (left), and mixed paint and neat acrylic gloss medium for vibrant, luminous glazes.

Several layers of very thin, water-diluted paint were used by Brian Yale to stain raw canvas (below left), providing a soft, matt surface for stencilling thicker paint.

The tactile quality of Paul Apps's painting (below) was achieved using texture gel, overlaid with glazes. The thinned colour settled in the crevices, accentuating the craggy texture of the thick paint.

Brian Yale
Japan
Acrylic on canvas
115 x 100cm (46 x 40in)

Paul Apps
Zebras
Acrylic on board
42.5 x 60cm (17 x 24in)

Textural effects

Exploit the versatility of acrylics by building up rich and varied textural surfaces, using impasto, collage and mixed-media techniques.

Collage

Acrylic gloss, matt and gel mediums all have excellent adhesive properties and dry transparently, so they are ideal for binding collage materials to a surface. Objects such as coloured papers, tissue, metal foil, magazine cut-outs, fabrics leaves, pebbles and weathered wood, to give a few examples, can be pressed into thick, wet acrylic paint or a layer of modelling paste.

Impasto

For impasto, use acrylic paint straight from the tube or diluted with a little water, matt or gloss medium, or a combination of any of these. The paint should be malleable, yet thick enough to retain marks and ridges left by the brush or painting knife. Paint can be further stiffened by mixing with gel medium or texture paste.

Mixed media

Because it is so versatile and fast-drying, acrylic lends itself exceptionally well to mixed-media work. Artists often combine acrylics with watercolour, gouache and ink, and with drawing media, such as pastel, pencil and charcoal, as a means of extending their range of expression.

Using found objects
Learn to cultivate a jackdaw mentality when considering making collages. Almost anything can be used!

• **Embedding heavy objects**
Lay your picture flat until the acrylic medium is dry; if you work vertically, the wet paste may slump, taking the objects with it.

• **Developing collage**
Collage composition can be developed with precise shapes, free shapes, or sculpted shapes with folded and crumpled forms. Objects can be painted before being fixed to the support, or the completed work may be enriched with acrylic colours and/or other media.

• **Protecting collages**
Apply a coat of matt or gloss picture varnish to a completed collage, or frame it under glass.

▶ **SEE ALSO**
▶ Mediums 118
▶ Varnishes 350

Jill Confavreux
Tail Ends of Summer
Acrylic and collage on canvas
75 x 100cm (30 x 40in)

Collage exploits the contrasts of shape, colour and surface texture between different materials. Jill Confavreux stuck tissue and watercolour paper to thin acrylic washes, and then embedded leaf skeletons, to suggest peacock tails and leaves. This was glazed with gold acrylic paint, onto which crumpled clingfilm was dropped. When the film was peeled away from the dry paint, the final texture unified the painting.

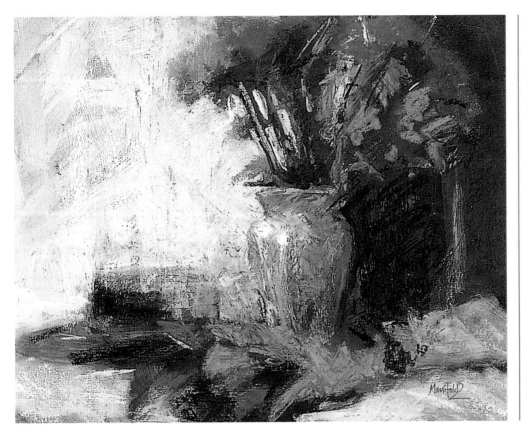

Debra Manifold
Still Life with Mat's Hat
Acrylic and oil pastel on board
35 x 37.5cm (14 x 15in)

The mixed-media combination of acrylics and pastels is popular. Debra Manifold makes a bold acrylic underpainting, before working oil pastels on top. Further acrylic washes produce a wax-resist effect.

Donald McIntyre
Cottage by the Sea
Acrylic on board
50 x 75cm (20 x 30in)

The lively, impasted surface of this painting comes from the artist's use of paint straight from the tube. Even when applied in very thick layers, acrylic paint remains flexible and will not crack.

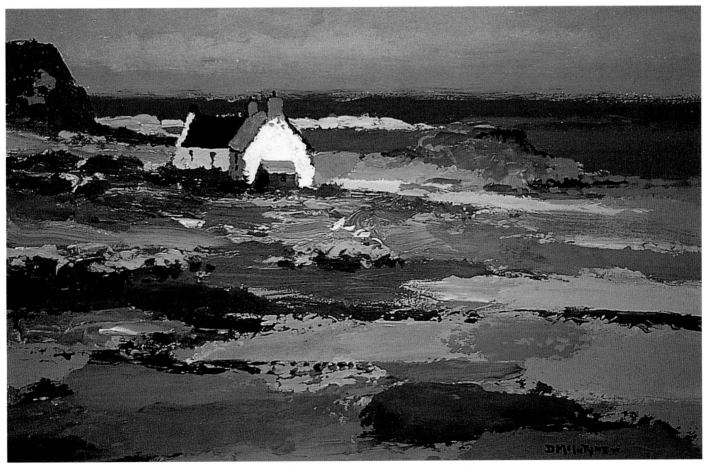

Chapter seven

Colour and composition

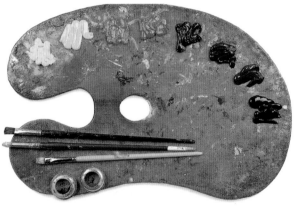

Why is it that some paintings draw us to them like a magnet, while others fail to capture our interest? Often, the immediacy of a picture's impact is due to a strong expressive design and knowledgeable use of colour. 'Art' is not merely about representing the outward appearance of a given subject; it is just as much about selecting its essence, accentuating and holding it for the viewer's contemplation. Art frames our view of a scene and freezes the moment in an ordered beauty of line and shape, form and space, and colour and tone.

Permanence of pigments

The permanence, or lightfastness, of a pigment refers to its resistance to gradual fading on exposure to light. This depends mainly on the chemical nature of the pigment; however, some colours which are lightfast when used at full strength lose a degree of lightfastness when strongly diluted or mixed in tints with white.

Range

The range of permanent colours is extremely wide, so it is possible to entirely avoid the use of fugitive colours, which fade on exposure to bright light, or only moderately permanent colours. Earth colours are the most permanent.

A few colours actually fluctuate, fading on exposure to light but recovering in the dark – Prussian blue and Antwerp blue are two examples.

Lightfastness standards

The ASTM (American Society for Testing and Materials) system has recently been established for the accelerated testing of artists' colours, relating to 20 years of gallery exposure. This test represents the most absolute classification in use for artists' materials. The ASTM codes for the permanence of pigments are shown on the right, and are used throughout this book.

Manufacturers' codes

Reputable pigment manufacturers code their colours according to their permanence, the code appearing either on their tube or jar labels, or in their catalogues and leaflets. Some also give information on toxicity, whether the colours are transparent or opaque, and whether they are susceptible to atmospheric pollutants. The codes for permanence (shown on the right) are the most commonly used.

Not all manufacturers use the same lightfastness standard. Some, for example, use British Standard 1006, also known as the Blue Wool Scale. Lightfastness ratings, therefore, vary between one brand of paint and another.

Permanence —
Lightfastness —

▶ SEE ALSO
▶ Oil paints 64
▶ Watercolour paints 87
▶ Pigments 92
▶ Reading a paint tube 387

Pigment quality
All manufacturers identify their colours for their lightfastness and permanence and will display the ASTM, star or alphabetical rating.

ASTM codes for lightfastness:

ASTM I: excellent lightfastness

ASTM II: very good lightfastness

ASTM III: not sufficiently lightfast

Common codes for permanence

**** or **AA**
Extremely permanent colours

*** or **A**
Durable colours, generally sold as permanent

** or **B**
Moderately durable colours

* or **C**
Fugitive colours

Typical permanent colours
Left to right: raw umber, raw sienna, yellow ochre.

Typical fluctuating colours
Left to right: Prussian blue, Antwerp blue.

Typical fugitive colours
Left to right: naphthol crimson, ruby red, reddish violet.

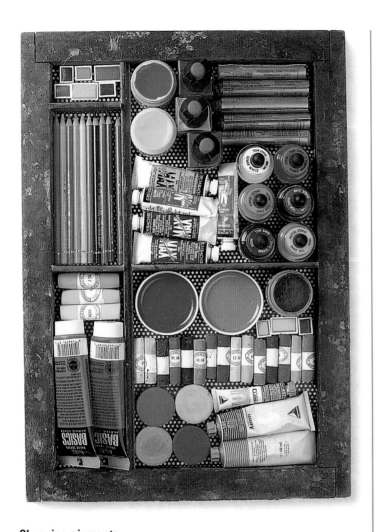

Choosing pigments

Good-quality materials, combined with sound technical practice in the preparation of supports and application of media, will help your work to survive the rigours of treatment and time. Which pigments you choose is therefore an extremely important part of the process – it is always worth using only the best (usually identified in catalogues and on packaging as 'Artists' quality'). Although these pigments may be expensive, the extra cost is well worth the investment.

Pigmentation and paint

This scene (above) shows the end of one phase in the manufacture of paint; the pigment has been selected, ground, mixed with the binder and milled for smoothness and consistency, with rigorous quality checks at every stage. The paint is then packed into the various containers used – pans and tubes for watercolour, tubes and jars for acrylics, and tubes for gouache and oil paints – and despatched to distributors and art-supply stores.

Forms of pigment

All coloured painting and drawing media include pigments of varying quality; the selection above shows only a few of the hundreds of colours and tones available.

| # The language of colour

'There are hidden harmonies or contrasts in colours which involuntarily combine to work together…'
Vincent van Gogh (1853–90)

Knowing how to mix and use colours is crucial to the success of any painting. Yet, because colour is essentially an abstract concept, many artists find it a difficult and bewildering area. This lack of confidence is largely the result of ignorance of the basic principles of colour. Here, as always, there are certain rules and guidelines to follow.

The colour wheel
One of the most important 'tools' for the artist is the colour wheel. This is a simplified version of the spectrum, bent into a circle. It is an arrangement of the primary colours (red, yellow and blue) and the secondary colours (orange, green and violet), from which all others, including the greys, browns and neutral colours, are mixed.

Primary colours
The primary colours are equidistant on the colour wheel. A primary colour is one that cannot be made by the mixing of any other colours. In theory, the primary colours can be mixed in varying proportions to produce every other colour known, but in practice things are not that simple, because primary red, yellow and blue do not exist in pigment colours.

Names and colours
All artists' pigment colours, whatever exotic names manufacturers may give them, are only permutations of those that are shown on the colour wheel (left).

Secondary colours
A secondary colour is obtained by mixing equal quantities of any two primary colours. Thus, blue and yellow make green, red and yellow make orange, and red and blue make violet.

Tertiary colours
A tertiary colour is made by mixing an equal quantity of a primary colour with the secondary next to it on the colour wheel. For example, if you combine red with its neighbour to the right – orange – you get red-orange; if you combine red with its neighbour to the left – violet – you get red-violet.

By adjusting the proportions of the primary and secondary colours, you can create a wide range of subtle colours. Further intermediate colours can be made by repeatedly mixing each neighbouring pair until you have an almost continuous transition of colour.

Colour wheel labels: Primary (Yellow), Secondary (Orange), Tertiary (Red/Orange), Primary (Red), Tertiary (Red/Violet), Primary (Blue)

▶ **SEE ALSO**
▶ Mixing colours 220
▶ Colour expression 224
▶ Colour harmony 225
▶ Colour contrast 226

Colour relationships

There are two basic ways in which colours react with each other: they contrast or harmonize. It is possible to explore the relationships of colours according to their positions on the colour wheel (opposite). Going round the wheel, you can see that those colours that harmonize are close to each other, and those that contrast are well apart.

Related colours

Colours that are adjacent to one another on the colour wheel form a related, harmonious sequence. The closest relationships are between shades of one colour, or between a primary colour and the secondary which contains that primary, such as blue and blue-green or blue-violet.

Complementary colours

The colours opposite one another on the colour wheel are contrasting partners, called complementary colours. There are three main pairs, each consisting of one primary colour and the secondary composed of the other two primaries: thus red is the complementary of green, blue of orange, and yellow of violet. These relationships extend to pairs of secondary colours, so that red-orange is complementary to blue-green, blue-violet to yellow-orange, and so on.

If two complementary colours of the same tone and intensity are juxtaposed, they intensify each other. The eye jumps rapidly from one colour to the other, causing an optical vibration that makes the colours shimmer.

Complementaries
The apparent riot of colour that is contained in this still life is, in fact, skilfully controlled by allowing two sets of complementary colours – red and green, and orange and blue – to predominate. The white areas act as a foil for the vibrant hues.

Peter Graham
Japanese Girl with Flowers
Oil on canvas
60 x 75cm (24 x 30in)

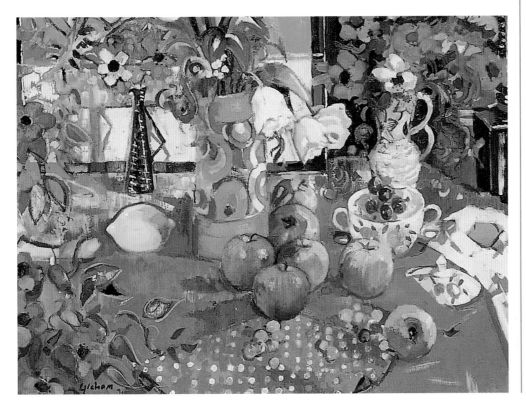

Defining terms
The terms used to describe the properties of colours, such as 'hue' and 'tone', are often used inaccurately, or are misleading.

Hue
Hue is another word for colour, and refers to the generalized colour of an object. It is used when describing close or similar colours: cadmium red, alizarin crimson and vermilion, all reds, are close in hue.

Intensity
Intensity (also referred to as chroma or saturation) refers to how bright or strong a colour is. Vivid, pure colours are strong in intensity; pale, greyed colours are weak. A vibrant, intense colour, e.g. cadmium red, will become less intense as white is added and it becomes pink (above). The intensity of a colour can also be reduced by mixing it with its complementary, which will make it become greyed.

Tone
Tone, or value, refers to the relative lightness or darkness of a colour. Some colours are by nature lighter in tone than others: for example, compare lemon yellow with burnt umber (above).

Tints and shades
When white is added to a colour in order to lighten it, the resultant mix is referred to as a tint of that colour. Shades are darker tones of a colour, which are achieved by adding black.

Warm and cool colours

Colours are either warm or cool. Broadly, the 'warm' colours are those that fall within the yellow-orange-red sections of the colour wheel, whereas the 'cool' colours range through the purple-blue-green segments. Because warm colours appear to come forward in the picture space and cool colours seem to recede, opposing warm and cool colours helps create space and form in a composition.

Depth and space

Because the eye perceives cool colours as being further away than warm ones, contrasts of warm and cool are used to create an illusion of receding space in landscapes. There is an impression of space in Terry McKivragan's painting (right). The foreground contains warm earth colours, which come forward; moving back to the horizon, the colours become progressively cooler and the tone lighter.

Terry McKivragan
Norfolk Broads
Acrylic on board
52.5 x 67.5cm (21 x 27in)

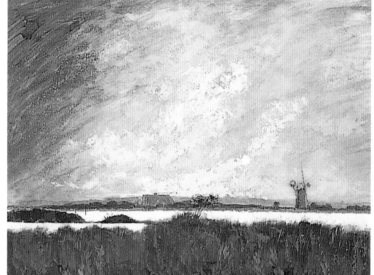

▶ **SEE ALSO**
▶ Composition 228

The effect of light

Each colour has its own degree of warmth or coolness: for instance, lemon yellow is a cool yellow, while cadmium yellow is warm. The colour of the prevailing light also determines the warmth of a colour. Here, for example, late afternoon light tinges every colour with its warmth (except in the shadow areas, which are correspondingly cool).

Arthur Maderson
Winter Sunlight, Normandy
Oil on canvas
70 x 85cm (28 x 34in)

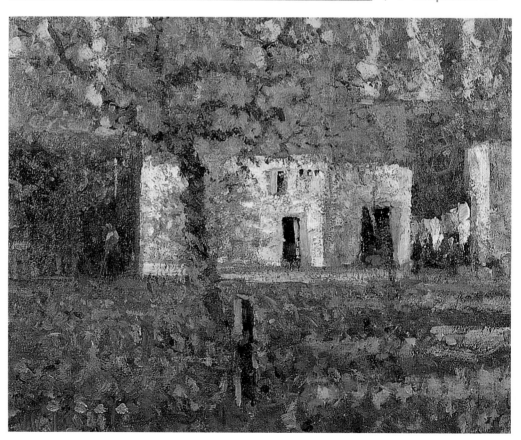

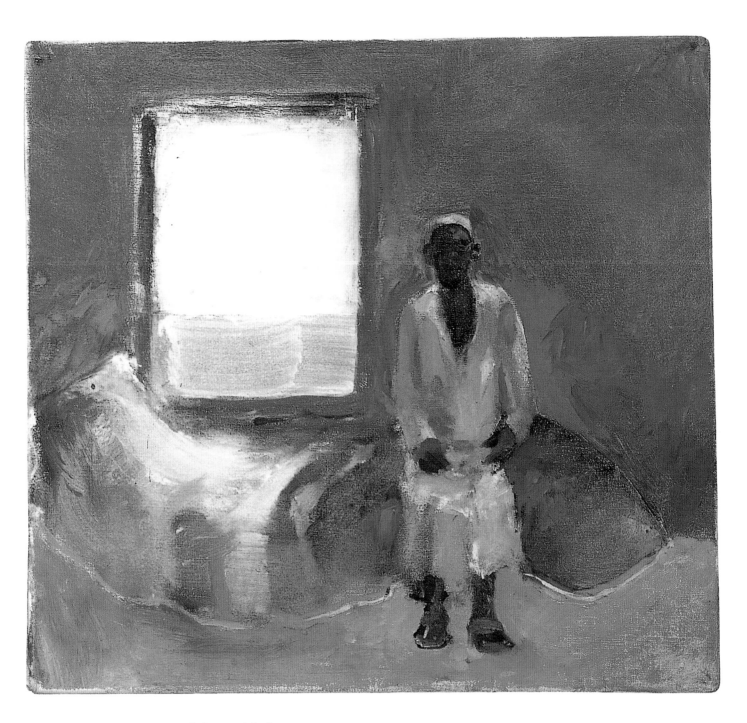

Anthony Fry
Asharaf, Cochin
Oil on canvas
30 x 32.5cm (12 x 13in)
Browse & Darby, London

Colour and design
The apparently casual design of this painting belies
its strong organization. Using near-flat areas of
vibrant colour, creative of space and light, Anthony
Fry arrives at a kind of pure harmony, the kind that
Matisse called 'spiritual space'.

217

Tonal key

The tones and colours in a painting can be compared to musical notes. Too many different tones produce visual dissonance, whereas a controlled range of tones, keyed either to the light or the dark end of the scale, produces harmony and underlines the emotional message. Trevor Chamberlain's painting is an example of how a limited range of tones, massed into a well-structured arrangement, can lend strength and unity to a busy subject.

Trevor Chamberlain

Tehran Bazaar
Oil on board
17.5 x 25cm (7 x 10in)

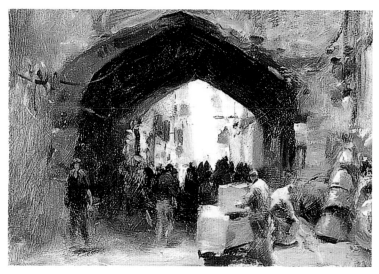

Tone and mood

Ken Howard is very much a tonal painter, and this early work derives its charm from its quiet statement and harmonious tonality of colour. Like the great still-life painters before him, from Chardin to Mondrian, he manages to bestow, even on a simple arrangement of everyday objects, a sense of significance and dignity.

Ken Howard

Still Life
Oil on canvas
60 x 50cm (24 x 20in)

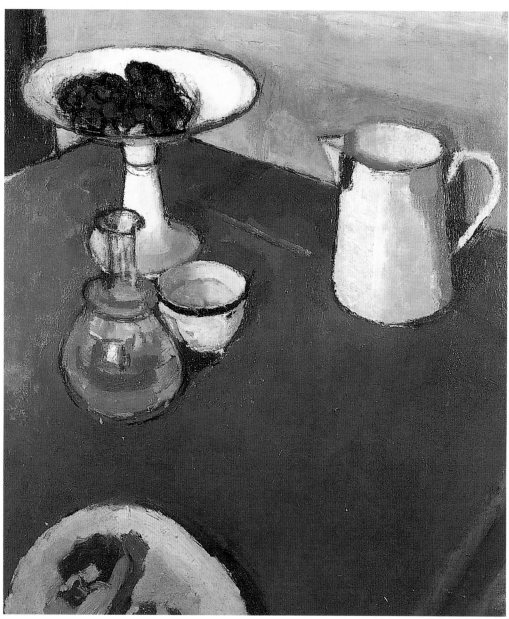

Tonal values

The word 'tone' tends to throw painters of all levels of experience into confusion. However, tone is an essential part of all painting and drawing, especially in achieving the effects of light on a subject. Tonal values are vital if you wish to model form, compose a picture well, and express mood and atmosphere.

Jan Vermeer (1632–75)
A Young Woman Standing at a Virginal
Oil on canvas
51.5 x 43.3cm (20½ x 17¾in)
National Gallery, London

Understanding tone
Tone describes the relative lightness or darkness of an area of colour. Some colours are more light-reflective than others and they appear to be lighter in tone: for instance, cerulean blue and Prussian blue are the same colour, or hue, but the former has a light tone, while the latter has a dark one.

Defining hues and intensities
Tone can be easily understood when it deals only with black, grey and white. However, it is hard to define tonally the hues and intensities of some colours. For example, an object may have an intense, warm colour, but that very warmth and intensity may make you think that the tone is lighter or darker than is actually the case.

Tones and colours are modified by adjoining colours, and a colour that appears dark when alone on a white canvas may well seem to have a lighter tone when surrounded by other colours, and vice versa.

Tone and design
The framework of light and dark areas that makes up any picture – the broad tonal pattern – is often what first attracts the viewer's attention and provides an immediate introduction to the mood and content of that picture.

If the tonal pattern of a painting is strong, it encourages a closer and more focused examination. Try looking at a wall of pictures in a gallery or an exhibition; the pictures with a well-designed tonal pattern are the ones that will make the most impact on the casual viewer.

Counterchange
Counterchange is the placing of light shapes against dark, and vice versa. It creates lively, interesting pictures, as the reversals of light and dark provide intriguing contrasts. Counterchange also gives movement and rhythm to a picture, leading the viewer from light to dark and back again. The great Dutch painters, such as Rembrandt and Vermeer, were masters of this technique, and they used it to great effect, particularly in interior scenes.

Comparative tones
All blues are basically the same colour, but cerulean blue is light in tone, while Prussian blue is darker.

The effect of light
The tone of a colour changes with the effect of light, and any colour will exhibit a range of tones – the more a surface faces away from the light, the darker it becomes.

 SEE ALSO
▶ Defining terms 215

Mixing colours

Learning to mix colours is the first step towards achieving a successful painting. Initially it is certain to involve some trial and error, but there are some general guidelines that will help you to achieve success.

Theory and practice

The colour wheel is of limited use to the artist when it comes to mixing actual paint, because pigments, unlike light, are not pure. In addition, pigments invariably have a slight bias towards another colour.

Blue and yellow make green?

In theory, blue and yellow make green; but in practice, mixing any old yellow and blue could end up with mud. Ultramarine blue, for example, has a reddish undertone, while lemon yellow has a greenish one. These red-and-green undertones are complementary colours; when two complementaries are mixed they make grey – which is why the result is a muddy green.

To mix a clean green from blue and yellow, it is important to choose the right blue and the right yellow for the particular shade you want (see left).

Phthalo blue · Lemon yellow

Ultramarine · Lemon yellow

A clean green and a muddy green

Palette for 'clean' colours

These colours, shown below left, give the widest range for mixing pure, clean colours.

Lemon yellow
(green-shade yellow)

Cadmium yellow
(red-shade yellow)

Cadmium red
(yellow-shade red)

Permanent rose
(blue-shade red)

Phthalo blue
(green-shade blue)

French ultramarine
(red-shade blue)

Viridian
(blue-shade green)

Phthalo green
(yellow-shade green)

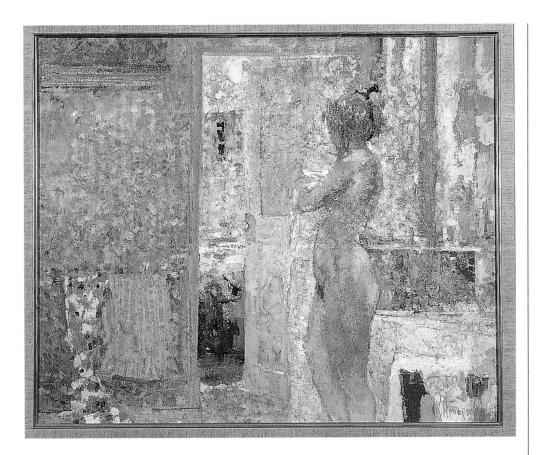

Arthur Maderson
From the Bathroom
Oil on canvas
65 x 80cm (26 x 32in)

Optical mixing
Following the Impressionist tradition, Maderson creates a shimmering illusion of light with myriad flecks and dabs of juxtaposed colour. The colours mix optically when viewed at a distance, and appear more vibrant than if they had been mixed together.

Mixing complementaries

When two complementary colours are juxtaposed, they intensify each other. However, when they are mixed together they neutralize each other and form neutral greys and browns. Depending on the colours used and the proportions of each, it is possible to create a wide range of colourful neutrals.

Take complementary red and green, for example. By mixing these in varying quantities you achieve muted, earthy colours. Adding white to the mixture creates a series of delicately coloured greys, which provide a marvellous foil for brighter, more vibrant colours. The greys produced in this way are more lively than the steely greys made by mixing black and white.

Modifying colours
If a colour appears too strident, it can be toned down, either with a complementary colour or with an earth colour.

Tone down red and green with raw umber

A red that is too hot can be cooled with a little green – and vice versa

Adding black to a colour tends to dull it

Making greys
Complementary mixing produces neutral greys, more colourful than those which come ready-mixed as tube colours.

Add white to red-green mixtures to produce delicate greys

Mix violet and yellow together to form warm grey

Mix red and green together to make earthy brown

221

Palette layout

Get into the habit of laying out colours on the palette in the same systematic order each time you paint. You will thus know where each colour is without having to search for it, so you can concentrate on observing your subject.

Some artists arrange colours in the order of the spectrum, with red, orange, yellow, green, blue and violet running across the palette, and white and earth colours down the side. Others arrange their colours from light to dark, or align warm colours (reds, oranges and yellows) on one side and cool colours (blues, greens and violets) on the other. Whichever method you choose, stick with it.

Keeping colours clean
Make several dabs of each colour on your palette rather than one large one. This makes it easier to keep colours, particularly the light ones, clean and clear.

Preferred layouts
The examples below show some of the methods employed by professionals for laying out colour on their palettes.

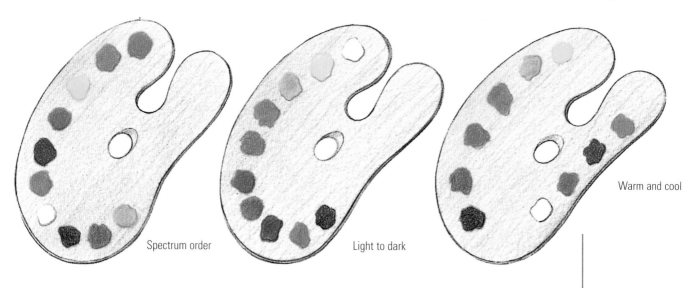

Spectrum order

Light to dark

Warm and cool

Broken colours blend at a distance

▶ **SEE ALSO**
▶ Oil palettes 84
▶ Glazing 170
▶ Wash techniques 182
▶ Tonal values 219
▶ Colour harmony 225

Broken colour

The Impressionists used a broken-colour effect, in which colours were made up of small flecks and dashes of paint. Because each colour remains unmixed on the picture surface, less light is absorbed than if the same colours were to be mixed on the palette. When viewed from an adequate distance, the colours blend, and have a vibrant, luminous quality.

Glazing

Glazing is another way of producing optical mixes. For example, if you apply a blue glaze over a yellow ground, the green produced is much more lively than one produced by mixing blue and yellow pigments. Light enters the transparent film and is refracted from below, to produce a rich, glowing effect.

Base colour modified with a transparent glaze

Bright colours seem richer next to neutral colours

Dark tones intensify next to light ones

Colour interaction

Colours and tones should never be regarded in isolation, but in terms of how they relate to those around them. All colours and tones are influenced by neighbouring ones; when two colours are viewed side by side, the contrast between them is enhanced or heightened. Each touch of colour added to a painting alters the relationship of the colours already there: a bright colour appears richer when it is placed next to a neutral or muted colour; similarly, a dark tone appears even darker when it is placed next to a light one.

Harmonious painting

Inexperienced painters will often work on one small area of a painting until it is 'finished', and then move on to the next area. This generally leads to a disharmonious and confused painting, because each colour is unrelated.

It is better to work on all areas of the composition at once. Work from landscape to sky and back again, or from figure to ground and back again. Keep your eyes moving around the subject, assessing and comparing one colour against another, one tone against its neighbour, and make adjustments as you go. In this way your painting will grow and develop, emerging finally as a homogeneous mass of colour and tone. Painting is a continuous process of balancing, judging, altering and refining – which is what makes it so absorbing.

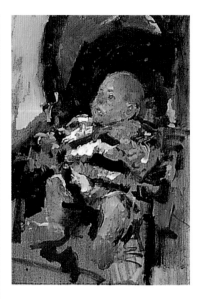

Tom Coates
Study of a Baby
Oil on panel
35 x 25cm (14 x 10in)

In this unfinished painting, the subject and background are progressing at more or less the same pace. The artist modifies the colours and forms of both parts of the work, keeping the image fluid and moving towards an integrated statement.

Leslie Worth
Windsurfer on Boldermere
Watercolour on brown paper
22.5 x 28.7cm (9 x 11½in)

Bright and neutral colours
Though a tiny shape, the windsurf board is very much the focal point of this picture. Surrounded by dark tones and neutral colours, the sharp accent of the white sail sings out with a piercing note.

▶ **SEE ALSO**
▶ **Oil paints 64**
▶ **Watercolour paints 87**
▶ **Acrylic paints 110**
▶ **The language of colour 214**
▶ **Broken colour 256**
▶ **Glazing 170**

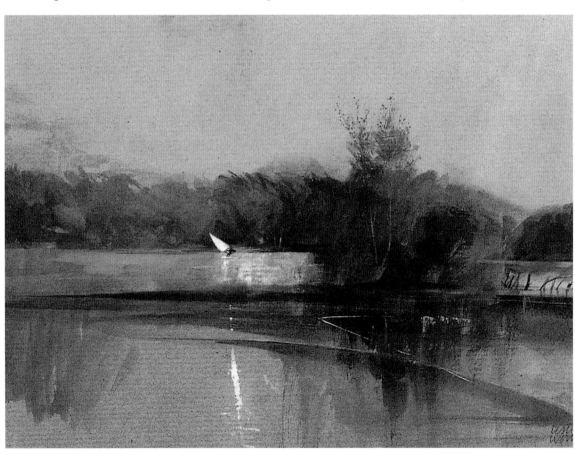

Colour expression

'Yellow can express happiness, and then again, pain. There is flame red, blood red and rose red; there is silver blue, sky blue and thunder blue; every colour harbours its own soul, delighting or disgusting or stimulating me.'
Emil Nolde (1867–1956)

One of the most important aspects of colour is that it is emotive – it stimulates all our senses, not just our eyes. Colour can be used to suggest and to accentuate the mood of a painting, as well as to create an emotional response in the mind of the viewer. It can be used directly and dramatically to provoke a strong response, or in a more subtle way.

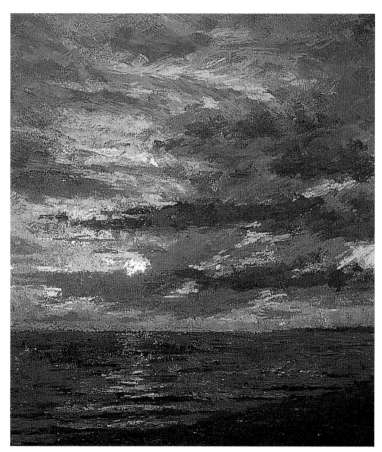

Simie Maryles
Sunset in Summer, Backshore
Acrylic and pastel on board
55 x 45cm (22 x 18in)
Lizardi/Harp Gallery, Pasadena

Sky colours
A variety of colours are used to create mood and express an interesting sky. Here, the artist weaves small patches of blue, violet, orange and creamy white, to create an impression of vibrating light. The dry paint is loosely dragged and scumbled, giving movement to the clouds. The same colours are repeated throughout the picture, enveloping the scene in a homogeneous light.

Using colour to suggest mood

Colours can trigger a flow of images, sounds and emotions. Blue makes us think of sky and sea, mountains and streams. Depending on the context in which it is used in an image, it can denote freshness and lightness, or melancholy and alienation. Yellow, however, conjures up images of sunshine and summer flowers – but it can also be a strong, harsh, acidic colour.

Warm (red and yellow) colours denote vitality, life, vigour and strength, and demand a strong emotional reaction from the viewer. Cool (blue and green) colours impart more passive, restful emotions.

The tone of the colour, and its intensity, also play a part. Red is a vital, dynamic colour (any fully saturated red object in a painting will immediately attract attention, regardless of its size). It can become desaturated by being mixed with white until it is a soft, romantic pink. The pale, desaturated blue that is associated with coolness and tranquillity can be so vibrant in its pure state that it has as strong an effect as red.

Fully saturated red

Mixed with white and desaturated

► **SEE ALSO**
► **The language of colour 214**
► **Tonal values 219**
► **Colour contrast 226**

Colour harmony

Harmony is possibly the most subtle and evocative of all the reactions between colours, and it can be used with great effect to create mood in your painting. While contrast is dramatic and emphasizes the subject, harmony is gentle and easy on the eye.

How colours harmonize

There is harmony between those hues which lie on the same section of the spectrum or colour wheel – between yellow and green, for example. Colours with the same characteristics will be in harmony when they are placed together.

Orange-brown and yellow very often have the same warm quality, and harmonize well. This combination is frequently found in nature – the reds and browns in autumnal scenes, for instance – as is the yellow-green harmony of spring landscapes.

Dominant hue

Although harmonious schemes are often the most pleasing and easy to handle, the very unification that makes them harmonious may make them monotonous. Enough variety of tone and intensity prevents monotony and places emphasis on one dominant line. This line can dominate through tonal contrast, intensity, or the space it occupies in the picture.

Complementary accents

A harmonious scheme can also be enlivened by the introduction of complementary accents. Such accents, if brilliant, have power even when used in small amounts. A small touch of red in a green landscape, for instance, can add zest to an image.

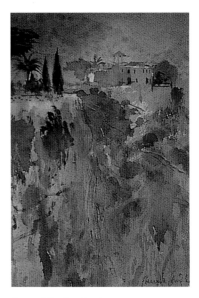

Grenville Cottingham
Early Morning in Simi
Watercolour on paper
37.5 x 27.5cm (15 x 11in)

• Harmony and light
At certain times of day and in certain weathers, colours which normally contrast will appear to be in harmony.

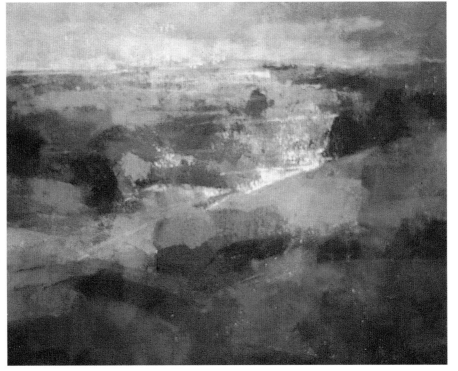

Keith Roper
Wiltshire
Gouache and pastel on paper
30 x 37.5cm (12 x 15in)
Kentmere House Gallery, York

Diffused light will desaturate colours, weakening their strength and brilliance so that they seem more in accord. This harmonizing effect is evident in both Keith Roper's (left) and Grenville Cottingham's (above) very different landscapes, in which colours are keyed to a unified level of tone and intensity, underlining the essential tranquillity of each scene.

Colour contrast

When colours of opposite characteristics meet, they create impact. The Renaissance painters used light-dark contrast, whereas the Impressionists exploited contrasts of warm and cool colour, and of complementary colours; again, Turner used intensity contrast, playing pure tints against neutrals.

Complementary contrast

When complementary colours are juxtaposed, they enhance each other, producing a very vibrant visual sensation; each colour seems brighter against its neighbour than it would alone.

To give one example, blues and greens contrast with their complementaries – orange and red. The success of this contrast depends very much on the proportions used: for example, equal amounts of the colours can create a jarring, unpleasant effect, but a small amount of red in a predominantly green area can be very exciting.

The most intense sensation of colour contrast comes from complementary colours which are equally matched in tone and intensity. If, however, there is a notable tonal difference between the colours, the contrast is less dramatic or dynamic.

Split complementaries

Absolute complementaries do not have to be used, and near, or 'split' complementaries are often more pleasing to the eye than true ones. Split complementaries are those which are separated by the true complementary; for example, violet is the true complementary of yellow, while blue-violet and red-violet are its split complementaries.

The complementary (violet) and split complementaries of yellow

Red flecks on an area of green, its complementary colour

Juxtaposed complementary colours

▶ SEE ALSO
▶ The language of colour 214
▶ Tonal values 219
▶ Colour expression 224
▶ Composition 228
▶ Creating a focal point 230
▶ Painting a landscape 274

Sophie Knight
China Bowl with Fruit
Watercolour on paper
55 x 75cm (22 x 30in)

This still life demonstrates an effective use of complementary colours. Notice how the artist introduces the complementary, blue, to make the yellows appear brighter and more luminous.

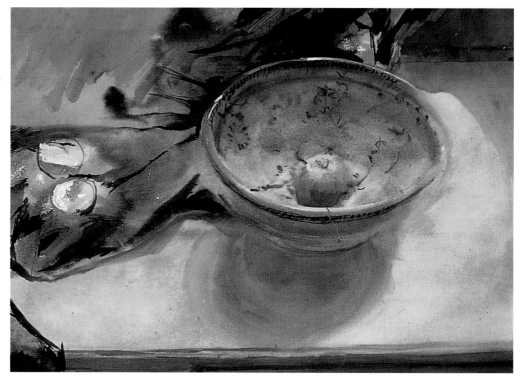

Intensifying colours
Neutral colours make saturated colours appear more brilliant.

Form and space
Contrasts of warm and cool colour can be used to describe form and to create the illusion of space and depth. Below, the limited palette of warm and cool colours gives sculptural modelling to the figure, Note the warm tones on the model's shoulders, calves and buttocks; by contrast, bluish-violet tones are used to describe the indented plane of the small of the back.

Desmond Haughton
Sue
Oil on canvas
45 x 117.5cm (18 x 47in)

Composition and contrast

The rules of composition apply when dealing with colour contrast. It is important that the area of greatest contrast in the picture draws the eye to it, so make sure that strong contrast occurs at the focal point of the picture, otherwise it will be a distracting influence. Employing equal areas of strong, contrasting colours results in a confusing image. You can achieve a balance by varying the proportions of the contrasting colours.

Intensity contrast

Saturated colours appear more brilliant when they are placed alongside neutral colours. A painting dominated by neutral tones may be enhanced by placing areas of pure colour near the centre of interest, to capture the eye and hold the attention. In the same way, a colourful subject is enhanced by restful neutral passages.

Tonal contrast

Tonal contrasts have considerable visual impact; the attention of the viewer may be attracted by the strong contrasts of tone before the emotional expression of the colour itself is felt.

Temperature contrast

All colours have familiar associations for us. Reds and yellows, for instance, conjure up sunlight and fire, and we connect blues and greens with snow, ice and water.

Contrasts of warm and cool colour have several applications in painting. A colour that is predominantly warm usually expresses joy, energy and forcefulness; cool, subdued colours are used to express moods ranging from calm and tranquillity to sadness and despair.

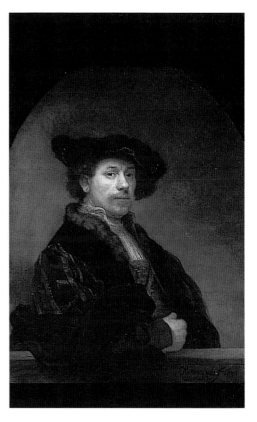

Rembrandt van Rijn (1606–69)
Self-Portrait Aged 34
Oil on canvas
102 x 80cm (40¾ x 32in)
National Gallery, London

Chiaroscuro
Rembrandt was a master of chiaroscuro – the contrast of light against dark – not only as a compositional device, but also to heighten tension and drama.

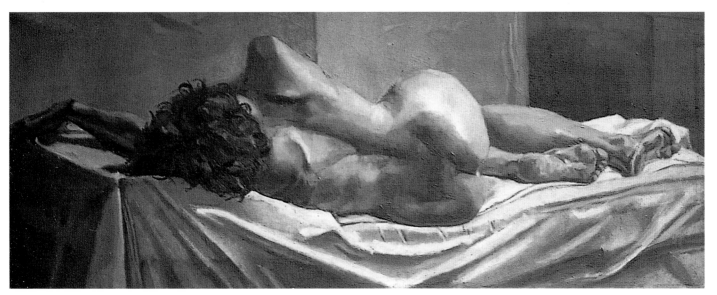

Composition

Before embarking upon any painting or a drawing, it is important to step back and to evaluate your subject, not only as a series of objects that are occupying three-dimensional space, but also as a flat pattern – a 'jigsaw' of interlocking shapes, colours and tones – that adds up to a balanced design.

Visual balance

One of the most important goals in composing a picture is achieving visual balance. In other words, the various elements that make up the image – lines, shapes, colours, tones and textures – must be arranged with care.

Artists and critics have put forward many theories about this balance. The ancient Greek philosopher Plato expressed succinctly what good composition is all about. He stated that 'composition consists of observing and depicting diversity within unity'; in other words, a picture should always contain enough variety to keep the viewer interested, but this variety must be restrained and organized to avoid confusion and disunity.

'Composition is the art of arranging in a decorative manner the various elements at the painter's disposal for the expression of his feelings…'
Henri Matisse (1869–1954)

Christa Gaa (1938–92)
Still Life with Inkwell
Watercolour on paper
20 x 27.5cm (8 x 11in)
New Grafton Gallery, London

Unity and diversity
Unity is achieved by introducing elements that relate to and echo each other, such as the bottles and bowls in this still life. These visual links are effective, because the eye finds related forms more satisfying than unrelated ones. However, notice how Christa Gaa has also introduced diversity – without distracting from the overall unity of the composition – by choosing objects that differ in size and shape, and by varying the spaces between them.

▶ **SEE ALSO**
▶ **Tonal values 219**
▶ **Colour harmony 225**

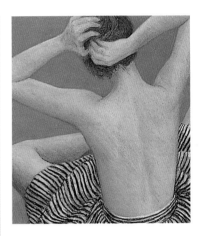

Roy Freer
Sky Blue
Oil on canvas
120 x 100cm (48 x 40in)

Asymmetry
Formal symmetry lends balance to an image, but lacks excitement. An asymmetrical arrangement, on the other hand, maintains visual equilibrium while setting up dynamic tensions and rhythms. Asymmetrical composition can be likened to an old-fashioned scale, in which a small but heavy metal weight on one side can balance a much larger pile of objects on the other. In this painting (left), for instance, there is a counterpoise between active and passive space – the busy clutter of objects serves as a strong attraction, but is held in check by the large, simply stated foreground.

Elsie Dinsmore Popkin
Nude with Striped Skirt
Pastel on paper
25 x 25cm (10 x 10in)

Positive and negative shapes
The positive shapes of objects in a picture are important, as are the negative shapes created by spaces around and between those objects. This picture (above) works on two levels: as a representation of the subject, and as a two-dimensional design of interlocking shapes.

John Martin
Vineyard Workers
Watercolour and gouache on pastel paper
20 x 15cm (8 x 6in)

Rhythm
Rhythm in a painting or drawing plays the same role as in music; it draws the different elements together and imparts the composition with a distinctive mood. These bending figures are grouped into a beautifully controlled central design, in which shapes, patterns, lines and colours repeat and echo each other. This sets up a rhythm which unifies the picture.

Creating a focal point

'Does a picture need a focal point? Indeed it does, just as a meal needs a main dish and a speech a main theme, just as a tune needs a note and a man an aim in life…'
John Ruskin (1819–1900)

Compositional shapes
These sketches show several different ways to break up the picture space in a pleasing way and help you to organize the elements so that the viewer's attention falls where you want it.

A representational picture should have one main subject – a focal point to which the viewer's eye is inevitably drawn. Thus, when planning your composition, your first question should always be, 'What do I want to emphasize, and how should I emphasize it?'

Leading the eye

When we look at a picture of any kind, we instinctively look for a visual pathway to guide us through the composition and make sense of it. If the elements in the picture are not connected in a pleasing and rhythmical way, we soon lose interest because the picture has a fragmented, incomplete feeling.

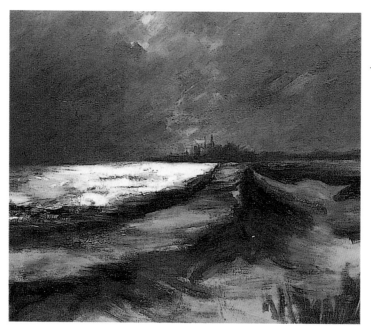

Annabel Gault
Easton Broad towards Southwold
Oil on canvas
15.3 x 19.8cm (6⅛ x 7¾in)
Redfern Gallery, London

Creating lead-ins
The drama of this scene is accentuated by the forceful directional lines of the sand dunes. The eye is propelled back in space to the focal point formed where the silver light on the water meets the dark tone of the coastline.

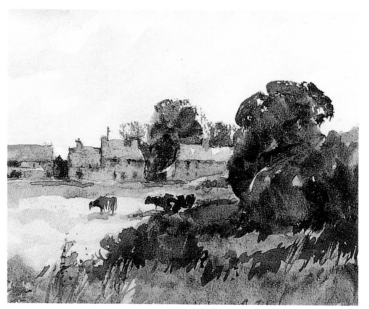

Valerie Batchelor
Cotswold Village
Watercolour on paper
27.5 x 35cm (11 x 14in)

Counterchange
The placing of light shapes against dark, and dark shapes against light, is another means of creating visual pathways through a picture; the eye is attracted by these strong contrasts and will jump from one to the next. Remember, however, that the greatest contrast should be reserved for the centre of interest, so keep tonal contrasts elsewhere in the painting relatively subdued.

The rule of thirds

To give the focal point maximum visual impact, take care to place it carefully within the confines of the picture space. A traditional way to produce a balanced, satisfying composition is to use the 'intersection of the thirds'. This formula is based on mathematical principles of harmony and proportion, and has been used by artists for centuries.

Using the rule

Mentally divide the picture area into thirds, horizontally and vertically, and then locate the centre of interest, and any secondary elements, at or near the points where the lines intersect. This simple principle produces well-balanced, comfortable compositions that are easy on the eye.

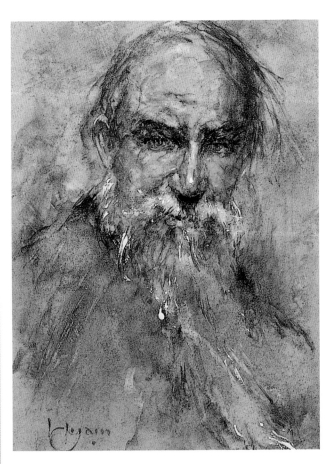

Michael Hyam
Study of Joachim
Pencil and watercolour on paper
22.5 x 12.5cm (9 x 5in)

Creating emphasis

Stressing one element is partly a matter of subordinating the others, for example by keeping the background less detailed and distinct than the foreground. The lyrical beauty of this portrait study derives from the 'lost-and-found' quality of the drawn and painted marks. The sitter's face is the focus of attention, and it is here that Michael Hyam concentrates more detail and colour. The looser treatment of the other elements emphasizes the modelling of the features by contrast.

Trevor Chamberlain
Railway Viaduct, Welwyn
Watercolour on paper
25 x 17.5cm (10 x 7in)

Focusing attention

There are several devices which the artist can use to bring attention to the centre of interest, such as placing more detail in that area, or more intense colours, contrasting shapes, or tonal contrast. When a human figure is included in a composition, the eye is inevitably drawn to it – even when, as here, the figure is dwarfed by its surroundings. Notice how the focal point – a dark tone against light – is framed by the arch of the viaduct, giving it further emphasis.

▶ **SEE ALSO**
▶ **Colour contrast** 226

Sally Strand
Girl with Mother Bending
Pastel on paper
35 x 27.5cm (14 x 11in)

Cropping images
Sally Strand's figure compositions (right) are always natural and unposed, conveying the effect of the snapshot. Deliberately cropping the figures at the edges of the frame brings the viewer in close for more intimate contact with the subject.

Maintaining tension
Lucy Willis's pictures seldom settle for the obvious. The figure on the right is walking out of the painting (below), apparently flouting the convention that the viewer should be led into the picture. Yet why is the eye held so firmly within the picture space? First, the vertical line of the door serves as a brake to the outgoing figure; then that figure is counterpointed by the small figure in the corner, creating a spatial 'push-pull' sensation which keeps the eye moving around the image.

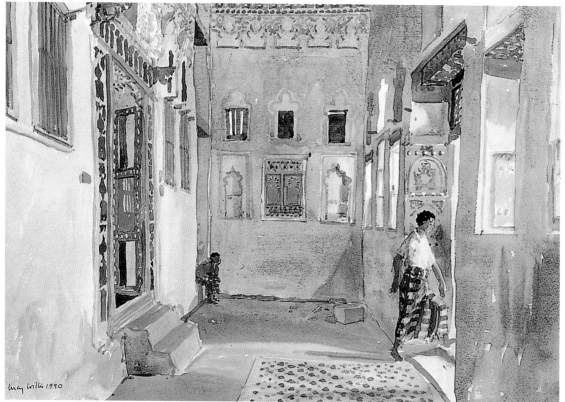

Alison Musker
Vicolo delle Riforme
Watercolour on paper
35 x 16.8cm (14 x 6¾in)

A tall narrow format like this (above) is certainly unusual, but here it is appropriate to its subject, underlining the haunting quality conveyed by this pared-down image.

Lucy Willis
Interior, Zabid
Watercolour on paper
42.5 x 62.5cm (17 x 25in)
*Chris Beetles Gallery,
London*

Breaking the rules

Composition is an important aspect of painting. However, an over-reliance on mathematical and geometric formulas may result in images which, though competent, are safe and predictable. As Cezanne once said, 'When I start thinking, everything's lost.'

Instinct and intuition

It is the unexpected and the personal that make an image memorable, and often it is better to let your creative instincts dictate when to follow the rules – and when to deliberately flout them. The 'rules' that govern painting and drawing should be taken only as guidelines for producing an acceptable image. Although they are useful for the new painter, with experience you will find that good composition is largely a matter of observation, instinct and intuition.

Formats

As a general rule, a horizontal format is the most appropriate shape for the broad sweep of a landscape, while an upright format is the usual choice for portraits (hence the terms 'landscape format' and 'portrait format'). But a more arresting image may often be produced by reversing these principles.

John Martin
Still Life with Watering Can
Oil on canvas
30 x 30cm (12 x 12in)

Square format
This format is used less frequently than landscapes or portraits, yet it has a stability which is attractive to the eye. In fact, it is no more difficult composing a square-format picture than a rectangular one, even when the subject is a landscape, and it is well worth experimenting with different formats.

Anthony Green
The Thirtieth Wedding Anniversary
Oil on board
157.5 x 148.8cm (63 x 59½in)
Piccadilly Gallery, London

Breaking away
One of the main reasons why the rectangular-picture format dominates all others is the Renaissance convention that 'a picture is a window opened on the world and then painted by an artist'. The contemporary artist, less hidebound by convention, realizes that the rectangular format is just one of many shapes you can use for a picture.

▶ SEE ALSO
▶ Composition 228

Chapter eight

What shall I paint?

The majority of artists, when they are choosing subjects to paint, turn to the classic themes – still life, landscape, interiors, wildlife, portraiture and figure painting. There are, of course, many variations on these themes. Still life alone can encompass anything from a single object to a complex group of fruit and flowers. Townscapes, seascapes, sky studies and gardens are merely different forms of landscape painting. And when artists construct pictures purely from imagination, any or all of the classic themes could be combined in a single picture. This section of the book combines major painting projects with helpful exercises to develop your skills.

235

Painting three dimensions

Representational paintings are actually illusions – two-dimensional interpretations of a three-dimensional world. You are about to take up the challenge of creating those illusions. So what is it that makes a painted image believable? To begin to answer this question, we have chosen a lemon as a simple subject to illustrate some basic principles.

Shape

One of the ways we recognize any object is by its shape – that is, by its profile as it appears against a background. Whether it is interpreted as a simple outline or as a silhouette, shape helps us distinguish one object from another.

Form

However, an outline provides very limited information about an object. For greater realism, you will need to explore ways of conveying three-dimensional form or solidity. One simple method is to draw contour lines representing the surface of the object. This may help you to understand the form of the object, even though it is a somewhat 'mechanical' interpretation.

Tone

To create a more realistic image, try making linear marks in the form of hatching and crosshatching to create a tonal image – one that interprets the subject in terms of light and dark. Faceted shapes have clearly defined faces, but rounded forms require a gradual gradation from light to dark. To evaluate tonal values, study your subject through half-closed eyes. This allows you to distinguish the lightest and darkest areas from the halftones.

Light and shade

Light falling upon an object casts a relatively dark area of shadow behind it. Including shadows in your painting will help to create an illusion of weight, because the object will appear to be resting firmly on a surface rather than floating in space. Shadows are strongest immediately behind the object, getting lighter as they stretch away.

Contour lines

▶ **SEE ALSO**
▶ **Crosshatching 41**
▶ **Masking fluid 102, 192**
▶ **Drawing papers 38**
▶ **Warm and cool colours 216**
▶ **Washes 182**
▶ **Wet-in-wet 188**
▶ **Wet-on-dry 189**

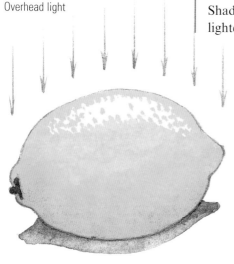

Overhead light

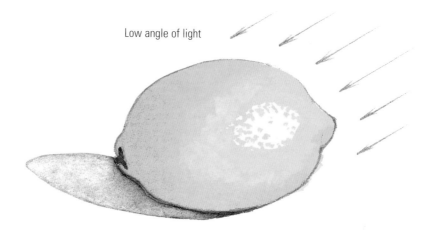

Low angle of light

A low angle of light will cast a long shadow, whereas an overhead light will cast a short one. Illuminating an object evenly tends to flatten its appearance, whereas light from only one direction exaggerates the tonal contrast.

Highlights

Highlights are high-key areas of tone, which are created by light reflecting back from a surface. Used in conjunction with shadows, highlights serve to enhance the illusion of three-dimensional form. You can create highlights by applying opaque paint over laid colour, or masking out areas of white paper before you apply a wash.

Reflected light and colour

Light reflected from a table top will brighten areas of deep shadow. Similarly, the colour of the subject itself may be reflected in the surface of the table. Adding these touches to your painting makes for greater realism.

Local colour
We know that a lemon is yellow – this is its 'local colour'. However, when painting an object, it is necessary to look beyond local colour. The colour that we actually see depends on whether a surface is in direct light, reflected light, or shadow. In this study (below), the artist has used cadmium yellow, modified with washes of yellow ochre, and a mixture of cobalt blue and burnt umber for the areas in shadow.

Modelling with tone
Coloured tones – a mixture of cobalt blue and burnt umber – are used to model three-dimensional form.

Highlights
Created by stippling masking fluid onto the paper before applying a wash.

Reflected colour
A white table top picks up the local colour of the subject.

Cast shadow
A cool grey wash gives the impression that the subject is resting on a flat surface.

Reflected light
Reflected light can brighten areas of the subject in shadow.

Interpreting form
Making drawings and paintings of simple objects is a good way of learning how to interpret solidity and form. This study of a lemon was painted in watercolour on smooth paper.

Colour sketching
Before committing to a major painting, make colour sketches of single objects to observe the play of light on the subject and its background.

Experimenting with paint

Before you tackle anything too demanding, experiment with your preferred medium to see just how versatile it can be. Try a wide range of techniques, from simple fluid washes to thick impasto, to discover different ways of interpreting the object you are painting. Water-soluble and quick-drying acrylic paint is ideal for experimentation, but be sure to wash your brushes frequently and only squeeze out as much paint as you think you will use in a single session.

Subject and equipment

Choose a simple object with a surface pattern or texture that is easy to interpret and helps you to see the volume and shape of the subject. The palette used here was opaque chromium oxide (green), light yellow ochre, titanium white, and a little burnt umber for the areas in shadow. Glaze medium, gel medium and texture paste were used to create the paint effects. As well as a small cranked painting knife, the artist used a No.10 round and Nos.2 and 3 synthetic-hair brights (flat short-bristle brushes).

▶ SEE ALSO
▶ Acrylic paint 110
▶ Glazing 170
▶ Knife painting 118, 174
▶ Mediums 76, 118
▶ Paintbrushes 78, 120
▶ Washes 182
▶ Wet-in-wet 188

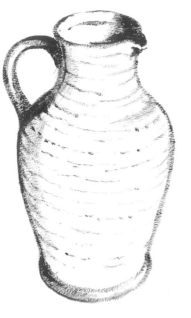

Drybrushing
Try making a simple brush drawing, using a small amount of undiluted paint and a short-bristle brush. The brushstrokes will soon run dry, giving a fresh sketch-like appearance to the work.

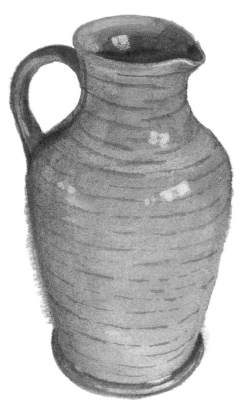

Using diluted paint
Here the paint is diluted with water and applied as washes, wet-in-wet. Draw the jug in pencil, then brush clean water within the pencil outline. Starting at the top, apply a light-coloured wash to the wetted area. Build up the form with successively stronger washes, starting from the darker areas – the colour tends to flow and bleed naturally, creating rewarding accidental effects. Remove excess colour while it is still wet, using a clean damp brush. Create highlights with white body colour.

Painting straight from the tube
Mix undiluted paint to match the lightest background colour and brush it over the pencil drawing. Give the painting form, using the paint at full strength or diluted with a little water to model the shape. Blend the tones, and add highlights to give a reflective quality to the surface.

A simple palette
Using just four colours,
acrylic paint offers you a
wide range of possibilities,
from translucent washes
to strong opaques.

Opaque chromium oxide Light yellow ochre Burnt umber Titanium white

Adding glaze medium

Glaze medium allows acrylics to be used in a similar way to oils. When added in small amounts to undiluted acrylic paint, glossy opaque colours are produced. Adding a larger amount of glaze medium creates thin transparent washes which, when they are used to overlay other colours, are known as glazes. Here, the paint was applied with bristle brushes, which were rinsed in water before each change of colour.

Using gel medium

Gel medium, which is thicker than glaze medium, dries to a transparent gloss. It creates a full-bodied paint with a rich depth of colour that can be worked like oil paint. Build up the form of the jug with opaque paint and thin glazes. As acrylics dry relatively quickly, you can soon overpaint the surface to modify the colour or form. Brushmarks left in the extra-thick paint will add character to the finished painting.

Mixing with texture paste

Create a distinctly textured painting by mixing acrylic paints with texture paste. Use a small cranked painting knife to apply the paint, allowing your strokes to follow the curved form of the jug to emphasize its bulbous shape. With acrylic paint, you can work from dark to light or vice versa when building up the form. Although relatively difficult to control, thick paint applied with a knife imparts a sense of freedom and spontaneity to the painting.

239

Interpreting colour and pattern

Even a simple painting encompasses a variety of skills. In addition to observing and communicating individual colours and form, a still-life painter has to compose and arrange elements within a given area, and also strive for balanced colour. This picture of a flower concentrates on colour and shape created with paint on paper. Brushes are eventually put aside as the artist employs a collage technique as a simple and effective means of focusing on the colours and shapes evident in this still-life subject.

Materials

Use quick-drying, water-soluble colours. Here the artist used gouache, but acrylic paints, watercolours and even poster colours or inks will serve equally well.

Any paper will do. Leftover scraps from sketchbooks and previous projects are ideal, and using papers with different surface textures will serve to enrich the finished work.

You don't need scissors unless you want very precise shapes. For this collage, the shapes were torn from the paper. You will need paste and a brush.

▶ **SEE ALSO**
▶ Collage 208
▶ Gouache 104
▶ Painting a vase of flowers 254
▶ Papers 21, 28
▶ Shape and form 236
▶ Washes 182, 204

Choosing your subject
It is important to select a flower that is well-defined in form and colour, and will thus lend itself to simple interpretation using the collage technique. In this case, the artist has opted for a seasonal flower and decided to focus on a single bloom offset by a hint of foliage. The iris is an elegant spring flower with distinctive shapes and colours.

Observing colours
Create your palette of collage materials with paint on paper. Interpret the colours of the object in front of you as closely as possible.

Forming shapes
Start by tearing the basic shapes of the flower from the appropriately coloured paper samples. Simply modify the shape and scale as you go.

Fixing position
Dry-lay the arrangement onto the background. Then, when you are happy with the composition, paste the various elements in position.

Arranging the collage
Arrange the torn-paper shapes to approximate the form of the flower. Change the shapes and add different colours, gradually building up the picture rather like a mosaic.

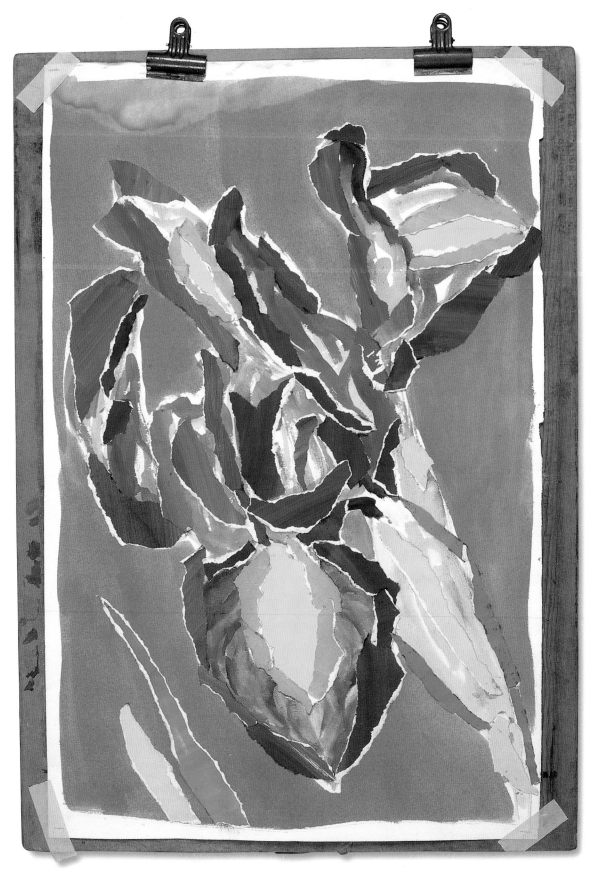

Ella Jennings
Blue Iris
Painted and tinted
paper collage
76 x 51cm (30 x 20in)

A single flower
Making simple collages of single objects will help you to see colour and pattern. This bold interpretation of an iris is made using gouache to colour the paper, which is then torn and arranged on a tinted-cartridge-paper background. It is an advantage to work at a fairly large scale when making torn-paper collages.

Interpreting surface textures

Each component in a still life has an intrinsic visual quality – hard, brittle, soft, flexible, warm, cold and so on. In addition, the surface of most materials will gradually develop its own peculiar character or patina – this is a result of ageing and exposure.

Capturing textures

Here, we see a number of ways to capture the essential nature of inanimate objects, using a variety of media. By making a number of studies of different materials, you can build up a repertoire of techniques that will help you with your still-life painting.

Household wares and found objects
Everyday objects can be used to provide your still-life table with a variety of interesting and challenging surface textures.

Wood and ceramic in pastel
Here, soft pastels have been used to depict contrasting materials – wooden spoons and a fired-clay pot. Draw the still life in soft pencil, then render the smooth surface of the spoons with suitable pastel colours, blended on the paper with a rolled paper stump. Draw the wood grain with pastels, using an eraser to lift off some of the colour. Render the surface texture of the pot with short diagonal strokes, using colours in various tones to create the cylindrical shape. Let the pastel strokes overlap and blend together.

Wood in pencil and watercolour

Coloured pencil (right)
Using water-soluble pencils, draw the light wood tones, following the direction of the grain. Build up the colour by crosshatching where darker tones are required. Using a wet brush, blend the pencil lines to make a colour wash. When dry, darken and modify the tones and create the grain pattern of the wood. Use a putty rubber to introduce highlights and clean up edges.

Watercolour (left)
First draw the box in soft graphite pencil. Using yellow ochre, raw sienna and burnt sienna, mix washes that resemble the tones of the wood. For the shadows, mix burnt umber and cobalt blue. Wet the drawn area and lay a wash of the lightest tone. When almost dry, paint the faces of the box with darker washes. Add streaks to represent grain, and apply a wash for the shadows.

Clay pots in pastel and acrylic

Pastel
Having made a simple underdrawing, you can depict the colouring and weathered texture of some old clay flowerpots by using overlapping strokes of colour. Try not to overwork the colours, or you will risk losing their freshness.

Acrylic paint
Liquid acrylic paint can be used straight from the pot or thinned with water. Apply the colour freely with a flat bristle brush, using a small round brush for detail. Once the surface is dry, overpaint with opaque paint or transparent washes to model the pots and introduce the pale tones of mildew-staining over the terracotta.

Drinking glass in watercolour and pastel

Pastel
It is difficult to be precise when working with pastels, so use a putty rubber to define the reflections and the highlights in the glass. A paper stump is useful for blending colours and for drawing in fine detail – rub the tip of the stump onto the pastel, and then transfer the colour to the work.

Watercolour
Mix watercolour washes to represent the silver-grey tones seen in glass. Study the shapes of the reflections and block them in with washes, wet-on-dry. Leave areas of white paper to represent the highlights. Carefully outline the darker edges, such as the rim, using the tip of a brush.

Folded fabric in oil pastel
Oil pastels have a paint-like quality, ideal for rendering the folds and texture of fabric. Draw the cloth on a coarse-textured paper and apply colour to delineate the squares, allowing some of the paper's texture to show through. Describe the various tones by overlaying with more pastel, or scrape it back with a scalpel. Use the pointed blade to draw the warp and weft of the fabric.

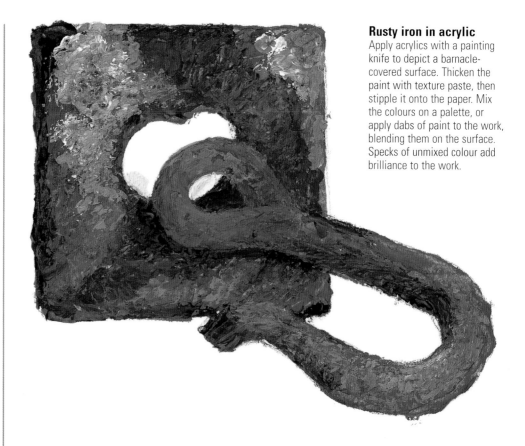

Rusty iron in acrylic
Apply acrylics with a painting knife to depict a barnacle-covered surface. Thicken the paint with texture paste, then stipple it onto the paper. Mix the colours on a palette, or apply dabs of paint to the work, blending them on the surface. Specks of unmixed colour add brilliance to the work.

Rusty can in watercolour
The worn surface and rust patches on this old screw-top can have been painted in watercolour. Warm and cool greys mixed from raw umber and cobalt blue are used for the metal surfaces, with washes of yellow ochre, green and raw umber for the old labels and tape. Make a line drawing of the container, then apply a light-grey wash for the metal. Adopt a similar treatment for the label and tape. Gradually add deeper tones with dabs of colour, wet-in-wet, to build up the form and character of the surfaces.

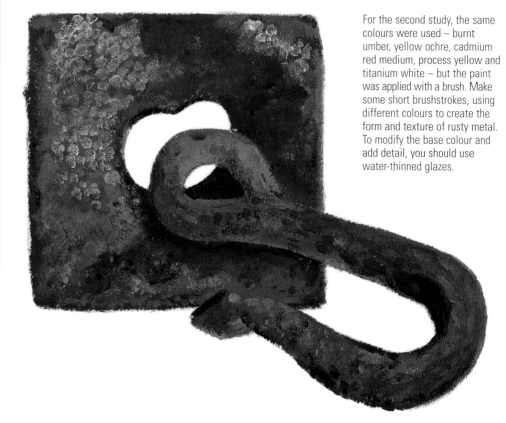

For the second study, the same colours were used – burnt umber, yellow ochre, cadmium red medium, process yellow and titanium white – but the paint was applied with a brush. Make some short brushstrokes, using different colours to create the form and texture of rusty metal. To modify the base colour and add detail, you should use water-thinned glazes.

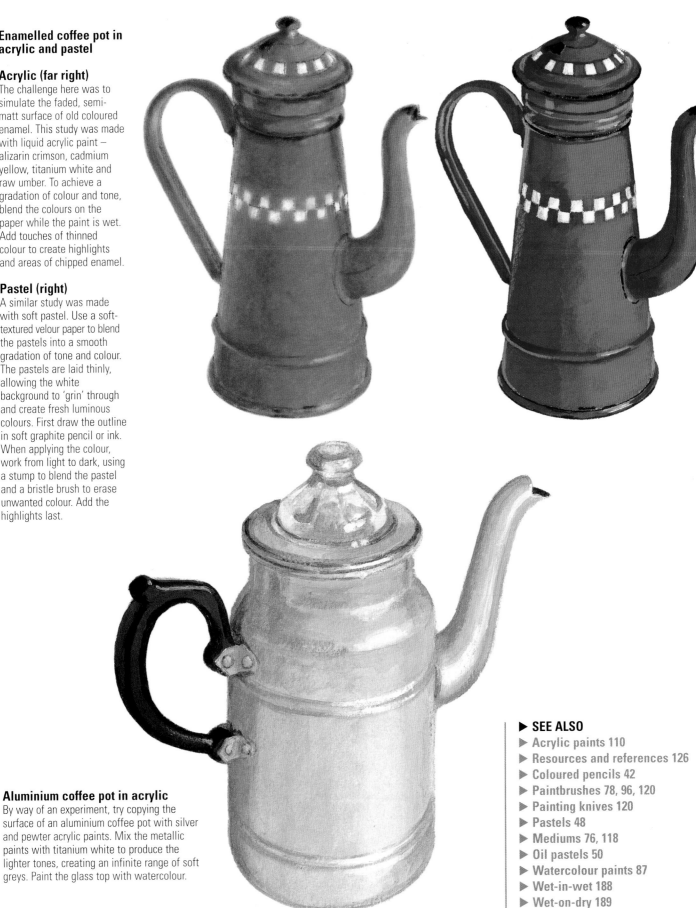

Enamelled coffee pot in acrylic and pastel

Acrylic (far right)

The challenge here was to simulate the faded, semi-matt surface of old coloured enamel. This study was made with liquid acrylic paint – alizarin crimson, cadmium yellow, titanium white and raw umber. To achieve a gradation of colour and tone, blend the colours on the paper while the paint is wet. Add touches of thinned colour to create highlights and areas of chipped enamel.

Pastel (right)

A similar study was made with soft pastel. Use a soft-textured velour paper to blend the pastels into a smooth gradation of tone and colour. The pastels are laid thinly, allowing the white background to 'grin' through and create fresh luminous colours. First draw the outline in soft graphite pencil or ink. When applying the colour, work from light to dark, using a stump to blend the pastel and a bristle brush to erase unwanted colour. Add the highlights last.

Aluminium coffee pot in acrylic

By way of an experiment, try copying the surface of an aluminium coffee pot with silver and pewter acrylic paints. Mix the metallic paints with titanium white to produce the lighter tones, creating an infinite range of soft greys. Paint the glass top with watercolour.

▶ **SEE ALSO**
▶ **Acrylic paints 110**
▶ **Resources and references 126**
▶ **Coloured pencils 42**
▶ **Paintbrushes 78, 96, 120**
▶ **Painting knives 120**
▶ **Pastels 48**
▶ **Mediums 76, 118**
▶ **Oil pastels 50**
▶ **Watercolour paints 87**
▶ **Wet-in-wet 188**
▶ **Wet-on-dry 189**

Fish on a plate

You can take the idea of painting a single object a step further by looking at the object in context. This requires you to observe a variety of textures, and introduces you to basic composition. Fish on a plate make a simple yet fascinating still-life subject. The brittle glazed ceramic of the plate and the natural colouring and delicate scale patterns of the recently caught mackerel provide an opportunity to explore ways of using paint to express their contrasting qualities.

The materials
Watercolour paint is the perfect medium for capturing the diffused colouring of the subject. This study was painted on 250gsm rough (coarse-surface) watercolour paper, taped but not stretched onto a drawing board. In addition, you will need a soft graphite pencil, round sable paintbrushes, an eraser for making corrections, and masking fluid to create the highlights.

The props
A pair of attractively marked fish arranged on a simple white plate make an ideal vehicle for developing visual awareness and learning to use watercolour (the chosen medium for this study). Look carefully at the harsh reflections from the hard glazed china, comparing them with the more subtle glistening skin of the fish, with its rainbow reflections and striped markings.

Underdrawing
Start the work by making a light pencil drawing of your composition. Draw the elliptical shape of the plate in full, but ellipses can be tricky to draw accurately, so don't be afraid to use an eraser to make corrections as necessary. Next add the fish, noting their overall shape and proportion. You can erase the lines of the plate that would be hidden by the fish once you are satisfied with your drawing.

Drawing in pencil
You can keep the underdrawing relatively simple.

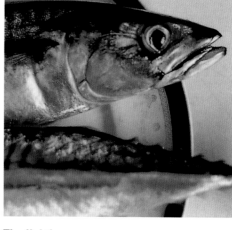

The lighting
A window to the right of the still-life table provides the main light source. Fish skin changes colour dramatically according to the direction of light, so you may need to try different arrangements to discover the most attractive viewpoint when you are setting up a composition of this kind.

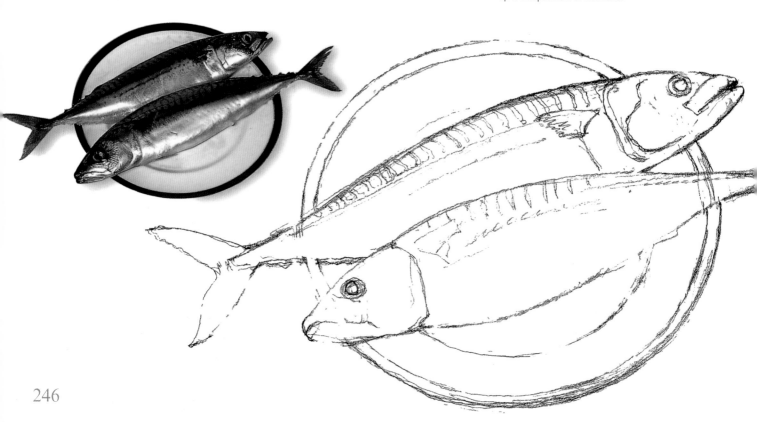

Masking out the highlights
Identify the highlights on the plate and fish, and paint them on to the drawing with masking fluid.

Painting the shadows
Mix tonal washes for the shadows and for modelling the form.

Painting the plate
Mix a suitable colour and carefully paint in the rim of the plate, taking note of the way reflected light gives it solidity and form.

Masking out highlights

Use the white of the paper to represent your strongest highlights. Paint the shape of each highlight with masking fluid which, when removed at a later stage, reveals the unpainted surface of the paper. In this study, the highlights occur on various parts of the fish and also around the rim of the plate. Masking fluid dries fast, so work quickly and wash out your brush in soapy water before the fluid clogs the bristles.

Start the painting itself, by wetting the areas of cast shadow around the plate, using clean water. With brushstrokes following the shapes made by the shadows, apply a light wash over the wetted area. Let the surface dry a little, then add darker washes to deepen and strengthen the tones. Also, add pale colour washes to model the hollow shape of the plate and to introduce some shadows beneath the fish.

Mixing and laying washes

Now begin to build up the form of the fish with overlapping washes of translucent colour. Note the subtle colour changes across the skin and mix suitable washes, testing them on a scrap of paper to check the strength of colour and tone. When dry, watercolours appear lighter than when they are first applied, so take this into consideration when mixing your colours. Lay the washes freely and let some blend together, wet-in-wet. If you need to modify the colouring, leave the wash to dry, then apply another colour over the top. Alternatively, lift off the paint while it is still wet by blotting with a soft paper tissue.

Light and shadow
Note how light illuminates your still life, creating highlights on one side and throwing shadows on the other.

Using glazes to give shape to the fish
Apply translucent washes to describe the firm, rounded bodies of the fish.

Fish on a plate *(continued)*

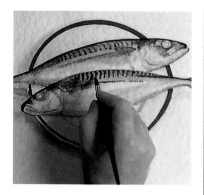

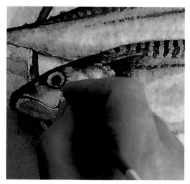

Picking out the details
Use a fine round paintbrush to draw the striped markings, and to touch in the dark centre of the eyes.

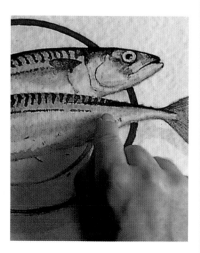

Revealing the highlights
Once the paint is dry, use your fingertip or an eraser to rub away the masking fluid, revealing the white paper beneath.

▶ **SEE ALSO**
▶ **Drawing circles in perspective 303**
▶ **Masking fluid 192**
▶ **Wash techniques 182**
▶ **Wet-in-wet 188**
▶ **Wet-on-dry 189**

Now begin to add detail to the painting, emphasizing the form and character of the subject. Use a fine brush to define the shape of the fish, and to pick out features such as the eyes and gills.

Let the painting dry, and then rub away the masking fluid applied at the beginning. Apply light washes to modify the shape and colour of the highlights, but leave the white paper to depict high-key reflections.

At this point, you should step back and take a good look at your painting to ensure you are maintaining an overall balance of tone and colour. Then make the necessary modifications with small touches of paint and coloured glazes, until you feel you have captured the essence of the still life.

David Day
Fish on a Plate
Watercolour on paper
25.5 x 38cm (10 x 15in)

This simple study demonstrates how you can make a successful still-life painting of commonplace objects, provided they are chosen with care and arranged to make a balanced composition. Make similar studies using a variety of media.

1 Surface textures
Each fish has its own individual markings. Paint them with a fine round brush.

2 Coloured glazes
Delicate colours can be achieved with overlapping glazes of watercolour.

3 Masked highlights
Mask off the white paper to create high-key accents.

4 Modelling
Describe the shape and form of objects with carefully applied washes.

5 Finest detail
Add the finest detail to a painting by drawing with a pointed brush.

Painting a bowl of fruit

Jennie Dunn
Fruit Bowl
Strong colours, uninhibited brushwork and bold outlines characterize Jennie Dunn's paintings. This simple still life relies on the careful orchestration of shape, tone and colour for its impact.

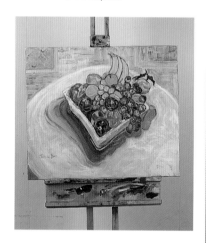

'Be quite free with your brushstrokes, and don't be afraid to let them show. You are not a housepainter, so try to create interesting textures and broken colour with your paint.'

• Brushes
When painting with water-mixable colours, it is advisable to use special synthetic brushes. For this painting the artist used Nos.2, 4 and 18 flats, and Nos.2, 4 and 20 rounds. To preserve their shape, always wash out your brushes in warm soapy water and wrap the bristles in a paper towel.

Preparatory drawings
Not every artist bothers to make preparatory sketches, but drawing will give you the opportunity to try out various arrangements of colour and tone. It is easier to evaluate the composition if your preparatory drawings are made on paper that has the same proportions as your canvas. Cut or tear the paper to match the canvas.

A selection of fruits is a relatively simple still-life subject, but by introducing a variety of shapes, strong colours and tonal contrasts into your composition, you are forced to think critically about the arrangement of these elements in your picture.

Be aware of shapes
Individually, most fruits are similar in outline, but pile them one upon another and you become aware of the more interesting 'negative' shapes that are created by the spaces between and around the fruits. A careful assessment of colours and tones is essential to make the best of these shapes and create a strong composition.

Water-mixable oil paints
The featured painting was made with water-mixable oil paints. They behave much like conventional oil colours and produce similar results, but they are thinned with water instead of a solvent such as turpentine.

Mediums
A range of mediums is available for altering the characteristics and working properties of the paint. For this painting, the artist used water as the diluent, plus a water-mixable painting medium when applying certain colours.

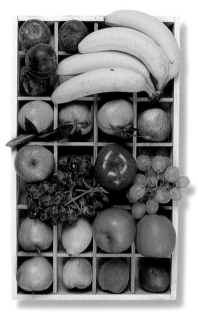

Complementary colours
When selecting the fruit for this painting, the artist intentionally chose colours that were complementary. When complementary colours are juxtaposed, they intensify the eye's perception of colour, creating a more dynamic and vibrant picture.

• Colours used:
Alizarin crimson
Cadmium orange
Cadmium red deep
Cadmium yellow light
Cadmium yellow medium
Cerulean
Dioxazine purple
French ultramarine
Lemon yellow
Sap green
Titanium white
Viridian
Yellow ochre

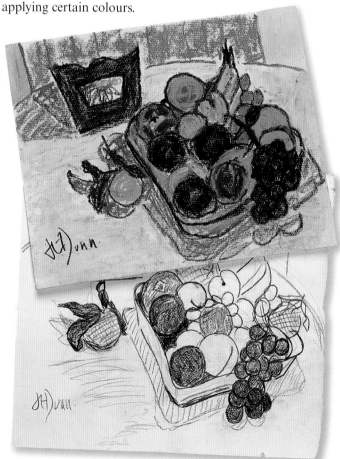

Coloured grounds

Coating a primed canvas or board with a neutral or coloured wash provides a surface upon which the artist can more accurately evaluate a range of colours and tones. In this case the ground colour is intended to form an integral part of the finished painting. A warm pink, mixed with just a touch of ultramarine, glows through to enliven the cool blues, greens and yellows, and forms a perfect mid tone for warm reds and oranges.

Applying a coloured ground
Scrub ground colour onto the canvas, using a wide flat paintbrush and a ball of damp paper towel. Provided you thin the paint with very little water, the ground will be dry enough to work on within a few minutes.

Underdrawing

Using a darker mix of the ground colour, draw the main elements of the composition in line only. Don't be afraid of making mistakes – while it is wet, water-mixable oil paint can be wiped off the surface very easily.

'You have to be aware of perspective, even when you are painting a simple study like this. In particular, the fruit bowl or dish must appear to be sitting firmly on the surface of the table.'

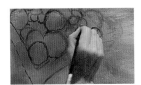

Modifying the composition
While making the underdrawing, the artist decided to simplify the picture by leaving out the extraneous picture frame and fruit she had included in her preliminary drawings.

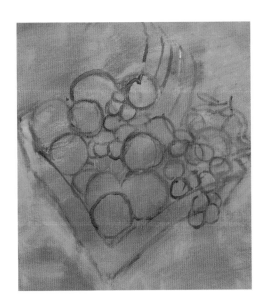

Blocking in the tones

During the early stages of the painting, Jennie Dunn is less concerned with form than with balancing the tones. At this stage, she leaves narrow gaps between areas of colour, allowing the mid-tone ground to show through.

'I'm primarily concerned with achieving the right balance between tones and colours. Ideally, you should be able to stop painting at any stage and the picture will be balanced.'

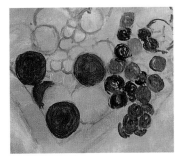

Darker tones
Start by blocking in the darkest shapes in order to suggest the plums and 'black' grapes. Note how the fruits in shadow have a different tonal value from those that catch the light.

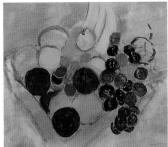

Lighter tones
Introduce the bananas and apricots. For the 'white' grapes, mix a cool base colour from cadmium yellow medium and cerulean, adding ultramarine and sap green to the grapes in the shade.

Introducing strong colours

When painting a subject that has strong colouring, your perception can become confused, making it quite difficult to differentiate tonal values. Narrow your eyes when looking at the still life, and you'll see the dark, light and mid tones more clearly.

'Now we can begin to see where the light is coming from. The various tones and a few key highlights indicate the source.'

Blocking in the stronger colours
Introduce the strong colours by painting the overall shapes of the orange-coloured satsumas and the red and yellow patches on the nectarines and the peach.

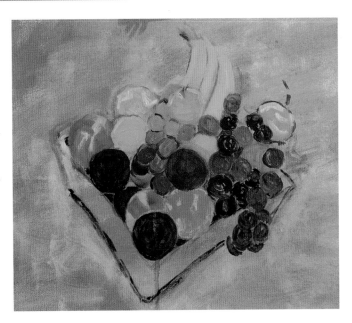

251

Bringing the painting to life

With the underpainting complete, the artist returns to the focal point of the picture – the bowl of fruit.

'This is where the fun begins. Don't hold back at this stage, thinking you are going to spoil your painting. Just go with the flow and enjoy it.'

With some deft strokes of paint, the picture is rapidly brought to life. The fruits begin to take on weight and solidity, and their surfaces glisten with reflected light.

'I like to draw rounded shapes with a series of straight lines. Fruits are not entirely round anyway, and straight lines are more dynamic.'

Painting the fruit bowl
Outline the bowl with deep ultramarine, then lightly brush pale Naples yellow along the sides of the bowl. Here the pink ground changes the colour to a warm grey. Define the inner edge of the bowl and deep shadows with sap green and purple.

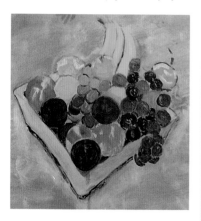

Defining shapes
To define the shapes and unify the painting, Jennie Dunn paints distinct outlines, using colours that complement the colours of the fruit – soft purple around the bananas, and dark green for the warm-coloured nectarines, apricots and satsumas.

Multiple shadows
The combination of natural and artificial light throws multiple shadows alongside the fruit bowl. With their sweeping bands of cool pink blended with sap green, ultramarine and viridian, these shadows are an important feature of the painting.

Painting the background
Using your largest flat brush, roughly block in the white tablecloth, scrubbing paint onto the canvas so that the warm ground shows through the brushstrokes. Before you start to detail the focal point of the picture, paint in the background shapes and tones. These will help you to evaluate accurately the colours that will be applied next.

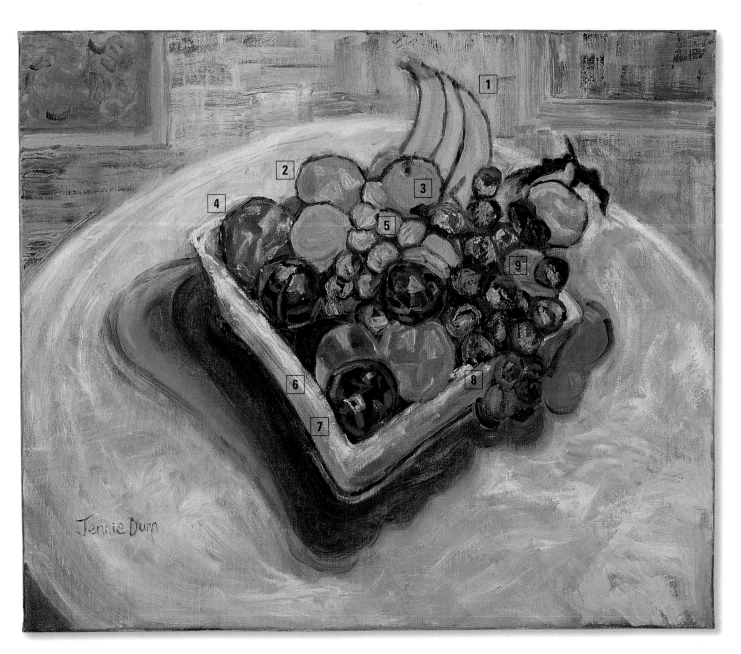

1 Bananas
Paint the distinctive planes separately, using various tones of yellow mixed with sap green.

2 Satsumas
With a combination of cadmium red and yellow, keep the orange colour relatively low-key to ensure that fruits at the back of the bowl appear to recede. Apply pale-yellow highlights and dark-green leaves with a large paintbrush.

3 Apricots
Bring the simplest of fruits to life with vigorous brushstrokes. The base colour is cadmium yellow warmed with cadmium orange.

4 Nectarines
Dry-brush highlights over a mixture of crimson and cadmium red.

5 White grapes
Paint some solid-looking grapes with complementary pink and yellow-green highlights, gradually blending into the blue-green shadows.

6 Peach
Having painted the yellow patches, stipple alizarin crimson and cadmium red onto the canvas to depict the velvety skin of a peach.

7 Plums
With bold brushstrokes, you can describe the form and rich colouring of the darkest fruits in the bowl. Use pale blue and pink for the highlights, and then define the darker areas with a deep purple.

8 Black grapes
Scumbling pink and blue-grey onto the canvas will create a texture that resembles a natural bloom on the skins of the black grapes. You can apply some highlights with a painting knife, and then enliven the spaces between with viridian.

9 Apple
A small patch of pale-green apple is the perfect complementary to the dark rich colours of the fruits that surround it in the bowl.

Jennie Dunn
Fruit Bowl
Water-mixable oil on canvas
51 x 61cm (20 x 24in)

▶ SEE ALSO
▶ Complementary colours 215
▶ Drybrushing 178, 196
▶ Mediums 76
▶ Mixing colours 220
▶ Painting knives 118, 174
▶ Painting three
 dimensions 236
▶ Scumbling 176
▶ Water-mixable oil
 paints 66

Painting a vase of flowers

There is little doubt that making preparatory studies will allow you to try out different compositions and absorb valuable information about a subject before you embark on a painting, but an artist must also be able to make sensitive and flexible responses to positive feedback as the work progresses. This will require the ability to recognize a good thing when it happens and also the courage to change course, perhaps even to abandon your original concept.

A flexible approach

Shirley Trevena has mastered this flexible and spontaneous approach to painting, taking pleasure in every fortuitous effect and texture an unpredictable medium like watercolour can offer. Don't approach this exercise with the idea that you are going to make an accurate botanical study. Instead, enjoy yourself as you try with colour and texture to convey an impression – your emotional response to a vase of flowers.

Choosing the subject

To avoid conflict within the painting, it is a good idea to select just one type of flower, and rely on the contrast between the blooms, leaves and stems for visual interest. You will have your own ideas for suitable subjects, but an arrangement of lilies, irises or tulips offers such dramatic possibilities that these flowers invariably make rewarding subjects for painting.

The vase or container you choose will make a difference to the picture. The simple brass vase depicted is a perfect foil for the display of white lilies, but other types of flower might look better in a glass vase or a ceramic jug. You don't have to put flowers in water. Wrapping paper presents exciting opportunities for colour and pattern, too.

Preparatory work

When following a more 'organic' approach to painting, there is no point in making a detailed underdrawing. But that does not preclude you from drawing the regular outline of a dish or jug if it helps you get started. Similarly, there is nothing to prevent you practising the techniques before you embark on a finished painting. The colour sketch opposite, for example, was made to try out a range of colours the artist was considering for the main work.

Flexible approach to composition
To develop a loose, intuitive style, you should try not to be restricted by the shape and size of your paper. And, as the work progresses, be prepared to develop the composition in ways that might be suggested by the painting itself, such as a strong directional flow or a balance of forms. For Shirley Trevena, the vase of flowers merely serves as the starting point for her composition.

'I work with one of the flowers in my hand. This allows me greater freedom of expression because, by taking information from the flower in my hand, I can paint a bloom from a slightly different angle, or insert a bud or a leaf in just the right spot.'

Colours
For this painting, Shirley Trevena used the following artist-quality tube colours mixed on white plates:

Alizarin crimson
Burnt sienna
Cadmium lemon
Caput mortuum violet

French ultramarine
Green gold
Olive green
Payne's grey

Lilies
The eye is drawn to the sculptural blooms of the lily, but for an artist, the shapes formed by the leaves and stem can be as important as the flowers.

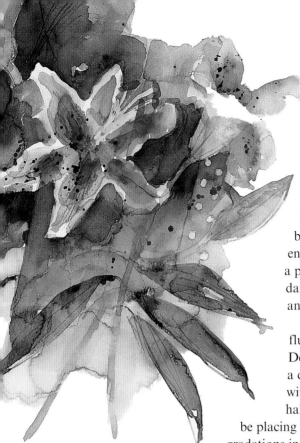

Painting a lily flower

To paint a lily, start with a wash of alizarin crimson down the centre of each petal, and draw the central stripes by dragging a sharpened stick through the wet paint. Partially dry the paint with a hairdryer, then brush clean water over the petals to encourage the colour to bleed, creating a pale-pink halo. Touch off a drop of dark violet into the root of each petal, and allow the colour to run.

Paint the stamens with masking fluid, then dry the painting once more. Define the edges of the petals with a dark, blue-grey wash. Be bold with your brushstrokes, but keep half an eye on where you might be placing the next bloom. Create delicate gradations in this background colour by dropping another colour into the wet paint. You can interpret shapes quite freely because a mere suggestion is sufficient to convey the character of the lily.

Colour sketch
Like the finished painting, this practice work (above) was made on stretched 300gsm cold-pressed paper. It was made using inexpensive brushes, but with good-quality artists' watercolours.

Speckled centres
You can suggest the speckling on the petals by spattering some dark-red paint across the flower. There is no need for accuracy – just tap a loaded brush across your finger to splash paint onto the centre of the bloom.

Stems and leaves
Now paint the stems and the base of each leaf with a brush, and then drag the sharpened stick through the wash to draw out the pointed leaf and its veins. Blot the paint with an absorbent paper towel if you want to remove some colour, or, alternatively, you can touch dark green into the yellow leaves to create broken-colour washes.

Background washes
Dry off each section of the painting as you go, and define the shapes with a dark background wash. Do not even try to disguise the joins; just delight in the opportunity to create interesting textures in your work. You can be as bold as you like with the colour – if you find that it is not to your liking, you can lift some of the colour off the surface with an absorbent paper towel or a damp brush.

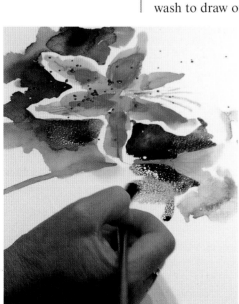

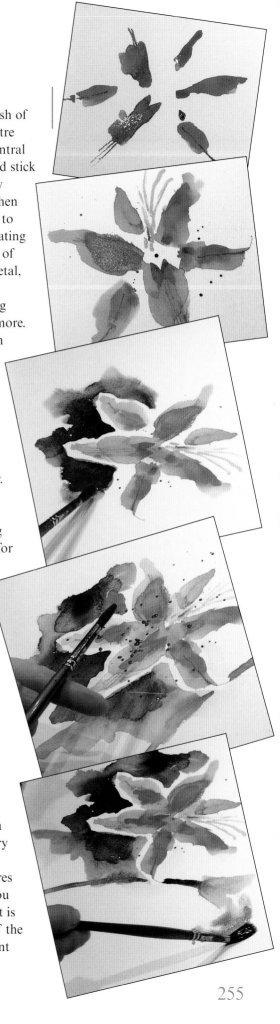

Painting a vase of flowers *(continued)*

Starting points

You want to get off to a good start, so select something that grabs your attention. From the beginning, the bold and colourful shape of the open flower (below) was seen as the focal point for this painting.

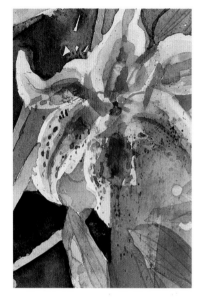

'I start painting whatever it was that drew me to the subject in the first place. In this case, it was the speckled "Stargazer" in the centre of the picture. Having established my starting point, I work out from there, adding to the painting like joining the pieces of a jigsaw.'

▶ **SEE ALSO**
▶ Glazing 170
▶ Masking fluid 102, 192
▶ Watercolour paints 87

The finished painting

A traditional watercolourist would construct a painting systematically by applying the paler washes first, and then overlaying them with progressively darker glazes of colour. It is also usual to work across the entire painting, rather than concentrate on small areas at a time. With this painting, the artist deliberately turns that approach on its head, in order to create a rich tapestry of both colours and textures which is largely the result of chance.

Although she paints a wide variety of subjects, ranging from still life to figures, Shirley Trevena is perhaps best known for her exuberant flower paintings. In the painting opposite, the lilies are bursting out of the painting, creating a thrust of energy that is counterbalanced by the dark weight of the vase. Flouting convention, the artist makes the stems visible.

'When I start painting I embark on a journey without knowing my destination. You should always be prepared to take a risk, because the unexpected accidents make for a more exciting painting. I am looking to incorporate those events that many watercolourists try to avoid. In fact, I try to re-create similar effects elsewhere in the painting, so that they become an integral and quite deliberate aspect of the work.'

Don't be mean with your paint

Rich textural effects are only possible if you apply plenty of paint. For this reason, it pays to use tube colours and mix your washes on white plates or saucers. A paintbox of pan colours is useful, but only during the later stages of a painting when you might want to add small colourful touches or modify an area of colour with a glaze.

Special effects
In addition to conventional brushwork, Shirley Trevena achieves free-flowing lines with a sharpened stick.

1 Broken colour

If you touch a loaded brush into a wash that is still wet, the colours merge, creating soft, irregular margins. To leave deliberate junctions between colours, let one wash dry before overlaying it with another wash.

2 Backruns

To create the delicate mottled edge of a backrun, drop paint or clean water from the tip of a brush onto a wash that has been allowed to dry out a little.

3 Masking off

It is difficult to reserve small areas of white paper when you are painting a background wash. Mask details like stamens with masking fluid, then paint over them and rub off the rubbery fluid when the paint has dried.

4 Spattering

Flicking paint from a brush creates the illusion of speckling on flower petals. Here the artist applied additional dots, using a sharpened stick.

5 Drawn lines

Leaf veining and other linear marks are made by drawing a sharpened stick through wet paint. You can create similar effects by dipping the stick into another colour before drawing the lines.

6 Lifting colour

To remove colour, scrub the surface of the paper with a fairly stiff damp paintbrush, and blot the area dry with a paper towel.

7 Drying the work

Using a hairdryer allows you to continue working on the picture. If you leave the paint to dry naturally, that will create richer textures.

Shirley Trevena

(opposite)
Tall Vase of Lilies
Watercolour on paper
58 x 46cm (23 x 18in)

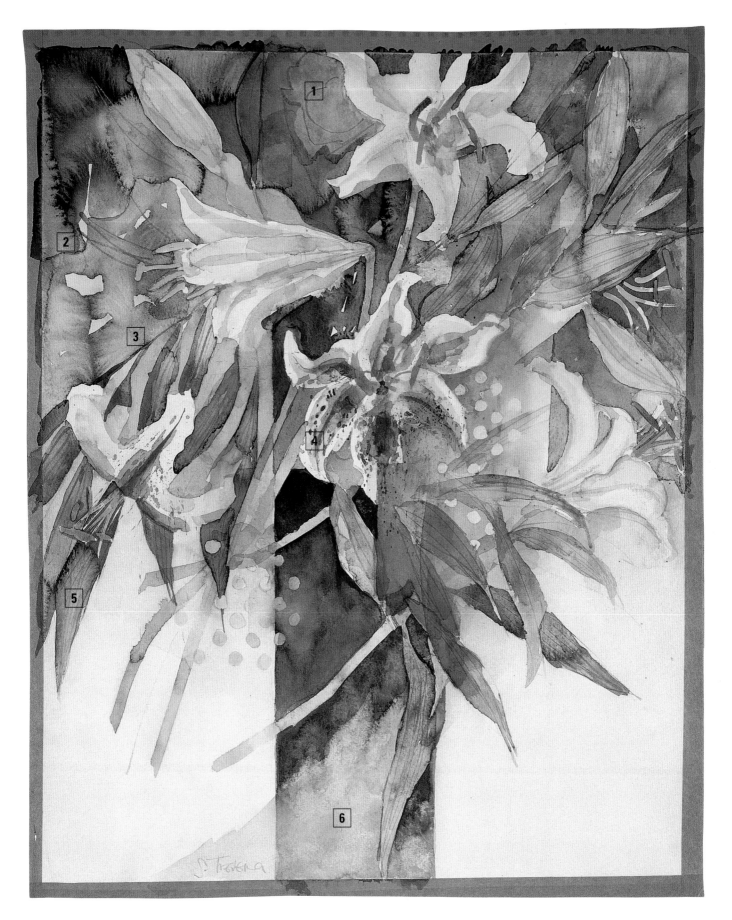

Painting a still-life group

This still-life painting brings together the core of subjects we have seen earlier, but this time the artist has chosen to introduce another vital element – light. Timothy Easton is known for paintings that are composed with a strong geometric structure. Here he arranges a simple still life on a square canvas, placing the main group just off centre. A diagonal shaft of winter sunlight balances the composition and throws dramatic shadows across the table and backdrop, creating a grid-like pattern with the folds picked out by the intense light.

Anticipating the light

All paintings rely to some extent on the way natural or artificial light falls on the subject, but in this case the artist has decided to allow the light to dominate his picture. A choice like this brings its own challenges, requiring the artist to devote much of the day to working partly from memory, anticipating those brief periods of time when conditions are just right.

Painting with oils

Some people seem to find using oil paint intimidating – something that they should work up to, having cut their teeth on another medium, such as watercolour or acrylics. There is also a widely held view that it is impossible to paint in oils without creating such a mess that you need a special studio to work in. Neither assumption is correct. Being slow-drying, oil paint will allow the beginner plenty of time for experimentation. Mistakes can be corrected by overpainting, or by scraping off the paint and starting again.

One drawback with any slow-drying paint is a tendency for colours to become 'muddy', simply because each new layer of paint stirs up the colours that have already been applied to the canvas. You can control this to some extent by starting with thin washes of diluted colour that are gradually overlaid with thicker paint as the painting develops. Also, it pays to keep your paintbrushes as clean as possible to avoid introducing colours inadvertently. Timothy Easton, who uses only the best-quality oil paints, takes extra care to keep his colours clean by premixing a range of shades from a relatively limited palette.

Various additives or mediums can be mixed with oil paint to modify its characteristics, but you can produce perfectly successful pictures using nothing but pure turpentine for thinning the paint and for washing out your brushes.

'Light is what interests me most as a painter. I like to work with very strong tonal contrasts and, in many cases, quite strong colours, too.'

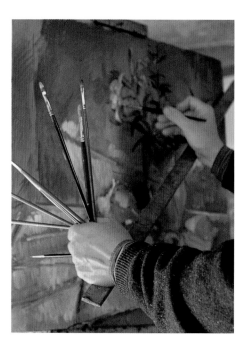

Paintbrushes

Timothy Easton likes to use a range of relatively small filberts for painting in oils, because it enables him to make a variety of strokes using a single brush. For very fine detail, he uses sable brushes.

Basic palette of colours

Titanium white
Cadmium yellow deep
Cadmium yellow
Raw sienna
Indian yellow
Cadmium red
Geranium lake
Permanent red
Alizarin crimson
Cerulean
Cobalt blue

Initial brush drawing

Having primed and painted the canvas with a neutral olive-green ground, the artist begins to draw the subject to establish the basic composition. Even though he is applying diluted paint with a small sable brush, the work at this stage resembles a lively pencil drawing, with bold hatching used to indicate the areas of shadow.

'Instead of painting the flowers and other objects on the table as they appear at this moment, I have to think ahead to what I anticipate they will look like a little later in the day. With this in mind, I am using a range of tones with very little contrast as a basis for the stronger shadows and highlights that I expect to see when the sun travels round.'

Tonal underpainting

With the underlying structure drawn in with line, the artist begins to block in a wider range of tones, using diluted blue-grey paint applied with bold diagonal brushstrokes.

During these initial stages, the artist can only approximate the depth of tone and degree of contrast that will be evident when the sunlight finally streams through the window to the left of the still-life table. Consequently, he concentrates on basic proportion and form, knowing that there may be considerable changes made to the colour at a later stage.

'Drawing is mark-making, painting is mark-making. All that is important is to find ways of translating what you see onto the canvas.'

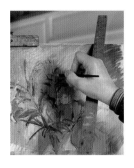

Improvised mahlstick
A traditional padded mahlstick is used for steadying the painting arm when executing precise work. When working at close quarters, improvise by resting any strip of wood against the frame of the stretched canvas.

• Stretching canvases
Timothy Easton likes to paint on supports he makes from rolls of linen canvas. Using rolled canvas reduces the risk of creases that may not show until varnish is applied to the finished painting.

Mixing colours in advance
Because he is in the habit of working on a number of paintings, all at different stages of development, Timothy Easton has more colours on his palette than he needs for any individual picture. Consequently there is less space on the palette for mixing, and there's the inherent risk of colours becoming contaminated. As a precaution, he squeezes out the minimum amount of raw paint, but then mixes a range of hues and shades from each colour before starting work.

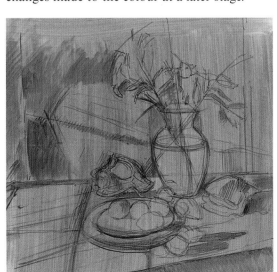

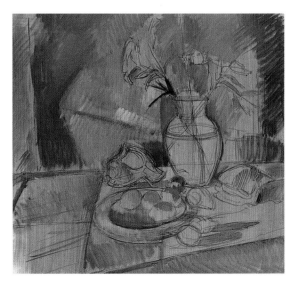

Introducing the lilies
The stems and leaves are drawn using broken lines and broad brushstrokes, and the position of each bloom is plotted with white and pale-yellow paint. Whenever you paint flowers, be aware that buds eventually open into full blooms which, in turn, wilt as the flower dies. Since you cannot arrest a flower's development, you have to decide what stage is best for your painting.

Flooding with light
Eventually the sunlight streams through the window, illuminating the still life as the artist anticipated. This gives him the chance to paint the high-key tones across the tablecloth and backdrop, and to introduce highlights to the flat dish and shells. With the more intense light pervading the scene, now's the time to balance the tones across the painting.

Working up form and detail

With the main elements of the painting blocked in to his satisfaction, Timothy Easton starts to work up the details of the still-life group. The form of each lily is greatly enhanced, and carefully drawn highlights and shadows are used to indicate the curve of individual leaves. More work goes into painting the water in the vase, introducing dark shadows, pink reflections and bright highlights, all of which serve to describe the rounded shape of the vase, the thickness of the glass and the surface of the water.

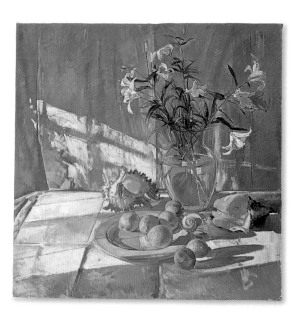

Applying stronger colours

The sunlight brings the stronger colours to life, and the artist seizes the opportunity to block in the lemons, using cool grey-greens for the shadows, orange for the mid tones and various shades of yellow to depict reflected light and highlights. At the same time, he strengthens the shadows cast by the fruit and gives the shells body and form with pink highlights and warmer shades of blue-grey.

Turning a painting upside down

If at any stage you feel that something is not quite right with your painting, turn it upside down. This invariably helps you to see the work afresh and makes you aware of problems with proportions, colour balance and tonal contrast.

▶ **SEE ALSO**
▶ **Painting against the light** 266
▶ **Drybrushing** 178, 196
▶ **Mahlstick** 86
▶ **Mediums** 76
▶ **Mixing colours** 220
▶ **Oil paints** 64
▶ **Paintbrushes** 78, 120
▶ **Painting three dimensions** 236
▶ **Primers and grounds** 24
▶ **Scumbling** 176
▶ **Stretching canvas** 16

Detailing the shells
The shells, too, receive more attention. The hollow nature of the large shell is indicated with pink light glowing from inside. Darker tones are applied to make a stronger contrast with the bright light reflected from the table and backdrop.

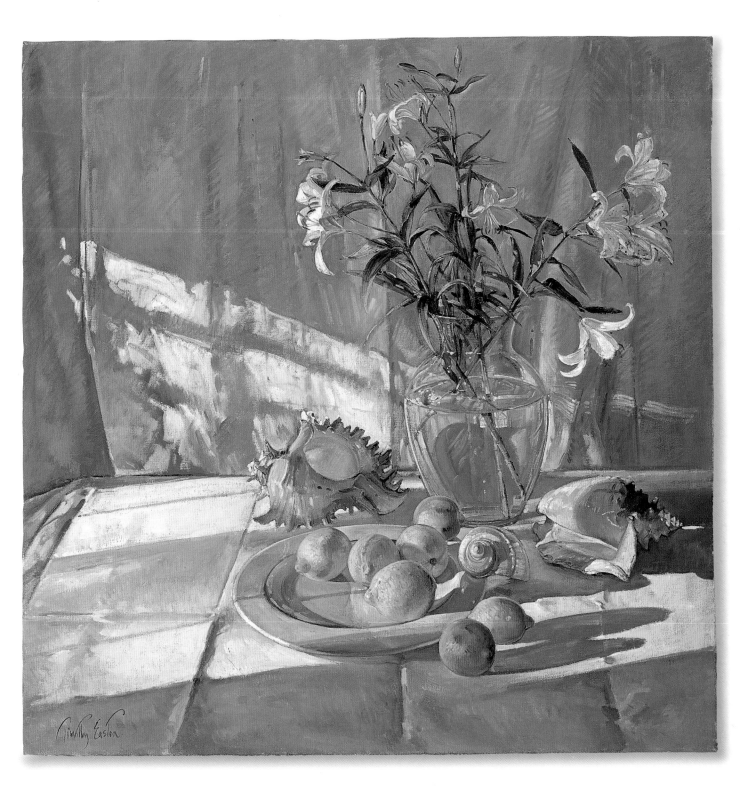

The final stages

The painting begins to glow with light and colour – an illusion created by tonal contrast and the juxtaposition of warm and cool hues. Colour is introduced to the shadows and areas of reflected light to imply the warm glow of evening sunlight. Although the glazing bars and raised folds are clearly defined, they are deliberately softened with dry-brushed and scumbled colour to break up any hard edges and create an interesting surface texture. To balance the composition, the area of shadow near the bottom of the picture is increased and, at the same time, reflected colour introduced onto the white surface. Colourful details bring the lilies into sharp focus, with a greater variety of tonal contrast among the leaves. The form and surface texture of the fruits are sharply defined with fine brushwork and blending. The shallow dish is described with cast shadow and reflected light, its rim is picked out with pale-pink and blue highlights. The shells are worked up with greater definition, their pearlized surfaces reflecting warm shadows and specks of colour.

Timothy Easton
Reflections and Shadows
Oil on canvas
61 x 61cm (24 x 24in)

Painting your room

'There are different ways to apply glazes with acrylics. You could overlay with wet translucent glazes, a bit like watercolour. I like to scumble my colours to create dry glazes that alter the colour beneath without obliterating it. The effect is similar to a pastel drawing, which is why it works so well with mixed media.'

Tonal sketch

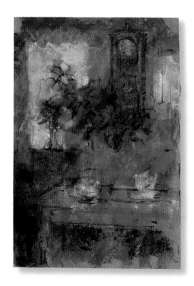

Colour sketch

Stepping back from the still-life table, an artist can take in a wider view of his or her surroundings, bringing pieces of furniture into the frame, and perhaps a window or the corner of the room. Some people would see it as just another still life on a larger scale, yet a room – someone's home or workspace – is much more than an accumulation of inanimate objects. Every interior has a character that reflects the personality of the people who live or work there. Painting a room you know well gives you a better chance of conjuring up that atmosphere and conveying it to the onlooker.

Capturing the subject

The featured painting is a picture of a small intimate space, fused with rich earthy colours and strong daylight streaming through the window. A glass-topped table, a chest of drawers and a mahogany wall clock emerge from the shadows. This is the living room of the artist Debra Manifold. Like most artists, she surrounds herself with a plethora of interesting objects and curios, but she has deliberately excluded most of these details to capture what she considers to be the essential character of the room. It's impossible to paint every object you see in a room. You have to simplify the clutter, and sometimes rearrange the furniture if you feel it's detracting from the painting.

Preparatory sketches

Before starting on the finished painting, Debra Manifold photographed her room from different angles. Having settled on a particular view, she made a tonal study, using pastel and acrylic paint on brown wrapping paper. She also made a coloured pastel sketch to get some idea of how she might interpret the effect of light on the room.

Everything you have learnt from painting still-life groups is relevant to painting an interior: form, shape, tone, light and shade all play their part. Basic perspective becomes even more important. You do not have to be precise with your calculations, but when making preparatory sketches and planning your composition, be aware of how the different surfaces – floor, walls, ceiling, table tops – relate to one another in space.

'I don't follow my drawings too closely. Painting's a different process from drawing. As a painting begins to develop, sometimes I find that what I liked about a drawing does not work as well when put down in paint.'

Scumbling colours

Debra Manifold creates rich overlays and subtle combinations by scumbling one colour over another. She scrubs the paint onto the surface, depositing very thin layers of colour. Scumbling is an easy technique to master because you can see the effect developing gradually.

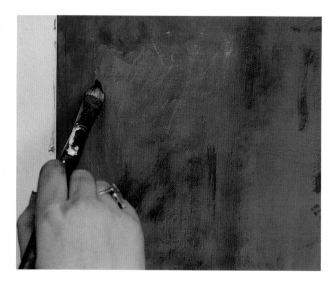

Underpainting

Having made two sketches already, Debra Manifold is prepared to launch straight into the painting itself.

'I would find an underdrawing too restrictive. I think many people would enjoy the act of painting more if they abandoned the notion of making a careful drawing first.'

Blocking in the darker areas
The positions of the window surround, door opening and furniture are blocked in, using a darker tone of the violet ground colour. The artist scrubs neat paint onto the surface of the board.

Laying complementaries
The real value of the strong violet ground becomes obvious when electric greens and blues are laid over it. This brings the painting to life.

'I like to apply these cool colours over the hot background. I want to get the feeling of a fairly dark room, but I still want the painting to be lively.'

Positive and negative shapes
A lampshade, silhouetted against the window, is brushed in with blue-grey paint; the furniture and dark floor area are indicated with hatching.

'I am looking for negative and positive shapes – that is the shapes between and around objects as well as the shapes of the objects themselves.'

Materials
The featured painting was made with acrylic paint overlaid with soft pastel. The support is Ingres board (pastel board), primed with gesso mixed with pumice. The primed board was coated with a rich ground colour – quinacridone violet – to establish a vibrant basis for the painting.

The artist's palette
Cadmium red medium
French ultramarine
Hooker's green
Maroon
Mars orange
Olive green
Payne's grey
Quinacridone violet
Titanium white
Yellow ochre

'A lot of people worry about using acrylics because they dry so quickly – but for me, that's their strength. It means I can work lights over darks without them picking up the underlying colours. This suits my technique.'

Keeping acrylics workable
Fast-drying acrylic paint is likely to develop a skin, sometimes before you have finished painting. One way to deal with the problem is to use a stay-wet palette that keeps the paint moist. Debra Manifold has a different approach. She simply squeezes out generous amounts of acrylic onto her palette – when a skin forms, the paint beneath remains workable, even on the following day.

Brushes
The artist prefers to use natural-bristle paintbrushes when working with acrylics, even though her vigorous painting style wears out her brushes at quite a rate. For this painting, she used two filbert brushes – Nos. 8 and 10.

The finished underpainting
The details of the room (left) are added quickly, with the wall clock and table receding into shadow. Light from the window is intensified, and brushstrokes suggest reflections from polished surfaces.

263

Scattering the light
After scumbling over the window (above right), the artist uses a dry brush, barely loaded with paint, to scrub colour onto the walls and furniture in the vicinity of the window.

'If you find yourself struggling with one area of a painting, it's often a good idea to work on another section for a while, and see how that affects the area that's giving you the problem. Sometimes the solution becomes obvious.'

Bringing light into the room
The way light spills into the room is vital to the painting.

'I am starting to diffuse the window surround, softening the edges in order to give the impression of strong light streaming in.'

Scumbling over the window
The artist begins to scumble neat paint over the window itself. This enhances the contrast and breaks up the edges of the barely discernible windowframe.

Changing the composition
The picture has reached a stage where Debra Manifold is forced to make a decision that will affect the composition of the painting.

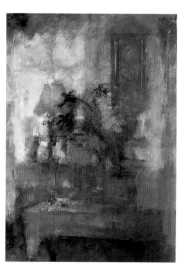
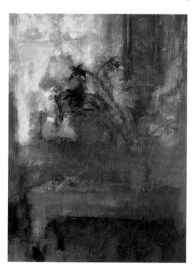

Moving the vase to the foreground
With a few brushstrokes, the artist finds the solution to the problem.

'I am going to move the vase onto the coffee table, so that the eye can come to rest there.'

'I am trying to decide whether to move the plant that is right in the centre of the painting. There's a strong diagonal line or flow that leads the eye from the window, down through the lampshade and plant, towards the foreground. But there's nothing in the foreground to arrest the eye.'

Returning to the underpainting
Before tackling the foreground detail, the artist decides to glaze over the wall clock – which at the moment is too dominant.

'I am going to work on this area around the clock, to take it back almost to the underpainting stage. Then I can build it up again.'

Overlaying with a wash of colour
With a wide brush, Debra Manifold paints a thin violet glaze over the right-hand side of the painting. Using diluted ground colour unifies this area of the picture but preserves the vitality of the other colours.

Debra Manifold

The Artist's Room
Acrylic and pastel on board
58.5 x 41cm (23 x 16in)

The final details are worked up with soft pastels. The doorway exudes cool light, but without detracting from the principal source of illumination. The same green light, scattered across the floor, balances the painting and throws the table legs into relief. As planned, the conflict between the background and the foreground is resolved with the addition of a vase that now contains flowers. These bring touches of colour into what is otherwise a sombre area of the painting. Points of reflected light sparkle across the glass table top, where a freely drawn fruit bowl encourages the eye to linger.

'You can be working away for hours, then suddenly discover that all you need are a few details and the painting is finished.'

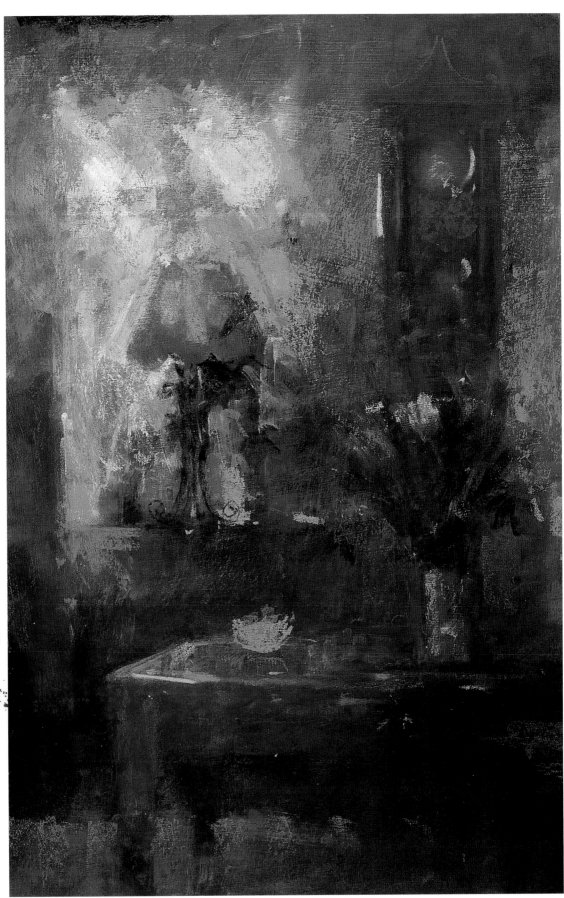

Painting against the light

The artist
Colin Willey has become a specialist in contre-jour painting. At one time a landscape artist, he finds himself drawn to painting the elusive play of light on simple still-life subjects.

Painting subjects in front of a window – known as *contre-jour*, (literally 'against daylight') – is an activity that fascinates artists because, in one picture, they are able to combine traditions as diverse as interior painting, still life, portraiture and landscape. Above all, there is the challenge of dealing with the capricious nature of daylight.

Choosing your viewpoint
You don't have to be blessed with a stunning view in order to make exciting pictures. There are so many options and permutations in every location that you could paint the same subject over and over without exhausting the possibilities. When making one of the paintings featured here, the artist was seated so that the picture could encompass everything from the still life to the houses at the end of his garden. For the other painting, he positioned himself so that the objects were viewed against a dark background in order to make the most of reflections in the glass.

Setting out the props
The props for these paintings were selected for their simplicity and for the way they would reflect light and colour.

'In this situation, the shadows and highlights change so dramatically, you have to work quickly to capture the light. In a sense, you have to seize the moment, then stick with it to avoid painting a picture that is full of contradictions.'

'There is so much to see in a set-up like this. There's light reflecting from the objects standing on the windowsill. Then there are the reflections of the same objects in the glass. Modulated colours are passed back and forth in a way that would never happen under a different form of lighting.'

'It can be difficult to set up a still life without it looking contrived, which is why I sometimes paint whatever happens to be there.'

Transient light
Because daylight is so transient, Colin Willey has adopted the practice of working on two or more paintings at once. For this exercise, he has painted a still life that is flooded with bright sunlight. By the afternoon, the sun no longer streams through the window of his studio, so he began another painting of the same subject from a slightly different viewpoint.

Oil paints
Colin Willey restricted himself to using just five colours: Venetian red, cadmium yellow, yellow ochre, French ultramarine and titanium white.

'I like to work with a limited palette as it means I have to mix my colours precisely. This reduces any tendency to paint the local colour of the subject.'

The palette
The artist mixes his paints on a sheet of glass laid over white paper. He uses turpentine as a thinner and for rinsing paintbrushes.

Brushes
These paintings were made, using a selection of rounds, flats and filberts. Working on coarse canvas is hard on paintbrushes, so Colin Willey is loath to spend too much on them.

'I use them up at such a rate that I think I would become too inhibited if I bought expensive brushes. In any case, I don't mind using cheap brushes so long as they do the job. If a brush makes the mark I want, that is all that matters to me.'

Applying coloured ground
In preparation for the paintings, the artist stretched two canvases, using coarse cotton duck, and then primed them with some white acrylic paint. He then applied a coloured ground in order to obliterate the white primer.

Blocking in
Colin Willey always likes to launch straight into a painting.

'I never make a separate preparatory drawing of the subject. I like to capture the moment directly on the canvas, so that the process of working everything out becomes part of the painting instead of it being a separate exercise. It can be hard work, but that for me is an advantage. When I am working on something that is difficult, it becomes totally absorbing and, after a while, I begin to see things in terms of paint and colour instead of actual objects. And that is good for the painting.'

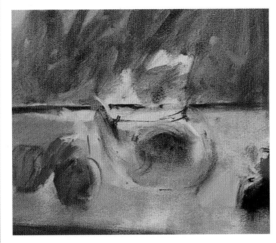

Fat-over-lean; light-over-dark
The featured oil paintings on these pages were both constructed conventionally, observing the well-tried principle of painting 'fat-over-lean', which prevents the top layers cracking as the paint dries.

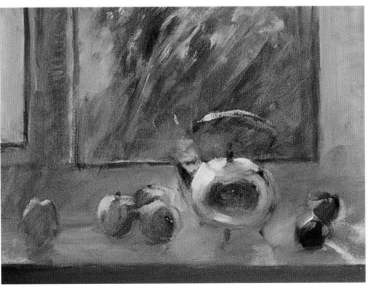

'I invariably use one of three colours for my grounds – burnt sienna, burnt umber or, as here, yellow ochre. I sometimes work over old discarded paintings. I just turn them upside down and incorporate the existing brushmarks into the new painting.'

Drawing in the main elements
The main elements are drawn onto the canvas, using a dark mixture of ultramarine and red. The main areas of tone are blocked in with thinned paint. Scrubbing paint onto the canvas forces the colour into the coarse weave.

'I always begin by blocking in with thinned paint, gradually applying thicker paint as the work proceeds. At the same time, I prefer to work light-over-dark, because it helps me preserve a richness of colour and tone in the darker areas of the painting. It is easy to scrape off highlights and work up from the darks again, but I find working in reverse more difficult.'

The finished underpainting
The main elements of the painting are now blocked in, and the composition has been firmly established to the artist's satisfaction.

'By this stage you can usually tell whether the painting is going to work or not. Although it is very ill-defined at the moment, there is already something about the painting that makes me want to carry on.'

Creating layers of colour

Colin Willey spends almost as much time removing paint from the canvas as he does applying it. Having brushed colour onto the surface, he will often smudge it with his fingers or wipe the paint off again with a rag, leaving subtle overlays of transparent colour.

'I am not correcting mistakes when I remove paint in this way. This is an integral part of the painting process.'

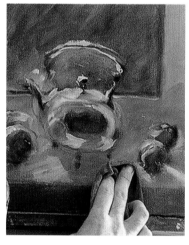

Using ground colour

Rubbing paint off the surface also exposes the warm ground colour. This technique is used successfully to suggest the warm sunlight reflected onto the windowframe and sill.

▶ **SEE ALSO**

Working on the still life

Having established the tonal balance between the foreground and background, the artist went on to work up the still-life elements, using a variety of techniques.

'The colouring is quite subtle here, because it is a combination of shadow and reflected light. The colours I have used to paint the apples have been smudged and reapplied several times, so the canvas around that area is stained with the same colours. This gives the impression that the fruits are being reflected in the white surface.'

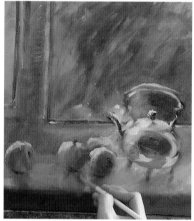

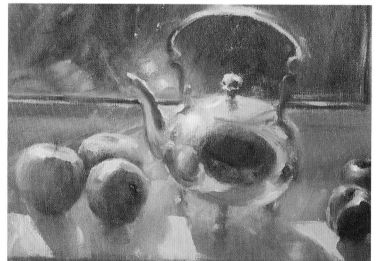

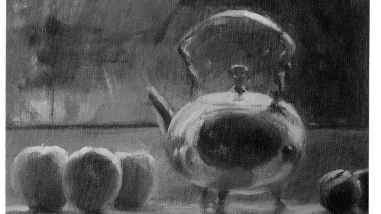

Contre-jour

The way that the light falls on the still-life group has a profound effect on the way in which the artist paints the subjects.

Painting shadows

Dry-brushing dark shadows under the fruit creates the illusion of solid objects resting on the windowsill.

Strong sunlight

In this painting, strong sunlight is falling onto the highly reflective surface of the metal teapot. To create the impression of dazzling light, the artist smears paint and blurs the edges so that parts of the object disappear in the highlights.

Cool daylight

In the second painting, the sun has moved round, so there is not as much tonal contrast. The light is cooler, the reflections less intense, and the objects are more clearly defined.

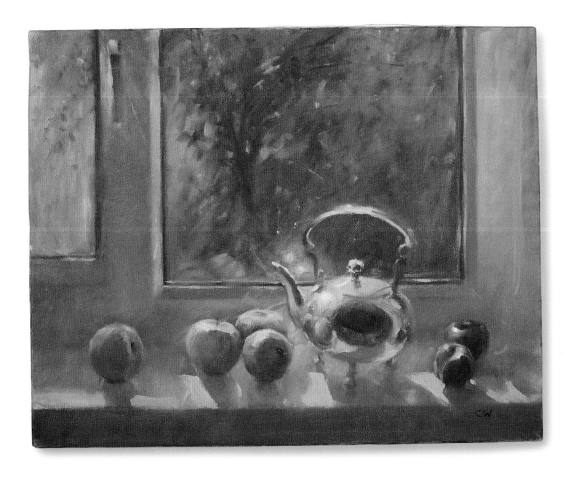

Colin Willey
Silver Teapot and Summer Fruits
Oil on canvas
41 x 51cm (16 x 20in)

The still life is the focal point of this painting. What you see through the window exists to create a relatively dark background without which the foreground objects lack drama. The view outside is kept to a bare minimum. There is a patch of sunlit grass and foliage, dark branches, leaves, and barely discernible red berries. A flurry of brushstrokes merely hints at a garden just beyond the glass.

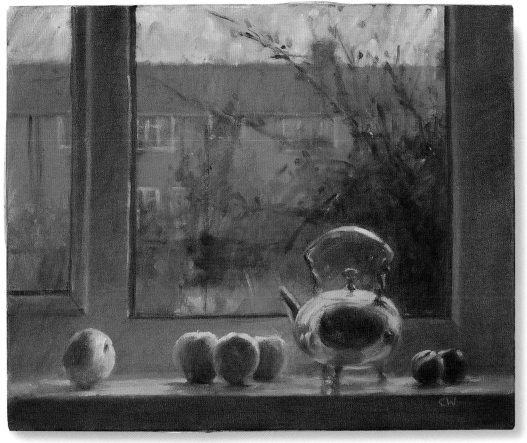

Colin Willey
Still Life with View Through the Window
Oil on canvas
41 x 51cm (16 x 20in)

This picture is perhaps the trickier one to paint, because the artist has to contend not only with a detailed still life but also with the challenge of creating the illusion of depth normally associated with landscape painting. This he does by painting the distant buildings and the middle distance with desaturated colours, which are all of a similar tone. By introducing darker tones into foreground foliage, he manages to bring the shrubs right up to the window.

'When I look at other painters' work, it often looks so easy. And, ideally, that is what you are trying to achieve – a finished image that looks as if it was achieved easily, even though it may have been a struggle.'

269

Painting a garden

As a way of introducing themselves to landscape painting, many artists turn to working in their gardens. A garden provides a safe and convenient location with all the pleasures of working outdoors, but none of the disadvantages of unwelcome attention or being caught out by inclement weather. And if the light changes dramatically, you don't have to travel very far to resume working the next day.

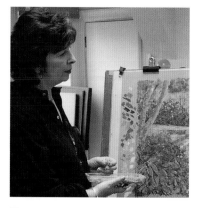

The artist
Jackie Simmonds started painting gardens as an extension of her work on still lifes. It was a natural progression from pot plants and cut flowers to natural forms on a larger scale.

'I prefer the intimacy of a garden to the wide-open landscape. For me, a garden seems to offer a greater variety of shapes and colours.'

Getting started

It couldn't be easier to move around within the confines of your own garden, looking for interesting subjects and viewpoints. Bear in mind that even familiar environments can vary in appearance, depending on the weather and time of day. And you don't have to be too literal. You can always omit a tatty shed if it is bothering you, or move an eyesore out of the way temporarily.

Jackie Simmonds likes to make preparatory sketches and colour notes on the spot, with perhaps a few photographic reference shots as a back-up.

Although not entirely satisfactory, you can work directly from photographs. This may be your only alternative if you want to paint during the winter, or if the garden is too far away from home to allow you to work from life.

Working with soft pastels

In many ways, pastel techniques have more in common with drawing than with painting. You need neither diluents nor mediums, and there's no need for a range of paintbrushes. However, just like other, more traditional painting methods, working with pastels relies on skilful mark-making and a developed sense of colour.

Despite being dry, pastel is still a messy medium. Gently blow away loose particles as pastel builds up on the surface of the paper, and use fixative sparingly to seal the finished painting.

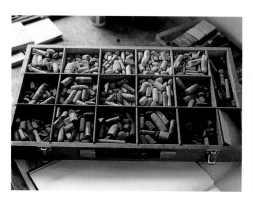

Choice of paper
The featured painting was made on a smooth neutral-coloured paper. The deep buff background serves as a warm complementary to the predominantly green hues of the painting, and is a useful mid tone for the stone walls and paving.

Be prepared
Carry a sketchbook with you when visiting friends, so that you can jot down ideas for garden paintings.

Range of colours
Pastel colours are not intermixable like paints. Consequently, pastels are made in an enormous range of subtly different colours. However, you need only about 30 to 50 colours to get you started. From your range of colours, choose those that closely match your subject and then place them in a shallow tray. On average, you will need about 20 colours per painting. In this case, the artist chose a range of dark, medium and light greens. Blues, greys, and purples were also selected for the trees; beige for the patio; and reds, yellows, oranges and white for the terracotta pot and flowers.

• Composition

Well-designed gardens often contain the same elements that make for exciting two-dimensional compositions. Look for the tensions created by curved and straight lines, repetition in the form of steps or posts, the contrast between hard and soft materials, and a variety of textures, tones and colours. Jackie Simmonds has included all of these elements in the featured painting. She uses a predominantly warm area of stonework as a foil for sumptuous cool foliage and vibrant complementary colours. The shapes and areas of tone are carefully balanced, with the focal point – a terracotta pot full of flowers – placed to the right of centre.

Underdrawing
Because it blends well with soft pastel, charcoal is ideal for making your preliminary underdrawings. Graphite pencil is too greasy.

Achieving colour balance

Basic pastel-painting technique

With practice, you can make a wide variety of descriptive marks and strokes, and you can learn to blend colours on the paper.

'It is quite helpful to get a feeling for the material before you start. Try out your selected colours in a sketchbook, experimenting with different linear marks, crosshatching and blending.'

Use the side of a pastel stick to make broad strokes, and draw fine lines with the point. It is important to vary the direction of your strokes, in order to avoid a 'rainy-day' effect. Use firm pressure if you want full-strength colour; a lighter touch will produce a thinner, more transparent coating of colour.

Achieving colour balance

Using the charcoal drawing as a guide, the foliage is blocked in with dark-green and blue pastels. Similar colours applied to different parts of a painting create balance and harmony.

Developing the foliage

Observe closely how light changes local colour. Sunlight adds a warmer yellow to the foliage, but broad leaves turned towards the sky may take on a bluish tinge.

Developing foliage

Creating depth

Abstract textures are sufficient to suggest foliage in the distance; but paint the leaves and stems in the foreground individually, to help reinforce the impression of depth in a painting. Pale shades applied over darker tones and deep colours separate areas of foliage from the background.

'As you progress as a painter, there comes a point in time when you no longer see the subject for what it is. Instead, you see it as an arrangement of shapes – shapes that interlock like the pieces of a jigsaw puzzle.'

Correcting mistakes
If necessary, you can remove pastel with a bristle brush and then use an eraser to get back to the original paper background. Or you can remove an area of pastel by scraping with a knife blade.

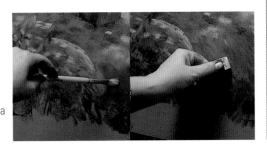

Creating depth

Accents of colour

Accents of bright colour add sparkle to a painting. Gradually working towards the high-key tones, the artist creates the effect of dappled sunlight across the patio. Small touches of red, orange and white suggest flower heads amongst the blues and greens of the foliage.

▶ **SEE ALSO**
▶ **Complementary colours 215**
▶ **Painting a landscape 274**
▶ **Painting outdoors 134**
▶ **Space, depth and distance 302**
▶ **Types of paper 34**
▶ **Pastels 48**

Jackie Simmonds
Shady Patio
Soft pastel on paper
46 x 61cm (18 x 24in)

As the work nears completion, step back to look at the composition as a whole, and check that the picture is balanced in colour, tone and shape. To put the finishing touches to this painting, the artist worked up the foreground detail by feeding in darker tones to clarify the shapes of the leaves, added lighter tones to the areas of dappled sunlight and applied charcoal to indicate the edges of the random-shaped paving slabs.

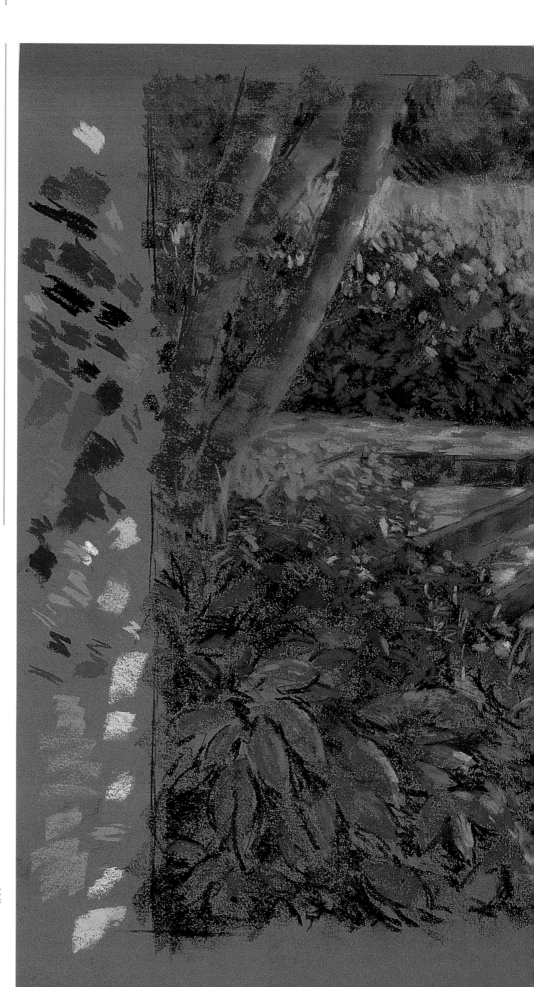

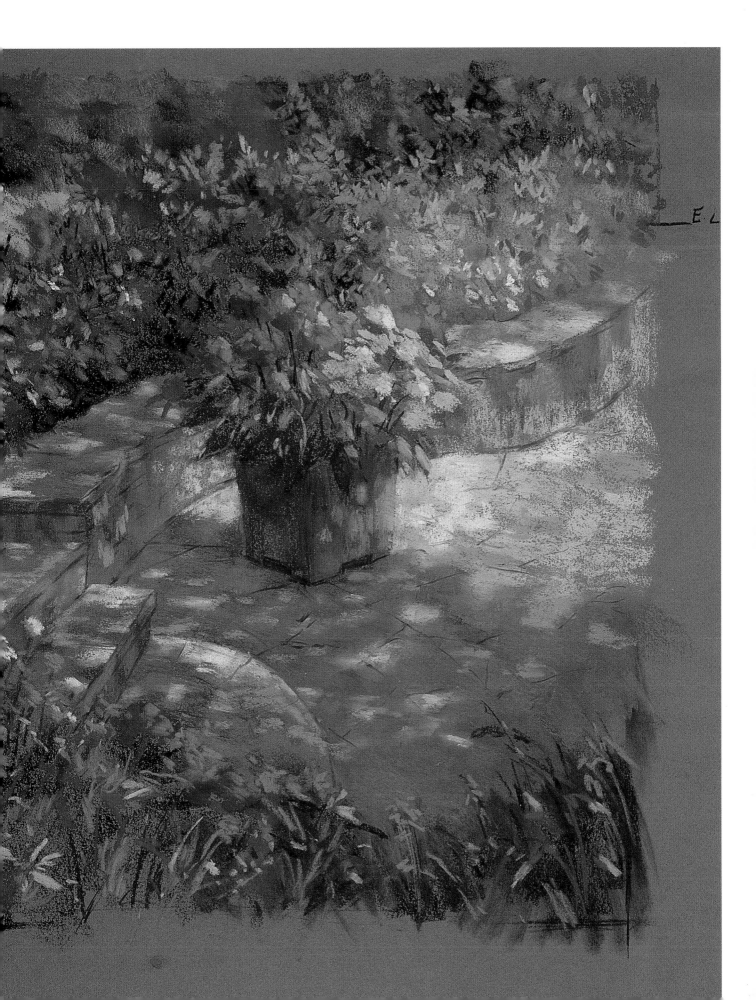

E L

Painting a landscape

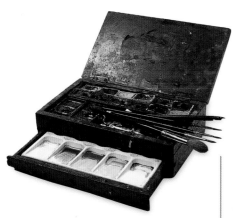

Not surprisingly, watercolour has enormous appeal for landscape painters. In practical terms, it is perhaps the ideal medium for working on location – but more importantly, it is possible to create a range of subtle atmospheric effects with an immediacy that is difficult to match using other comparable media.

There are two distinct phases to John Lidzey's landscape paintings. First, he works directly from nature, making colour notes and relatively detailed sketch paintings. For him, there's no better way of experiencing the many qualities of the living landscape and translating them onto paper. Back in the studio, he uses his sketchbook observations to create finished paintings on a larger scale.

'Some of my sketches have inspired as many as three or four completed paintings.'

Working in the studio provides a greater degree of control. You have more time to work on your composition, and the freedom to experiment with techniques and materials.

Paints and materials

John Lidzey keeps his watercolour paints and brushes in two reproduction nineteenth-century wooden boxes. Now well used and somewhat battered, they have been his constant companions for over 30 years. When working on location, he always uses a simple portable paintbox.

Like most artists who have been painting landscapes for a number of years, John Lidzey picks his watercolours from a standard palette that he knows will give him the range of colours and effects he is after. For the featured landscape painting, he chose aureolin, cadmium yellow pale, yellow ochre, French ultramarine, monestial blue, indigo, Payne's grey, cadmium scarlet, carmine, and burnt umber. He also used white gouache to mix the opaque body colour.

He paints with round Kolinsky sables – Nos.2, 4, 6, 8 and 12. He also uses an 18mm squirrel-hair mop for broad washes, and some cotton wool for lifting out colour and for removing dried paint.

The paper used for the samples and the studio painting is 300gsm smooth (hot-pressed) watercolour paper, wetted and then stretched on a drawing board.

Tips for watercolourists

• When looking for suitable subjects to paint, don't be too readily seduced by overly dramatic or picturesque views. They do not always make the best subjects – and it's your painting that should be beautiful, not the view.

• On occasion, allow the paint to 'do its own thing'. Let one colour run into another, and create unpredictable textures by dropping clean water into areas of concentrated colour.

• Avoid too many sharp edges – they look out of place in a landscape.

A wealth of possibilities

Sketchbook studies are no more than starting points: points of reference from which any number of compositions could evolve. Not only can you vary the scale and position of the various elements contained within a sketch, but you can also alter the light, suggest different weather conditions, change the time of day, or even substitute summer for winter.

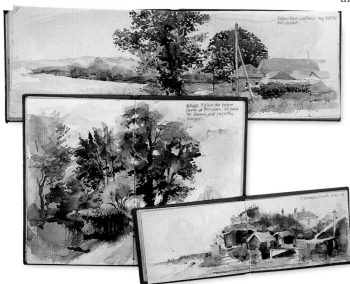

Sketches made on location

John Lidzey's field studies are more than simple sketches. Some of them are so detailed that they are almost finished paintings, but even these are merely the basis for the larger works that he creates in his studio.

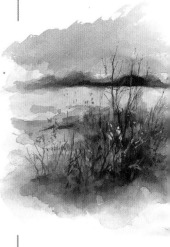

Attention to scale

There has to be a difference in scale between the foreground, middle distance and background. But don't be overly concerned with foreground detail. It's enough to suggest the plants – you are not painting a botanical study.

Making the finished painting

Despite their apparent freshness and spontaneity, traditional watercolours require an element of planning or forethought. Colour is built up with translucent washes laid dark over light; and since it's a process that is difficult to reverse, watercolourists adopt a systematic approach. More importantly, white highlights are created by leaving areas of paper unpainted – something the artist has to consider at an early stage.

Laying the first washes

Initially, pale washes are laid over a simple pencil drawing. The principal areas of the composition, including the sky, are blocked in with diluted yellow ochre. Aureolin – a golden yellow – is laid over the meadow in the foreground.

Building up the sky and middle distance

The sky is then built up with washes of French ultramarine mixed with monestial blue. To add variety, pale yellow is dropped from a brush to break up some areas of the blue sky. To create the impression of billowing cumulus clouds, cotton wool is used to mop up some of the colour while the washes are still wet, revealing white paper and some of the original pale-yellow wash.

Pale carmine is washed over the mountains. The meadow is neutralized with a hint of monestial blue, and the track is laid in with a weak wash of yellow ochre.

The mid-ground trees are now defined with mixes made of aureolin, cadmium yellow pale, yellow ochre, monestial blue and carmine. Yellows and blues suggest foliage, and the pale carmine red brings the warmth associated with woody growth.

Once the initial washes are dry, the artist draws grasses in the foreground and a gate at the end of the track, using a dip pen and some masking fluid.

Painting the tree line and undergrowth

At this point, the foliage is strengthened with deeper tones and stronger colours, creating depth and shadow. The main trunks and branches are painted with Payne's grey, then the smaller branches are drawn with a dip pen charged with watercolour.

Several loose washes of colour are laid for the undergrowth beneath the trees. These washes are made using various strengths of indigo, cadmium yellow pale and aureolin, mixed with small amounts of Payne's grey, to create neutralized greens.

When these washes are dry, a slightly opaque yellow ochre is laid in patches over the greens of the undergrowth, in order to suggest mixed foliage that is turning autumn gold.

The gate at the end of the track

To complete this stage, the masking fluid is removed to reveal the gate. The stark white paper is toned down with a pale wash, then French ultramarine is brushed across the gate to imply cast shadow.

Painting characterful skies

Give your skies plenty of character. Paint them freely, using lots of water and washes of different colour. The background to this page was created by painting warm colours, wet-in-wet, alongside a deep-blue wash. Colour was lifted to indicate the clouds, using the technique described for the finished painting.

Applying the first washes

Using his sketchbook studies as reference, John Lidzey makes a simple pencil drawing to help him fix the positions of the main features. Then he applies the first pale-yellow washes across the sky and foreground.

The sky and middle distance

Clouds are blotted from a blue sky; foliage is indicated with broad washes.

Tree line and undergrowth

Trunks and branches are drawn in with watercolour. Strong tones suggest deep shadows beneath the trees and undergrowth.

Removing masking fluid
Pale grass stems are revealed against dark washes in the foreground.

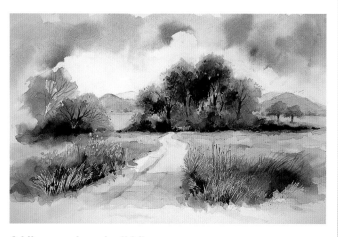

Adding weeds and wild flowers
Shadows are deepened, then weeds and flower heads are introduced.

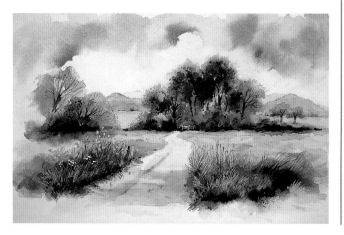

Foreground shadows
The correct tonal balance adds depth to the picture.

Masking fluid
This is a rubbery solution that prevents colour soaking into the paper. It is used primarily to mask off fine details and highlights that would be difficult to paint in later with opaque body colour.

Working up the foreground

The foreground in shadow helps to balance the composition. The finished painting is divided horizontally into bands of contrasting tone – the bright sky, the dark groups of trees, a sunlit meadow, and the foreground in shadow. This is a device often used by painters to draw the viewer into the picture; it is an invitation to step into the sunnier parts of the scene.

Revealing grass stems and flower heads

Loose washes of colour are laid across the foreground to lower the tonal values and give a feeling of shade. When the washes are dry, the artist removes the masking fluid, applied during an earlier stage in the painting, by rubbing it with a fingertip. By revealing the pale underlying colour, the grass stems and flower heads stand out clearly against the dark background washes.

The distant trees and meadow

Before proceeding with foreground detail, the artist paints the merest hint of a tree line at the base of the mountains, and adds two small trees to the right of the main group. Very little detail is required at this distance, and it is important to use pale desaturated colour to make the trees recede. Loose washes of cool green are laid across the distant meadows, with just a few horizontal lines of a darker colour to suggest uneven ground.

Painting weeds and flowers

Freely applied brushstrokes add interest to the foreground. Warm yellows and brown give an impression of tall weeds and dried grasses, and the flower heads revealed by removing the masking fluid are coloured with cadmium yellow.

Some additional flowers provide accents of bright colour to complement the dark weeds and foreground scrub. These flower heads are painted randomly with red and white gouache – opaque paint that has exceptional covering power.

Don't make your arrangements of flower heads too regular. Clump them together in groups, and vary their shapes and sizes.

Foreground shadow

The shadow that runs across the track is deliberately light in tone. Any darker, and it would begin to compete with the tone of the trees in the middle distance and destroy the illusion of depth. The colour is built up in stages by applying three pale washes of French ultramarine mixed with yellow ochre. This allows the artist to judge the weight of the tone precisely.

Don't paint shadows with hard edges, unless you want to create an impression of strong sunlight. And avoid using black paint to darken your shadows – deep blues or purples have a similar effect, but without creating a dead, inky blackness.

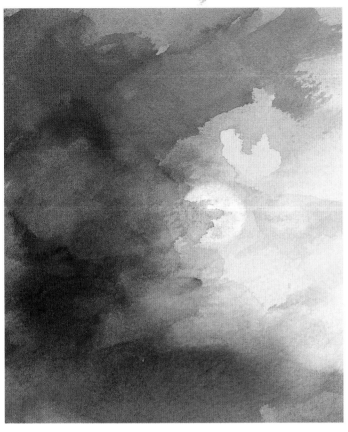

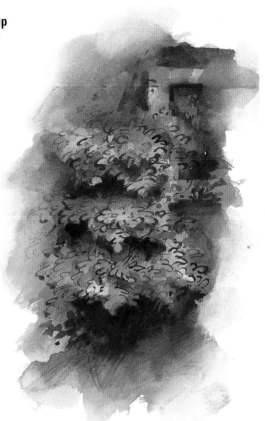

Foliage in close-up
A dip pen loaded with watercolour paint is useful for indicating foreground foliage, without it becoming too tight. Use the pen to draw detail over a range of tones and colour washes.

Weak sun (left)
Here the artist shows how to paint the sun trying to break through a cloudy sky. Lift out some of the colour with cotton wool, using a circular mask cut from paper.

The paint surface
Many watercolourists make the mistake of trying to achieve a photographic representation. The end result may be highly accurate, but it invariably lacks vitality. Here are some ideas and techniques for creating a paint surface that will add to the interest and enjoyment of your pictures.

Trees and movement
Trees can be suggested simply, using nothing more than washes of colour for the foliage. Put in the trunk and branches with loose brushmarks or pen strokes. The bent trees and flying leaves suggest a windy day.

▶ SEE ALSO
▶ Atmospheric perspective 292, 293
▶ Gouache 104
▶ Watercolour brushes 96
▶ Painting outdoors 134
▶ Painting trees and foliage 280
▶ Stretching paper 33
▶ Watercolour paints 87
▶ Wet-in-wet 188
▶ Wet-on-dry 189

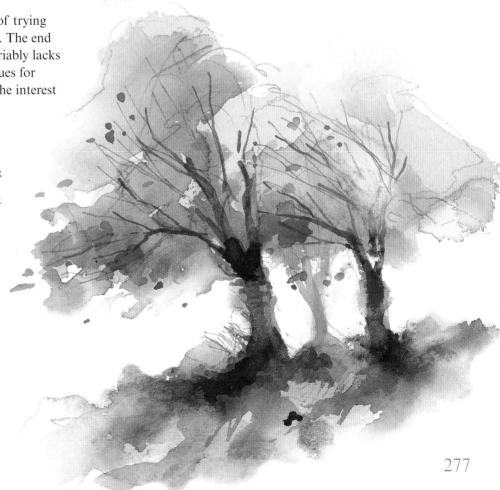

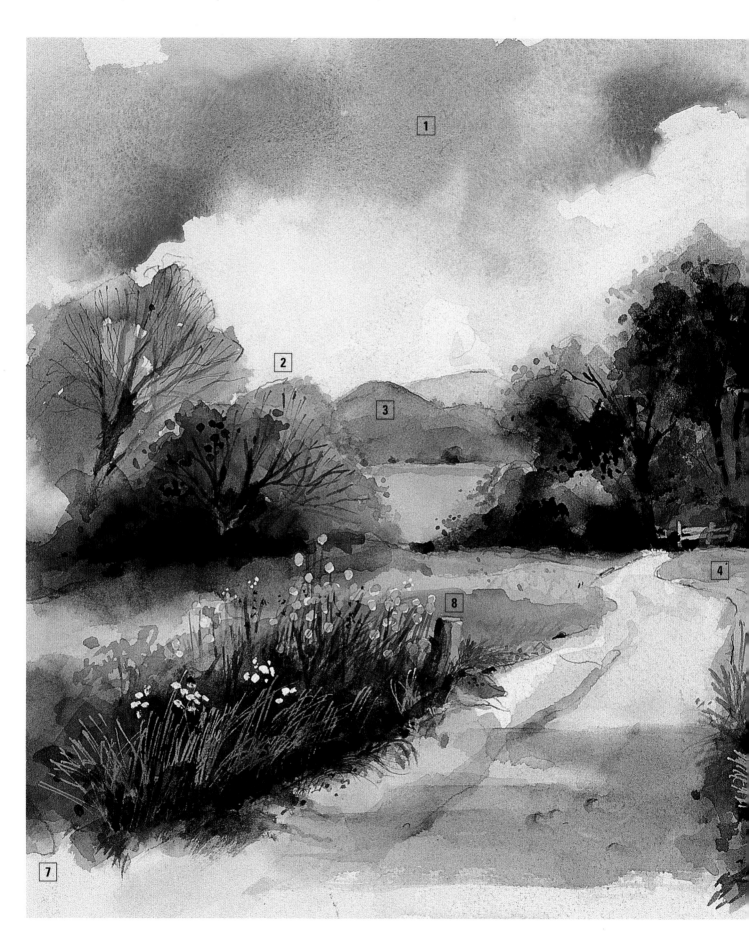

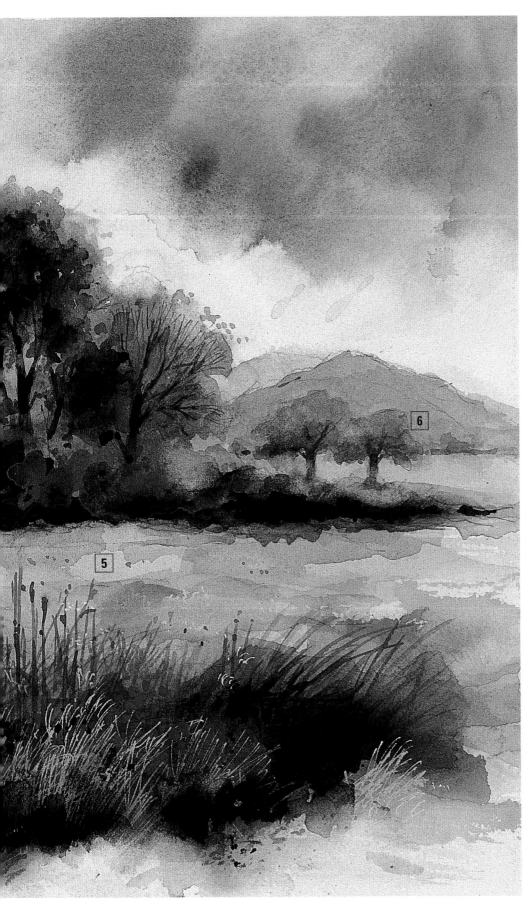

1 Sky
Leave a pale wash of yellow ochre to dry, then paint over it with deep-blue washes. While the paint is wet, mop out some of the colour with cotton wool to create a bank of clouds.

2 Middle-distance trees
You can apply detail to the middle distance, but don't overdo it. Painting some of the trunks and branches dark and some light creates a sense of depth. Soft edges suggest that the foliage is moving.

3 Distant hills
A range of relatively light tones and cool colours creates a sense of perspective. A mere suggestion of tone at the base of the hills can be interpreted as distant trees. Keep detail to a minimum.

4 Undergrowth
Apply simple washes, wet-on-dry, to convey a suggestion of bushes and undergrowth. A warm yellow-ochre wash adds variety.

5 Meadow
Paint successive washes wet-on-dry to break up the area of grass and low-growing scrub. Cool shadows indicate the uneven ground.

6 Trees in silhouette
Painted to break up the line of distant hills, these small trees are barely more than silhouettes. Cool colours and shading at the base of the foliage adds form to the crown of each tree.

7 Foreground shadows
Apply a pale wash of ultramarine mixed with a small amount of yellow ochre. The soft-edged shadows in this painting imply diffused sunlight. They also help to create the illusion of depth.

8 Long grass and wild flowers
Free brushwork suggests tangled weeds and wild grasses. Wet-in-wet indigo brushmarks create deep shadows. Use a dip pen to draw paler stems with masking fluid, and apply random specks of gouache to indicate flower heads.

John Lidzey
Suffolk Landscape
Watercolour on paper
33 x 51cm (13 x 20in)

Painting trees and foliage

In landscape painting, trees and foliage are often represented by little more than abstract brush-marks, but it is helpful to be acquainted with individual species in order to make those marks convincing. Not only do species differ in their shape, but many change their appearance with the seasons and, in so doing, confer a very different atmosphere on the painting.

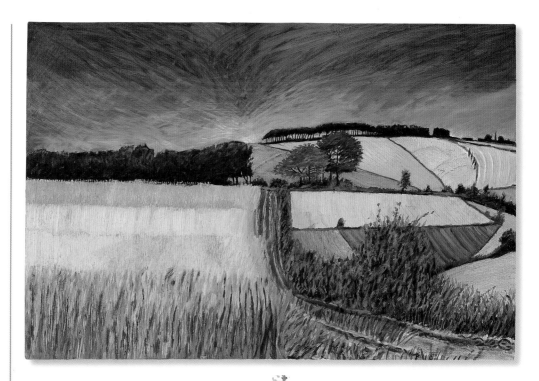

Atmospheric perspective

Create a sense of depth in your pictures by painting foreground trees with strong colours and well-defined details. Treat those in the distance more like silhouettes, using lighter tones to make them recede. Soft-edge forms, painted wet-in-wet with watercolour, also create an illusion of distant trees.

Simon Jennings
Trees in a Landscape
Oil on canvas
51 x 76cm (20 x 30in)

▶ **SEE ALSO**
▶ **Drybrushing 178, 196**
▶ **Textural effects 208**
▶ **Washes 182**
▶ **Wet-in-wet 188**
▶ **Wet-on-dry 189**

David Day
Trees: Colour Studies
Sketchbook pages
Watercolour and mixed media

Textured effects

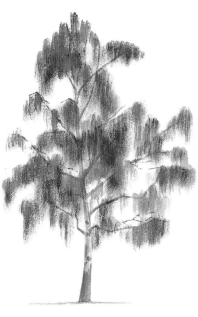

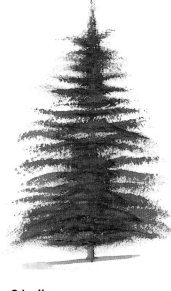

Dry brushing
Having painted the trunk and branches, dry-brush the clumps of foliage that hang from a silver birch.

Stippling
Stippling oil paint or watercolour – using the tip of a flat brush or fan blender – produces the layered foliage of a typical fir tree.

Sponging
Create a subtle dappled effect by stippling with a natural sponge dipped in paint. As each layer dries, apply another colour or tone, then brush in the trunk.

Knife painting
Paint the distinctive foliage of a tall pine by using a painting knife to apply thick acrylic paint. Add texture with the edge of the blade.

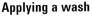

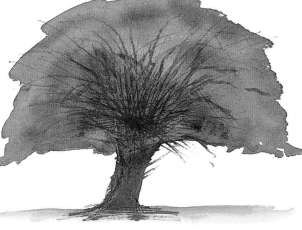

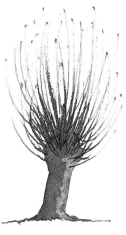

Applying a wash
Paint the overall shape of the tree's canopy with a broad wash, then scribble in the branches, using a pointed stick.

Stick drawing
Paint the bare branches of a pollard by drawing a pointed stick through wet paint.

Seasonal changes
An oak tree illustrates seasonal changes. In spring and summer, the tree displays a full canopy of green leaves. Typically, patches of light can be seen through the foliage. The form is the same in autumn, but the leaves have changed to warm russets. By the end of the year, however, the underlying structure is revealed.

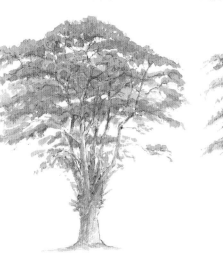

Spring or summer

Autumn

Winter

Landscape on location

This stretch of countryside is at least five miles wide, and stretches another ten miles to the horizon. It is a patchwork of fields and woods on rolling hills set in a valley that melds into a range of hills visible in the distance. There is the occasional farm building, and the foreground and middle distance are bisected by rows of trees. The viewpoint chosen by the artist provides exceptional width and depth, and looks down onto the scene from a high vantage point.

Known as an 'open landscape', this would appear at first sight to be a daunting mosaic of shapes and undulations, with many different hues and colours beneath a deep-blue sky. The first challenge is to decide what to focus on, and how to begin the painting.

Starting points

Preliminary sketches and visual notes help you to 'get your eye in' and to familiarize yourself with the colours and shapes in a landscape. One automatically thinks of painting landscapes in the horizontal 'landscape' format. In this case, the artist made his preparatory sketches in this format, but executed the final painting in an upright 'portrait' format.

MONTALTO — SIENNA

Preparatory sketches

The artist was drawn, in particular, to the stripes in the recently mown fields and to the shapes of the distant hills against the sky. The work began with colour sketches in a wide-format landscape sketchbook. The colours were taken directly from the tubes, as required. For broad areas such as the sky, for example, the paint was squeezed onto the page and blended with the fingers.

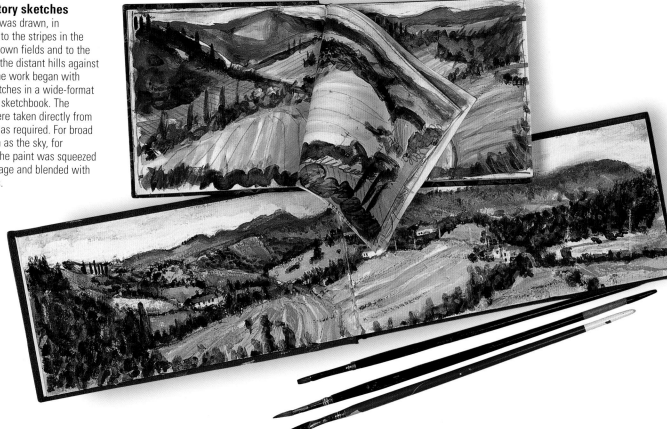

Selecting colours and setting out the palette

You can set out a palette in whatever order you wish but, as there were many shades of green in this landscape, the artist laid out the ready-mixed colours in line on the left, because these were to be picked up and used 'straight from the tube'. The earth colours, yellows and blues were laid out on the right as these were more likely to be mixed. Water is the only diluent needed for acrylics – but keep two jars on the go, one for thinning paint and the other for washing out your brushes.

Laying a toned ground

Artists have traditionally primed their canvases with a base colour. The chosen ground colour affects the surface and appearance of the finished painting.

In this painting, the toned ground serves two purposes. Firstly, it works as a primer to seal and stretch the paper – a purely practical function. However, it also acts as a ground colour that is integral to the painting. Here, a mixture of cadmium red and permanent rose is laid onto the paper. Being a 'hot' colour, it reflects the warm climate of the location and it is complementary to the predominantly cool colours in the landscape. As the painting builds up, the ground shows through here and there, lifting the other colours and creating a vibrant surface. Lay a fairly thin wash, evenly but quickly, with a decorator's paintbrush.

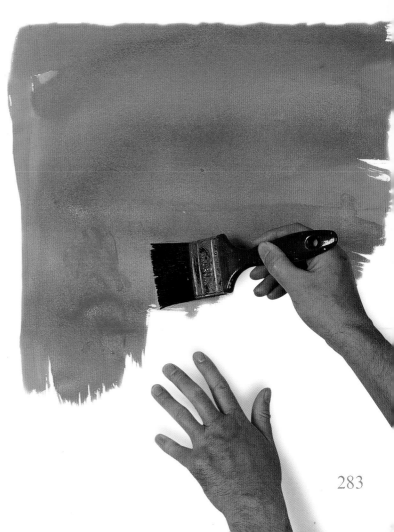

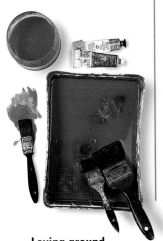

Laying ground colours
Use decorator's brushes to lay ground colours.

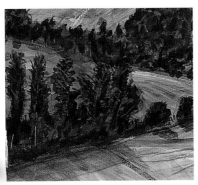

Creating a vibrant surface
The 'hot' ground colour shows through the painted surface.

283

Expert advice

There is no prescribed formula for making a painting. All artists have distinctive styles and tackle the job in their own way. For many painters, especially beginners, the main difficulty seems to be in getting started, and the first stages that are depicted here are often the most difficult and disheartening.

The best advice is to seek out a subject that will hold your attention for several hours – in this case, an arresting view – then keep at it, concentrating on the crucial elements and adding essential detail until the picture begins to emerge, almost by itself. Only then does the real enjoyment begin. Here is some invaluable advice on how to approach landscape painting from a world-famous artist:

'When you go out to paint, try to forget what objects you have in front of you, a tree, a field… Merely think here is a little square of blue, here an oblong of pink, here a streak of yellow, and paint it just as it looks to you, the exact colour and shape, until it gives you your own naive impression of the scene.'
Claude Monet (1840–1926)

Blocking in broad strokes
Using tones of the original ground colour, broad strokes are blocked in quickly in order to get a feel for the overall composition.

Plotting the composition
The main elements of the composition are sketched in with some charcoal, using paint to define the shapes and focal points.

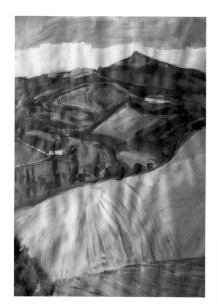

Building up the surface
The colour, tone and surface detail are gradually introduced and then refined as the work continues.

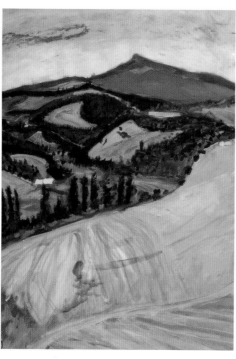

Creating depth
Having sketched in the sky, the artist concentrates on creating depth and space by using deeper tones and strong colour.

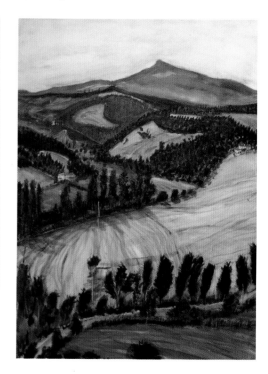

Foreground detail
The foreground comes to life with the clearly defined trees, foliage and the all-important ground textures.

When is a painting finished?

Every painting has a knack of telling you when you should leave it alone. Many a picture has been stripped of its essential life and initial spontaneity by being overworked.

When you reach a point where you feel satisfied that you have done your best within the given constraints, then leave the painting alone for a while – perhaps for hours or even a couple of days – and then come back to it with a fresh eye. At that stage, you will be better able to judge whether the painting has reached a satisfactory conclusion. If not, you can either return to the location or make any further modifications and improvements in the studio.

► SEE ALSO
► Acrylic paints 110
► Painting outdoors 134
► Painting trees and foliage 280
► Types of paper 21
► Primers and grounds 24

Simon Jennings
View from Montalto
Acrylic on paper
100 x 79cm (40 x 31in)

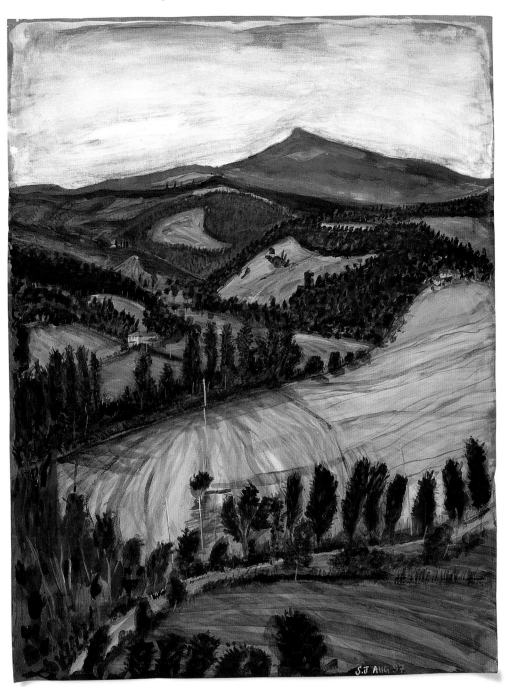

Six hours later
This landscape is the result of about six hours' work. The sequence opposite shows key points in the development of the picture, but the creation of any painting is rarely a straightforward linear process. The various stages show how the artist established a foundation and then built a loose framework for the picture. From then on, it was a matter of constant modification within this framework until the painting arrived at this point.

Finishing touches
Back in the studio, you can include any additional details, such as telegraph poles and fence posts, using a fine paintbrush. These details will help to reinforce the illusion of depth and add textural interest to the painting.

Painting skies and weather

For every landscape painter, the elements provide an endless supply of inspiring and often surprising source material, and how you incorporate it is vital to the outcome of a painting. As a rule, if the land mass is complicated and highly detailed, then keep the sky simple. Changing the emphasis gives you the freedom to include dramatic cloud formations and atmospheric skies.

Sketching with water-soluble pencils

Quick impressions sketched in monochrome (right) can play a vital role in exploring the tonal relationships and mood. Brushing clean water over water-soluble pencil turns a line drawing into a watercolour. As soon as the washes dry, you can strengthen the tones with darker hatching.

Sunset in pastel

You have to work quickly when painting sunsets. Soft pastels (below) are ideal, because they are so expressive and no time is wasted mixing colours. For this sketch painting, colours are blended on smooth pastel paper, and a strip of land is reduced to a simple silhouette.

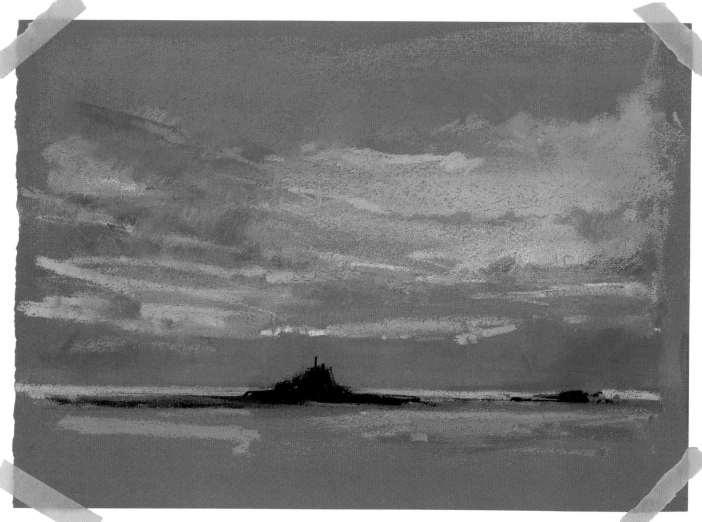

Sketching outdoors

Draw and paint outdoors as often as you can; there is no substitute for direct, first-hand experience. You can't rely on the light and weather – but, with luck, you will be able to work for a couple of hours before conditions change too dramatically. Place the horizon in the lower half of your sketch if you want the sky to dominate.

Fair-weather clouds in gouache
Gouache is a versatile medium for painting skies (left). Diluted with water, it can be used like watercolour; opaque body colour acts more like oil paint. Evoking a balmy summer's day, these towering cumulus clouds are painted with broad brushstrokes over a tinted-paper background. The rules of perspective apply to the sky as well as the landscape.

Sunrise in watercolour
Early-morning skies are usually more subtle in colouring than those at the close of the day. Watercolour (left) lends itself to these soft atmospheric effects. Here, washes of cadmium orange and cerulean blue, laid wet-in-wet, create the required softness of a dawn sky. Touches of opaque body colour suggest the sun is about to break through. It always helps to balance a painting if you can pick up certain sky colours in the landscape. Reflections in water provide the ideal opportunity.

Ray Balkwill
Sky Studies
Various media on paper
Average size: 14 x 19cm (5¹/₂ x 7¹/₂in)

287

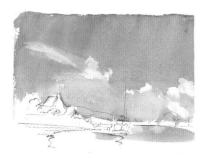

High-summer sky in watercolour
Using soft paper tissue, the artist blotted clouds from a cobalt-blue sky (above). Alizarin crimson adds warmth to the clouds on the horizon.

Mist and fog in watercolour
When mist and fog descend upon a landscape, colours are starved of intensity, and forms become ill-defined, with little variation in tone. Watercolour is perfect for conveying these effects, provided you keep detail to an absolute minimum. Here, a light mist rises from a body of water at dawn (right). Pale winter sunshine tries to burn off the dense mist or fog painted wet-in-wet (below).

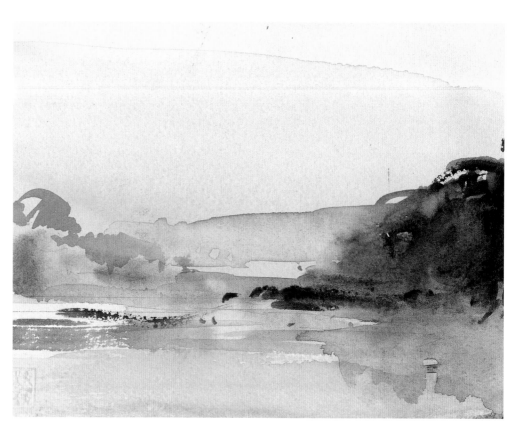

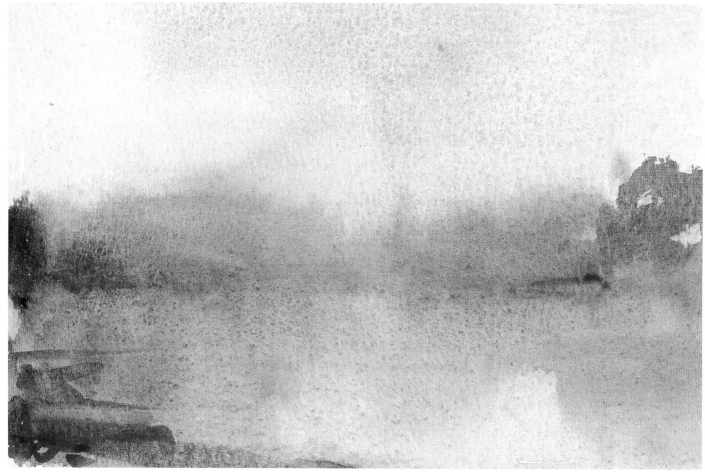

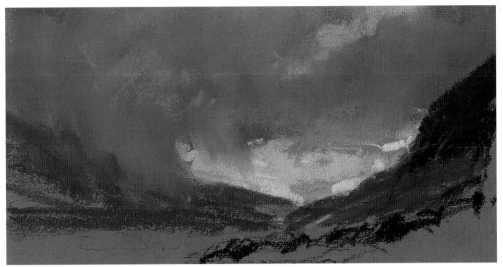

Ray Balkwill
Studies of Weather Conditions
Various media on paper
Average size: 14 x 19cm (5$^{1}$/$_{2}$ x 7$^{1}$/$_{2}$in)

Stormy weather in pastel
Distant hills shrouded by a dark brooding sky suggest approaching rain (left). The downpour on the hillside is created simply by smudging the pastel with a fingertip.

Snow scene in watercolour
Leave some areas of white paper to depict drifting snow (centre), and paint in the shadows with cool blues and purples. Create flying snowflakes by spattering white gouache across a heavy, snow-laden sky.

Wind in gouache
Windy weather is difficult to convey in any medium. You usually have to rely on devices such as trees bent in the wind or a flurry of leaves. In the sketch painting (bottom), horizontal strokes made with a dry brush help convey a sense of movement in clouds that scud across an energetic sky. Also, birds can be seen battling with the strong wind.

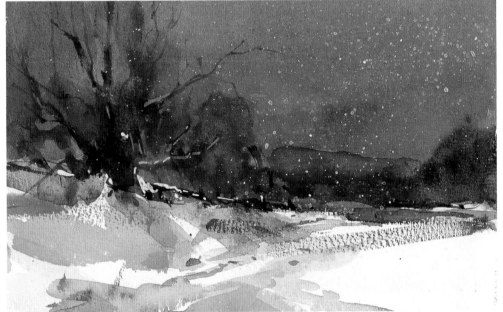

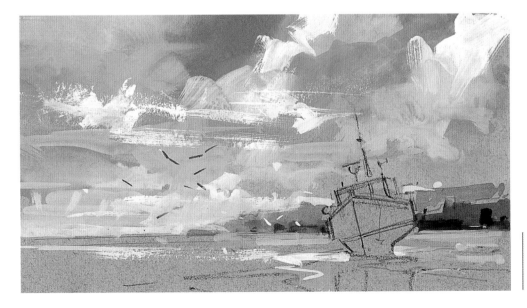

▶ **SEE ALSO**
▶ Drybrushing 178, 196
▶ Perspective 302
▶ Wet-in-wet 188

289

The changing landscape

'Light changes all the time. When painting, I may stay with the original light or amend it as time goes by, and even change it again back in the studio. The knack comes with experience, but you have to be flexible and open-minded to get a result.'

All landscape painters have to deal with the realities of working outdoors, which inevitably means coping with changeable light and weather. As we have already seen, some artists make rapid sketches to capture the moment. Others might start another painting when there's a radical change in conditions. And then there are artists who accept the inevitable, and are prepared to allow their paintings to change and adapt along with the elements.

David Griffin, an experienced marine painter, has learnt how to deal with the changing landscape – and with working in public.

'On one occasion, I was being watched closely by two tattooed youths, each drinking from a can of lager. I found the experience most disconcerting, but kept on painting and tried to ignore them. After about ten minutes, one of them approached me – but not with the usual sneering question: 'How much do you expect to get for that?' Instead, he asked, 'How do you come to terms with the problems of changing light, tide and lengthening shadows?' At the time I was really surprised, as this is one of the fundamental challenges of landscape painting. The simple answer is: 'Carry on regardless!' – and when it feels like an uphill struggle, just remember you are not the first to feel that way.'

Paints, brushes and support

When he is painting outdoors, David Griffin usually works on stretched canvas, but on this occasion he used a lightweight canvas board (primed cotton canvas which is mounted on thick cardboard), measuring 30 x 40cm (12 x 16in). He uses three or four brushes only – a No.10 or 12 flat bristle brush, a couple of medium-size filberts, and a rigger.

The overall impression of the featured painting is one of subtlety – it is tonal rather than colourful. In order to create the brooding atmosphere of an impending storm, the artist used a limited palette of good-quality oil colours (right).

Laying the ground

'I like a warm painting. It's very inviting to have a bit of warmth – like a nice open fire!'

Having set up his easel, David Griffin's first step is to lay a warm ground to cover the stark white board, using whatever colours come to hand.

Applying a coloured ground
Heavily diluted with turpentine, the paint is scrubbed on, using a large flat brush.

Broad strokes

Blocking in the sky and water with bold washes of colour conveys an impression of the prevailing weather and also the general direction of light.

With the one large brush, thinned paint is mixed and blended on the board to represent a stormy sky and sunlight reflecting off the surface of the water.

The finished painting
This picture was painted during a period of quite unsettled weather, when the artist was forced to deal with an ever-changing sky and the fleeting shadows and reflections that come with it.

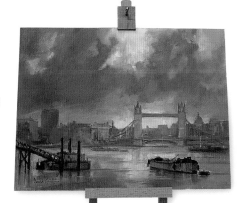

The coloured ground
The ground for this painting is a bold mix of cadmium yellow and cadmium orange.

Viridian green

Yellow ochre

Cadmium yellow

Cadmium orange

Cadmium red

Alizarin crimson

Indian red

French ultramarine

Cobalt blue

Burnt umber

Titanium white

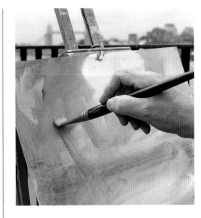

Broad-stroke brushes
Use large brushes when laying the ground, and for blocking in. A No.12 flat is the only brush you need for blending paint on the board.

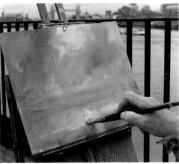

Fixing the horizon line
Because the turbulent sky is crucial to this painting, the horizon is placed well below the centre line of the picture. To place the horizon at the centre, or even above it, would dramatically alter the balance and emphasis of the landscape.

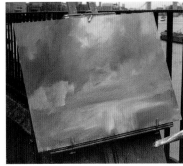

'This is when most artists hate people looking over their shoulder – simply because the painting often looks a mess at this stage. However, one advantage with oil paints is that you can easily take out parts you don't like and start again.'

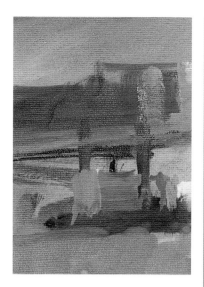

Adjusting the composition

As a painting evolves, the artist is free to rearrange the different elements in order to improve the composition and the dynamics of the picture.

'What can I put in to make the painting more interesting – a boat, a buoy, some figures on the deck? Here, I moved a jetty into the picture. In reality it is way out to the left, but the composition is stronger for its inclusion.'

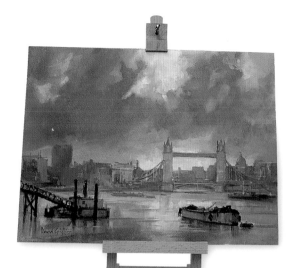

Atmospheric perspective

Water vapour and dust particles suspended in the air tend to obscure our view of distant objects. Introducing what is known as atmospheric perspective helps the artist to reinforce the illusion of depth in a painting.

Using some relatively dark tones and warm colours in the foreground pushes the sketchy skyline back into the distance. Darker reflections beneath the barge and jetty serve a similar purpose, and also keep them from looking as if they are free floating in space.

Telling details
The moored barge balances the composition and draws the eye into the picture. A buoy is introduced to add interest to the foreground.

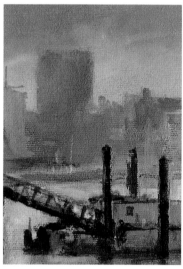

Creating depth
The sharper details in the foreground and the reflections beneath the jetty both add depth to the picture.

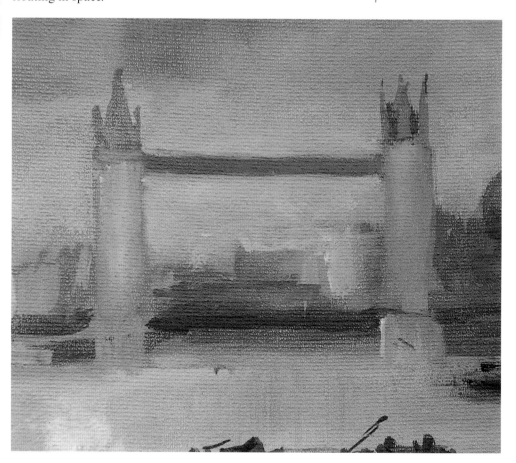

▶ SEE ALSO
▶ Capturing water 296
▶ Painting skies and weather 286
▶ Space, depth and distance 302
▶ Primers and grounds 24

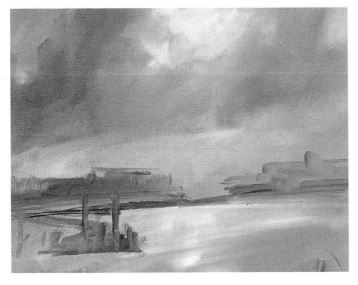

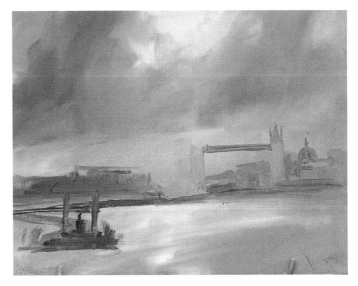

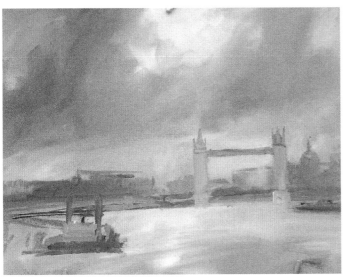

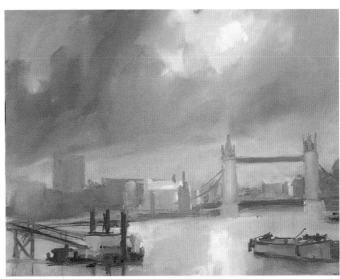

'I sometimes blend paint with my fingers. I find it more convenient than using brushes. Kids love making mud pies and getting dirty – I suppose finger painting must be an extension of childhood.'

Finishing the painting

After about two hours' work, the artist has conjured up an atmospheric landscape that accurately captures the mood of the river on that particular day. However, he invariably continues a painting back in his studio, where he can work without the constraints of trying to portray the actual scene in front of him.

'Before I set off home, I sometimes take a photograph of the scene I have been painting – but I seldom use it except occasionally as reference for the details of something in the foreground. I find that having looked intently at a landscape for a couple of hours, the image is imprinted firmly in my head.'

Back in the studio

When he gets home, David Griffin usually mounts his paintings temporarily in a frame. He admits there is an element of brief satisfaction in gazing at a newly painted picture, but there is also a practical point to the frame.

When you are painting seascapes and river scenes on location, it can be difficult to get all the horizontals and verticals aligned with the edges of the board. Using the frame as a visual guide, you are able to correct any mistakes with a fine brush or the point of a knife.

David Griffin
Storm Brewing
Oil on board
30 x 40cm (12 x 16in)

Looking at the finished painting, you can see the additional work done in the studio. There is considerably more variation in colour and contrast in the sky, with bright accents of light piercing the clouds. Similar colours and tones are reflected in the water.

Distant buildings have been picked out with colour. And much greater detail has been included in the foreground — with spots of intense colour that attract the eye, and sparkling highlights scratched into the water with the edge of a blade.

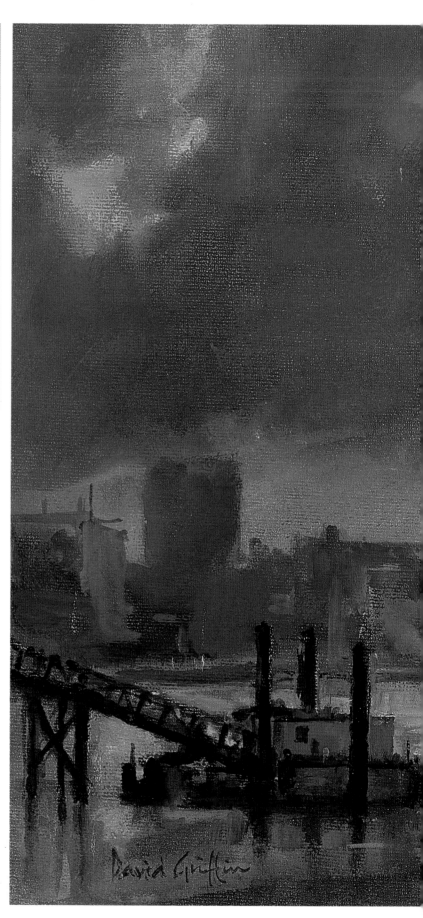

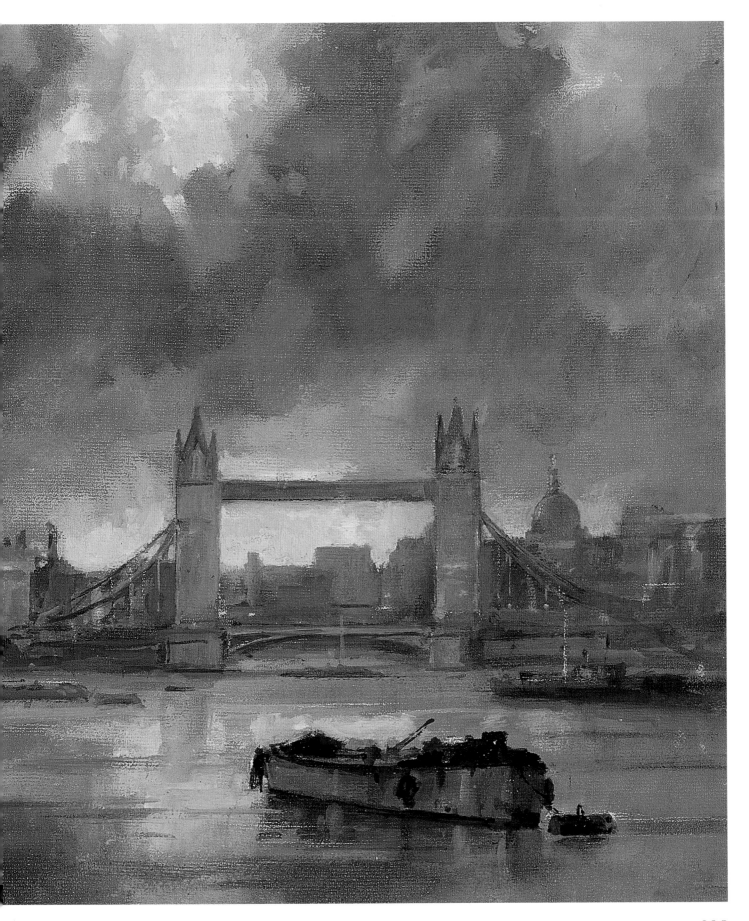

Capturing water

Within the context of landscape painting, we tend to think of water as a calm element seen in a river, lake or harbour scene. However, although water is often associated with a vision of tranquillity, that is not always the case. In addition to conventional composition and techniques for painting water, the artist David Jackson introduces some alternative ideas for capturing the energy and excitement of water, rain, mist and spray.

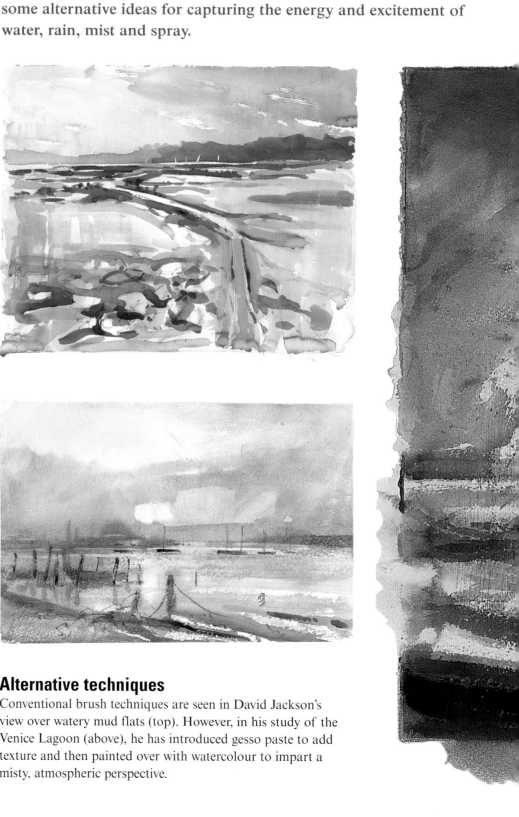

David Jackson
Colour Studies
Watercolour on paper
40 x 50cm (16 x 20in)

In this painting, the artist made use of a stiff brush (like the ones used for combing in hair conditioner) to create etched linear indents; and scratched the surface of the painting with a sharp blade to create the effect of a late-spring cloudburst over an exceedingly watery lake.

▶ SEE ALSO

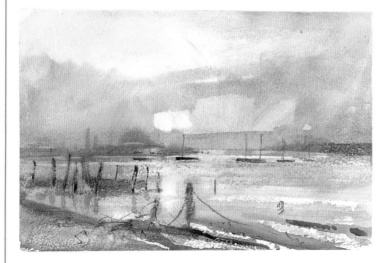

Alternative techniques

Conventional brush techniques are seen in David Jackson's view over watery mud flats (top). However, in his study of the Venice Lagoon (above), he has introduced gesso paste to add texture and then painted over with watercolour to impart a misty, atmospheric perspective.

David Jackson
Blue Breaker
Watercolour on paper
54 x 71cm (21 x 28in)

Movement and energy
Fluid, liquid paint is applied vigorously and generously
to dampened paper, wet-in-wet. In places, the white
of the paper is left showing through to represent foam
and spray. Colour is lifted out with a sponge and rag,
and then reapplied to build up the opacity of the
ocean surface. Paint is splattered and thrown, and the
surface scored with a hard-point hairbrush – so that
the paint sinks into the grooves, creating a linear
directional effect of an exploding wave in a boiling
rain-dashed ocean.

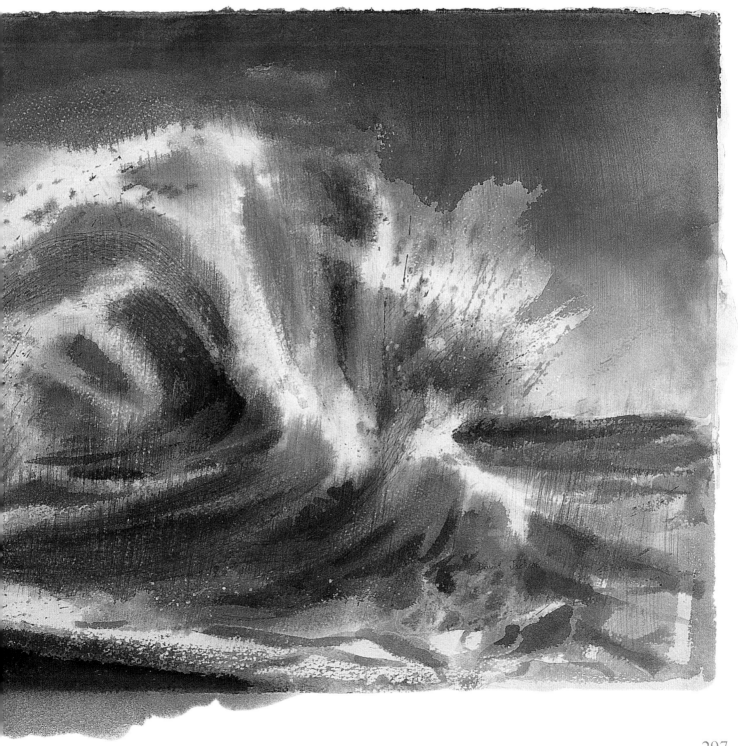

Painting a townscape

Making buildings the focal point of a landscape can introduce the possibility of a greater variety of colour and texture. Whether it be modern steel and glass or the mellow patina of crumbling render and battered woodwork, there is much to paint and enjoy.

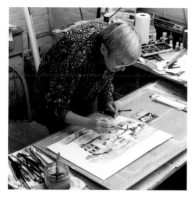

The artist at work
Kay Ohsten prefers to stand at her worktable. Painting on unstretched paper, she moves deftly from table to sink when creating her unique paintings of buildings and landscapes.

Sketching on location
Kay Ohsten makes drawings on the spot, which include detailed notes on colour, texture and tone. She also takes one or two reference photographs, and then starts work in earnest at home while her memory is still fresh.

A personal approach

Watercolourists usually start by painting the sky, then work systematically from background to foreground, gradually overlaying pale washes with darker and richer colours. For the artist Kay Ohsten, conventional methods are too inhibiting. She prefers to work in reverse, because she feels it helps to inject more depth into her pictures. Her vigorous painting style encompasses a range of techniques, from drawing with a pointed stick to holding the paper under running water. Spontaneity is the key word, which is why she is unable to recall the colours she uses for a particular painting.

'Without thinking, I let my brush dance in and out of the palette.'

Underdrawing

The first stage of the painting is a moderately detailed pencil drawing. Although it includes little architectural detail, there is still sufficient information to enable the artist to begin painting with confidence.

Painting equipment
In addition to a standard square-tipped flat paintbrush, Kay Ohsten employs a variety of less conventional equipment, including a sharpened stick and a calligraphy pen.

First brushstrokes
Using a broad flat brush, the artist blocks in the sides of the buildings that are in direct sunlight. She applies a pale parchment yellow to the walls and light terracotta to the roofs.

Removing colour with a palette knife
Before the washes have had a chance to dry, the artist begins to remove colour by drawing the rounded tip of a palette knife through the paint. Short strokes represent highlights on the pantiles.

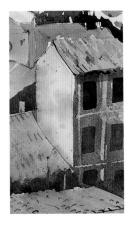

Working into the shadows

Dark shadows define the shapes of the buildings. Broken colour is flooded into these areas, with the occasional touch of a warmer shade to give the impression of sunlight reflected from buildings across the street. Once the washes dry, the windows are added with a single brushstroke.

Unstretched paper

It is impractical to work on stretched paper if you are going to hold the painting under the tap to make the colour flow across the surface. A tough 300gsm paper will flatten out if it is left under weights overnight.

Painting foreground textures

Before the painting gets very far, Kay Ohsten introduces her colours and textures into the foreground in order to capture the nature of the weathered surfaces.

'I love painting buildings that are crumbling, because the rougher I paint, the more mistakes I make, and the more accidents I have, the more authentic the buildings look.'

Pale mauve, red and umber brushstrokes warm up the roof tiles; and other colours are splattered across the paper to meld with the wet paint. Additional texture is created using the edge of a pastel stick and by blotting the surface with absorbent paper.

Painting the distant landscape

In the distance is a fertile valley that stretches away to a range of mountains. Fields and vineyards are described with freely applied brushstrokes, leaving a few small patches of white paper that add sparkle to the landscape and also give a vague impression of some distant buildings.

The darker-green foliage that is immediately behind the buildings throws the strongly lit walls into relief. Tall cypress trees are indicated with the edge of a flat brush, and dark lines that crisscross the landscape are applied with a pen loaded with diluted watercolour paint.

Having brushed in the blue-grey mountains, Kay Ohsten tilts the paper to encourage the colour to run towards the skyline, then back again to avoid leaving a dark edge.

Brushmark library

Kay Ohsten likes to use a single flat paintbrush with which she is able to make a wide variety of marks.

Full-width brush

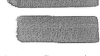

To make broad strokes, she uses the full width of the brush. Nipping the tip of the brush between finger and thumb creates narrow strokes.

Brush edge

Using the edge of the same brush makes linear marks; the dryer the paint, the narrower the strokes.

Brush tip

Placing the brush tip on the paper makes rows of identical brushmarks.

Printing with the edge

Printing with the edge of the brush makes attractive tapered brushstrokes.

Pressing with the side

Pressing the side of the brush against the paper leaves broken colour.

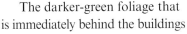

Flicking and spattering

Flicking the brush spatters paint across the paper. If you spatter onto wet paint, the colour disperses. Tip the paper to control the run.

Kay Ohsten

Bonnieux, Provence
Watercolour on paper
42 x 46cm (16 x 18in)

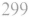

• Perspective

As a subject, townscapes will require at least a basic appreciation of perspective, but an exciting painterly surface is more delightful to the eye than a carefully measured drawing.

• Blotting

Lift paint off the surface by blotting it with absorbent paper. Blot out stripes, using some tissue paper wrapped round a ruler.

Load a calligraphy pen with watercolour

1 Linework

You can make broad expressive lines with a sharpened stick which has been dipped in watercolour. For finer work, use a calligraphy pen loaded with thinned paint.

2 Painting shadows

Cool-grey shadows create the impression of strong sunlight. Broad areas are blocked in with a flat brush; linear marks are made with a pen.

3 Pastel and conté

Create textures by drawing with the tip of pastel and conté sticks.

4 Spattering

Flicking paint onto a painting creates random textures.

5 Scraping with a palette knife

Scraping the tip of a palette knife through wet paint squeezes the colour out of the paper. To make very pale marks, lift the paint soon after applying the wash. Waiting longer will allow more time for the paint to stain the paper.

Kay Ohsten
Bonnieux, Provence
Watercolour on paper
42 x 46cm (16 x 18in)

The overall impression is one of looking down onto a jumble of rooftops that beat back the sultry heat of late-afternoon sunlight.

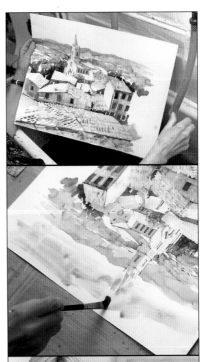

Painting on damp paper

One advantage of working with unstretched paper is that you are free to manipulate the colour with copious amounts of water. Provided the paint is dry, you can hold your painting under running water without fear of the colours running.

Creating an orange glow

An overall tone of orange-yellow creates an impression of warm sunlight. Wet the bottom half of the painting by holding it under a running tap, allowing surplus water to run off into the sink. Spatter the wet paper with dilute cadmium orange and yellow, then tilt the paper back and forth to move the colour around on the surface. Blot excess water with a paper towel.

Painting the sky

Turning the painting upside down, you can adopt a similar method to paint the sky. Having wet the paper, paint a blue wash around hills and buildings, then tilt and bend the paper to direct the colour exactly where you want it. This also prevents the paint pooling and leaving obvious ridges. If you want to create clouds, blot them out of the blue sky, using an absorbent paper tissue.

▶ SEE ALSO
▶ Atmospheric perspective 292, 303
▶ Paintbrushes 96
▶ Painting a vase of flowers 254
▶ Painting outdoors 134
▶ Painting skies and weather 286
▶ Space, depth and distance 302
▶ Watercolour paints 87

Space, depth and distance

Perspective is an optical illusion whereby objects appear to diminish in size as they recede into the distance. It is possible to reproduce this illusion in a drawing or painting, using a system of lines and reference points for plotting the real three-dimensional image onto a two-dimensional surface. Although perspective drawing can be precisely measured and constructed, you only need to apply the basic principles when you are painting and sketching.

Using a viewfinder
Some artists use a cut-out cardboard window to establish their viewpoint, and to help assess perspective in relation to the picture plane.

Establishing the horizon line
To establish the horizon line from any working position, hold a ruler horizontally in front of your eyes, so you see only the edge. Make a mental note of the line the ruler makes across the scene in front of you. Mark this line across your drawing to represent the horizon.

Picture plane

Your drawing or painting is a representation of a view as it might appear when projected onto an imaginary clear screen in front of you – this is similar to looking at the same subject through a windowpane. This surface, known as the picture plane, is taken to be at right angles to your centre of vision.

Horizon line

When you look straight ahead, neither looking up nor down, your eyelevel falls on the horizon line (**HL**). This is the primary line of reference in perspective construction and is always at eyelevel no matter what height you are looking from. In a seascape the horizon line is visible, but in most situations it is obscured by high ground or buildings.

Vanishing points

In perspective views, all lines at right angles to the picture plane and parallel to the ground appear to converge on the horizon line. These points of convergence are called vanishing points (**VP**). Usually, one or two vanishing points are used, depending on the angle of the subject being observed in relation to the picture plane. Sometimes a third vanishing point is introduced above or below the horizon line. In practice, vanishing points may fall outside your picture area.

Two-point perspective
This method, which is also known as angular perspective, uses two vanishing points for constructing three-dimensional objects set at an angle to the picture plane. It provides a more natural view than single-point perspective.

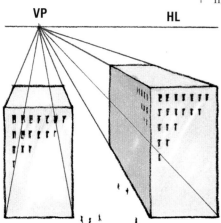

Single-point perspective
Subjects seen head on – with one face parallel to the picture plane – can be constructed, within limits, using a single vanishing point.

Three-point perspective
This is used to give a sense of realism to subjects viewed from above or below. Unless the vanishing points are widely spaced, the view is distorted.

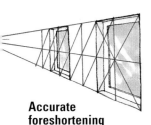

Accurate foreshortening
One way to achieve this illusion is to draw the subject, say a window, in perspective, then draw in the diagonals. Draw a line through the centre of the cross to the vanishing point, then draw a vertical line through the same centre, dividing the window into four quarters.

Now draw a diagonal through one quarter and extend the line to cross the lower receding line. Draw in a vertical where these lines cross. Mark the diagonal as before and then continue in this way towards the vanishing point.

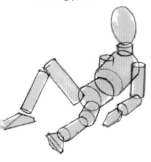

Figure drawing
When drawing figures, foreshortening affects the proportions of the limbs and torso. As an aid, think of these elements as cylinders in perspective.

▶ **SEE ALSO**
▶ Landscape on location 282
▶ Painting a landscape 274
▶ Painting a townscape 298
▶ The changing landscape 290

Foreshortening

When an object is seen in perspective, receding towards the vanishing point, it appears shorter than it is in reality. This phenomenon is known as foreshortening. This diminishing in size is progressive, so that a row of windows of equal size and spacing, for example, will appear to get smaller, and the spaces between them narrower, as they recede into the distance.

Foreshortening is relevant to everything you draw or paint, not only landscapes or townscapes but figures as well, as shown in the illustration (below left).

Atmospheric perspective

Dust and water vapour suspended in the atmosphere partly obscure our view of distant objects. As they recede into the distance, details become less distinct, tones become lighter and colours appear to get cooler, moving towards shades of blue. Simulating these effects with paint helps create the illusion of depth and distance, as illustrated in the painting below.

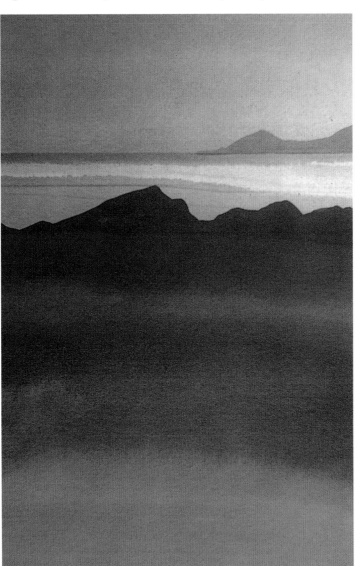

Circles on the horizon
When the centre of the circle coincides with the horizon line, the minor axis of the ellipse is also horizontal and the ellipse appears upright.

Circles below the horizon
When the centre of a circle falls below the horizon, the minor axis continues to point towards the vanishing point. As a result, the ellipse appears to rotate in order for the circle to be seen in true perspective.

Foreshortened circles
Note how ellipses appear to get flatter as they approach the horizon line.

Drawing circles in perspective
A circle touches all four sides of a square. When it is seen in perspective, the square is foreshortened and the circle becomes an ellipse.

Robert Tilling
Rocks, Low Tide
Watercolour on paper
65 x 50cm (26 x 20in)

Putting life into a painting

Painted cityscapes and interiors bereft of people appear eerily deserted. John Yardley, who is well known for his ability to inject vitality into these subjects, shows us how to bring a painting to life by including simple well-conceived figures.

Proportion and scale

If a figure is wrong, even by a small margin, it can spoil what is potentially a good painting. In particular, it is easy to forget that if people and animals aren't in scale the whole picture will look out of balance. The heart of the problem lies in the fact that the eye is capable of perceiving very subtle differences.

'Artists often make their figures appear stiff and wooden, almost like clothes pegs. If you paint a figure with the legs just a fraction too far apart, it no longer reads convincingly.'

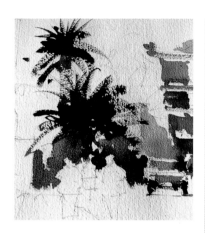

Planning your painting
When painting in watercolour, the artist John Yardley adopts the conventional method of working from background to foreground, leaving white space in which to paint the figures.

Working position
It is often best to paint standing up, especially when working outside. When seated, you look across the paper at an acute angle, which can give a distorted view of perspective and proportion.

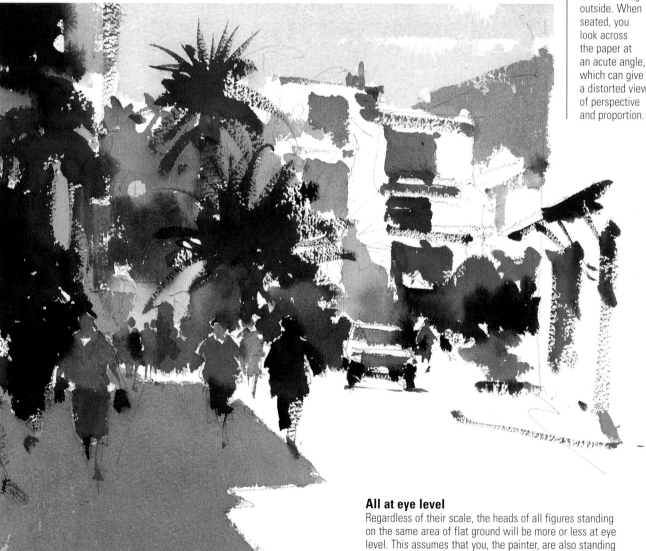

All at eye level
Regardless of their scale, the heads of all figures standing on the same area of flat ground will be more or less at eye level. This assumes that you, the painter, are also standing on the same surface. If you are seated, then the heads of the figures closest to you will appear higher than the rest.

'There is only so much you can say about painting – painting is a doing thing.'

John Yardley always starts by drawing in pencil (see right) to indicate where he wants to place the figures. They constitute an integral part of the composition, not merely afterthoughts that are inserted at random.

The background is painted first to establish broad areas of tone and colour, leaving patches of white paper where the artist intends to introduce local colour, perhaps to suggest a dress or a man's coat, for instance.

Figures are painted freely to suggest movement, precluding detail that would spoil the illusion. A broad area of shadow anchors the group of figures to the ground.

'The secret to successful watercolour painting is knowing how much water to use. This only comes with experience, but once you get a feel for the right combination of water and colour, you have control over the medium.'

Brushes

The artist is in the habit of using two No.10 round sables. One is a new brush, which takes a point well and is ideal for painting detail. The other brush is older and slightly worn, but is perfect for broad washes.

Economy of means

Figures should look credible, even when painted simply – but don't concentrate on unnecessary detail. For example, the brain tells the viewer that people have legs that end with feet, so there is no need to paint the shoes.

The most basic effects can be used to imply movement and direction. A small white 'V' left at the neckline will indicate that a figure is coming towards you. Paint it in with solid colour and the figure appears to be walking away.

Cast shadows suggest that figures are standing on solid ground, but they too need to obey the rules of perspective.

John Yardley
Street Scene, Sorrento
(opposite and above)
Watercolour on paper
51 x 76cm (20 x 30in)

Figure Studies (left)

Painting a face

There's no question that portraiture can be somewhat daunting, even for experienced artists. It can be quite difficult to concentrate on the mechanics of drawing and painting when, at the back of your mind, you are wondering what your sitter is going to think of your efforts. The image we have of ourselves is often quite different from how others see us. Consequently, attempting to create a faithful portrait of your sitter that neither offends nor flatters may well be a delicate balancing act.

Choosing your model

One way to avoid embarrassment is to paint a self-portrait. You can then be totally objective, and work for as long as you like without fear of tiring your model! If you don't want to paint a full-face portrait, set up a pair of mirrors in such a way that you can see yourself from different angles.

Other obvious candidates are your friends and members of your family, who will usually prove to be willing participants. Painting people you know intimately should help you bring out their true character, provided that you can discipline yourself to look beyond your own preconceptions.

Whatever the relationship with your sitter, you are more likely to approach the task with enthusiasm if you genuinely feel that person will make an interesting subject to paint.

Working from photographs
There is no substitute for painting from life, but it's useful to take photographs of your sitter at the beginning of a session and again at the end. Photos are helpful if you want to work on the painting between sittings, or if your model is very young and likely to tire quickly. However, a camera lens can produce a distorted image, particularly when shooting close-ups with a wide-angle lens (top).

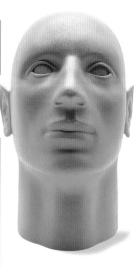

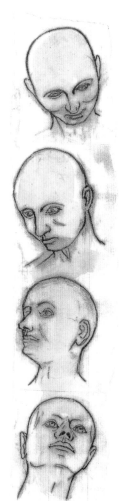

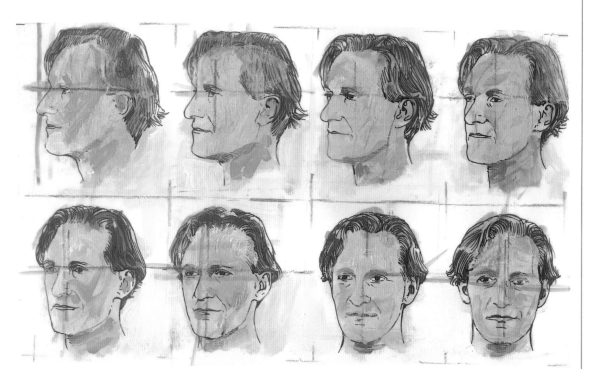

Posing your model
Before you settle on a pose, try out various views, from full face to three-quarter view and profile. Tilting the head up or down offers even more possibilities.

Composing a portrait

The featured painting is a conventional head-and-shoulders portrait against a plain background that emphasizes the contours of the face and throws the features into stark contrast. The artist has selected a three-quarter view, which makes it easier to see the features in three dimensions. Lighting will also affect your subject. A face under even illumination can appear almost flat, whereas a strong sidelight throws the features into relief.

You could show more of your sitter, and also include a setting that helps to convey the model's lifestyle or interests, but if your objective is to achieve a recognizable likeness, it pays to keep the composition simple.

Help your model to feel comfortable and relaxed – don't expect anyone to hold a smile or other exaggerated expression for any length of time. Be encouraging, and involve your sitter in the process by allowing him or her to see and comment on your work during the breaks.

Agree on what your sitter should wear. It does not have to be anything elaborate, but the addition of jewellery, a scarf or necktie, or even a hat, may contribute something to the painting. As the work progresses, feel free to alter the colour and texture of the sitter's attire if you feel it would improve the painting.

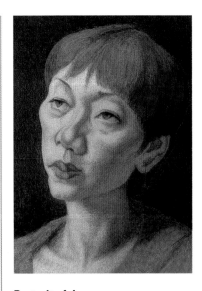

Portrait of Joyce
Nick Hyams
A strongly lit three-quarter view makes the model's features stand out against the dark background.

Making a preliminary drawing

We all have the capacity to recognize individuals and can tell when a portrait actually looks like someone we know. As an art tutor, Nick Hyams encourages his students to harness this instinctive power of observation when they are drawing or painting a likeness of another human being.

Before you commit yourself to paint, it is worth making a preliminary drawing of your subject. Drawing concentrates the mind and gives you an opportunity to observe your sitter closely.

Even a basic understanding of how the body is constructed enables an artist to draw and paint with confidence, and it is the underlying bone structure that gives us the most important clues to work with.

The eyes are set deep within roughly circular sockets in the skull (you can detect them beneath the layers of skin and muscle). The cheekbones just below the sockets are invariably prominent features, as is the curve of the lower jawbone. Even when it is covered with hair, the size and shape of the cranial dome is vital to the overall proportion of the sitter's head.

Achieving a likeness
A person's skull contributes in large measure to their appearance. Our model has high cheekbones, quite large well-defined eye sockets, and a delicate chin. These characteristics, together with her full lips, slightly almond-shape eyes and distinctive nose, distinguish Joyce from every other individual.

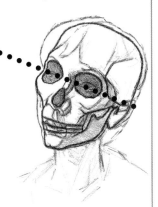

Basic proportions
A line through the bottoms of the eye sockets divides the human skull in half. When painting someone with a full head of hair, the line runs through the centre of the eyes.

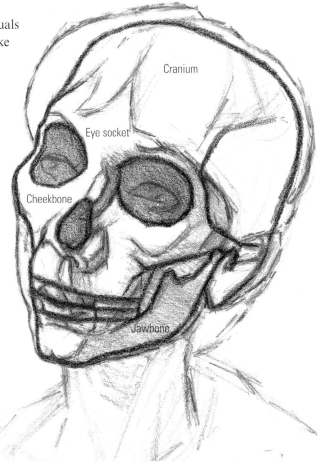

Cranium

Eye socket

Cheekbone

Jawbone

The drawing

Portraiture is never easy, but the artist Nick Hyams advocates a method of painting that allows you to correct the inevitable mistakes you will make without having to throw away all the valuable work you have put into creating a portrait.

The featured painting is the result of a number of sessions, spread over an extended period. Although the drawing was made from life, the finished portrait was painted from memory.

The advantage that a painted portrait has over a photograph is that the artist is free to make subtle changes of emphasis in order to draw attention to a person's unique characteristics. Compare the finished painting with the carbon-pencil study on the right, and you can see how Nick Hyams has deliberately emphasized the sitter's cheekbones and pointed chin.

'Almost instinctively, I will select certain features that characterize the model. I am trying to arrive at something that says more about the sitter without it becoming a caricature.'

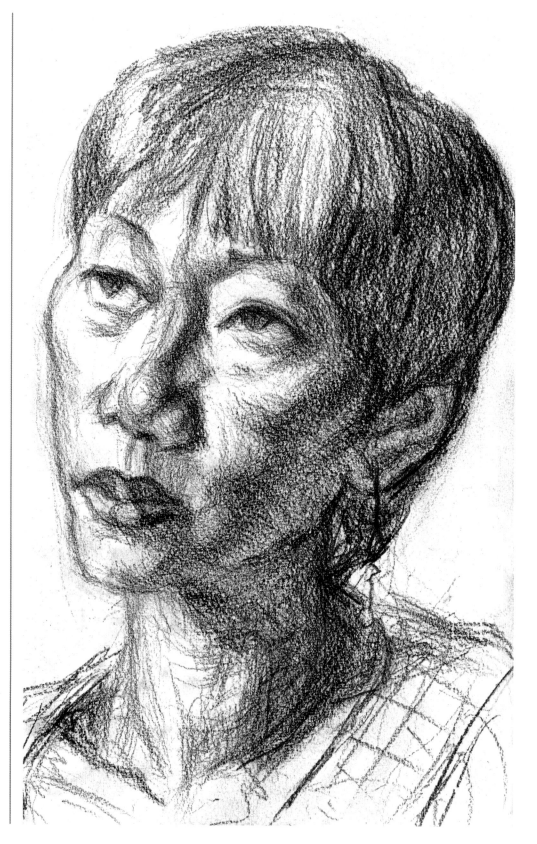

Nick Hyams
Preliminary Drawing
Carbon pencil on paper
38.5 x 28cm (15¹/₂ x 11in)

• Medium
A gloss medium was used to increase the transparency of the acrylic paint and to improve the flow.

Paper
This painting is made on 100 per cent cotton, 300gsm hot-pressed paper. Having a smooth surface, the paper does not impose a texture on the painting.

Underdrawing and ground

The finished work began with a simple pencil drawing that was used as a guide to the painting. The whole surface was then covered with a wash of raw sienna, applied with a 50mm (2in) brush.

'I like to start with a coloured ground. It imparts harmony to a painting. It also gives you a warm background so that you are not having to deal with the stark white paper, which can be very distracting.'

Don't attempt to create a flat wash, just apply the paint in any direction, even mixing in a second colour if you want a bit more variation. The ground fixes the pencil underdrawing, so there is no fear of it smudging.

Brushes
Synthetic brushes are ideal for acrylics. Their bristles are strong and springy, and are relatively easy to clean. Nick Hyams uses round brushes in a range of sizes.

'Personally, I use round brushes because I prefer the marks they make. I might start with a No.8 or 10 in order to work freely, but I will switch to something like a No.4 as the painting gets closer to what I am trying to achieve.'

Underpainting
Using the coloured ground for your halftones, develop an underpainting to work out the basic tonal values. For this painting, various mixtures of raw umber, cadmium lemon and white were used to roughly paint in the darker areas and highlights with washes of colour. Having blocked in the basic lights and darks, paint a dark wash across the background so that you can check the relative tonal values of the face before you proceed with colour.

Paints
If you are new to painting portraits, and especially if you are intending to use acrylic paints, it is a good idea to confine yourself to a limited palette consisting primarily of 'earth' colours. Until you become more experienced, painting a portrait with bright colours can make your sitter look like a painted doll. The featured portrait was painted using the following colours:

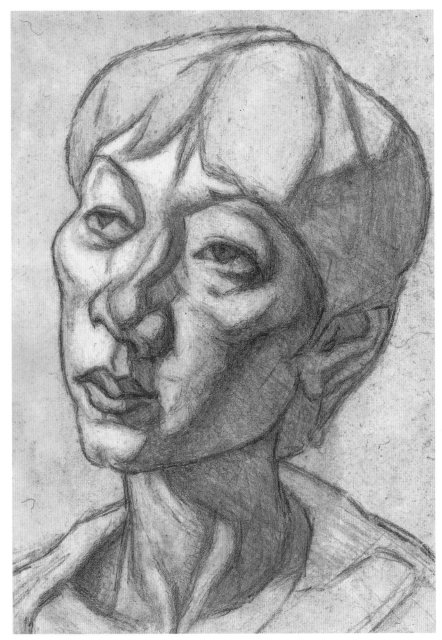

Cadmium lemon

Raw sienna

Raw umber

Red oxide

French ultramarine

Titanium white

Ivory black

If you feel a need to expand your palette slightly, the following colours are also recommended for portraiture:

Yellow ochre

Burnt sienna

Burnt umber

Chromium-oxide green

• Optical mixing

This process utilizes optical mixing, whereby small specks of pure colour laid side by side merge together when viewed from a distance, suggesting a different and more subtle colouring.

Modelling with colour

Some artists adopt a bold approach, attacking the canvas with gusto. Such paintings are often alive with energy and amply reward the risks taken by the artist. However, what appears to be carefree abandon is often the result of years of experience and experimentation.

You have a better chance of success, especially with acrylic paints, if you approach your work systematically. Nick Hyams' technique, which relies on simple combinations of colour, enables you to keep the process under control.

As you work up the painting, keep stepping back to evaluate the effect of the modelling and also to check the overall tonal balance. If one part appears too dark, just add a few specks of a paler tone to modify it. If the highlights are too bright, knock them back with dots of darker colour.

Highlights

The lightest areas are painted with cadmium lemon and white. These highlights are warmed with specks of red oxide which, when grouped together, begin to model the form.

Shadows

The same three colours are used in the shaded areas, where the underlying raw umber makes for a cooler colouring generally. Deepen the shadows with specks of darker and cooler colours until you achieve the required depth of tone.

Nick Hyams

Joyce
Acrylic on paper
38 x 28cm (15 x 11in)

The hair

Don't lose sight of the underlying shape of the head when you are painting hair. Linear brushstrokes are more expressive than dots, and scumbling with a dry brush adds texture.

Painting the eyes

Note how the circular iris is partly hidden beneath the eyelid, which also casts a shadow across the eyeball. The spherical shape of the eyeball is suggested with modelling of the upper and lower lids. Here, specks of red oxide, cadmium lemon and white paint have been used to depict the 'whites' of the eyes. Make sure that both eyes are looking in the same direction. Many a portrait has been spoilt by the artist giving the sitter a squint.

Working up the details

Line is an artistic convention. In reality, there are only edges where a curved surface is seen as a horizon or where one surface meets with another. Draw these margins as broken lines, using dots of colour that merge and blend to create the shape you want. The darkest areas of drawing in this painting are made with specks of raw umber and black.

Background

What appears to be a plain background from a distance, shimmers with tiny blue-grey, brown and black brushstrokes.

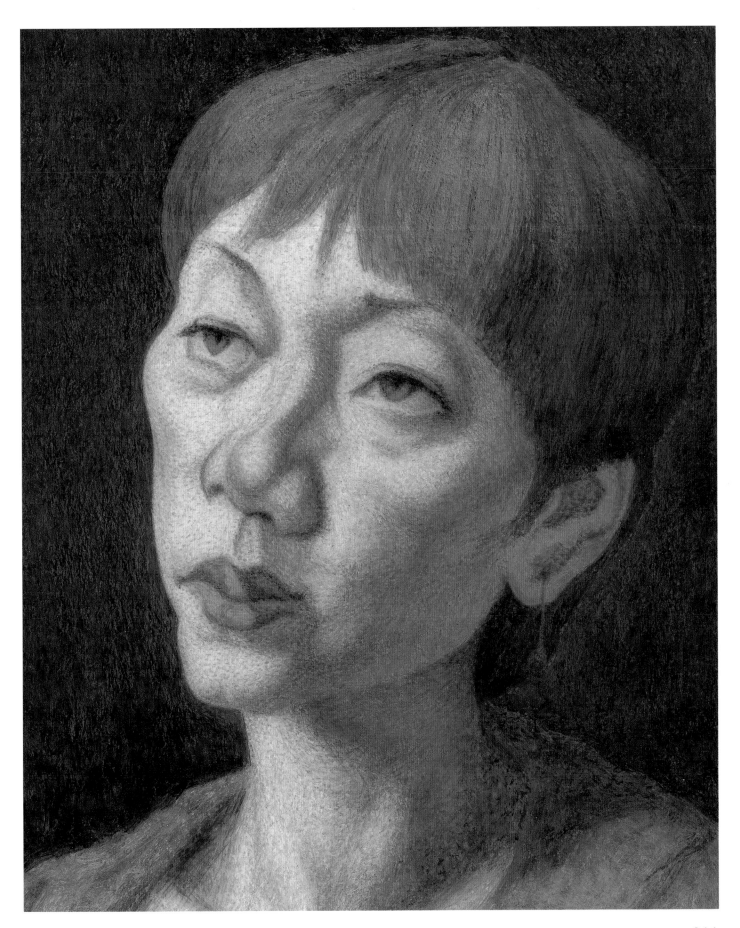

Working on the features

When using words to identify an individual, we tend to rely on descriptions of their distinguishing features – thin lips, long nose, big ears, and so on. Similarly, in painting, an accurate depiction of facial features goes a long way towards obtaining a recognizable likeness. This is what most portraitists are striving to achieve, and what most sitters want to hang on the wall.

Preliminary sketches

Before painting a full portrait, get to know your model's unique facial characteristics by making preliminary sketches, not forgetting to relate them to the overall proportions of the face and head. Use the opportunity to make tonal studies and colour notes.

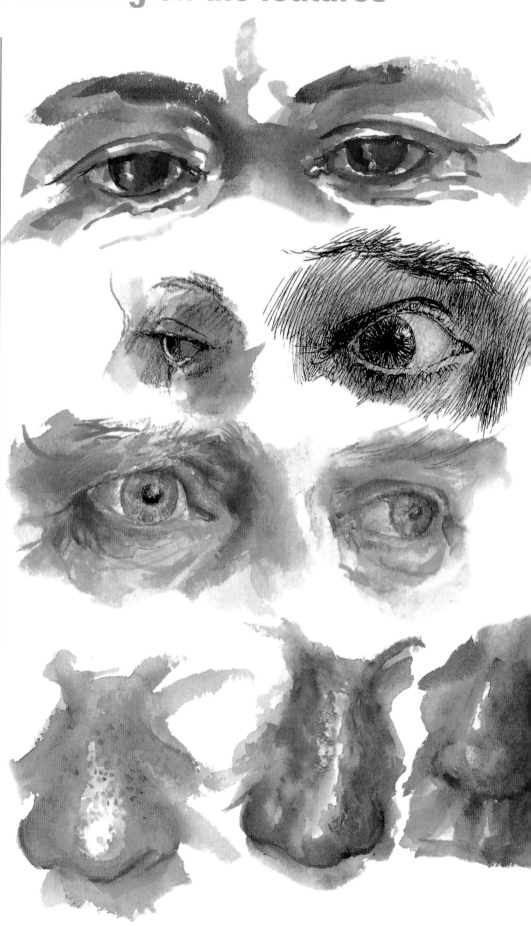

Close observation
This artist moves around her sitters, sketching details in watercolour and conté crayon before embarking on a finished painting.

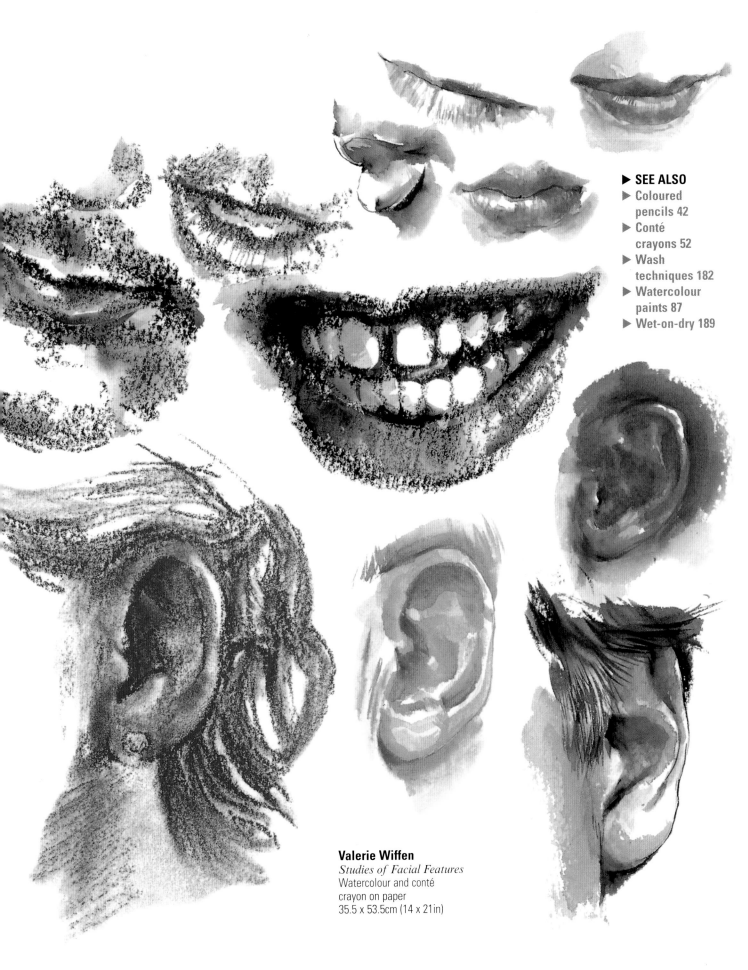

▶ **SEE ALSO**
▶ Coloured
 pencils 42
▶ Conté
 crayons 52
▶ Wash
 techniques 182
▶ Watercolour
 paints 87
▶ Wet-on-dry 189

Valerie Wiffen
Studies of Facial Features
Watercolour and conté
crayon on paper
35.5 x 53.5cm (14 x 21in)

Painting a friend

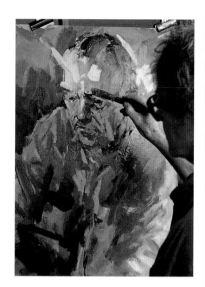

This is an example of portraiture made with panache and energy. It's a style no complete beginner could hope to emulate, but it is a goal to which many artists aspire. Watching Ken Paine at work is an invigorating experience, because he is a firm believer in throwing caution to the wind. 'Be bold. It's only a painting. It's never going to be life-threatening.'

Painting more than superficial appearance

As we have seen previously, an artist will sometimes exaggerate facial characteristics in order to convey the true likeness of the sitter. Taking it a step further, a perceptive painter can express more than superficial appearance.

'When I am painting a portrait, I don't set out to flatter the sitter. I am more concerned with how I feel about him or her on the day, because that helps me make appropriate marks – energetic marks, gentle marks, and so on. Unless you know the person, it may not be a totally accurate assessment, but it's what comes over that counts.'

Mark making
Expressive marks, made with brush and pastel stick, are the artist's direct response to the subject of the painting.

Mirror image
Use a mirror to look at your portrait from a different viewpoint. This will help you evaluate the painting in terms of composition and tonal balance. It also enables you to see the canvas from a distance – useful if you work in a small studio.

Materials

This is a painting made with acrylic paint and soft pastels, a rich combination that allows for a huge variety of bold and expressive marks. There is very little time spent waiting for the paint to dry – so the artist can switch from paint to pastel and back again, as the mood takes him.

The support is a good-quality mounting board which has been coated with gesso, and then sprinkled with powdered pumice. This provides a finely textured surface that accepts both materials equally well.

When working with mixed media, Ken Paine uses one, or possibly two, large filberts for the underpainting, which is subsequently overlaid with layer upon layer of pastel strokes.

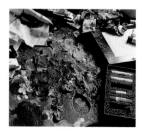

Posing your model
When you pose your model, think about how you can use 'body language' to convey different aspects of the sitter's personality. It is easy to imagine how taking up a forceful aggressive stance would give a completely different impression from, say, lounging in an armchair. But human beings can pick up more subtle messages. A model staring straight out of the canvas could be interpreted as challenging or engaging, whereas downcast eyes may be seen as passive or melancholy. With a little direction from the artist, this model took up a natural contemplative pose.

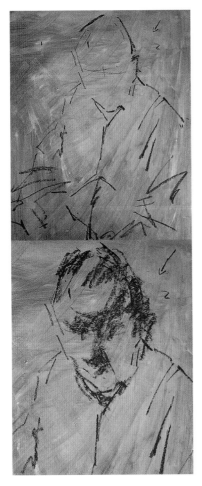

Underdrawing

In order to pin down the main elements of the composition, the artist begins by drawing with pastel. From the beginning, the lines of the torso direct the onlooker towards the focal point of the picture, the sitter's head. Placing the focal point slightly off centre helps create well-balanced shapes on each side of the figure and makes for a more dynamic composition.

Underpainting

Within minutes of starting the portrait, Ken Paine picks up a brush and starts modelling the form with light and shade. He blocks in the darker tones, using a wet brush to manipulate the pastel, and paints the highlights with white acrylic.

'When I look at a person, I don't see their body or their features: I see shapes – shapes within shapes and shapes between shapes. And if I paint those shapes well, I will get a good likeness of that person.'

The artist brings in warm and cool accents, using a mixture of yellow ochre and raw sienna for the flesh tones, and a cool green for the areas in shadow. Flashes of scarlet, warm black and deep yellow are used to chisel out the features. Painting a dark background shows up the side of the face and shoulder.

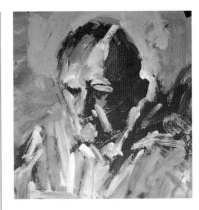

Blocking in the tones

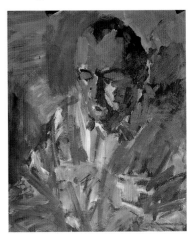

Adding warm and cool accents

'When you are drawing, try to feel the form as if you were a sculptor. Don't worry about the details for the moment – just work on the overall picture, checking that the proportions are reasonably accurate.'

Creating a painterly surface

Having established the basic form, the artist becomes engrossed in the struggle to get the sitter's likeness down onto the canvas. Using cool greys and ochres, he draws in the halftones; brings the sitter's face to life with deft strokes of black and red pastel; and then introduces the strong highlights with the side of a pastel stick.

'A painting goes through many different stages. You must be prepared to build it up then break it down again. It's not easy, but it is an essential part of the process.'

Eventually, the painting reaches a point which the artist feels is a firm foundation for the final stages.

'These are the underlying colours that will show through the all-important marks I shall be making to finish the portrait. If you proceed with that process before the painting is ready, the portrait will be lifeless, but if you persist with the basic modelling until you are happy with it, then you can really enjoy the next stage.'

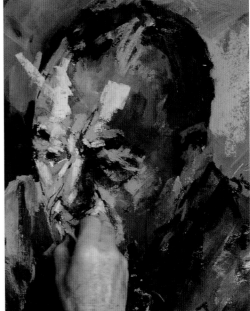

Bringing the face to life
Ken Paine draws the features with bold pastel strokes, but he doesn't hesitate to take up a paintbrush and rework the portrait when it isn't quite going his way.

315

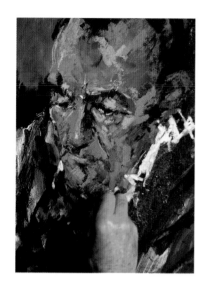

'I am trying to produce an interesting painterly surface. It is important to realize that you are creating a painting, you are not making a copy of what you can see in front of you. Just as a jazz musician might improvise on a theme, so I am taking certain liberties with the portrait. It's what we call artist's licence.'

Finishing touches

Returning to pastels once more, the artist puts the finishing touches to the portrait. Even when he is concentrating on detail, Ken Paine continues to work freely; he applies broad strokes, using the side of a stick, then makes delicate marks and lines by drawing with the point and edge.

'This is what art is all about, making marks and lines that are exciting and full of rhythm.'

Balancing the painting

The portrait is all but complete, but now the artist must decide how to convey the bulk of the figure without distracting from the focal point of the portrait. This he achieves with bold brushstrokes and vigorous lines that break down the edges of the torso and direct the viewer's attention towards the highly detailed features. The final balance is made by blocking in the background colours, using dark and light areas to throw the sitter's head into relief.

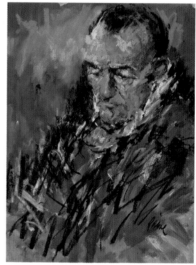

A complete illusion
Close up, the finished painting could be compared with the work of an abstract painter, yet step back and all those expressive marks coalesce into a compelling and convincing portrait of the artist's friend, Andy.

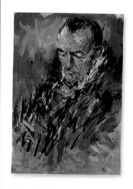

Ken Paine
Andy
Acrylic and pastel on mounting board
84 x 58cm (33 x 23in)

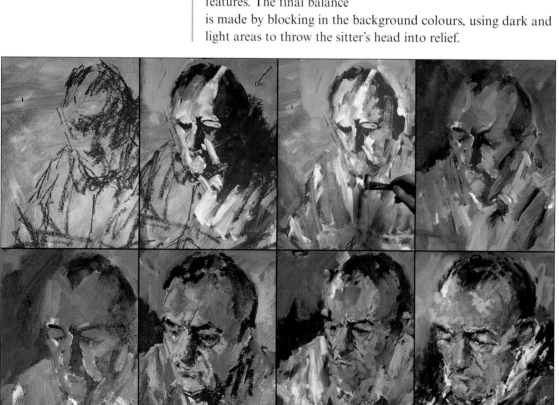

▶ SEE ALSO
▶ Acrylic paints 110
▶ Experimental poses 322
▶ Figure drawing 140
▶ Painting a face 306
▶ Pastels 48

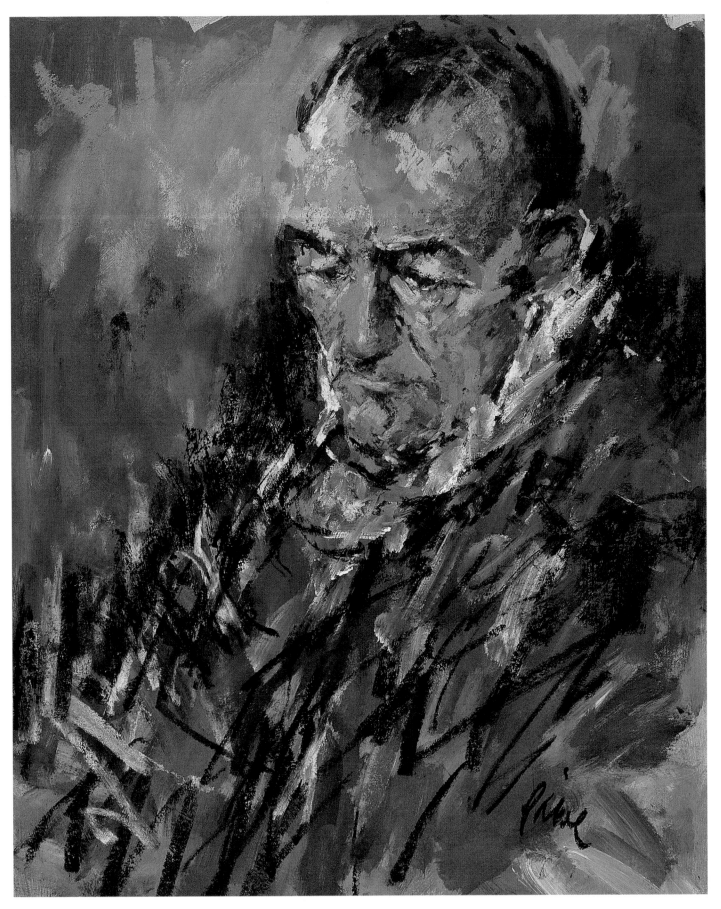

Painting a person

A portrait can encompass more than a person's head and shoulders. With this exercise, we set out to paint a full figure, clothed and set against a simple background. It is perhaps more important to create an impression of a solid well-proportioned human being than it is to achieve a recognizable likeness of the model.

Materials and equipment
This painting was made on 410gsm watercolour paper, using gouache and tempera-block colour applied with a single weasel-hair brush.

As the artist, Val Wiffen, is quick to point out, there is often too much emphasis placed on the features, when at this scale posture and meaningful gestures are equally important for conveying character and personality.

'Don't be too concerned if you don't achieve an obvious likeness, because your painting may still be a very good representation.'

Making a sketch plan
Val Wiffen dispenses with a detailed underdrawing, opting instead to make a sketch plan, using a sepia water-soluble coloured pencil and wash in order to plot the main elements of the composition.

'I like to put down a few lines, sort of landmarks that will guide me through the early stages of painting. I can check the proportions of the figure and at the same time resolve the composition, which in this case is a play on triangles within a square format.'

To strengthen the image on the paper, the artist takes a brush loaded with clean water and draws it across the linework, dissolving the pencil and creating washes of colour.

Dressing your model
Encourage your sitter to choose clothes that he or she is used to wearing – something that expresses the sitter's personality. This will help to reinforce the sense of likeness in your painting. The simplest textiles are often the most difficult to paint. Distinct patterns, such as stripes or checks, will follow the contours of the body and make it easier to depict the model in three dimensions.

Choosing your viewpoint
In quite a small studio, standing over a seated model may produce an awkward bird's-eye view – in which case, you may be better off seated at the same level as your sitter. However, standing at your easel will give you greater freedom of movement, and you can step back from time to time in order to look at your work from a distance.

Tonal washes are created by brushing water over the initial water-soluble pencil drawing.

The first washes are then laid in by the artist with tempera-block colour (see below left).

Tempera blocks are a solid form of gouache (see page 104).

▶ **SEE ALSO**
▶ **Foreshortening 303**
▶ **Gouache 104**
▶ **Textural effects 208**
▶ **Painting a face 306**
▶ **Painting hands and feet 330**
▶ **Stay-wet palettes 121, 283**
▶ **Wash techniques 182**
▶ **Working on the features 312**

Keeping gouache moist
The artist uses a stay-wet palette when working with tubes of gouache. She keeps the paint moist by misting it occasionally with water from a small plant spray.

Keeping colours fresh
When laying gouache, make a single stroke in one direction only. This deposits the paint on the surface without disturbing the underlying colour.

Paints and paintbrushes

Paints

Gouache is a versatile medium. It can be laid as transparent washes, much like watercolour; but when applied in a thicker consistency, gouache has good covering power, which gives an artist the option to alter or correct a painting without the colours becoming muddy. When dry, the surface of the paint has an opalescent glow, similar in some ways to soft pastel. Unlike watercolour, which stains the paper, gouache merely sits on the surface and can be washed off with a damp sponge, leaving very little trace of colour behind.

For the early stages of the featured painting, the artist used tempera blocks (gouache in solid form) to render colour washes. As the work progressed, she reverted to conventional gouache paint supplied in tubes.

Paintbrushes

Val Wiffen's personal preference is for Chinese-made brushes, with which she can make a wide variety of marks. For figure painting, she advocates using at least one brush that comes to a fine point and a large mop for applying broad washes. For a small-scale work like this, however, she can make do with a single brush that fulfils both purposes – a large weasel-hair brush (equivalent to a No.14 round).

The picture develops

Positive and negative shapes

With the next stage, the artist gets to grips with drawing and working on the tonal values of the composition. Applying tempera washes, she blocks in the positive shapes, which constitute the focal point of the picture, and also the negative shapes created by spaces and areas of colour surrounding the figure.

'If I am having trouble painting the negative shapes, it means the figure drawing requires some adjustment.'

Solidity and form

With the pose firmly established, the artist begins to home in on specific shapes and colours. She introduces stronger and richer colours to render folds in the clothing, the striped sofa cover and the model's boots. With only the minimum of detail, the figure already looks solid, with his weight nestling into the soft seating.

Introducing detail

With deft strokes, the artist begins to model the basic facial features. Folded fabrics take shape, with cast shadows and highlights indicated with strokes of paint. Although broadly painted, details such as collars, cuffs, pockets and seams give form and definition to the clothing.

Blocking in positive and negative shapes

Introducing stronger and richer colours

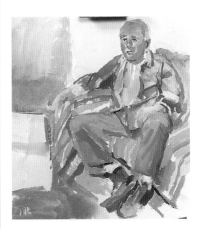

Detailing the features and clothing

319

'Don't try for a likeness too early. It is so easy to get bogged down with detail before the figure has any real substance.'

From start to finish

Allowing for rest breaks, the painting was brought close to fruition over a period of about five hours. The sequence below shows how the portrait evolved from the sketch plan and loose washes, until the finished painting (opposite) finally emerged. It is worth noting that the artist resisted the temptation to paint the model's features until the very end of the session.

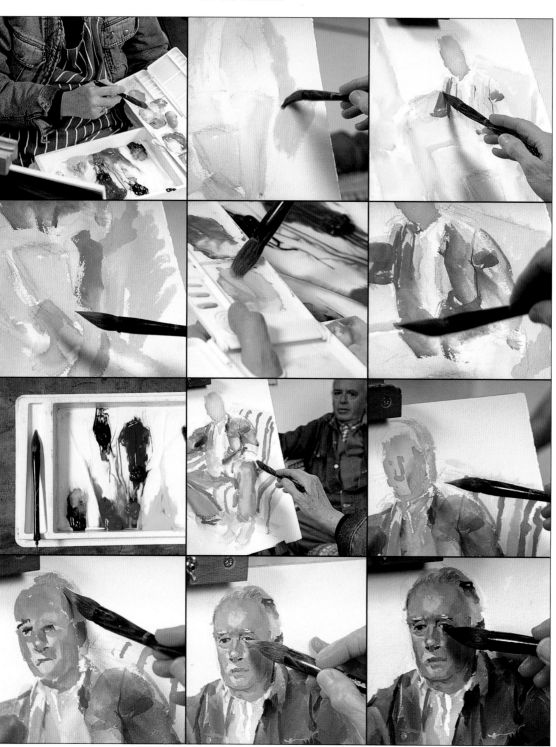

Valerie Wiffen
Portrait of Simon
Gouache on paper
38 x 38cm (15 x 15in)

Painting skin tones
In this case, so-called white skin is more like a warm grey with mauve-tinted shadows. Always look carefully at flesh tones and try to identify the colours objectively.

Painting eyes
Don't allow the eyes to dominate. If you paint them with pure white paint, your model can appear to be staring unnervingly out of the picture.

Painting hair
Hairstyle contributes to the sitter's appearance. There is no need to paint every wisp of hair, but here the artist was able to introduce sufficient detail to convey the age and character of her model.

Painting hands
For most painters, the hands are a source of consternation, because they appear to be such complex structures. Paint them simply, as planes separated by rows of knuckles, remembering that these joints are only capable of hinging in one direction.

'There is nothing like a degree of success for building confidence, and with confidence comes the enthusiasm to do better still. So don't be over-critical when evaluating your own work. Look for the positive aspects of your painting, and try to recognize your achievements as well as your shortcomings.'

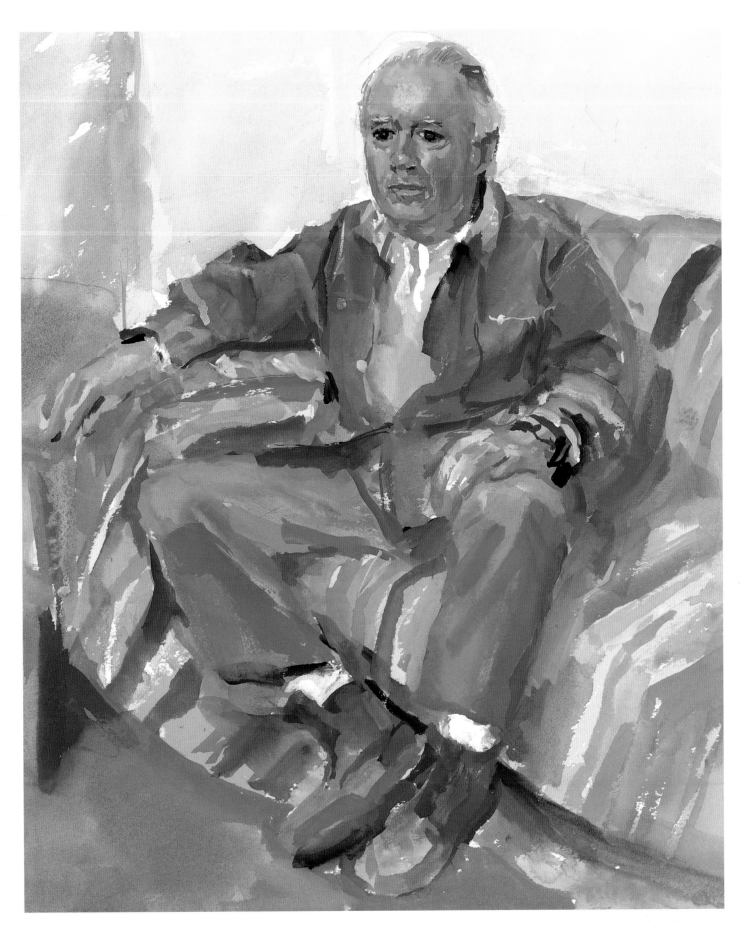

Experimental poses

For long figure-study sessions, artists generally ask their model to take up a conventional seated or standing pose. But you can extend your repertoire with some ten-minute sessions, to enable the model to adopt a more dramatic pose, or to let you practise capturing the essence of a figure in motion, using a rapid and sketchy style.

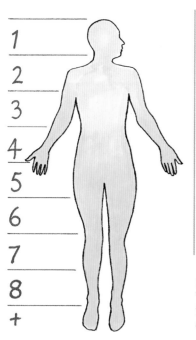

Rule-of-thumb proportions
You can divide the average human figure, from crown to ankle, into approximately eight head lengths.

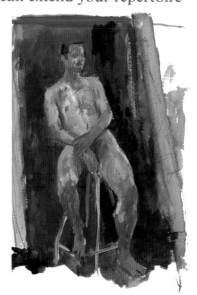

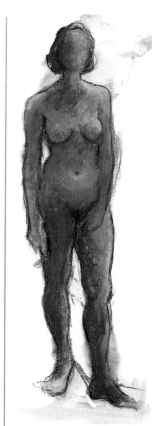

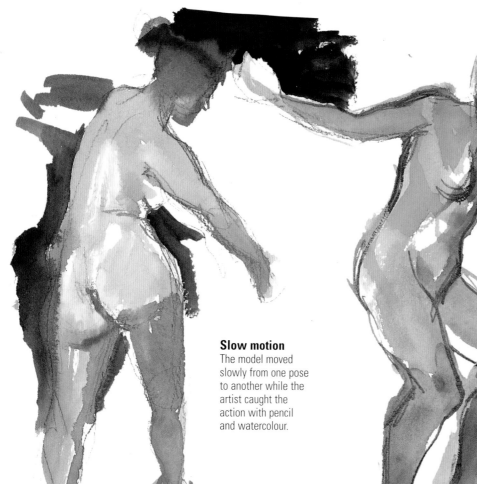

Slow motion
The model moved slowly from one pose to another while the artist caught the action with pencil and watercolour.

Relaxed poses (top)
With short breaks, a model can hold these poses for hours on end. Note the tilt of the shoulders induced by shifting the weight onto one foot.

► **SEE ALSO**
► Figure painting in the studio 324
► Painting a friend 314
► Painting hands and feet 330
► Putting life into a painting 304

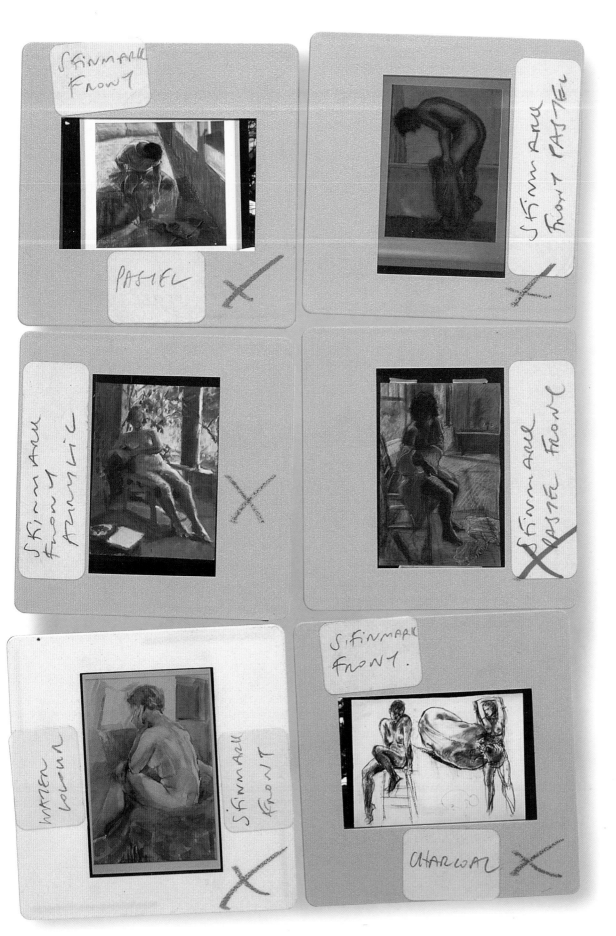

Handwritten slide labels: SFINMARK FRONT · PASTEL · S FINMARK FRONT PASTEL · SFINMARK FRONT ACRYLIC · S FINMARK PSTR FRONT · WATER COLOUR · S FINMARK FRONT · S FINMARK FRONT. · CHARCOAL

Sharon Finmark
Transparencies of figure studies and paintings from the artist's collection
Various media on paper

Figures in context
Furniture and simple props can be employed to make an eye-catching pose look plausible. Bedrooms and bathrooms will make appropriate settings for nude or semi-clothed figures.

323

Figure painting in the studio

For many amateur artists, making a studio painting of a nude model is a relatively ambitious project, but one to which most aspire. To Ken Howard, well known for his back-lit life studies, it is a familiar process, but his painting featured here goes a step further.

Working with a model

Hiring a professional model is a luxury few painters can afford, but there's no need to go to such lengths if there are close friends or family who are willing to sit for you. Particularly when using amateur models, it's essential to choose a comfortable pose that your subject can hold for extended periods. You should also allow for regular breaks, marking the key points of the pose with masking tape so that your model can take up the same position. Be sure to keep your workroom warm, and to provide somewhere where your model can change in private.

Setting up the pose

It pays to think about how you want to pose your model before he or she arrives. That way you won't waste valuable time arranging your props and lighting. In this painting, the model is posed against the diffused light from a window, with a dark-tone picture hanging behind her to provide dramatic contrast to her profile. A table, which is positioned to break the foreground, holds a selection of jars and bottles that add sparkle and colourful detail to the picture.

This particular picture is a sophisticated combination of three themes – figure painting, room interior and still life. Making all these elements work successfully in one picture brings us to the core of this artist's approach to painting.

'Painting is the process of keeping everything working in a proper relationship. Keep your eye on the total picture, bringing everything along together right up to the last mark. That is the key.'

This is a very important theme that we will return to again and again as the work progresses.

Ken Howard
Paula
Oil on canvas
60 x 50cm (24 x 20in)

The following sequence covers approximately three hours' work, and was executed in a 'one-wet' session. The finished painting opposite was the result of a further two-hour session.

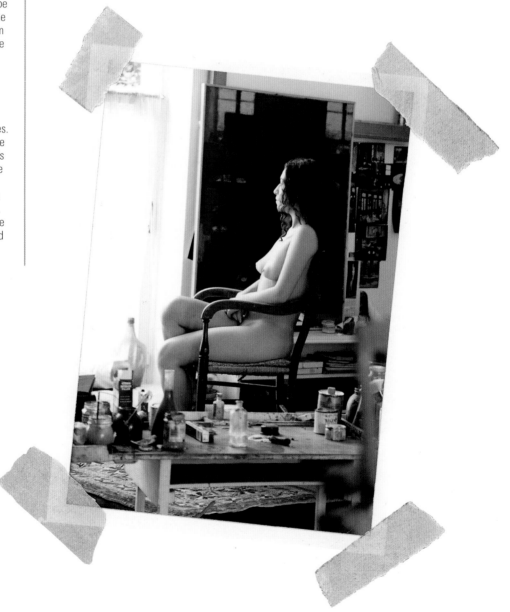

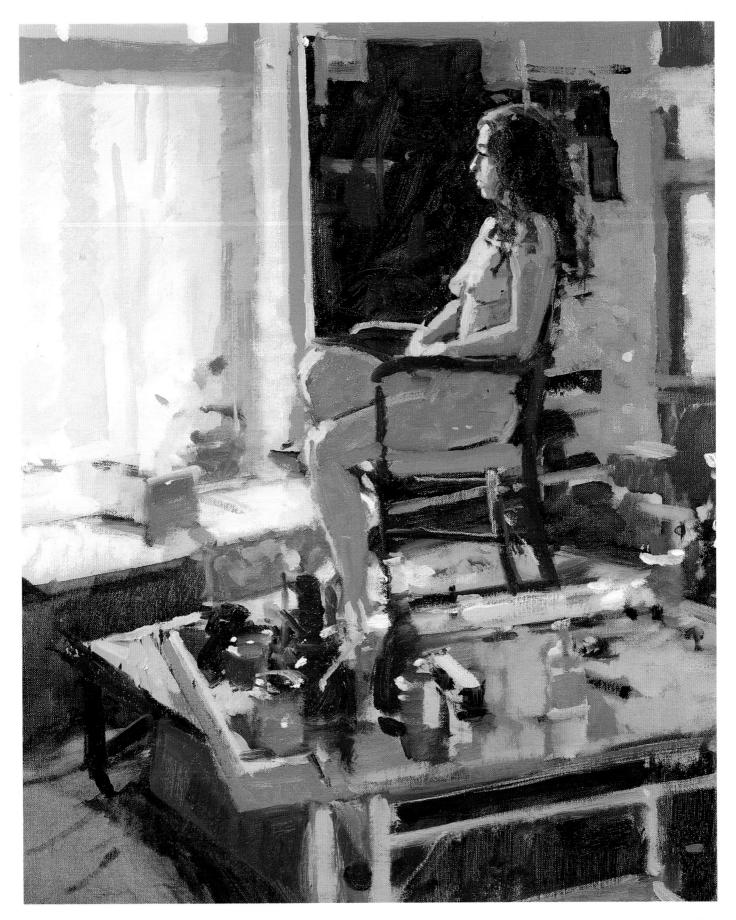

Paints
Oil paint is Ken Howard's preferred medium.

The canvas
The support for this work is a sized linen canvas, measuring 60 x 50cm (24 x 20in), coated with a white oil primer. A neutral ground colour was applied to provide the important mid tone.

Paint, brushes and canvas

'There is no reason to be afraid of using oils. If you want to be afraid of something, be afraid of watercolour or gouache – there's no turning back or scraping off with these paints.'

As with much of Ken Howard's work, this is in essence a tonal painting which is made with a limited palette, in this case cadmium lemon, cadmium red, French ultramarine, Naples yellow, raw umber, black and white. He uses glaze medium to accelerate the drying while preserving the transparency of the paint, and rinses his brushes in a jar of pure turpentine.

'The palette of colours that an artist uses is a bit like the key a composer might choose when writing music. The composer wouldn't write every piece of music in the same key and no artist uses the same palette for every picture. Each time you come to a painting you should be trying to do something better or different.'

Ken Howard stresses the importance of always keeping your paintbrushes clean.

'I prefer to work with relatively large brushes. If you start using small brushes during the early stages of a picture, you lose spontaneity and freshness. While I am working on a particular painting I reserve specific brushes for the different colours I am using. It is a mistake to keep using the one brush, because even when you have rinsed it in turps there is still a minute amount of paint left in the bristles which gets transferred along with the next colour you put on the canvas. Using several brushes is the only way to keep your colours looking fresh.'

Brushes
This picture was painted with hog-hair flats and filberts, plus the odd decorator's brush.

'If you are a tonal painter, you are constantly working between the darker and lighter ranges of tone. The half-tone ground of the canvas is the vital key tone.'

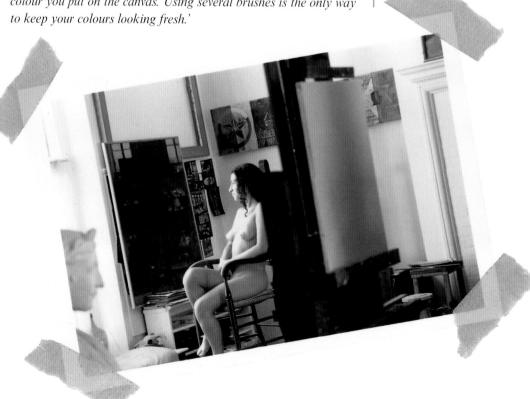

Gauging proportions and relationships

Use the model's head to gauge the proportions of her body. At the same time, establish the relationship between the different parts of the figure, using key vertical and horizontal grid lines that run through the picture.

Drawing with charcoal

Don't make the mistake of thinking you can simply fill in the finished charcoal drawing with colour. As you make each mark with paint, you should be relating it back to your mental grid, constantly improving on the drawing as you add colour and tone to the painting.

Blocking in the dark tones

To define the model's profile and hair, the darker areas of the picture are blocked in with broad washes of paint thinned with turpentine.

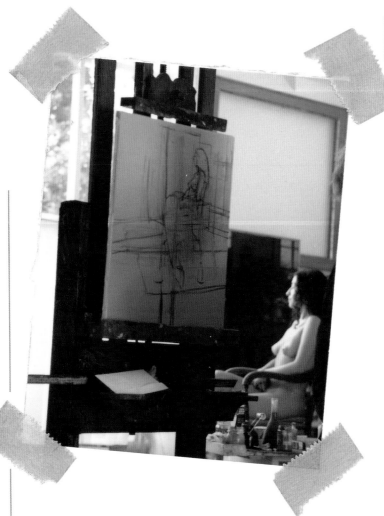

Underdrawing

'*I have met a lot of good draughtsmen who could not paint, but I have never met a good painter who could not draw.*'

From the very earliest stages of a painting, Ken Howard is concerned with working out proportions and relationships. When faced with a blank canvas, he likes to 'get his eye in' by drawing with charcoal. This not only allows him to check the proportions of the figure, but also to work out how the various elements of the painting relate to each other.

Laying in

The next stage of the painting is the vital 'laying in' of the full range of tones and key colours, establishing a firm foundation upon which the picture is built. Tonal balance is all important at this point, but you should also be aware of how the colours relate. Having identified and mixed a colour, look to see where that colour appears elsewhere in the picture, and brush that in too. This will have the effect of unifying a painting.

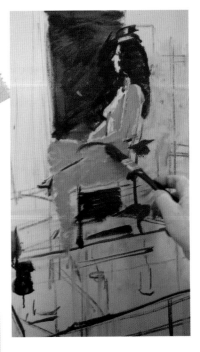

Painting flesh tones

Warm flesh tones are applied to the figure, followed by the neutral grey wall behind the model, then red-brown brush strokes for the chair.

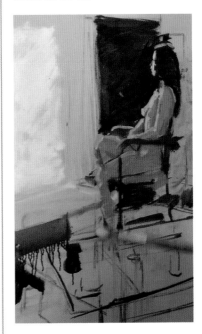

Inserting highlights

Now the lighter tones and highlights are introduced, including the curtained window.

327

Figure painting in the studio *(continued)*

The image on the canvas begins to clarify, much like looking through a camera lens while the picture is slowly brought into focus. A painting can often look its best at this early stage because it seems to breathe life and spontaneity.

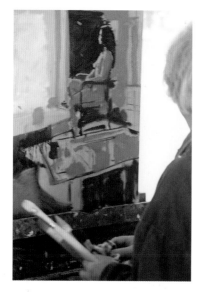

Painting the foreground
The foreground begins to emerge. The shadows beneath the table are painted in with a brush, then lifted off with a rag to suggest reflected light.

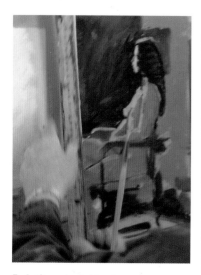

Painting straight edges
A long ruler is used to guide the brush when painting the straight edges of the window frame.

▶ SEE ALSO
▶ Experimental poses 322
▶ Painting hands and feet 330

Focusing attention

There is more than one approach to painting. Some artists will work up the entire painting in detail until the whole picture is finished to the same degree. Alternatively, a painter can focus the onlooker's attention on what he or she considers to be the important elements of the picture. This is achieved by concentrating on the focal points and painting the peripheral parts of the picture in less detail. This is the approach favoured by Ken Howard.

'I have a point in a picture where I want the eye to linger, because I believe that is the way one sees in reality. If you look someone in the eye, the rest of their face is out of focus, a sort of impression. That is the way I like to paint.'

As you work, it pays to compare mixed colours with the lighter and darker areas of the painting to avoid becoming absorbed in detail at the expense of the overall picture.

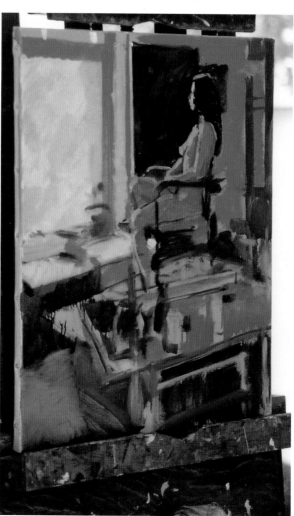

Still-life elements
The still life in the foreground is one focal point that receives special attention. Small dabs or streaks of paint suggest reflections, highlights and areas in shadow.

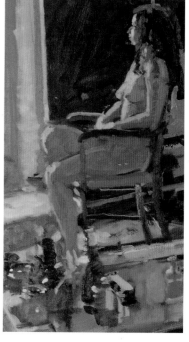

Features and flesh tones (above)
As the painting progresses, more work goes into the model's features, and the flesh tones are strengthened to give solidity to the figure.

Introducing detail (left)
Dashes of colour and tone are added to represent the bottles and other objects in the foreground.

An individual approach

Ken Howard believes people teach themselves to paint.

'There are no fixed rules that you can pass on – there is no method that suddenly makes it possible to draw or paint.
As a teacher, all you can do is explain your approach to painting and encourage people to observe with a painter's eye. Teaching art is about sowing seeds in people's minds – to inspire them to search for their own way. Some students have told me the most encouraging thing I have taught them is that I too can get myself in a mess, but then find my way out again.'

A tonal painting made with a limited palette.

Cadmium lemon

French ultramarine

Naples yellow

Raw umber

Cadmium red

Black and white

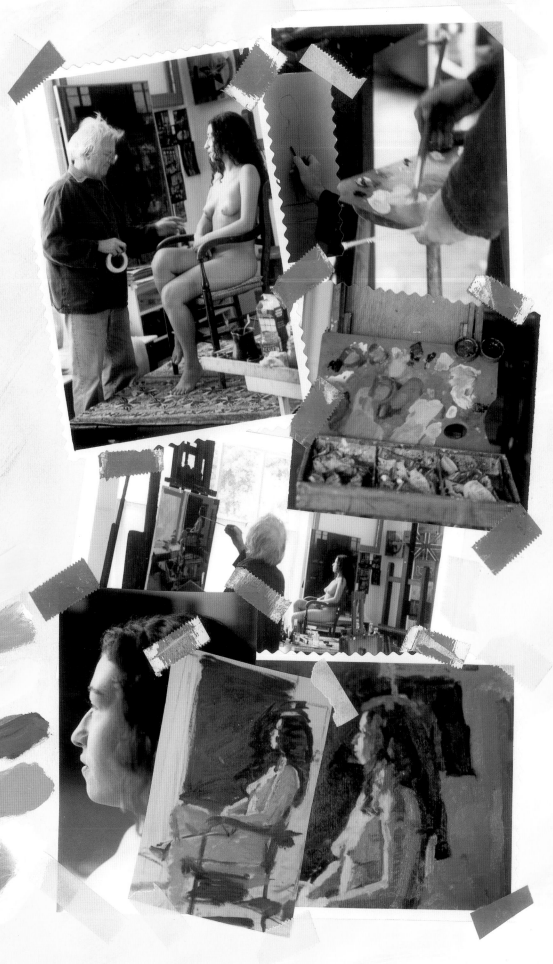

329

Painting hands and feet

Like faces, hands and feet have distinctive characteristics – fleshy, slim, elegant, pale, dark, young or elderly – that contribute significantly to a likeness of your sitter and towards the success of your painting. When making figure drawings and paintings, pay attention to the size and proportion of hands and feet in relation to the rest of the body.

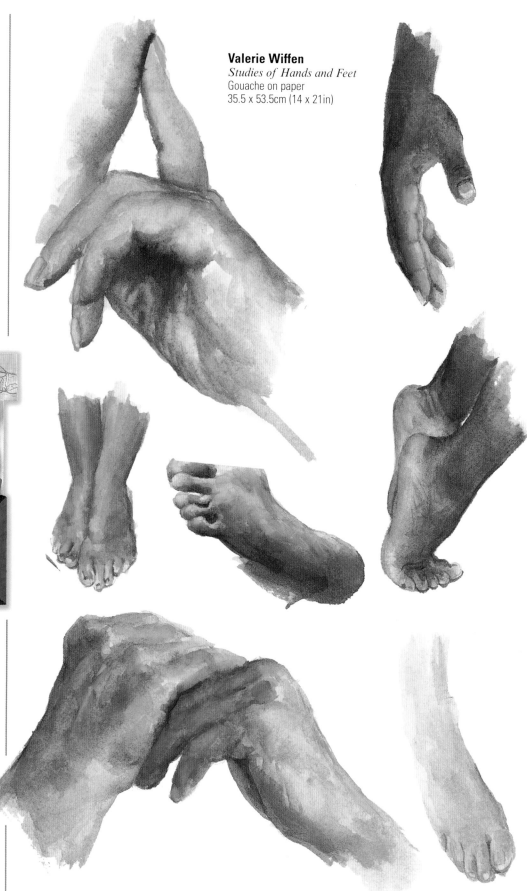

Valerie Wiffen
Studies of Hands and Feet
Gouache on paper
35.5 x 53.5cm (14 x 21in)

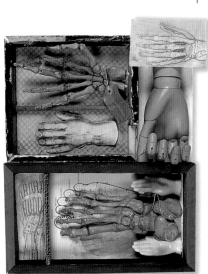

Making colour studies

Working mostly from live models, Valerie Wiffen has created a sketchbook page of colour studies in gouache. Making similar studies will help you to appraise the complex shapes and proportions of hands and feet, and give you the experience to develop a visual shorthand for painting them convincingly when you are creating full-figure portraits.

▶ **SEE ALSO**

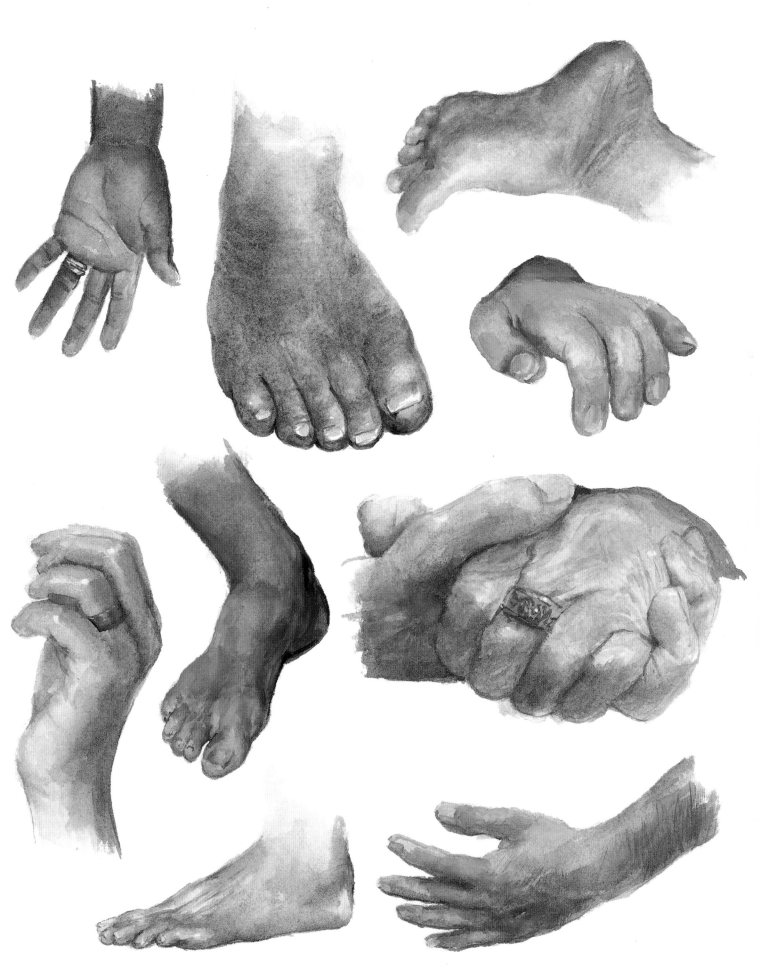

Painting animals and birds

Wildlife artists often specialize in naturalistic drawings and paintings of animals and birds. It takes dedication and experience to render wild animals in their natural habitat, but you will find that domestic pets can be challenging and rewarding subjects, too – although they can be just as uncooperative!

Sketching from life
The wildlife artist Peter Partington favours a soft graphite pencil.

'The point of a pencil glides effortlessly across the paper, and you can use it to suggest a wide variety of textures. I find it the ideal tool when working at speed.'

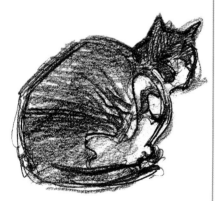

Working with unreliable models
Animals and birds are notorious for refusing to cooperate. There is no point in trying to control their habits; you simply have to work round them. One obvious way is to paint your pet while it is resting, but even then it pays to get the essentials down as quickly as possible. Also, most animals will settle quietly for a short period while they are feeding. If you want to progress to something more exciting, you have to find ways of rendering animals on the move.

With fur and feather featured strongly, animals and birds can offer a wealth of colour and texture. And they have a natural talent for striking quite stunning sculptural poses.

However, before you launch into a full-scale painting, develop a few ideas for possible compositions by studying your pets' habits and also by recording their daily lives with some rapid sketches or reference photographs.

Preparatory sketches and studies

Some artists rely entirely on photographic reference. This is a method with obvious advantages, especially for recording intricate markings and for capturing fleeting poses. Nevertheless, sketching is still the best way to create a mental bank of images that you can translate into finished paintings. If you spend enough time looking intently at animals and birds, you will be surprised at how much information you can store in your memory.

At first, it may well seem impossible to do anything worthwhile. However, by persevering, you will soon discover that animals have a tendency to replicate actions and postures. So even though you may only have time to get down one or two lines, the odds are that the animal will eventually take up a similar pose, giving you a chance to add more detail or to scribble tones and textures over your initial line drawing.

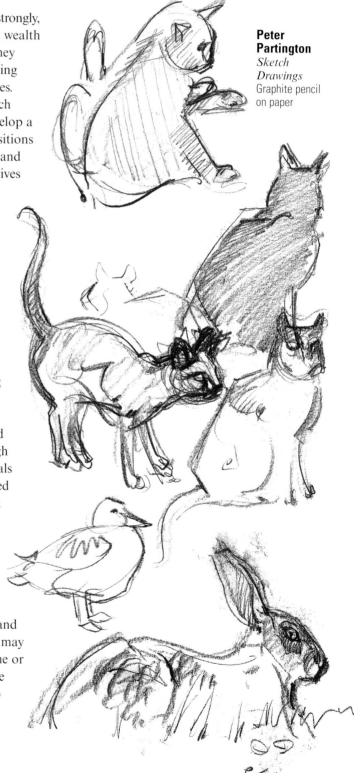

Peter Partington
Sketch Drawings
Graphite pencil on paper

Painting birds

Even more than animals, caged birds present the challenge of capturing rapid movement. Feathers are fascinating and often colourful, providing endless possibilities for pattern and design.

Rendering plumage

A bird's plumage comprises different-sized feathers arranged in groups or tracts that overlap one another. As a general rule, the feathers get smaller towards the breast, and longer towards the back. The longest ones are the primary flight feathers that form the wingtips and tail.

Using a diamond grid
A quick way to re-create this layering is to draw a diamond grid, which you then fill in to suggest the coloured tips of individual feathers. Keep a close eye on local colour and the effects of light.

Birds' eggs
These are perfect examples of nature's ability to create wonderfully subtle colours and textures. If you come across abandoned eggs, you will find them fascinating subjects for detailed studies and paintings.

Painting your cat's portrait

Just like humans, individual animals have their distinctive characteristics, which enable you to distinguish your pet from perhaps hundreds of similar animals in your neighbourhood. Here, the cat is singled out as a worthy subject for portraiture, but making similar observations and studies will enable you to create an intimate picture of any animal.

Study the features and the overall shape of the animal's head. The average cat has large triangular ears, which are set high on a rounded head. Except for certain exotic species, cats have a short, almost flat, muzzle.

The relatively large eyes are on a line that divides the cat's face in half. Divide the lower half in two to define the top of the triangular nose, which more or less spans the space between the cat's eyes.

Ears
With velvet-like fur on the outside and smooth skin protected by delicate hairs on the inside, a cat's ears face forward for most of the time. There are intricate folds where the lower ear joins the head.

Facial markings
The fur is grouped into ridges that run vertically across the forehead. Some breeds of cat have striped markings that follow these ridges.

Whiskers
The cat's whiskers are coarse hairs that sprout from among the shorter and softer fur that covers the muzzle.

Eyes
The leaf-shape eyes are outlined in black. The eyelid casts a deep shadow across the iris; the distinctive pupil changes shape in response to the light.

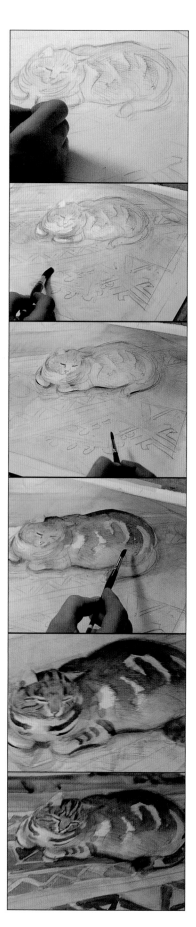

A cat at rest

Peter Partington takes up the cat theme by painting a brindled tabby who – though not actually asleep – is perfectly relaxed and enjoying the heat from the stove nearby. She is lying on a faded Persian rug that adds colour and pattern to the painting.

The artist starts by drawing in the main elements of the composition, including the cat's markings, and then applies a warmish blue-grey wash that is mixed from cobalt blue and light red. Some areas of the paper are left white for highlights.

Shadows and local colour are introduced to give form to the composition, and to indicate the tabby cat's striped markings. Colours are allowed to merge, to good effect.

The artist then begins to strengthen the tones and work up the surface of the fur, using a blue-grey mixed from cobalt blue and raw sienna. It's best to apply the paint in the direction of the fur, blotting the highlights with some soft tissue paper to lift out areas of colour.

Peter Partington develops the cat's features and facial markings with the smaller paintbrush, and then introduces a hint of burnt umber in order to warm the fur around the cat's nose and cheeks.

Finally, the carpet is worked up to balance the foreground. Once the painting has dried thoroughly, the last touches and textures are added, using coloured pencils.

Painting fur

There's no need to include every hair when painting a cat's coat. It is more important to look for distinctive markings that help to describe the animal's form and character. You may find it pays to concentrate most detail around the cat's face and head, keeping the rest of its markings sketchy and free-form.

Materials and equipment
The featured painting was made on 300gsm watercolour paper, lightly taped to a drawing board. Most of the work was carried out with watercolour, but details and textures were added with coloured pencils. For this painting, the artist used just two brushes – a No.16 round for the broad washes, and a No.10 round for painting details.

'Tabby cats make wonderful subjects for painting. The linear markings help describe the contours of the body, giving the image a strong three-dimensional quality.'

Preliminary drawings
Before embarking on the painting, the artist made two or three pencil studies from different angles. He also made colour notes and drew a diagram of the patterned carpet. Armed with this information, he retired to the studio to paint the picture.

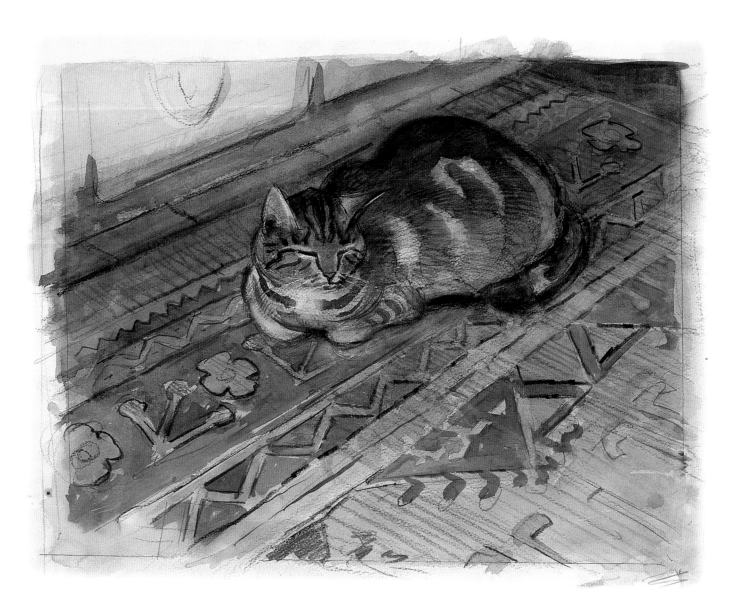

Fur absorbs and reflects light

When depicting fur in a drawing or painting, look for changes of tone caused by the way the fur absorbs and reflects the light. As a general rule, when the hairs are pointing towards you, fur looks dark in tone. When they are lying flat and pointing away from you, the fur appears glossy and lighter in tone.

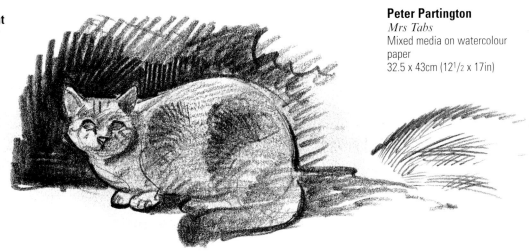

Peter Partington
Mrs Tabs
Mixed media on watercolour paper
32.5 x 43cm (12$^1$/$_2$ x 17in)

▶ **SEE ALSO**
▶ **Coloured pencils** 42
▶ **Painting a face** 306
▶ **Watercolour papers** 28
▶ **Watercolour paints** 87

Getting your ideas down

Drawing machines
In the past, inventive artists devised many ways of tracing the outlines of three-dimensional objects onto sheets of glass.

There's a popular misconception that 'real' artists balk at the idea of tracing an image onto canvas or paper. Nothing could be further from the truth. For centuries artists have sought ways of accurately transferring images onto a flat surface – and although a great deal of cunning technique was (and still is) often employed to achieve a successful result, the notion that it might be construed as 'cheating' never entered their heads.

Pricking and pouncing

One of the most widespread methods of transferring images was to make a full-size drawing or 'cartoon' and then, following the lines with a toothed wheel, punch a series of closely spaced holes through the paper. The perforated drawing was laid onto the support and 'pounced' by tapping with a cloth bag filled with fine charcoal or chalk. The pouncing forced the powdered material through the holes, leaving a replica of the pricked image on the support.

Tracing

Tracing is a simple way of copying either drawn or photographic images onto a paper or canvas support. You can buy flat sheets and rolls of good-quality tracing paper that have sufficient transparency and strength to enable you to work easily.

Tracing paper

Tape tracing paper over your original and lightly trace the image, using a sharp pencil or fine felt-tip pen. Scribble across the back of the tracing with a soft graphite pencil; then tape the tracing, graphite side down, onto your support. You can transfer the linework by drawing over the traced lines with a pencil, and then remove the tracing to reveal the image marked out in graphite on the support.

Using transfer paper

As an alternative to graphite, sandwich a sheet of carbon paper or dark-red rouge paper between the tracing and the support. Rouge paper is a specialized paper used by professionals to transfer designs. Its main advantage is that unwanted linework can be erased easily. You may find the lines created by carbon to be a little too opaque and permanent.

Tracing on a light box

You can trace an image directly onto paper or an unstretched canvas, using a photographer's light box designed for viewing transparencies. This type of box comprises a fluorescent strip light mounted beneath a sheet of translucent glass or plastic. The light is bright enough to throw a clear image through reasonably thick paper or canvas.

Tracing wheel
Used to punch a design onto a support.

Camera obscura
Using cameras to establish a basic image for painting is not a new idea. With the advances in lens making in the sixteenth century, it became possible to project an image onto a flat surface inside a darkened chamber, so that an artist could make a tracing from it.

• Scanners and digital cameras
For relatively little money, you can buy a scanner that will copy flat artwork and photographs onto a computer, where it is possible to change the scale and recrop the image before printing it. You can now also transfer pictures taken with a digital camera directly into the computer's memory.

• **Working with large projections**

You can use a slide projector to fill a large canvas, or buy an artists' tracer projector to blow up flat artwork and printed photographs. Ensure that the projector and canvas are aligned accurately and mounted securely, to prevent distortion and movement while you are transferring the image.

Working in a dimly lit room, either copy the image in line or block in the major areas of tone and colour with paint before proceeding with the painting under ordinary lighting conditions.

Alternatively, continue to build up more and more detail, using the projection as a guide – remember to switch off the projector and turn on the lights from time to time to check the progress of the painting.

▶ **SEE ALSO**
▶ Composing from
 imagination 338

Changing scale

Artists frequently need to change the proportion of the original image in order to fit a larger or smaller sheet of paper or canvas support. There are several methods for enlarging, transferring and manipulating images, some of which are mentioned below.

Gridding-up

To make an accurate enlargement or reduction, draw a squared grid across the original image. If you don't want to mark the original, draw your grid on a tracing-paper overlay or on a sheet of transparent acetate.

Draw a similar grid of larger or smaller squares on the support. To plot the grid across the width of the support, count the number of squares in one row drawn across the original (say nine squares), and then align the tip of your ruler or tape measure with one edge of the canvas and the tenth division with the other. Make a pencil or charcoal mark against divisions one to nine, then use a T-square to draw a row of vertical lines across the support from each mark.

You can create the grid of squares by drawing a series of horizontal lines with the same spacing and at right angles to the first set of lines. Finally, copy the image square by square onto the canvas support.

Using a photocopier

If you have ready access to a photocopier, then enlarging and reducing pictures couldn't be simpler. Most modern machines will print copies up to 400 per cent larger or 75 per cent smaller than the original.

Projecting pictures

To throw an image onto a sheet of paper or small canvas, you can use a photographer's enlarger or a table-top overhead projector. Adjust the focus, then draw the main elements on the support with a soft pencil or charcoal.

Tiling with photocopies

Very large assemblies can be created by taping photocopies or computer printouts together. These can then be gridded or traced and transferred to the support.

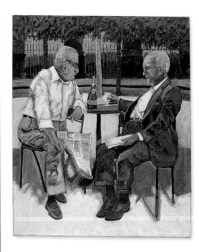

Work in progress
The painting above is based on a cutting from a newspaper (far left). The artist has enlarged and cropped the proportion of the original image and transferred it to the canvas using the gridding-up method. The original drawing and grid lines are gradually obliterated as the painting progresses (below).

Composing from imagination

Most of the paintings in this book have been made from life or by using direct photographic reference. Although artists may have reinterpreted the subjects to some extent, they are more or less faithful representations of what the artists could see in front of them. However, it can make a stimulating change to construct a picture from imagination, using a variety of reference material, such as sketches, photographs and magazine cuttings, as a basis for the composition.

Choosing a location

Alastair Adams wanted to paint a café or bistro scene, which would give him the opportunity to include groups of people and individuals engaged in a variety of activities. He tried out a number of small intimate locations – which had plenty of atmosphere, but not enough going on. Most of them were also dimly lit, making it virtually impossible to take reference shots.

Eventually he decided on a dining area in a shopping mall, which supplied all his needs. It was a large open interior with a good source of natural light where an artist could sit unnoticed while he watched, sketched and photographed the numerous characters that passed through. In no time, he could retire to the studio with more than enough reference to begin the painting.

Researching the location
If you have made a habit of collecting pictorial reference, you could begin by sifting through your files to see if there's anything you might use as a starting point for your painting. Alternatively, you may prefer to start from scratch and look for a location that offers a wealth of diverse material.

On-the-spot observation and back-up references
Alastair Adams constructed his painting from a series of references. You will never use all the images you gather on location, but it pays you to accumulate as much reference as you can, including sketches, photographs and magazine cuttings.

Working on the composition

By the time you get to the studio, you probably have a fairly strong image of the painting in your mind's eye. Some artists will make a preliminary drawing, using reference they have gathered on location to jog their memory. Alastair Adams prefers to incorporate his reference material by enlarging and reducing tracings of his drawings and photographs on a photocopier, and then tapes the images to an enlarged drawing of the interior.

Working on tracing paper gives him complete freedom to redraw the interiors, figures and inanimate objects to suit his composition. Not only can he change the scale, but he can also flip the tracing paper so that a person is facing in the opposite direction, modify a pose by combining details from different shots of the same person, or compose a group of seated figures.

When combining disparate images, it is important to correct the perspective as you construct the composition. In the sequence (right), the artist's viewpoint is from a seated position, so the heads of all the seated figures share that same eyelevel. Only the standing waitress appears at a different level.

Working on tracing paper

The sequence (right) shows how Alastair Adams built up a preparatory collage of tracing-paper overlays as a basis for his composition. Being translucent, tracing paper allows the artist to impose layer upon layer without completely obscuring the underlying structure and detail.

Transferring the image

Having finalized the composition, the artist makes an enlargement of the collage to match the size of the support, then draws a squared grid on the enlargement and an identical grid on the support. By copying the image exactly, square by square, he is able to re-create the composition on the support as an underdrawing for the finished painting.

'I start by re-creating the setting, using the background as an empty stage for my characters, which I arrange to balance the composition and to suggest depth in the painting by providing close-up detail in the foreground.'

Flesh tones

Flesh tones are based on white mixed with cadmium red medium or crimson and cadmium yellow light or cadmium yellow medium. To prevent these combinations becoming too warm and pink, the artist also adds purple or green to neutralize the mixes.

Painting signs

In this type of situation, there are always a number of printed signs and graphic images. It is essential to include them to convey the atmosphere of the location, but if you make them too legible they can detract from the main subject matter. It is better to suggest lettering and symbols with simple brushstrokes and spots of colour.

Painting neutrals

The neutral areas of the painting comprise a number of subtle greys and off-whites. They were created by adding complementary colours to a basic white mix – for example, white with cadmium yellow light and a small amount of purple. The neutral colours just below the glazed atrium had to be kept cool so that they would recede and suggest depth in the painting. They are made with greens and blues mixed with crimson and cadmium red, and just a hint of cadmium yellow light.

Materials and equipment

The finished picture was painted with a fairly limited palette of acrylic colours – titanium white, cadmium yellow light, cadmium yellow medium, cadmium red medium, quinacridone crimson, dioxazine purple, phthalo green-blue shade and phthalo blue-green shade.

For fine detail, the artist used Nos.3 and 5 round synthetic-bristle brushes, designed specifically for applying acrylic paints. When manipulating thicker paint, he prefers to use relatively stiff natural-hog brushes, in this case Nos.2, 4 and 6 flats.

The painting was made on a sheet of medium-density fibreboard (MDF), which does not buckle when wet paint is applied. The board has a smooth surface and it is stiff enough to allow the paint to be built up quite thickly.

Having transferred the underdrawing to the board, the artist coated it with a clear acrylic primer that allows the natural colour of MDF to be used as a warm mid-tone ground colour.

The finished composition

The action takes place within the lower two-thirds of an almost square format. This mass of colour and detail is balanced visually by the neutral colours, geometric planes and simple linear patterns of the shopping-mall walls and skylights.

The painting is divided vertically by a concrete pillar that directs the viewer's gaze towards a foreground dominated by an elderly gentleman reading a newspaper. Foreground detail serves to add depth to the painting and encourages the eye to linger until it is eventually led away by a curving chair back, towards the waitress clearing the table on the left of the picture. Her activity is crucial in counterbalancing the passive, almost contemplative postures of the other characters in the painting.

The relatively large area of neutral-coloured floor creates a calm balance, giving the eye a rest before it alights upon a young woman sipping her coffee and groups of people finishing their meals or engaged in conversation. Though small in scale, these figures are beautifully realized, with sufficient detail and animation to make them believable – yet kept simple enough to ensure they recede into the background.

▶ **SEE ALSO**
▶ Acrylic paints 110
▶ Getting your ideas down 336
▶ Paintbrushes 78, 120
▶ Putting life into a painting 304
▶ Resources and references 126
▶ Space, depth and distance 302

A protective coat of varnish

To maintain their rich colouring and prevent the paint absorbing dust, Alastair Adams invariably protects his pictures with a coat of varnish.

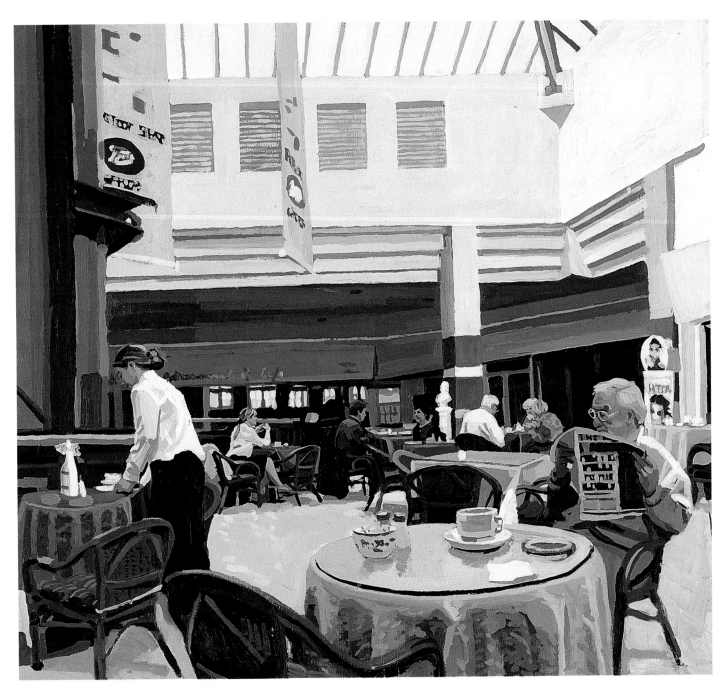

Empathy with the characters (above)

We are not directly engaged with any of the figures in this painting – we are merely spectators. Yet as onlookers, we cannot help speculating whether the man reading a newspaper may perhaps be waiting for his wife or a friend to return from shopping; or if the waitress is taking advantage of a temporary lull in her busy day's work to clear the tables.

Keeping colours fresh (left)

The artist manages to keep his colours fresh and uncontaminated by building up an image with distinct patches of colour laid side by side. This method also prevents a painting becoming fussy and overworked.

Alastair Adams

Café Scene
Acrylic on board
51 x 54.5cm (20 x 21$\frac{1}{2}$in)

Chapter nine

The studio

Whether your workplace is a large, airy studio, a spare room or even just a corner of a room or a kitchen table, it is important that it should be comfortable, well-lit and properly organized. In addition to being the place where you create art, the studio area is most probably where you will store it and protect it from damage and the elements. Varnishing, using fixative, and mounting and framing are not only the methods of preserving your artworks, but they are also effective ways of showing them off to their very best advantage.

Studio organization

'Concerning the light and place wher yo worke in, let yr light be northward, somewhat toward the east which commonly is without sune, shininge in. One only light great and faire let it be, and without impeachment, or reflections, of walls, or trees.'
Nicholas Hillyard (1547–1619)

Handy brush holder
If you use a lot of brushes, this simple device will keep them all neatly to hand and prevent them from rolling off the table onto the floor. And because they are propped at an angle, they are easier to pick up when needed. Cut a series of V-shaped notches along the upper surface of a length of 25 x 25mm (1 x 1 in) wood. Lay it on your painting table and rest the brushes in the grooves, with the bristles protruding from the edge.

It goes without saying that your studio should have adequate lighting and ventilation, but there are no hard-and-fast rules about the way to organize your studio equipment. The main requirement is that you should be able to reach everything comfortably and conveniently with the minimum of effort. The more mobile your set-up, the easier it is to adapt it to changing light conditions, different subjects, and both sitting and standing working positions.

Storing paper

Paper should be stored flat in a dry place, wrapped in clean paper to protect it from dust and light. Watercolour paper, in particular, should be protected from damp, which can activate impurities, producing spots that won't take colour.

Storing canvases and boards

To prevent canvases and boards from warping, store them upright in a dry place. A painting rack is easily built from lengths of 25 x 50mm (1 x 2in) timber, and can be used to store both unused canvases and unfinished paintings.

Storing drawing tools

If pencils, crayons and sticks of charcoal are thrown together in a drawer, they will become disorganized and may break or chip. Stand them end-up in a pot or jar, or you can keep them in a box. Another place to store them is in groups in the separate compartments of a plastic cutlery tray for easy access.

Equipment layout

The surface on which you lay out your paints, palette and other equipment may consist of an ordinary table, or a trolley with wheels or casters for mobility (an old tea trolley or tea wagon is ideal – the shelf underneath is useful for storing equipment you are not using all the time). For easy access, it should be placed at right angles to your easel or work surface.

Improvising storage
A metal wine rack can be used to store wet oil paintings; this is useful if you don't have the space for a wall-mounted painting rack.

▶ **SEE ALSO**
▶ **Canvas 14**
▶ **Watercolour papers 28**
▶ **Drawing media 37**

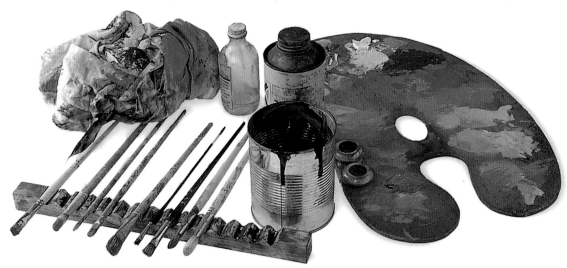

Simulating daylight

If you have to make do with artificial lighting, then lamps fitted with daylight-simulation bulbs are the best alternative. These blue-tinted light bulbs simulate north light, which allows perfect colour matching and is relaxing to the eyes. Daylight-simulation fluorescent tubes are also available; they are inter-changeable with standard fluorescent tubes.

Lighting

Good lighting is crucial to the successful execution of creative artwork – without it, you will have problems seeing clearly and rendering colours accurately. The type of light and its source are also important in protecting your eyes from strain.

Natural light

The best natural light for both drawing and painting is cool and even, with no direct rays or changing shadows. A room with north-facing light is ideal for a studio (south-facing in the southern hemisphere). It offers indirect light, largely reflected from the sky, that remains constant during the whole day. North light is also neutral in hue, since it has none of the yellow cast of direct sunlight. Harsh light can be cooled and subdued by covering the window with some thin gauze, cotton drapes or a shade.

Artificial light

In addition to altering the colour values of objects, artificial light tends to cast rather harsh shadows. Whereas a painting done in natural light will look fine under artificial light, the reverse is not always true.

An ideal studio

A well-organized studio frees your mind to concentrate on painting instead of searching for materials and equipment. The entire studio below was designed around some inexpensive, ready-made furniture. The strong plywood boxes and wall-hung shelving take care of storage requirements, and the worktable can be raised to a convenient height if you prefer to work standing up.

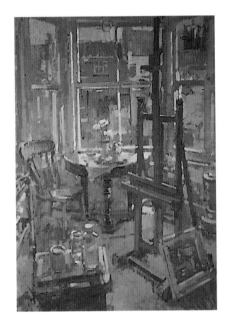

John Martin

Morning Studio, Brighton
Oil on canvas
45x 60cm (18 x 24in)

Their own studio features in many an artist's work. John Martin, for example, has painted this same studio on many occasions, forever fascinated by the different light that falls through the window.

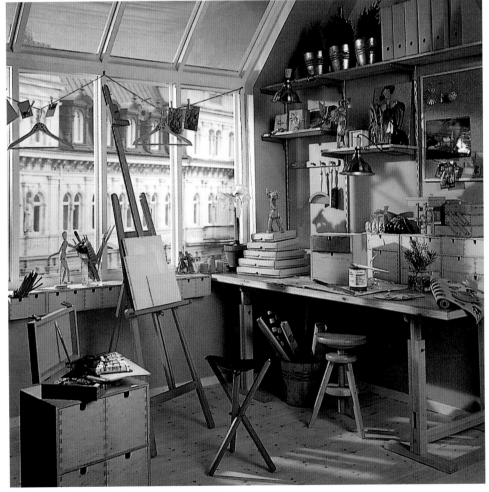

Easels

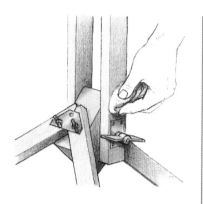

From the various styles and sizes of easels, your choice will be dictated by the space you have for working, whether you work mostly indoors or outdoors, and by the scale on which you work.

Easel positioning

You should always position your easel so that the light source is slightly behind you and coming over your left shoulder if you are right-handed – vice versa if you are left-handed. By working in this way, your hand will not cast a shadow across the working surface.

Maintaining easels
Wooden easels will benefit from being treated with furniture oil or wax polish, particularly in damp conditions. Keep wing nuts treated with light oil or Vaseline.

Table-top easels
The table-top easel provides a useful, compact support for smaller paintings and drawings, and can be folded flat for storage. There are various designs, from a simple collapsible tripod to a sturdy frame that folds flat when not in use, and which can be set at different angles. Wooden easels are sturdier than the aluminium versions.

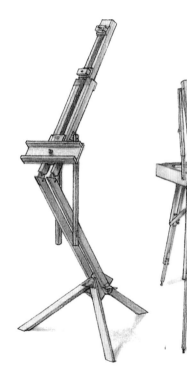

Studio easels
A heavy-duty studio easel is expensive and cumbersome, but provides a sturdy support for work on a large scale. The painting rests on a ledge that also forms a compartment for holding paints and brushes, while a sliding block at the top holds the painting firmly in position. The height is adjustable. Some models are on wheels or casters so that they can be moved around the studio.

Radial easels
If you have limited space, the compact radial easel provides a reasonably firm, but less expensive, alternative to the studio easel. Sturdy and versatile, it consists of a central pillar with adjustable tripod struts. The central joint tilts back and forward so that you can angle your work to avoid glare, and the height is adjustable for sitting or standing. It can be folded for easy storage when not in use.

Combination easels
A folding radial easel and drawing table combined, the combination easel can be locked in any position between vertical and horizontal. In the horizontal position the easel becomes a flat working surface that will hold a large drawing board.

Box easels
The wooden box easel is sturdier than an ordinary sketching easel, but equally portable. It combines a palette, a deep drawer for storing paints and equipment, a collapsible easel and a carrier for canvases, all of which can be folded up into one compact unit, complete with a strong carrying handle.

Sketching easels
The tripod-style sketching easel is lightweight and easily portable, and is suitable for outdoor work and small-scale work indoors. Available in aluminium and wood, it has telescopic legs to enable you to work at a convenient height, and the pivoted central section can be tilted to a horizontal position. It can be folded away when not in use.

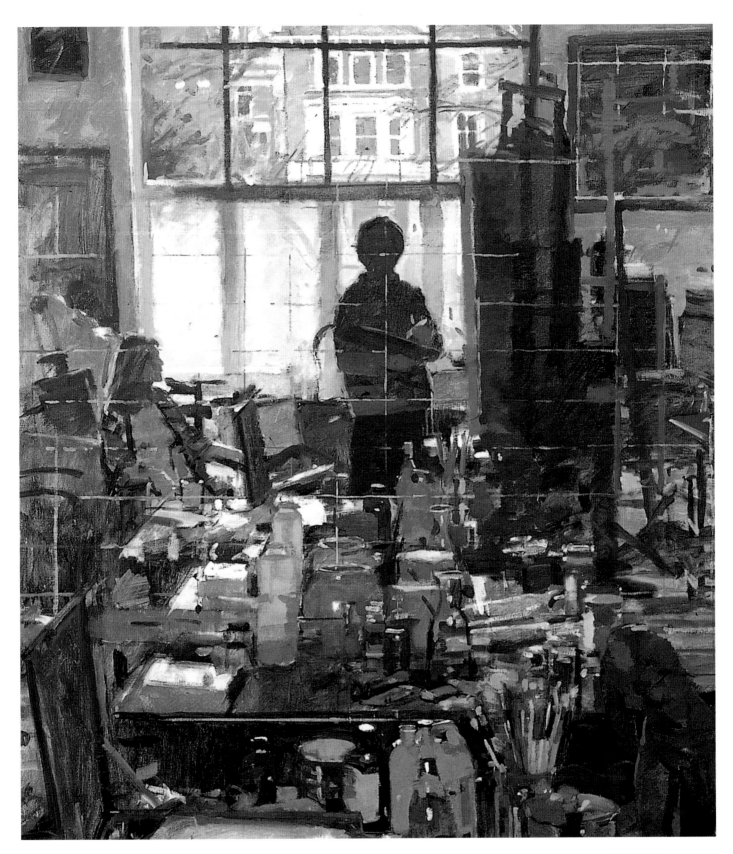

Ken Howard
Self-portrait at Oriel
Oil on canvas
120 x 100cm (48 x 40in)

Ken Howard rejects the conventional portrait by painting his studio as an extension of himself. He revels in the brushes, jars of thinners, props and paraphernalia that gradually take over every artist's studio, conveying the relaxed atmosphere in which he chooses to work.

▶ **SEE ALSO**
▶ Painting outdoors
134

Protecting artwork

Transporting paintings

(**1**) Cut out four shapes.

(**2**) Fold the flaps.

(**3**) Fit and secure the sleeves.

All too often, pictures are stored in damp basements or leaking attics, or hung in rooms with inappropriate or harmful lighting. They are often displayed or stored away without any means of protection. A few simple precautions can do much to preserve your pictures in the best possible condition – having laboured with love and time on an artwork, it makes sense to look after it.

Avoiding damp, light and heat

Keep all artworks away from damp and humid conditions, which encourage mildew, and also from excessively dry conditions. In addition, you should avoid extreme temperature changes, such as those caused by room heaters, radiators or draughty windows.

Some of the greatest damage to pictures is done by strong, direct light, which can fade colours and discolour varnishes. In strong sunlight, or under spotlights, heat can be equally damaging, so display your pictures, particularly works on paper, away from direct sunlight and in diffused artificial lighting.

Storing watercolours and drawings

Unmounted watercolours and drawings should not be left unprotected for long, and should be stored in a safe place until such time as you can have them framed. They should be stored flat in large drawers or a plan chest, or at least in a portfolio, interleaved with sheets of waxed paper, cellophane or acid-free tissue, in order to prevent them rubbing together and becoming smudged. A heavy board laid on top will prevent any lateral movement.

Do not stack too many drawings on top of each other, as this may compact and damage the surface pigment. It is not a good idea to roll up and store drawings that have not had fixative applied (see opposite), as the pigments will tend to drop off or smudge.

Transporting paintings

If you need to transport framed paintings, you should protect the corners of the frames by padding them out with plastic foam or bubble-wrap, or with cardboard sleeves. This will also prevent the paintings leaning flat against each other in storage.

Making protective cardboard sleeves

1 To make cardboard sleeves, cut out four shapes as shown (above left), making the space between the parallel dotted lines slightly larger than the width of the frame.
2 Fold flaps A and B and then tape them closed.
3 Fit the sleeves over each corner and tape them to the backing or the glass (not the frame, as it may damage any surface decoration) to keep them in place.

Unframed pictures
Pictures that you want to keep, but not frame, should be stored in a safe place, such as a portfolio or plan chest.

▶ **SEE ALSO**
▶ Charcoal 46
▶ Pastels 48
▶ Oil pastels 50
▶ Conté crayons 52
▶ Drawing accessories 61
▶ Mounts and frames 352
▶ Health and safety 386

• Protecting oil-pastel drawings

Unlike other pastels, oil pastels do not require fixing, because the blend of pigments, fat and wax never fully dries. For this reason, it is inadvisable to apply varnish over oil pastels; should you need to remove the varnish at a later date, it will take most of the oil-pastel colour off the surface with it. The most effective and lasting protection is to mount oil-pastel drawings under glass.

Protective framing

The way you present artwork not only displays it to best advantage but also protects it from pollutants and accidental damage. Below, the drawing is hinged from the top edge only, within a folded bookmount that holds the glass at a safe distance. A stiff backing board of hardboard or MDF keeps the drawing flat.

Protecting drawings

Drawings executed in a friable medium, such as charcoal, pastel, conté crayon and chalk, are easily smudged; and when they are framed, there is a danger of pigment particles drifting down under the glass and soiling the mount board.

Fixative

To prevent these problems, this kind of drawing should be protected with fixative. This is a thin, colourless varnish which is sprayed onto the picture and fixes the pigment particles to the surface. It is most commonly available in aerosol spray cans, which are the most convenient method to use. Alternatively, there are mouth diffusers which have a plastic mouthpiece, through which you steadily blow a fine mist of fixative.

Spraying a drawing with fixative requires a delicate touch; it should be applied sparingly, as a couple of light coats are better than one heavy one. It is worth practising on pieces of scrap paper until you discover how to produce a fine, uniform mist without getting any drips on the paper. If you hold the spray too close, it will saturate the surface and may run and streak your work.

Make sure that you always work in a well-ventilated area, in order to avoid inhaling too much of the spray.

Applying fixative

Pin your finished work vertically and hold the atomizer at least 30cm (12in) away from the image, pointing directly at it. Begin spraying just beyond the left side of the picture. Sweep back and forth across the picture with a slow, steady motion, always going beyond the edges of the picture before stopping (see right). Keep your arm moving so that the spray does not build up in one spot and create a dark patch or start to drip down the paper.

Mouth diffusers
These have a plastic mouthpiece through which fixative is blown.

Spraying directions

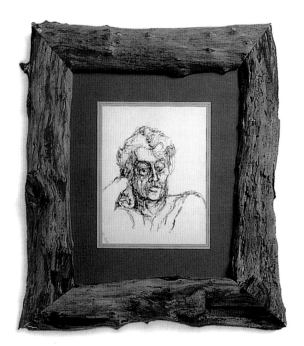

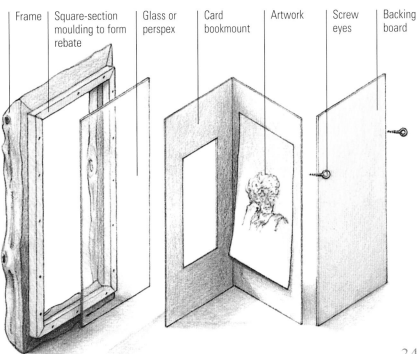

| Frame | Square-section moulding to form rebate | Glass or perspex | Card bookmount | Artwork | Screw eyes | Backing board |

Varnishing paintings

A layer of varnish will give the surface of a painting a uniform gloss or semi-matt finish that will bring the whole picture together and will enhance the depth and lustre of the colours.

Why use varnish?

If oil and acrylic paintings are well cared for and are cleaned occasionally, they do not necessarily have to be varnished. However, varnish will certainly protect the paint film from any damage caused by scuffing, humidity, dust and atmospheric pollutants. The varnish itself will eventually be stained by these elements, which is why a removable varnish is preferred by restorers; when it becomes dirty or cracked, it can be removed with solvents and replaced.

Natural varnishes

Natural dammar varnish, which is composed of dammar resin and white (mineral) spirit, enhances colours with minimal gloss and yellowing; it does not crack or bloom (become opaque). Natural mastic varnish, with mastic resin and turpentine, dries to a high gloss. However, it does have a tendency to darken, crack and bloom.

Synthetic varnishes

Synthetic-resin picture varnishes, such as those made from ketone, are preferable to traditional natural-resin varnishes. Whereas varnish was once quite likely to darken and crack, modern versions can be relied upon to be non-yellowing and tough, yet flexible enough to withstand any movement of the canvas without cracking.

▶ **SEE ALSO**
▶ Oil paints 64
▶ Oil-paint sticks 70
▶ Oil mediums 76
▶ Avoiding
 problems 164
▶ Acrylic paints 110
▶ Acrylic
 mediums 118
▶ Health and
 safety 386

Varnishing paintings made with oil-paint sticks

When the paint is really thoroughly dry, traditional oil-paint varnishes may be used. There is a special isolating varnish, which may be applied 6 to 12 months after completion; this first-stage varnishing is followed 24 hours later by the application of a finishing varnish. The dual process involved enables the finishing varnish to be easily removed at a later date, if required, with white (mineral) spirit or turpentine.

Varnishing oil paintings

It is very important that an oil painting is completely dry before final picture varnish is applied; this can take anything from six months to a year, perhaps more for thickly impasted paint. Oil paint expands and contracts as it dries, and premature varnishing may cause cracking as varnish is less flexible than oil paint. Retouching varnish, however, can be applied as soon as the paint is touch-dry – normally within a few days. This will protect the surface until it is dry enough for final varnishing.

Varnishing acrylic paintings

Despite popular belief to the contrary, it is as advisable to varnish completed acrylic paintings as oils; although acrylic dries waterproof and as tough as nails, it picks up dirt just like any other kind of paint. A coat of varnish gives your painting extra protection and also enhances the brilliance of the colours. It evens out any differences in gloss when the paint dries; these differences are caused by mixing varied amounts of water or medium with the colours.

Do not use acrylic mediums as a final varnish, because they cannot be removed when dirty. Always use a proprietary acrylic varnish, which dries quickly to a clear film that can be cleaned easily with some mild soap and warm water. It can be removed, if required, using white (mineral) spirit. You can buy either gloss or matt varnish, or you can mix the two in order to create a pleasing semi-matt finish.

Acrylic paintings can be varnished as soon as the paint is dry, which normally takes a couple of hours at most.

Varnishing oils and acrylics

Varnishing should be done in a warm, dry, dust-free ventilated room. Avoid varnishing in damp or humid conditions, as this may cause the varnish layer to turn hazy.

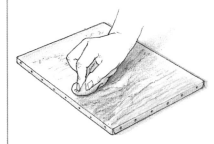

(1) Clean off dust and grease
Ensure that the painting is free of dust and grease.

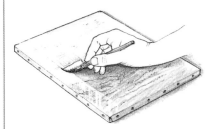

(2) Apply varnish in one direction
Apply the first thin coat of varnish with a broad, soft-haired brush, preferably a varnishing brush. Stroke the surface smoothly and evenly, working in one direction, so as not to create air bubbles.

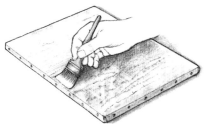

(3) Apply a second coat at right angles.
Leave to dry overnight, then apply a second coat at right angles to the first, unless you are using a matt varnish, in which case brush in the same direction as before. Leave the picture in a horizontal position, protected from dust and hairs, until the varnish has dried hard.

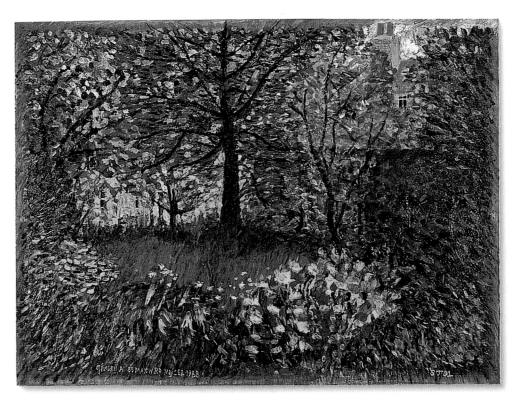

Simon Jennings
Leaves of Grass
Acrylic on cardboard with Cryla varnish
45 x 60cm (17 ¾ x 23 ¾in)

Mounts and frames

Integral painted frame (P. Quested)

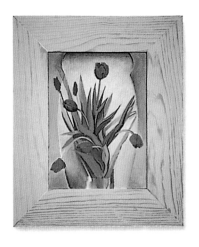

Close framing (B. Yale)

When selecting a frame for an artwork, your choice will be affected by personal taste, prevailing fashions and the type of image being framed. The one golden rule, however, is that the style and colour of the frame should complement and enhance the image but should not attract too much attention to itself.

Basic considerations

A well-chosen frame not only enhances the appearance of a painting or drawing, it also protects and conserves it. Unless you already have some experience of framing, this task is best left to a professional framer. However, whether you frame your own work or not, there are certain aesthetic points to consider when choosing the style and colour of the mount and frame.

Framing works on paper

Watercolour-based paintings, pastels and drawings are fragile and vulnerable to surface damage. Most of these pictures arc framed under glass and are surrounded by a window mount, or mat – a wide 'frame' of thick card. The mount serves two purposes: first, it acts as a buffer between the picture and the glass, allowing air to circulate. If the paper is in contact with the glass, condensation may build up and eventually damp stains and spots of mildew – known as 'foxing' – may stain the surface of the paper. In the case of drawings, the mount also prevents the glass from crushing the surface pigment and compressing the paper's texture.

The other function of a mount is to provide an aesthetically pleasing border around the picture and a clean, finished look. It also provides a kind of breathing space – a sympathetic surrounding that separates the image itself from the hard edge of the frame. The window aperture is cut with a bevelled edge, which avoids sharp shadows failing on the image and creates a recess which leads the eye into the picture.

The width and colour of the mount will exert a considerable influence on the impact of a picture, so it is important to make a careful choice. Works on paper, for example, are traditionally surrounded by a wide mount and a narrow frame, an arrangement which enhances the delicacy of an image. However, since every artwork is different, the same 'rules' do not always apply, and thus it pays to cut strips of card and experiment with different mount widths and colours until a particular drawing or painting seems to sit comfortably in its surroundings.

Mounting board

Made from thick board faced with bonded paper, mounting board is available in a range of colours, some with subtle decorative finishes and textures. You can either buy sheets of mounting board and cut your own window mounts, or have it done professionally. Cheaper mount boards are made of unrefined woodpulp, which contains acids that can be harmful to works on paper. Except for temporary framing, always choose conservation board, which is acid-free and won't yellow or fade with time.

Double mounts

A double mount has a 'stepped' effect which gives an added touch of opulence to the picture. The inner and outer mounts can be of the same colour, or complementary or contrasting colours can be used. Sometimes the inner mount is gilded or decorated while the outer mount is left plain.

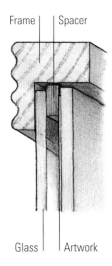

Frame | Spacer

Glass | Artwork

Spacers

Where you feel a mount is inappropriate to the type of picture being framed, keep the glass and picture surface separated by inserting spacers between the front rebate of the frame and the glass. Spacers are narrow strips of wood (or conservation board, in the case of works on paper).

▶ **SEE ALSO**
▶ **Protecting artwork 348**
▶ **Varnishing paintings 350**

Width of mount

The margins of the mount must be in pleasing proportion to the image. Generally, a small image looks more impressive with a wide mount, which gives it added weight and importance. For example, for an image measuring 30 x 22.5cm (12 x 9in), margins of 10–12.5cm (4–5in) are suitable. A large painting with bold shapes and colours, on the other hand, looks better with a narrow mount.

It is usual for the base of the mount to be slightly deeper than the remaining sides – between 6mm ($\frac{1}{4}$in) and 18mm ($\frac{3}{4}$in) is enough in most cases, depending on the size of the picture. This is to prevent a visual illusion in which an equal bottom margin appears narrower than the other three, and the image appears to be dropping out of the frame.

Selecting a colour

Generally speaking, a cream or neutral-coloured mount is the most sympathetic choice for watercolours and drawings, or perhaps one which subtly echoes one of the dominant colours in the image. The mount may be embellished with narrow wash lines drawn around the inner edge, either in gold or in a colour that complements the colours of the mount and the work.

Although in some cases a richly coloured mount might be appropriate, its colour should never overpower the image. If, for example, the mount is of a lighter key than the lightest tone in the picture, or deeper than the darkest areas, you will tend to see the frame before the picture.

Framing oil paintings

Oil paintings are more robust and less prone to damage than works on paper, so they do not need to be framed behind glass. Indeed, they are better left unglazed, to avoid distracting reflections and to allow the texture of the paint surface to be more readily appreciated.

Framing acrylic paintings

With acrylic paintings, you have the choice of framing as for an oil painting or a watercolour, depending on the size of the painting and the technique employed. For example, a plain, narrow frame may be appropriate for a bold, abstract painting, but a traditional watercolour frame with wide mount might suit a delicate painting that involves wash techniques.

Frame inserts

Just as works on paper may be enhanced by a window mount, more substantial mediums not under glass may be set off by a frame insert, or 'slip'. This is a thin frame moulding, either gilded, painted, or covered with cloth, which provides a separation between the outer frame and the picture surface. Most framing shops sell a range of ready-made frame inserts, or you can make them yourself.

Frame with insert (S. Jennings)

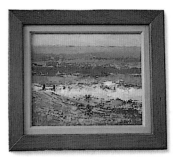

Flat frame with inner slip (J. Elliott Bates)

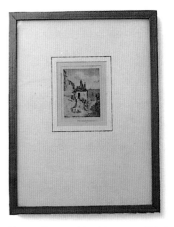

Narrow frame with wide mount (Print)

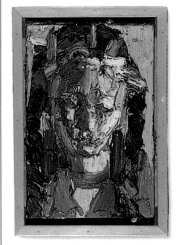

Inset canvas with box frame (G. Rowlett)

28mm (1⅛in)

10mm (⅜in)

Ideal depths

To conserve and protect your work, the moulding should ideally be at least 28mm (1⅛in) deep for a stretched canvas (top) and 10mm (⅜in) deep for a work on paper (above). It is also important to choose a moulding that has a rebate deep enough to accommodate the thickness of the work, plus glass and backing boards, if they are required.

Frame mouldings

The choice of frame moulding is as important as the choice of mount, and the two should ideally be chosen together. A well-chosen moulding can give even a mediocre painting a feeling of purpose and authority, whereas an inappropriate one can actually ruin a good picture.

When choosing a moulding, it is vital that you consider its width, colour and design in relation to the picture itself. Look for mouldings that complement rather than dominate your pictures. As a general rule, simple mouldings are usually best for delicate works on paper; more ornate ones are better for oils and acrylics. Highly elaborate mouldings tend to distract the viewer and draw attention away from the picture.

Width of moulding

If your picture contains small, delicate areas or is surrounded by a wide mount, then choose a narrow frame. If the picture is large and it contains strong colours and shapes, it will look more imposing with a wide frame and no mount, or a very narrow one.

Colour and design

The colour of the moulding should harmonize both with the colours in the painting and with the mount. Generally, a frame with a colour of a similar or slightly darker tone to the overall tone of the painting works best. The character of the picture itself should be the touchstone of the design you choose – whether the image and colours can take, for example, a heavy, architrave moulding or a simple, flat one.

• Glazing a picture

There are two kinds of glass to choose from: ordinary and non-reflective. Ordinary picture glass is best; non-reflective glass is more expensive, and tends to cast a matt sheen over the picture, robbing it of its freshness and textural beauty.

Types of moulding

Framing shops have a bewildering array of frame mouldings on display. The designs, however, fall into a few basic categories. From left to right below: reverse-spoon moulding; half-round moulding; spoon moulding; box moulding; reverse-slope moulding; flat moulding.

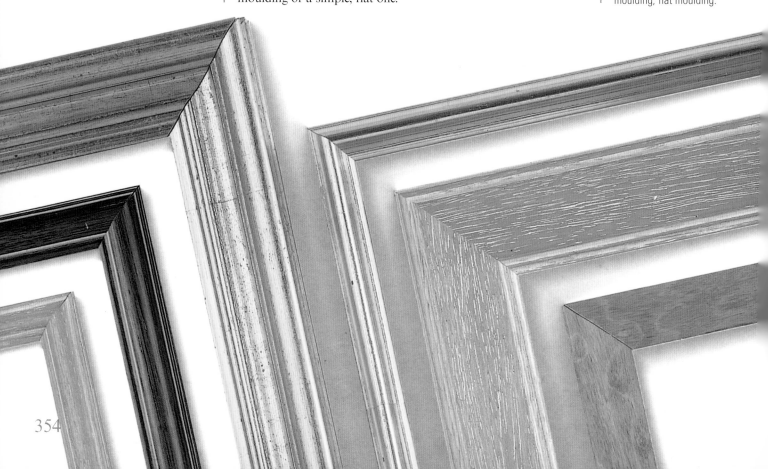

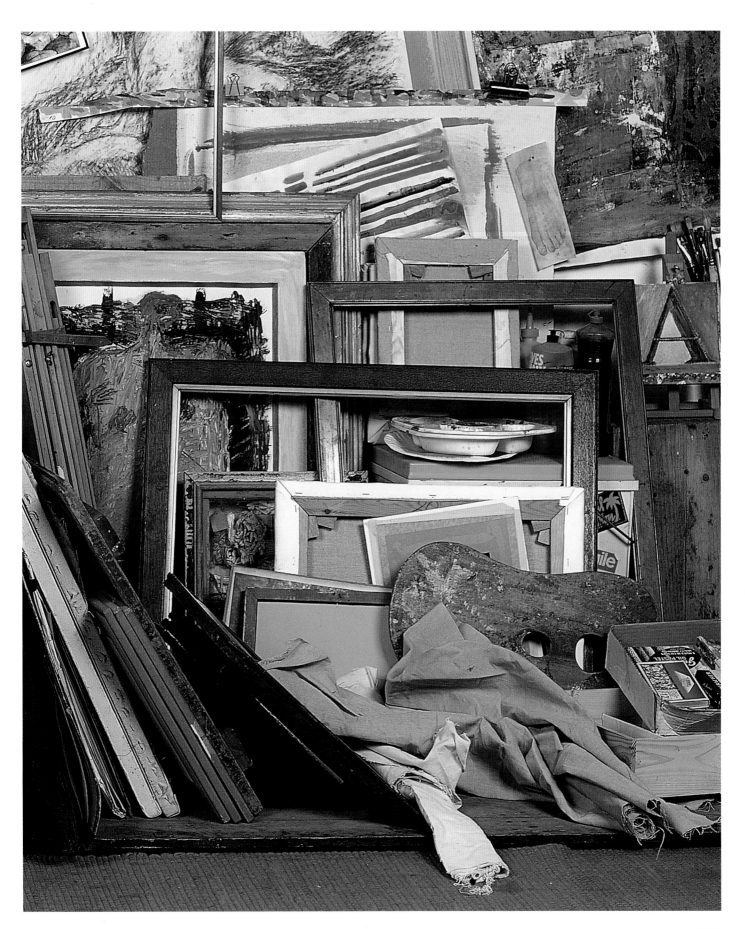

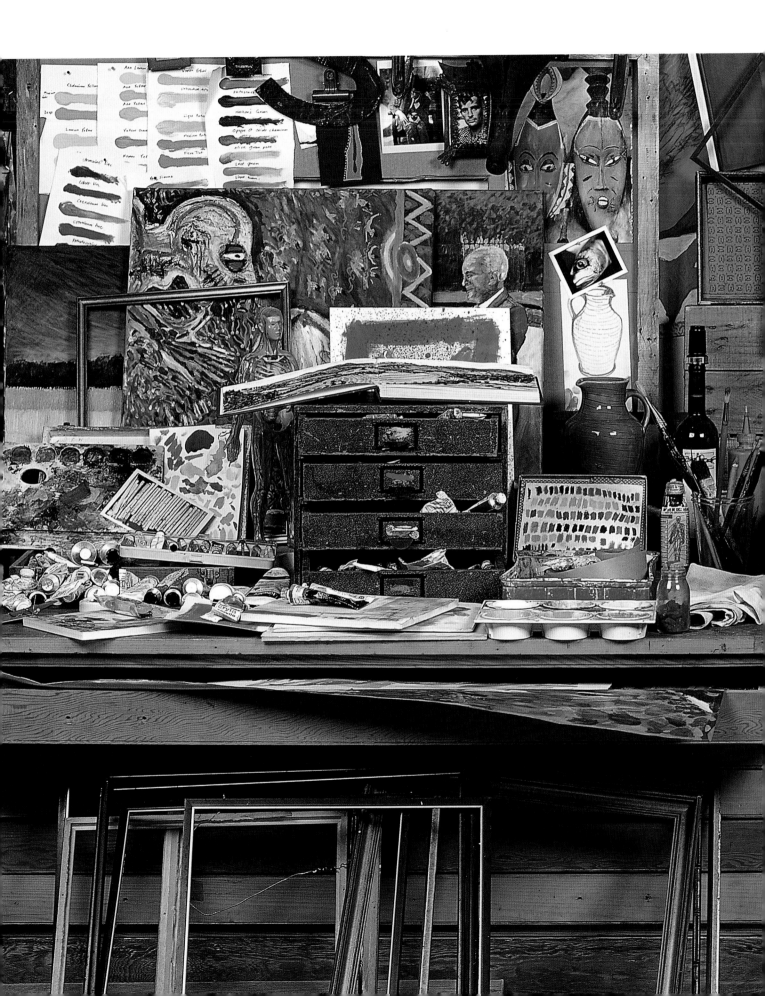

Chapter ten

Gallery of art

When choosing subjects to paint, most artists turn to the classic themes of still life, landscape, interiors, wildlife, portraiture and figure painting. There are, of course, many variations on these themes. Still life alone can encompass anything from a single object to a complex group of fruit and flowers. Townscapes, seascapes, sky studies and gardens are merely different forms of landscape painting. And when artists construct pictures purely from imagination, any or all of the classic themes could be combined in a single picture. The following pages feature a gallery of paintings to help you choose a subject and to inspire you.

Choosing a subject

Interpreting subjects

Ranging from a quintessential landscape to a striking nude study, this selection of pictures illustrates how a handful of artists drew inspiration from the classic painting themes. The potential for individual interpretation is further exemplified by a table-top still life, an intimate domestic scene, a view across a sun-dappled garden, and a stylistic representation of an artist's nightmare.

Presented on the following pages is a gallery of pictures that reflect the popular subjects to which artists return again and again. These pictures have been selected to show as wide a variety of painting styles as possible. But whatever you decide to paint, let it be your own choice and be sure to give your personal style full rein.

Chris Perry
(above)
Clockwork Dogs
Acrylic on hardboard
56 x 81cm (22 x 32in)

Ray Balkwill
(above right)
Vineyards near Alba
Pastel on paper
53 x 35.5cm (21 x 14in)

Timothy Easton
Roof Ridge with Roses
Oil on canvas
20 x 35.5cm (8 x 14in)

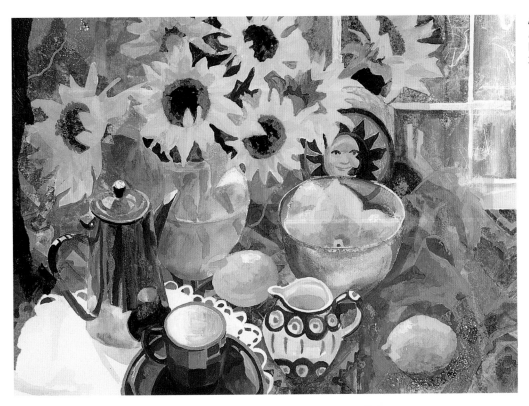

Anuk Naumann
Sunflowers and Lemons
Mixed media on paper
35.5 x 53cm (14 x 21in)

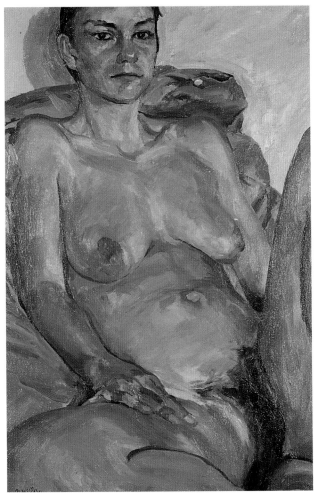

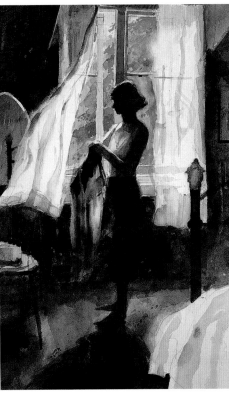

John Lidzey
*A Woman Dressing
at the Dell*
Watercolour on paper
50.5 x 35.5cm (20 x 14in)

Valerie Wiffen
Saxophonist
Oil on canvas
40.5 x 30cm (16 x 12in)

Painting still lifes

Still life

Painting some inanimate objects, either singly or in arranged groups, has obvious appeal – it's so easy to control. You can select and compose the objects at your leisure, pick a background that sets off the still life to advantage, choose the direction and form of lighting that gives you the required mood and, perhaps more importantly, you can take up and lay down your brushes at your convenience.

Ronald Jesty
(above)
Just a Lemon
Watercolour on paper
18 x 13cm (7 x 5in)

Colin Willey
(below)
Red Pepper
Oil on canvas
13 x 15cm (5 x 6in)

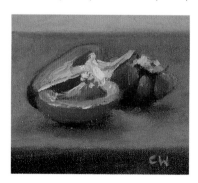

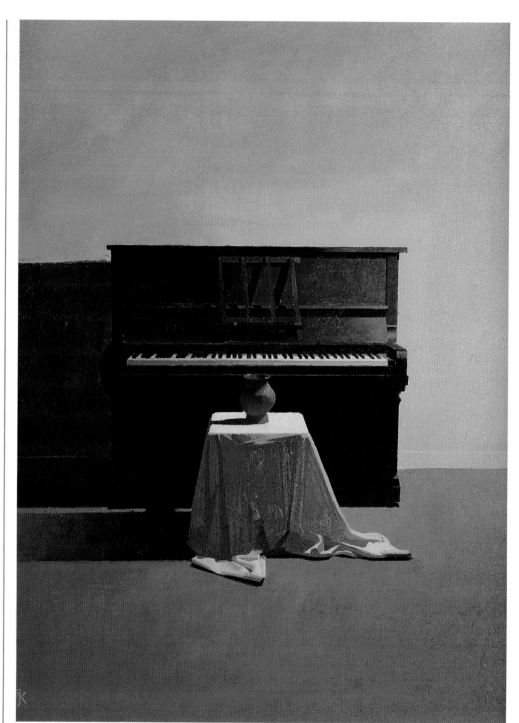

Peter Kelly
(above)
The Red Vase
Oil on canvas
43 x 33cm (17 x 13in)

From a single fruit to a kitchen dresser

Still-life painting offers such a variety of possibilities. Some artists enjoy making careful and detailed studies of simple objects, and will gain tremendous satisfaction from precisely rendering the skin of a fruit. For others, the exhilaration comes from painting more-complex arrangements of their favourite flowers and colourful props. For most painters, the object is to make their still-life paintings look as natural as possible, but a formal arrangement of props can lend a quite different, almost surreal, atmosphere to a painting.

Annie Williams
The Crocus Jug
Watercolour on paper
38 x 42cm (15 x 16¹/₂in)

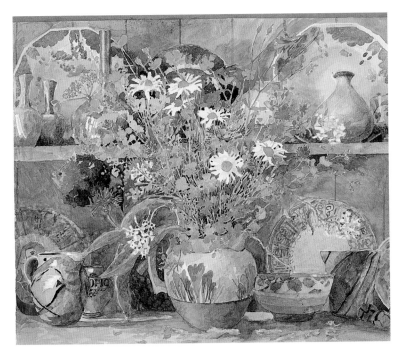

John Mitchell
Studio Window
Watercolour on paper
33 x 25cm
(13 x 10in)

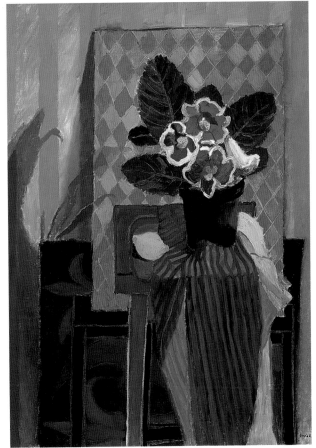

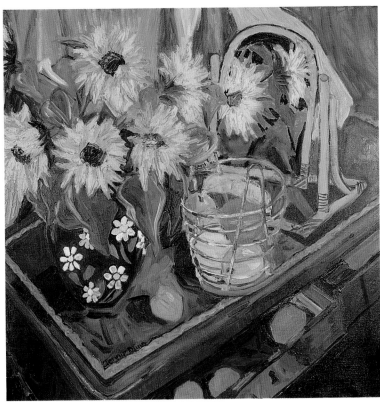

Jennie Dunn
Sunflowers Too
Oil on canvas
61 x 66cm (24 x 26in)

David Martin
Still Life with Gloxinia
Oil on canvas
101.5 x 76cm (40 x 30in)

361

Painting interiors

Rooms and interiors

Throughout history, artists have painted their familiar surroundings, often providing us with intimate snapshots that reveal the details of their personal lives. But if you are prepared to step into the wider world, there are also exciting possibilities for painting in public spaces, such as pubs, restaurants, railway stations and historical buildings.

John Lidzey
Cottage Bedroom
Watercolour on paper
30 x 30cm (12 x 12in)

Anuk Naumann (above)
A Mackerel for Supper
Mixed media on paper
25 x 25cm (10 x 10in)

Debra Manifold (below)
The Lady Chapel, Glastonbury Abbey
Acrylic on board
53 x 76cm (21 x 30in)

Inside outside

Painting a small corner of your own room is akin to painting a still life – you choose the viewpoint, rearrange the furniture to suit your composition and, if you don't already own suitable props to enrich the scene, you can buy, borrow or even invent them. You can also adjust or supplement ambient lighting to throw shadows exactly where you want them.

When you set up your easel to take in a wider view of an interior, daylight almost invariably plays a part. Strong, even diffused, light from a window can transform a scene, creating bold shadows or shafts of light and bringing the room to life with sparkling highlights and intriguing reflections.

In many instances, an artist will use a window to frame the view beyond, creating, in a single picture, a back-lit still life, an interior and a landscape.

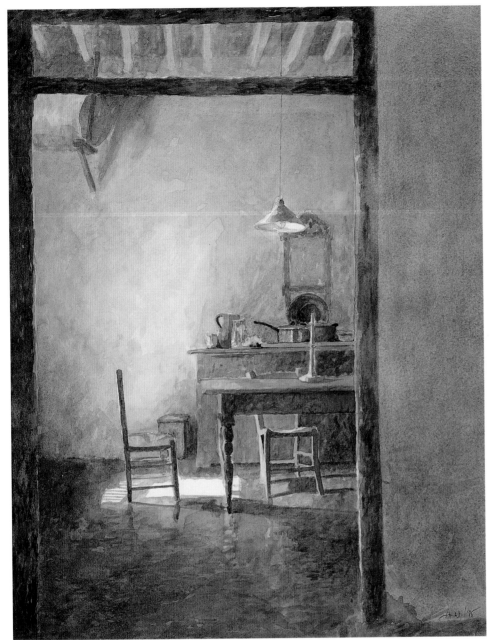

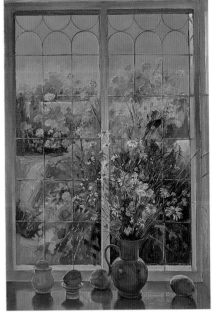

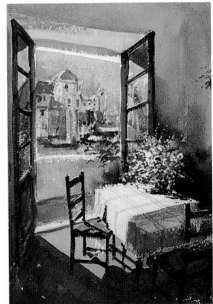

Annie Williams (above)
The Kitchen
Watercolour on paper
58.5 x 45.5cm (23 x 18in)

Timothy Easton
(top)
*Summer Flowers
at Dusk*
Oil on canvas
58 x 40.5cm
(23 x 16in)

Gerald Green
(above)
Interior
Watercolour on paper
35 x 25cm
(13$^1$/$_2$ x 10in)

Peter Kelly
*Table – Château
Champ de Bataille*
Oil on canvas
35.5 x 53.5cm (12 x 21in)

Buildings and townscapes

Urban landscapes

The urban landscape is a fascinating subject for many painters. Some beginners find the disciplines of perspective a little daunting, but the opportunities for including a rich variety of colour, texture and copious detail make townscapes and individual buildings irresistible subjects.

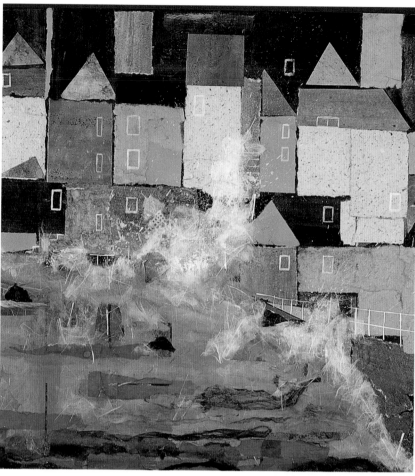

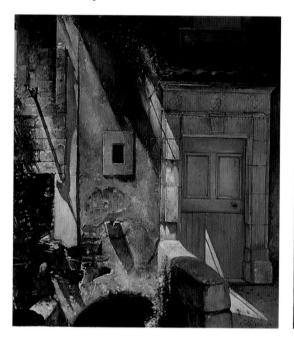

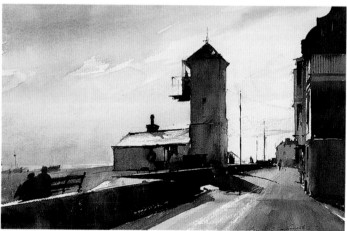

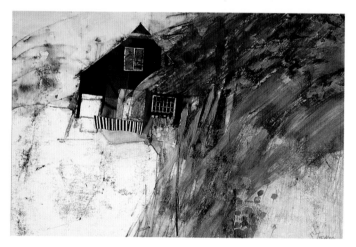

Brian Lancaster
(above)
The Watchtower
Watercolour on paper
34 x 52cm (13$^1$/$_2$ x 20$^1$/$_2$in)

Timothy Easton
(top left)
Noon Shadows
Oil on canvas
76 x 71cm (30 x 28in)

Shirley Trevena
(above)
House by the Forest
Mixed media on paper
27.5 x 39.5cm (10$^1$/$_2$ x 15$^1$/$_2$in)

Anuk Naumann
(top right)
Seawall, St. Ives
Mixed media on paper
30 x 30cm (12 x 12in)

Peter Graham
La Belle Promenade,
Villefranche-sur-Mer
Oil on canvas
66 x 65.5cm (26 x 25¹/₂in)

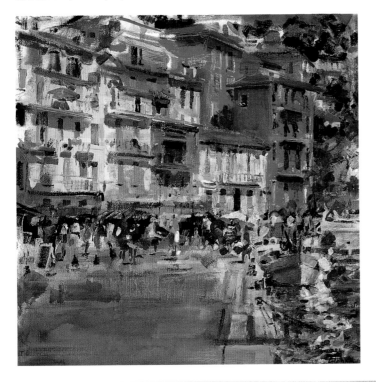

Buildings make a difference

Look around you, and you can hardly fail to see buildings that could make interesting additions to your paintings. Some merely nestle into a conventional landscape, providing a pleasing contrast to natural forms and colours. In other locations, however, the buildings might constitute the focal point of a painting, with industrial complexes or street scenes that are full of life and bustle.

Whether you choose to document your own town or village, or bring home sketchbook reminders of a holiday abroad, there are countless opportunities for painting buildings and townscapes.

Gerald Green (above)
Industrial Plant
Watercolour on paper
35 x 53cm (13¹/₂ x 21in)

David Curtis (left)
City Crowds – Piccadilly
Watercolour on paper
57 x 77.5cm (22¹/₂ x 30¹/₂in)

Painting landscapes

Landscapes

The classic open landscape has a broad appeal. It not only provides the unique experience of working directly from nature, but it also offers challenging opportunities for capturing almost limitless nuances of light and atmosphere. The more intimate 'close' landscape is characterized by comparatively detailed, sometimes colourful imagery, epitomized by a formal garden or dense woodland.

Timothy Easton
Buddleia and Lavender Field
Oil on canvas
25.5 x 30.5cm (10 x 12in)

Debra Manifold
(right)
Corner of the Woods
Pastel on sandpaper
51 x 63.5cm (20 x 25in)

John Mitchell
(far right)
Sgurr an Fheadain
Mixed media on paper
57 x 41cm (22$^1$/$_2$ x 16in)

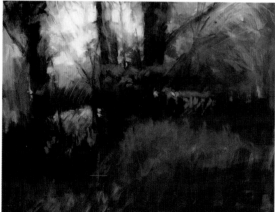

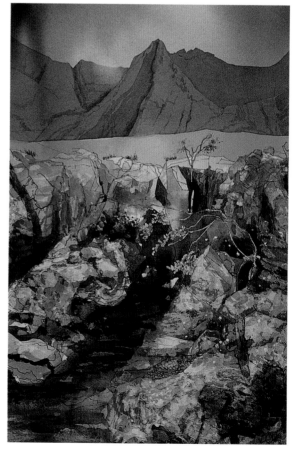

Colin Willey
(right)
Receding Clouds
Oil on board
20 x 25.5cm (8 x 10in)

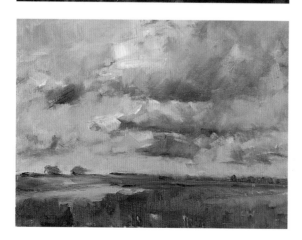

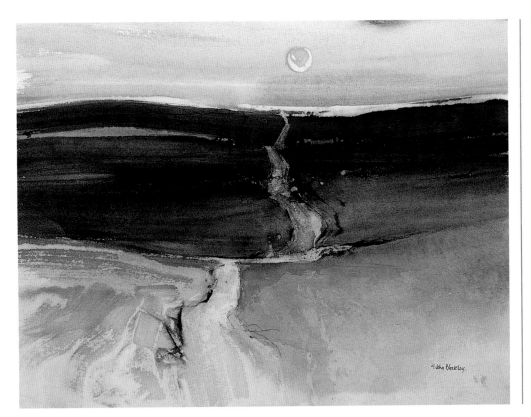

The natural landscape

Landscape is a genre that accommodates any style and treatment, from the semi-abstract to highly finished realism. Artists seem able to relax in front of a landscape, re-creating the easy-flowing lines, shapes and textures of nature. Furthermore, there isn't a single medium that does not lend itself to landscape painting, although some are perhaps more suited to studio painting than to working en plein air.

John Blockley
Moorland Road
Watercolour on paper
30.5 x 46cm (12 x 18in)

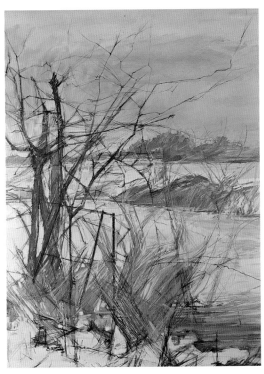

Anthony Atkinson
Winter at Horkesley
Oil on canvas
101.5 x 76cm (40 x 30in)

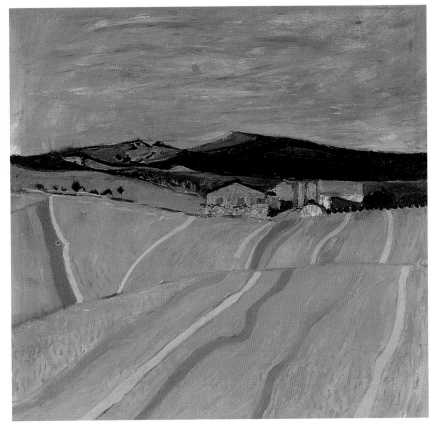

David Martin
After the Harvest, Cupar
Oil on canvas
91.5 x 91.5cm (36 x 36in)

367

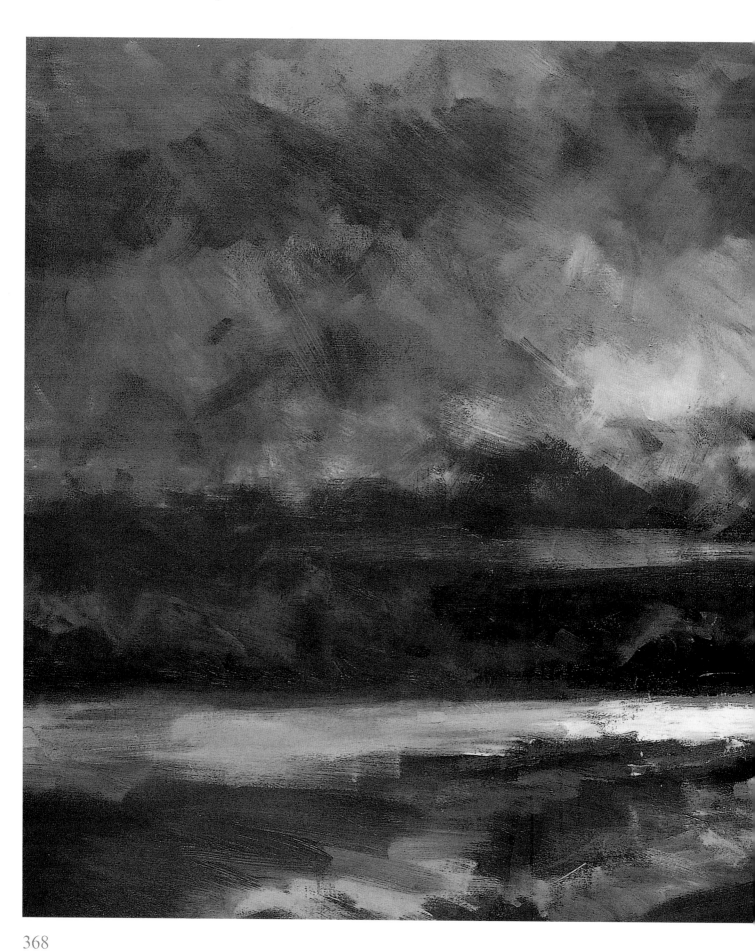

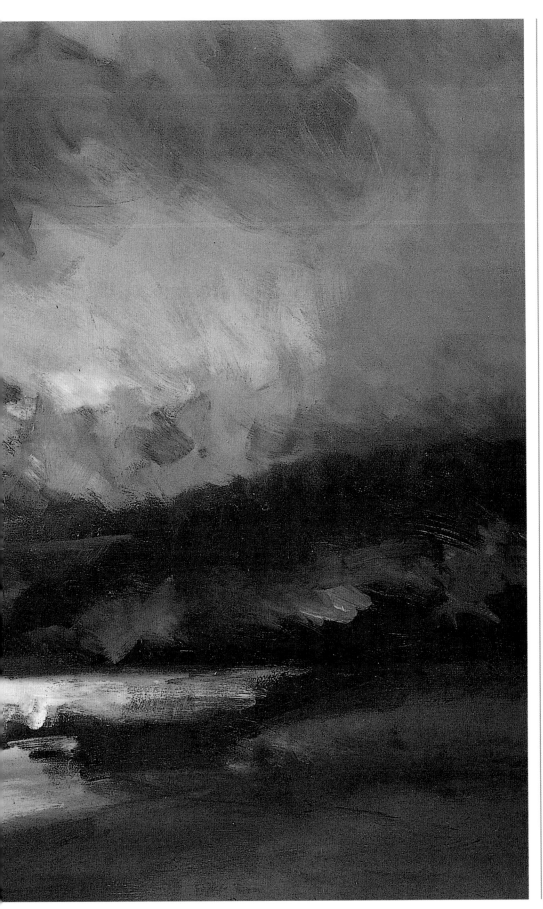

Simple landscapes

It is not necessary to search for 'picturesque' landscape subjects; some of the most memorable paintings are simple, everyday scenes. Begin with the places you know best, and try to uncover those things that awaken an emotional response in you. When you spot something that gets the adrenaline going, paint it there and then if you can, or at least make a sketch of it. Don't pass it by, thinking there might be greener pastures around the corner. That first moment of seeing is unique and cannot always be recaptured when you return to the subject at a later time.

Annabel Gault
Inverlussa Bay II
Oil on canvas
102 x 153cm (40 x 61 in)
Redfern Gallery, London

Painting water

Water and seascapes

There are few landscape artists who have not at some time been drawn to paint seascapes and other scenes featuring water. Whether a tranquil lake or breaking waves, water always adds drama to a picture. In fact, the sea and nautical subjects can be so compelling that some artists make marine painting their life's work.

Peter Kelly
Sunlight and Rain on the Grand Canal
Oil on canvas
28 x 38cm (11 x 15in)

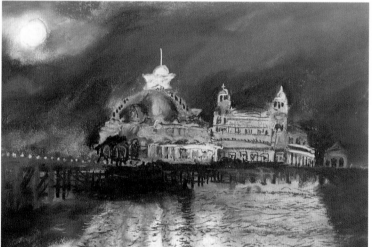

Anthony Atkinson (above)
Bend in the River near Langham
Oil on canvas
63.5 x 76cm (25 x 30in)

Chris Perry (above right)
Full Moon West Pier
Pastel on paper
30 x 42cm (11³/4 x 16¹/2in)

Timothy Easton (right)
Nettle, Willowherb and Lily Pads
Oil on canvas
25 x 35.5cm (10 x 14in)

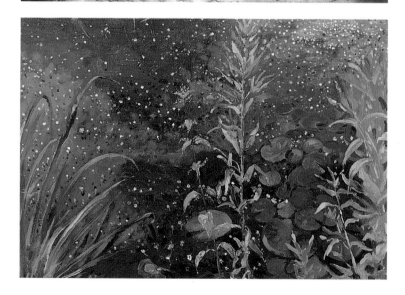

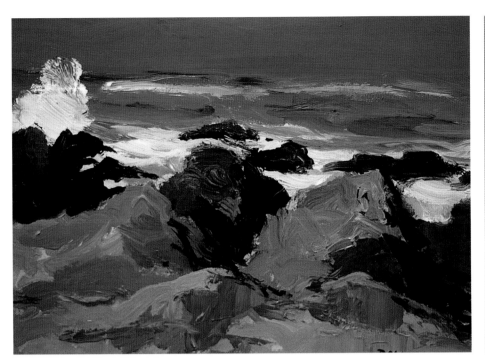

Beautiful obsession

If you are so inclined, painting water can easily become an obsession. From the reflections and play of light across a garden pond to the hypnotic motion of the sea, with its elusive textures of spray and foam, there is so much for you to paint. Water also provides the perfect foil for other elements in the landscape, be they mountains or buildings that are mirrored in a flat surface, or waterside plants and trees screened against a backdrop of shimmering colour.

Donald McIntyre
(left)
Green Sea
Acrylic on board
30.5 x 41cm (12 x 16in)

Brian Lancaster
(below)
Times of Change
Watercolour on paper
25 x 34cm (10 x 13½in)

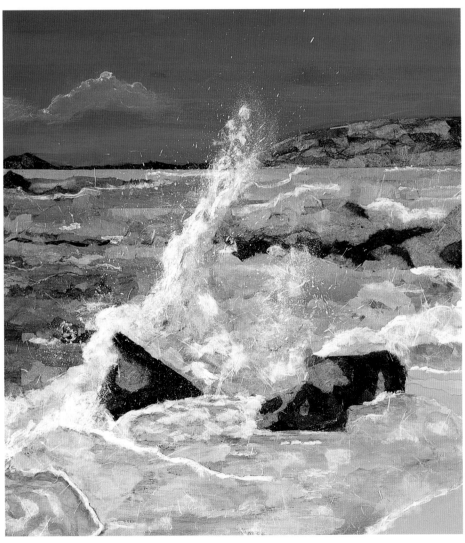

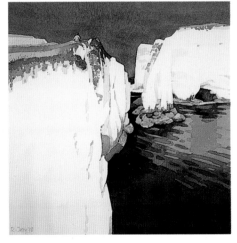

Anuk Naumann
(left)
Rough Sea
Mixed media on paper
40.5 x 40.5cm (16 x 16in)

Ronald Jesty
(above)
Handfast Point
Watercolour on paper
45.5 x 45.5cm (18 x 18in)

Expressing colour

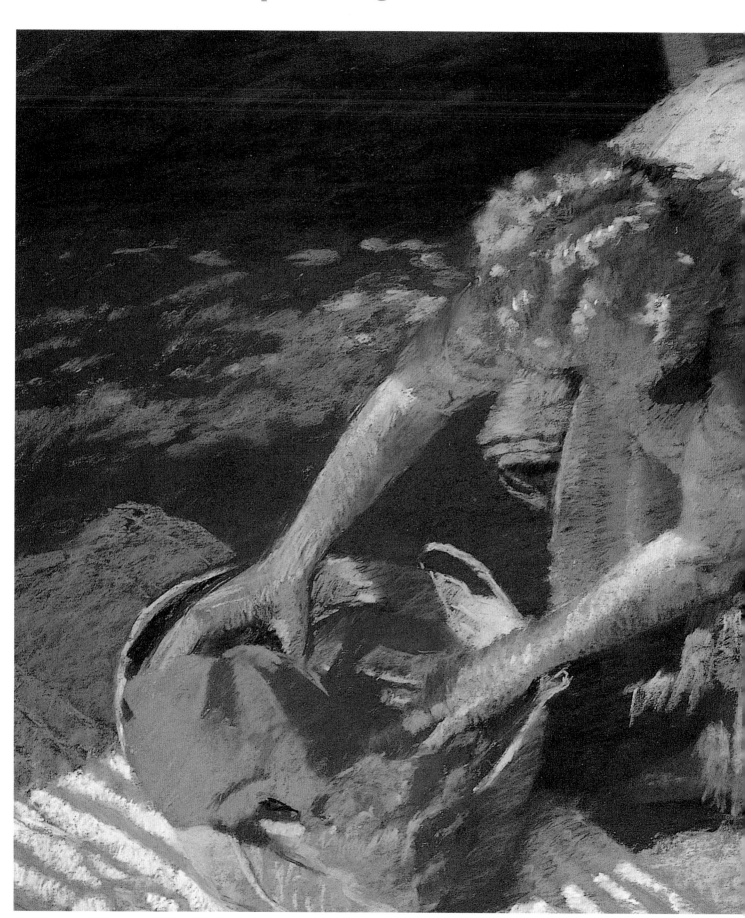

Understanding colour

Colour is such a personal and subjective area that it is perhaps inappropriate to discuss it in terms of rules and theories. Nevertheless, to paint well, it is important for an artist to have some understanding of how colours behave and how they relate to each other. Knowing how colours affect one another when mixed together or applied side by side; how they change under different kinds of lighting; why they fade and how they can be used to re-create form, shape, perspective and mood; understanding the optical effects of certain colour combinations and their psychological impact – all these are important if you are to succeed in making colour do what you want it to do.

Sally Strand
Knitting
Pastel on paper
57.5 x 76cm (23 x 30½in)

Painting figures

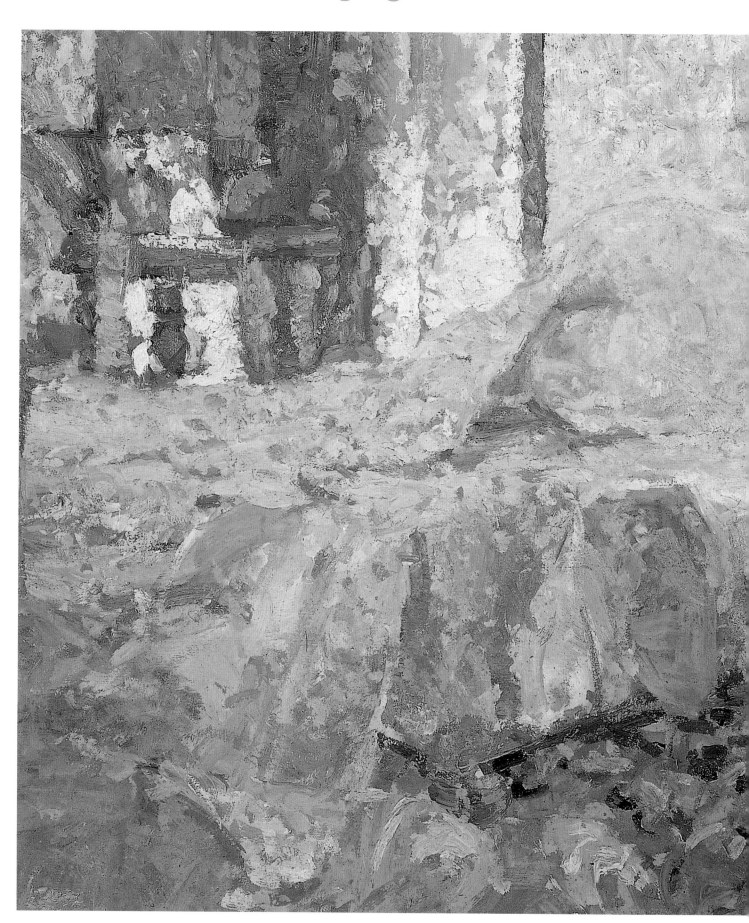

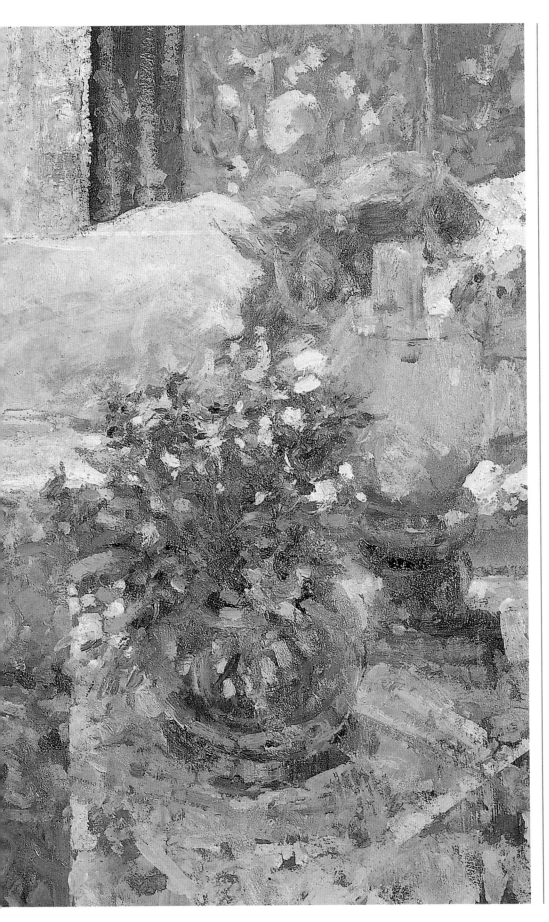

The human form

There is a continued fascination with the human form among artists, despite the advent of photography, and the traditions of portrait and figure painting are as strong today as they ever were. There is some truth in the old adage that 'if you can paint people well, then you can paint anything.' However, it is not essential to know about anatomy in order to paint or draw the human form successfully. More important are an enquiring eye and a willingness to keep practising, even if your first attempts are not successful.

Arthur Maderson
Verlayne Reclining
Oil on canvas
80 x 110cm (32 x 44in)

Figures and portraits

Figure painting and portraiture must be among the oldest artistic traditions, and the urge to depict the human form is as strong as ever. There are few subjects that hold such a fascination for artists, and fewer still that offer such a wealth of subtlety and variety.

Painting individuals and groups

You will no doubt want to tackle a nude study or clothed figure, either at a local life-painting class or in your own studio. But it is also worth going out into the street, or into cafés and bars where you can sketch interesting groups of figures and individuals. The workplace and sports clubs offer opportunities for observing people engaged in more-active pursuits.

Timothy Easton (right)
Down to the Sea
Oil on canvas
30 x 35.5cm (12 x 14in)

Debra Manifold
(below)
Lunchtime at the Café Rouge
Acrylic on board
76 x 48cm (30 x 19in)

Timothy Easton
(below right)
Returning the Blades, Henley
Oil on canvas
30 x 25cm (12 x 10in)

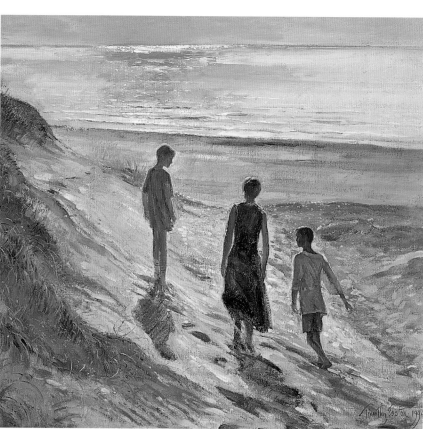

Chris Perry (left)
Tina
Pastel on paper
84 x 61cm (33 x 24in)

Ronald Jesty (below)
Red nude
Watercolour on paper
40.5 x 51cm (16 x 20in)

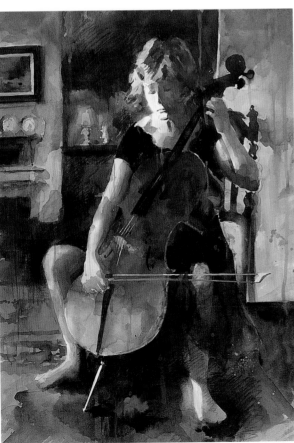

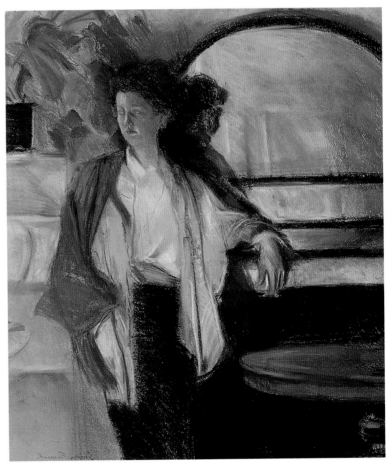

John Lidzey (left)
Anna Playing the Cello
Watercolour on paper
66 x 45.5cm (26 x 18in)

Sharon Finmark (above)
The Mirror
Pastel on paper
132 x 120cm (52 x 48in)

Painting figures and animals

Portraits

In the face of some strong competition from the camera, paintings of colleagues, family and friends constitute a unique personal record. Although we tend to think of a portrait as being a head-and-shoulders likeness of the sitter, there is much to be said for stepping back to take in the full figure. This may allow you to include a glimpse of the sitter's home, and perhaps incorporate their pets or partner. And don't forget the self-portrait – a time-honoured genre that enables you to work at your own speed and at your convenience.

David Cobley (below)
Girl with Wet Hair
Oil on canvas
51 x 51cm (20 x 20in)

Ken Paine (right)
The Flower Seller
Pastel on board
71 x 53cm (28 x 21in)

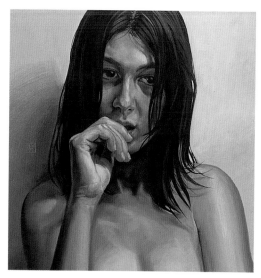

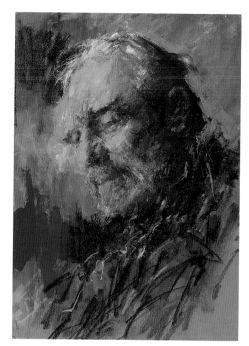

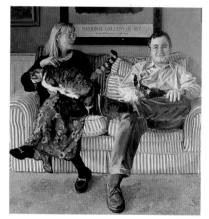

Alastair Adams (above)
Mr and Mrs G. Poston and Cats
Acrylic on MDF board
101.5 x 101.5cm (40 x 40in)

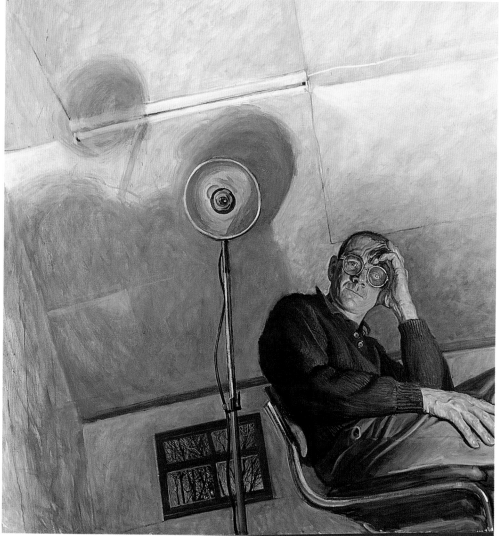

David Cobley (right)
Doubt – Self-portrait
Oil on canvas
168 x 168cm (66 x 66in)

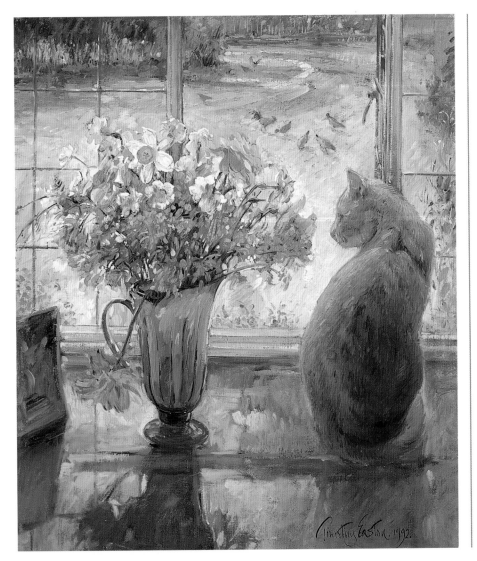

Wildlife painting

It takes a special talent, and not a little dedication, if we are to capture the unique qualities of animals and birds in their natural surroundings. But there is much to be gained from painting the delightful diversity of wildlife and other animals – including those that are literally on your doorstep, in the form of domestic animals and pets.

Animals and birds

If you are looking for the ideal quiescent model, what could be more perfect than the average domestic cat, who is usually to be found sprawled lazily somewhere in the house or outdoors in the shade? Birds and other natural history subjects are often perceived as the preserve of the specialist, requiring a great deal of scientific accuracy and detail. However, if you enjoy working outdoors and have an affinity with nature, don't be put off by the apparent difficulties of including wildlife in your paintings.

Timothy Easton (left)
Striped Jug with Spring Flowers
Oil on canvas
40.5 x 35.5cm (16 x 14in)

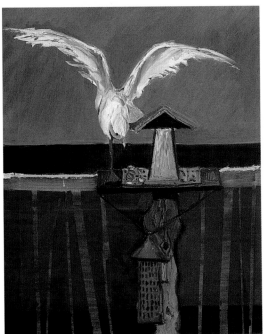

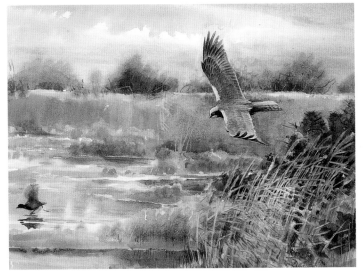

David Martin (left)
Gull on a Bird Table
Oil on canvas
101.5 x 76cm (40 x 30in)

Peter Partington (above)
Marsh Harrier Surprising Coot
Watercolour on paper
56 x 66cm (22 x 26in)

Painting from imagination

Imaginative painting

Painting pictures from your imagination can be very liberating. To what extent you allow fantasy to take over will dictate the degree of your inventiveness. Some artists put together images and references from disparate sources, creating imaginative compositions that are perfectly believable but which exist only in their heads. Other artists take the process much further, putting down their more fanciful thoughts, dreams and surreal visions onto paper and canvas.

Chris Perry
Scott of the Antarctic
84 x 61cm (33 x 24in)

Cutting loose

Follow your own muse, and let your ideas and thoughts bubble to the surface. Try developing the first idea that comes to mind and see where it takes you. You may discover that it's not a first idea at all, but a long-lost memory of some past experience, or a subconscious thought that has been lurking in the recesses of your mind, waiting for an opportunity to articulate itself.

Gigol Atler (below)
X-ray Hallucination
Oil on canvas
25.5 x 30.5cm (10 x 12in)

Surrealism and abstraction

Conjure with reality to create images that go beyond conventional representation. Go one step further and invent abstract images that are based on your own experiences and observations, creating paintings of pure colour and pattern.

David Cobley (left)
Mr Steven Berkoff
Oil on canvas
122 x 101.5cm (48 x 40in)

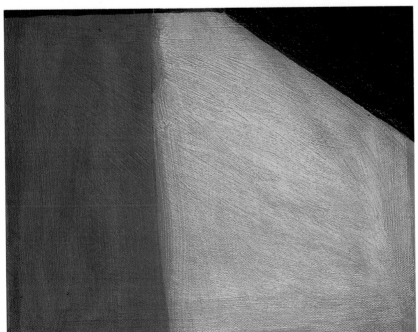

Simon Jennings (left)
Red and black No.1
Oil on canvas
20 x 25cm (8 x 10in)

John Ehrlich (above)
Ribbon
Acrylic and gouache on paper
42 x 29cm (16$^1$/$_2$ x 11$^1$/$_2$in)

Expressing light

Ken Howard
Spring Light, Mousehole
Oil on canvas
60 x 50cm (24 x 20in)

Simplicity and light
A vase of daffodils on a sunny windowsill is transformed
by the light behind it, shining through the translucent petals;
it is as if they were lit from within.

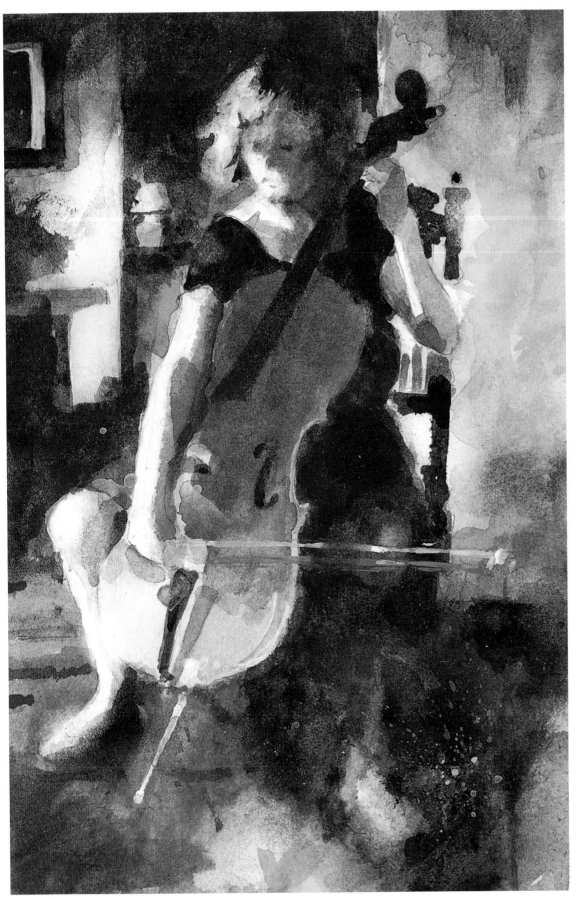

John Lidzey
Cello Practice
Watercolour on paper
31 x 19 cm (12 x 7½ in)

Watercolour may be freely
laid over other colours to
provide a painterly effect.
You can use paint in various
dilutions, allowing it to
blend with and cover the
underlying applications.

Reference & Index

This reference section contains invaluable information and is designed to back up the core of the book. Health and safety are featured, together with advice on how to read a paint tube. In the extensive glossary there are detailed explanations of all the specialized words and terms that are used, together with terminology that you may encounter in further reading. You can use the directory of art suppliers to source the artists' materials that you need. In addition to manufacturers' addresses, websites and email contacts are given in most cases.

Health and safety

Manufacturers of art materials pay a great deal of attention to current safety legislation; most manufacturers' catalogues provide reasonably detailed information on safety, toxicity and the like, and the products themselves are generally clearly labelled (see below).

Health hazards

Safety legislation differs from country to country, and there is no single international classification for all art materials, which basically means that a substance that is regarded as hazardous to health may be withdrawn or substituted in one country but not another, depending on the legislation.

Some of the most determined opposition to changes in the composition of paint has come from artists who fear that modern substitutes cannot give them the same results as traditional (but possibly more hazardous) pigments, such as cadmiums, lead chromes or cobalts.

Manufacturers, however, put a vast amount of time, money and research into finding alternative materials that approximate the original as closely as possible, in order to comply with evermore-stringent laws.

In the end, the decision of what to use and how to use it must be made by each individual artist, and the best way to work safely is to be well informed about the materials you are using. Read the catalogues, check the labelling, and don't be afraid to contact the manufacturers if you are concerned about a product's safety or quality.

Above all, you should always follow the manufacturer's instructions where printed. Making art is many things – creative, fun, inspiring, frustrating – but it need not be hazardous to your health.

Highly flammable
Products bearing this international label have a flash point of below 21°C. The containers should be kept closed when not in use, and should not be left near sources of heat or ignition. Do not breathe the vapour or spray, and keep the product away from children.

Harmful/irritant
This international label is used to mark products that are classified as either harmful or irritant; each classification has its own particular warnings. In both cases, do not breathe the vapour, and keep the product away from children. Avoid contact with skin and eyes, and wash thoroughly after use.

• **Interpreting labels**
These are the hazard labels you are likely to see on art products. Familiarity with their meanings will enable you to evaluate standards and possible hazardous use at a glance, and to use and store materials with minimum risk.

Health label (HL)
This American label, from the Art and Craft Materials Institute (ACMI), means that the product has been reviewed by an independent toxicologist under the auspices of the American Society for Testing and Materials (ASTM).

CP
An American label, again from the ACMI. 'CP' stands for Certified Product, in which the contents are non-toxic, even if ingested, and which meet or exceed specific quality standards.

AP
Another American label from the ACMI. 'AP' means Approved Product, one where the contents are non-toxic, even if ingested.

Reading a paint tube

It is well worth knowing the characteristics – permanence, lightfastness, transparency, and so on – of the paints you use. Although there may appear to be a bewildering amount of coded information on a standard tube of paint, this is actually quite simple to decipher, and the ability to 'read' a tube will help you to choose the right paint. The tube shown (right) is a composite, but all the information on it can be found on different tubes; each manufacturer's catalogue will provide further details particular to its brands.

Product code
This refers to the manufacturer's catalogue data or ordering code.

(Hue)
The suffix (Hue) indicates that a synthetic pigment has been substituted for a natural one because the latter is either no longer available, is too expensive or has been withdrawn due to possible health hazards. In some cases, a pigment name in brackets, such as (Phthalo), is added, to indicate the basic pigment used.

Permanence
The permanence of the colour is indicated by alphabetical, star or ASTM ratings,

Transparency
Some manufacturers also display transparency ratings of 0 (opaque), TL (translucent), or TP (transparent).

Content
The statutory declaration of tube content weight is given in millilitres (ml) for Europe and US fluid ounces (US fl.oz) for the United States.

Colour
Most names of colours are common to all brands, but some colourmen give certain colours a proprietary name: Winsor Violet or Rowney Turquoise, for example.

Quality
This name refers to the quality of the paint. Artists' colour is high quality, students' colour is the second grade and often features trade names, such as Georgian (Daler-Rowney) or Gainsborough (Grumbacher).

Series
A series number denotes the quality and cost of the pigment used. This typically ascends from 1, the cheapest, to 5 or 7, the best quality and most expensive.

094

FLAME RED
ROUGE FEU
FLAMENROT
(HUE)

ARTISTS
COLOUR
Couleur pour artistes
Künstlerfarben
Series 4

Permanence AA
★ ★ ★ ★
ASTM I

| 1 |
| 0 |

120 ml e
4 U.S. fl. oz.

• Codes and symbols
In additional to the above, some products carry other coded information to indicate transparency, mixing potential, safety information, and so on. The manufacturer's catalogue gives details.

Glossary of terms

In addition to the many everyday words used to describe art materials and techniques, there are equally as many that are unique. Most of the specialized words and terms used in this book are explained here, plus some others which you will come across in further reading.

A

Acrylic paint Any paint containing acrylic resin, derived from man-made acrylic or propenoic (derived from petroleum) acid.

Alkyd resin A synthetic resin used in paints and mediums.

Alla prima (Italian for 'at the first') Technique in which the final surface of a painting is completed in one sitting, without any underpainting. Also known as *au premier coup*.

ASTM The American Society for Testing and Materials. An internationally recognized, independent standard for certain paint qualities, adopted by most manufacturers.

B

Balance In a work of art, the overall distribution of forms and colour to produce a harmonious whole.

Binder A liquid medium mixed with powdered pigment to form a paint.

Bistre A brown, transparent pigment made by boiling beech-tree soot.

Bleeding In an artwork, the effect of a dark colour seeping through a lighter colour to the surface. Usually associated with gouache paint.

Blending Smoothing the edges of two colours together so that they have a smooth gradation where they meet.

Bloom A dull, progressively opaque, white effect caused on varnished surfaces by being kept in damp conditions.

Body colour Opaque paint, such as gouache, which has the covering power to obliterate underlying colour. 'Body' also refers to a pigment's density.

Brushwork The characteristic way in which each artist brushes paint onto a support, often regarded as a 'signature'; also used to help attribute paintings to a particular artist.

C

Casein A milk-protein-based binder mixed with pigment to make paint; most often associated with tempera.

Chiaroscuro (Italian for 'clear-obscure') Particularly associated with oil painting, this term is used to describe the effect of light and shade in a painting or drawing, especially where strong tonal contrasts are used.

Cissing The effect caused when a water-based paint either does not wet the support enough to adhere effectively, or is repelled by the surface. Also known as crawling or creeping.

Cockling Wrinkling or puckering in paper supports, caused by applying washes onto either a flimsy or inadequately stretched and prepared surface.

Composition This is the arrangement of elements by an artist in a painting or drawing.

Contre-jour (French for 'against the daylight') A painting or drawing where the light source is behind the subject.

Copal A hard, aromatic resin used in making varnishes and painting mediums.

Crosshatching More than one set of close parallel lines that crisscross each other at angles, to model and indicate tone. (*See also* hatching.)

D

Dammar A resin from conifer trees, used in making oil mediums and varnishes.

Dead colour A term for colours that are used in underpainting.

Diluents Liquids, such as turpentine, used to dilute oil paint; the diluent for water-based media is water.

Distemper A blend of glue, chalk and water-based paint, used mostly for murals and posters, but also sometimes for fine-art painting.

E

Earth colours These colours, the umbers, siennas and ochres, are regarded as the most stable natural pigments.

Encaustic An ancient technique of mixing pigments with hot wax as a binder.

F

Fat Used to describe paints which have a high oil content. (*See also* lean.)

Filler In painting, the inert pigment added to paint to increase its bulk, also called extender; or the matter used to fill open pores or holes in a support or ground.

Film A thin coating or layer of paint, ink, etc.

Fixative A solution, usually of shellac and alcohol, sprayed onto drawings, particularly charcoal, chalk and soft pastels, to prevent them smudging or crumbling off the support.

Format The proportions and size of a support.

Fresco (Italian for 'fresh') A wall-covering technique which involves painting with waterbased paints onto freshly applied wet plaster. Also known as *buon fresco*.

Fugitive colours Pigment or dye colours that fade when exposed to light. (*See also* lightfast and permanence.)

G

Genre A category or type of painting, classified by its subject matter – still life, landscape, portrait, etc. The term is also applied to scenes depicting domestic life.

Gesso A mixture, usually composed of whiting and glue size, used as a primer for rigid oil-painting supports.

Glaze In painting, a transparent or semi-transparent colour laid over another, different colour to modify or intensify it.

Grain *See* tooth.

Grisaille A monochrome painting in shades of grey, or a grey underpainting.

Ground A specially prepared painting surface.

Gum arabic A gum, extracted from certain Acacia trees, used in solution as a medium for watercolour paints.

H

Hatching A technique of modelling, indicating tone and suggesting light and shade in drawing or tempera painting, using closely set parallel lines. (*See also* crosshatching.)

Hue The name of a colour – blue, red, yellow, etc. – irrespective of its tone or intensity. (*See also* Reading a paint tube, page 245.)

I

Impasto A technique of applying paint thickly by brush painting knife or hand, to create a textured surface. Also the term for the results of this technique. (*See also* page 248.)

Imprimatura A primary coat of diluted colour, usually a wash, used to tone down or tint a white canvas or other support before painting.

Intensity The purity and brightness of a colour. Also called saturation or chroma.

Impasto
A technique of applying paint thickly by brush, palette knife or hand.

K

Key Used to describe the prevailing tone of a painting: a predominantly light painting is said to have a high key, a predominantly dark one a low key. In modern mural painting, the key is the result of scratching and preparing a wall surface ready for the final layer of plaster.

L

Landscape format A painting or drawing wider than it is tall. (*See also* portrait format.)

Lay figure A jointed wooden manikin which can ideally be moved into almost any pose or attitude, for studying proportions and angles, and for arranging clothing and drapery. Lay hands and horses are also available. (*See also* page 248.)

Leaching The process of drawing out excess liquid through a porous substance.

Lean Used as an adjective to describe paint thinned with a spirit such as turpentine or white (mineral) spirit, and which therefore has a low oil content. (*See also* fat.)

Lightfast Term applied to pigments that resist fading when exposed to sunlight. (*See also* fugitive.)

Local colour The actual colour of an object or surface, unaffected by

Lay figure and lay hand
Jointed wooden models which can ideally be moved into almost any pose or attitude.

shadow colouring, light quality or other factors; for instance, the local colour of a carrot is always orange, even with a violet shadow falling across it.

Loom-state Canvas that has not been primed, sized or otherwise prepared beforehand for painting.

M

Medium This term has two distinct meanings which are as follows: the first is the liquid in which pigments are suspended, for instance, linseed oil for oil painting, and acrylic resin for acrylic paints (the plural here is mediums). However, a medium is also the material chosen by the artist for working – paint, ink, pencil, pastel, etc. (the plural in this instance is media).

389

Mixed media
Different paints are used together.

Mixed media In drawing and painting, this refers to the use of different media in the same picture – for instance, ink, watercolour wash and wax crayon – or on a combination of supports – for instance, newspaper and cardboard.

Mixed method The process of using oil glazes on top of a tempera underpainting.

Mural Also sometimes referred to as wall painting, this word describes any painting made directly onto a wall. (*See also* fresco and secco.)

O

Opacity The covering or hiding ability of a pigment to obliterate an underlying colour. Opacity varies from one pigment to another.

P

Palette As well as describing the various forms of holders and surfaces for mixing paint colours, palette also refers to the artist's choice and blends of colours when painting.

Patina Originally the green-brown encrustation on bronze, this now includes the natural effects of age or exposure on a surface, such as old, yellowing varnish on an oil painting.

Pentimento (Italian for 'repented') In an oil painting, this is when evidence of previous painting shows through the finished work when the surface paint becomes transparent. The word also refers to unerased attempts to fix a line or contour in a drawing or painting.

Permanence Refers to a pigment's resistance to fading on exposure to sunlight. (*See also* fugitive and lightfast.)

Pigments The colouring agents that are used in all painting and drawing media, traditionally manufactured from natural sources but now including man-made substances. The word is also used to describe the powdered or dry forms of the agents.

Plasticity In a two-dimensional drawing or

Plein air
(French for 'open air')

painting, plasticity describes figures, objects or space with a strongly three-dimensional appearance, often achieved by modelling with great contrasts of tone.

Plein air (French for 'open air') A term describing paintings that are done outside, directly from the subject.

Portrait format A painting or drawing taller than it is wide. (*See also* landscape format.)

Primer Applied to a layer of size or directly to a support, this acts as a barrier between paint and support, and provides a surface suitable for receiving paint and mediums.

Proportion The relationship of one part to the whole or to other parts. This can refer to, for instance, the relation of each component of the human figure to the figure itself, or to the painting as a whole.

PVA Polyvinyl acetate, a man-made resin used as a paint medium and in varnish.

R

Recession In art, this describes the effect of making objects appear to recede into the distance by the use of aerial perspective and colour.

Reduction The result of mixing colour with white.

S

Sanguine A red-brown chalk.

Saturation The intensity and brilliance of a colour.

Scumble The technique of dragging one or more layers of dryish, opaque paint over a bottom layer that partially shows through the overlying ones.

Secco (Italian for 'dry') A technique of wall-painting onto dry plaster, or lime plaster that is dampened shortly before paint is applied.

Sfumato (Italian for 'shaded off') Gradual, almost imperceptible transitions of colour, from light to dark.

Sgraffito (Italian for 'scratched off') A technique of scoring into a layer of colour with a sharp instrument, to reveal either the ground colour or a layer of colour beneath.

Shade Term for a colour darkened with black.

Shaped canvas Any non-rectangular picture.

Shellac A yellow resin formed from secretions of the lac insect, used in making varnish.

Silverpoint A drawing method almost entirely superseded by the graphite pencil. A piece of metal, usually silver wire, was used to draw on a ground prepared with Chinese white, sometimes with pigment

added to the ground. There was no possibility of erasure. Also called metalpoint.

Sinopia A red-brown chalk used for the preliminary marking-out of frescoes; also the preliminary drawing itself.

Size A weak glue solution used for making gesso and distemper, for stiffening paper, and for making canvas impervious before applying layers of primer or oil paint.

Size colour A combination of hot glue size and pigments.

Sketch A rough drawing or a preliminary draft of a composition, which is not necessarily to be worked up subsequently. Sketches are often used as a means of improving an artist's observation and technique.

Squaring up A method for transferring an image to a larger or smaller format. The original version is covered with a grid of horizontal and vertical lines, and each numbered square is then copied onto its counterpart on a larger or smaller set of squares on

Scumble

a different support. Also known as gridding up.

Study A detailed drawing or painting made of one or more parts of a final composition, but not of the whole.

Support A surface used for painting or drawing: canvas, board, paper, etc.

T

Tempering In painting, mixing pigments with tempera to produce a hue.

Thixotropic Stiff fluids which become liquefied when stirred, shaken or brushed.

Tint Term for a colour lightened with white. Also, in a mixture of colours, the tint is the dominant colour.

Tinting strength The power of a pigment to influence mixtures of colours.

Tone The relative darkness or lightness of a colour, without reference to its local colour.

Tooth The texture, ranging from coarse to fine, of canvas or wood.

Traction In oils this is the movement of one layer of paint over another.

Traction fissure This usually occurs when the principles of painting 'fat-over-lean' in oils have not been applied, leading to cracking of the top layer or layers of paint or varnish.

Tragacanth A gum, which is extracted from certain Astragalus plants, used as a binding agent in watercolour paints and pastels.

Transparency The state of allowing light to pass through, and of filtering light.

Trompe l'oeil (French for 'deceive the eye') A painting, usually a still life with extreme, naturalistic details, which aims at persuading the viewer that he or she is looking at actual objects, rather than a representation of them.

U

Underpainting The traditional stage in oil painting of using a monochrome or dead colour as a base for composition, overall tone and subsequent colour glazes. Also known as laying in.

V

Value An alternative word for 'tone', 'value' is used mainly in the United States. The term 'tonal value' refers to the relative degree of lightness or darkness of any colour, on a scale of greys running from black to white.

Veduta (Italian for 'view') An accurate representation of an urban landscape.

Vehicle A medium that carries pigments in suspension and makes it possible to apply them to a surface; sometimes called the base. The word also

describes a combination of medium and binder.

Venice turpentine An oleo-resin – the semi-solid mixture of a resin and an essential oil – derived from the larch and used primarily in making mediums and diluents for oil painting.

Verdaccio An old term for green underpainting.

Volume The space that a two-dimensional object or figure fills in a painting.

W

Wash A thin, usually broadly applied, layer of transparent or heavily diluted paint or ink.

Wetting agent A liquid – oxgall or a synthetic equivalent – added to watercolour paint to help it take evenly and smoothly on a support.

Whiting Ground and washed chalk which is used in making gesso and whitewash.

Y

Yellowing This effect on oil paintings is usually caused by one of three reasons: excessive use of linseed-oil medium in the paint; applying any of the varnishes that are prone to yellowing with age; or – most often of all – an accumulation of dirt that embeds itself into the surface of the varnish.

Art-materials suppliers

For reasons of space, this manual cannot list all the manufacturers and distributors of artists' materials worldwide, but the principal contacts in Europe, North America and the United Kingdom are included here.

If you are unable to purchase a particular art material, the manufacturers and distributors listed below will be able to put you in touch with your nearest supplier, and will be pleased to send you catalogues, information and advice on their products.

Berol

(graphite, charcoal, coloured and water-soluble pencils; marker, fountain and fibretip pens; drawing supports and accessories)

Berol Ltd
Berol House, Oldmedow Road,
King's Lynn, Norfolk PE30 4JR
www.berol.co.uk

Berol Corporation
105 West Park Drive, PO Box 2248
Brentwood, TN 37024–2248, USA
www.berol.com

Bird & Davis Canvases

(painting supports)

Bird & Davis
45 Holmes Road, Kentish Town,
London NW5 3AN
Tel: 0207 485 3797
www.birdanddavis.co.uk

Canson

(watercolour and drawing papers; mounting boards)

ArjoWiggins Fine Papers Pty Ltd
Fine Papers House, PO Box 88,
Lime Tree Way, Chineham,
Basingstoke, Hants RG24 8BA
Tel: 01256 728728
Fax: 01256 728889
www.arjowiggins.com

ArjoWiggins SAS
Headquarters
117 Quai du Président Roosevelt,
92 44 2 Issy-les-Moulineaux, France

ArjoWiggins USA Inc
2187 Atlantic Street, Suite 603,
Stamford, CT 06902, USA
Tel: 203 674 6700

Caran d'Ache

(graphite, coloured, water-soluble and pastel pencils; marker and fibre-tip pens; drawing accessories)

Jakar International Ltd
Hillside House, 2–6 Friern Park,
London N12 9BX
Tel: 0208 445 6376
Fax: 0208 445 2714
Email: info@jakar.co.uk
www.jakar.co.uk

Caran d'Ache SA
Headquarters
19 Chemin du Foron, PO Box 332,
CH–1226 Thônex-Genève,
Switzerland
www.carandache.ch

Caran d'Ache of Switzerland
38–52 43rd Street, 11101 Long Island
City, New York
Tel: 718 482 7500
Fax: 718 482 6700
www.CdAofS@aol.com

ChromaColour

(Chroma colours and accessories; moist palettes)

ChromaColour International
Unit 5, Pilton Estate, Pitlake, Croydon,
Surrey CR0 3RA
Tel: 0208 688 1991
Fax: 0208 688 1441
sales@chromacolour.co.uk
www.chromacolour.co.uk

ChromaColour International
Head Office, 1410–28 Street NE,
Calgary, Alberta T2A 7W6, Canada
Tel: 403 250 5880
Email: info@chromacolour.com
www.chromacolour.com

Arts Desire
5604 North East, St John's Road,
Vancouver, Washington 98661, USA
Email: artsdesire@bevelar.com
www.bevelar.com

Daler-Rowney

(oil, acrylic, gouache and watercolour paints, brushes, supports and accessories; pastels; drawing supports; framing and mounting equipment; studio equipment)

Daler-Rowney Ltd
PO Box 10, Bracknell, Berkshire
RG12 8ST
Tel: 01344 461000
Fax; 01344 486511
www.daler-rowney.co.uk

Daler-Rowney USA
2 Corporate Drive, Cranbury, NJ
08512–9584, USA
Tel: 609 655 5252
Fax: 609 655 5852
www.daler-rowney.com

Daler-Rowney Europe
Rue des Technologies 4, B–1340
Ottignies, Belgium
Tel: 01045 2545

Faber-Castell

(graphite, coloured, watersoluble, charcoal and conté pencils; charcoal sticks; graphite sticks; marker and fibre-tip pens; pastels, technical pens; drawing accessories)

West Design Products Ltd
Unit 1A, Part Farm Road, Folkestone, Kent CT19 5EH
Tel: 01303 247110
Fax: 01303 247111
Email: sales@westdesign.cix.co.uk
www.faber-castell.com

A.W. Faber-Castell USA Inc
9450 Allen Drive, Cleveland, OH 44125, USA
Tel: 216 643 4660
Fax: 216 643 4664

Falkiner Fine Papers

(painting and drawing supports, specialist papers)

Falkiner Fine Papers Ltd
76 Southampton Row, London WC1B 7AR
Tel: 0207 831 1151
Fax: 0207 430 1248

Gerand

(brushes)

Gerand Brushes
Gerand House, 41 Alric Avenue, London NW10 8RA
Tel: 0207 515 9355

Grumbacher

(oil, water-friendly oil, acrylic and watercolour paints, brushes and accessories; pastels)

M. Grumbacher Inc
100 North Street, Bloomsbury, NJ 08804, USA

Koh-i-noor Rapidograph
1815 Meyerside Drive, Mississauga, Ontario L5T 1G3, Canada

Inscribe

(watercolour and Chinese paints and brushes; painting accessories; pastels; marker and fibre-tip pens; coloured and water-soluble pencils; drawing accessories; studio equipment)

Inscribe Ltd
51 Woolmer Way,
Woolmer Industrial Estate, Bordon, Hampshire GU35 9QE
Tel: 01420 475747

Khadi

(Asian painting and drawing papers)

Khadi Papers
Unit 3, Chilgrove Farm, Chilgrove, Chichester, W. Sussex POI8 9HU
Tel: 01243 535314
www.khadi.com

Lefranc & Bourgeois

(oil, gouache and watercolour paints and accessories; pastels; conté crayons and pencils; graphite, coloured, water-soluble and charcoal pencils; charcoal and compressed-charcoal sticks; drawing accessories)

Lefranc & Bourgeois
5 Rue René Panhard, 21 Nord 72021 Le Mans, Cedex 2, France
Tel: 02 43 83 83 00
Fax: 02 43 83 83 09
www.lefranc-bourgeois.com

Liquitex

(acrylic and oil paints and accessories)

ColArt
Whitefriars Avenue, Wealdstone, Harrow HA3 5RH
Tel: 0208 427 4343
Fax: 0208 863 7177
www.Liquitex.com

Maimeri

(oil, acrylic, watercolour & gouache paints, brushes and accessories; oils supports; studio equipment)

Maimeri SpA
Via Gianni Maimeri 1, 20060 Mediglia, Milano, Italy
Tel: 02 906 98229
Fax: 02 906 98999
www.maimeri.it

Martin/F. Weber

(oil, acrylic and watercolour paints, brushes and accessories; charcoal; oil pastels; studio equipment)

Martin/F. Weber Co.
2727 Southampton Road, Philadelphia, PA 19154–1293, USA
Tel: 215 677 5600
Fax: 215 677 3336
Email: info@weberart.com
www.weberart.com

Pebeo

(oil, acrylic and gouache paints, brushes and accessories; watercolour and drawing paper; drawing inks; studio equipment)

Pebeo SA
Parc D'Activites de Gemenos 305, Avenue du Pic-de-Bertagne, Cedex F–13881 , Gemenos, France
Tel: 33 (4) 42 32 08 08
Email: info@pebeo.com
www.pebeo.com

Pebeo of America Inc
Route 78 Airport Road, PO Box 717, Swanton, VT 05488, USA
Email: info@pebeo.net

Pentel

(watercolour paint; pastels; technical, marker and fibre-tip pens; graphite pencils)

Pentel (Stationery) Ltd
Hunts Rise, South Marston Park Swindon, Wiltshire SN3 4TW
Tel: 01793 823333
Fax: 01793 823366
www.pentel.com

Pentel of America Ltd
Corporate Headquarters
2805 Columbia Street, Torrance,
CA 90509, USA
Tel: 310 320 3831

Pentel GmbH
Ladermannbogen 143,
2000 Hamburg 63, Germany

Euro Pentel SA
43 Rue Francois de Troy,
94360 Bry sur Marne, France

Pentel Stationery of Canada Ltd
140–5900 No. 2 Road, Richmond,
British Columbia V7C 4R9, Canada

Pentel (Australia) Pty Ltd
Unit 4/7–9 Orion Road, Lane Cove,
NSW 2066, Australia

Pro Arte
(brushes)

Pro Arte Ltd
Park Mill, Brougham Street, Skipton,
North Yorks BD23 2JN
Tel: 01756 791313
Fax: 01756 791212
Email: admin@proarte.co.uk
www.proarte.co.uk

Raphael & Berge
(brushes)

Max Sauer SA
2 Rue Lamarek, BP 204,
22002 Saint-Brieuc, France
www.max-sauer.com

Rexel Derwent
(graphite, watersoluble, pastel,
charcoal, coloured and conté pencils;
drawing supports; accessories)

Acco-Rexel Ltd
Gatehouse Road, Aylesbury, Bucks
HP19 3DT
Tel: 01296 397444
www.acco.co.uk

Rotring
(technical, fountain and art pens;
drawing inks; pencils)

Rotring UK
430 Strathcona Road Wembley
Middlesex HA9 8QP
Tel: 0208 908 2577
Fax: 0208 908 4476

Koh-i-noor Rapidograph Inc
100 North Street, PO Box 68,
Bloomsbury, NJ 08804-0068, USA
www.koh-i-noor.com

St Cuthbert's
(watercolour supports)

St Cuthbert's Paper Mill
Wells, Somerset BA5 IAG
Tel: 01749 672015
Fax: 01749 678844
www.inveresk.co.uk

Schminke
(oil, watercolour and gouache paints;
pastels)

C. Roberson & Co
1A Hercules Street, London N7 6AT
Tel: 0207 272 0567
www.robco.co.uk

H. Schminke & Co GmbH
Otto-Hahn-Straße 2 , D–40699
Erkrath, Germany
Tel: 02 11 25090
www.schminke.com

Sennelier
(oil and watercolour paints and
brushes; pastels; inks;

Tollit & Harvey Ltd
Lyon Way, Greenford,
Middlesex UB6 OBN

Sennelier
Rue du Moulin à Cailloux Orly Senia
408, 94567 Rungis Cedex, France
www.sennelier.fr

Talens
(oil, acrylic and gouache paints,
brushes, accessories)

Royal Talens BV
Head Office, PO Box 4, 7300 AA
Apeldoorn, The Netherlands
Tel: (55) 527 4700
Email: info@talens.com
www.talens.com

Two Rivers
(watercolour supports)

Two Rivers Paper Co
Pitt Mill, Roadwater, Watchet,
Somerset TA23 OQS
Tel: 01984 641028

Unison
(soft pastels)

Unison
Thorneyburn, Tarset, Hexham,
Northumberland NE48 INA
Tel: 01434 240457

Winsor & Newton
(oil, acrylic, gouache and watercolour
paints, brushes, materials and equipment)

Winsor & Newton
Whitefriars Avenue Wealdstone, Harrow
HA3 5RH
Tel: 0208 427 4343
www.winsornewton.com
Email: uktechhelp@winsornewton.com

Winsor & Newton US
ColArt Americas Inc, PO Box 1396,
Piscataway, NJ 08855-1396, USA
Tel 732 562 0770

The Yorkshire Charcoal Company
(beech charcoal)

Yorkshire Charcoal Co
Brompton Moor House, Sawdon,
Scarborough N. Yorks YO13 9EB
Tel: 01723 864957